HISTORICISM, PSYCHOANALYSIS, AND EARLY MODERN CULTURE

CULTUREWORK
A book series from the Center for Literary and Cultural Studies
at Harvard University
Marjorie Garber, editor
Rebecca L. Walkowitz, associate editor

Also published in the series:

Field Work
Marjorie Garber, Paul B. Franklin,
and Rebecca L. Walkowitz

Media Spectacles
Marjorie Garber, Jann Matlock,
and Rebecca L. Walkowitz

Secret Agents
Marjorie Garber and Rebecca L. Walkowitz

The Seductions of Biography
Mary Rhiel and David Suchoff

One Nation under God?
Marjorie Garber and Rebecca L. Walkowitz

HISTORICISM,

PSYCHOANALYSIS, AND

EARLY MODERN CULTURE

CARLA MAZZIO AND DOUGLAS TREVOR, EDITORS

Routledge

New York and London

Published in 2000 by

Routledge
29 West 35th Street
New York, NY 10001

Published in Great Britain by

Routledge
11 New Fetter Lane
London EC4P 4EE

Routledge is an imprint of the Taylor & Francis Group.

Chapter 16, "Second-Best Bed," by Marjorie Garber, is
reprinted from *Symptoms of Culture*, by Marjorie Garber,
Routledge, 1998.

Library of Congress Cataloging-in-Publication Data
Historicism, psychoanalysis, and early modern culture /
 edited by Carla Mazzio and Douglas Trevor
 p. cm. — (Culture work)
 Includes bibliographical references and index.
 ISBN 0-415-92052-3. ISBN 0-415-92053-1 (pbk.)
 1. Historicism. 2. Psychoanalysis. 3. Civilization, Modern.
 I. Mazzio, Carla, 1965– . II. Trevor, Douglas. III. Series
 D16.9.H529 2000
 901—dc21 99-31717
 CIP

CONTENTS

LIST OF FIGURES

ACKNOWLEDGMENTS

We would like to thank our contributors not only for their essays but also for their remarkable generosity and thoughtfulness throughout the process of putting this book together. Marge Garber has supported our project from the very beginning, adding invaluable insight and encouragement at every step. Bill Germano, our editor, was an endless fount of wit and wisdom. The Renaissance Colloquium and the Center for Literary and Cultural Studies at Harvard University, and the Society of Fellows at the University of Michigan, provided important support for us at various stages of the project. For their challenging and helpful comments, we are deeply grateful, as always, to Barbara Lewalski, Jeffrey Masten, John Guillory, Derek Pearsall, Tom Conley, Eric Wilson, and Gina Bloom. Our thanks most especially to Paula Mazzio and Ben and Libby Trevor.

CARLA MAZZIO AND DOUGLAS TREVOR

DREAMS OF HISTORY

An Introduction

Psychoanalysis is history. This sentence might be taken to encapsulate the methodological shift in early modern studies over the past decade, where "historicism" has become the default mode of critical practice and where histories of religion, education, material culture, and textual production are emerging from literature departments and academic presses in the form of dissertations, books, conferences, and collections. We invoke this sentence, however, to begin to rethink what might seem to be a methodological incompatibility and to challenge the seeming eclipse of one mode of inquiry by another. While psychoanalysis is history in the sense that it has been powerfully challenged over the last several decades of literary study, in another important sense psychoanalysis really *is* history: a method of interpretation organized around generating narratives of the past. As Meredith Skura puts it, "[T]he past is inseparable from recapturing the past, psyche is inseparable from history," and indeed for many recent critics of early modern literature and culture the practices of psychoanalysis and historicism are deeply entwined.[1]

This has not always been the case. With the rise of the new historicism in the 1980s, an increasing number of critics have emphasized the contestatory relations between psychoanalysis and historicism.[2] Most notably, perhaps, Stephen Greenblatt's "Psychoanalysis and Renaissance Culture" posed a challenge to the ahistoricism of some Freudian approaches

to early modern culture, positing that "psychoanalysis can redeem its belatedness only when it historicizes its own procedures."[3] More recently, however, a range of less contestatory cross-pollinations have begun to surface: Debora Shuger has explored the historical roots of psychoanalytic models, arguing that "Calvinist anthropology . . . seems less an early version of Cartesian dualism than a precursor of the Freudian allegory of id, ego, and superego";[4] Leah Marcus has considered the way in which "recent psychoanalytic theory and psychohistory can be placed in the service of postmodernist self-reflection and speculation about the hidden agendas behind our interpretive practice";[5] and Greenblatt himself has found some psychoanalytic terms to be useful for articulating the implications of his own work, as his recent invocation of the writings of Lacanian theorist Slavoj Žižek suggests.[6]

Although historicism and psychoanalysis have often been positioned as incompatible methodologies, much recent theory has worked to draw links between conceptions of history and psyche.[7] In her most recent work, Judith Butler sets out to theorize the "psychic life of power," suggesting that "[s]uch a project requires thinking the theory of power together with a theory of the psyche, a task that has been eschewed by writers in both Foucauldian and psychoanalytic orthodoxies."[8] Similarly, cultural theorist Joan Copjec rejects what she terms a Foucauldian "reduction of society to its indwelling network of relations of power and knowledge" in order to privilege a Lacanian model, which she finds more amenable to the analysis of the linguistic and ideological aspects of the historical process.[9]

With psychoanalytic turns to history (largely filtered through readings of Lacan) and historicist turns to discourses of interiority (largely indebted to Foucault), the distinctions between historicist and psychoanalytic criticism become more difficult to draw. Accordingly, the work of theorists of early modern culture has become increasingly complicated. Less intent on upholding particular models of analysis than on rethinking and recasting their effects, many contemporary critics have come to resist the labels that once accompanied certain sets of topical interests and reading strategies.[10] We see here the influence of postmodern epistemologies at work in critical theory; for, as Ernesto Laclau and Chantal Mouffe point out, "[T]here is not *one* discourse and *one* system of categories through which the 'real' might speak. . . . Just as the era of normative epistemologies has come to an end, so too has the era of universal discourses."[11] Indeed, the powerful influence of deconstruction in the

fields of political theory and psychoanalysis has sparked a whole series of dialogues between seemingly disparate methodologies and discursive practices.

It is suggestive in this respect to note the ways in which the methodologies of historicism and psychoanalysis often operate by means of the same constellations of terms: *anxiety, alienation, desire, otherness, fetish,* and *symptom,* to name a few.[12] Theorizing the terminology of the "symptom" as it surfaces in both cultural materialism and psychoanalysis, Žižek suggests that "there is a fundamental homology between the interpretive procedure of Marx and Freud — more precisely, between their analysis of commodity and of dreams."[13] The shared terminologies of Marx and Freud, in other words, call attention to the often unacknowledged intersections between the discourses of historicism and psychoanalysis.[14] While there is no doubt a series of vexed relations at stake in the intersection of particular narratives of history and psyche, it is important to note that when these methodologies are divorced from each other they can offer quite limited models and vocabularies of experience. In early modern studies, for example, while psychoanalytic criticism has been taken to task for its historical belatedness and its reductive articulations of states of subjective experience, historicist work has often been criticized for leaving its own lexicon of interiority and phenomenology untheorized and overgeneralized.[15]

The confluence of critical approaches and subject matters in this volume might then be seen as a response to the increased attention paid to the limitations of particular modes of inquiry — not only psychoanalytic but also historical.[16] "In our current eagerness to establish political readings of early modern texts," writes Michael Schoenfeldt, "we have allowed political concerns to consume a range of other discourses through which individuals in the period attempted to comprehend their experience of the world and wring meaning from it."[17] And in a survey of theoretical models for "discerning the subject," Paul Smith writes that "[t]he urge, currently *de rigueur,* to historicize one's analyses — that is, to follow the Marxist imperative of always stressing the historical and social conditions of production above all else — is insufficient on its own as a way toward understanding the articulation of the subject/individual and the social formation it inhabits."[18] If much recent work in early modern studies has shifted from a focus on the Burckhardtian subject to the historical object, this book returns to questions of identity and subjectivity from a post-Burckhardtian, cultural materialist perspective.[19]

Theorizing topics such as "fetishisms and Renaissances," "the topographic imaginary," and "violence and philosophy," the essays in this volume attempt to rethink the relationship between a whole range of historicist and psychoanalytic narratives in an attempt to map out new histories of early modern subjectivity.

Of course, the very project of historicizing subjectivity in terms of early modern economic, religious, sociopolitical, and technological forces itself needs to be qualified. In recent years, medievalists such as David Aers, Lee Patterson, and David Wallace have done much to critique the location of emergent forms of modern consciousness and subjectivity in early modern Europe.[20] Indeed, given the disciplinary establishment of historically specific fields of specialization, what may appear to early modern scholars to be the "birth" of the subject may well be the adolescence or even the "middle-age" of the subject to medievalists. Taking as an example the recent historical work on the precapitalist market economies and urban expansions of the thirteenth century, as well as the pervasiveness of tropes of inwardness, secrecy, and privacy in religious discourses from the thirteenth to the fifteenth century, Aers suggests that cultural forces informing "modern" conceptions of individuality, subjectivity, and psychology were well under way before the sixteenth century. He also argues that much new and seemingly "radical" work on formations of subjectivity and interiority in early modern studies relies, paradoxically enough, on "old," positivist conceptions of medieval history — on a conservative, homogeneous, and largely outdated worldview. While Aers, Patterson, and contemporary thinkers as diverse as Charles Taylor and Peter Stallybrass have called attention to the need to qualify statements about the origins of subjectivity, for example, in fifteenth-century Italy or sixteenth- and seventeenth-century England,[21] what *is* remarkable, as many of the essays in this volume point out, is the marked proliferation of discourses of inwardness and self-analysis in the sixteenth and seventeenth centuries. The anatomical investigations of Vesalius, the psychological lexicons of Bright and Burton, the devotional practices of Protestantism, and the articulations of loss and desire integral to the Petrarchan lyric all saw an unprecedented proliferation through the technology of print in early modern Europe.[22] While Augustinian inwardness is certainly foundational for what many have located as an "inwardness topos" in early modern literary and religious culture, the marked dissemination of tropes of bodily and psychic interiority worked in many ways to mark out a specifically spatialized notion of the

self that, as David Hillman and Katharine Eisaman Maus argue in this volume, anticipates psychoanalytic and philosophical models of persons, psyches, and systems of belief.[23]

Indeed, the critical tensions between historicism and psychoanalysis that have often animated early modern studies find a corollary in the complex interplay between the material and the psychic integral to many early modern discourses. These tensions are clear, for example, in early modern representations of the body, where psychic and material phenomena often exist in the same space and scene of representation and investigation. In Juan Valverde's *Historia de la composicion del cuerpo humano* (1556), a self-demonstrating anatomical subject holds the totality of his flayed skin in hand; once separated from his body, the skin takes on a ghostly autonomy and haunts the scene of anatomical analysis (Fig. 1.1). The skin, with facial features and a beard, almost seems to function as an epidermatological mnemonic: "Remember me."[24]

Valverde's ghost at once figures and disfigures, faces and potentially effaces the very anatomy so vividly displayed. The illustration reflects a range of early modern discourses beyond the medical; the drooping skin might recall, for example, the resurrected bodies that were imagined by some theologians as "so rarifyed, so refined, so attenuated, and reduced to a thinness, and subtleness, that they were *aery bodies*."[25] As Jonathan Sawday notes, the image also evokes Apollo's flaying of Marsyas, which afforded artists and anatomists a whole new mythography of "self-figuration."[26] The memento mori, traditionally configured through relics of the dead positioned near living bodies, is also here eerily present, but as an extension *of* the living body itself, calling to mind a number of other mythological figures featured prominently in anatomical illustrations of the period, such as the disembodied head of Medusa. At the same time as these multiple iconographic and historical traditions converge in this illustration, the acutely self-reflective image, at once familiar and strange, anticipates what Freud calls the "most uncanny [of] themes," the moment at which "[a]pparent death and the re-animation of the dead have been represented."[27] Indeed, the self-displaying body of early modern anatomical illustration is neither living nor dead, or more precisely, it is *both* living and dead. The conflation of self-estrangement and self-knowledge in Valverde's illustration visually registers the intimately entwined domains of the material and the psychic, and also blurs distinctions not only between anatomist and anatomized but also between realms of the natural and supernatural and the animate and inanimate.

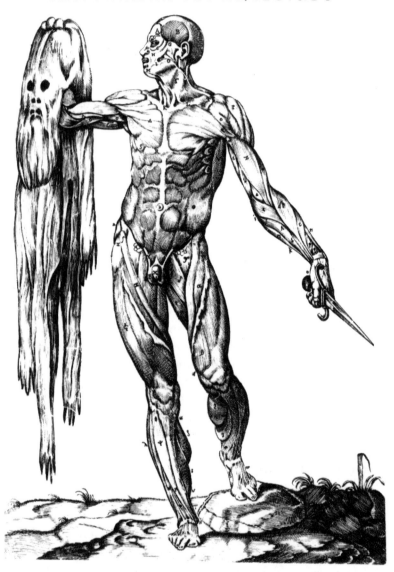

Fig. 1.1 Flayed anatomical figure with ghostly exterior from Valverde,
Historia de la composicioun del cuerpo humano (1556).

Even distinctions specific to the corporeal, such as the classical and the grotesque body, are called into question, as the classical body here *is* grotesque.

Through its vivid evocation of multiple frames of reference, the Valverde illustration in many ways embodies the questions central to this book. The implications of historicist and theoretical approaches to Renaissance texts are explored in the first section, "Fielding Questions." In these first five essays, a number of critical vocabularies—Marxian, Freudian, Lacanian, Foucauldian—are examined in terms of a range of early modern texts and contexts. In "Fetishisms and Renaissances," Ann Rosalind Jones and Peter Stallybrass theorize the problematic relation between Freudian and Marxian conceptions of the "fetish" in terms of the emergence of the fetish in the Renaissance. According to Jones and Stallybrass, the demonization of the process whereby subjects are constituted through relations to objects—and objects are treated and imagined as external organs of the body—begins as early as the sixteenth century in the attack upon the supposed fetishism of Africans and, later, children. The disavowal of formative powers of the object by means of the demonization of the fetish, they argue, is not only uncovered but also reproduced in the work of Freud and of many social theorists, and hence in many dominant theories of the subject in material culture.

With a similar interest in the historical specificity of critical terms, James R. Siemon draws on Pierre Bourdieu's theories of social analysis to bridge the discourses of psychoanalysis and historicism. In "Dreams of Field: Early Modern (Dis)Positions," he examines the ways in which questions of class position and professional standing shape the mental disposition of Shakespearean characters, from Shylock to Coriolanus. According to Siemon, Bourdieu's emphasis on the restricted economies of semi-autonomous professional fields opens up interpretative possibilities for both historicist-minded and psychoanalytically oriented critics. Grounding his rereading of Žižek in the more sociologically inflected notion of the *habitus*, Siemon explores the ways in which theater-house exchanges between playwrights, actors, and audiences are themselves encoded in performance, and he urges us to rethink Shakespearean criticism that tends to focus exclusively on one "field."

Karen Newman's "Toward a Topographic Imaginary: Early Modern Paris" argues that the development of the metropolis in seventeenth-century Paris produced figures of address and modes of subjectivity that many contemporary theorists have imagined as a distinctly modern

phenomenon. Exploring the "new world" of the early modern city, Newman explores how representations of urban space often distorted scale and size so as to emphasize the greater intermingling of classes, leisure activities, and economic exchanges that would have been more rigorously partitioned in feudal and early modern villages. On the bridges and in the streets of early modern Paris, Newman finds not only nascent forms of individualism and democracy, but also a new attention to the logics and metaphorics of spatiality that will inform the topographical vocabulary of psychoanalysis.

In " 'To Please the Wiser Sort': Violence and Philosophy in *Hamlet*," John Guillory traces the links between the sublimation of courtly aggression and the burgeoning restlessness with the philosophical limitations of early modern theology. Arguing that the Foucauldian lens through which violence is so often understood by literary critics conflates two separate movements (one regulating aristocratic aggression, the other disciplining bourgeois sexuality), Guillory reads Hamlet as a character who has internalized the "courtly *habitus* of inhibition and refinement." In his performances of philosophy, Hamlet invokes a skeptical mode of inquiry that is perpetually fixated on its own incompleteness, an incompleteness that cannot be recognized by the predominant philosophical discourse of theology.

Whereas Guillory historicizes *Hamlet* in order to call into question psychoanalytic readings of the play, Eric Wilson deploys psychoanalysis to rethink "the lure of the object" in cultural materialist criticism. In "Abel Drugger's Sign and the Fetishes of Material Culture," Wilson argues that the object relations at the center of Ben Jonson's *The Alchemist* thematize anxieties surrounding the commodification of persons and things and the materialization of desire. Wilson locates this desire explicitly in the protocapitalist discourse of Jonson's play and in the critical discourses of Marx, Freud, and Žižek. Exploring the dimensions of a critical historical fantasy, Wilson challenges the historicist privileging of a material site of excavation (the alchemist's shop) and its inevitable orientation around the elusively phantasmagoric material object: the philosopher's stone.

The essays in the second part, "Graphic Imaginations," historicize relations between desiring, dreaming, speaking, and praying subjects in terms of varied conditions of textual production and transmission. Each essay considers the material registers of self-articulation in light of recent developments in the history of the book. Of course, there is no one book,

nor one history, nor, for that matter, one subject. Rather, these essays explore the ways in which a variety of textual forms—from cartographic publications to commonplace books—were inseparable from the dissemination, structuring, and emergent vocabularies of private experience.

Tom Conley's "Erotic Islands: Contours of Villon's Printed *Testament* (1489)" links, in his words, the "mapping impulse of northern artists of the incunabular era to that of poets and writers." Reading François Villon's *Le Grant Testament* through the spatial dimensions opened up by cartographic publications, Conley details how the Petrarchan conceit of the longed-for but inaccessible female figure is graphically transformed into "a horizontal account of lands visited, seen, remarked, and left behind when seen in the register before our eyes." Situating the woodcut images of Pierre Levet's edition of Villon in relationship to the poems they gloss and the cartographic forms they mimic, Conley reconceptualizes generic categories of the lyric and the cartographic as mutually constitutive, bridged by common textual features and print technologies.

In "The Interpretation of Dreams, circa 1610," Jeffrey Masten historicizes dream interpretation in early modern culture by reading a set of pages from a seventeenth-century commonplace book in which dream symbols are carefully categorized and explicated. Masten considers how we might interpret the early modern tendency to read nocturnal visions not so much as psychic displacements but rather as imaginative and interpretive templates. Drawing attention to the unfamiliar terrain of a pre-Freudian dreamscape—one in which premonitory readings of dreams are often privileged—Masten theorizes the relationship between dreaming and writing matter, reading accounts of dreams as they are shaped by attention to literary and classical genres, and through the archival space created by their transcriptions.

Carla Mazzio's "The Melancholy of Print: *Love's Labour's Lost*" argues that speech pathologies integral to articulations of love melancholy in early modern England were largely a sign and a symptom of print. Linking the impaired speech of the melancholy lover with the proliferation of amatory discourses in literary and educational texts of sixteenth-century England, she argues that what is experienced by the melancholic as vocal self-alienation (and a painful and visually mediated distance from the object of love) can and should be read in terms of a historical transition of technology and representation that entailed a heightened awareness not only of alterity of voice, but of the ocular dimensions of both word and sound. Positing a direct relation between

theatrical performance and developing practices and technologies of literacy in the period, Mazzio argues that the theater functioned as a specific response to the imagined textualization of voice, identity, and passion in the literature and culture of early modern England.

In "George Herbert and the Scene of Writing," Douglas Trevor argues that the Lacanian understanding of the self as fractured and extrinsically constituted by the gaze of the Other has its roots in a distinctly Protestant interpretive mode that emerged in the early modern period. Reading the poems that make up *The Temple*, Trevor emphasizes Herbert's thematization of collaborative writing and his conflation of religious and textual practices. Turning to psychoanalysis, Trevor examines Lacan's appropriations of theological vocabulary, his use of the Church as an analogy for the splintering federation of French psychoanalysts, and his likening of Christian rituals to analysis, arguing that Judeo-Christian discourses inform rather than oppose Lacanian psychoanalysis.

"Depth Perceptions," the third section of the book, focuses on specifically early modern concepts of spatiality, interiority, and subjectivity, ranging from the erotic and the mythographic to the religious and the occult. Using Renaissance texts to rethink psychoanalytic models of cognitive and emotional development, these essays examine the corporeal contours of desire, skepticism, and belief in early modern England. Jonathan Goldberg's "The Anus in *Coriolanus*" challenges contemporary critical assumptions about erotic desire and male subjectivity in Shakespeare and in early modern England. Arguing against earlier psychoanalytic readings of *Coriolanus* that privilege the oral sphere as the key to readings of social relations and interiority, Goldberg argues that oral and anal exist "in a substitutive relationship in the play." Reading the anus as a site of originary self-formation (that is, incorporative rather than merely evacuative), this essay challenges the pathologies implicit in Freud's theory of anality.

Kathryn Schwarz's "Breaking the Mirror Stage" similarly distinguishes between modern and early modern theories about the development and articulation of subjectivity. Her essay explores the ways in which Amazonian mythography (in Renaissance texts ranging from exploration narratives to allegorical romances to rewritings of classical myth) uncannily prefigures Lacan's theory about the formation of subjectivity in the "mirror stage." At the same time, Schwarz foregrounds the logic whereby Renaissance mirror stages, such as those that surface in Spenser's *The Faerie Queene*, are constructed out of anxieties about

the potentially disarticulated bodies and identities of men. Drawing on the theories of Eve Sedgwick and René Girard, Schwarz argues that the mirrors of identity and desire integral to Amazonian myths work apotropaically, warding off threats of homoeroticism and triangulation.

David Hillman's "The Inside Story" points out that emergent states of subjectivity have often been conceptualized, in both historicism and psychoanalysis, in terms of the spatial metaphor of the inside and the outside, and argues that this is precisely because the spatial schema of cognitive organization is itself powerfully implicated in issues of skepticism and doubt. The epistemological crises that marked the emergence of early modern modes of subjectivity were accompanied by a vigorous renegotiation of the boundaries between inner and outer, a largely defensive strategy aimed at stabilizing new conditions of identity. In exploring the representation of the inside-outside dichotomy in *Hamlet*, Hillman demonstrates how Shakespeare stages and reconceptualizes the self in terms of the developing spatial structures of knowledge and perception in early modern Europe.

With a similar concern about the ways in which metaphors of permeability and spatiality are integral to modes of skepticism and belief, Katharine Eisaman Maus explores competing notions of personhood in Renaissance debates about sorcery. Examining a number of texts that either dismiss or accept the supernatural, Maus demonstrates how nuanced and variegated these different positions were in the early modern debates about witchcraft. Believers in sorcery, she argues, generally subscribed to permeable models of subjectivity, while skeptics of witchcraft more rigorously distinguished between material and mental phenomena, insisting on rigid boundaries between selves. Paying particular attention to the representations of witchcraft and magic in the plays of Shakespeare and Jonson, she contrasts Shakespeare's willingness to consider the possibilities of supernatural phenomena with Jonson's "satiric, antimagical conception of dramatic character," and uses these oppositions to reevaluate the dominant critical approaches to each author.

The two essays in "Legacies," the final section of this volume, draw together concerns about the material legacies of Shakespeare (his land acquisitions, his will, even his furniture) and his status as a valued cultural and critical commodity. By juxtaposing historicist and psychoanalytic perspectives, these essays call into question a range of critical attempts to discern Shakespeare as subject, icon, and author. Margreta de Grazia's "Weeping for Hecuba" opens with a question about *Hamlet*:

Why have analyses of the Prince of Denmark's presumed interiority fo-
cused on his entrance scene, where he gestures toward a hidden locus of
grief, rather than the graveyard scene, where he puts his grief on full
display—and articulates interiority through tropes of dirt and land?
Although Freud recognized that the "common theme" of the death of fa-
thers is at the heart of the play, what is *un*common about Hamlet's state, de
Grazia argues, is that his father's death leaves him with the patronymic
but no patrimony. In a society that grounds both social stability and
personal identity on land tenure, psychic disorientation may occur
around alienation of estate, and the play, she argues, links conditions of
psychic reality with landed realty.

Focusing on Shakespeare's famous bequest to his wife, Marjorie Gar-
ber traces the ways in which the "second-best bed" has become a locus
of scholarly anxiety and critical debate. Traditionally read as a symptom
of Shakespeare's troubled marital life, the bed becomes, in Garber's
analysis, "that perfect tester for the intersection and mutual embedded-
ness of historicism and psychoanalysis." Though it spawns biographical
speculation about Shakespeare, the second-best bed also undermines
such speculation by engendering multiple readings of its own question-
able symbolism as a token of either affection or scorn. Moving from
Shakespeare's bed to Freud's couch and even into the Lincoln bedroom
of the White House, Garber demonstrates the ways in which the
fetishistic allure of the material object simultaneously propels psycho-
analysis, historicism, and cultural studies.

"Dreams of History," the title of our introduction, is meant to fore-
ground what George Steiner has called the "historicity of dreams," that is,
the distinctly historical approach to the matter of psychoanalysis.[28] At the
same time, it emphasizes the investments and ideologies at stake in the
very project of historical inquiry. Indeed, if the historicist dream to recon-
stitute the past is intertwined with the psychoanalytic desire, in Michel
de Certeau's words, "to relate the representations of the past or present to
the conditions which determined their production,"[29] so too do the critics
in this volume attempt to move beyond statements of methodological in-
compatibility to generate new forms of synthesis and contestation, ex-
ploring the complicated and often surprising interstices of history and
subjectivity in both early modern and contemporary critical discourses.
The essays that follow, by investigating the specific and changing rela-
tions of persons in urban spaces, market economies, religious discourses,
wills, books, bodies, and beds, attempt to rethink the vocabularies of

thought, experience, and emotion that in many ways constitute the contestatory and ever-shifting contours of early modern culture.

NOTES

For their careful reading of an early draft of this introduction, we would like to thank Marjorie Garber, Jeffrey Masten, Linda Schlossberg, Michael Schoenfeldt, and Peter Stallybrass.

1. Meredith Skura, "Psychoanalytic Criticism," in *Redrawing the Boundaries: The Transformation of English and American Literary Studies*, ed. Stephen Greenblatt and Giles Gunn (New York: Modern Language Association of America, 1992), 349–73, 356. To a large degree, the kind of psychoanalytic criticism practiced in the 1970s and early 1980s has been radically reconfigured. Harry Berger Jr., for instance, characterizes his own recent psychoanalytic readings as "impelled by the desire to shift what is normally psychological and characterological interpretation away from the form of analysis that examined speakers as if they were the Doctor's analysands, individuals with bodies, psyches, and organic histories" (*Making Trifles of Terrors: Redistributing Complicities in Shakespeare* [Stanford: Stanford University Press, 1997], xvii). The new direction described by Berger might be taken to reflect a larger redefinition of interests on the part of psychoanalytic critics interested in using psychoanalytic templates to reassess historical processes, generic categories, and theories of emotion, body, and mind. See, for example, Juliana Schiesari, *The Gendering of Melancholia: Feminism, Psychoanalysis, and the Symbolics of Loss in Renaissance Literature* (Ithaca: Cornell University Press, 1992). See also "Introduction: Worlds Within and Without," in *Desire in the Renaissance: Psychoanalysis and Literature*, ed. Valeria Finucci and Regina Schwartz (Princeton: Princeton University Press, 1994), 3–15.

2. Whereas new historicism has privileged the notion of a culturally constructed subject—the Foucauldian idea, as H. Aram Veeser phrases it, that "the autonomous self and text are mere holograms, effects that intersecting institutions produce" (*The New Historicism*, ed. Veeser [New York: Routledge, 1989], xiii)—some early modes of psychoanalytic criticism privileged concepts and models of a unified self and a unified psyche. Indeed, while historicists such as Margreta de Grazia have challenged psychoanalytic critics for deploying historically belated and totalizing models of the self, psychoanalytic thinkers such as Janet Adelman have challenged historicists for overemphasizing the sociocultural determinants of identity—often at the expense of a powerfully articulated (if historically

contingent) forms of subjectivity. See de Grazia, "Motives of Interiority," in *Style* 23 (Fall 1989), where she defines her own critical approach in opposition to the psychoanalytic work of critics such as Joel Fineman and Janet Adelman.

3. Stephen Greenblatt, "Psychoanalysis and Renaissance Culture," in *Learning to Curse: Essays in Early Modern Culture* (New York: Routledge, 1990), 131–45, 142. For a response to Greenblatt's essay, and a theorization of the relations between history and psychoanalysis, see Elizabeth J. Bellamy, "Psychoanalyzing Epic History," in *Translations of Power: Narcissism and the Unconscious in Epic History* (Ithaca: Cornell University Press, 1992), esp. 1–13. For a critique of the conceptual limitations of Freudian psychoanalytic criticism, see Brian Vickers, "Psychocriticism: Finding the Fault," in *Appropriating Shakespeare: Contemporary Critical Quarrels*, 272–324. See also Marshall Grossman, *The Story of All Things: Writing the Self in Renaissance Narrative Poetry* (Durham: Duke University Press, 1998).

4. Debora Kuller Shuger, *The Renaissance Bible: Scholarship, Sacrifice, and Subjectivity* (Berkeley: University of California Press, 1994), 190.

5. Leah S. Marcus, "Renaissance/Early Modern Studies," in *Redrawing the Boundaries: The Transformation of English and American Literary Studies,* 41–63, 59.

6. As Greenblatt writes in "Remnants of the Sacred in Early Modern England,"

> For Renaissance England, the sublime object of ideology is a piece of common baked bread. The language that surrounds this object is in certain ways strikingly similar to Žižek's Lacanian rhetoric. Primordial wholeness, wounds, excess, the thing which at once precedes and exceeds symbolization, the intertwining of intense pleasure with equally intense grief or lack, the coincidence of opposites: virtually all of the terms used to describe the indescribable — the Real that is both out of our grasp and the basis for everything that we are — are terms that not simply resemble but rather emerge from the fevered attempts in the late Middle Ages and Early Modern period to theorize the Eucharist.

Subject and Object in Renaissance Culture, ed. Margreta de Grazia, Maureen Quilligan, and Peter Stallybrass (Cambridge: Cambridge University Press, 1996), 337–45, 338.

7. While psychoanalytic approaches to early modern studies have often been challenged for drawing on ahistorical and unitary notions of the self, the writings of contemporary psychoanlytic theorists such as Lacan and Žižek are notable for their strenuous rejection of these very concepts. See, for example, Slavoj Žižek's attempt to synthesize Marxism and psychoanalysis in *The Sublime Object of Ideology* (London: Verso, 1989). "In psychoanalysis," writes Lacan, "history is a dimension different to that of development, and it is an aberration to try to reduce the former to the latter." *Ecrits* (Paris: Seuil, 1966), 875 (cited by Dylan Evans in *An Introductory Dictionary of Lacanian Psychoanalysis* [New York, London, 1996], 41). Lacan emphasizes the fictionality of narratives of origin and de-

velopment, noting that developmental stages (oral, anal, and genital) are ahistorical and work as retrospective projections which create rather than discern the genealogies of the psyche.

8. Judith Butler, *The Psychic Life of Power* (Stanford: Stanford University Press, 1997), 3.

9. Joan Copjec, *Read My Desire: Lacan against the Historicists* (Cambridge and London: MIT Press, 1994), 6, 7. Michel de Certeau also considers "the possibilities and limitations of the renewal of historiography promised by its encounter with psychoanalysis" ("Psychoanalysis and Its History," in *Heterologies: Discourse on the Other*, trans. Brian Massumi [Minneapolis: University of Minnesota Press, 1986], 5). See also *The Writing of History*, trans. Tom Conley (New York: Columbia University Press, 1988), esp. 285–354.

10. See, for example, Louis Montrose's critique of the new historicism and his "resistance to its now-conventional representation within critical discourse as a fixed and homogeneous body of doctrines and techniques" (392). "New Historicisms," *Redrawing the Boundaries: The Transformation of English and American Literary Studies*, 392–418. See also *Making Trifles of Terrors*, where Berger writes of the advantage of "shifting psychoanalytic themes from causal to effectual and structural frameworks of interpretation" (216).

11. Ernesto Laclau and Chantal Mouffe, *Hegemony and Socialist Strategy: Toward a Radical Democratic Politics*, trans. Winston Moore and Paul Cammack (London: Verso, 1985), 3. Or as Catherine Belsey puts it in *Critical Practice* (London: Routledge, 1980), "[C]riticism can no longer be isolated from other areas of knowledge. The new critical practice requires us to come to terms with concepts of ideology and subjectivity drawn from fields which have no relation to a theory or practice of literary criticism conceived as self-contained" (144–45).

12. On the multiple senses of "otherness" and "alienation" as they inform changing conditions of the self in the early modern period, see Steven Mullaney, *The Place of the Stage: License, Play, and Power in Renaissance England* (Chicago: University of Chicago, 1988), esp. 88–117. Historicizations of the body are perhaps most notably marked by terms that are dense with implication, such as *fetish* and *symptom*, or *site* and *zone*, as if the body itself were at a crossroads between conflicting worlds. The "erotogenic zones" of Freudian discourse, the "contact zones" of Bakhtinian literary theory, and other "zones" in the field of sociology might compel us to wonder what it means to have different disciplines converging upon the same terms (on zones, see the "manipulatory zones" of the sociology of Peter Berger and Thomas Luckmann in *The Social Construction of Reality: A Treatise in the Sociology of Knowledge* [New York: Doubleday, 1966] and the "contact zones" of Mikhail Bakhtin, *The Dialogic Imagination*, ed. Michael Holquist, trans. Caryl Emerson and Michael Holquist [Austin: University of Texas Press, 1981]). See also Gail Kern Paster, *The Body*

Embarrassed: Drama and the Disciplines of Shame in Early Modern England (Ithaca: Cornell University Press, 1993).

13. Žižek, *The Sublime Object of Ideology*, 11. "According to Lacan," writes Žižek, "it was none other than Karl Marx who invented the symptom. . . . [I]f Marx really articulated the notion of the symptom as it was at work in the Freudian field, then we must ask ourselves . . . how was it possible for Marx, in his analysis of the world of commodities, to produce a notion which applies also to the analysis of dreams, hysterical phenomena, and so on" (3).

14. Laclau challenges the logic of contemporary attempts to synthesize discourses of Marxism and psychoanalysis, and gestures toward "a possible confluence of (post-) Marxism and psychoanalysis" (333). "Psychoanalysis and Marxism," trans. Amy G. Reiter-McIntosh, *Critical Inquiry* 13 (1987), 330–33. Also, on another important challenge to attempts to draw together Marxism and psychoanalysis, see Ann Foreman, "Psychoanalysis and Marxism," in *The Material Queer: A LesBiGay Cultural Studies Reader* (Boulder: Westview Press, 1996).

15. Many historicists such as Louis Montrose have themselves worked to challenge and revise historicist methodologies. In "New Historicisms," Montrose writes that "New Historicist work has been particularly susceptible to [critical] . . . responses because it has frequently failed to theorize its method or its model of culture in any sustained way" (400). And as Claire McEachern has recently argued,

> the failure of historicist inquiry to address the chief terms in which
> early modern England imagined both the group and the individual has
> no doubt compromised the adequacy of its historical description. Dis-
> senters from new historicism (for instance) would no doubt claim that
> such a neglect only corroborates its other lapses: its anecdotal notion of
> what counts as history; its dependence upon loose analogies; its eva-
> siveness when it comes to causal argument; its tendency to adduce a
> *Zeitgeist* from an accident; its sullenly Hobbesian assumptions about
> psychology and politics; its propensity towards schematic binarisms. (2)

"Introduction," *Religion and Culture in Renaissance England*, ed. Claire McEachern and Deborah Shuger (Cambridge: Cambridge University Press, 1997), 1–12. Or as Katharine Eisaman Maus has put it, "The new-historicist critique . . . that the 'self' is not independent of or prior to its social context . . . often seems to assume that once this dependence is pointed out, inwardness simply vaporizes, like the Wicked Witch of the West under Dorothy's bucket of water" (*Inwardness and Theater in the English Renaissance* [Chicago: University of Chicago Press, 1995], 28).

16. In recent reevaluations of early modern studies, critics such as Steven Mullaney have gone so far as to cast the new historicism in the past tense, describing it as a movement that has already mutated into something else. See Mullaney, "After the New Historicism," in *Alternative Shakespeares*, vol 2, ed.

Terence Hawkes (London: Routledge, 1996), 17–37. As Richard Strier has recently noted, "The new historicism needs the old to give history an existence in persons; the old history needs the new to give persons an existence in a complex and often violent world." *Resistant Structures: Particularity, Radicalism, and Renaissance Texts* (Berkeley: University of California Press, 1995), 77. For Greenblatt's account of the ways in which new historicism insists on human agency, see "Resonance and Wonder," in *Learning to Curse*, 161–83, esp 164–66.

17. Michael Schoenfeldt, "Fables of the Belly in Early Modern England," in *The Body in Parts: Fantasies of Corporeality in Early Modern Europe*, ed. David Hillman and Carla Mazzio (New York: Routledge, 1997), 243–61, 243.

18. Paul Smith, *Discerning the Subject* (Minneapolis: University of Minnesota Press, 1988), 72.

19. On this trend, see *The Production of English Renaissance Culture*, ed. David Lee Miller, Sharon O'Dair, and Harold Weber (Ithaca: Cornell University Press, 1994), Introduction, 1–12, and *Subject and Object in Renaissance Culture*, ed. Margreta de Grazia, Maureen Quilligan, and Peter Stallybrass (Cambridge: Cambridge University Press, 1996), Introduction, i–xvi.

20. David Aers, "A Whisper in the Ear of Early Modernists; or, Reflections on Literary Critics Writing on the 'History of the Subject,' " in *Culture and History 1350–1600: Essays on English Communities and Identities and Writing*, ed. David Aers (Detroit: Wayne State University Press, 1992), 177–202. Aers' essay is an important contribution to histories of subjectivity, but its own conceptual strength at times depends upon a suppression of the subtle arguments and qualifications in the very essays he critiques. Also see Lee Patterson, "On the Margin: Postmodernism, Ironic History and Medieval Studies," *Speculum* 65 (1990), 87–108; and David Wallace, *Chaucerian Polity: Absolutist Lineages and Associational Forms in England and Italy* (Stanford: Stanford University Press, 1997).

21. Charles Taylor, *Sources of the Self: The Making of Modern Identity* (Cambridge: Harvard University Press, 1989), esp. 111–99. For a historicization of keywords such as *individual, consciousness, inwardness,* and an important recontextualization of emergent models of subjectivity in early modern England, see Anne Ferry, *The "Inward" Language: Sonnets of Wyatt, Shakespeare, Donne* (Chicago: University of Chicago Press, 1983), esp. 1–70; and Stallybrass, "Shakespeare, the Individual, and the Text," in *Cultural Studies*, ed. Lawrence Greenberg, Cary Nelson, and Paula Treichler (New York: Routledge, 1992), 593–612. For a powerful critique of the totalizing terminology of historical periodization, see Margreta de Grazia, "Soliloquies and Wages in the Age of Emergent Consciousness," *Textual Practice* 9: I (1995), 67–92.

22. For recent work on emergent modes of self-description, from autobiography to self-portraiture to anatomy in the early modern period, see Peter Burke, "The

Self from Petrarch to Descartes" (17–28), Jonathan Sawday, "Self and Selfhood in the Seventeenth Century" (29–48), and Roger Smith, "Self-Reflection and the Self" (49–57), in *Rewriting the Self: Histories from the Renaissance to the Present*, ed. Roy Porter (New York: Routledge, 1997).

23. Katharine Eisaman Maus, *Inwardness and Theater in the English Renaissance*, 13. Also see David Hillman, "Visceral Knowledge: Shakespeare, Skepticism, and the Interior of the Early Modern Body," in *The Body in Parts: Fantasies of Corporeality in Early Modern Europe*, 80–105.

24. *Hamlet* (1.4.91), *The Arden Shakespeare*, ed. Harold Jenkins (London: Methuen, 1982). Valverde's eerie ghost in many senses *is* the very haunting of prosopoesis that Marjorie Garber maps out in her reading of *Hamlet* (*Shakespeare's Ghost Writers: Literature as Uncanny Causality* [New York: Methuen, 1987], 124–76). Garber draws on Paul de Man's etymological dismantling of prosopoeia ("the fiction of the voice-from-beyond-the-grave" [77] as *"prosopon poiein*, to confer a mask or a face" (63) to emphasize the logics of representation and "figuration" at work in the haunted conditions of authorship and subjectivity in *Hamlet*. Valverde's ghostly face (marking the *literal* defacement of the anatomical figure) might well be glossed by de Man's statement about the relations between defacement and acts of autobiography or *self*-description: "Our topic deals with the giving and taking away of faces, with the face and deface, *figure*, figuration, and disfiguration" (75–76). See Paul de Man, "Autobiography as De-Facement," in *The Rhetoric of Romanticism* (New York: Odyssey Press, 1957).

25. John Donne, *The Sermons of John Donne*, ed. George R. Potter and Evelyn M. Simpson (Berkeley: University of California Press, 1957), vol. 3, 114–33, 114.

26. Jonathan Sawday, *The Body Emblazoned: Dissection and the Human Body in Renaissance Culture* (London: Routledge, 1998), 185. For a general and pictorial history of anatomical illustration and self-demonstrating anatomy, see K. B. Roberts and J. D. W. Tomlinson, *The Fabric of the Human Body: European Traditions of Anatomical Illustration* (Oxford: Oxford University Press, 1992).

27. Sigmund Freud, "The 'Uncanny,'" in *The Standard Edition of the Complete Psychological Works of Sigmund Freud*, trans. James Strachey (London: Hogarth Press, 1995), 219–52, 246. Also, on the uncanny autopics of early modern medical practice, see Jonathan Sawday, *The Body Emblazoned: Dissection and the Human Body in Renaissance Culture*, 141–82.

28. George Steiner, "The Historicity of Dreams," in *No Passion Spent: Essays 1978–1995* (New Haven: Yale University Press, 1996), 207–23.

29. Michel de Certeau, "Psychoanalysis and its History," in *Heterologies: Discourse on the Other*, trans. Brian Massumi (Minneapolis: University of Minnesota Press, 1986), 5.

FIELDING QUESTIONS

ANN ROSALIND JONES AND PETER STALLYBRASS

FETISHISMS AND RENAISSANCES

In a series of brilliant articles, William Pietz has traced the concept of the fetish in early modern Europe.[1] Pietz argues that

> the fetish, as an idea and a problem, and as a novel object not proper to any prior discrete society, originated in the cross-cultural spaces of the coast of West Africa during the sixteenth and seventeenth centuries.[2]

The word *fetish* derives from the pidgin *fetisso*, which can be traced to the Portuguese *feitiço* (meaning "magical practice" or "witchcraft"). *Feitiço* has its root in the Latin *facticius*, meaning "a manufactured (as opposed to natural) object." *Fetish,* like *fashion,* is derived from the Latin *facere,* "to make."[3] But the *fetisso* marks less the earlier distrust of false manufactures (as opposed to the "true" manufactured wafers and images of the Catholic Church) than a suspicion both of material embodiment itself and of

> the subjection of the human body . . . to the influence of certain significant material objects that, although cut off from the body, function as its controlling organs at certain moments.[4]

The *fetisso* thus represents "a subversion of the ideal of the autonomously determined self."[5]

Fetish, Pietz argues, came into being above all as a term of religious and economic abuse. As a term of economic abuse, it posited the Akan as a people who worshiped "trifles" ("mere" fetishes) and "valuable things" (i.e., gold) alike. This meant that they could be "duped" (i.e., what the Europeans considered valueless — beads, for instance — could be exchanged for "valuable" goods). But it also implied a new definition of what it meant to be European: a subject unhampered by fixation upon objects, a subject who, having recognized the true (i.e., market) value of the object-as-commodity, fixated instead upon the transcendental values that transformed gold into ships, ships into guns, guns into tobacco, tobacco into sugar, sugar into gold, and all into an accountable profit. What was demonized in the concept of the fetish was the possibility that history, memory, and desire might be materialized in objects that are touched and loved and worn. The emergent European subject was founded through the disavowal of the power of objects.

But if the concept of the fetish emerged in the Renaissance, its emergence should not be confused with its triumph. That is, if a subject "unconstrained" by its relations to objects was first theorized in the Renaissance, this emergent subject was in tension with the subject implicit in religious theories of the sacrament and of the incarnation, in aristocratic theories of a subject defined by property, and in guild theories of a subject defined by specific forms of work. We will argue below that the forms of "fetishism" that were supposedly characteristic of the Akan were in fact equally prevalent in Renaissance Europe.

But Freud, when he came to develop his own theory of the fetish, was the unacknowledged heir of the elaboration of the concept in the Renaissance and the Enlightenment as a defining feature of historical "backwardness." Freud consequently perpetuated the disavowal of objectification that was constitutive of the concept's formation in the Renaissance.[6] His definition of the fetish as a form of disavowal in fact reinscribes a prior historical disavowal in which all objectification is imagined as a violent constraint upon the "free" subject. Freud's implicit hostility to objectification is suggested by the speed with which he moves from the fetishist's object to the fetish as a system of meaning, in which the material bearer of meaning is lost to sight and to thought and to touch. The fetishist's shoe appears for only the briefest of moments before it is allegorized, its presence displaced by its function as the sign of an absence (the absent phallus).

Like the European traders who could not recognize "true" value in Akan amulets of "Fetiche Gold," Freud assumes that value cannot be

found in a "shoe or slipper." Or rather, the value of the shoe is allegorical. As a result, the fetish-as-object rapidly disappears in Freud's account into meaning:

> In every instance, the meaning and purpose of the fetish turned out, in analysis, to be the same. . . . The fetish is a substitute for the woman's (the mother's) penis that the little boy once believed in and — for reasons familiar to us — does not want to give up.[7]

In the place of the fetish-as-object is the woman's fantasmatic penis, and in the place of that penis is the boy's anxiety about castration. At the same time, Freud's treatment of the fetish as a mere bearer of other significations enables him, in a most un-Freudian move, to imagine a fully constituted subject prior to the fetish, a subject with what he calls a "normal sexual aim."[8] Freud does allow that even "normal love" involves "a certain degree of fetishism," but fetishism proper emerges only when attachment to the object "*takes the place* of the normal aim and, further, when the fetish becomes detached from a particular individual and becomes the *sole* object."[9] At the moment of formulating the fetish, Freud thus disavows his own central insight: namely, that from the child's perspective in the anal and oral stages, fetishized parts precede any "particular individual" and that it is only through specific social and symbolic labor that the "individual" belatedly emerges as the concept of a bounded whole.

In the fetish, that is, Freud repudiates his own theory of the constitution of the subject through its relation to attachable/detachable parts (the breast, excrement). His disavowal of our constitution through external organs of the body is articulated through his insistence both upon the "normal sexual aim" and upon the fact that the fetish is "entirely unsuited to serve" it.[10] Yet Freud vacillates on this point. Indeed, in the essay "Fetishism," he seems to be subject to what Marjorie Garber calls "fetish envy."[11] The fetishist suddenly emerges as the very epitome of a person who has found what will "entirely suit his need": "What other men have to woo and make exertions for can be had by the fetishist with no trouble at all."[12] Freud further claims that the pervert has overcome the fear of castration through the fetish. He has done so, though, by a disavowal enacted in one case by the use of an athletic support that conceals the genitals. The support materializes through the fetishist's own body the undecidability of whether or not anyone has a penis.[13]

Whereas this undecidability is the mark of the fetishist's disavowal, Freud himself manages to reproduce that disavowal in his theory of the fetish. Indeed, he seems quite decided that the fetish signifies the disavowal of the mother's "castration," that only men can be fetishists, and that only *straight* men can be fetishists, since the fetish "saves the fetishist from becoming homosexual, by endowing women with the chartacteristic which makes them tolerable as sexual objects."[14] Indeed, when Freud interprets the meaning of the fetish, the problems posed by the specific materiality of the fetish (shoes, supports, stockings) seem to vanish.

But the problems return as Freud continues to meditate on the material forms of the fetish and they are most acute in the *Three Essays on Sexuality*. Freud concludes the *Essays* by noting that the etiology of a specific fetish can be hard to trace. The problem can be resolved, however, through symbolic interpretation. "The foot," he writes "is an age-old sexual symbol which occurs even in mythology."[15] Lest we be in doubt as to the meaning of this symbol, Freud added a footnote in 1910: "The shoe or slipper is a corresponding symbol of the *female* genitals."[16] So, reading back from the 1910 footnote, we can be assured that the 1905 *foot* is *male*. But then, having assured us that feet and shoes are the symbols that mark the difference between male and female genitals, he adds a further footnote in 1910 that tells us that smell is often crucial for the fetish and that smell is about "a coprophillic pleasure," organized around the anal rather than the genital.[17] The implication in 1910, then, is that the fetish marks the site of a pre-gendered fixation that cannot yet figure the opposition of male and female. Moreover, smell characterizes foot and shoe alike. But there is a further twist: in 1915, Freud added a final footnote in which he claimed that "a fetish in the form of a foot *or* shoe" (emphasis ours) allows the little boy to imagine the female genitals as male.[18] In other words, feet and shoes alike, rather than marking the difference between male and female genitals, symbolize the male genitals.

While Freud is at first intent upon differentiating the penis from the vagina, male genitals from female genitals, his later analysis makes it impossible to distinguish them. The foot is a penis; the shoe is a vagina? Or the foot and the shoe both figure the penis? Yet in all this talk of the fetish, we never encounter a shoe as a shoe; it is always only the bearer of something else. Penises and vaginas come into focus and slide out of focus; the shoes return to the closet. The fetishized object remains on the periphery of our field of vision.[19]

Compare this with how the fetish appears in Samuel Delany's essay "Aversion/Perversion/Diversion." Delany writes about cruising a movie theater called the Cameo. He is attracted to a man called Mike, but Mike shows no interest at all, until one year Delany buys a pair of running shoes:

> This was back in the years when today's ubiquitous running shoe was emerging as *the* casual fashion choice. As is more usual than not, I was at least a year behind most other people; and it was only that week that I broke down and got my first pair—in which, I confess, I never ran in my life.
> They were a conservative gray.[20]

Wearing running shoes, Delany now enters into Mike's field of interest:

> One day I stopped at the Cameo and, on my way to the balcony, passed Mike sitting on the steps. Several people stood near the top, watching the movie; I stopped behind them, largely to watch them.
> Minutes later, I happened to glance down. Mike's hand was on the step, the edge of his palm against my shoe sole. I was surprised, because till then I had considered myself outside his interests. My first and most innocent thought was that his hand's straying to that position had been an accident, even while more worldly experience said no. Precisely because of what I knew of him already, while it might have been an accident with someone else, *his* hand resting there could *only* have been on purpose— though his attention all seemed down the stairs.
> I tried to appear as though I was not paying any attention to him. He continued to appear as though he was not paying any attention to me. I moved my foot—accidentally—a quarter of an inch from his hand. His hand, a half minute later, was again against my shoe. Again—accidentally—I moved my foot a quarter of an inch closer, to press against his fingers—and two of his fingers, then three—accidentally—slid to the top of my foot.
> In ten minutes, Mike had turned to hold my foot with both his hands, pressing it to his face, his mouth, leaning his cheek down to rub against it.
> To make the point I'm coming to in all this, I must be clear that I found his attention sexually gratifying enough so that I continued to rub his hand, his face, his chest, his groin with my shoe until, at last, genitals loose from his gray work pants, he

came—and, over the next three weeks, when we had some four more of these encounters, I came as well during one of them.

Mike's fetishism marks an embarrassing level of contingency, for Mike has no interest in Delany *until* he wears the right shoes. In fact, one might say that Delany enters Mike's field of vision *as* a particular pair of shoes. (Similarly, the prince searches not just for Cinderella but for a foot that will fit a glass slipper.) Freud's fear before such objects is, perhaps, that they appear to be no longer functional, and yet, at the same time, that they appear to act as an external organ of the body. Mike's fetish, unlike Freud's, resists both the melancholy gaze of modernity and the nostalgia for a savage god. The shoe he wants is, after all, just emerging as *"the* casual fashion choice." In desiring Delany's shoes, Mike gives him the gift of his desire, but it is a desire with a specific historicity: "It was . . . *his* desire, and therefore exciting."

But the contingency of this desire, its dependence upon a particular kind of shoes is marked also, as Delany notes, by the wear and tear of material life:

> Running shoes, at least the brand I'd bought at that time, do not last as long as they should. Soon it was time to replace them.
>
> I thought of Mike.
>
> By now, though, I'd glimpsed him several times get as involved with other men's running shoes or sneakers as he could from time to time with mine. I felt nothing but empathy and goodwill toward him. But clearly some excited him more than others. The specifics of his preference, however, I hadn't been able to piece together. How, I wondered, do I ask about such a thing? How do I put such a question into language?

While Delany is pondering what new pair of shoes to buy, he meets Mike by accident in line at a "legitimate 42nd Street movie house":

> "You know," I said, as we joined each other, walking toward the lobby, "I've got to get a new pair of sneakers, one of these days soon. What kind do you think I should get?"
>
> He seemed not to have heard me. So I persisted: "Is there any kind you like particularly—some kind you think are the best?"
>
> Mike stopped, just inside the lobby door. He turned to me, a look blooming on his face that, in memory, seemed a combina-

> tion of an astonishment and gratitude near terror. He leaned
> forward, took my arm, and whispered with an intensity that
> made me step back: "Blue. . . ! Please . . . *Blue!*" Then he rushed
> away into the street. (p. 127)

Mike's desires are not directed towards shoes in general but towards
particular kinds of shoes: running shoes. Ideally, blue running shoes. A
general theory of fetishism all too easily assumes the materialities that
the fetishist carefully distinguishes between (the shape, the texture, the
kind of heel, the color, the smell).

"What is truth?" said jesting Pilate, and would not stay for the an-
swer. "What is a fetish?" asks Freud, and does not ask the fetishist. He
was already following a chain of displacement in which blue or gray
running shoes, the fixations of the fetishist, will disappear. In the *Three
Essays* he wrote:

> What is substituted for the sexual object is some part of the
> body (such as the foot or hair) which is in general very inappro-
> priate for sexual purposes, or some inanimate object which
> bears an assignable relation to the person whom it replaces and
> preferably to that person's sexuality (e.g. a piece of clothing or
> underlinen). Such fetishes are with some justice likened to the
> fetishes in which savages believe that their gods are enclosed.[21]

Freud's claims here seem radically skewed in the light of Delany's ac-
count. In Delany: (1) The fetish exists prior to the person, so it cannot be
in any simple sense a displacement of a person. Desire emerges through
the fetish, it does not precede it. (2) The fetish is absolutely appropriate
for sexual purposes. The concept of a "person" may well pose many
more problems and difficulties. (3) The fetish bears no necessary assign-
able relation to the person. Mike has no interest in Delany until he wears
the right shoes. Delany enters Mike's field of vision, his field of desire,
as a pair of shoes of a particular kind. Finally, Delany's own desire is in-
creasingly shaped by Mike's fetishism. It is the desire for the desire of
the other that turns Delany on. As Delany writes, with some anger:

> We do not even have a term for the perversion complementary
> to fetishism. The myth of the sexual fetish is precisely that it is
> solitary. Its presumed pathology lies in the fact that it is thought
> to be non-reciprocal. (p. 126)

In disavowing the materiality of the fetish, Freud disavows the constitu-
tive power of the object in the formation of desire. That constitutive power
will be denied by the bourgeois subject, disowned as the desire of savages.
Although Freud opens up the subject of the fetish, he repeats a move that,
as some recent work has begun to suggest, has its origin in the Renaissance,
a move in which the fetish-as-object, the object-as-fetish, is recharacterized
as a mere thing, exchangeable, displaceable, forgettable.[22] But what if the
proliferation of the commentary on the genitals is a displacement of our
anxieties about the gender and sexuality of shoes — our anxiety before the
silence of the prostheses through which we become who we are?

Delany's narrative dramatically calls into question Freud's disavowal
of his general argument that gender is complexly learned through social
signs. By insisting, in his discussion of the fetish, that masculinity is
shored up by the structure of the penis and castration, of presence and
absence, Freud not only gets sexuality wrong (his fetishist has to be a
man, and the fetish wards off homosexuality), he gets gender wrong. In
the Renaissance, the obsession is rarely that men have penises and
women don't. It is, rather, that men and women alike have tongues, have
mouths, have feet.[23] Both genders are constituted through "presences"
and "absences." The differentiation of gender, though, may indeed erupt
as a form of violence. The female shrew is "curst," that is, condemned
by an epithet before she can curse the man who attempts to silence her;
the need to differentiate the woman's phallic tongue or mouth from the
man's is registered by cutting out her tongue (Lavinia in *Titus Androni-
cus*, for example) or restricting her movement (Kate in *The Taming of the
Shrew*, mewed up like a falcon). The attempt is more to make a difference
than to proclaim one that always already exists.

In Thomas Dekker's *The Shoemaker's Holiday* (1600), shoes, far from
fixing gender, trace its lability. True, Freud's claim that "the shoe or slipper
is . . . a symbol of the female genitals" is partially worked out through
the commonplace of women as clogs or as "a pair of old shoes" that can
be discarded. But this commonplace is set against the shoes that are so
insistently staged, the shoes that Rafe makes for his wife, Jane, when he
parts from her, through which he constructs a material reminder of him-
self to put upon Jane's foot:

> Now gentle wife, my louing louely *Iane*,
> Rich men at parting, giue their wiues rich gifts,
> Iewels and rings, to grace their lillie hands,

> Thou know'st our trade makes rings for womens heeles:
> Here take this paire of shooes cut out by *Hodge*,
> Sticht by my fellow *Firke*, seam'd by my selfe,
> Made up and pinct, with letters for thy name,
> Weare them my deere *Iane*, for thy husbands sake,
> And euerie morning when thou pull'st them on,
> Remember me, and pray for my returne,
> Make much of them, for I have made them so,
> That I can know them from a thousand mo.[24]

The shoes that Rafe gives to Jane are not private fetishes but a work of corporate homage, since they have been crafted by Hodge and Firk as well as by Rafe himself. But the shoes, in spite of being the work of men and standing in for a man, are most certainly not phallic shoes. On the contrary, they are the "rings" into which Jane will put her heels: her feet into his shoes, his body as worn matter, as skin "pinkt" (that is, pierced) with her name.[25]

The *man* as shoes, but shoes into which a woman's foot can be put, is already present in the Greek anthology. As an anonymous translator writes in the late seventeenth century: "Make me your *Necklace, Shape,* or *Shoe,* / Nay any thing that *belongs* to you."[26] He imagines himself as the hollow form (necklace, shape, or shoe) into which she enters.

Freud can understand shoes only in terms of disavowal because he theorizes the fetish as a falling away or displacement of the person. In this he repeats "the conceptual polarity of individualized persons and commodified things," which is, as Igor Kopytoff reminds us, "recent and, culturally speaking, exceptional."[27] We all know that we should not treat people like objects. But what we "all know" is historically specific and, indeed, bizarre. We should not need Althusser to tell us that to be a "subject" is to be thrown under.[28] What does it mean to be a monarch or an aristocrat, if not to be powerfully objectified? Robert Dudley is transformed by the act of objectification that names him earl of Leicester. The power of those lands transforms him from a mere subject into a form of objectified power. In the same way, one might call the king of France "France" or the queen of England "England." Power here comes not from being a subject but from the value of the objects (land, in these cases) that accrue to the subject.

Take the value of those objects away and what is left? Shakespeare's Bolingbroke, deprived of his objectification as duke of Lancaster, claims that Richard's favorites have

> Dis-park'd my Parkes, and fell'd my Forrest Woods;
> From mine owne Windowes torne my Household Coat,
> Raz'd out my Impresse, leauing me no signe,
> Saue mens opinions, and my liuing blood,
> To shew the World I am a Gentleman.[29]

Just how immaterial and valueless "men's opinion" and "my living blood" (that is, the internalized sap of the family tree) are in contrast to the actual trees of the parks and forests that constitute the name Lancaster will be demonstrated by the fate of Richard II himself. Deprived of his lands, he is deprived also of all that makes him him:

> I haue no Name, no Title;
> No, not that Name was giuen me at the Font,
> But 'tis vsurpt: alack the heauie day,
> That I haue worne so many Winters out,
> And know not now, what Name to call my selfe.
> (4.1.255-59 [TLN 2177-81])

The power of the name is given by the power of the objectification. Take away King Lear's retainers, and he is merely Lear, no longer the "we" of the absorptive object but the "I" of the private — that is, deprived — subject.

That is a distinctively precapitalist way of thinking about the relations between person and thing: the person as the bearer of the power that comes from things. Perhaps we have been absolutely wrong about the prehistory of capitalism. It is not we who have resolutely wanted to put a value on objects. To the contrary, we are squeamish about that process — at least outside the stock market. And our squeamishness is inscribed in our attempts to separate economics from social valuation, persons from things, subjects from objects, the "priceless" or "inestimable" (us) from the "valueless" (all the rest of what we imagine as the detachable world).

It is in the Renaissance, though, that spirit and body, subject and object, start to go in antithetical directions as the commodity form achieves increasing dominance. The spirit of the commodity, as Marx so cogently argued, is "suprasensible"; insofar as an object becomes a commodity, "all its sensuous characteristics are extinguished."[30] The commodity, lacking a sensuous life, can be a fetish only in the most ironic of senses. Two commodities that became increasingly suprasensible were paintings and books.

In what sense are the easel paintings that develop in the Renaissance suprasensible? The first point is a crude one of expense. The *value* of medieval paintings was directly related to the materials out of which they were made, and above all to the money spent on wood, gold leaf, and lapis lazuli. Spiritual worth was defined unabashedly in the economic value of the paints and painting supports. The Virgin was often depicted in the most costly lapis lazuli and the lesser saints and commoners in correspondingly cheaper blues. Renaissance easel painting, though, steadily discarded the material value of the object.[31] Using canvas instead of wood, cheaper paints instead of gold leaf and lapis lazuli, its value was no longer worn on its surface. But the emergence of a value that lay outside the painting's materiality was a surprisingly lengthy process. In comparative terms, indeed, most easel paintings were cheap.[32]

Even an expensive artist such as Van Dyck was cheap—not by the standards of a laborer, of course, but by the standards of what an aristocrat or a gentlewoman might spend money on. A portrait by Van Dyck rarely cost as much as £30.[33] The clothes that he depicted might well cost from £400 to £1,200 and the jewels much more. A tapestry made from a painting nearly always cost far more than the painting itself (thousands of pounds when a series was made with gold or silver thread). In fact, a Van Dyck usually cost less than a Hilliard miniature, the latter requiring not only very expensive pigments but also a "frame" (that is, a case) that often cost more than the painting itself.[34] The value of the Hilliard, in other words, parades itself as a material value (as had medieval reliquaries), for Hilliard was keeping alive the ancient skills of the goldsmith. Van Dyck, on the contrary, was trying to develop a value that lay not in the physical materials but in the imagined presence of the artist.

The development of an art market for connoisseurs in the early seventeenth century produced a transformation of the "value" of art, which less and less was materialized in the paint and the frame. The value of a Rembrandt resided in the invisible presence of Rembrandt himself. Take that invisible presence away and, as the Rembrandt Research Project has demonstrated over the last few years, no one knows what the value of a "Rembrandt" is. To put it another way, the value of the painting comes not from its materials, but from a hypothetical narrative that lies *behind* the painting: the narrative of the master at work.

Similarly, the development of the printed book meant that value was less and less likely to be found in the beautifully worked material surface of parchment or vellum; instead, it lay behind the book, in the

imagined workings of the author's mind. The book itself became waste matter. One learns, that is, to read through a book, no longer conscious of its material surface. What is a "page-turner" if not an invisible book that turns its own pages? The book becomes the immaterial support where the mind of the reader communes with the mind of the author. And the author becomes a transcendental value who finds no place in the material world. Byron insisted that he never be painted with books or pens around him, for inspiration is immaterial.[35]

We are here at the furthest remove from the medieval iconography of writing, which was dominated by two prototypes: the work of translation (Jerome at his fully materialized desk, translating the Bible, in Dürer's print, from Hebrew and Greek into Latin) and the work of inspiration (Matthew or John, equally in need of a desk and quills, and taking down dictation from God and/or from their own symbols—the man-angel of Matthew, the eagle of John). Writing in both cases, then, was a fully materialized scene. In an illumination for a Rouen Book of Hours of about 1480, St. John sits on Patmos, a scroll across his legs.[36] To his left, his eagle speaks to him, his mouth wide open. Above him, God speaks to him. And to his right, Satan appears, in the act of stealing his ink bottle. One prevents the gospels being written by taking away their material supports. In Caravaggio's first great painting of the inspiration of St. Matthew, Matthew is depicted as an illiterate laborer, his hand able to form the Hebrew letters that we see only because his androgynous boy-angel leans across him and guides his hand.[37] Inspiration is here a writing lesson. Matthew's brow is wrinkled in concentration and anxiety before this strange task. The painting shows the materiality of writing, the unfamiliar powers of one's own material hand. Byron, by contrast, inscribes the immateriality of the idealized author, an author whose writings are invisible mental tracings.

One might say that the easel painting and the printed book already figured capitalism's profoundest mystery: the value of paper money. In the process, they created a new, profoundly paradoxical form of fetishism: the fetishism of the commodity, a fetishism of the suprasensible.

As we noted above, the concept of the fetish developed in the Renaissance on the boundaries of capitalism. By the eighteenth century, the "fetish" came increasingly to point to demonized forms of materialization. If a fetish is an external organ of the body, the emergent regime of the individual will deny that the body can have external organs. To be dependent upon "mere things" is to invalidate the individual's supposed autonomy. The theory of the fetish, then, produces by back-formation the subject of

modernity: an individual who, freed from fetishism, is freed from materialization. Similarly, writing is imagined as detaching itself from the material supports of papyrus, parchment, rag paper, wood pulp; painting is imagined as detaching itself from the material supports of walls, panels, canvas, paint. And finally, the theory of the fetish can turn back against the fetish itself and find immateriality inscribed even there.

What Freud discovers in the fetish is the emptiness of the object. Freud, in this at least, is the true heir of Protestantism. The fetish cannot be a real presence; rather, it symbolizes an absence. It is true that the material forms of Freud's fetishes resemble the saints' relics that became the sites of pilgrimage throughout Catholic Europe. Like the fragments of saints' clothing and bones, "waste" fragments are the privileged signifiers of Freud's fetishists: the "thin, scraggy foot" of a governess; "a piece of underclothing"; a "shoe or slipper"; "dirty and evil-smelling feet."[38] But, like saints' relics in a Protestant country, these material supports rapidly disappear in Freud's account. They can be interesting only as signifiers, not as numinous objects.

The subject of modernity feels the greatest embarrassment before materiality, for the object reduces the subject to silence. This subject enters speech by the disavowal of the materiality of the object. Its gaze is, as Walter Benjamin wrote, melancholic:

> If the object becomes allegorical under the gaze of melancholy, if melancholy causes life to flow out of it and it remains dead, but eternally secure, then it is exposed to the allegorist, it is unconditionally in his power. That is to say it is now quite incapable of emanating any meaning or significance of its own; such significance as it has, it acquires from the allegorist. He places it within it, and stands behind it; not in a psychological but in an ontological sense.[39]

The scandal of fetishism is less that it is sexual than that it unashamedly finds its satisfaction in a material object: in a conservative gray running shoe, for want of anything better; in the fantasized blue shoes that Mike never sees or touches; in the dependence of the human subject upon external organs of the body. Against the melancholy gaze of modernity, the utopian moment of the fetish asks us "to contemplate all things as they would present themselves from the standpoint of redemption."[40] As Benjamin writes, "[T]o perceive the aura of an object we look at means to invest it with the ability to look at us in return."[41]

NOTES

1. William Pietz, "The Problem of the Fetish, I," *Res* 9 (1985), 5–17; "The Problem of the Fetish, II," *Res* 13 (1987), 23–45; "The Problem of the Fetish, IIIa," *Res* 16 (1988), 105–23. See also his "Fetishism and Materialism: The Limits of Theory in Marx," in *Fetishism as Cultural Discourse*, ed. Emily Apter and William Pietz (Ithaca: Cornell University Press, 1993), 119–51. We have analyzed the concept of the fetish in the Renaissance more fully in the introduction to *Renaissance Clothing and the Materials of Memory* (Cambridge: Cambridge University Press, forthcoming).

2. Pietz, "The Problem of the Fetish, I," 5.

3. Pietz, "The Problem of the Fetish, II," 24–25.

4. Pietz, "The Problem of the Fetish, I," 10.

5. Pietz, "The Problem of the Fetish, II," 23.

6. Marx has also been interpreted as hostile to "objectification." But in fact he distinguishes between different forms of objectification. For Marx's assertion of the *necessity* of objectification in the positive form of the imbuing of objects with subjectivity through our work upon them and of the imbuing of the subject with objectivity through our materializations, see his *On James Mill*, in *Karl Marx: Selected Writings*, ed. David McLellan (Oxford: Oxford University Press, 1977), 114–23.

7. Sigmund Freud, "Fetishism" (1927), in *On Sexuality*, the Pelican Freud Library, vol. 7, ed. Angela Richards, trans. James Strachey (Harmondsworth: Penguin, 1997), 352–53.

8. Freud, *Three Essays on the Theory of Sexuality* (1905), the Pelican Freud Library, vol. 7, ed. Angela Richards, trans. James Strachey (Harmondsworth: Penguin, 1997), 65.

9. Ibid., 66–67.

10. Ibid., 65.

11. Marjorie Garber, "Fetish Envy," in *Vested Interests: Cross-Dressing and Cultural Anxiety* (New York and London: Routledge, 1992), 118–27. We are indebted throughout to Garber's fine analysis of the fetish.

12. Freud, "Fetishism," 354.

13. Ibid., 356–57.

14. Ibid., 353–54.

15. Freud, *Three Essays*, 67.

16. Ibid., 67 n.

17. Ibid., 68 n.

18. Ibid.

19. On the significance of specific forms of manufacture in the formation of fetishism, Gayle Rubin writes: "I do not see how one can talk about fetishism, or sadomasochism, without thinking about the production of rubber, the techniques and gear used for controlling and riding horses, the high polished gleam

of military footwear, the history of silk stockings, the cold authoritative qualities of medical equipment, or the allure of motorcycles and the elusive liberties of leaving the city for the open road. . . . To me, fetishism raises all sorts of issues concerning shifts in the manufacture of objects" ("Sexual Traffic," an interview with Judith Butler, in *Feminism Meets Queer Theory,* ed. Elizabeth Weed and Naomi Schor [Bloomington: Indiana University Press, 1997], 85).

20. Samuel R. Delany, "Aversion/Perversion/Diversion," in *Longer Views: Extended Essays* (Hanover, NH: Wesleyan University Press, 1996), 126. All further references are in our text.

21. Freud, *Three Essays,* 65–66.

22. In addition to the articles by Pietz cited above, see also the essays in *Subject and Object in Renaissance Culture,* ed. Margreta de Grazia, Maureen Quilligan, and Peter Stallybrass (Cambridge: Cambridge University Press, 1996).

23. For a fine account of the ambivalence of the tongue in the Renaissance, see Carla Mazzio, "Sins of the Tongue," in *The Body in Parts: Fantasies of Corporeality in Early Modern Europe,* ed. David Hillman and Carla Mazzio (New York and London: Routledge, 1997), 52–79.

24. Thomas Dekker, *The Shoemakers' Holiday,* in *The Dramatic Works of Thomas Dekker,* ed. Fredson Bowers, vol. 1 (Cambridge: Cambridge University Press, 1953), 1.1.224–35.

25. For further considerations on shoes and feet in the Renaissance, see Peter Stallybrass, "Foot Notes," in *The Body in Parts,* 313–25.

26. "The Wish to His Mistress," *Anacreon* (Oxford, 1683), 41.

27. Igor Kopytoff, "The Cultural Biography of Things: Commoditization as Process," in *The Social Life of Things: Commodities in Cultural Perspective,* ed. Arjun Appadurai (Cambridge: Cambridge University Press, 1986), 64.

28. See Louis Althusser, "Ideology and Ideological State Apparatuses," trans. Ben Brewster, in *Lenin and Philosophy* (London: New Left Books, 1971), 127–86.

29. William Shakespeare, *The Life and Death of King Richard the Second,* in *The First Folio of Shakespeare: The Norton Facsimile,* ed. Charlton Hinman (New York: Norton, 1968), 3.1.23–27 (TLN 1335–39). This and the following quotations from Shakespeare are from this edition and references are to the act, scene, and line numbers of *The Riverside Shakespeare,* ed. G. Blakemore Evans (Boston: Houghton Mifflin, 1974), followed by the through line numbers (TLN) of Hinman's First Folio.

30. Karl Marx, *Capital: A Critique of Political Economy,* vol. 1, trans. Ben Fowkes (New York: Vintage, 1976 [1867]), 165, 128.

31. Yet as late as 1599, when Caravaggio was commissioned to make two paintings for the Contarelli chapel, the contract named an assessor to evaluate the price of the blue and ultramarine that Caravaggio used. See Howard Hibbard, *Caravaggio* (New York: Harper and Row, 1983), 117.

32. On the relations between easel paintings and price, see Michael Baxandall, *Painting and Experience in Fifteenth-Century Italy*, 2nd ed. (Oxford: Oxford University Press, 1988), 2–11; Marcia B. Hall, *Color and Meaning: Practice and Theory in Renaissance Painting* (Cambridge: Cambridge University Press, 1992); Ann Rosalind Jones and Peter Stallybrass, "Composing the Subject," in *Renaissance Clothing and the Materials of Memory*.

33. Oliver Millar notes that Van Dyck's portraits typically cost about £20, although his largest and most elaborate paintings of the monarch might cost as much as £100. See Millar, "Van Dyck in London," in Arthur K. Wheelock, Susan J. Barnes, Julius S. Held, et al., *Anthony van Dyck* (New York: Harry Abrams, 1990), 53. In 1638 Van Dyck submitted a list of his paintings to Charles I with prices attached. In three cases where Van Dyck had valued portraits of Henrietta Maria at £20, Charles had himself crossed out the valuation and substituted £15. He also revalued one of Van Dyck's most magnificent compositions, *Roi à la Chasse*. According to Van Dyck, it was worth £200; Charles thought it was worth only £100. See Christopher Brown, *Van Dyck* (Ithaca: Cornell University Press, 1983), 164–65.

34. See Erna Auerbach, *Nicholas Hilliard* (Boston: Boston Book and Art Shop, 1961), 170. On the miniature as a portable jewel, see John Rowlands, *Holbein: The Paintings of Hans Holbein the Younger* (Boston: David Godine, 1985), 89.

35. See Richard Holmes, "The Romantic Circle," *New York Review of Books*, 44, 6 (April 10, 1997), 34–35.

36. The illumination is reproduced in Christopher de Hamel, *Scribes and Illuminators* (Toronto: University of Toronto Press, 1992), 31. The image of the devil trying to steal St. John's inkpot can be found in other Books of Hours.

37. The painting for the Contarelli chapel in Rome was probably completed in 1602, and was destroyed by a bomb in Berlin in 1945. The painting was rejected as unsuitable, "the priests . . . saying that the figure with its legs crossed and its feet rudely exposed to the public had neither decorum nor the appearance of a saint." Caravaggio replaced it with a different version of the inspiration of St. Matthew in 1603. See Hibbard, *Caravaggio*, 138–48.

38. Freud, *Introductory Lectures on Psychoanalysis* (1917), in *The Standard Edition of the Complete Psychological Works of Sigmund Freud*, trans. James Strachey (London: Hogarth Press, 1963), 16:348, 305; *Three Essays*, 67 n, 68 n.

39. Walter Benjamin, *The Origin of German Drama*, trans. John Osborne (London: New Left Books, 1977), 183–84.

40. Theodor Adorno, *Minima Moralia*, trans. E. F. N. Jephcott (London: New Left Books, 1974), 247.

41. Walter Benjamin, "On Some Motifs in Baudelaire," in *Illuminations*, ed. Hannah Arendt, trans. Harry Zohn (London: Fontana, 1973), 157–202, 190.

JAMES R. SIEMON

DREAMS OF FIELD

Early Modern (Dis)Positions

*[There is] no action without . . . interest, or, if one prefers, without in-
vestment in a game and in a stake, illusio, commitment. . . . [I]nterest is
a historical arbitrary. . . . [I]nstitutions can constitute just about any-
thing as an interest.*

—*Pierre Bourdieu,* An Invitation to Reflexive Sociology

Taking a cue from the recognized interests of psychoanalysis and his-
toricism in the genre of the anecdote, I will begin with half a story, ex-
cerpting from a narrative that is at once historical and apparently
psychopathological. Subsequently, I will briefly examine a potentially
significant encounter between historicism and psychoanalysis as em-
bodied in the work of Slavoj Žižek in order to suggest an alternative em-
phasis that adds to Žižek's post-Lacanian/post-Marxist dimension one
aspect of the socioanalysis of Pierre Bourdieu. This suggestion is in-
tended to complicate polar alternatives that determine some thinking
about the psychoanalysis/historicism opposition — that is, either desire
or the economy — with a third, potentially median, term: the field. The
argument for the usefulness of this term will be supported by specific

Shakespearean examples suggesting the interpenetration of desire, economy, and social fields upon the site of the body. These examples will include brief instances from *Troilus and Cressida, Cymbeline, Coriolanus, Titus Andronicus*, and the sonnets.

First, the anecdote, part one: When arrested on charges of burglary in July 1992, Chuck Jones was found to have in his possession a cache of women's shoes, mostly high heels, but including sneakers and boots as well. All had been stolen from one woman. There was also a copy of a magazine called *Spike*, notable for its photographs of women's feet, mostly in heels. Police were surprised that all the boots in Jones' collection had been slashed, which one might think would lessen their attraction. When asked about this fact, Jones testified that he cut open the boots in order better to see the imprints left by the owner's feet.[1] For reasons that will become, I hope, quite relevant, I leave the personal identity of the owner, her relation to Mr. Jones, and Jones' own professional position uncharacterized until the end of this essay.

The particular (and complementary) interpretive advantages of historicism and psychoanalysis seem to me to be that historicism has encouraged reading the political in the personal, while psychoanalysis, in Constance Penley's phrase, has insisted that "the political is personal."[2] The two are further complementary in that historicism enables the basic Marxist exposure of the real as ideological, while psychoanalysis, in Slavoj Žižek's phrasing, enables resistance to an "over-rapid historicization" by encouraging awareness of the degree to which "fantasy construction serves as a support for our 'reality' itself."[3] My own interest lies with a *p*-term that is neither quite the historicist political-topical, nor exactly the Lacanian phallic. If the personal may be seen as the political and the political as personal, then a third term that Pierre Bourdieu's socioanalysis could contribute is the positional. Bourdieu's relational account of social space and of the dispositions of those who occupy positions within its multiple overlapping and conflicting fields offers potentially useful terms for conducting what Klaus Eder has called a mesolevel analysis of desire, agency, ideology, and fantasy.[4]

Desire, agency, ideology, and fantasy are familiar players in the exciting recent work of Žižek, but Žižek's treatment of Shakespeare reveals some potential limitations of his form of historicizing psychoanalysis (or psychoanalyzing historicism). With characteristic modesty, Žižek has

claimed to prove that Shakespeare read Lacan.[5] Yet when Žižek reads Shakespeare, his otherwise innovative blend of post-Lacanian/post-Marxist analysis offers surprisingly predictable old favorites: *Richard II* provides a transhistorical allegory of the *objet petit a*, on the one — Lacanian — hand, and a material topicality in evoking the "emergence of . . . capitalism," on the other — historicizing — hand.[6] What interests me is that Žižek's twinned Lacanian and historicist readings are suspended in a discourse that suggests a missing third term between a history of the market and a psychoanalysis of desire. When, for example, he describes "the basic problem" of Richard II, Žižek mentions "the *hystericization of a king*, a process whereby the king loses the second, sublime body that makes him a king, is confronted with the void of his subjectivity outside the symbolic mandate-title 'king,' and is thus forced into a series of theatrical, hysterical outbursts from self pity to sarcastic and clownish madness."[7] Seen in the context of certain other trends in psychoanalytic interpretation, such an assessment could be viewed positively insofar as it addresses Carl Schorske's criticism of Freud for forgetting that Oedipus was a king. Nevertheless, Žižek's overriding concentration on two analytic poles — either individual subjectivity or the macroeconomic market — prevents further attention to an obvious but, I believe, important, Bourdieuvian point: Sophocles was a fifth-century Athenian *dramatist* and Shakespeare an early modern *theater professional*.[8]

If the position of king and its accompanying dispositions partially determine Oedipus, then the position and dispositions of dramatist repay attention as well, whatever the state of the field of cultural production might be at a particular historical moment. Žižek's own language almost acknowledges this fact when he describes Richard's "theatrical, hysterical outbursts" and when he alludes to Richard's specifically theatrical dispositions: "from self pity to sarcastic and clownish madness." My point is to draw an obvious connection between Žižek's vocabulary of behavioral theatricality — hysteria, pity, sarcasm, and clowning — and the theatrical profession. Far from being merely representations of individualized psychic turmoil, such manifest dispositions by a character in a play could be seen rather as objects of positive desire and/or negative aversion for an actor-playwright-manager engaged in his own struggles for positional recognition, both for himself individually against near neighbors in the emerging literary-theatrical field and for his discipline(s) against other contenders also questing for legitimacy and authority in the wider social/political fields of society at large. Thus, as Žižek himself might, but does not, say, King Richard's symptoms

could be seen as resembling political signifiers in being, according to Žižek, "performative" rather than merely or simply "representational."[9] Rather than merely *referring* to the posited behavior of a historical King Richard, the outbursts of Shakespeare's Richard *do* something — something at once political, social, and theatrical — for the playwright.

Certainly, there is no doubting Shakespeare's interest in the power and paradoxes of desire and aversion. Leontes grandly pronounces upon desire's active power and unpredictable volatility in claiming that "Affection" "communicat'st with dreams" and is "coactive" both with "what's unreal" and also conjunctive "with something" that is conceived as nonimaginary.[10] But the degree to which that "something," the object of either positive desire or of its negative form, aversion, is itself arbitrary or is explicable in other logics appears to be debatable. Mercutio and Shylock register two extreme opinions in this regard. Mercutio's Queen Mab speech represents desire as thoroughly mediated by social conditions: Mab visits the brains of representative vocational types, causing courtiers to dream of suits, parsons of tithe pigs, and soldiers of the acts and accoutrements of war:

> Sometimes she gallops o'er a courtier's nose,
> And then dreams he of smelling out a suit.
> And sometimes comes she with a tithe-pig's tail
> Tickling a parson's nose as 'a lies asleep;
> Then dreams he of another benefice.
> Sometimes she driveth o'er a soldier's neck,
> And then dreams he of cutting foreign throats,
> Of breaches, ambuscadoes, Spanish blades,
> Of healths five fathom deep, and then anon
> Drums in his ear, at which he starts and wakes,
> And thus, being frighted swears a prayer or two
> And sleeps again. (1.4.77–88)

In Shylock's gaping-pig speech, by contrast, desires and aversions appear to be mysteries with no specific ties to occupation or position. According to Shylock, "[s]ome men," even presumably some parsons, just cannot abide pigs — or cats, or bagpipes:

> Some men there are love not a gaping pig,
> Some that are mad if they behold a cat,

And others, when the bagpipe sings i' the nose,
Cannot contain their urine; for affection,
Mistress of passion, sways it to the mood
Of what it likes or loathes. (4.1.47–52)

Although these speeches appear to stake out opposing positions, when taken in their respective contexts their opposition is less clear.

Mercutio's sociomaterial reduction of desire to a predictable drive for a socially defined object is occasioned by the character's express need to counter Romeo's romantic fixation on an ostensibly individualized object of desire.[11] Conversely, Shylock's account of the effects of mysteriously unmotivated "affection" or "humors" misrepresents an aversion of his own that is just as materially logical as any of the occupational desires mentioned by Mercutio. Shylock may tell others that he cannot choose but to pursue his desire for Antonio's flesh, but he also tells us that he hates Antonio for a specific occupationally defined fault: Antonio has harmed Shylock's economic interests by lowering "the rate of usance" in Venice (1.3.40). Yet I would not want to be "over-rapid" in historicizing Shylock's aversions by reducing them entirely to the terms of material economy. After all, his hatred also invokes religious antipathy—"I hate him for he is a Christian"—as well as something more vague, an odd disgust for Antonio's physical appearance and disposition: "How like a fawning publican he looks" (1.3.38–39). Since Shylock's simile so little matches its designated referent, fitting neither Antonio's unfawning preeminence on the Rialto nor his harsh treatment of Shylock, and since Antonio is neither innkeeper, tax collector, nor humble sinner, in three typical glossings, the aversion condensed into "fawning publican" remains puzzling.[12] The oddity of this terminology suggests other, possibly symptomatic, Shakespearean moments where strange things happen in treatments of the body.

In a recent brilliant reading that implicates the body, Stephen X. Mead directs broadly economic arguments like Žižek's to textual specifics, claiming that *Troilus and Cressida* "reflects . . . larger economic concerns" and "anxieties" found in contemporary disputes about "the discrepancy between abstract ideals and manipulated commodities."[13] Mead maintains that early modern England was torn between "economic nostalgia" (245) for an idealized past when a "bullionist disposition" anchored an order in which "language, worth, and identity

corresponded," making a person as stably self-identical as a pound ster-
ling (241, 245), and an anxious sense that money and identity were
merely signifiers, "no longer specie of absolute value" (243).[14] Seen
through contemporary eyes, the devalued and manipulated pound both
was and was not worth a pound of sterling, as the physical Cressida, in
Troilus's phrase, both "is and is not Cressid" (5.2.150). While this his-
toricizing reading has much to recommend it, there is something that
might be lost by its focus on what Christopher Pye has defined as the
new historicism's favorite signified—economy.[15] What is potentially
overlooked can be suggested by looking at Ulysses looking at Cressida's
body with some help from Žižek and Bourdieu.

Linking the microanalytic aspects of personal identity to a role as
"reflec[ting]" macroeconomic issues and discourses they "really" signify
amounts to substituting the dominance of one lost signified, the absolute
value of bullion, for another, the loss of stable personal identity. In this
substitution Mead's argument constitutes a version of what Bourdieu has
criticized in some forms of Marxist analysis as a "short-circuit."[16] That
is, it omits from consideration semiautonomous fields of practice such as
art, religion, or theater, to name three, which may have, to varying de-
grees and in varying historical configurations, their own "restricted
economies" with their own capitals and dispositions, while it also ig-
nores the problematic positionality of those fields within a larger social
space.[17] Similarly, making a straight base-superstructure link between
cultural phenomena and an economic order they signify would be to
miss Žižek's development of the Lacanian theme of "quilting," in which
he argues that amid a symbolic order defined by gaps and slippage
among signifiers, certain signifiers may serve as "nodal points" that de-
termine the shape of given "ideological fields." As such, they may
"quilt" together the more or less arbitrary dimensions of that specific
ideological field in remarkable, even symptomatic, ways, "stitch[ing] up
the inconsistency of . . . ideological system[s]," as Žižek puts it, "beyond
all possible variations in . . . positive content."[18]

For a textually specific example, take Ulysses' diatribe on the semi-
otic imbrication of Cressida's body:

> There's language in her eye, her cheek, her lip,
> Nay, her foot speaks; her wanton spirits look out
> At every joint and motive of her body.
> O, these encounterers, so glib of tongue,

> That give accosting welcome ere it comes,
> And wide unclasp the tables of their thoughts
> To every ticklish reader! Set them down
> For sluttish spoils of opportunity,
> And daughters of the game. (4.5.56–64)

Mead interprets the threat to "set down" Cressida as an economic metaphor that means Ulysses intends to "debase" her, as in the debasement of currency. This interpretation ignores the obvious reference to the practice of writing—a linkage that is clear in Hamlet's call for his commonplace book: "My tables—meet it is I set it down" (1.5.108). Seen in the context of this specific field—that is, of writing rather than of economy—Ulysses' phrase appears to be an imperative to "set" Cressida's identity "down" among loose women, evoking the fixity that is attributed to writing by Hamlet and by certain of the sonnets (e.g., Sonnet 55). Furthermore, this aggressive situating of Cressida's body in the field of writing recalls another complex interaction that has specific reference to writing.

Curiously, Ulysses extends his disdain for Cressida to include the audience that might want to read what he desires to set down about her; his animus becomes interwoven with a strange resentment toward the "ticklish reader" his imaginary writing anticipates. This attack is the more remarkable since this imagined audience shares with Cressida herself the distinction of being an object of manifest desire for Ulysses: What else would prompt him to demand a kiss or to wish to record his observations? In their odd double *Verneinung*, the self-contradictions of Ulysses mimic a dilemma that Shakespeare elsewhere depicts as specific to the discursive subfield of satire. In his mocking vilification of the failings of others, the satirical critic, exemplified by Jaques in *As You Like It,* is said to denounce the object that had initiated his own desire while also expressing disdain for the further desire that he anticipates his denunciations will arouse in his audience. As Duke senior puts it, Jaques sins in chiding sin, disgorging onto the world evils that are already resident in himself, then attacking and belittling his audience for responding to his polemical "anatomiz[ing]" in the first place (*As You Like It* 2.7.45–87). Seen in such a quasi-institutional context, Ulysses' phrasing is further revealing in that his attack condenses into one imaginary figuration—the "encounterer"—the eroticized personification of two distinct positions that are derived from the restricted economy of the subfield of satirical

writing: both the writers who "wide unclasp the table of their thoughts" and "every ticklish reader" who desires to be titillated by what that wide-open, unclasped table promises to provide. Of course, a field-specific awareness of contemporary literary and dramatic satire, as critics have long noted, pervades *Troilus and Cressida*, and the dispositional politics attending the playwright's awareness of his competitors within such a field is further adumbrated in Troilus' disapproving characterization of "stubborn critics," who are said to be "apt, without a theme" (5.2.134).[19] Such figures represent a threatening potential that is paradoxically both fixed and yet free-floating, embodying a "stubborn" pathology, a habit of being, that is at once insistently determined and yet also wide open to opportunity, being sluttishly "apt" by nature to unload a burden of unvarying aversion upon any object or occasion — in Žižek's phrase, "beyond all possible variation in content." To use Bourdieu's terms, the disposition associated with the critical satirist constitutes a habitus that is both fixed and relatively transposable from one object or field of application to another; the "stubborn critic" is constant neither in choice of a particular target nor in reacting to limited occasions, but only in a fascinated disapproval — desire and aversion mixed inextricably.

Since such descriptions suggest something resembling a mechanism of projection and since gender is so prominent in them, individual psychology or gender dynamics could obviously determine the categories of analysis; but tentatively I follow Bourdieu's stress on the inextricability of such analytical categories from sociopolitical factors of class and position. This choice of emphasis may be supported by Stephen Orgel's argument for the historical dominance of class and status over considerations of gender in the bodily regimen prescribed by the early modern sumptuary laws:

> For all the pulpit rhetoric about the evils of cross-dressing, sumptuary legislation said nothing about the wearing of sexually inappropriate garments. It was concerned with violations of the sartorial badges of class, not those of gender. Tradesmen and their wives were enjoined from wearing the satins and velvets of aristocrats, people below the rank of gentry were limited to clothing made of certain kinds of wool and other plain cloth.[20]

In light of this apparent primacy of class as a determining factor, it is not surprising to find the object of bodily inflected aversion in two

other Shakespearean moments to be not a *"daughter* of the game" but the male product *"of the game"*—stress falling on the object's occupation of a position within a disposing field having its own semiautonomous forms of capital and distinction. But before turning to these masculine instances from *Cymbeline* and *Coriolanus*, it would be useful to consider further the matter of psychological projection.

The prominent references to anamorphosis in *Richard II* and the presence within the play of interpersonal relationships that are articulated in terms suggesting anamorphic configuration have prompted Ned Lukacher to claim a relation between Shakespeare and Lacan, but Lukacher does not pursue the social-ideological specificity that Žižek authorizes, even if he does not always follow, in his own version of Lacan.[21] Lukacher takes John of Gaunt's line to King Richard, "Now He that made me knows I see thee ill; / Ill in myself to see, and in thee seeing ill" (2.1.93–94), as making a Lacanian point: "The effect of the conceit is to break down the difference between the seeing subject and that which is seen, as well as the difference between the illness that afflicts the one who sees and the illness that afflicts the one who is seen."[22] Now, however accurate this formula may be, it overlooks one important element. The premise of Lukacher's argument is that Gaunt diagnoses Richard's situation and his own accurately, but actually Gaunt's diagnosis misses something. Gaunt himself is "ill" in a precise sociopolitical sense that he is unable to see, and this illness, this ideological disorder, is (mis)taken by himself and by the entire social order for a kind of health. Specifically, Gaunt and Richard share a misrecognized complicity in sustaining the ideological conditions that enable Richard's abuses of royal power. That is, they share a traditional form of ontologized state religion that will be thoroughly compromised by the larger play. The point that one might make from a Žižek-inspired analysis is thus not strictly specific to individualized projection located in "the" *psychological* subject but takes important elements of its contours from the embracing context of a historically specific order that appears quilted to one arbitrary—its monarchical system. A hystericized, "religious" order is premised upon a gap or separation between the king's sacrosanct royal authority and the divinely ordained abjection expected of any *political* subject.[23] Neither Gaunt nor Richard can see what is "ill" with both of them because the quasi-absolutist political order they inhabit defines their shared illness as health. However, by virtue of its concern with a very broad notion of an entire political order defined in

terms of state politics, this account still occupies familiar new-historicist territory. More might be done in more circumscribed arenas of positional analysis.

In a passage from *Cymbeline* that exhibits structural similarities to Ulysses' attacks on Cressida, Iachimo imagines the compromised bodily integrity of Posthumus Leonatus in terms that are not derived from state politics, although they do at first suggest derivation from a generalized market. Iachimo's description of a body caught in a threatening network of erotic relationships recalls Ulysses' lines, but the articulating discourse differs. Instead of invoking a semiotic "game"—such as the erotic intercourse of the sexes—in which the meanings of the desired body are produced and always already at play, Iachimo hypothesizes a specific material base for which sexuality is merely one superstructural instantiation. Pretending "pity," Iachimo praises the body of Imogen, his supposedly betrayed female interlocutor, while simultaneously representing her husband's own body as having been "partnered" with "diseased ventures" among Rome's prostitutes. Moreover, this imagined sexual "play" is said by Iachimo to be in fact no game at all, but actually a kind of "labor":

> Had I this cheek
> To bathe my lips upon; this hand, whose touch,
> Whose every touch, would force the feeler's soul
> To th' oath of loyalty; this object, which
> Takes prisoner the wild motion of mine eye,
> Fixing it only here; should I, damned then,
> Slaver with lips as common as the stairs
> That mount the Capitol; join grips, with hands
> Made hard with hourly falsehood—falsehood, as
> With labor; then by-peeping in an eye
> Base and illustrous as the smoky light
> That's fed with stinking tallow. . . .
> to be partnered
> With tomboys hired with that self exhibition
> Which your own coffers yield; with diseased ventures
> That play with all infirmities for gold. (1.6.9–124)

As in Ulysses' attack on Cressida, the body evoked in lips, hands, and eyes disintegrates into a larger field of relations, but while commodification and

economic activity define the terms of aversion, the fantasy object it-
self—Posthumus's sexualized body—exhibits a strategic condensation
reminiscent of that which appears in Ulysses' constructed figure of the
"encounterer." The hands with which Posthumus's hands are "part-
nered" appear in Iachimo's discourse to be "[m]ade hard with hourly
falsehood (falsehood, as / With labor)." Against expectation, the hands
are not soft and pliable but hardened by repeated labors of falsehood,
and stand as synecdoches for imaginary erotic partners. This image con-
denses the calloused hands of the ordinary laborer and the bodies of
those who take money from those hands in exchange for sexual acts. This
condensation and displacement construct an object of aversion that
amounts to a conjoined figure of prostitute-client standing for commodi-
fied sexual labor, as Ulysses' fantasy had constructed the erotically con-
joined writer-reader standing for written satire. But the similarities and
differences of the two passages do not end here.

This fantasy aversion, too, may be related to a self-compromised
speaker, for Iachimo embodies the very commercial and laboring dispo-
sitions that he professes to loathe. He trades in desires and aversions and
pursues specifically financial profit from commodified sexuality. This
economic motive makes him quite different from Iago in *Othello* or Pan-
darus in *Troilus*, whom he might otherwise seem to resemble. Iachimo
also differs from them in that he graphically represents the physical
difficulties that come with being a sex worker. Forbidden by his eco-
nomic motives from taking the slightest enjoyment, left not even "one
touch" of Imogen's body for himself, he is represented as being physi-
cally hardened to a labor that literally constrains him by locking him up
in a trunk, that demands he punctually attend an "hourly" clock, and
that requires he carefully catalogue his own erotic perceptions for imag-
inary consumption by others. Thus, when Iachimo expresses vehement
disgust for literal prostitutes and their activities, he, like Ulysses de-
nouncing literary satirists, expresses revulsion for transactions and dis-
positions that he to some extent embodies; also like Ulysses, he displaces
his disgust onto a composite figure that might have carried considerable
symbolic significance for the early modern theater professional. After
all, what he embodies is commodified sexual *imagination*. As near neigh-
bors in social and physical space, the personnel and practices of South-
wark's brothels offered a physical product that competed directly with
the imaginary eroticism the public theaters purveyed in exchange for
the tribute of labor-hardened "hands." This competition in providing an
erotic product—whether material or fantastic—set the actual brothels

against the theaters or "put-downe stews," as Davies of Hereford called them. In the case of *Coriolanus*, passages suggesting bodily aversion allude to a positional contention located not between next-door neighbors, but squarely inside the theater itself.[24]

Famously, *Coriolanus* has offered opportunities for historical/economistic or psychoanalytic approaches. On one hand, Coriolanus' reluctance to enter "the marketplace" does appear to represent a struggle between an archaic sense of identity and an anxious awareness of the dispersed, placeless market of negotiated identities that Jean-Christophe Agnew and others associate with the emergence of early capitalism.[25] On the other hand, by virtue of his demands to "stand / As if a man were author of himself" (5.3.34–35), Coriolanus articulates a self-definition that suggests what Janet Adelman calls a "sustaining fantasy" of "phallic exhibitionism."[26] The term *author*, however, deserves attention, for this reference to authorial self-identity occurs in proximity to a polar opposite that represents helpless ineffectuality to Coriolanus: "Like a dull actor now / I have forgot my part and I am out, / Even to a full disgrace" (5.3.40–42). This negative alternative — the actor uncertain of a part that is not even his own possession in the first place — is most fully articulated in lines invoking bodily dispossession:

> You have put me now to such a part which never
> I shall discharge to th' life . . .
> Away, my disposition, and possess me
> Some harlot's spirit! My throat of war be turned,
> Which choired with my drum, into a pipe
> Small as an eunuch, or the virgin voice
> That babies lulls asleep! The smiles of knaves
> Tent in my cheeks, and schoolboys' tears take up
> The glasses of my sight! A beggar's tongue
> Make motion through my lips, and my armed knees,
> Who bowed but in my stirrup, bend like his
> That hath received an alms! I will not do't,
> Lest I surcease to honor mine own truth
> And by my body's action teach my mind
> A most inherent baseness. (3.2.107–125)

The vocabulary here employed is insistently, even technically, theatrical in its references to "discharg[ing]" a "part," to "prompt[ing]," and to the

praise promised for "perform[ing]." Furthermore, these lines deploy recognizable elements from contemporary antitheatrical discourse. However, Coriolanus does not merely echo attacks on the baseness and harlotry of the theater and its professionals; instead he employs a more highly specialized, field-specific discourse. His account of perverse physical possession derives from a writerly polemic against actors that runs from Greene through the references to actors as leaden spouts in the *Parnassus Plays* to Donne's remarks about them as puppets animated by the air of organ pipes.[27]

In 1592 Robert Greene warned three "rare wits" among his fellow London dramatists against a professional dependency inhering in their newly emergent profession: "Base minded men all three of you, if by my miserie you be not warnd: for vnto none of you (like mee) sought those burres to cleaue: thos Puppets (I meane) that speak from our mouths, those Anticks garnisht in our colours."[28] Greene warns that the playwrights will forfeit a degree of social standing, which somewhat surprisingly he assumes they must lose in the first place, by giving up their discursive superiority to become artistically (and financially) dependent on the support and loyalty of players, who are rightly presumed to be not only mere vessels for them, but their social inferiors.

As in the case of the hardened hands attributed by Iachimo to prostitutes, the denunciation of actors in *Coriolanus* is oddly articulated in bodily terms. Coriolanus envisions his debasement by imagining himself in the figure of an actor who is not the limbs or pipe controlled by a dictatorial author's voice but who is the morcellated embodiment of responses from that other inescapable partner in the playhouse enterprise — the audience. The weak voices of eunuch and virgin, the compromised smiles of knaves, the uncontrolled tears of schoolboys, the compelled deference of beggars: not quite like Bottom, Coriolanus does not imagine himself projected into all the parts, but imagines all the parts that threaten to go into comprising himself. Instead of coming to him from a controlling authorial plenitude, however, they are reflected onto/into him from a sociosymbolic order that appears to be constituted by a plurality of lacks. The self that he fearfully imagines himself becoming is composed from the systemically constituted spaces and negations constituting the distinctions of sexuality, gender, age, power, standing, and wealth that comprise a social order into which others must perforce fit and fail to fit — a suggestively Lacanian (k)not.[29]

This particular aversion could be defined according to the individual character of the speaker and, as such, would exhibit a limited irony by registering Coriolanus's personal confusions. After all, the play intersperses his intentions to "honor mine own truth" with insistent reminders of the part played by his mother's role as voice of the father who has truly been prompting him even at those moments when she had seemed to be merely a passive *audience* for him: Her praises, as she puts it to him, "made thee first a soldier," and he must further continue to "perform a part," she says, in order to "have my praise for this" (3.2.110–11). By no means autonomous, he is, through his family, always already in the market, subject to interested transactions in scarce goods such as honor and reputation while caught in multiple relations of dependency, but he is also already in the theater, prompted by anticipated reactions of an audience. In addition to its psychological implications for a particular character, however, this highly ironic situation could also constitute a broader attack on the key virtues of early modern honor culture, since the self-sufficiency that is postulated as primary by that culture is dramatically represented as embedded in a larger symbolic economy that compromises its presumed integrity with evidence of negotiations that permeate right down to muscle and emotion.[30] Such an animus against the pretensions of military culture might go some way toward furnishing an understanding for related moments in other plays — such as the humiliation of the drawer Francis, whose near-speechless paralysis is oddly made to figure for Prince Hal as an image that condenses commercial and military limitations of body and language (*Henry IV, Part 1*, 2.4). But how to reconcile such nightmares of the actor as the (dis)possessed victim of his own audience with the figure of Hal himself, who constructs his own superiority precisely out of his self-proclaimed capacity to time his actions according to audience expectations and to its demands for dramatic surprise, "redeeming time when men think least [he] will"? Again perhaps, as in the earlier cases cited, analysis in terms of a slightly different field-defined context could be useful.

In the sonnets, the speaker occasionally expresses fear of being left, Francis-like, as "an unperfect actor on the stage" (Sonnet 23). Here there is an implied difference between the perfect and imperfect actor that seems to be determined by relative command of language. The threatening scenario imagined by the sonneteer, in which a body is left speechlessly inert,

dispossessed of agency while being exposed to visual and verbal objectification articulated in recognizably social-professional terms, is embodied in *Titus Andronicus*.

Most notoriously among the bodily disempowered, the raped and mutilated Lavinia is left onstage to suffer silently the strangely paralleled insults, first of her violators' joking dismissal and then of her ostensibly sympathetic uncle Marcus's lyrical apostrophes to those physical parts and agencies she no longer possesses. While there is obvious justification for critical approaches to these shocking moments in terms of gendered violence itself or for reading them as suggesting psychoanalytic categories, there is, nonetheless, an odd writerly, professional dimension present here as well.[31] When Marcus reacts to the ghastly transformation of Lavinia, the striking thing is that although he does invoke the authorial precedent of Ovid, whose poetry has "patterned" (4.1.59) her condition in the story of Tereus and Philomel, his lines also pointedly refer to an identifiable faction among Shakespeare's writer-contemporaries. That is, Marcus's lines render Lavinia as an object of strangely eroticized attention like the beloveds encountered in contemporary love lyric, dwelling lovingly on the erotic potential of her lost or maimed attributes—tongue, fingers, hands, and even the "rosèd lips" of her bloodied mouth—while grotesquely posing the central demand of the sonnet tradition: "O, that I knew thy heart" (2.4.34). The problem here, of course, is that instead of a poetic amator addressing the conventionally morcellated beauties of the beloved in the context of an ultimate question about whether she will give herself to him or belongs to another, Marcus addresses the damaged or absent portions of a rape victim, whose physical violation by the desire of others is grotesquely likened to the sonneteer's enigmatic object: the mysterious desires poetically attributed to the beloved's own "heart."

Here in Marcus and Lavinia we see a nightmarish exaggeration and condensation of the aggression and desire elsewhere distributed more decorously in Elizabethan love lyric. The object of poetic attention becomes identical with the victim of physical degradation; conventionally familiar idealizing verse is confused with her grotesque mutilation; the loving poet is confused with her clumsy protector and desiring violator(s).

Thus, in this case, the struggles articulated upon the (dis)possessed body situated at the conjunction of desire, aversion, and the professional are not resolved into a tension between the author's and player's claims to superiority—or into the struggle of author with audience,

with readers, or with other providers of sexual fantasy. Instead, as in *Troilus*, the authorial position is itself a site of physically inflected conflict, where authors of the same sort — for example, love lyricists in this case, as satirical critics in the other — contend with each other over and about the specifics of their trade. A sense of such intramural contention among similar authors riddles the sonnets, especially Sonnets 78–86, which lament the poet's "sick muse" or "tongue-tied muse" and depict "every alien pen," including those said to be graceful, majestic, learned, or simply of a "better spirit," as threatening to silence the poet by enforcing a sense of his own "rude ignorance." When he actually does turn to praising the beloved, furthermore, the poet-speaker imagines body parts as scarce goods that are already circulating:

> Yet what of thee thy poet doth invent
> He robs thee of and pays it thee again.
> He lends thee virtue, and he stole that word
> From thy behavior; beauty doth he give,
> And found it in thy cheek; he can afford
> No praise to thee but what in thee doth live.
> Then thank him not for that which he doth say,
> Since what he owes thee thou thyself dost pay. (Sonnet 79)

Here in this odd evocation of patron-client relations, there is a structural confusion resembling those in the earlier passages. As Ulysses condenses satirical authors and readers, Iachimo sexual prostitutes and their laboring customers, Coriolanus theatrical actors and audience, Marcus erotic poets and violators, so the sonneteer delineates a poetic subject, who is also simultaneously a sexual object and a patron:

> So oft have I invoked thee for my Muse
> And found such fair assistance in my verse
> As every alien pen hath got my use
> And under thee their poesy disperse. (Sonnet 78)

How much of this is praise and gratitude for support and inspiration, and how much of this is blame for an availability that could be equated with fickleness? The competitors have gotten the poet's "use" from the beloved object and now "disperse" their own verse under a patron who is, perhaps significantly, on top physically as well as fiscally.

But more, the vocabulary of "use" here metaphorically employed to characterize at once the sonneteer's style and usage as well as the object-patron's sexualized availability also pointedly recalls financial usance; and in that sense, when coupled with reference to the "alien" pens of imagined professional competitors, the phrasing might direct our attention back to the phrase that earlier proved puzzling when employed by an alien usurer to describe his own professional competitor. Despite efforts at explanation in terms of the biblical account of the humble publican and the gloating Pharisee, no one, to my mind, has succeeded in making Shylock's epithet "fawning publican" convincingly suit its ostensible referent, Antonio.[32] Antonio is never an instrument of official taxation, nor is he, especially in the scene in which the phrase occurs, personally humble or ingratiating; quite the contrary. However, when taken in a different Elizabethan context, the phrase does turn out to be surprisingly apt in application to Shylock himself. And as in the case of Gaunt's assessment of King Richard's illness, the speaking subject's (mis)attribution of qualities to its object is mediated by categories that are at once personal, physical, socioideological, and certainly, in the case of Shylock and Antonio, professional.

First of all, *publican* is not merely broadly synonymous with *sinner*, but an equivalent for *usurer* in contemporary polemical discourse.[33] Furthermore, the professional disposition of the usurer is also tellingly defined within that same discourse in ways that resonate with Shylock's reference. Although typically described as being cruelly rapacious, the behavior of the usurer is also said to appear changeable. Usurers may be said to display the "*rauenousnes* & *gripplenes*" of the biblical publicans, who, according to Miles Mosse, furnish "a liuely patterne of yt greedinesse & couetousnesse of the *vsurer*," but their demeanor is frequently said also to involve exhibitions of false friendliness. So, although he claims that "vsurers are vnmercifull and very cruell men, that they take pleasure in the miserie of the poore, and will haue no compassion on them," Thomas Bell also maintains that in their transactions, they are given to seeming sympathy: "[S]o soone as the silly poore man maketh mention of vsurie, and willingly offereth the ouerplus aboue the princi-pall, he abateth his sowre countenance, and beginneth to smile; . . . and calleth him neighbour and friend."[34] Such a sudden about-face from stern antagonism to apparent friendliness appears in Shylock's reaction to Antonio's rage:

Antonio

> I am as like to call thee so again,
> To spit on thee again, to spurn thee too.
> If thou wilt lend this money, lend it not
> As to thy friends, for when did friendship take
> A breed for barren metal of his friend?
> But lend it rather to thine enemy,
> Who, if he break, thou mayst with better face
> Exact the penalty.

Shylock

> Why, look you how you storm!
> I would be friends with you and have your love,
> Forget the shames that you have stained me with,
> Supply your present wants, and take no doit
> Of usance for my moneys, and you'll not hear me.
> This is kind I offer. (1.3.128–140)

As John Russell Brown argues, this development, in which Shylock goes from coldly recounting Antonio's insults to him to professing kindliness, appears prompted by Antonio's reference to a financial "penalty" (i.e., interest payment).[35] Thus, when seen in the context of contemporary usage, this passage suggests not simply a case of something like projection, nor only a competition of two early forms of capital for an emerging market, but also a struggle in which bodily deportment and dispositions are deeply implicated. Shylock detests the self-interested duplexity or changeableness that his epithet attributes to the "fawning publican," but he shares it with Antonio as a necessary, perhaps unthinking, but certainly useful aspect of the behavior demanded by his own occupation. From the testimony of contemporaries, it appears to be included in his job description as a usurer; it comes with the territory as a *habitus*. But what is he? What is a usurer, as Theodore B. Leinwand and others have usefully reminded us, but a condensed figure for processes and procedures that are at once widely dispersed throughout early modern English society in acceptably (mis)recognized forms of financial dealings and equally widely disavowed?[36]

Whether or not this constitutes a partial explanation of Shylock's phrasing, I hope in any case to have suggested the dense resonance of

some middle-level, field-based concepts of position and disposition that might repay further systematic and symptomatic attention. Now, to return to the interrupted anecdote with which this essay began.

The woman whose shoes were stolen was not just anyone, and certainly not just anyone to Chuck Jones. Although the existence of *Spike* magazine makes it clear that paraphilia is an institutionalized field with recognizable stakes and positions, it seems relevant that at the time the woman was the then-famous Marla Maples, at the time married to Donald Trump, and Chuck Jones was her trusted public-relations representative. Perhaps there is an institutional logic after all to the choice to slash a woman's — in this case, an employer's — boots. But which institution? Does Jones slash the boots to follow the recognized and reigning logics of institutionalized paraphilia, whether to see the imprint of the foot or to mutilate the covering that would hide it from his gaze? Is he an artist of footwear seeking the image of the ideal object? Or does he act as an embittered professional public-relations specialist taking vengeance on the employer whose bodily capital, her image of desirability, he is paid to preserve — without touching — from any taint of corporeal limitation? Whether Jones's act is seen as personal or political, it remains *positional* in either case and mediated by logics of respective relevant fields. That such fields might meet upon a seemingly arbitrary site — a shoe — that is nevertheless both capable of material explication and also highly charged with emotions of desire and aversion should come as no surprise to readers of Shakespeare. After all, this is a playwright whose works notoriously include the tragedy of a handkerchief, the loss of which prompts a surprising renunciation of "occupation" that is further enacted bodily by Othello upon the desired but repellent female body that represents the quilting point for the symbolic order of his detested, but nevertheless "most approved," Venetian employers.

Just what fields are relevant, when, to what degree, and in what ways remains to be determined, though any inquiry should begin with the realization that the positions and dispositions involved are multiple and intersecting. Whatever Shakespeare may be as political-economic or psychoanalytical subject, in the broadest or narrowest of senses he is also sometimes, somewhere, somehow interpellated into the middle as writer, actor, theater professional, purveyor of erotic fantasy, sonneteer, and, yes, financial debtor and creditor.

NOTES

1. *The New Yorker*, Feb. 21, 1994, 1–2.

2. Constance Penley, *The Future of an Illusion: Film, Feminism, and Psychoanalysis* (Minneapolis: University of Minnesota Press, 1989), xvi.

3. Slavoj Žižek, *The Sublime Object of Ideology* (London: Verso, 1989), 50, 45. Although he might hardly be considered friendly to Lacanian thinking after some of the things he has written, Jacques Derrida offers a similar compliment to psychoanalysis from the poststructuralist perspective. One value of psychoanalysis, Derrida writes, is that the "logic of the unconscious" questions "the authority of consciousness, of the ego, of the reflexive cogito, of an 'I think' without pain or paradox" ("Let Us Not Forget—Psychoanalysis," *Oxford Literary Review* 12 [1990], 3–7, 3). Derrida offers an extended treatment of psychoanalysis in *The Post Card: From Socrates to Freud and Beyond*, trans. Alan Bass (Chicago: University of Chicago Press, 1987).

4. Klaus Eder, *The New Politics of Class: Social Movements and Cultural Dynamics in Advanced Societies* (London: Sage, 1993).

5. Slavoj Žižek, *Looking Awry: An Introduction to Jacques Lacan through Popular Culture* (Cambridge: MIT Press, 1991), 8.

6. Žižek, *Looking Awry*, 9–12.

7. Žižek, *Looking Awry*, 9.

8. Schorske's view of Freud's Oedipus is remarked on by Bourdieu in *Sociology in Question*, trans. Richard Nice (London: Sage, 1993), 47.

9. I borrow from Judith Butler's response to Žižek in *Bodies that Matter: On the Discursive Limits of "Sex"* (London: Routledge, 1993), 210.

10. Shakespeare is quoted from *The Complete Works of Shakespeare*, ed. David M. Bevington, 4th ed. (New York: HarperCollins, 1992).

11. Revealingly, Romeo's egocentrism is evoked by his descriptions of dreams not only as about "things true" but as the means to be "an emperor" (1.4.52; 5.1.9). His beloved, furthermore, is only provisionally individualized at best, of course, since his love moves instantaneously and effortlessly from one object to another, from Rosaline to Juliet. My reading of Mercutio's speech as expressing a sociomaterial reductionist view of desire does not contradict Marjorie Garber's claim that he speaks "in an assumed voice, the voice of the romantic daydreamer and fabulist"; his romantic articulation, with its fairies and lovers, is self-mocked by the materialism of its theme (*Dream in Shakespeare* [New Haven: Yale University Press, 1974], 39). On the difficulties of critics in relating this speech to its speaker or the context of its utterance, see E. Pearlman, "Shakespeare at Work: *Romeo and Juliet*," *English Literary Renaissance* 24 (1994), 315–42; 332–33.

12. For glossings of *publican* in these senses, see the notes to 1.3.41 in the Variorum Edition of *The Merchant of Venice*, ed. H. H. Furness (Philadelphia: J. B. Lippincott, 1888).

13. Stephen X. Mead,"'Thou Art Chang'd': Public Value and Personal Identity in *Troilus and Cressida*," *Journal of Medieval and Renaissance Studies* 22 (1992), 237–59; 237–38.

14. The idea of such a shift is not new, of course; for an earlier account of the "transition from intrinsic to exchange value" in the language of Renaissance drama, see Sandra K. Fisher, *Econolingua: A Glossary of Coins and Economic Language in Renaissance Drama* (Newark: University of Delaware Press, 1985), 21.

15. Christopher Pye, "The Theater, the Market, and the Subject of History," *ELH* 61 (1994), 501–22. As Pye says, "The writings arrayed under that heading [i.e., new historicism] are bound together in good part by their reliance on the ease with which economic description seems to lend itself to a generalized metaphorics of speculation and exchange, to a thrilling measure of discursive liquidity" (502). Pye offers a particularly interesting case for the rhetorical usefulness of economic discourse such as exchange, circulation, and market, for purposes of conveying a "residual empirical aura" while evoking a combination of "fungibility on the level of discrete phenomena and totalizing force at the level of the social field itself" (503).

16. Bourdieu discusses the Marxist short circuit, which explains all social phenomena in terms of economics, in *The Field of Cultural Production: Essays on Art and Literature*, ed. Randal Johnson (New York: Columbia University Press, 1993), 181.

17. On the special prominence of struggles over proper dispositions for those seeking the "relatively uninstitutionalized" positions offered in the literary and artistic fields, see Bourdieu, *The Field of Cultural Production*, 29–73. On Bourdieu's twinned considerations of larger sociohistorical context and of different, relatively autonomous, domains within that context, see Vera L. Zolberg, "Debating the Social: A Symposium on, and with, Pierre Bourdieu," *Contemporary Sociology* 21 (1992), 151–52.

18. Žižek, *Sublime Object of Ideology*, 48, 87–88.

19. On satire in *Troilus*, see Oscar James Campbell, *Comicall Satyre and Shakespeare's "Troilus and Cressida"* (Los Angeles: Adcraft, 1938).

20. Stephen Orgel, "Insolent Women and Manlike Apparel," *Textual Practice* 9 (1995), 13; as quoted in Linda Charnes, "Styles that Matter: On the Discursive Limits of Ideology Critique," *Shakespeare Studies* 24 (1996), 136.

21. On the figure of the anamorphosis in *Richard II*, see also Ernest B. Gilman, *The Curious Perspective: Literary and Pictorial Wit in the Seventeenth Century* (New Haven: Yale University Press, 1978); Scott McMillin, "*Richard II*:

Eyes of Sorrow, Eyes of Desire," *Shakespeare Quarterly* 35 (1984), 40–52; and Christopher Pye, "The Betrayal of the Gaze: Theatricality and Power in Shakespeare's *Richard II*," *ELH* 55 (1988), 575–98.

22. Ned Lukacher, "Anamorphic Stuff: Shakespeare, Catharsis, Lacan," *SAQ* 88 (1989), 863–96, 865.

23. See the discussion of the complicity of Gaunt and Richard in the abuses of authority by Richard and in the downfall that comes as their result in James R. Siemon, *Word against Word: Shakespeare's Richard II as Bakhtinian Utterance* (forthcoming). Compare the joke in *Richard III* in which Richard corrects Clarence to the effect that they become the queen's "abjects" and "must obey" rather than her subjects who "will obey" (1.1.105–6).

24. See *The Complete Works of John Davies of Hereford*, ed. A. B. Grosart, 2 vols. (1878; reprint, Hildesheim: Georg Olms, 1968), 1: 82.

25. Jean-Christophe Agnew, *Worlds Apart: The Market and the Theater in Anglo-American Thought, 1550–1750* (New York: Cambridge University Press, 1986).

26. Janet Adelman, *Suffocating Mothers: Fantasies of Maternal Origin in Shakespeare's Plays, "Hamlet" to "The Tempest"* (New York: Routledge, 1992), 155.

27. For Greene, see note 28 below. For the Parnassus plays, see *The Three Parnassus Plays* (1598–1601), ed. J. B. Leishman (London: Nicholson and Watson, 1949), 344–45. Donne's reference to the players is in "Satyre II" (*John Donne: The Satires, Epigrams and Verse Letters*, ed. W. Milgate [Oxford: Clarendon Press, 1967], 7). I think, too, of Hamlet's resistance to the idea of being reduced to a "pipe" for Rosencrantz and Guildenstern to play upon (3.2.369).

28. Robert Greene, *Greene's Groatworth of Witte, Bought with a Million of Repentance* (1592), ed. G. B. Harrison (New York: Barnes and Noble, 1966), 43.

29. As Jean-Luc Nancy and Philippe Lacoue-Labarthe define it, the signifier itself for Lacan is not "the other side" of the sign, relating to the signified, but "rather it is that order of spacing, according to which the law is inscribed and marked as difference" (*The Title of the Letter: A Reading of Lacan*, trans. François Raffoul and David Pettigrew [Albany: State University of New York Press, 1992], 46).

30. Mervyn James defines the relations of honor culture and self-sufficiency in *Society, Politics, and Culture: Studies in Early Modern England* (Cambridge: Cambridge University Press, 1986).

31. Psychoanalytic interpretations of *Titus* include David Willbern, "Rape and Revenge in *Titus Andronicus*," *ELR* 8 (1978), 159–82; cf. Marion Wynne-Davies, " 'The Swallowing Womb': Consumed and Consuming Women in *Titus Andronicus*," in *The Matter of Difference*, ed. Valerie Wayne (Ithaca: Cornell University Press, 1991), 129–52. For a recent feminist interpretation in terms of agency, see Carolyn Asp, " 'Upon Her Wit Doth Earthly Honor Wait': Female

Agency in *Titus Andronicus*," in *Titus Andronicus: Critical Essays*, ed. Philip C. Kolin (New York: Garland, 1995), 333–46. On the relation between Lavinia's condition and Shakespeare's own art, see Nicholas Brooke, *Shakespeare's Early Tragedies* (London: Methuen, 1967), 13–47; Barbara Mowat, "Lavinia's Message: Shakespeare and Myth," *Renaissance Papers 1981* (1981), 55–69.

32. For a fuller discussion of the biblical and contemporary uses of *publican* and *Pharisee*, see Joan Ozark Holmer, *The Merchant of Venice: Choice, Hazard and Consequence* (New York: St. Martin's Press, 1995), 151–54.

33. See, for example, Miles Mosse, *The Arraignment and Conviction of Vsurie* (London: 1595), Short Title Catalogue 18207. "The *Pharisies* noted it as a contemptible thing in our *Sauiour Christ*, that he did eate and drinke wt *Publicanes*. Now *fœneratores Publicanos agunt* (saith *Plutarch*:) *the vsuerers play the Publicanes*. And so they do indeed. For ye *Publicanes* were *vectigaliū redemptores, such as gathered tols* or customes, or tributes, or taskes, or subsidies of the people. And the *vsurers* will haue their custome penny, a man must pay their taske or he cānot escape their hāds, he must pay deepe tribut that is subiect to their dominion. And as for their cōditiōs, the *Publicanes* were such as *rapacitate prouinciales exugerēt by their rauenousnes* & gripplenes, *did sucke vp*, & soake dry the poore people of the *Prouinces* under their iurisdictiō. Wherein they were a liuely patterne of yt greedinesse & couetousnesse of the *vsurer*: whereby he casteth into an irrecouerable consumption, all those which for their disease seeke phisicke at his hāds. Wel then, the *Publicane* was an infamous person: and the *vsurer* playeth the *Publicane*: and therefore no maruaile though he be of bad report among men" (148–49).

34. Ibid., and Thomas Bell, *The Specvlation of Vsury* (London, 1596), STC 1828, B3v–B4r.

35. *The Merchant of Venice*, ed. John Russell Brown, rev. and corr. ed. (Cambridge: Harvard University Press, 1959), 1.3.134 n.

36. On the pervasiveness of credit relations and interest-bearing transactions in early modern England, see Marjorie K. McIntosh, "Money Lending on the Periphery of London, 1300–1600," *Albion* 20 (1983), 557–71; Craig Muldrew, "Interpreting the Market: The Ethics of Credit and Community Relations in Early Modern England," *Social History* 18 (1993), 163–83; and especially Theodore B. Leinwand, *Theatre, Finance and Society in Early Modern England* (Cambridge: Cambridge University Press, 1998).

FOUR

KAREN NEWMAN

TOWARD A TOPOGRAPHIC IMAGINARY

Early Modern Paris

Paris had been for many years the goal of my longings, and the bliss with
which I first set foot on its pavements I took as a guarantee that I should
attain the fulfillment of other wishes also.

—Sigmund Freud, "Das Traummaterial und die Tranquellen"

Cultural historians have long claimed the nineteenth century as the pre-
eminent metropolitan moment. Despite Raymond Williams' observation
some twenty-five years ago that the city as a "distinctive order of settle-
ment, implying a whole different way of life" dates from the seventeenth-
century predominance of London and Paris, Dickens' London and the
Paris of Baudelaire and Haussmann have been the primary focus of
scholars of the city as both trope and place.[1] At least since Benjamin's
study of Baudelaire and the edition of his *Passagen-Werke* (1982), the
great metropolitan themes — the crowd, the commodity, the street, and
flânerie — have been read as historically specific to nineteenth-century
urban culture. "Paris, capital of the nineteenth century," in Benjamin's
often-cited phrase, has been read as a production in time, the result of
so-called advances in architecture and engineering, in manufacturing
and marketing, brought about by industrialization.[2]

In what follows I want to offer a challenge to such temporal readings of the urban and argue for what I will call a "topographic imaginary" by shifting the terms for discussing urban culture away from *time* to the category of *space* as a determining condition of social and psychic life. My claim is not that time is not such a determining condition, nor that there are not specificities to nineteenth-century urban culture and its symbolic forms; instead I will consider how time and space are articulated in early modern Paris. The stakes of this shift to the category of space are not merely thematic, since the nineteenth-century city and its arcades and commodity culture are said to entail hegemonic positions of enunciation and thereby to produce a particular mode of "metropolitan" or "bourgeois" subjectivity. Metropolitan subjectivity is theorized by Georg Simmel in his essay "The Metropolis and Mental Life" as a problem of the individual attempting to assert his autonomy in the face of metropolitan distraction: noise, traffic, a market economy, the crowd.[3] Does urban space produce certain discursive figures of address and modes of subjectivity in the early modern period that have been claimed exclusively for modernity? How might the subject be constituted in and through historical space?

Urban historians have recently moved away from studying what has sometimes been called the "urban aspect of local history" to consider larger processes of urbanization and the importance of networks or systems of cities.[4] Conventionally, urbanization is defined as population concentration, with cities distinguished from other forms of settlement by population size and density. By all counts, the late sixteenth and seventeenth centuries saw remarkable urbanization in western Europe. Both London and Paris grew prodigiously: London more than quadrupled its population in the period between 1550 and 1650, from 80,000 to 400,000; though Paris did not grow at the same rate as London, and though a smaller proportion of the overall population of France lived in the capital—2.5 percent as compared with about 7 percent in the English case—the Parisian population was greater overall.[5] Even though the wars of religion and later the Fronde checked the city's growth, Paris's population increased from roughly 250,000 in 1564 to 500,000 by 1645.

But demographic urbanization represents, of course, merely a statistical definition of cities. More important for my purposes is what sociologists term the "urbanization of society."[6] While medieval towns and the smaller urban settlements of the early modern period were pervaded by the countryside, during the late sixteenth and seventeenth centuries

London and Paris became increasingly urbanized cultures.[7] Scholars of urbanization describe what they term structural urbanization — the concentration not of populations but of activities such as the operation of a centralized state, the production of and exchange of goods via large-scale markets and the need for coordinated movement through space.[8] Such large-scale, coordinated activities foster urban behaviors that justify, as Jan de Vries puts it, "the apparently nonsensical phrase, the urbanization of the cities."[9]

Inhabitants of early modern Paris recognized the profound changes wrought by urbanization and appropriated older genres to explore them; they also produced new ones such as the urban topographies of Jacques du Breul (*Le théâtre des antiquitez de Paris*, 1612) and Germain Brice (*Description nouvelle de ce qu'il y a de plus remarquable dans la vie de Paris*, 1684), both of which went through numerous editions, and many others that take movement through space as their organizing principle of textual development.[10] And not only new verbal forms; visual culture also grappled with representing and ordering urban development and the social disarray attributed to the rapid growth of the Parisian metropolis.

As early as the *Nuremberg Chronicle* we find illustrations of cities, but in the early modern period the most famous collection of city images is Braun and Hogenberg's *Civitates orbis terrarum* (1572–1618) with its stereographic prospects and its bird's eye urban views (Fig. 4.1). Such early modern maps and cityscapes often represented their objects from the perspective of a "voyeur-god," in Michel de Certeau's phrase, from impossible, aerial heights that give the illusion of mastering vast urban spaces and foster what de Certeau has called an "erotics of knowledge," a pleasure recognized already in the seventeenth century.[11] Here is Burton in *The Anatomy of Melancholy*:

> A good prospect alone will ease melancholy. . . . [W]hat greater pleasure can there now be, than to view those elaborate maps of Ortelius, Mercator, Hondius? To peruse those books of cities put out by Barunus and Hogenbergius?

Braun and Hogenberg's *Civitates orbis terrarum* appeared in a series of expensive folio volumes, but cheap, useful books of city maps for merchants were also published with titles such as *The Post of the World* (1586). This small, practical, pocket-size book is described on its title

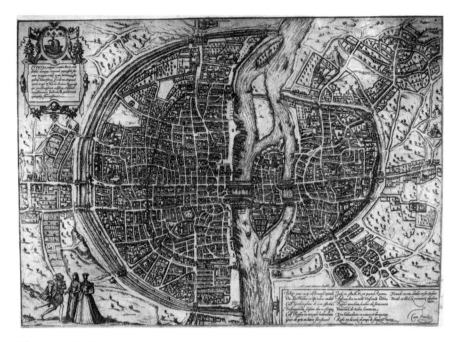

Fig. 4.1 Paris, 1572, Georg Braun.

page as "very necessary and profitable for Gentlemen, marchants, factors or any other persons disposed to travaile" and included not only maps of the major mercantile cities of Europe, but directions, value and denominations of coin, and lists of principal fairs and markets.

Until the early modern period, depictions of cities in the West were conventional and formulaic, often based on the scriptural model of the heavenly Jerusalem, but Renaissance representations of cities conformed increasingly to the secular expectations and aspirations of a patron or prince, or to the mercantile interests of travelers and merchants.[12] Early modern cityscapes, like their medieval predecessors, were also stylized, but in different ways, often foregrounding particular buildings or landmarks that symbolized the collective life of a city, its religious and governmental hierarchies, civic priorities, or sometimes technological progress. Images of Jerusalem, for example, often depicted an out-of-scale Dome of the Rock, Florence was represented with a highlighted Santa Maria del Fiore, and medieval Parisian city scenes show Notre Dame looming extravagantly large.

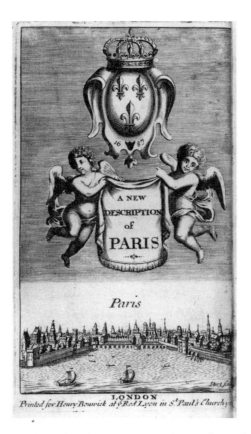

Fig. 4.2 Title page, Germain Brice, *A New Description of Paris* (London, 1687).

By far the most frequently represented landmark of seventeenth-century Paris is the Pont Neuf.[13] Represented in guidebooks, visual topographies, and books of all sorts, in engravings and advertising, on fans and ceramics, the Pont Neuf was the privileged sign of seventeenth-century Parisian modernity. Scholars of early modern Europe have made much of the early modern fascination with the so-called New World, its wonders and spectacles of strangeness, but travelers to early modern Paris were often amazed at marvels closer to home. Opposite the title page of the English version of Germain Brice's popular guidebook, *Nouvelle Description de Paris*, the Pont Neuf appears in an engraved view (Fig. 4.2) looking toward the Île de la Cité. Brice highlights the bridge in a long and emphatically positioned verbal description:

[W]e are now arrived at the last article of this description, which
cannot be better concluded than with the Pont Neuf . . . this
bridge is one of the most beautiful that can be seen for its length
which extends over the two arms of the Seine . . . for its breadth,
which is divided into three ways, one in the midst for Coaches
and great carriages, and two on each side raised higher for those
who go on foot, and lastly for its structure, which is of such so-
lidity and of such ordinance, that has but few equals. . . .
Among [its] advantages one may also add the delicate Prospect
which the Passenger has from it: a view which passes for one of
the most pleasing and finest in the World.[14]

Brice goes on to compare the Pont Neuf with two wonders of the early
modern world, the port of Constantinople and Goa in India. Both Brice
and his predecessor Jacques du Breul recognize the social, aesthetic, and
economic consequences of the reconfiguration of urban space effected by
the building of the Pont Neuf. Du Breul, for example, observes that the
tip of the Île de la Cité had been *inutile* (useless) before the building of the
bridge, but since its completion it had become "*la plus belle et la plus utile
place de Paris.*"[15] Like Brice, du Breul gives pride of place to the Pont Neuf
by making his description of it the climax of his section on *la cité*. Travel-
ers and inhabitants of the seventeenth-century city recognized the extraor-
dinary changes in everyday life wrought by urbanization; both Parisians
and foreign visitors alike marveled at the bridge: its length across two arms
of the Seine, its breadth (which accommodated the newly problematic ve-
hicular traffic of the early modern city), its structure, and its water pump,
La Samaritaine (a feat of modern engineering).

A bridge is, of course, first and foremost a connector. Two bridges,
one each from the right and left banks to the *cité,* served Paris until circa
900; two more were built across each arm of the Seine by 1420, making
four bridges in all. Seventeenth-century urbanization prompted bridge
building, and by the end of that century Paris was served by ten
bridges. The Pont Neuf, now the oldest bridge in Paris, first connected
the left bank and the *cité* proper with the Louvre and Tuileries on the
right bank, which up until the late sixteenth century was in part dan-
gerous, consisting of fields and woods, which the bridge helped trans-
form into urban space (Fig. 4.3). Begun by Henry III in 1578, work on
the bridge was interrupted by religious wars and money problems, and
then taken up again by Henry IV as part of his vast reconfiguration of

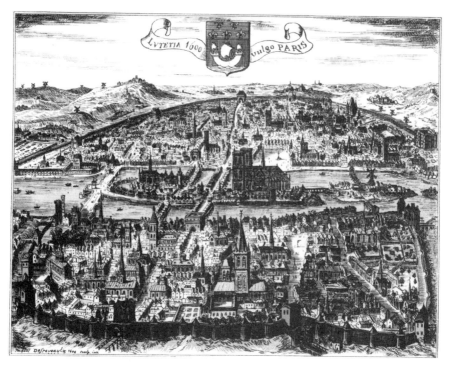

Fig. 4.3 Lutetia 1600, by Jacques Defrevaulx (Paris, 1600).

public space in Paris, which included extending the Louvre, building the Hôpital Saint-Louis and the Palais Royale, now the Place des Vosges, beginning the Collège de France, and completing the Pont Neuf.[16]

What immediately distinguishes the Pont Neuf from previous bridges is its open plan, designed to accommodate the vehicular traffic that both plagued the early modern city and also fostered its development (Fig. 4.4). Unlike the four bridges that preceded it, the Pont Neuf was not lined by several stories of shops and houses (Fig. 4.5). Contemporaries describe the bridge as divided in three parts with what we would term sidewalks on each side of a central wider path for "carosses & cheveaux."[17] On the bridge itself Henry commissioned another technological marvel, the Samaritaine water pump (Fig. 4.6), which was designed and installed by engineers imported from the Low Countries.[18] Contemporaries recognized the importance of water to urban life and remarked the moment the pump began to deliver water to the Louvre; the poet Malherbe wrote

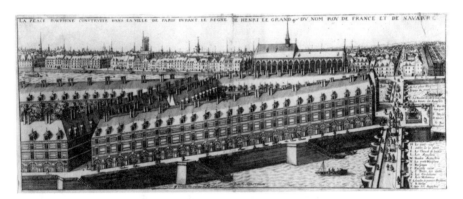

Fig. 4.4 Pont Neuf and Place Dauphine, 1607–1615, engraving after Claude Chastillon.

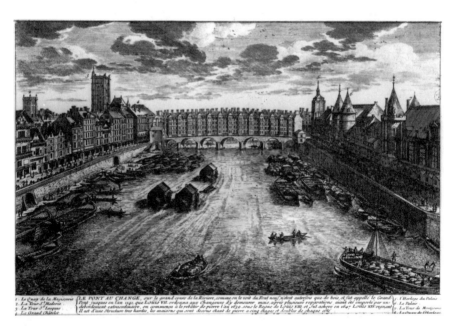

Fig. 4.5 Le Pont au Change, early seventeenth century, anonymous engraving.

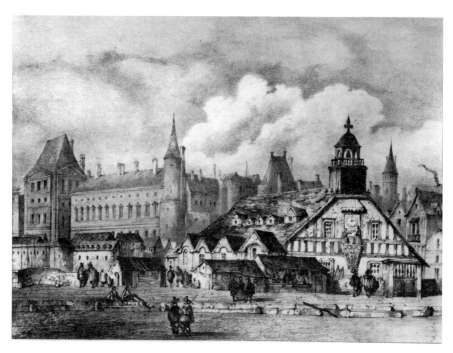

Fig. 4.6 La pompe de la Samaritaine (Samaritan Pump), c. 1635, nineteenth-century rendering.

portentously to a friend that "l'eau de la pompe du Pont Neuf est aux Tuileries."[19] Water from the Samaritaine pump was designated only for the palace and a select few privileged by the king, a state of affairs that provoked bitter disputes with city officials, who demanded water from the pump for inhabitants of the city.[20] The Samaritaine pump was embellished with yet another wonder of modern technology, an elaborate clock that marked the hours, days, and seasons that increasingly regulated work and everyday life in the early modern city.[21] Still another sign of the bridge's state-of-the-art technology was the equestrian statue of Henry IV commissioned by Marie de Medici following the assassination of the king, the first such monumental, free-standing bronze in France (Fig. 4.7). The bridge fostered commerce by facilitating traffic and supporting lively market stalls, criers, hawkers, and colporteurs who sold political pamphlets and street poetry on its pavements; it connected the court with the city, the royal palace with the Palais de Justice; and it was, notoriously, the site of burgeoning urban crime.

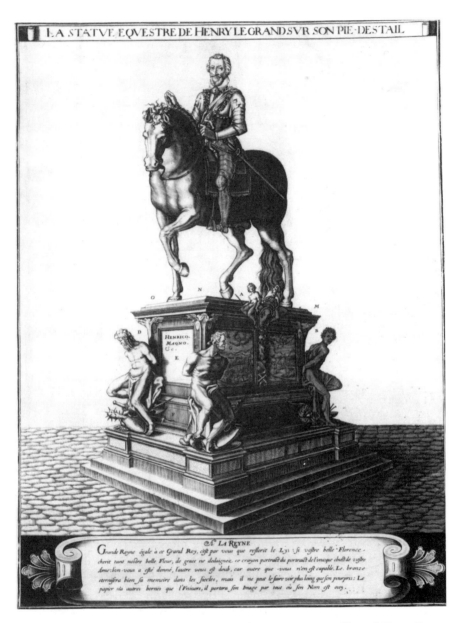

A. LA REYNE

Grande Reyne égale à ce Grand Roy, c'est par vous que ressort le Lys si vostre belle Florence cherit tant nostre belle Fleur, de grace ne dedaignez ce crayon portraict du portraict de l'onique obiect de vostre Amour: son vous a esté donné, l'autre vous est deub, car autre que vous n'en est capable. Le bronze eternisera bien sa memoire dans les siecles, mais il ne peut le faire voir plus loing que son pourpris: Le papier ois autres bornes que l'Vniuers, il portera son Image par tout où son Nom est ouy.

Fig. 4.7 Equestrian statue of Henry IV, c. 1614, Pietro Francavilla and Pietro Tacca, anonymous engraving.

Demographic growth and the reconfiguration of urban space effected by the Pont Neuf had aesthetic and cognitive consequences that can be traced in visual representations of early modern Paris. Guidebooks and engravings alike represent the "continual press of people passing over this Bridge, by which," as Brice puts it, "one may guess at the infinite number of inhabitants in Paris."[22] To represent this newly constituted metropolitan space with its mix of persons and activities, seventeenth-century artists distorted the scale of the bridge by inflating it, making the Pont Neuf larger than life, larger than it actually was. Though a general inflation of perspective is characteristic of the visual conventions of some seventeenth-century art, particularly engraving, distortion of this overdetermined space of the early modern Parisian metropolis testifies to the cognitive and visual impact of urbanization.[23] Figure 4.8, an engraving by Adam Pérelle, represents only the area immediately before the equestrian statue of Henry IV and not the entire bridge; his inflation of perspective can be gauged by comparing it to a photograph of the same area taken from the Place Dauphine (Fig. 4.9). Pérelle's engraving shows some six coaches, each drawn by numerous horses (a mark of status in the early modern period), two sedan chairs, ten individual horse-

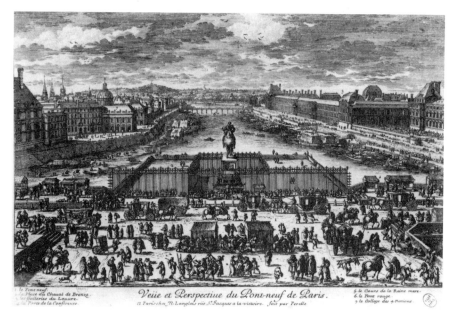

Fig. 4.8 Pont Neuf, engraving by Adam Pérelle.

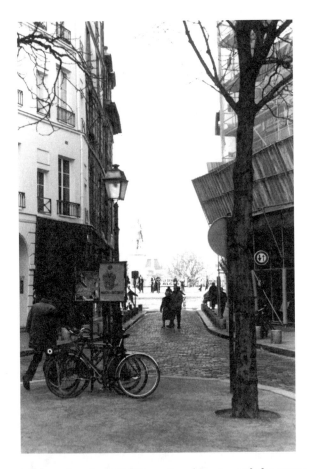

Fig. 4.9 Present view from the Place Dauphine toward the statue of Henry IV, 1997. Photograph by Thomas R. Brooks.

men, nine booths for selling goods, three additional tables for street sellers, two open-air theatrical entertainments taking place on platforms with substantial audiences, five criers and hawkers, three dogs, one duel — well over three hundred persons in all. Figure 4.10 shows a reverse shot of the same space looking toward the Place Dauphine. Single-point perspective and symmetry manage the threatening hurly-burly of urban life — the transients, criers, vagabonds, and poor that made up the lion's share of the Parisian population and that frequented the Pont Neuf alongside the elite and middling sort.

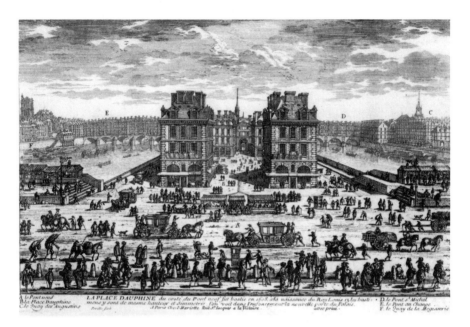

Fig. 4.10 Pont Neuf, c. 1650, engraving by Adam Pérelle.

Not only Pérelle but many other artists and engravers of the period, including Israel Sylvestre, Stefano della Bella, and Aveline, to name a few, represent this Parisian landmark and the crowds that frequented it (Figs. 4.11 and 4.12). Such images were not only produced in response to urbanization; they also themselves produce an ideology of the urban—traffic, the crowd, the mix of classes, the mingling of work and leisure, economic exchange, and conspicuous consumption. For the inhabitants of early modern Paris, wealthy and impoverished alike, the Pont Neuf was the privileged sign of the city; its image was reproduced in various media and contexts, from Abraham Bosse's engraving of Paris' *petits métiers* to the illustration of mathematical textbooks and fashionable fans. By the early eighteenth century, when the bridge was no longer the novelty it once had been and the representation of urban experience was no longer visually new, such distortion of perspective diminishes (Fig. 4.13).

In these engravings, the Pont Neuf, a bridge twenty-eight meters wide, expands to represent the entire hierarchical spectrum, from street singer to carriage-borne aristocrat, by connecting city to palace and estate to estate in heretofore unimagined proximity—a democratizing feature of

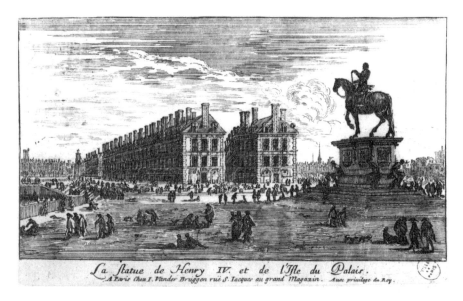

La statue de Henry IV. et de l'Isle du Palais.
A Paris Chez I. Vander Bruggen ruë S. Iacques au grand Magazin. Auec priuilege du Roy.

Fig. 4.11 Pont Neuf and statue of Henry IV, c. 1660s.

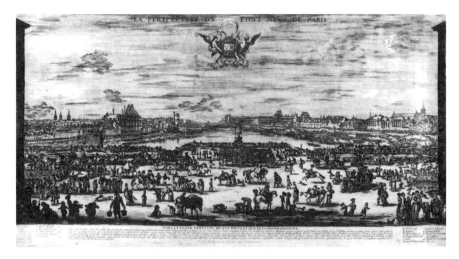

Fig. 4.12 Pont Neuf, 1646, engraving by Stefano della Bella.

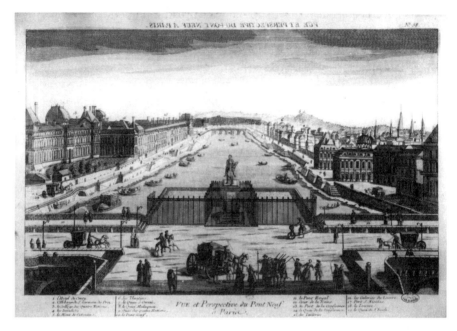

Fig. 4.13 Pont Neuf, c. 1700.

urban life Simmel and others ascribe to the nineteenth-century city. Urban space had aesthetic, cognitive, psychic and social effects registered in a variety of cultural forms: guidebooks, engravings, plays, pamphlets, and poetry, including both high-cultural artifacts and popular materials.[24] These various representations helped to produce a distinctive urban discursive space in which persons of different status and degree mixed, in which the "rights of man" could be imagined, a public space Habermas terms the public sphere.[25] Put another way, I am tracing an emerging psychic, cultural, and material logic that leads to the Enlightenment with its notions of individualism, liberalism, and democracy.

In one chapter of his powerful reading of contemporary culture, *Postmodernism or the Cultural Logic of Late Capitalism*, Fredric Jameson reads new historicism not by way of its Renaissance performers, usually said to have instituted its practice, but by reading Walter Benn Michaels' *The Gold Standard*.[26] Jameson claims that new historicism does not constitute a methodology, but is merely engaged in the production of homologies. According to Jameson, then, this essay would merely show how the Pont Neuf

is linked homologically to absolutism, urbanization, and the Enlightenment discourse of rights, and would then, in the classic new-historicist move, turn briefly, as in fact I am about to do, to a canonical author. Though Jameson is certainly justified in making this charge in the case of many examples of so-called new historicist practice, he is wrong theoretically. New historicism is not merely the production of homologies; it works, on one hand, to delegitimate older, purely formalist, literary hermeneutics, and, on the other, to legitimate a different hermeneutic practice fully engaged with both formal and historical problems.

Consider, for example, the seventeenth-century French polemicist and poet Nicolas Boileau. Boileau is perhaps best known as the exemplar of French neoclassicism.[27] He took the side of the ancients in the late seventeenth-century culture wars by attacking women writers of romance novels and the salon culture in which they flourished. His poetry has been considered mainly in terms of neoclassical canons, imitation of the ancients, and as staunchly exemplifying "high culture." His well-known sixth satire, for example, modeled on Juvenal's *Satire III*, is invariably discussed in terms of imitation.[28] But Boileau's *Satire VI* is about a Parisian traffic jam and warrants comparison not only with Juvenal and high-cultural artifacts, but with the guidebooks I have cited and with popular street poetry of the period such as Sieur Berthaud's *La Ville de Paris en vers burlesques* (c. 1652); in both poems the speakers move peripatetically through the streets of early modern Paris, buffeted by noise, crowds, and urban crime. Formal satire is usually said to present an encounter between an "I" and its adversary who drives the satirist to speech; in Boileau's sixth satire, that encounter is with the city itself. The poem opens with a question:

> Qui frappe l'air, bon Dieu! de ces lugubres cris?
> [Who beats the air, dear God, with these mournful cries?][29]

"Ces lugubres cris" assault even the air; they point to their perpetrators —stray cats—but they also indicate those who apparently hear the cries, speaker and addressee. The next line offers another question, but one that furnishes the poem's first personal pronoun:

> Est-ce donc pour veiller qu'on couche à Paris?
> [Is it by staying up that one goes to bed in Paris?]

Here the oxymoronic juxtaposition of *veiller* and *coucher* surrounds the pronoun *on*, which would seem to refer to the urban populace. Boileau's speaker is awakened by an unknown, unavailable other and leaves his sleepless bed for the streets of Paris; there he finds no one in particular, no differentiated addressee, but pressing, teeming crowds: gutter cats and thieves, coaches and carts, lackeys and blacksmiths, groans and gunshots, hue and cry. Bombarded by sense impressions in its itinerary through urban space, the speaker is continually assailed by the populace into whose space he unwittingly stumbles:

> En quelque endroit que j'aille, il faut fendre la presse
> D'un peuple d'importuns qui fourmillent sans cesse.

Not even bodily contact admits of differentiation among faces in the crowd; no relation between the "I" and the swarming, antlike mass can be established. Boileau's poem ends with an acerbic recognition of the power of money in metropolitan life: Sleep, he opines, can only be bought for a price.

> Ce n'est qu'à prix d'argent qu'on dort en cette ville.

The rich, the speaker tells us, can turn the world upside down; they can change the noisy urban Paris of crowds and traffic into the quiet of the countryside; their gardens are "peuplé d'arbres verts" rather than by the undifferentiated mass, the *peuple* the speaker encounters in his nightmarish, toponarcotic plunge through urban space. Satire, with its opposition of an "I" and an adversary is the formal means here of differentiating between persons of different social statuses and degrees, a differentiation that metropolitan space erodes, yet the "I" is produced paradoxically through the very anonymity of the urban crowd: Paris is at once the object of satire and that of desire.

Boileau, of bourgeois origins, produced himself as a defender and producer of high-cultural forms, and he has been read since the seventeenth century in precisely those terms as exemplifying neoclassical canons. Commentators invariably point out his debt to Juvenal in the satires and thus his classicism, but as I have demonstrated, this poem plays its part in the reconfigured cultural logic I am analyzing: to situate *Satire VI* in relation to the urbanization of early modern Paris is to challenge

readings of Boileau as simply a high-cultural, elite author harkening back to the classical past; it is to read him instead as part of that configuration we call modernity — the "je" of the sixth satire is never a unified subject, but is bumped and buffeted, jostled and shoved, knocked down and run over, divided and individual, with all the complexities of meaning that word accretes in the course of the seventeenth century.[30] The implications of my claims here are important not so much for reading a particular author — Boileau — but for refuting, on one hand, Jameson's criticism of new historicism and, on the other hand, the constitution of cultural studies in today's academy. Cultural studies continues to operate as if "politics" inheres in the object of study, and it has been therefore focused almost exclusively on late-nineteenth- and twentieth-century mass culture and, less frequently, on popular culture of the past. Renaissance studies, for example, has been preoccupied with popular cultural forms, most notably, of course, Shakespeare. Hence my own perverse choice of Boileau to make my argument. The fundamental arena in which political struggle is waged is the legitimacy of concepts, of ideologies.[31] Politics inheres not in the object of study, but in the way we *read*. *Pace* Jameson, new historicism does not merely produce homologies, but legitimates ways of reading that are neither narrowly literary nor historical and that depend not on the content or provenance of a text for their political valence, but on reading both high- and low-cultural forms.

In closing, I want to return to the cognitive and psychic consequences of urbanization and to my epigraph, which records Freud's memorial account of his early sojourn in Paris in 1885–86. There he first met Charcot, an encounter that Ernest Jones claims turned Freud from neurologist to psychopathologist and which thus is represented as a founding moment of psychoanalysis.[32] In Freud's letters of this period, Charcot is oddly figured in terms of Parisian monuments and pastimes: After his lectures, Freud goes out "as from Notre Dame, with new impressions to work over," and his brain, he relates, "is sated as after an evening at the theatre."[33] He refers frequently to Notre Dame as an emblem of the city and twice recounts climbing its towers. He even came to admire Hugo's *Notre Dame de Paris,* which he claimed not to have appreciated before his sojourn in Paris — more even, Jones recounts, than neuropathology. On departing, Freud carried back to Vienna as a souvenir of Paris a photograph of the cathedral. Not only Notre Dame but other city landmarks figure prominently in Freud's letters from Paris, including the Louvre and

—

Père Lachaise; Jones also reports that Freud wrote a long, illustrated account of Paris's topography and sights to his betrothed, Martha Bernays, that included a sketch of the city.[34]

But Freud's letters from this period are far from presenting Paris in the nostalgic, even ecstatic terms of my epigraph's retrospective depiction. In the letters to Bernays during his first months in Paris, he recounts being bewildered by its crowds, paranoid of his surroundings (he apparently tested the green curtains around his hotel bed, fearing they contained arsenic); he records meticulously the cost of lodging, food, and books; he disparages the city's inhabitants whom he dubs arrogant, inaccessible, shameless cheats. They are hostile, subject to psychical epidemics and mass convulsions, allusions to the continuing anxious preoccupation with the French Revolution displayed by European visitors observing the French scene. In a telling anecdote from his first day in Paris he recounts feeling so isolated and lonely that had he not, as Jones reports, had "a silk hat and gloves he could have broken down and cried in the streets."[35] Only his sense of his separation from the crowd, marked by class—silk hat, gloves—prevents psychic breakdown. In other words, Freud's later topolatry, that is, reverence or excessive adoration for a particular space or place—Paris—is retrospectively produced in the register of the imaginary, a topographic imaginary in which he also locates the fulfillment of his ambitious wishes. He writes at this time to Bernays from densely populated Paris: "I feel it in my bones that I have the talent to bring me into the 'upper ten thousand.' " Freud's retrospective bliss at traversing the streets of Paris begins as topophobia, a topophobia produced by a xenophobic intensification of the peripatetic experience of city noise, space, and urban anonymity.[36]

Traversing urban space—streets and gardens, bridges and quays, public buildings, fairs, markets, and exchanges—was the chief pastime of the early modern city dweller regardless of social rank.[37] In his work on everyday life, Michel de Certeau compares walking the city to speech acts and describes its "triple 'enunciative' function: it is a process of *appropriation* of the topographic system on the part of the pedestrian . . . ; it is a spatial acting-out of the place . . . ; and it implies *relations* among differentiated positions."[38] Social theory, particularly those traditions that derive from Marx, Weber, and Adam Smith, has privileged time over space by focusing on processes of social change and technical, social, and political revolutions. As David Harvey describes this process in his work on postmodernism, "[P]rogress is the theoretical object [of social

theory], and historical time its primary dimension . . . progress entails the conquest of space . . . the annihilation of space through time."[39] And though psychoanalysis is sometimes imagined as similarly privileging time and concerned with theories of the subject as constituted in and through the past, psychoanalytic processes have, of course, a resolutely spatial dimension — not merely etymological, as in *displacement* or *transference*, but gestured at in Virginia Woolf's famous phrase describing psychoanalysis and the unconscious: "the moment of importance came not here but there." Past trauma is presented spatially — "there, not here" rather than "then, not now." Though the space of psychoanalysis is, of course, profoundly a mental space, and for Freud a neurological one, we need to consider that space prosaically, to refuse its figurality and to look at the urban spaces in which the human sciences, including history, psychology, and psychoanalysis, came to be produced.

NOTES

1. Raymond Williams, *Keywords* (New York: Oxford University Press, 1976), 47.

2. "Paris, Capital of the Nineteenth Century" (1935, 1939), in *Reflections,* ed. Peter Demetz, trans. Edmund Jephcott (New York: Harcourt Brace Jovanovich, 1978). The literature on nineteenth-century Paris is immense; see Jean Favier's *Paris, deux mille ans d'histoire* (Paris: Fayard, 1997), which considers the development of the city from its origins, as the title indicates, but nevertheless devotes itself primarily to nineteenth- and twentieth-century Paris in both its text and bibliography.

3. Georg Simmel, "The Metropolis and Mental Life," in *The Sociology of Georg Simmel,* ed. Kurt Wolff, trans. H. H. Gerth with C. Wright Mills (New York: Macmillan, 1950).

4. H. J. Dyos, "Agenda for Urban Historians," in *The Study of Urban History,* ed. H. J. Dyos (New York: St. Martin's Press, 1968), 7, quoted in Jan de Vries, *European Urbanization 1500–1800* (Cambridge: Harvard University Press, 1984), 3.

5. On urban migration, see de Vries, *European Urbanization,* 199–252.

6. See especially L. Wirth, "Urbanism as a Way of Life," *American Journal of Sociology* 44 (1938), 1–24, and *Readings in Urban Sociology,* ed. R. E. Pahl (Oxford: Pergamon, 1968).

7. John Patten, *English Towns, 1500–1700* (Folkestone, England: Dawson, 1978).

8. See Charles Tilly's longer definition in *The Vendée* (Cambridge: Harvard University Press, 1964), 16−20.

9. De Vries, *European Urbanization*, 12.

10. Among the many such guides to Paris are texts by Gilles Corrozet and his followers, Jean, Nicolas, and Pierre Bonfons, and examples by François Belleforest (1575), André Thevet (1575), Estienne Cholet (1614), Pierre d'Avity (1619), and Michel de la Rochemaillet (1632−56). All of these texts borrow heavily from earlier examples. See Maurice Dumolin, *Etudes de topographie parisienne* (Paris: Editions A. Picard, 1929−31), 3 vols.

11. Michel de Certeau, *L'invention du quotidien* (Paris: Gallimard, 1990), 139−63.

12. See Spiro Kostof, *The City Shaped* (Boston: Little, Brown, 1991).

13. Prompted by royal and aristocratic patronage, the Louvre, the Tuileries, and many of the new *hôtels particuliers* that were being built in Paris in the course of the seventeenth century are frequently represented in contemporary engraving. Though it extends beyond the limits of this study and into the eighteenth century, the 1997 exhibit "Paris et les Parisiens au temps du Roi-Soleil" at the Musée Carnavalet documents pictorially the urbanization of Paris.

14. Germain Brice, *A New Description of Paris* (London: Henry Bonwicke, 1687), H10v–H11r.

15. Jacques du Breul, *Le Theatre des Antiquitez de Paris* (Paris, 1612), iiiiv.

16. Particularly useful is Jean-Pierre Babelon, *Paris au XVIe siècle, Nouvelle Histoire de Paris* (Paris: Hachette, 1986); René Pillorget, *Paris sous les premiers Bourbons, Nouvelle Histoire de Paris* (Paris: Hachette, 1988); Hilary Ballon, *The Paris of Henry IV* (Cambridge: MIT Press, 1991); and Roger Chartier, "Power, Space and Investments in Paris," in *Edo and Paris*, ed. James L. McClain, John M. Merriman and Ugawa Kaoru (Ithaca: Cornell University Press, 1994), 132−52.

17. Du Breul, Hhiiiir.

18. Du Breul reports that Henry "employe les plus ingenieuses & hardie inventions qui se sont offertes," iiiir.

19. Malherbe to Peiresc, quoted in François Boucher, *Le Pont Neuf* (Paris: Le Goupy, 1925−26), 126.

20. On the debate, see Laure Beaumont-Maillet, *L'eau à Paris* (Milan: Hazan, 1991).

21. On clocks, time, and urban life, see Simmel, "The Metropolis and Mental Life."

22. Brice, *A New Description of Paris*, H11v.

23. On cognitive mapping and city space, see Kevin Lynch, *The Image of the City* (Cambridge: MIT Press, 1972).

24. The bridge seems to have prompted a popular subgenre dubbed "les ponts neufs." See Frédéric Lachèvre, *Les recueils collectifs de poésies libres et satiriques publiés depuis 1600 jusqu'à la mort de Théophile* (Genève: Slatkine, 1968).

25. Jürgen Habermas, *The Structural Transformation of the Public Sphere: An Inquiry into a Category of Bourgeois Society*, trans. Thomas Berger with Frederick Lawrence (Cambridge: MIT Press, 1989).

26. Fredric Jameson, *Postmodernism, or the Cultural Logic of Late Capitalism* (London: Verso, 1991).

27. See, for example, the collection edited by Marc Fumaroli and Jean Mesnard, *Critique et création littéraires en France au XVII^e siècle* (Paris: CNRS, 1977); Gordon Pocock, *Boileau and the Nature of Neo-classicism* (Cambridge: Cambridge University Press, 1980); Bernard Bray, "Le classicisme de Boileau: les personnages et leur fonction poétique dans les satires," *Dix-septième Siècle* 143 (1984): 107–18.

28. Critics have recently begun to consider Boileau's presentation of Paris in *Satire VI* as "farce" or "absurde avant la lettre," but not in terms of contemporary Paris. See Pocock, *Boileau and the Nature of Neo-classicism,* and Simone Ackerman, "Les Satires de Boileau: Un théâtre de l'absurde avant la lettre," in *Ordre et contestation au temps des classiques*, eds. Roger Duchene and Pierre Ronzeaud (Paris: *Papers on French Seventeenth-Century Literature,* 1992); on Boileau's presentation of Paris, see Robert T. Corum, "Paris as Barrier: Boileau's Satire VI," *Papers on French Seventeenth Century Literature* 19,17 (1982): 627–39.

29. Nicolas Boileau, *Oeuvres,* ed. G. Mongrédien (Paris: Garnier, 1961).

30. Peter Stallybrass, "Shakespeare, the Individual, and the Text," in *Cultural Studies*, ed. Larry Grossberg, Cary Nelson, and Paula Treichler (London and New York: Routledge, 1992); Lawrence Manley, *Literature and Culture in Early Modern London* (New Haven: Yale University Press, 1995), 216.

31. See particularly Stuart Hall, "The Toad in the Garden: Thatcherism among the Terrorists," in *Marxism and the Interpretation of Cultures*, ed. Cary Nelson and Lawrence Grossberg (Urbana: University of Illinois Press, 1988), 35–57.

32. See Ernest Jones, *The Life and Work of Sigmund Freud* (New York: Basic Books, 1953), 1:199ff.

33. Ibid., 119.

34. The complete letters to Martha Bernays from which Jones quotes remain closed subject to restrictive covenants; a few have appeared piecemeal, and a full edition is now under way (personal communication, Harold Blum, M.D., executive director, The Sigmund Freud Archives, Inc.). Whether Jones reports the letters reliably must await the appearance of this edition, expected in 2000.

35. Jones, *The Life and Work of Sigmund Freud,* 1:118.

36. On topophobias, see Anthony Vidler, "Psychopathologies of Modern Space," in *Rediscovering History*, ed. Michael J. Roth (Stanford: Stanford University Press, 1994); on topolatry, see Yi Fu Tuan, *Topophilia: A Study of Environmental Perception, Attitudes and Values* (Englewood Cliffs, NJ: Prentice Hall, 1974).

37. See Marcel Poète, *La Promenade à Paris au XVIIe siècle* (Paris: A. Colin, 1913) and *Paris. La vie et son cadre. Au jardin des Tuileries. L'art du jardin. La promenade publique* (Paris: Editions A. Picard, 1924).

38. Quoted in Michel de Certeau, *The Practice of Everyday Life*, trans. Steven F. Rendall (Berkeley: University of California Press, 1984), 97.

39. David Harvey, *The Condition of Postmodernity: An Enquiry into the Origins of Cultural Change* (London: Blackwell, 1989), 205.

JOHN GUILLORY

"TO PLEASE THE WISER SORT"

Violence and Philosophy in Hamlet

[P]ractice compels philosophy to recognize that it has an exterior. Maybe philosophy has not introduced into the domain of its thought the totality of what exists, including mud (of which Socrates spoke), or the slave (of which Aristotle spoke), or even the accumulation of riches at one pole and of misery at the other (of which Hegel spoke)? For Plato, philosophy observes the whole; for Hegel, philosophy thinks the whole. In fact, all the social practices are there in philosophy—not just money, wages, politics and the family, but all social ideas, morality, religion, science and art, in the same way that the stars are in the sky.

—*Louis Althusser, "Transformations in Philosophy"*

I. SYMBOLIC VIOLENCE

In his 1605 treatise *The Advancement of Learning*, Francis Bacon remarks that Aristotle, "as though he had been of the race of the Ottomans, thought he could not reign except the first thing he did he killed all his brethren."[1] Bacon pronounces his judgment on Aristotle in a passage of the *Advancement* describing the "diversity of sects" among the ancient

philosophers. Aristotle hoped to bring dispute among these parties to an end by overwhelming his competitors with the weight and rigor of his arguments; yet he succeeded only in creating another sect—the Peripatetics. The sect of Aristotle was dominant in Bacon's day, and no one struggled more than Bacon to dislodge Aristotle from this position. The analogy to Ottoman princes evokes the intensity of Bacon's philosophical polemic, its symbolic violence.[2] The evocation of violence, however, is more than rhetorical in another probable context of Bacon's sentence, the "wars of religion" that transformed Christianity itself into a "diversity of sects." Bacon had before him the recent example of these wars in France. In the following decades England, too, would prove unable to contain the social forces impelling sectarian violence.

The subject of this paper is the relation between philosophy and violence in *Hamlet*, an unsurprising conjunction in a play that oscillates so conspicuously between moments of arrested fascination with the "pale cast of thought" and uncontrollable bloodletting. Yet one must acknowledge that for many reasons, interpreters of *Hamlet* (especially in the twentieth century) have been less interested in explaining the violence of the play, which is of course a given of the revenge narrative, than in detecting an underlying psychological dynamic whose interpretive role has been to resolve the relation between thought and inaction. Shakespeare's play is full of "philosophical" ideas, but its ideas seem to explain very little about Hamlet's thought, if that thought is the cause of his inaction. Hamlet's philosophical ideas are at best echoes of Montaigne, and at worst quotations from a stock of knowledge common to the literate culture of the day. The great critical motif of Hamlet's anticipatory modernity is founded on just the inadequacy of the ideas in the play to what Hamlet is presumed to be thinking, an inadequacy that opens up the space of his interiority, now a decidedly psychologized, even sexualized space.[3]

Even if this psychologized interiority were nothing more than a critical invention, it has nonetheless accommodated the play to modern understanding. More recent historicist versions of criticism are properly skeptical of such accommodations, but in the case of *Hamlet* the imponderables are so great that speculation on Hamlet's psychology is likely always to be with us. By comparison with the prince's absorbing complexity, Claudius's act of fratricide, like that of the Ottoman prince, seems more like a case of primate aggression. I propose to argue in this essay that if there is a compelling difference between the psychological complexity of Hamlet's deferred action and the motives of Claudius, it is

just like the difference between Aristotle and the Ottoman prince in Bacon's account, that is, the difference between symbolic and real violence. This difference, I will also argue, is parallel to the difference between philosophy and theology as early modern discourses; philosophy, as we shall see, can be seen to counter the fratricidal or sectarian violence provoked by theological dispute. I will propose further that if there is a psychological dynamic underlying and determining the relation of thought to action (or inaction) in *Hamlet*, this dynamic might best be described as the sublimation of aggressivity. I would like to move away, then, from the current thematization of sexuality in *Hamlet* criticism (without discounting its illumination of gender relations especially in the play) in order to recover the historical priority of aggression in the psychic and cultural dynamic of Hamlet's situation.

Symbolic violence is not simply reducible to real violence, but as a symbolic act, it has real social effects. The complex relation of symbolic to real violence has been explored in an essay by Stephanie Jed entitled "The Scene of Tyranny: Violence and the Humanistic Tradition."[4] Jed reminds us that humanist discourse was very much preoccupied with political violence, particularly in those civic republican texts on the subject of tyranny. If some humanists were admirably concerned with how to prevent or resist the tyrant's violence, Jed argues that the transmission of their discourse was contaminated by that violence in two ways. First of all, in extreme cases, some humanists were "incited by their reading of classical literature to commit real acts of violence" (p. 32). Second, the mode of textual transmission itself could be said to constitute a kind of violence, by virtue of the fact that humanist texts were unavailable to those not literate in Greek or Latin. What Jed calls the "violence of the code" excluded segments of the population from realms of discourse or power in a manner analogous to the threat of real violence. To these versions of symbolic violence, we must add a third: the *representation* of violence, its enjoyment in narrative or theatrical form. This is a less subtle instance of symbolic violence than the structural coercion to which Jed refers, but it is perhaps the more common.

If symbolic violence, then, can take the form of provocation, structural effect, or representation, it is generally the last that has interested literary scholars, for obvious reasons. And yet it is the representation of violence that most perplexes the relation between the real and the symbolic. Symbolic violence cannot be reduced to real violence, as though there were no difference between Aristotle and the Ottoman prince; nor

is real violence a necessary effect of the symbolic, as though social violence only literalized the violence already there, fully and really, in the symbolic. To conflate symbolic with real violence is ultimately to embrace an idealism that finds its inevitable reduction in a familiar theme of anti-intellectualism, according to which the philosophers themselves are held responsible for the violence of history —Rousseau for the Reign of Terror, Marx for totalitarianism, Nietzsche for fascism.[5] This theme is rather scurrilous, but it stands on a continuum with Jed's entirely just observation that some humanists were incited to violence by reading the works of civic republicanism. Another example is Annabel Patterson's recent argument about the relation between *Hamlet* and the Essex rebellion. For Patterson, the fact that the rebellion "was plentifully supported by intellectuals" suggests that "an overly-theorized approach to sociopolitical interventions could produce, paradoxically, rash and self-destructive behavior."[6] In her reading of Shakespeare's play, Hamlet's intellectuality leads not to inaction but to act 5's bloody stage. This is an argument one has to take seriously, if only because it takes the violence of the play seriously, as something other than the residue of the revenge plot, wholly exterior to Hamlet's interiority.[7]

There is a relation between symbolic and real violence, but we have not yet grasped it. Let us approach this question from another direction, by returning to the hint contained in Bacon's comment on Aristotle. If we are correct to discern in Bacon's reference to "diversity of sects" an oblique allusion to the wars of religion, then Bacon's own anti-Aristotelian polemic no longer seems to be merely expressive of the violence that inheres in the symbolic. In historical context, the motive of his philosophical polemic must on the contrary be described as irenic — to establish a peaceful and progressive "art of discovery" on the ruins of interminable philosophical dispute. Philosophical argument is prosecuted with great vehemence in order to supersede an existing state of discursive warfare, of *polemikos*. As we shall see, this warfare is the analogue, or "sublimated" version, of the real social violence wrought by the "diversity of sects" in theological discourse. Violence is present in philosophy, then, but sublimed, "as the stars in the sky."

The polemical vehemence with which Bacon attempts to resolve the underlying principles of philosophical conflict thus measures precisely the intensity of the irenic motive. And yet the example of Aristotle testifies both for and against this motive. What is to prevent the polemic/irenic argument from becoming once again an incitement to sectarianism,

if not, as in theology, to violence? In fact, this is a question with a specific historical context, which can be conveyed at present only in the form of a hypothesis: The pacific motive of philosophy in early modernity was founded on the possibility of a distinction between philosophical discourse and theology, a distinction that proved impossible to sustain in the seventeenth century. Further, if philosophy was powerless to prevent sectarian conflict, this conflict was greatly magnified whenever it was channeled through political agencies, when theological positions became aligned with political factions. As we shall see, the relation between sect and faction in *Hamlet* is expressed not in a clash of theological doctrines, but in the fact that political violence in the play has a certain theological tincture.

II. THE OUTSIDE OF PHILOSOPHY

Hamlet invokes the name of philosophy in a line, like so many other lines, as baffling as it is familiar: "There are more things in heaven and earth, Horatio, / Than are dreamt of in your philosophy" (1.5.75).[8] In the early modern period, the word *philosophy* referred to knowledge in general, potentially inclusive of every kind of knowledge. For Shakespeare's contemporaries, every discourse that made truth claims could be called "philosophy," whether such discourse dealt with astronomy, medicine, mathematics, morality, politics, metaphysics—everything. Only theology or "divinity" was distinguished in conventional usage from the domain of philosophy by virtue of its status as revealed knowledge. Revelation thus defined the outside of philosophy, what it excluded. The question of philosophy in Hamlet's address to Horatio is, not surprisingly, a question of what it excludes, what is beyond its capacity to think or even dream. But dreaming already hints at the form of this knowledge, in the sense that the dream was conventionally regarded in premodern culture as a kind of ambiguous revelation. What philosophy excludes in *Hamlet* is revealed knowledge, the ghost's revelation of Claudius's crime.

As critics have long recognized, the question raised by the ghost is not that of its existence, but the one that troubles Hamlet himself, whether the ghost is his father or a devil in disguise. This question, which is not decided in the play one way or the other, discloses a certain instability in the relation between philosophy and theology in the early modern period. The skepticism about ghosts implied by Hamlet's reference

to philosophy was a vehemently held doctrinal position for Protestant theologians.[9] Rejection of the notion that the dead could return to haunt the living was a logical consequence of Reformation theology's dismissal of the doctrine of purgatory, an innovation of feudal theology that legitimated the practice of indulgence. At various points in the play, Shakespeare seems to invoke both the Catholic and the Reformed positions without, apparently, adjudicating between them. But his position on such questions is more than simply elusive; it is also, in a sense, uninteresting. The theological dispute is already preempted by a reflection on the limits of philosophy, of *human* knowledge. Shakespeare associates the ghost with the outside of philosophy, with the limits of human knowledge, without endorsing particular theological positions, all of which have the same uncertain status as the ghost itself. The ghost thus haunts the interface between the two discourses of theology and philosophy, just as it haunts the space between the living and the dead.

Here, as throughout the play, a line of demarcation, a distinction, is established between philosophy and theology; but the point of introducing the distinction is not simply to confound it by setting the ghost athwart its threshold. Rather, the space of overlap allows Shakespeare to convert a current theological dispute, where the stakes are presumably very high, into a small philosophical reflection on philosophy's incomplete comprehension of reality. While this gesture perplexes his critics — they would like to know whether he endorses the Catholic or the Protestant position on ghosts — his strategy only rehearses a typical maneuver of sixteenth-century skepticism, of the sort Montaigne espoused. Within this tradition of Pyrrhonian skepticism, the temperature of theological dispute could be lowered by rewriting theological controversy as philosophical controversy, by this means imputing to theology some of the fragility and vulnerability of merely human knowledge. The undecidable diversity of philosophical opinion could be taken to confirm the indifference of these positions, and at the same time to raise the possibility of a similar indifference of theological positions. The tendency of Pyrrhonian skepticism was thus to enlarge the domain of "things indifferent" in theology.[10]

My point, however, is not to locate Shakespeare within the history of philosophy, as holding some position like or identical to that of Montaigne. My point is rather to recognize philosophy as a discourse that in the sixteenth century could contemplate its own incompleteness, in contrast to the field of theology, where every position violently excluded

some other position. As a discourse, theology could not admit of incompletion. It was driven to achieve rational coherence by its monumental task of reconciling every text of revelation with every other, upholding the "harmony of scriptures." Further, it was in the nature of theology's symbolic violence that this violence was always capable of being literalized, first as the violence of the stake, but later through civil and state warfare. The dynastic and interstate rivalries of Reformation Europe were thus both complicated and intensified by sectarian passions, to such an extent that in historical retrospect it remains difficult to disentangle religious and political motives of conflict during the period.

Stephen Toulmin has recently argued in a study of early modern thought that the most important context for sixteenth- and seventeenth-century philosophy was the emergence of Protestant sects, and Europe's wars of religion.[11] Theological debate was always bleeding at the door of the philosopher's chamber. Toulmin argues that Renaissance philosophy passed through two phases of response to this violence, first a skeptical humanist phase, in which the variety of philosophical opinion in antiquity (much of it recently recovered by humanist scholarship) became the basis for a rigorous skepticism that entailed both toleration of religious diversity, and in the case of Montaigne, a "fideist" acceptance of the religion of one's own locality.[12] The second, seventeenth-century phase represents for Toulmin a repudiation of this humanist skepticism and a renewed search for the grounds of certainty, a search that produced the rational-empiricist systems of Bacon, Descartes, Hobbes, and Spinoza.

From this unduly abbreviated account I would like to derive a certain principle for describing the relation between philosophy and theology in the early modern period. I will call this principle *transitivity*, by which I mean that certain theological problems could be transposed into philosophical discourse, where their theological (or sectarian) implications could be bracketed and their return to the field of theology deferred. The relative transitivity of discourses in the early modern period thus allowed certain questions — for example, the status of ghosts — to be posed alternatively within philosophy and theology, with different consequences. The condition of transitivity imparted a fundamental incoherence to early modern philosophy, an incoherence that persisted into the rational-empiricist systems of the seventeenth century. Indeed, early modern thought may be said to have become ever more incoherent the harder it struggled to reduce the transitivity of discourses to what Bacon called *philosophia prima*, or Descartes's "universal mathesis," or

method. *Philosophia prima* set out from what could be known, without recourse to revelation, but it hoped to meet and rejoin theology, which set out from revealed truth.

If early modern philosophy attempted to go behind theology, it was thus always drawn back into theology's discursive field. The sixteenth century had already seen the emergence of strange hybrid versions of philosophical theology, or, in the jargon of the time, "natural theology"— the very theology, for example, of Raymond Sebond, for whom Montaigne composed his ironic apology. The historian of science Amos Funkenstein describes this hybrid discourse as "secular theology," which he considers to be distinctive to early modernity.[13] It is not surprising that much of this "secular theology" concerns nothing other than the question of spirit, or rather, the relation between spiritual substance and material substance. In fact, the early modern philosophers developed their epistemologies, whether skeptical or dogmatic, as a reflection on the problem of substance. Here one need only invoke Descartes and the trajectory of his *Meditations*—radical doubt gives way to the assertion of a radical dualism of thinking substance and material substance. Early modern thought is a reflection on substance, on the "things in heaven and earth," but it does not know without equivocation to which discourse this question definitively belongs, to philosophy or theology.

III. THE MATTER OF PHILOSOPHY

This is the larger context in which I would like to insert Hamlet's invocation of philosophy: as a question about the things of heaven and earth, and about early modern philosophy's failure to include all of these things in some comprehensive system of knowledge. The problem of the ghost in *Hamlet* can thus evoke the most significant occasion for the transitivity of early modern discourse without having to produce anything like a quotation from a philosopher or theologian. *Hamlet's* ghost is nothing other than spiritual substance, or spirit. The failure of "philosophy" to account for this ghost testifies to philosophy's eagerness to address just this problem in response to the ruinous and inconclusive theological debates between Catholics and Protestants and among Protestants— debates over such issues as whether the dead can return as ghosts, whether Christ is really present in the Eucharist, whether miracles are supernatural interventions or extraordinary natural events, whether

witches are demonically empowered, or whether the soul dies with the body.[14] For philosophy, these questions might perhaps be resolved by reasoning behind or beside theology, paratheologically, in order to determine on more certain (and nonsectarian) grounds the nature of matter and spirit, and the principle of their interaction.

The ghost, as we shall now be able to acknowledge, represents for philosophy only one side of the problem of substance. Both philosophy and *Hamlet* are equally troubled by a question about matter, which we will have to say now is the same question. By the early 1600s new conceptions of matter, advanced by "mechanical philosophy" or the "New Philosophy," were becoming increasingly hard to ignore. Only a little later in the century the New Philosophy provided Hobbes with a set of hypotheses for resolving the question of substance entirely on the side of matter. On the basis of this early version of materialism, Hobbes confidently exorcised all ghosts (along with all spirits) from the domain of reality as logical impossibilities—"incorporeal substance" became a contradiction in terms. Yet Hobbes was compelled, like his contemporaries, to construct his materialist philosophy as a paratheology, a theology in which God himself was a material being. By insisting upon the "incoherence" of even the Hobbesian logic machine, I do not mean to say that Hobbes's philosophy might have been made coherent, if only it could have been purged of its residual theology. On the contrary, the incoherence was integral to the thought, an inescapable consequence of the transitivity of discourse in the early modern period. This is to say that philosophy could not have been other than it was in this period, because it was only as paratheology that it could perform the cultural work of responding to the internecine conflicts of Reformation Europe.

If radical materialism of the Hobbesian sort was not yet possible in 1600, the conditions that made such a materialism conceivable only a few decades later were already present in the very unsettling of spiritual substance to which the ghost of Hamlet's father is testimony. The ghost appears in the play as a spirit that has not successfully freed itself from the body; it is an ontologically intermediate thing, belonging neither to heaven nor to earth. Now, it might be interjected here that the folkloric tradition upon which Shakespeare so consistently drew provided ghosts enough without recourse to such abstract language. Yet I would argue that *Hamlet*'s ghost has somewhat more sophisticated associations (already indicated by the invocation of Wittenberg and by Hamlet's scholarly pursuits), and that Shakespeare grafts a high-cultural discourse of

substance onto the folkloric derivation. This is why spiritual substance in the play generates its thematic complement in the *corporeal* king, Claudius. Hamlet insists (and let us begin to read this now as philosophical insistence rather than psychological obsession exclusively) upon Claudius's corporeality, sensuality, bestiality. If Hamlet's father is Hyperion to this Satyr, Hamlet's admiration for his transcendent father remains less convincing than his revulsion for Claudius, the corporeal king. This disgust, as many have observed, is not limited to Claudius but is inflated into a generalized disgust with the body—"the sun breeds maggots in a dead dog" (2.2.181). It extends, as we shall see, beyond the bodies in the play, including those of Gertrude and Ophelia, to matter itself.

The status of matter is unsettled in a fashion precisely complementary to that of spirit. This need not mean that Shakespeare was particularly au courant with the mechanist science of his day, although we can assume that he must have heard something of it from the sophisticated circles around his patrons, the earls of Southampton and Essex. And of course he would have read about Copernicus in Montaigne's *Apology*. (Florio, the translator of the *Essays*, was in Southampton's circle.) He heard enough, at least, to turn the New Philosophy into a skeptical joke, somewhat at Hamlet's expense, in the doggerel poem Hamlet writes to Ophelia: "Doubt thou the stars are fire / Doubt that the sun doth move, / Doubt truth to be a liar, / But never doubt I love" (2.2.115–18). The burden of the doubt is much greater than its immediate context, since what is doubted is not just the Ptolemaic system but the whole architecture of Aristotelian physics, with its founding distinction between corruptible sublunary and incorruptible translunary realms. It is just this question of the corruptibility of all matter that elicits the paradox of which I spoke earlier: Matter is at once the obsessive subject of Hamlet's philosophizing ("O that this too too sullied flesh, would melt, / Thaw and resolve itself into a dew" [1.2.129–30]) and the limit of philosophy for him, another "thing" which finally defies philosophical explanation.

Nowhere is this paradox more apparent than in Hamlet's repeated return to the subject of dirt, which constitutes one of the more obsessional thematics in the play. Most notably, this thematic culminates in the famous pseudo-Montaignean disquisition on man: "What a piece of work is a man, how noble in reason, how infinite in faculties, in form and moving how express and admirable, in action how like an angel, in apprehension how like a god: the beauty of the world, the paragon of animals—and

yet, to me, what is this quintessence of dust?" (2.2.303–8). Even the most modestly literate of Shakespeare's auditors might have had cause to wonder about the phrase "quintessence of dust," for of course it was a commonplace of Renaissance thought that man is a mysterious union of quintessential soul-substance and dust; but the genitive construction has the effect of simply reducing Aristotle's incorruptible fifth essence, out of which the stars are made, into the matter and sign of corruption itself—quintessence *of* dust.

Let us suppose, then, that the invocation of dirt, dust, or matter provides Shakespeare with the occasion of philosophical discourse. Citing here a point already observed by a number of critics, that the word *matter* occurs with great frequency in the play,[15] we might recover also for future reference (in addition to the soliloquies' manifest obsession with matter) some of the more curious byways of this thematic network: for example, Hamlet's wonder at Fortinbras' campaign against the Poles over a "little patch of ground"; or the "noble dust of Alexander," which Hamlet traces to its ignoble end stopping a bung-hole; or the satiric demolition of the courtier Osric, who is scorned by Hamlet as a social-climbing yeoman "spacious in the possession of dirt." If nothing else, these smaller instances confirm act 5's graveyard scene as a thematic nodality; that scene buries all human matters in the play's great accumulation of dirt (the "fine dirt" to which the lawyer's pate comes) at the same time that it provides the occasion for nonstop philosophizing. And yet one would also have to admit that most of the philosophical set pieces in the play are not in themselves philosophically sophisticated, however rhetorically indelible their commonplaces may be. They are much more a *performance* of philosophy than the thing itself. That performance, as I would like now to argue, is just the point of the play's invocation of philosophy's name.

IV. FASHION AND FACTION

There is some evidence to suggest that Shakespeare had a definite interest in 1600–1 in producing a play that could be received by a sector of his audience as evoking the learned, high-cultural discourses of philosophy. Support for this hypothesis can be derived from the Q1 and Folio texts of *Hamlet*, in the much controverted scene in which Rosencrantz explains how it happens that the company of players has decamped from the city. Without attempting to decipher every cryptic detail of

this passage (as we shall see, its topicality is both blatant and en-crypted), we can begin by affirming what is least disputed, that the con-text for Rosencrantz's remarks is competition between the public or "common" theaters and the so-called private company of boy players, the Children of the Chapel, who acted at Blackfriars.[16] The Folio text concedes the popularity of the boy companies of the competing private theaters, which were smaller, more expensive, and patronized by a somewhat more exclusive audience: "There is, sir, an eyrie of children, little eyases, that cry out on the top of question, and are most tyranni-cally clapp'd for't. These are now the fashion, and so berattle the com-mon stages — so they call them — that many wearing rapiers are afraid of goose quills and dare scarce come thither" (2.2.336–42). If this pas-sage implies that Shakespeare's own company, as a common stage, had recently suffered some decline in popularity as a result of the success of the boy companies, this need not be taken to mean a decline in absolute attendance, much less a "war of the theaters." The complaint extends only to those "wearing rapiers." The concern of the passage is with this elite audience, presumably of courtiers.

It is in this context that we might begin to understand one motive for *Hamlet*, if not also Hamlet's motives, for Shakespeare's dramaturgical strategy in redoing an older and popular play, interrupting its revenge narrative at every opportunity in order to insert little Montaignean philosophical essays, did seem to be successful in attracting the esteem of an elite audience. This fact we cannot know, of course, by any mea-sure so certain as that of, say, exit polls from the Globe, but that a sector of the play's elite audience recognized its deliberate appeal to their culti-vation is attested by a remark of Gabriel Harvey's in his marginalia: "The younger sort takes much delight in Shakespeares Venus, & Adonis; but his Lucrece, & his tragedie of Hamlet, prince of Denmarke, have it in them, to please the wiser sort."[17] Hamlet himself produces the dramatur-gical apparatus for the reception of *Hamlet* in his discourse to the play-ers (no doubt glancing ironically at the difference between *Hamlet* and its precursor text): "[F]or the play, I remember, pleased not the million, 'twas caviare to the general" (2.2.431–32).

Harvey's marginalia and Hamlet's line point to an internally differenti-ated and stratified Shakespearean audience, differentiations that may not be confined to the elite and the vulgar. I would like to propose that the performance of philosophy in *Hamlet* may identify a "wiser sort" as a constituency within, and not simply identical to, the courtly elite. This

constituency would ideally be none other than the arbiters of court fashion, such an arbiter as was Hamlet himself before Claudius' accession, "the glass of fashion." Theatrical fashion and court fashion stand in a certain relation of reciprocity: Fashions in the theater follow fashions in the court, but also, to a certain extent, vice versa, if the playwrights of the private theaters could intimidate some of the courtiers and gallants into disdaining the public theaters, at least for a while. This relation between court fashion and theatrical fashion is remarked on by Hamlet himself in the latter end of the passage from act 2, scene 2, when he links the city players' fall from fashion to the rise of Claudius: "Do the boys carry it away? *Ros.* Ay, that they do my lord, Hercules and his load too." To which Hamlet replies: "It is not very strange; for my uncle is King of Denmark, and those that would make mouths at him while my father lived give twenty, forty, fifty, a hundred ducats apiece for his picture in little." The reference here is to the fashion for miniatures Elizabethan courtiers were fond of carrying on their persons, sometimes signaling their relation to some powerful patron, or to the monarch.[18] The invocation of court fashion sets up the next line, which provides a crucial hint about how we might read what I have called the performance of philosophy: "'Sblood, there is something in this more than natural, if philosophy could find it out" (2.2.338–64). For a second time in the play, the name of philosophy is invoked, again in order to call attention to philosophy's limits, its frustration before a fact "more than natural."

But what fact is this? The answer to this question demands that one recognize fashion as neither trivial nor arbitrary. On the contrary, fashion is the sublimated, aestheticized expression of *faction*, a political reality.[19] Claudius was formerly out of fashion in King Hamlet's court, the object of derision. It was rather Hamlet himself who was the "glass of fashion." The triumph of Claudius's faction is expressed by the fashion of purchasing miniatures of his figure, a practice that doubly conceals the fact of King Hamlet's murder. Indeed, the courtiers themselves may not know what is truly signified by their wearing of Claudius' picture. An unspeakable political truth is encrypted in the fashion system of court society, and even philosophy cannot "find it out" or decrypt it. It is a truth revealed only by revelation, and this point links the passage unmistakably to the invocation of "philosophy" in act 1. Again Hamlet invokes a kind of "ghostly" knowledge, the truth of the fratricide. It is all too evident that a political response to this reality can only be violent. And this vio-

lence will necessarily have a theological character, since it will be capable of justification solely on the basis of revelation.

Hamlet's analogy between theatrical fashion and the practice of wearing miniatures of Claudius points to a relation between theatrical fashion and court faction, but the meaning of the fashion that so berattled the common stages may also exceed the capacity of criticism to "find it out." In other words, the apparent decline in the popularity of the common stage among the courtiers may conceal a political reality that cannot be spoken in the play. Shakespeare may be commenting here in some oblique way (as many critics have supposed) on his patron, the earl of Essex, whose abortive rebellion in 1601 resulted in the earl's execution and in Southampton's imprisonment.[20] While the consequences of the rebellion for Shakespeare himself were happily not punitive, let us recall that in the two years prior to the rebellion, as a result of Essex's disastrous Irish campaign, the earl's faction was decidedly out of fashion. We cannot now know the extent or the exact nature of Shakespeare's involvement in the Essex faction, and this deficit of knowledge effectively blocks any construction of the play as a topical allegory. But such allegory is any case almost completely absent from Shakespeare's plays, which generally deploy a much more oblique topicality.

I propose here a relatively limited hypothesis about what may be topical in the scene under scrutiny. The experience (for Hamlet, for Shakespeare, perhaps for Essex) of being in a certain complex politico-cultural sense "out of fashion" provokes the performance of philosophy in the play, which we may now read as an attempt to consolidate "the wiser sort" around their knowledge of an unspeakable political truth. The name *philosophy* locates this knowledge at the limit of what can be known, and beyond the limit of what can be spoken. *Hamlet* stages scenarios of knowledge again and again at this limit, because the guilt of Claudius is unspeakable in the court. Philosophy cannot find it out. In fact we need look no farther than Elizabeth's court for an analogous occasion of such knowledge: the unspeakable fact of the succession. For those in the know, it may have been an inside joke of the "little eyases" passage when Hamlet says that the writers for the private theater have the boys "exclaim against their own succession." This was, after all, the issue for Essex, if indeed the problem of the succession was something more than the cover for his ambition.[21]

But these oblique reflections of the immediate political context of the play fall well short of an allegory, especially one in which Hamlet is a

figure for Essex. If Shakespeare glances at all at Essex's rebellion, it would have to be with Laertes' chaotic march into Claudius' palace, a rebellion quickly defused by the king himself. Even this topical allegory, however, would assume composition of act 4 after the rebellion, whereas it is just as likely that Essex ended up playing the part of Shakespeare's Laertes in Elizabeth's (or Cecil's) London. The motive of *Hamlet* seems to me much more the performance of philosophy than the representation of rebellion. Philosophizing in the play is provoked in response to a condition of factional isolation that has no *political* solution, certainly not the solution of rebellion. The performance of philosophy may be addressed to a faction of the courtly elite; but it advances no political agenda, and that is one point of the interference of the philosophical set pieces with the progress of the revenge narrative.

I would argue, then, for taking the political context of philosophizing in the play much more seriously than we are accustomed to do, with the appropriate adjustments to our reading of the figure of Hamlet himself. That is to say, however inclined we may be to read his soliloquies as revelations of inexhaustible interiority, these passages might be understood more accurately as a performance of philosophy designed to please a certain "faction" of Shakespeare's elite audience, those who are now displaced from their position as arbiters of fashion.[22] For this smaller circle within the circle of the courtier elite, the play's generalized reflections on the human condition reproduce the same sophisticated skepticism one finds in Montaigne's essays, but displaced into the play's fictional political context. Skeptical philosophy's irresolution of fundamental questions, its reflection on its failure to comprehend the "things in heaven and earth," tends toward the suspension of action, especially violent action. But the pleasures of this philosophy are not for the many, the "general," and not even for the dominant faction, the followers of such as Claudius. This "wiser sort" is all the wiser for being out of fashion, for having achieved a certain distance on court faction by means of the intellectual exercise of reducing faction to fashion.

V. THE PACIFICATION OF THE COURT NOBILITY

The problematic of fashion and faction in *Hamlet* directs our attention to what Norbert Elias would call the sociology of "court society." The pacification of the court nobility was a long-term project of the early modern monarchy, a project Elias describes (following Max Weber) as

the state's "monopolization of violence."[23] Elias argues that court society imposed upon its participants the necessity of exercising great restraint on impulsive modes of behavior, including the impulse to aggression. Aggression was channeled into what he calls "intrigue," and "faction" is only the most elaborated form of this behavior. Intrigue implies secrecy, the capacity to conceal one's plans; it calls forth surveillance as its necessary complement.

Both of these political behaviors are amply represented in *Hamlet* and go a long way toward explaining the protagonist's vaunted interiority. Whether or not this interiority has irreducibly idiosyncratic aspects, it is *formally* just what we would expect of an early modern courtier who must keep his plans secret from the king and the king's agents. In any case Hamlet's interiority cannot anticipate bourgeois subjectivity in advance of the age. Nothing can get ahead of history, and even the prophets only reveal the present as it really is to those who still see it with the eyes of the past.

The "modernity" of the courtiers resided in the fact that they had to resist the impulse to resolve disputes within their class stratum by an immediate and unreflective resort to violence. This internalized self-constraint was the principal mechanism of social control in a court that dispensed with the armed retainers of its medieval predecessors. Elizabeth's court we know to have been largely peaceful, despite the fact that the courtiers carried rapiers and daggers (and no doubt her cultic use of her gender promoted the cause of this peace). Court society's elaborate machinery of ceremony, manners, and fashion served to sublimate the violence latent in struggles for position or patronage by forcing the courtiers into competitive displays of *courteoisie*. This cultural program supplemented the more direct strategies for managing aggressivity, primarily surveillance and control over access to powerful persons. When those strategies failed to prevent violence, Elizabeth could resort to the Star Chamber or peremptory imprisonment in the Tower; but these measures were last resorts and in certain respects less effective than the cultural program.[24]

The above point can be enlarged for its historiographical implication: Before the bourgeoisie took up the task of disciplining sexuality, the early modern aristocracy undertook to discipline aggressivity. Unfortunately we have come to understand aggressivity too exclusively through a Foucauldian lens, in which violence is always already eroticized as a scopophilic spectacle. This lens is anachronistic, because it

makes insufficient distinction between the technique of discipline in the two contexts of sexuality and aggressivity. Because we have as yet no history of violence like the history of sexuality, we have scarcely begun to understand, in social and psychological terms, how aristocratic violence came to be disciplined. For the armigerous nobility, violence was its right and even its source of pleasure, quite distinct from other pleasures, such as the sexual. And yet, as Lawrence Stone observes, the pacification of the nobility succeeded to a surprising degree: "[B]y 1640, the bellicose instincts of the [noble] class had been sublimated in the pursuit of wealth and the cultivation of the arts."[25]

Stone's allusion to sublimation raises an interesting question about the possible limits of the disciplinary effect that can be imputed to culture. If *courteoisie* sublimated generalized aggressivity in competitive cultural displays, this program was never sufficient to eradicate violent behavior altogether.[26] Court society also had to establish among the courtiers an inhibition to violence where the immediate provocation was particularly strong. By "inhibition" here I mean the sense of an inner impediment to the gratification of an impulse, the sense that an act *cannot* be done — at least, not without shame or disgust. Inhibition is a necessary psychic complement to the sublimations of culture, which are supposed to gratify impulses by simultaneously transforming them and moderating their intensity. The "civilizing process" must have entailed (as it perhaps still does) both sublimation and inhibition.

Because this process was historical, it was also uneven. This point can be appreciated by glancing briefly at an instance of inhibited violence, one in which inhibition almost failed. In July 1598 Elizabeth had to choose a lord deputy to send to Ireland. The incident that followed is narrated by J. E. Neale, after the sole surviving report of its occurrence in William Camden's *Rerum Anglicarum* of 1625:

> Elizabeth wanted to send Sir William Knollys, Essex's uncle; Essex urged the appointment of Sir George Carew, an enemy of his, whom he hoped to remove from court in this way. The Queen proved obstinate, and Essex lost his self-possession. With scorn and anger blazing on his face, he deliberately turned his back on Elizabeth. Furious at the insult and contempt, she boxed his ears and "bade him get him gone and be hanged." His hand leapt to his sword, and as Nottingham hastily stepped between them, he swore a great oath that he neither could nor would put

up with such an affront and indignity; he would not have taken it even at Henry VIII's hands. In a tearing rage he left the Court.[27]

The fact that Elizabeth lost her temper with Essex is not the point of recalling this incident. Violence belonged to her, as monarch. The high tension of the moment inheres in Essex's gesture of reaching for his sword. His gesture expresses a contradiction in his historical situation, as he was caught between the assertion of his traditional right, and his duty, as Elizabeth's favorite, to manifest above all others the virtues of courtliness. Two years later Essex did contemplate violence against the queen, but it is not evident that he would have been able, even then, to overcome the inhibition to violence. By "inhibition," then, we must understand not an individual pathology but the politico-cultural project of the early modern court.

Shakespeare's Hamlet is like Essex only in being located at such a point of historical contradiction. He has thoroughly internalized what we may call, after Elias, the courtly *habitus* of inhibition and refinement, a *habitus* emphasized again and again in the play—for example, in Hamlet's fastidious protest against the drunkenness and lewdness of Claudius' court, on behalf of what he calls "the form of plausive manners" (1.2.30); in his discourse on acting styles, so full of disdain for the uncontrolled expressiveness of the players who "tear a passion to tatters" (3.2.10); and above all in his conspicuous endorsement of Stoic precepts, as in the line "[G]ive me that man that is not passion's slave" (3.3.71). This antipassional stance constructs Hamlet as an embodied ideal of courtly civility.

It is scarcely surprising that this ideal type of the modern courtier is ill prepared to respond in kind to the real, if hidden, violence of Claudius' court. Hamlet would prefer to expose this violence rather than redress it; hence his resort to the cultural form of the theater, first to the "antic disposition," and then to the players' performance of *The Mousetrap*. But the failure of these means to expose Claudius by provoking an unequivocal public manifestation of guilt exposes instead a weakness of court culture, in its very dependence on the mechanism of sublimation. The represented violence of *The Mousetrap* fails to expose Claudius and thus to provoke the sort of mimetic violence Stephanie Jed describes in the circulation of classical texts among the Humanists. For that very reason Hamlet's resort to the cultural form of theatrical representation delegitimates not Claudius but court society itself.

The failure of *The Mousetrap* to constitute a successful political act calls into question court society's sublimation of politics into culture by revealing it as nothing other than the occultation of the real violence upon which the court is founded. The cultural sublimations of Claudius' court are belated. By definition, past violence cannot be sublimated. Because that violence is occulted rather than sublimated, cultural forms in the play take on the task of repeatedly and impotently alluding to it. In the presence of such violence, the cultural form is emptied of social power. And just as culture is powerless to redress violence in the form of revenge, it is equally powerless to provoke it in the form of rebellion. Shakespeare may have understood much better than Essex that playing *Richard II* before the rebellion, however much it may have annoyed the queen, was powerless to incite an uprising, that is, to desublimate or deinhibit violence.

VI. HAMLET'S PHILOSOPHICAL IMAGINARY

Philosophy is analogous to cultural forms such as theatrical representation in undertaking to sublimate violence, while possessing no guarantee that this project will succeed. In the event that sublimation fails, the theater may represent what it cannot prevent; but philosophy, as Hegel famously argued, must reflect on historical inevitability. I want to propose now that there is such a reflection in *Hamlet*, something more than the performance of philosophy. This reflection comes in the aftermath of Hamlet's stabbing of Polonius through the arras, which can be understood as the moment in which court society's *habitus* of sublimation and inhibition breaks down. The violence of Hamlet's act achieves no political resolution, but it does provide the occasion for entertaining a philosophical reflection somewhat more profound than we have heard before. This thought is inaugurated with Hamlet's response to Rosencrantz: "The body is with the King, but the King is not with the body. The King is a thing—" (4.2.26–27). It is developed further in the immediately following conversation with the king:

> *King*. Now, Hamlet, where's Polonius?
> *Ham*. At supper.
> *King*. At supper? Where?
> *Ham*. Not where he eats, but where a is eaten. A certain convocation of politic worms are e'en at him. Your worm is your only

emperor for diet: we fat all creatures else to fat us, and we fat
ourselves for maggots. Your fat king and your lean beggar is but
variable service — two dishes, but one table. That's the end.
King. Alas, alas.
Ham. A man may fish with the worm that hath eat of a king,
and eat of the fish that hath fed of that worm.
King. What dost thou mean by this?
Ham. Nothing but to show you how a king may go a progress
through the guts of the beggar. (4.3.16–31)

Jenkins glosses this scene with reference to the notion of the "king's
two bodies," as explicated by Ernst Kantorowizc.[28] But if Hamlet ges-
tures here toward a conventional theological distinction between the
king's mystical or spiritual body and his physical body, the spiritual
body is simply absent from his imaginary scenario. Reduced to mere
matter, the king "progresses" not through his realm with all the auratic
trappings of office, but "through the guts of a beggar." This thought, I
would like to say, is radical but not rebellious; it does not threaten the
body of the king with anything other than a thought about the king's
body. Hamlet returns to a tactic of sublimated aggression, after a mo-
ment of deinhibited violence; but this return is also a turn away from
the forms of court culture to philosophical reflection. Hamlet's thought
sets out from a fantasized wish — that the king might be dead — but it
exceeds this wish by abstracting the question of matter from the partic-
ular instance of the king's body. The body of the dead king is thus re-
duced to the status of philosophical example.

The same speculative thought is elaborated in the graveyard scene,
where it appears as the "revolution" of all bodies into dirt: "Here's fine
revolution and we had the trick to see't" (5.1.89). Hamlet's reduction of
all "things" to dirt is of course authorized by a biblical text — the "dust
to dust" of Genesis — but it would be a mistake to read his amplification
of that text as nothing more than a repetition of its memento mori. The
revolution of which Hamlet speaks goes beyond the equation of dust
with death: "Why, may not imagination trace the noble dust of Alexan-
der till a find it stopping a bung hole?" Horatio replies, " 'Twere to con-
sider too curiously to consider so" (5.1.96). In Hamlet's philosophical
imaginary, Alexander is nothing more than the matter of his body. The
identity of this body-which-is-Alexander can then be pursued in imagi-
nation (like the king's body) through its material migrations, quite apart

from its being the habitation of a "soul." Hamlet invents a kind of material afterlife for Alexander, in contrast to the tortured "spiritual" afterlife of his father.

Hamlet's speculation on material substance, which resonates with the great materialist philosopheme of early modernity, is no more and no less profound than it needs to be for the purpose of responding to an insoluble political dilemma. The reduction of all things to dirt appears to withdraw legitimacy from the body politic, from the world itself. The poles of king and beggar are collapsed together as mere appearances of the same matter. Just as kings devolve into beggars, so beggars rise to kings — or at least, in the case of Osric, the yeoman farmer who is "spacious in the possession of dirt," peasants become courtiers: "The toe of the peasant comes so near the heel of the courtier, he galls his kibe" (5.1.136–37).

The social elitism that accompanies Hamlet's materialist speculation indicates that it is nothing like a "critique" in the modern sense. The reduction of everything to dirt is a way of reflecting (*post festum*) on the original violence against King Hamlet, but also on its consequence for the prince, that he "lacks advancement." The retreat of the "wiser sort" into a marginalized elite, cut off from validation by the monarch or by the culture of court society, is a favorable condition for the entertainment of philosophical speculation, which is both elitist in an inward, socially nonvalidated way, and pacific, even resigned. The events of the day are over, and in the dusk of reflection one sees that nothing can be other than it is. In the course of the seventeenth century, the materialist philosopheme took on just this pacific agenda in the work of Hobbes and Spinoza, both of whom may be said to have philosophized in the hope of preventing violence. However unlikely to accomplish this end, philosophy offered its reflection on the cause of violence as an alternative to violence itself.

Hamlet's radical thought about material substance is, I have suggested, the footprint of philosophy in the play, in contradistinction to the performance of philosophy. But the fact that this thought turns first and last on the question of what happens to bodies after death disallows us from claiming for it the status of a *pure* philosophy, a discourse wholly distinct from theology. This would be to repeat the mistake of discovering in Hamlet the modern subject before his time. Hamlet's philosophical imaginary looks for a way out of theological dilemmas. The appeal of imagining the dust of Alexander stopping a bung-hole is

surely that such an Alexander cannot return from the dead bearing a revelation. Yet Hamlet's philosophizing can relieve him only temporarily of the burden of revealed truth; philosophy can neither confirm that truth nor bring it within the canons of rationality. Just as skepticism rendered theological dispute undecidable and so yielded to fideism, so Hamlet admits the irresolution of his philosophical thought on the way to declaring his "readiness" for further revelation. I do not, however, find in this recourse to the theological an expression of easy piety, since the truth revealed — in the place, as it were, of Christian doctrine — is the necessity of further violence. The revenge script is nothing other than a text of revelation. This leaves us with a curious consideration indeed. Hamlet's resignation, which is implied by his philosophical thought, is the converse of his "readiness," his faith in predestination, in the will of God. Theology overtakes the play not to announce an exilic peace, but to incite violence.

The dead hand of theology that presses upon the final acts of *Hamlet* may seem perplexing if we think of Montaignean skepticism as somehow more "modern" than Calvinist doctrine. They are in fact equally modern — equally of their time. Essex's circle sponsored the translation of Montaigne, but when Essex returned from Ireland, he opened his house in London to the more radical Puritan divines, perhaps in the belief that his cause would need the warrant of something "more than natural." The faction of Essex became the sect of Essex. It is difficult to imagine that Shakespeare was sympathetic to Essex's courting of the Puritans, but neither need Shakespeare's auditors sympathize with Hamlet's invocation of predestinarian theology. Predestination shifts the burden of devising a political response to Claudius' usurpation — a burden the play archaically calls "revenge"— onto divine providence: "There is a special providence in the fall of a sparrow" (5.2.216). Hamlet's fideism, however, does not simply displace his skeptical materialism. Underlying both stances is a certain determinism that functions as paratheology in the play. Hamlet's materialism is very like Calvin's theology in that it too would make the characters in the last two acts into puppets, bits of inert matter, pushed and pulled by other, higher powers.

If the "special providence" Hamlet invokes extends to the fall of a sparrow, to the most minute perturbations of matter, that is because a certain kind of theological determinism was in fact the complement of early modern materialism, of the mechanical philosophy. The Protestant reformers were eager to endorse the materialist philosopheme when it

supported their case against the "superstitions" of Catholicism, such as transubstantiation or belief in ghosts. Predestinarian theology prepared the way for the mechanical body in its rejection of the will. When that body was reduced to mere matter, undifferentiated primal dirt, it became God's puppet.[29] To be sure, the divinity that shapes our ends, the God who determines the fall of the sparrow, was replaced in Western science by laws of nature, by occult forces such as gravity — but not for a long time, and perhaps not ever completely. In the interim of Shakespeare's moment, an apparently insoluble political dilemma could provoke the "wiser sort" to entertain the most radically pacific of philosophical thoughts, what we now call materialism, the great philosopheme of early modernity. And yet when we look closely at this materialism, we see that it aspires at the same time to be a theology, and as such, a provocation to violence.

NOTES

1. Francis Bacon, *The Advancement of Learning*, 1605, in *Francis Bacon*, ed. Brian Vickers (Oxford: Oxford University Press, 1997), 204. Elsewhere in the *Advancement* Aristotle is compared to his pupil Alexander, "with whom it seemeth he did emulate, the one to conquer all opinions, as the other to conquer all nations" (194).

2. It is frequently observed in accounts of Bacon that he retains more of the Aristotelian system than his anti-Aristotelian rhetoric would imply. Even in the passage from which I have drawn my opening quotation, he declares his indebtedness to the work of Aristotle. On occasion his rejection of Aristotle is more categorical, as in this passage from "The Masculine Birth of Time": "Come, then, let Aristotle be summoned to the bar, that worst of sophists stupefied by his own unprofitable subtlety, the cheap dupe of words." Bacon's essay is translated in Benjamin Farrington, *The Philosophy of Francis Bacon* (Chicago: University of Chicago Press, 1967), 63.

3. This thesis, which has dominated criticism of the play for so long, has been given an up-to-date Foucauldian restatement in Francis Barker, *The Tremulous Private Body: Essays in Subjection* (London: Methuen, 1984). Barker argues for the "incipient modernity" of Hamlet, whose interiority is described as "premature" or "anachronistic." In addition to arguments for Hamlet's modernity, there now exists a considerable body of criticism exploring the question of gender in the play, in particular Hamlet's sometimes extravagant expressions of misogyny. I shall not be engaged directly with these arguments, except to register here my

sense that, as an instance of the metaphysics of hierarchy in the early modern period, gender cannot solve the *Hamlet* problem as it has been formulated over the preceding century. This has nothing to do with the explanatory power of the category, which is great, but with the fact that no psychology can give an account of Hamlet's interiority adequate to the action of the play. My argument thus falls on the side of those critics (descending from Eliot) who wish to emphasize the play over its protagonist.

4. Stephanie Jed, "The Scene of Tyranny: Violence and the Humanistic Tradition," in *The Violence of Representation: Literature and the History of Violence*, ed. Nancy Armstrong and Leonard Tennenhouse (London: Routledge, 1989), 29–44.

5. See, for example, Paul Johnson, *Intellectuals* (New York: Harper and Row, 1988). The same idealist error, one might observe, underlies much current debate about the social effects of representations of sex and violence.

6. Annabel Patterson, *Shakespeare and the Popular Voice* (Cambridge, MA: Basil Blackwell, 1989), 31. Interestingly, Paul Johnson offers a similar reading of the Essex rebellion, which he cites in introducing his critique of Brecht, *Intellectuals*, 173: "Those who want to influence men's minds have long recognized that the theatre is the most powerful medium through which to make the attempt. On 7 February 1601, the day before the Earl of Essex and his men staged their revolt in London, they paid the company to which Shakespeare belonged to put on a special, unexpurgated performance of his *Richard II*."

7. Another way to put this point is to say that the injunction to violence is a problem *for* Hamlet, and that his resistance to violence cannot for that reason be given a psychosexual etiology. The injunction to violence is a given of the revenge narrative, but the obvious implications of this fact remain difficult to see, above all because we do not know what parts of the narrative are integral to Shakespeare's conception of Hamlet's character, and what parts are reworked from the earlier ur-*Hamlet*. One need not endorse Eliot's conclusion that *Hamlet* is a failure to see that the action of the play is not so much overdetermined (psychologically) as it is underdetermined (narratively). That is, no rationale can be recovered for the narrative as it is transmitted through the medium of Shakespeare's redaction. We have no current theory of underdetermination (but deconstruction perhaps gestured toward such a theory at the level of the signifier, if not of textual transmission); yet the underdetermination of the text is precisely what enables readings of *Hamlet* to multiply without limit, as though the text were nothing more than an inkblot. Underdetermination is an effect of a deficit of information, in this case the absence of the precursor text. As a palimpsest with no discernible undertext, *Hamlet*'s meanings are as illimitable by virtue of underdetermination as they are by virtue of the contextual density or "overdetermination" that also authorizes interpretation.

8. Quotations from *Hamlet* are cited from the Arden edition, *Hamlet*, ed. Harold Jenkins (London: Methuen, 1982). The Folio reading "our philosophy" is not without interest, but does not alter in my view the sense of "philosophy" invoked by Hamlet, meaning the aggregate of high-cultural knowledge discourses.

9. Keith Thomas, *Religion and the Decline of Magic* (New York: Charles Scribner's Sons, 1971), 588–614.

10. This agenda can be found even in Bacon, who is by no means a Pyrrhonian skeptic, but who rather thinks through the challenge of skepticism. See his essay "Of Unity in Religion," where he argues that "the points fundamental and of substance" in religion should be "discerned and distinguished from points not merely of faith, but of opinion, order, or good intention." *Frances Bacon*, ed. Brian Vickers (Oxford: Oxford University Press, 1996), 345.

11. Stephen Toulmin, *Cosmopolis: The Hidden Agenda of Modernity* (Chicago: University of Chicago Press, 1990).

12. Toulmin echoes here the thesis of Richard H. Popkin in *The History of Scepticism from Erasmus to Spinoza* (Berkeley: University of California Press, 1979). Popkin examines the consequences of the convergence of the Reformation crisis with the revival of the classical texts of skepticism, chiefly those of Sextus Empiricus, who definitively influenced Montaigne. He goes on to demonstrate how skepticism, which in the sixteenth century could seem at least to limit the claims of theology, became a powerful weapon for Counter-Reformation thinkers in their polemics with the reformers. Popkin's examples are usually drawn from French thinkers. One would like to have available a fuller account of skepticism in England, which developed somewhat differently than on the Continent; but for Shakespeare the figure of overwhelming significance remains Montaigne.

Two relatively recent works addressing Shakespeare's relation to skepticism can be acknowledged here: Graham Bradshaw, *Shakespeare's Scepticism* (Ithaca: Cornell University Press, 1987), and Stanley Cavell, *Disowning Knowledge in Six Plays of Shakespeare* (Cambridge: Cambridge University Press, 1987). Of the two, my own argument is closer to Bradshaw's than to Cavell's, but neither interpreter of Shakespeare is interested in placing Shakespeare very precisely in the context of early modern philosophy. Both writers define skepticism in post-Cartesian terms, as a kind of epistemological doubt about the existence of the world and other minds, and regard Shakespeare as having produced an anticipatory theatrical exploration of this doubt. While I would accept that Shakespeare's play has a definite relation to the subsequent history of skepticism, I am most concerned not to construct these implications as primarily anticipatory in valence, as does Cavell: "My intuition is that the advent of skepticism as manifested in Descartes's *Meditations* is already in full existence in Shakespeare" (3).

With Cavell's reading of *Hamlet*, this assumption authorizes a return to a very Freudian reading of the play, in which the play provides Cavell with the opportunity to produce a psychoanalytic account of skepticism itself. The interest (and brilliance) of this account quite transcends the question of its historical plausibility, but it is within this distinctly lesser realm of plausible reading that I must locate my own effort.

13. Amos Funkenstein, *Theology and the Scientific Imagination from the Middle Ages to the Seventeenth Century* (Princeton: Princeton University Press, 1986).

14. Stephen Greenblatt, "The Mouse-trap," unpublished manuscript, comments at length on the Eucharistic controversy as a probable context for some of the puzzles about matter in *Hamlet*. I am grateful to Professor Greenblatt for allowing me to read this essay, and hope to have extended his argument by demonstrating that the question of matter could be posed, with different consequences, in both discourses of philosophy and theology.

15. See for example, Margaret Ferguson, "*Hamlet*: Letters and Spirits," in *Shakespeare and the Question of Theory*, ed. Patricia Parker and Geoffrey Hartman (New York: Routledge, 1985), 292–309.

16. Q1 makes this context explicit: "Yfaith my Lord, noueltie carries it away, / For the principall publike audience that / Came to them, are turned to priuate playes, / And to the humour of children."

17. See Virginia F. Stern, *Gabriel Harvey: His Life, Marginalia and Library* (Oxford: Clarendon Press, 1979), 127.

18. See Patricia Fumerton, *Cultural Aesthetics: Renaissance Literature and the Practice of Social Ornament* (Chicago: University of Chicago Press, 1991), on the wearing of miniatures at court, a practice that began in the 1560s. Fumerton comments on the use of the miniature to "publish" at the same time as to maintain the secrecy of a particular affiliation.

19. For a recent discussion of faction in the 1590s court of Elizabeth, see Paul E. J. Hammer, "Patronage at Court: Faction and the Earl of Essex," in *The Reign of Elizabeth I: Court and Culture in the Last Decade*, ed. John Guy (Cambridge: Cambridge University Press, 1995), 65–86. Hammer distinguishes faction from the patronage system generally, defining it not as an expression of that system but as a crisis in patronage relations: "Faction, in other words, involved a rigidity in personal relations which was inimical to the kinds of dutiful courtesies and horse-trading on which the normal pursuit of patronage depended" (68).

20. My reading of this passage entails no position on the meaning of the "late innovation," which was once confidently understood as alluding to the Essex rebellion. Whether or not some version of *Hamlet* was completed after the rebel-

lion, factional politics was most certainly the contemporary context throughout the period of the play's composition.

21. Hammer notes that factionalism in the 1590s possessed "a strong ideological dimension," and that Essex and his faction were struggling not only for the usual perquisites of patronage but "for control of the direction of the queen's policies, and for the assertion of those values which that control would represent" (86).

22. My argument here runs parallel to that of Margreta de Grazia, "Soliloquies and Wages in the Age of Emergent Consciousness," *Textual Practice* 9 (1995), 67–92. De Grazia casts doubt on some of the assumptions guiding the reading of Hamlet's soliloquies as revelations of modern interiority, pointing out that the soliloquies are largely pastiches. In my reading, this is just the point of the soliloquies. There is some corroboration for my hypothesis about the meaning of Shakespeare's invocation of philosophy in his other plays of this period, particularly *Julius Caesar* and *Troilus and Cressida*, both of which bring together political faction and philosophizing rhetoric.

23. Norbert Elias, *The Civilizing Process*, trans. Edmund Jephcott (Oxford: Blackwell, 1994), 156ff.; and *The Court Society*, trans. Edmund Jephcott (New York: Pantheon Books, 1983), 110ff. See also Lawrence Stone, *The Crisis of the Aristocracy* (London: Oxford University Press, 1967); Anthony Giddens, *The Nation-State and Violence* (Berkeley: University of California Press, 1987); John Keane, *Reflections on Violence* (London: Verso, 1996); Peter Spierenburg, *The Broken Spell: A Cultural and Anthropological History of Preindustrial Europe* (New Brunswick: Rutgers University Press, 1991), 193ff.; and for a revisionist view, Alan Macfarlane, *The Culture of Capitalism* (Oxford: Basil Blackwell, 1987), 53–76.

24. Lawrence Stone, *The Crisis of the Aristocracy*, 112, remarks that "Elizabeth was forced to turn a blind eye to much sporadic violence among her courtiers and their followers."

25. Lawrence Stone, *The Crisis of the Aristocracy*, 116.

26. Can the psychoanalytic concept of sublimation be modified to account for the mechanism by which violence was disciplined in early modernity? The place to begin might be with the later Freud, of *Civilization and Its Discontents*, which adumbrates a theory of aggressivity. This question is far too large to enter into here, but I hope at least to have indicated the need for a reconsideration of sublimation in the context of what Elias calls the "civilizing process." I am, however, doubtful that the concept of sublimation can be developed in strictly psychoanalytic terms, for the reason Elias points out, that sexuality and aggressivity are in fact not analogous "drives." If psychoanalysis has given us an elaborate "bourgeois" psychology, based on the disciplining of sexuality, the theoretical analysis of violence begun by Elias remains to be completed. See *The Civilizing Process*, 478: "It is particularly in the circles of court life that what we would

today call a psychological view of man develops, a more precise observation of oneself and others in terms of longer series of motives and causal connections, because it is here that vigilant self-control and perpetual observation of others are among the elementary prerequisites for the preservation of one's social position."

27. J. E. Neale, *Queen Elizabeth I* (Chicago: Academy Chicago Publishers, 1992), 362.

28. Ernst Kantorowicz, *The King's Two Bodies* (Princeton: Princeton University Press, 1957).

29. See Hans Blumenberg, *Legitimacy of the Modern Age*, trans. Robert M. Wallace (Cambridge, MA: MIT Press, 1983), 173ff., on the historical relation between late medieval theological absolutism, which set the will of God over against an inert and will-less universe, and the emergence of early modern materialism, which posited a natural world of mechanical forces.

ERIC WILSON

ABEL DRUGGER'S SIGN AND THE FETISHES OF MATERIAL CULTURE

The value of a certain commodity . . . is effectively an insignia of a network of social relations between producers of diverse commodities.

—*Slavoj Žižek,* The Sublime Object of Ideology

Fired by an ever-growing stockpile of texts and contexts, the cauldron of Renaissance studies has in recent years positively bubbled over with cultural *material*—with objects, things, and household stuff. While often critiquing the positivism through which such properties have been appropriated as cultural trophies then and since, materialist accounts of early modern culture seem increasingly, irresistibly drawn by the lure of the object. A series of critics have detailed some of the material conditions through which the habits and desires of Tudor and Stuart England were impressed and expressed. The Renaissance *wunderkammer*, the metaphysical prayer closet, Bankside theaters, pedagogical manuals, and aristocratic bedrooms: These are just a few of the locations that have contributed to our understanding of a profoundly material fascination in the "rehearsal of cultures," to adapt Steven Mullaney's influential phrase.[1] At the same time, the shelves of Renaissance literature

have become crowded with colorful objects formerly consigned to the dustbins of inquiry, or held in the footnotes of insignificance. Rich with the stuff of London's shops and streets, trafficked by a comical cast of citizens, plays such as *The Alchemist*—to take my central example in this essay—seem themselves wonder cabinets of a sort, treasuries to be sifted, identified, and encoded through a variety of critical spectacles.

(Enter Pot.)

Foregrounding the symptomatic move of such approaches, my stage direction here cues attention to the role that objects have been summoned to play in shaping critical narratives of the past. To get a better handle on our pot and its telling value, consider *The Key Keeper*, Ben Jonson's remarkable "masque in praise of trade," composed just months before the more celebrated *Alchemist*—a text that rivals even Henslowe's diary in its theatrical traffic in things. Buried for centuries beneath the archive's indiscriminate scrawl, *The Key Keeper* has itself been recently unearthed amidst the State Papers in the Public Record Office.[2] In the astonishing density of its dramatic materials, its pointed evocations of particular person, place, and thing, this urban pageant shapes for us a fantastic invitation to the missing: echoing forth the sounds of a day (now past), celebrating a rich edifice (now ruined), heralded alike by patron and poet (now dead). To promote the marvels of the New Exchange, a Jacobean mall for luxury goods designed by Robert Smythson, the ever-busy Robert Cecil commissioned Jonson to script an entertainment to be performed at the royal family's inaugural visit, on April 11, 1609. While several contemporary accounts were at pains to witness the "pleasant speeches, gifts, and ingenious devices" that surrounded its commemoration, the New Exchange is made most materially manifest in the catalogue of abundant commodities that structures Jonson's text.[3] *The Key Keeper* records the fantastic revelation of such cabineted curiosities, as the chatty Keeper of the Exchange, a breathless shop boy, and his proud Master jointly unmasque a host of dazzling stuff—sundials, Indian rats, billiard balls, ewers and voyders, toothpicks and globes, Chinese trinkets of all sorts. Amidst these remarkable "rarities," the Keeper pauses to deliver a particularly arresting description of a porcelain basin which "you can put noe poison in it," but it will "profoundly breake or discolour, out of a naturall disloialty to man" (Fol. 145), a mystical container—laced with "Hieroglyphicks"—that could find easy

home among the "lily-pots" of Jonson's more comically occulted shop (1.3.28).[4] Flanked by the varied crafts of strange discovery, this peculiar vessel steers us toward a shadowed past, beckoning us in silence to take our fill. As the curtain is drawn to tempt our audience, the numinous pot solicits attention, implicates our desires.

But it does not do so alone, emerging only at the crossings of language and object, the seductive crux known by any other name as theater. In other words, pots of this sort do not exist in and of themselves but are successively revealed by the hands and tongues of others. History's pots—like stage properties—come to make sense through a series of framings, duly figured through display and description. Enticing as they may seem, we must still wonder at the degree to which these historic and histrionic pots are "really there" or whether they are more subtly conjured to mind by Jonson's words (or indeed my own). Is this a pot fired by such stuff as dreams are made on, or is it composed of sterner stuff? What can this pot now tell us about the desires of its presumed audiences, at once royal, commercial, and theatrical? And what is in this pot that I will have wanted?

To such pots, and to other bearers of potted history, there will be further return. But in this essay I want not only to dwell on the commodity circus that spills across Jonson's stage, but also to take this cornucopia as a point of departure in considering how we present early modern culture to ourselves through the material objects and texts we've assembled. If Marx argues that "to discover the various uses of things is the work of history," of what use is the literary historian interested in the discovery of things? Under what conditions do the objects of historical inquiry become revalued, fetishized, and to what extent is the allure of such objects contingent upon our own cultural fantasies, disavowals, and misrecognitions?

In order to get at such questions, I want to insist that we draw upon several tool-kits—the literary, the historical-materialist, and the psychoanalytic. Such divisions of labor have generally been noted for their faultlines, strategic compatibility between them occasionally warranted, but viewed, from various sides, with varied suspicions. Yet rather than rehearsing the conflicts and contradictions between such paradigms, I want to foreground some of the ways in which these three habits of thought can be harmonized. Instead of proceeding, as *The Alchemist* does, from the fraught dialogues through which a con job masquerades as a "venture tripartite" (1.1.135), the critical alchemy I'm imagining

here stages a performance not cast in masks of wary dispute, but marked by strategic collaboration, collective innovation, even wonder. Attending thus to the problem of fetishism, not only in the crucibles of *The Alchemist*, but in our own laboratories for conjuring the historical past, a more avowedly materialist method of psychoanalytic critique — or from Joan Copjec's perspective, a form of historicism more "literate in desire, [reading] what is inarticulable in cultural statements" — may take shape, issuing in new methods, new objects of inquiry and discovery.[5]

In her recent series of Clarendon Lectures, entitled "Objects Lost and Found: Pyschoanalysis and the Scene of Reading," Mary Jacobus outlined some of the ways in which Kleinian paradigms — ranging from consumption to introjection and introversion — have been understood to characterize the basic psychic mechanisms, the unconscious dynamics of the reading process.[6] In bridging the cognitive, the material, and the textual, such frameworks prompt us not only to assess exactly what we are thinking when we think we are reading, but to query from alternative sightlines the very *objectivity* of thought. Once the question of reading becomes implicated in a system of object relations, then it becomes clear that fetishism — the process by which associations, desires, and interpersonal relations are materialized into some concrete, if displaced, form — becomes a crucial term to "think through."[7] Does the object merely mask the historical subjectivity of the student and the studied, or does it crystallize more fully forms of experience whose traces afford only partial, fractal views?

Different disciplines have, of course, developed alternative vocabularies to describe what's most at stake in their particular models of fetishization and fetishistic objects. On the analytic couch, the fetish figures both Oedipal desire and the fear of primal loss, traumatic Lack.[8] Within a Marxist economy, the fetishized commodity mystically condenses its attendant social relations, and at the same time bears witness to socioeconomic alienation.[9] From atop an anthropological totem, fetishes enact a paradoxical play of invocation and warding off, the object standing as both the medium for and the shield against the supernatural.[10] However you slice it, the fetishized object tells a certain story, represses another. Fetishism, it seems, is ever enlisted in the intimate dramas of misrecognition, of disavowal, of valuation.

As I have begun to suggest, the lure of the object lies at the heart of Jonson's play, Marx's theses on commodity fetishism, various traditions of psychoanalytic theory, and contemporary studies of material culture.

While some will surely cavil that these various schools of thought make awkward bedfellows for a seventeenth-century play, their collective concerns seem to me at least as important a point of consideration as their distinctive historical moments and discursive modes. Shakespeare may not have read Freud, but Freud's writings inevitably read their way through Shakespeare. Rather than arguing for the import of contemporary theoretical frameworks in illuminating a strangely historical text, this essay tends more toward the inverse. With its own precedent claims to what Arjun Appadurai has called "the social life of things," Jonson's play talks back to our materialist frameworks, elaborating these dialogues about the social construction of value through its cast of peculiarly dramatic terms. The object relations at the center of *The Alchemist* raise suggestive questions about the commodification of persons and things, while at the same time playing with the shades of desire, bodied forth through a range of commercial, sexual, spiritual, and intellectual configurations. The critical engagements I've proposed promise not only to complicate our understanding of those hybrid desires, but to acknowledge *The Alchemist*'s remarkable capacity to coordinate the play of the prop, the price of pleasures, and the pull of the past. This is not to propose synthesis for synthesis' sake, but rather to acknowledge felt conjunctions that, from the start, resist our disentanglements. In fitting echo of my own ceramic ruse, the opening chapter of *Ulysses* pokes fun at the absurdity of trying to keep separate things that are always already deeply interfused; when Old Mother Grogan articulates a staid desire for binary distinction—"When I makes tea I makes tea . . . and when I makes water I makes water"—her interlocutor retorts with satiric corrective: "God send you don't make them in the one pot."[11]

My own title takes for its emblem but one of the curious objects crowding the stage of Jonson's alchemical fantasia. Operating under the front of an alchemist's shop, an enterprising trio of con artists named Subtle, Face, and Dol Common conspire to cheat a series of Londoners by hustling goods and spurious services. One such gull hoping to bank on the performative labors of this "venture tripartite" is Abel Drugger, a young tobacconist seeking a competitive advantage in building his new shop. In an attempt to drum up business, Drugger solicits the expertise of the resident "master Doctor" in orienting his shopfront, and in devising a sign sure to attract customers with subtle "necromancy" (1.3.11). When Face suggests that the placard be adorned with Drugger's astrological

symbol, Libra's Balance, Subtle summarily dismisses such trite significa-
tions as "stale and common . . . a poor device" (2.6.11,14). Subtle has
something more cleverly magnetic in mind, much like the lodestone he
recommends burying beneath the shop in order to draw in spur-wearing
gallants. Advertising in such a material world requires *sensible* mea-
sures: "I will have his name / Formed in some mystic character," Subtle
declaims, "whose radii / Shall, by a virtual influence, breed affections, /
That may result upon the party owns it" (2.6.14–18). If we buy into this
logic, Abel Drugger's sign is not only desirable—as evidenced by the
gold he continues to plunk down for Subtle and Face—but capable of
producing desire, breeding affect. The radial allure of this "mystic char-
acter" must proceed, however, through a rather circuitous path, a se-
mantic detour that invites its spectators only by indirections, to find
directions in. Improvising with characteristic flair, Subtle shuttles be-
tween graphic simplicity, punning contortion, and rhetorical flourish in
blazoning this simpleton's shop:

> He first shall have a bell, that's Abel;
> And, by it, standing one, whose name is Dee,
> In a rug gown; there's D and Rug, that's Drug:
> And, right anenst him, a dog snarling *Er*;
> There's Drugger, Abel Drugger. That's his sign.
> And here's now mystery, and hieroglyphic. (2.6.19–24)

As Subtle spells out the rebus, Abel Drugger's sign figures at once as ut-
terly transparent, its patent meaning articulated in plodding letters and
syllables, and at the same time as elliptically obscure, cryptically ci-
phered. The belabored presentation of this commercial device would
seem to mystify, in the end, the presumed mechanisms of desire, whether
figured in the "virtual influence" of the sign itself or in the mystery of
what it represents, an itch to crack its code. From one vantage point, the
ruse of Abel Drugger's sign is all too obvious, ridiculous in its vacuous
signification. Yet from another critical position—be that Drugger's imag-
inative naïveté or our own interpretive curiosity in reading the fantastic
signs of the past—it stands as an emblem that promises a bigger payoff
than it evidently reveals.

At these thresholds of temptation, *The Alchemist* appears especially
accommodating to the Marxist tradition. Draped in the language of
magic, necromancy, and even alchemy itself, Marx's classic account

"The Fetishism of Commodities and the Secret Thereof" supplies an un-
canny return to Jonson's alchemical playhouse, a crucible in which the
masquerades of labor and kaleidoscopes of value are hysterically staged
for its paying audiences.[12] In introducing the concept of commodity
fetishism, Marx repeatedly notes the "mystical character of commodi-
ties," "the enigmatical character of the product of labour, so soon as it
assumes the form of commodities." He famously continues, defining a
commodity as a "mysterious thing, simply because in it the social char-
acter of men's labour appears to them as an objective character stamped
upon the product of that labour" (*Capital*, 222–24). As a "social thing[
], whose qualities are at the same time perceptible and imperceptible"
(216), Drugger's "hieroglyphic" fits Marx's account of the fetishized
commodity to a "T." Or perhaps, more enigmatically, fits it to a "Dee."
After all, the figure stamped onto the wooden sign — the "one, whose
name is Dee / In a rug gown" — is none other than John Dee, the Eliza-
bethan mathematician and court alchemist who is often taken as the
prototype of Dr. Subtle himself. With Dee as his stand-in, Subtle's ap-
parent labors are written into Abel Drugger's sign, a token ostensibly
heralding a trade "that shall yield him such a commodity / Of drugs"
(1.3.60–61), but marking for us his subjection to this performative
swindle. Itself dearly bought, the dubious value of this "thriving sign"
(2.6.7) lies in its inscription of "an insignia of a network of social rela-
tions between producers of diverse commodities," parodic witness to
Žižek's claim, as the tobacconist's profits are exchanged for little more
than the con artist's theatrical inventions.

Though his account of Jonson's objective fascinations rests more ex-
clusively in a Marxist discourse of fetishism than my own, Walter Cohen
takes similar notice of Marx's description of the "occult quality" charac-
teristic to both alchemy and the "mystery" of capital, language that
echoes Jonson's own dramatic experiments in those fields of transforma-
tive exchange. Cohen reads Jonsonian satire as mediating between neo-
classical nostalgia and a proleptic economic sensibility involving a
"reorientation toward Europe's future, toward the modern Atlantic
economy whose origin went back only to the late fifteenth century."[13] In
terms that bridge various registers of desire and suspicion, Jonson's play
might thus be said to *tease* at the social and commercial relations of
emergent capitalism, a formation in which the Renaissance English the-
ater companies were vitally, if not fully, invested.

Through the whirling exchanges of crisscrossing plots, Jonson sets a collective scene in which the play's contested commodities increasingly assume the value of their social relations. So chaotic are the successive confusions of person and thing, of the authentic object and its simulations, that the correlation between utility and exchange value goes up — literally and spectacularly — in smoke. A case in point is the promising cocktail sought by Sir Epicure Mammon, who hopes to buy through this *lapis philosophicus* dreams of sexual, financial, and culinary abundance. For Mammon, the "golden mines" imagined to lie within the alchemists' shop open the gateway to a "*novo orbe . . .* the rich Peru" (2.1.2–3), the ever-missing philosopher's stone, a "commodity" that links the rich "golden calf" (2.1.9,19) with the more "perfumed" seductions of "livery-punk" and "sublimed pure wife" (2.2.55) in this fantasy of possessive desire. Pontificating upon the luxurious expectations he holds for Subtle's concoction — an elixir he tellingly terms a "projection" — Mammon dismisses the doubts voiced by his more canny companion, Mr. Surly:

> Do you think, I fable with you? I assure you,
> He that has once the flower of the sun,
> The perfect ruby, which we call elixir,
> Not only can do that, but by its virtue,
> Can confer honour, love, respect, long life,
> Give safety, valour: yea, and victory,
> To whom he will. (2.1.46–52)

Whereas Marx would come to see the European exploitation of American colonies as a project "cleverer than the alchemists, [making] gold out of nothing," Mammon's misrecognition of such "projections" illuminates — as does Žižek's Lacanian synthesis — the blind spots that structure both commodity fetishism, and plots of desire more generally.[14]

In the following scene, however, such fantastic disavowals are ridiculously exposed, as Subtle's projections appear to all eyes (save Mammon's) as a stew of bogusly named liquids, with a pinch of insulting crap thrown in for good measure.[15] As in the rendering of Drugger's sign, the value of these transparently lettered glasses — or, rather, the perceived use-value that seduces Mammon into giving Subtle his money — is only achieved through the *performance* of Subtle's chemical labors, disingenuous

as they may be. So wholly have these fraught commodities absorbed the character of the alchemists' industry that when the offstage lab is said to explode with a "great crack and noise within," Subtle is directed to "fall down as in a swoon" (4.5.62). And as Face catalogues the disastrous loss to Mammon—"All the works / Are flown *in fumo*: every glass is burst. / Furnace, and all rent down! As if a bolt / Of thunder had been driven through the house. / Retorts, receivers, pelicans, boltheads, / All struck in shivers"—he equivocally announces the dissolution of his own facetious identity, crying, "My brain is quite undone with the fume, sir, / I ne'er must hope to be mine own man again" (4.5.50).

Face's wry lament winks at the significant structural transformations that *The Alchemist* holds up to inspection and wary laugh, a shift from traditional modes of service, fealty, and mastery to a more fluid economy of exchange in persons and things. A protocapitalist fantasy of independence—of becoming "mine own man," with the gendered and psychic contingencies that are duly implicated—steps forward here, even as its irony sounds a retreat, signals the ruse.[16] Along these lines, Žižek's important definition of the symptom—the kernel of the real that resists the logic of ideology it enables—reads as a critical gloss on the plots of Subtle and Face, who find their purchase in Master Lovewit's vacant home:

> What we have here are, as Marx points out, "relations of domination and servitude"—that is to say, precisely the relation of Lordship and Bondage in a Hegelian sense; and it is as if the retreat of the Master in capitalism was only a displacement: as if the defetishization in the "relations between men," was paid for by the emergence of fetishism in the "relations between things"—by commodity fetishism. The place of fetishism has just shifted from inter-subjective relations to relations "between things."[17]

Master Lovewit's retreat from London's plague opens the doors to new modes of exchange, as his servant stage-manages a remarkable traffic in things: tobacco, linen, religious plate, crowns, even gingerbread. Face pauses to articulate this slurring of subject and object, reminding Subtle that gullible people are ingredients as necessary for the crucibles of their cunning alchemy as the stage properties that masquerade their authority:

> Now, do you see, that something's to be done,
> Beside your beech-coal, and your corsive waters,

> Your crosslets, crucibles, and cucurbites?
> You must have stuff, brought home to you, to work on? (1.3.101–4)

As the relations between men are reduced to "stuff," mere "veins" in the crafting of "these rare works" (1.3.106, 109), a symptomatic confusion of persons and things is enacted in Jonson's alchemical theater.

While these theatrical relations offer suggestive evidence for an argument about the emergence of capitalism — so central to debates as to what constitutes or characterizes the early modern — I want to use them more specifically here as touchstones for another model of exchange: the cultural commodification of historical artifacts so central to a materialist study of Renaissance culture.[18] For if the characters in *The Alchemist* are continually mistaking their objects, overvaluing things in their absence, the social misrecognitions figured in such commodity relations may also be symptomatic of our own critical standpoint, our own attempts to trade in history.[19] In excavating and framing the textual and material traces of a rarefied past, critical practice will do well to remember that such telling signs, like the alchemical commodity, are "hieroglyphics." While interpreting the value of such figures is a necessarily belated process, it is also a productive one: "Value," Marx writes, "does not stalk about with a label describing what it is. It is value, rather, that converts every product into a social hieroglyphic. *Later on*, we try to decipher the hieroglyphic, to get behind the secret of our own social products; for to stamp an object of utility as a value is just as much a social product as language" (218, italics mine).

Values, like language, vary considerably in time and context. Malvolio's ridiculous gymnastics in twisting a scrip bearing the letters M.O.A.I. into a primer of erotic and economic assertion are perhaps a more infamous example of the fickle hieroglyphic's capacity both to reveal and to obscure. From one perspective, Abel Drugger's sign patently inscribes the identity of its hapless proprietor. Yet seen in another light, it might as readily suggest a licensed zone for bell-ringing and dog-barking. Jonson is typically eager to police — or to pretend to police — such hermeneutic play. In a preface to the 1612 first quarto of *The Alchemist*, Jonson attempts to discriminate between the privileged understander and the ignorant pretender, writing in terms wholly of a piece with the play that follows:

> To the Reader: If thou beest more, thou art an understander, and then I trust thee. If thou art one that takest up, and but a

> pretender, beware at what hands thou receivest thy commodity;
> for thou wert never more fair in the way to be cozened (than in
> this age) in poetry, especially in plays. ("To the Reader," 1–5)

Cozening, after all, is not only at the heart of Jonson's plot, but at the
bull's-eye of Drugger's sign. If we circle back to the tobacconist's shop, a
wary eye casts new light on the matter, as Abel's commission reveals it-
self to be not merely a shopfront sign, but the front of a book. For all the
anamorphic play that Subtle unleashes between a bell and Abel, a Ja-
cobean audience eager to revel in the satiric trials of civic vice would
have been keen to note one of the period's most noted characters, the
Bellman of London, his image repeatedly issued in woodcut (Fig. 6.1).

As the Bellman joins Drugger and Dr. Dee in this satiric compass, the
irony is pushed yet further, for Subtle is drawing before our very eyes
the image of a figure heralded for his capacity to expose deceit, to secure
the place from dangerous cheats and dark plots. That Abel still can't rec-
ognize the object for which he continues to pay so dearly only makes the
con more accomplished. The emergent palimpsest of the Bellman, the
cautionary guide through the Jacobean city, thus functions as the pur-
loined letter of Abel's rebus, staring him blind.

Clear as these connections may be, they are also easy to miss. For all the
texts' joint, contemporary interest in "[b]ringing to light the most notori-
ous villainies that are now practised in the Kingdome," no modern editor
seems to have glossed *The Alchemist*'s pointed nod to one of the period's
most popular texts, reprinted and serialized more than ten times between
1608 and 1616.[20] Dazzled by the proliferation of word, image, and thing,
our own peerings into the past run some of the same risks of misrecogni-
tion to which Abel Drugger is so ridiculously subject. Fit place to pause,
perhaps, and listen to one account of such elusive inscriptions:

> Was not all the knowledge
> Of the Egyptians writ in mystic symbols?
> Speak not the Scriptures, oft, in parables?
> Are not the choicest fables of the poets,
> That were the fountains, and first springs of wisdom,
> Wrapped in perplexed allegories? (2.3.202–7)

In this world of perplexing poststructuralist parable, what is a reader to
do? Armed with characteristic scoff, Thomas Nashe similarly acknowledges

The Belman of London:

BRINGING TO LIGHT
THE MOST NOTORIOUS

Villanies that are now practised in the
Kingdome.

Profitable for Gentlemen, Lawyers, Merchants, Cittizens, Farmers, Ma-
sters of Housholdes, and all sorts of seruants to mark, and delightfull for
all men to reade.

Lege, Perlege, Relege.

The third impression. with new aditions.

Printed at London for Nathaniell Butter. 1 6 o 8.

Fig. 6.1 Abel Drugger's sign, from the title page of *The Belman of London* (London, 1608).

a contemporary concern over the loss of textual stability, a groping for material faith in things: "[M]ost of them, because they cannot grossly *palpabrize* or feel God with their bodily fingers, confidently and grossly discard him."[21] Such questions would, of course, have had particular resonance in sixteenth- and seventeenth-century England, as a series of religious reforms and retrenchments posed decisive challenges to the integrity of Word and Icon. With the advent of the Reformation came new thoughts about Loss—of primal origins and ritual traditions—a repeated rethinking of the problem of representation in Christianity. Milton's own proposals for spiritual and intellectual reform are centrally concerned, for instance, with recovering the obscured forms of antique knowledge, uncannily echoing Subtle's own recollection of "the first springs of wisdom":

> The end of learning is to *repair the ruins* of our first parents by regaining to know God aright, and out of that knowledge to love him, to imitate him. . . . But because *our understanding cannot in this body found itself but on sensible things*, nor arrive so clearly to the knowledge of God and things visible as by orderly conning over the visible and inferior creature, the same method is necessarily to be followed in all discreet teaching.[22]

The religious grounds of fetishism deserve more sustained attention than I can here afford in attempting to locate the early articulation of other models of objective fantasy and knowledge conned from "sensible things." But in emphasizing that in the English Renaissance history was fundamentally religious, I don't want to sell short the indications that, at the concurrent vanguard of a new economic order, a coordinate suspicion of objective value may well have been stalking from another corner.[23] It would be another 250 years before Marx would wryly note, "So far no chemist has ever discovered any exchange-value either in a diamond or a pearl" (224), but the satiric emptiness at the core of Jonson's play suggests that such thoughts may have been rumored much abroad.

For if Jonson's alchemists teach us through counterexample to be careful with words, neither should we trust so easily in objects. In *The Alchemist* old wine is put in new pots, broken things are papered over, cosmetically framed, and, most intriguingly, withheld. At the alchemist's shop, the fetishized object par excellence is the philosopher's stone, the object that itself promises to transvalue all others. It never appears, of

course, beyond the words of its conjuring, its fantasmatic "projection." Its material essence is precisely, exclusively its presence as a means of linking the various characters and their needs, a fabled construct that sutures their quilt of fantastic value. The missing object is, in fact, the most valuable one, a precocious nod to the Lacanian principle that desire is structured through Lack, as well as an ironic inversion of the Marxian commodity, in which the fetishized object is here obscured and overwhelmed by the insistent transactions through which it will be made to have never appeared. For Jonson, the most cutting irony is that the phantom philosopher's stone is *only* what is made of it, the social relations that conjure its value, that structure its economy. The dialectic between presence and emptiness, figured in both Drugger's sign and Mammon's stone, finds another pertinent echo in Lacan's "Fable of the Pot and the Vase," in which he moves beyond the distinction between the vase's "use as a utensil and its signifying function" to suggest that "if it really is a signifier, and the first of such signifiers fashioned by the human hand, it is in its signifying essence a signifier of nothing other than signifying as such, or, in other words, of no particular signified."[24] The pot emerges as a profound emblem in repositioning a long philosophical tradition negotiating between "matter" and "nothing"; when considering the vase

> as an object made to represent the existence of the emptiness at the center of the real that is called the Thing, this emptiness as represented in the representation presents itself as a *nihil*, as nothing. And that is why the potter, just like you to whom I am speaking, creates the vase with his hand around this emptiness, creates it, just like the mythical creator, *ex nihilo*, starting with a hole. (121)

Reading Jonson's play as a critique of these basic problems of materialist encounter, we might well wonder about our own attempts to claim the missing objects of the past, the ones we will into existence, into an intelligibility or value that may be, if not laughable, then perhaps more illusory than we care to think.

Like the psychic formations that would apprehend them, all material objects — whether playbooks or tobacco pipes — are overdetermined, subject to a variety of appropriations, uses, frames, and descriptions. What I'm calling the historical fetish — like its psychoanalytic counterpart — is

best understood not as the fantastic object of singular value but as a sig-
nifier in a matrix of overlapping, at times contradictory relations. An-
chored in a history of displaced origins, the fetishized objects of
historical materialism emerge at the point where an empirical histori-
cism crosses into the alchemy of historical fantasy, coordinate with the
desires, distinctions, and delusions of our own cultural imagination. In
working to "discover the *various* uses of things" that Marx described as
the work of history, the study of material culture stands to complement
the rewards of specificity with the multiple contingencies of value.
Sometimes a cigar may just be a cigar, but sometimes it just might also
point to Abel Drugger's shop. And no sooner do we puff away in self-
assurance, than René Magritte reminds us, "This is not a pipe," that the
figurative and the material may collapse before our very eyes. Such
depth of vision may further help to survey in ever more peculiar detail,
the shifting relations between "the pastness of the things we seek to un-
derstand and the presentness of our seeking to understand them." To
continue in Gary Tomlinson's lyrical phrasings, "[A] new historical goal
emerges: not to recreate a docile past 'the way it really was' but to build
a past that resists our intellectual attempts to occupy it even while it
takes its shape from us — and moreover, takes only the shape we give it.
We build into our histories a keen responsiveness to the evidence of the
historical traces we (for our own reasons) select."[25]

POTTED HISTORIES

I share Tomlinson's instincts for a dialectical mode of history writing
that is variably responsive and admittedly creative. And I've been advo-
cating, moreover, a materialist approach to the study of facts and fic-
tions past, one that takes account of the object in history and makes
itself accountable to the histories of desire.

If I began with the desire to speak with the pot, the impulse seems,
by now, to have become axiomatic, if not clichéd. As my own survey
suggests, objects seem more and more to be claiming the ground of au-
thority so famously colonized by the anecdote in the cultural poetics of
new historicism. As Stephen Greenblatt notes in his recent retrospective
on the influence of the Geertzian tradition, the value of the anecdote as
a unit of cultural analysis lies, in part, in its capacity to reveal itself as
both "raw" and "compressed." In identifying the anthropological affilia-
tions new historicists have often cultivated in apprehending cultures of

the past, Greenblatt's article calls attention to the complex methodological interplay of words and things that such moves necessarily entail. As these interpretive horizons have expanded, the forceful attractions of "thick description" have nevertheless enabled a critical slippage between the methods and objects of analysis, as "thickness begins to slide almost imperceptibly from the description to the thing described."[26]

The rapid growth of interest in material culture from the seedplots of literary historicism would do well, nevertheless, to continue its investments in an alternative tradition of "archaeology" that grounds its study in "discursive objects."[27] Without this vital crosscurrent, things and artifacts, relatively innocent of the vagaries of the letter, would seem to promise a more honest reality-effect, the real skinny, the unmediated stuff of history: a promise that threatens to compromise cultural critique in a simplistic recourse to the concrete, the fetishization of an all-too-easy shorthand of late, "the material." If we have learned not to judge every book by its cover, the humility of things can yet prompt too gross a gaze, the apparent immediacy of the Real requiring perhaps more subtlety than has oft been afforded.

As the price for such cross-disciplinary voyeurism, literary studies has been getting it from both sides. A recent interdisciplinary conference titled "Material London" closed with a contentious debate as to the proper constitution of evidence and the fit methods for assessing those objects of inquiry. From a voice in the balcony, the well-worn claim that historicist approaches to literary study were little more than "potted history" was made more pointedly material, claiming that for all their attention to the "discourses of domesticity," literary critics stopped short of asking how much a pot cost, how it would have been glazed or used in a kitchen — in short, they knew neither its means of production and consumption, nor its standards of value.[28] Though maneuvers of the sort tend to range from valuable corrective to reductive defense, such claims nevertheless rest on a problematic assumption: that one epistemological mode or disciplinary pedigree (art history or museology in this case) should provide a more definitive portrait of the object-in-history, a less distorted lens (and it is only that) as to *wie es eigentilich gewesen ist*. On the other hand, Žižek has cautioned against breezy historicism, defending the import of psychoanalytic considerations in the face of the "commonplaces of Marxist-feminist criticism." The problem here is not that history fails to get us close to the best vista, but that history pretends to obscure the symptom, the material surplus of the Real that will out:

> In other words, if over-rapid universalization produces a quasi-universal Image whose function is to make us blind to its historical, socio-symbolic determination, over-rapid historicization makes us blind to the real kernel which returns as the same through diverse historicizations/symbolizations.[29]

Implied in either case is a felt push to approach the object as the repository of something ever more real, less wavering materials that might seem to allow us to "at least seize upon those traces that seemed to be close to actual experience" in the wake of bodily and textual absence.[30] Such attempts to "read from the thing" are further compounded (ironically enough) by advances in the history of the book and of reading; these hermeneutical questions lead us closer to the complexities of discursive change, but at the same time point toward a fundamental horizon of textuality. After all, for all the bridging of oral and literate cultures in the early modern period, we have to reckon with the basic fact that the great majority of its populace had neither the skill to comprehend the scripts we've trained ourselves to read nor the means to leave their own written traces.[31]

In the face of such discursive lack, a surrogate desire is born, sometimes from the motives of political redress, partially out of a scholarly instinct toward logical comprehension, more generally out of a desire for the dim burn of the alien and unknown. If the hand we want to have touched held not books but pots, then History's pot — so the story goes — must become our own philosopher's stone, the agent of cultural translation, a means of valued conversion. And because we can't touch this hand that held our pot, shards of History are asked to suture the value we need to ascribe to the missing subject. This, in short, is the moment of historical fetishism: the metonymy through which the scolding bridle stands in for the mouths it silenced, sheets for the bodies they bedded and shrouded. To return again to the words surrounding Jonson's own mystical pots: "I assure you he that would study but the Allegory of a China shop, might shew worthely to be the Doctor of an Academy."[32]

If deconstruction set out to address the deferred, the critical pendulum swings still on, as our own academies have sought to study the allegories of shifting meaning in a variety of cultural materials. While the sweeping force of the "linguistic turn" has helped us be more attentive to the siren songs of the signifier, recent developments in the study of material culture witness a gyroscopic tendency toward the other pole,

an attempt to access from a different angle an ever-elusive signified. To rest at such a stillpoint, I fear, would be to forget the basic Saussurian principle that meaning lies not in the signified or the signifier, but in the sign itself, the network of signification. The problem is a pressing one, not only for critics of the postmodern era but for early modern writers as well. In his Christmas sermon of 1618, Bishop Lancelot Andrewes wrestled with the signals of Christ's birth—and the signification of Christian doctrine more generally—by acknowledging a *Logos* with strikingly linguistic tenor:

> Make of the *Signe* what ye will; it skills not what it be; never so meane: In the nature of a *Signe* there is nothing, but it may be such; All is, in the thing *signified*. So it carrie us to a rich *Signatum*, and worth the finding, what makes it a matter, how meane the *Signe* be? We are sent to a *Crib*; Not to an empty *Crib*: Christ is in it. Be the *Signe* never so simple, the *Signatum* it carries us to, makes *amends*. Any *Signe* with such a *Signatum*.[33]

If Andrewes ultimately finds his payoff in the telling "signatum," my approach to Abel Drugger's sign rather seeks to focus attention on the cultural dynamics of the symbolic, on the process of valuation rather than on a presumably immanent value in and of itself. In the classic definitions of thick description, to echo once more, density pertains not to the object of analysis itself, but to its mode of narrative presentation, the prismatic intricacy through which its social engagements come to make sense.

In rehearsing the cultures that most intrigue us, we continue to assemble our own wonder cabinets stocked with the curious texts and treasures of a history that can be touched only remotely. How are the tokens of this veiled past—the signs that mark not so much a primal loss, but a cultural one—how are such words and objects fetishized by a historically minded program of cultural studies? What is the payoff in salvaging such objects, placing them more neatly in view, turning them as we must? To ask such questions is to point historiography not only toward the marketplace of goods, but toward the marketplace of ideas. In such a place we must find ourselves concerned as much with cultural capital, the way in which interpretive paradigms accrue the weight of authority and critical value, as with more quantitative registers of cost and exchange. Relevant here is Appadurai's conclusion that "knowledge

about commodities is itself increasingly commodified." Moreover, as I've argued that the traffic in things proceeds not only across space but time, our consumption of history's commodity might also pause to translate the corollary that "as distances increase, so the negotiation of the tension between knowledge and ignorance becomes itself a critical determinant of the flow of commodities."[34] When, for example, do we understand the "still unravish'd bride" of Keats' fabled urn as art, when as history? Are truth and beauty really all we need to know, or can only certain kinds of history join the pantheon of monumental constructs?[35]

The archive for such questions is not merely an issue of institutional legacies past, but one bound up in the future perfect of desire: What is it that will have been wanted? To get at such impressions, we must attend to the material traces of words, of things, of words as things, and at the same time open our lexicons to the range of methods and places through which culture has seen fit to think itself. In his rigorous polemic for the indelible influence Freudian paradigms have had over subsequent traditions of thought, Derrida argues that any archival impulse must, fundamentally, "include psychoanalysis, a scientific project which, as one could easily show, aspires to be a general science of the archive, of everything that can happen to the economy of memory and to its substrates, traces, documents, in their supposedly physical or techno-prosthetic forms (internal or external: the mystic pads of the past or of the future, what they represent and what they supplement)."[36] Even more sweepingly, history becomes the punch line for psychoanalysis, as he proclaims:

> I wish to speak of the *impression left* by Freud, by the event which carries this family name, the nearly unforgettable and incontestable, undeniable *impression* (even and above all for those who deny it) that Sigmund Freud will have made on anyone, after him, who speaks *of him* or speaks *to him*, and who must then, accepting it or not, knowing it or not, be thus marked: in his or her culture and discipline, whatever it may be, in particular philosophy, medicine, psychiatry, and more precisely here, because we are speaking of memory and of archive, the history of texts and discourses, political history, legal history, the history of ideas or of culture, the history of religion and religion itself, the history of institutions and of sciences, in particular the history of this institutional and scientific project called psychoanalysis. Not

to mention the history of history, the historiography. In any given discipline, one can no longer, one should no longer be able to, thus one no longer has the right or even the means to claim to speak of this without having been marked in advance, in one way or another, by this Freudian impression.[37]

For all their baroque insistence, such claims go a long way toward dismissing the facile critique of psychoanalysis as too self-centered, as anachronistically immaterial, a critique that underestimates the broader interventions of psychoanalytic thought as a *social* science. This kind of materialist analysis (at once psychologically and historically sensitive) has found elegant expression in the context of Renaissance literary studies, as Valeria Finucci and Regina Schwartz write: "Both the literature of psychoanalysis and Renaissance literature are testimony to how specious that distinction between inner and outer worlds is, embracing, as they do, a continuum between the psychological, social, economic, scientific, and physical realms."[38] It is to that continuum, in our own presentations of the past, that this essay turns, considering how English Renaissance culture has been both materialized and conceptualized.

Psychoanalytic theory — like etymology and archaeology, Marxism and poetics — gives us valuable tools and vocabularies through which to assess the strange play of the human in history. Because the kernel of the Real ever refuses the comprehension of a single perspective, psychoanalysis functions here less as the most transcendent of paradigms (as for Derrida) than as one of many strategic methods necessary in exploring the traces of individual and collective memory. In fielding those varying perspectives, the grounds of historical imagination thus prompt a *variety* of "reality effects," as the objects we study make evident the spectres of a material absence, the potted emptiness that fills the void between creation and critical apprehension. And so, in the recess of echo,[39] I close simply by excavating another dramatic artifact, an opening address to an object of redress, a ghostly hologram that flickers between a material, substantial figure of history, and that immanent hand that beckons us to remember: "Remember me." In so doing, I'd like to close the door on some of the more misleading deceptions shadowed beneath Abel Drugger's sign, with the words spoken to Horatio that rest in cautious hope: "Thou art a Scholler, speake to *it*."[40]

NOTES

1. *Subject and Object in Renaissance Culture* (ed. Margreta de Grazia, Maureen Quilligan, and Peter Stallybrass [Cambridge: Cambridge University Press, 1996]) provides a timely overview of recent critical interest in "tracing the object" in literary studies, and Steven Lubar's anthology *History from Things* (Washington: Smithsonian Institution Press, 1993) avails a broader historiographic approach to the study of material culture. Among other exemplary accounts of the sort are Steven Mullaney, *The Place of the Stage* (Chicago: University of Chicago Press, 1988), Douglas Bruster's *Drama and the Market in the Age of Shakespeare* (Cambridge: Cambridge University Press, 1992), Lisa Jardine, *Worldly Goods* (London: Macmillan, 1997), and Lena Cowen Orlin, "The Performance of Things in *The Taming of the Shrew*," *Yearbook of English Studies* 23 (1993), 167–88. While I am interested here more in the psychoanalytic than the rhetorical purchase that these materialist grounds open up, my own approach owes much to Karen Newman's analysis of the historical "syntax" of text and object, as in her "Sundry Letters, Worldly Goods: The Lisle Letters and Renaissance Studies," *Journal of Medieval and Early Modern Studies* 26 (1996), 139–52.

2. *Jacobean SPD* 14, vol. 44, fol. 144–48. Announcing this important discovery in the *Times Literary Supplement* (February 7, 1997, pp. 14–15), James Knowles convincingly demonstrates Jonson's authorship of this "masque in praise of trade," of which he is currently preparing an edition. My thanks to Sean Cunningham at the Public Record Office for helping me locate this manuscript. For a compelling reading of Henslowe's diary, and the broader social circulation of "theatrical properties," see Natasha Korda's "Household Property/Stage Property: Henslowe as Pawnbroker," *Theatre Journal* 48 (1996), 185–95.

3. Knowles surveys the responses of Stow (here cited), the Venetian Ambassador, and the plans designed by Thomas Wilson, Cecil's secretary. For a pertinent account of the relation between rhetoric and commodity, duly constructed in catalogic form, see Karen Newman's own address to the New Exchange in "City Talk: Femininity and Commodification in *Epicoene*," in *Fashioning Femininity and English Renaissance Drama* (Chicago: University of Chicago Press, 1991), 131–43.

4. Parenthetical citations of *The Alchemist* are from Elizabeth Cook's New Mermaids 2nd ed. (London: Norton, 1991).

5. Joan Copjec, *Read My Desire: Lacan against the Historicists* (Cambridge, MA: MIT Press, 1995), 14.

6. Delivered at Oxford University, October 1997.

7. I continue the chain of citation from William Pietz and Emily Apter's own appropriation of the phrase in the introduction to their important volume,

Fetishism as Cultural Discourse (Ithaca: Cornell University Press, 1991), 7. In emphasizing the structural conditions of misrecognition and displacement, fetish discourse seems more enabling to the modes of cultural analysis I'm describing than do most developmental theories of object relations. Critical methods invested in the interpretation of things as well as of texts might nevertheless take suggestive cues from D. W. Winnicott's propositions concerning "transitional objects," emphasizing the dialectical play between the "vitality" of the internal object, and the "behavior of the external object." In his materialist critique of Klein's "internal object," Winnicott stresses that the transitional object is not merely a "mental concept" but a "possession"; "Transitional Objects and Transitional Phenomena" (1953), reprinted in *Playing and Reality* (London: Routledge, 1989), 9. Winnicott's own attempts, moreover, to move beyond child development toward a model for "the cultural life of the individual" promise interesting grounds for rethinking the ways in which objects function *historically*: appropriated, used, neglected, and revalued through time, across various cultural pathways.

8. The classic texts here are Sigmund Freud, "The Problem of Fetishism" (1927), in *The Standard Edition of the Complete Psychological Works of Sigmund Freud*, trans. James Strachey (London: Hogarth, 1964), and its poststructuralist elaborations in Jacques Lacan, "The Phallus as Signifier," in *Ecrits*, trans. Alan Sheridan (New York: Norton, 1977). For recent use of such terms in Renaissance literary criticism, see Coppelia Kahn's concise definition of the fetish in her Introduction to *Roman Shakespeare* (New York: Routledge, 1997), 17–20, and Marjorie Garber's critique of the Freudian fetish, "Fetish Envy," in *Vested Interests: Cross-Dressing and Cultural Anxiety* (New York: Routledge, 1992), 118–27. Garber's opening citation of Robert Waller's clinical observation that "[a] fetish is a story masquerading as an object" bears obvious resonance for my attempts to bridge the discursive and material traces of cultural history.

9. Žižek differentiates these two models with unusual clarity: "In Marxism, the fetish conceals the positive network of social relations, whereas in Freud a fetish conceals the lack ('castration') around which the symbolic network is articulated" (*The Sublime Object of Ideology*, [London: Verso, 1989], 49). Other helpful discussions in a post-Marxist tradition include Thomas Keenan's "The Point Is to (Ex)Change It: Reading Capital Rhetorically," in *Fetishism,* ed. Pietz and Apter; Peter Stallybrass' materialist analysis of clothing on the Renaissance stage, "Worn Worlds," in *Subject and Object*; and the range of essays in John Brewer and Roy Porter's comprehensive anthology, *Consumption and the World of Goods* (London: Routledge, 1993).

10. See William Pietz, "The Problem of the Fetish, I," *Res* 9 (1985), 5–17, and "The Problem of the Fetish, II," *Res* 13 (1987), 23–45; Arjun Appadurai, ed.,

The Social Life of Things: Commodities in Cultural Perspective (Cambridge: Cambridge University Press, 1986), and Mary Douglas and Baron Isherwood, eds., *The World of Goods* (London: Basic Books, 1979).

11. James Joyce, *Ulysses*, ed. Hans Walter Gabler (New York: Vintage, 1986), 11. Steve Connor, in a recent paper about the practice and theory of history, recalled these resonant phrases to my attention.

12. Citations from Marx's *Capital* refer to *The Marx-Engels Reader*, ed. Robert Tucker (New York: Norton, 1972), and will be noted parenthetically in the text.

13. Walter Cohen, *Drama of a Nation: Public Theater in Renaissance England and Spain* (Ithaca: Cornell University Press, 1985), 292–300.

14. Ibid., 296, where Cohen similarly notes Marx's "ironic" inversion of Mammon's discourse of "primitive accumulation" and the play's "overlapping rivalries . . . of the new Atlantic economies."

15. Gail Kern Paster's account of the excremental obsessions played out in *The Alchemist* demonstrates another avenue through which psychoanalytic and historicist critiques might find productive synthesis, assessing the discourses of bodily shame in the early modern period (*The Body Embarrassed* [Ithaca: Cornell University Press, 1993], 143–62).

16. Slavoj Žižek's *Sublime Object* and Teresa Brennan's *History after Lacan* (New York: Routledge, 1993) effect two compelling syntheses of Lacanian and Marxist critique, both turning to the seventeenth century as the crucial rupture point from which psychological mechanisms of sujectivity and ideology begin to take on radically different forms. In the service of her interrogation of the place held by the "psychical fantasy of woman" in this "ego's era," Brennan notes that "Like Max Weber, Lacan makes the psychological conditions under which capital could gather steam predate its social dominance" (3).

17. Žižek, *Sublime Object*, 27.

18. See Margreta de Grazia's series of essays, "The Ideology of Superfluous Things: *King Lear* as Period Piece," in *Subject and Object*, and "World Pictures, Modern Periods, and the Early Stage," in *A New History of Early English Drama*, ed. John Cox and David Scott Kastan (New York: Columbia University Press, 1997); from the perspectives of economic history, see Jan de Vries and Ad van der Woude, *The First Modern Economy* (Cambridge: Cambridge University Press, 1997).

19. In characterizing the methodological strategies of new historicism by reference to techniques of museum display, Stephen Greenblatt articulates subtle distinctions between two modes of encounter with the texts and things of the past ("Resonance and Wonder"). The critical debate surrounding this influential essay — and the "peregrinations of Wolsey's hat" (161) with which it opens —

witness an abiding concern with the status of objects and texts as evidence for interpreting the past: what we can trust when we give ourselves license to imagine how to draw the fine line between finding and creating that the etymology of "invention" itself belies. "Resonance and Wonder," in *Learning to Curse* (New York: Routledge, 1990), 161−83.

20. Thomas Dekker, *The Belman of London* (London: Nathaniel Butter, 1608), T.P. Mark Bland was helpful in reminding me of this connection to Dekker's text, which plays itself out in a series of related if distinctive woodcuts used to illustrate covers, prefaces, and key points of the text in the sequel issues of *Lanthorne and Candlelight* (1608) and *O Per Se O* (1609). For more on the Bellman's echoes, and an argument seeking to complicate visual history with a sense of acoustic materialism, see my "Plagues, Fairs, and Street Cries: Sounding Out Space and Society in Early Modern London," *Modern Language Studies* 25 (1995), 1−42.

21. Thomas Nashe, *Christ's Tears over Jerusalem*, in *The Unfortunate Traveler and Other Works*, ed. J. B. Steane (New York: Penguin, 1971), 479.

22. John Milton, "Of Education," in *The Complete Poems and Major Prose*, ed. Merritt Hughes (London: Macmillan, 1957), 631 (my italics). My thanks to Linda Gregerson for pushing me, during a recent panel entitled "Formalism and Historicism," to reconsider the alternative forms of loss articulated in religious discourse during the Reformation, at once retrospective and anticipatory.

23. For more on the coordinations of religion and commerce in shaping fetishistic "fixations" in the early modern period, see Ann Rosalind Jones and Peter Stallybrass's essay in this volume.

24. *The Seminar of Jacques Lacan, Book VII: The Ethics of Psychoanalysis* (1959−60), ed. J. A. Miller, trans. Dennis Porter (New York: Norton, 1992), 119−21. Lacan's critique here attempts to forge a synthetic understanding of "the Thing," taking up the classic paradigms offered by Freud and Heidegger (whose heuristic "thing" also takes the form of a jug, in *Poetry, Language, Thought*, trans. Albert Hofstadter [New York: Harper and Row, 1971], 165−86).

25. Gary Tomlinson, "Unlearning the Aztec *Cantares*: Preliminaries to a Postcolonial History," in *Subject and Object*, 261.

26. Greenblatt, "The Touch of the Real," *Representations* 59 (1997), 14−17; see also his "Remnants of the Sacred in Early Modern England" in *Subject and Object*, 337−45, which more patently addresses the hybrid values of *res* and *verba*.

27. The implicit reference here is to the Foucauldian tradition, as expressed in *The Archaeology of Knowledge* (1972; reprint, New York: Routledge, 1989).

28. Ian Archer, Derek Keene, and Karen Newman have been helpful in revisiting this exchange from the Folger Institute's conference, "Material London," March 1995.

29. Žižek, *Sublime Object*, 50.

30. Greenblatt, "The Touch of the Real," 21.

31. Among the many useful correctives addressing this particular cultural divide, see Roger Chartier, *The Cultural Uses of Print in Early Modern France* (Princeton: Princeton University Press, 1987).

32. *The Key Keeper*, fol. 145.

33. *Sermon of the Nativity*, I.203 in *XCIV Sermons* (Oxford: Oxford University Press, 1891), editor's italics. I was first directed to Andrewes' sermon by Stephen Bann's perceptive study *Under the Sign* (Ann Arbor: University of Michigan Press, 1996), which draws in turn from T. S. Eliot's 1928 essay "For Lancelot Andrewes."

34. Appadurai, "Introduction: Commodities and the Politics of Value," in *The Social Life of Things*, 54, 41. Appadurai's shrewd methodological concern with the problems of "critical fetishism" is certainly of a piece with what I've been addressing as historical fetishism in order to emphasize not only cultural but temporal distance.

35. I'm indebted to Barbara Johnson's reading of the poem, in which she identifies an "urnomorphic" trajectory of things as an alternative to anthropomorphic figuration, acknowledging a broad tradition in which "the ego ideal of poetic voice resides in the muteness of things." In my own concerns with the study of material culture, I am similarly fascinated by Keats' implication that "Heard melodies are sweet, but those unheard / Are sweeter," here using such concerns to query the conditions of historical imagination, rather than foregrounding them in a feminist critique that asks, as Johnson does, why "female muteness is a repository of aesthetic value." "Muteness Envy," in *Human, All Too Human*, ed. Diana Fuss (New York: Routledge, 1995), 131–48.

36. Jacques Derrida, *Archive Fever: A Freudian Impression,* trans. Eric Prenowitz (Chicago: University of Chicago Press, 1995), 34.

37. Ibid., 30, concluding the "Preamble."

38. Valeria Finucci and Regina Schwartz, "Worlds Within and Without," in *Desire in the Renaissance: Psychoanalysis and Literature* (Princeton: Princeton University Press, 1995), 3.

39. Echoing Derrida here in *Archive Fever*, 39.

40. *Hamlet* 1.1.43 (italics mine), quoting from the facsimile edition of the First Folio, ed. H. Kokeritz (New Haven: Yale University Press, 1954).

For their persistent pressures in helping me to articulate more clearly the distinctions of words, things, and history, my particular thanks to Marjorie Garber, Stephen Greenblatt, Jeff Masten, Karen Newman, and Peter Stallybrass. I am grateful as well for the responses of the Research Seminar in Renaissance Material Culture at the Victoria and Albert Museum, January 1998.

GRAPHIC IMAGINATIONS

TOM CONLEY

EROTIC ISLANDS

Contours of Villon's Printed Testament (1489)

When Bartolomeo dalli Sonetti (or Bartolomeo Turco) published the first printed version of an *isolario* (a book of island maps) in Venice in 1485, he was counted among the first editors to standardize recent representations of the Aegean archipelago. His *Isolario* was a book of "fantasy islands" drawn from real space and recent history. Its images and poems pulled his readers through an ordered scatter of Grecian islands inhabited by strange and alluring shapes. With its forty-nine maps of the Aegean islands, his quarto *Isolario* was a modest undertaking by comparison with the synchronous printing of folio editions of Ptolemy's *Geographia* in Rome and Florence.[1] But the work bore implications of a consequence similar to that of the dissemination of the printed atlas of the second-century Alexandrian cartographer.

Until the publication of the *Geographia* or the *Isolario,* no two maps had been alike. In the manuscript culture that preceded the new technology, every map, each a product of an individual or a team of craftsmen, had been been endowed with a signature and style. A mystical or auratic effect of the world seen from outside of human boundaries, what we can imagine to be the impact of manuscript versions of Ptolemy, was on the route leading toward mass production of worldviews. The images appealed to perspectives on the known continents and seas from points that humans could not occupy. The views that the maps were offering

would no doubt soon become norms for deviation and correction—indeed, for scientific study. They were politically invested, but they were also of interest for historiographers and poets exploring the spatial character of writing.

Suddenly incunabular culture of cartography mobilized the fantasy that would ultimately lead to the Borgesian vision of a map, executed on a 1:1 scale, identical to the territory it covered. But long before a dream—or nightmare—of this proportion could be thought, cartographers and writers no doubt envisaged the future of a world-as-book that would be sufficient unto itself, shared by a virtually infinite number of readers, and that would possibly be a creation less of the lands and seas it represented than of its own form. With Sonetti's modest *Isolario* the reader suddenly glimpses the future of the culture of simulation.[2]

Such is a commonly accepted view of what seems to be the effect of the beginnings of cartographical standardization begun at the end of the *quattrocentro*. In order to deviate from this position (no doubt while running the risk of arriving at a result that might confirm its power of containment), I would like to argue that the disposition of text and image in Sonetti's embryonic *Isolario* can lead the interpretive eye in different directions. Its form shows that the geographical image can acquire a force of generation through its relation with language; inversely, it suggests that printed poetry of the same moment develops spatial dimensions through an implicitly cartographic form that conjugates ordered arrangements of printed writing with schematic figuration. The *Isolario* will be used as a cartographic model to establish a relation of map and poem inverse to that of woodcuts and texts in the first printed edition of François Villon's *Le Grant Testament*. Where the Italian book of maps develops a strong analogical relation between a navigational chart and a poem, the French work uses woodcut illustrations to suggest a carnal and metaphysical itinerary through a local space—mid-fifteenth-century Paris—constructed by a mix of octaves and ballads that comprise a sardonic confession and a last will.[3]

The innovation of Sonetti's book may reside in a pliable form that juxtaposes striking images of Greek islands (usually on the recto side) to a descriptive sonnet often situated on the verso page and to the left of the intervening gutter. The poetry recounts the travels of an Italian tourist who sailed about the islands and who reports the distinctive features—architecture, flora, fauna, topography, the prevailing winds—of each body of land. A reader versed in the lyrical strains of the *canzoniere* discovers

that the sonnet serves the purpose of those areas of cosmographies devoted to the depiction of the elemental character of the world and its peoples.[4] The Petrarchan tradition in which the desire for alterity— evinced in the longing for an idealized female figure held up, over, and beyond the reach of the poet opining for her presence—is transformed into a horizontal account of lands visited, seen, and sketched. The marvel of geographical singularities that mark the islands of Rhodes, Metellin, Cyprus, or Cythera turns the form that conveyed the terse expression of desire into textual units no less singular or visually arresting.

In Sonetti's work the woodcut, marked by a jagged depiction of shorelines with meanders, zigzags, and anfractuosities, recalls both the drawings of islands and the Mediterranean coast of contemporary portulan charts and the depictions in the likely model for the *Isolario*, Cristoforo Buondelmonti's *Liber insularum archipelagi*, a work that is among the most copied of all cartographical manuscripts in the fifteenth century.[5] The optical itinerary that follows the indentations and sharply rendered capes and *presqu'îles* carries over to the sonnets. The graphic detail endows each of the angular edges of the *lettre bâtarde* with the outline of a demarcation of land and sea. Every one of the poems becomes something of a miniature island or even archipelago in a text in which the space between both characters and words is identified as a paginal sea isolating the earthly material of the form of language. The letter is a telluric mass and the page the surrounding sea. Each expressive fragment can be a piece of land emerging from the copiously aqueous space that surrounds the sonnet and its island. The disposition of the maps and the texts would indeed be proof of the relation that ties the irregularity of the surface of the earth and of language to Albertus Magnus' observation that land emerges from the sea by way of providence, allowing the human creation to live and to behold from the *terra firma* of a library the very image of the moving bodies of islands in printed forms embossed on thick paper.[6] Hand-colored copies of the *Isolario*—such as the one displayed in an exposition in the Salle Mazarine of the Bibliothèque nationale de France, "Les couleurs de la terre" (Fall 1998), confirm the impression. A contrast of relief is created by which the islands in brown ocher are given a hatched effect of contour set against a surrounding shimmer of aquamarine waters.

Sonetti's work of 1485, then, is notable in addition not just because it launches the first of many printed *isolarii* to flood the shelves of European booksellers in the century to follow, from that of Benedetto Bordone to

that of Tomasso Porcacchi, but for a more immediate—and graphically obvious—reason, that it begins to equate the form of an island with that of a sonnet. Both the sonnet and the drawing of the island are figments of lines that define singularities of space and discourse; both are containers of varia or registers of virtual areas encountered, remembered, or concocted; both attest to verbal and spatial limits drawn within and outside of their ambient borders. A closed form, each of Sonetti's islands constitutes a shape describing a general pattern of possible accidents or events that "take place" as the eye imagines a journey around the jagged edges of the shore. An open form, the sonnets invite the thought of water flowing in the space between its lines and in the lagunas of its letters.[7] Since the islands often sit over or lie adjacent to compass roses that mark their cardinal position in the midst of winds they bring to the map, the superimposition of the diagram and the island contours invites a reading, affiliated with navigation, that must figuratively weigh anchor, tack, go full sail, come about, and so on. A reader of the original edition cannot fail to find a sonnet on the verso side of the page bearing the impression of an island's contours from the other side of the page, or a landscape with alphabetical contours pushing into the paper crust. An imaginary topography is suggestively defined within the borders of the woodcut images.

Sonetti's work confirms the modern reader's suspicion that a "fixed," "ruled," or "rhumbed" form of verse, such as a sonnet, a rondeau, or a ballad, can be laden with cartographical implications. To say that a collection of sonnets is conceived with cycles of reiteration or divagation, that it betrays—as will Du Bellay's lines about Ulysses and Jason far from home in his *Regrets* of 1558—a sense of homesick itinerary or disillusion that comes with voyage, that it espouses travel, the most elemental and viable of all narrative matrices, and that its will to wander is moved by convection, tempest, storm, and hazard along the edges of the lands by or through which it moves, means respecting a quasi-equivalence of sonnet and island. Sonetti inaugurates and reiterates the point in the form of his modest *Isolario*, but to the degree that the work conveys the way the map reflects a desire for containment of singularities. In the dots and stipples of the Aegean archipelago it depicts, when each page follows upon the other, there results a dissemination, a collection of varia reproducing the very condition of the book holding some of the scatter of the world in which it is purveyed. Gained is the conjunction of a landscape and a contained textual mass. We feel ourselves

in places where language and space are miscible. The distinction that separates the sonnet from the island is also, we avow, what unites them.[8]

The incunabular moment that confuses the island and sonnet in the *Isolario* can be indicative of a psychogenesis of space and language in concurrent illustrated works of poetry. Can the *Isolario* serve as a template or a comparative model for a reading that produces spatial invention? Can it be used to find in the spatial order of printed writing and image what has been called a "lacunary reserve" that unsettles discourse because of the irruption of space in the apprehension of strange visibilities inhering in language?[9] To respond to the question we can look northward, to a nascent map of verse, to François Villon's *Le Grant Testament* in its first printed form, in Pierre Levet's edition of 1489. The printed text represents a literal bastardization—if we think both of the changes in spelling and of the *lettre bâtarde* in which the text was printed—of manuscript copies in circulation since the middle years of the century. In the eyes of Jean Rychner and Albert Henry, the value of Levet's edition when compared to earlier copies of the *Testament* "is extremely weak. Countless innovations mar the text" because the editor misused an earlier copy that was soon to be put to better use among other editors, such as Germain Bineaut (Paris, 1490) and Jean Dupré (Lyon, about 1490).[10] Certain words replace others that were misunderstood or badly read; occasionally whole lines are redone "with an apparent pleasure that might have seduced modern editors" (5).

Omitted from Rychner and Henry's consideration are the woodcut images that punctuate Levet's text and that serve, because of their retinal presence in the body of language, as points of reference and of textual navigation in the world of Villon's signature. If, as we observe in Sonetti's book of islands, the text immerses the reader in a cartographical space inviting ocular travel, and if the cartography implies that the form of the sonnet becomes a visual singularity, it follows that the woodcut images in Levet's edition of Villon tend to "plot" the main lines of the poem with a strange spatial urgency. They serve as virtual wind roses or imaged bearings that bring forth the latent cartography of the poem.[11] Through the relation of the woodcuts to the text we begin to discern a psychogenesis of space plotted by the very shape of the lyric.

Le Testament constitutes the last words and the living will of a profligate who declares that he was abused and tortured by an immoral priest. He defends himself before a superior judge—ostensibly the reader—

who listens to the account of his unsown life and ways. The poem counts 2,023 lines and is carried by 186 octaves arranged in a tessellated rhyme scheme of both narrative and aspectual valence. Two sets of alternating rhymes (lines 1−3, aba, and lines 6−8, cbc), either masculine or feminine, frame a fourth and fifth couplet (bb) in the center of each octave. Inserted in the poem, like land masses in the verbal flow of the octaves, are fifteen ballads comprised of three octaves (ababbcbc) and an envoy (bcbc), three ballads of decasyllabic lines with the same rhyme scheme, four ballads in decasyllables that include envoys of four, five, or seven lines, a "double ballad" comprised of six octaves without an envoy, and three rondeaux of standard manufacture, with four octosyllabic quatrains. The fluid shape of the eight-line stanzas that prevail is defined by the "fixed" forms punctuating the whole. In 1533, in the first ostensibly critical edition of the *Testament*, Clément Marot inserted titles over some of the poems in order to identify or interpret their content. They survive as textual markers that most students of Villon now know by heart. What we recall as "La ballade des dames du temps jadis," "La belle heaulmière aux filles de joie," "Ballade des langues ennuyeuses," "Les contredictz de Franc Gontier," and other titles, more than labeling poems in the text, locate its narrative points and provide sites from which a general itinerary can be constructed.[12]

The named ballads also seem to draw on the play of woodcut and text in Levet's edition. Four series of paired images recur at decisive intervals in the confessional and implicitly autobiographical narrative. The images serve to plot out the space of the text with an economy that was probably not lost on Marot when he published the text in the "new" Roman font of humanistic signature. In each of the series on the verso page is placed a figure of a common person, dressed in a robe tied by a belt that carries a dagger strapped by his left hip, whose right hand is placed over his midsection and whose left hand is raised as if to make a sign of dismissal of everything on his sinister side. His head bends slightly to the right, and his facial expression is sober. Below the woodcut, in the same typography as the poem, is the name *Villon*.

To his left, on the opposite recto page, are two variants. The first, on the initial page of Levet's edition of poem, stands the figure of a bearded prelate, identified by his miter, who holds a crozier in his right hand and whose left clutches an erect, seemingly penile shape within the folds of the tunic. Under the image is the legend-caption "L'evesque." Like the image of Villon, the man is seen in three-quarter view and is in

an oblong frame of the same size as that of Villon to his right. The second, which recurs three times, displays a figure opposite the poet: a woman dressed in a full-length robe, a coiffe on her head, who looks downward (somewhat demurely), her arms crossed, as if she is lost in thought or meditation. In the first occurrence she is named as "la vieille" who is indeed "la belle heaulmière" regretting her past (ll. 533–60). In the second she is suddenly the woman the poet loves to despise, "faulse beaulté," the recipient of the canine ballad that ends, as Villon announces beforehand, in the growl of the errant letter *r* (ll. 942–69). Finally, the same figure recurs in the guise of "la grosse Margot" (ll. 1591–1627), the madam who runs the house of ill repute of the same name, "en ce bordeau ou tenons nostre estat," in the final pairing. A last woodcut is appended to the collection that features a frontal view of three doll-like bodies, two dressed in the linen garb in which criminals were clothed, that is placed above the famous "ballade des pendus" at the close of Levet's edition (see Fig. 7.1).

Fig. 7.1 Villon abjuring his fate at the end of *Le Grant Testament* (1489, Levet edition).

What can be made of these illustrations and the strategies that inform their relation with the poem? At once little and much. First, the woodcuts are found in other popular texts of Parisian manufacture of the same time and seem merely to punctuate the poem or to offset its arcane allusions to the legal society of the "Bazoche" with a modicum of visual variety.[13] Their reiteration and their poverty of expression make them hard to interpret. In the view of Jeanne Veyrin-Forrer, a historian of incunabular culture, the same woodcuts circulated among different printers and were carried by hand from one workshop to another as needed. The woodcuts were "ready-made" to serve a variety of contexts and editions.[14] That the three women, each of a different age and way of life, are seen as the same person would indicate that the work was published, as Rychner and Henry observe of Levet's sloppy composition of the verbal material, for quick sale and profit. The economy of popular incunabular literature produced a "Villon" that could be conflated in the same all-purpose image of a hooligan or a would-be trickster.

Histories of print shops in Paris before 1500 would buttress the argument sustaining the impoverished value of the image in Levet's Villon. Editors of popular writings employed *tailleurs d'images* (image cutters) to carve woodcuts for the production of playing cards for games and divination. In this light Levet's "L'evesque" would resemble a card comparable to a king in the modern deck, or else the bishop in a chess game, whereas the figure of Villon would be a knave, a jack of any trade, or a pawn, and the woman a queen or else a figure fit for the back of any number of types of cards. Seen thus, the images of *Le Grant Testament* figure in a broader history of popular culture, emerging predictably from the limited array of decorative forms at the behest of the first publishers of xylography, then of *littérature de colportage* that later the humanists—Erasmus, Rabelais, and Marot—would use to convey reformed ideology to a broad public that included both the higher and lower ends of literate culture.

Another reading of the images might enhance their relation to the text: Would it be wrong to note that the illustrations draw out the spatial and even cartographic latency of the *Grant Testament*? Seen from the standpoint of minimal and maximal points that define a singularity in a topological sense, by which contours or "intensities" are obtained if the text is conceived as a partial function of the images (and vice versa), the woodcuts would locate privileged sites of contradiction or paradox, drawing various lines of force into the volume of the poem.[15] They would mark and possibly map out different trajectories of seeing and

reading the text. The woodcuts would perhaps betray the affinities of the editors for given poems or else might dictate, because of their strong retinal persistence in the drift of the speech of the *Grant Testament*, where dialogue is most likely to occur. In this way each of the sets of paired woodcuts brings spatial and highly colored dialogue to the context in which it is placed.

In the initial instance the figure of Villon stands to the right of the bishop. Villon is poised to deny or reject the figure with the gesture of his left hand while, with his right hand over his genitals, he properly swears—he testifies—on his genealogical jewels the truth and evidence of his confession and last will (see Figs. 7.2 and 7.3). In the woodcut the testamentary scene begins with the hand placed over the crotch. Thus, immediately beneath the image, the first octave finds its mute speaker in the figure above. The image of the poet reasonably fits the expression that abjures the bishop in the seventh and eighth lines:

> S'evesque il est seignant les rues
> Qu'il soit le mien je le regny
> [If he's a bishop fleecing the streets
> That he's mine I must deny] (ll. 7–8)

The poem thus begins with the graphic recall of violence committed against the author. Incarcerated, sodomized, and starved, the poet cries out for justification against cruel and unusual torture. On trial is not an individual but a founding act of violence that the rest of the text will seek to correct. The initial gesture in the woodcut implies a rejection of the bishop in contiguity with the stanza below.

The same holds for the relation of the second stanza to the bishop standing above. The text is given to suggest that he holds in the folds of his vestments a rod of power:

> Mon seigeur n'est ne mon evesque
> Soubz luy ne tiens s'il n'est en friche
> Foy ne luy doy n'ommaige avecque
> Je ne suis son serf ne sa biche.
> [My lord is barely my bishop
> I can't stand under him when he goes
> Bond or homage I'll not serve up
> I'm not among his bucks or does]

Fig. 7.2

Villon to the right of
Bishop Thibaut at
the beginning of
Le Grant Testament.

Fig. 7.3

The bishop carrying
his attributes to the left
of Villon.

The voice on the left would seem to be saying no to the ludicrous pose of the cleric on the right. The point is underscored when the end of the stanza describes the physical effect of starvation and sodomy:

> Peu m'a d'une petite miche
> Et de froide eaue tout ung este
> Large ou estroit moult me fut chiche
> Tel luy soit Dieu qu'il ma este
> [He fed me with a little crumb
> And with cold water a whole summer
> Wide or narrow, it was tight in the bum
> As God for me he was a cummer]

The poem begins with the success of narrating what would be an otherwise unnameable trauma, and the image, like a visual signifier that brings an unconscious memory of violence into a world in which it can be negotiated, signals the salubrious nature of the poem as a cry, a shriek, or a

symptom of a drive to affirm the force of nature by spurning the figure representing everything that seeks to control it for its own ends.

The scene recalling abuse, channeled through the first image, stands among three variant images in which denatured or denaturing forces are decried. The first comes with the ghost of the "belle heaulmière," who appears to sing a song lamenting the loss of her seductive powers. Following the ballad of the ladies of yesteryear, the "regrets" of the old helmet maker embody decay and loss. The text seems to cue the placement of the pairing of images by which the poet now would like to deny the effect of sterility and senescence she personifies. Villon returns in the same guise as the beginning, and is set over the lines that describe how he meets the woman face-to-face, listens to her regrets, and moves away. The legend to the woodcut brings a narrative turn to the image. "Comment Villon voit a son advis la vieille en regrettant le temps de sa jeunesse" [how Villon sees in his view the old lady regretting the times of her youth] cues the lines that follow directly below:

> Advis m'est que j'oy regrecter
> La belle qui fut heaulmiere
> Soy jeune fille soubzhaicter
> Et parler en telle maniere
> Ha vieillesse felonne et fiere
> Pourquoi m'as si tost abatue?
> [It seems to me I hear bemoan
> The belle, once a helmet maker,
> Desiring of her life its fleshy tone,
> Sing in a way that won't shake her:
> "Alas, old age," boastful and with anger
> "Why now do you strike me down?"](ll. 453–58)

The figure of "la belle heaulmière" to the right is not pocked or riddled with age. She is merely the first of a series of women who return in the same, almost ageless guise in which are conveyed in different ways the signs of the decay of nature. Here they are cast in the commonplaces of *ubi sunt* and *carpe diem*.

"La belle heaulmière" is the first of three women whose figure passes through the verse. She returns a second time in the personage of "faulse beauté, the woman whom the poet loves to hate, the "orde paillarde" (l. 941), or filthy bitch, who has jilted him but who also establishes one of

several crucial instances of counterwriting or of acrostics that cut through the poem. As with the bishop and the helmet maker, Villon is impelled—again—to wave the woman out of his field of view, but all the while she is clearly, we detect from the image, a serial recurrence of the same, a figure who becomes different or is transformed into another identity, like that of Villon, by virtue of repetition. The return of the *same* seems to be that of the "double" who is repressed into other figures of nature denatured. On this occasion the pairing suggests that the ballad can be read with two voices. Villon is placed above the first stanza, which lacks the familiar title of *ballade* that would be suspended above. In its place is the name of the poet, set between the woodcut and the first stanza of the ballad, in which the first letter of each line forms an acrostic of the first name of the poet:

> Faulse beaulté qui tant me couste chier,
> Rude en effect, ypocrite douleur,
> Amour dure plus que fer a macher,
> Nommer ne te puis de ma deffaçon seur,
> Cherme felon, la mort d'un povre cueur,
> Orgueil mussé qui gens met au mourir,
> Yeulx sans pitié ne veult droit de rigueur
> Sans empirer un povre secourir?
> [False beauty so costly and so dear
> Rough, hypocritical pain I endure,
> Ardor harder than iron to chew,
> No name for you can I invent to spew!
> Charming felon with the heart of a cur
> Boasting only to kill with silence demure,
> You—pitiless eyes—you seek in rigor,
> Sending off forever the tiniest favor] (ll. 942–49)

And on the recto side of the following page is the same woman, with her calm disposition and crossed arms, who stands above the words that she seems both to speak and to behold in her field of view:

> Mieulx m'eust valu avoir esté serchier
> Ailleurs secours, ç'eust esté mon honneur
> Riens ne m'eust sceu hors de ce fait hacher
> Trocter m'en fault en fuyte et deshonneur.

Haro haro le grant et le mineur
Et qu'esse cy? Mouray sans coup ferir?
Ou pictié veult selon ceste teneur
Sans empirer un povre secourir
[My way would have been better, to seek
Aid elsewhere — it would've been honor,
Right, so little I'd have had to labor,
Trot, flee I must and a life must eke,
Here, here now, I hear the cry and shriek,
Eh, hell . . . what? I'll die here in horror!
He wants pity in words of this tenor
Sending off forever the tiniest favor] (ll. 950–57)

The dialogic aspect of the ballad, signaled in the acrostic inscription of the names of *Francoys* and *Marthe* in the first two stanzas, becomes clear when the images imply that the partners spit hate and venom at each other across the page. Villon protects his ear from the vituperation of the second stanza. "Marthe" seems to fulminate in an inner world of calm meditation. Her name is "enclouse," or set between *François* in acrostic in the first stanza and the jumbled surname *Ujjlvon*, in the third, in which there returns the words of the "la belle heaulmière" warning about the passing of life's charms. One voice is transmuted into another in the very way that the woodcut figures return to bring back or to anticipate inflections occurring elsewhere in the poem. Now Villon seems to be the mouthpiece for the speech that warns of the decay and decrepitude to which all mortals fall prey:

Ung temps viendra qui fera dessechier,
Jaunir, flectrir vostre espanye fleur
Je m'en risse se tant peusse macher
Lors mais nennil ce seroit dont folleur
Viel je seray: vous laide a douleur
Or beuvez fort tant que ru peult courir
Ne donnez pas a tous ceste douleur
Sans empirer ung povre secourir
[A time will come when you'll be shriveled,
Yellowed, your once flourished flower crumpled.
I'd laugh as much as I can stand it
When, no, it will thus be folly for some,

Old I'll be, you, ugly as kingdom come,
So tipple while you can bring 'em down,
Don't make others show pain with frown,
Sending off forever the tiniest favor.] (ll. 958–65)

The signs predicting decay indicate spatial construction of the ballad by suggesting that the noise of the text is concealed in the letters. Villon eschews Marthe by anticipating her future condition that would resemble what was seen in the personage of the "la belle heaulmière."

An accumulation of chagrin comes with the movement from one image to the next. A similar expression of resentment crowns the work with the last pairing of images that stand over "La ballade de la grosse Margot" (ll. 1591–1627). They may indeed be the clearest signpost of the latent topography of affect that composes *Le Grant Testament*. In this pairing Villon seems to be abjuring "la grosse Margot," the woman who runs the brothel of the same name. The woodcut indicates that the relation with Margot is the same as that which was developed in the ballad of "Faulse beaulté," but here with the difference that the ballad has an especially compassed latency in the relation that extends vertically in two ways, from the initial question posed in the first lines (ll. 1591–92) to the envoy that tenders an equivocal response (ll. 1624–27), and the image of the poet above the poem and his signature, below, in acrostic in the same final stanza (ll. 1621–26). But it also has a horizontal axis in the strange rhyme that ends each of the poem's lines on the letter *t*. If, in the orthography, or the architectural façade, of the text, the poem might be likened to a physical and spiritual ground plan of a gothic church, the letter *t* would be a reduced diagram, its vertical line the length of the nave and choir, the crossing member the figure of the transept.[16] Since the church had been valorized by cardinal means, the "east" or sacred end of the letter would be the top, and the "west" or profane side the bottom.[17] The voyage from the narthex or the entry at the portal of the edifice would move in the direction of the sacred, from the part of the nave or side aisle furthest from the choir to the ambulatory or chapels housing sacred relics at the east end. In this fashion the cadence of the rhyme that falls on *t* also graphs the sign of the itinerary that the eyes follow in moving from the "western" end of each line of the ballad to its "eastern" side. The narrative moves toward the cruciform shape, meets it, and reiterates the same passage with each new line.

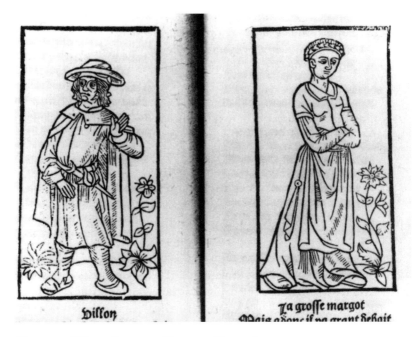

Fig. 7.4 Villon adjacent to "la grosse Margot."

It would be tempting to see in the refrain of the ballad "En ce bordeau ou tenons nostre estat" (ll. 1600, 1610, 1620, 1627) a modulated expression of the same movement in space, especially at a point in the poem where the woodcut tells the reader to behold the form of the text that is beneath the images of Villon and Margot. The word *bordeau* bears multifarious meanings. It can be a brothel (as Sargent-Baur translates it into English, ratifying the common meaning that Rychner and Henry underscore by opposition with the "stately" phrase *"tenons nostre estat"*: in this brothel "where we lead our lordly ways" [2:223]), but it can also denote a border or a boundary between land and water, as well as a plank or a sign that would hang from an iron post extended from the wall over the establishment (see Fig. 7.4).

The uncanny rhyme that ends in the unvoiced *t* might also be seen as a figure paired with the circular shape implied by the *o* of *bordeau*, *o* translating the *eau* or water in such a way that the "world" of the *bordeau* would be defined by the border of *bord* of the first syllable at the edge of the liquid mass of the second syllable.[18] Thus the word *bordeau* would be totalizing and inclusive, an all-environing world that would

be surrounded by the water of a *mare oceanum*, say, of the *oikomene* of a contemporary T/O-style *mappaemundi*.[19] It would be both a signboard hanging over a street in the topography of Paris and a cartographic figure of the world in which that very space is contained.

It would be tempting to see in the last syllable of the name *Margot* the letters of the *orbis terrarum*, the *o-t* that is the whisper of the figure of the world in the jargon (argot) of the ballad. At the moment beginning the congress of the servant and the tavern keeper, the former reports, "Gogo me dit et me fiert sur le jambot" (l. 1614) [Go, go, she says and hits me on the leglet]. For Sargent-Baur "Gogo" resists translation ("obscure . . . direct or indirect discourse"), whereas for Rychner and Henry, too, "le mot reste obscure" [the word remains obscure] despite its obvious English equivalent in the invitation, *en attendant*, to "go do it."[20] In the spatial reading based on occasional coextensions of letters and cosmographic shapes, *Gogo* would point back to the proper name and the image, Mar-*go*-t, thus using the echo to force the eye to break and to join the *o* and the *t* in the argot hidden in the orthography, that is, in the overall architecture — clearly an *art gothique* — of the poem. It would bring the eye to bear on the mapped dimension of the ballad that reproduces in a shimmer of details the tension that stretches between the pair of woodcuts at the top of Levet's presentation and the acrostic of the poet's signature at the bottom.

It would also explain another of the enigmas surrounding the text, the exclamative "brulare bigot" (l. 1585), which seems to be a senseless cry of anguish when the poet thinks about what will happen when he provides a "portraiture" of the woman who owns and controls him.[21] *Bigot* transliterates "by God," to be sure, but it also charts the spatial configuration of the poem by announcing the English *big* that modifies the letters *o-t*. As in "grosse Marg*ot*," in the name of the fat lady who personifies the brothel-as-world, there is the presence of the *orbis terrarum*, the earthly frame of human existence. The woodcuts invite the reader to look at shards of the text as detached pieces of the world and as autonomous forms that are, in themselves, like the *bordeau* of the lower reaches of the universe, *mappaemundi* within configurations of letters.

To recapitulate: The placement of the woodcuts in the 1489 edition exerts stress on a narrative of reiterated abjuration of violence done to the poet in the "last will" that is *Le Testament*. The first pair, which sets Villon to the right of the bishop, Thibaut d'Aussigny, underscores an inaugural violence that grants sufficient cause for the confession that follows.

The sequence of the complaints of "la belle heaulmière" recants the evidence of nature undone or worn by time — the topos of the *ubi sunt* that rejoins the ballad of the ladies of yesteryear — in which appeal is made for a renewal of the forces of life. The figure of "faulse beauté" underscores chagrin and frustration over a world denatured, a world of eros denied, and it anticipates the miniature world of the brothel in the last of the poems set under paired woodcuts. A cosmic space is contained in the Parisian brothel, but it is folded into the specific situation — the narrative topography — of the other poems. The woodcuts reiterate the distance the poet seeks from the four symbolic personages, but they also plot a city-space and an affective topography of beings and events in an eternal recurrence. Closer analysis would demonstrate how webbings of space and language, enhanced by the illustrations, simultaneously confer on the poem a local character and a cosmic volume. Much of that space, what critics have called "a practice of place" or a "spatial deixis," owes to a texture of images and of printed discourse that is at once endowed with figural and diagrammatic shape and with the sound, speech, and noise of an oral world.[22] The relation of poetry to geographical space is clearly delineated in a comparative document, Bartolomeo dalli Sonetti's *Isolario*. Its form allows us to perceive a latent and affective, even erotic, cartography in the verbal and visual form of the earliest printed copies of the *Grant Testament*. It is in no way as specific or as programmatic as what was seen in Sonetti's itinerary of sonnets and islands, but it brings forth a trait, a subject of more extensive study, that binds the mapping impulse of northern artists of the incunabular era to that of poets and writers.

NOTES

1. The most significant of Florentine scholars and mapmakers was Francesco Berlinghieri, who published a translation of Ptolemy's *Geographia* in 1482 that included old and new maps of the known world. Its open-ended structure and copperplate engravings, notes Jerry Brotton, "produced an image of remarkable visual clarity and geographical precision, which surpassed previous manuscript attempts to re-create the Ptolemaic *oikoumene*," in *Trading Territories: Mapping the Early Modern World* (London: Reaktion Books, 1997), 87–90. Brotton shows that when Berlinghieri dedicated his work to the Ottoman sultan Mehmed II,

"the Conqueror" and "Scourge of Christendom," the mapmaker indicated that a traffic of geographical information was circulating between Istanbul and Italy. Sonetti's work no doubt figures in a world in which the "mapping of land and strategic locations across which diplomats and armies moved like pieces on an enormous geographical chessboard" (103). In this essay the logistical dimension of Sonetti's work cannot be addressed; rather, its virtue as a scheme of poetic and graphic organization of spatial knowledge will be drawn through the early modern lyrical tradition.

2. In *L'empire des cartes* (Paris: Albin Michel, 1993), Christian Jacob shows how print culture inaugurates decisive changes into the production of the representation of space. Following the hypotheses of Elizabeth Eisenstein apropos of early modern print culture, he insists that the standardized map yields a new culture of readers. Many of them, engaged in the new science of cartography, use the printed map as a model for the production of accuracy; others, who collect knowledge, find that the atlas whets their desire to believe that they can contain and englobe simulations of world in the space of their rooms or even their memory. See chapter 1 (section on "The Atlas: A Book of Maps").

3. The method here bears resemblance to what Hélène Cixous has called a *lecture de regard*, a comparative gaze, specific to reading, that is cast upon two different composite works for the purpose of bringing forth some of the pertinent traits of their poetry. Cixous's concept is developed in her *Readings*, trans. Verena Andermatt Conley (Minneapolis: University of Minnesota Press, 1991).

4. See Numa Broc, "Fortunes de la cosmographie," in *La géographie à la Renaissance* (Paris: Bibliothèque nationale, 1982), chapter 4, and Frank Lestringant, "Fortunes de la singularité à la Renaissance: Le genre de *l'isolario*," reprinted in *Ecrire le monde à la Renaissance: Quinze études sur Rabelais, Postel, Bodin et la littérature géographique* (Caen: Editions Paradigme, 1993), 17–48. I have studied the virtual aspect of the isolario in "Virtual Reality and the *Isolario*," "L'odeporica/ Hodoeporics," ed. Luigi Monga, special issue of *Annali d'ialianistica* 14 (1996), 121–30.

5. Michel Mollat du Jourdain includes two illustrations of Buondelmonti's colored drawings of Corfu and Chios in his coauthored work (with Monique de la Roncière), *Sea Charts of the Early Explorers*, trans. by L. Le R. Dethan (London: Thames and Hudson, 1984), 13–14. "Buondelmonti had opened up a new road that would be followed until the end of the seventeenth century: his book, thanks to its sketches, marks a new stage in the history of maritime cartography" (206). Ian R. Manners, in "Constructing the Image of a City: The Representation of Constantinople in Christopher Buondelmonti's *Liber insularum archipelagi*" (*Annals of the Association of American Geographers* 87, 1 [1997], 77–102), argues that the maps played a strong role in the "reappropriation of

[Constantinople] from the Ottomans" (96), a reedition in the Christian project of regaining the Holy Land. The space of the representation is "contested" (97), and the sum of the copying of Buondelmonti's maps yields a composite image of desires and yearnings of spaces seen and invented.

6. Broc, *La géographie de la Renaissance*, 68.

7. See Paul Saenger, *Space between Words: The Origins of Silent Reading* (Stanford: Stanford University Press, 1997), in which the areas seen between letters are perceived at the end of the Middle Ages as loci of fantasy. The author notes that in France — and the point is well taken for what concerns Villon — "where pornography was forbidden, private reading encouraged the production of illustrated salacious writings intended for the laity, writing that were tolerated precisely because they could be disseminated in secret" (274). Their secrets, it might be added, are part of a latent cartography.

8. In *Perpetuum mobile* (Paris: Macula, 1997) Michel Jeanneret makes similar claims about the inchoate force of the figure of wind that blows about the landscapes and the language of Leonardo's *Notebooks*. On another register it could be said that Sonetti's *Isolario* offers a blanched view of an archipelago that had been depicted with all the confusions and the speculations concerning the Christian desire to recover the East it had lost to the Ottoman empire. In the guise of tourism it suscitates a desire to retake lands lost to infidels, but now in the mode of a touristic economy, in which the theme of "seeing and visiting" conveys the drive that had fueled earlier crusades.

9. See Michel Foucault, "Le langage de l'espace" and "La folie, absence de l'oeuvre" in *Dits et écrits 1: 1954–1969*, ed. Daniel Defert and François Ewald (Paris: Gallimard, 1994), 407–20. In these essays Foucault explores the coextension of space and language in ways that anticipate the conundrums and tourniquets of "discursive" formations and formations of "visibility" studied in *Ceci n'est pas une pipe* (Montpellier: Fata Morgana, 1973), in which he argues that the long tradition of calligraphy and the calligram has perverse consequence on Western traditions of truth and rectitude of meaning.

10. *Le Testament Villon*, critical ed. (Geneva: Droz, 1974), 1:5. For the sake of efficiency, subsequent textual reference will be made to this edition. Rychner develops his treatment of the incunabular editions in "Observations sur les textes incunables du *Testament de Villon*," in *Etudes de langue et littérature du Moyen Age offertes à Félix Lecoy* (Paris: Champion, 1973), 529–39.

11. The critical heritage of *Le Grant Testament* reveals an obsession with the time and space of the text. Pierre Champion's classic *François Villon: Sa vie et son temps*, 2 vols. (1913; reprint, Paris: Champion, 1984) is illustrated with city views and contemporary topographical images that provide a background to the poems and their history. Barbara N. Sargent-Baur introduces her meticulous

and elegant translation, *François Villon: The Complete Poems* (Toronto: University of Toronto Press, 1994), with a map of Paris and two illuminations that contextualize the work. Neither, however, studies how the urban space is created *within* and *through* the disposition of the text and its images.

12. In *The Art of Memory* (London: Routledge and Kegan Paul, 1966) Frances Yates shows how the memorization of place-names is crafted according to the imagination of volume and surface. Jack Goody, in *The Domestication of the Savage Mind* (Cambridge: Cambridge University Press, 1977), determines that lists and listings of names have a proto-cardinal character that is not far, it is implied, from the way gazetteers order points already conferred with spatial valence. In lists words "become enduring objects rather than evanescent aural signals" (76), determining that "writing is not simply added to speech as another dimension" (78). The list "relies on discontinuity rather than continuity; it depends on physical placement, on location; it can be read in different directions, both sideways and downwards, up and down, as well as left and right; it has a clear-cut beginning and a precise end, that is, a boundary, an edge, like a piece of cloth" (81).

13. Pierre Guiraud's construction of the world of the poem in *Le gai savoir de la bazoche* (Paris: Gallimard, 1972) stands, with the work of David Kuhn (see note 18 below), among the most powerful readings of Villon's poems, tied to both cosmographic and political themes.

14. Conversation with the author at the Salle de réserve of the Bibliothèque nationale. The point is confirmed in the figure of Villon, who appears in the guise of the trickster in Levet's edition of *La farce de Pierre Pathelin* and is seen in *Le calendrier des bergiers*, two works of the same time. The woodcuts, precious objects, that could serve different ends, circulated from book to book and from one context to another.

15. Bernard Cache, *Earth Moves: The Furnishing of Territories* (Cambridge, MA: MIT Press, 1996), 12−18.

16. *Orthographe* is a term that Clément Marot uses to confuse typography and architecture in the preface to his 1538 edition of his *Adolescence clémentine*. Gérard Defaux underscores the point in his gloss of the term in his edition of the *Oeuvres complètes* 2 (Paris: Garnier, 1994): 48. The meaning is not lost in Paul Robert's *Dictionnaire de la langue française* (Paris: Le Robert, 1985), when it is recalled that as late as the seventeenth century *orthographie* meant "perpendicular view, profile of a fortification" and, in an architectural sense, "a drawing that represents an edifice with its dimensions reduced, without account being taken for perspective."

17. Ernst Robert Curtius, in "The Book as Symbol," a chapter of *European Literature and the Latin Middle Ages*, studies the way that the form of the book

had approximated that of the spatial values accorded to the Christian church ([New York: Harper and Row, 1963], 304–42).

18. In his study of the currents of water and seasonal change in both "La ballade des femmes du temps jadis" and in "La ballade de la grosse Margot" David Kuhn remarks that the fluid texture of the prosody signals the hope and promise of a return of life in a world that risks being denatured at the hands of man, in *La poétique de François Villon* (Paris: Armand Colin, 1965).

19. T/O maps are schematic representations of the three continents of the known world. Each of the three continents is seen within the circle of an O, by virtue of the division afforded by a T inscribed within the field. See David Woodward, "Medieval *Mappaemundi*," in *The History of Cartography 1: Cartography in Prehistoric, Ancient, and Medieval Europe,* ed. J. B. Harley and David Woodward (Chicago: University of Chicago Press, 1987), 297 and 301–2.

20. Sargent, *Complete Poems* 223; Rychner/Henry 2:225. The latter note that earlier French readings see in "go, go" the English imperative inviting the act of love, such that Margot, a sort of "go-go girl," might also be seen *à gogo,* or "in her ease."

21. In Levet: *bourlare.* If the unvoiced *t* that marks the ballad is respected in the enunciation of this substantive, *pourtraicture* almost rhymes with *pourriture,* the condition of the lower depths that the middle stanzas of the ballad describes. In *The Spirit of Romance* (1925) Ezra Pound observed that where Dante saw the world from a site over and above it, Villon was the foremost European poet to see it from below. If there exists a bottom point in the *Testament,* it is probably located in "La ballade de la grosse Margot," a text that establishes a city-space from which the figure of the poet is as much excluded as he is from rural life, as shown by the liminal position he occupies in the "Contredictz de Franc Gontier" (1473–1506), a ballad closely tied to the world of the *bordeau* of Margot's tavern. The relation is taken up in my "Poetic Space and 'Les contreditz . . . ,'" in *Medieval Practices of Space,* ed. Barbara Hanawalt (Minneapolis: University of Minnesota Press, 1998).

22. See Karen Newman's study of human movement around and about the Pont Neuf of Paris elsewhere in this volume; it draws on Michel de Certeau's concept of "spatial stories" in *Arts de faire: L'invention du quotidien 1,* 2nd ed. (Paris: Gallimard, 1990), 170–79.

JEFFREY MASTEN

THE INTERPRETATION OF DREAMS, CIRCA 1610

I am writing, in these pages, a commonplace book. This involves copy-
ing down, into windows, on a desktop, a number of extracts. These I
compile, in no particular order—for example, this, already apparently
transcribed in memory somewhere, in earliest childhood, so as even to
make its transcription here unnecessary, the advice of a girl in an ani-
mated film who later wears slippers of glass: "A dream is a wish your
heart makes."[1]

Or an extract from the text from which this Disney commonplace
must surely have derived, something called, in that earlier text on
dreams as wish fulfillment, a "[*Footnote added* 1911:]"—itself one of
many additive moments in a text (like mine) that is agglutinative, com-
piled:

> I was astonished to learn from a pamphlet by K. Abel, *The Anti-
> thetical Meaning of Primal Words* (1884) . . . —and the fact has
> been confirmed by other philologists—that the most ancient
> languages behave exactly like dreams in this respect . . . they
> only form distinct terms for . . . two contraries by a secondary
> process of making small modifications in [a] common word.[2]

Or this: Derrida reading Freud in his recent *Archive Fever:*

> [T]he archive, as printing, writing, prosthesis, or hypomnesic technique in general is not only the place for stocking and for conserving an archivable content *of the past* which would exist in any case . . . without the archive. . . . No, the technical structure of the *archiving* archive also determines the structure of the *archivable* content even in its very coming into existence and in its relationship to the future.[3]

There are other extracts, but one more commonplace I have copied down, for its seeming relevance to a project of the commonplace, Derrida saying something he says is "a bit like" a moment in Freud:

> [I]n the end I have nothing new to say. Why detain you with these worn-out stories? Why this wasted time? Why archive this? Why these investments in paper, in ink, in characters? Why mobilize so much space and so much work, so much typographic composition? . . . Aren't these stories to be had everywhere? . . . [T]his [gesture] turns out to be itself a useless expenditure, the fiction of a sort of "rhetorical question."[4]

I am also *reading* a commonplace book, a book placed at the Newberry Library in Chicago, Case MS A 15 179. It is an uncommon book in manuscript—some of it, the part I am reading, written most likely sometime between about 1606 and 1659,[5] in a single italic hand that occasionally registers the traces of what may have been its owner's prior (or other) hand, the secretary hand, in some of its letter forms.[6]

More specifically, I am reading a set of pages called, simply enough, "Dreames," pages that record a set of dreams from (largely) classical antiquity and sometimes their sources, and, to the right of a bracket, the meaning attributed to these dreams (Figs. 8.1 and 8.2).

This archive—sixty-three dreams, all but a few of which are from classical antiquity or the lives of the early Christian popes and saints—are of the following predictive, or as Freud would say, "premonitory," form:

| Antonius Marcus that his right hande was stroken w^th a thunderboulte. plu— | } | ouerthrowne in Battell at Modena. |

. . .

Dreames. 76

Julius Cæsar that hee comitted incestwth his Mothr ⎱ Conquered y earthe
 ⎰ dominions

Astiages that his daughter Mondanes vrine ⎱
ou'flowed all Asia ⎱ Hir sonne Cyrus had
that a Vine springe out of her wombe whose ⎱ the souvraynty of y
branches ou'shadowed Asia Justin ⎰ Region /

Cyrus that Darius Histaspes sonne had two ⎱
winges grew out of his shoulders, of wch on shadowed ⎱ The like
Asia Other Europe Herodot ⎰

Alcibiades that his sweet hart covered him ⎱ she did so whe hee
wth her garment whiles hee slept Val: Max — ⎰ was slayne.

• prince of Condies dreame see popislhemer

• Jo Comnene Emp of Greece that his sonne ⎱ The only title an other
Alexius, sate vpon a Lyon houldng him by y eare ⎰ the rule of y Empire

Antigonus that hee sowed grounde wth goulde and ⎱ hee invaded and
Mithridates caried it into Pontus. App flex. ⎰ spoyled his Contry.

Philip that hee seald Olimpias belly wth a rynge ⎱ Alexander be=
wherin was graude a Lyon _ _ Curt _ ⎰ gettinge.

Seuerus that a goodly horse adorned wth the Em= ⎱
periall ensignes threw Pertinax downe and ⎱ Pertinax slayne
offred him selfe to him / Herodian — ⎰ hee succeeded.

Policrates da: that hee brings a loft in the — ⎱ Hanged. washed wth
ayre was washed by 27 and anoynted by O Herod ⎱ rayne falt drawne
 ⎰ out by the sunne.

Alexander that Clitus sate in a mourninge ⎱ Hee shewe Clitus
amongest Parmenios sonnes who were all — ⎰ next night at
deceased plutarch supper.

Antonius Marcus that his right hande was ⎱ ourethrowne in
stroken wth a thunderboulte plu — ⎰ Battell at Modena.

Calphurnia that the pinacle wch by the senate ⎱ slayne the next
decree was set vpon her husbands house — ⎱ day in y senat house
fell downe Pl. ⎰

Cynna that Cæsar being dead bad him to ⎱ Slayne by mistak=
supper and refusing drew him by force — ⎰ Cæsars frinds

— Darius that Alexanders army was ⎱ Alexander over=
stroken wth lightninge ⎰ came him. /

Olympias that her belly was stroken wth lightninge } Alexanders
in a great thunder, fro wch rose vpa great } birth and
fyre, and burninge into a flame, disperghed } fortune.
and straightwayes quenched

Cymon that a ferrer bitch barked at him and } the bitch an
sayd thou shalt bee a friende to mee and my whelpes } enemy the
 friendshy death.

An Ephorus that theyr 4 frates were taken } cromenes
away, and on set in theyr place ——— } supplanted them.

Mithridates that sayling wth full winde on the }
pontick sea, her came within sighte of Bosphorus }
and talkinge merely wth his company as full } pompey over-
of good hope, sodenly they all forsooke him, and } threw him.
her was tossed by the waures on a perce of
a ship ———

pompey at pharsalia that the people gaue him } Cæser descended
a shoute in the theater, and that hee decked } from brutes over-
Venus temples wth many spoyles and offringes } came him.

pirhus that Laced. wch hee besieged was } as places stroken wth
fyred wth a flash of lightninge wch himselfe threw } lightninge so yt vnappro
 chable.

To kill serpents victory
To see saylers of shipps Eurll
yt your teeth ar bloody ——— yr owne death
yt your teeth ar drawen out an others death
that birdes enter into an howse losse
To weepe Ioy
To hawke mony adger
To see dead horses good luck
To see fat oxen plenty
To see oxen plowe gayne
To enter into waters bad luck
That eagles fly ouer yr head bad fortune
That ye see yr face in ye water longe life
To follow Bees gayne
To bee maried death of kindred
To worshyp god glad newes
To lucke in a glasse a childe
To haue oyle powred on yu Ioye
A sheepe spottedly white very good fortune

Fig. 8.2 Case Ms A 15 179. Courtesy The Newberry Library, Chicago.

Pompey at pharsalia that the people gaue him
a shoute in the theater, and that hee decked
Venus temples wᵗʰ many spoyles and offeringes —

} Cæsar descended
from Venus ouer
came him.[7]

These dreams follow a form typical among classical dreams: They are taken to encode a premonition, to gesture toward some future event. Freud, as is well known, has little patience with the premonitory reading of dreams, and we shall return to this, but for the moment I want to notice the attractiveness of premonition to the italic hand here, who copies out, again, sixty-three such premonitory dreams. The interpretations of these, even or perhaps especially when faced with what we would see as complicatedly sexual manifest dream content, is resolutely predictive, and in large part political (Fig. 8.1):

Julius Cæsar that hee com'itted incest wth his Mother } Conquered yᵉ earthe.
Suetonius

Astiages that his daughter Mondanes vrine
ouerflowed all Asia . . .

Her sonne Cyrus had
the soueraynty of yᵉ
Region.[8]

These dreams are invariably dreams of conquest ("he invaded and spoyled his Contry" [76] or "Conquered Africk" [78]) or of political overthrow ("slaughtered . . . slayne next day . . . behedded" [77]) or of succession ("Pertinax slayne hee succeeded" [76] or "The daye followinge elected [pope]" [78v]). The flow of urine over all Asia, even Conon's dream of having "companyed wᵗʰ his dead mother . . . theron shee reuiued" [78v], does not disrupt the transcriber's resolute interpretations here: The dreams are about succession, rule, empire, space.[9] The dream of the company of the son that revives the mother — should you be curious of the outcome and not as widely read in the classical sources as our compiler of these commonplaces — predicts that he "restored his Contry Messema to liberty" (78v).[10]

I don't want to belabor this point, since I have nothing new — nothing not commonplace — to say; this is the point against which Freud writes, even to the point of writing, six days after the publication of the first edition of *The Interpretation of Dreams*, an extended manuscript, now published as an appendix to the book, arguing strenuously against the

possibility that an apparently premonitory dream is in fact predictive.[11] But I want to take the premonition of these dreams seriously, to imagine dreaming as futurity, since this obviously held great appeal for the hand that gathered these dreams as commonplaces. What does it mean to read dreams with an eye toward prediction? What does it mean, reading to write a commonplace book, to collect from history dreams of classical conquest? Why these worn-out stories? Why this wasted time? Why archive this? Why these investments in paper, in ink, in characters?

For the moment, I will only articulate these as "rhetorical questions": What would it mean to copy out dreams not as descriptions or displacements of the present psychic life of the individual, but rather as a kind of template for imagining, on the basis of sixty-three or so precedents, dreams as the history that will be? What would it mean to imagine this commonplace book and its commonplaces as structuring for its writer (and perhaps a circle of readers) a psychic life literally of another order,[12] a structure first that might imagine subjectivity, or at least dream-life, as signally occupied with conquest, succession, empire, territory? But also, what of a book that might be instrumental in reflecting and thus reproducing a psychic structure in which one thought of one's dreams (as modeled on, say, Plutarch's transcription of Marc Antony's) as premonitory, pre/script/ing?[13] Writing and reading this book, how might one conduct a life differently, or have a life conducted? Might not such a set of assumptions and investments (the investments in pen and paper and characters and reading and gathering and time that write this book) eventuate in differently structured psyches, differently stocked psychic archives? If the flow of urine will lead to sovereignty of regions, might such a reading and rewriting of dreams reflect and produce a different relation to the body, its processes, its products, their retention and flow, the overflowing child?[14]

You may object at this point that I'm reading this commonplace compiler's interest in earlier dreams as prescriptive *for him*, rather than as historical, that is, that I'm seeing his interest in this succession of classical dreams as descriptive of or instrumental for the interpretation of dreams circa 1610. I think there is, within the admittedly various material genre of the English commonplace book, good reason for this: for reading this transcription of dreams as not unlike, say, the transcription of household and medicinal remedies transcribed in commonplace books,[15] or the transcription of poems or quotations said to have some usefulness.[16] Indeed, the commonplace book in which I am reading seems, as we will see, to follow

the model of the humanist commonplace book as set out by Erasmus, who in *De Copia* influentially sets down a method for the collection of commonplaces, but toward a purpose, the purpose of composition, oratorical performance, persuasion: His system imagines the instrumentality of the commonplace.[17] Or, to cite another commonplace, we could attend to the words of a son, himself a sufferer of "bad dreams" and concerned with succession, recopying his commonplace book at his father's suggestion:

> Remember thee?
> Yea, from the Table of my Memory
> Ile wipe away all triuiall fond Records,
> All sawes of Bookes, all formes, all presures past
> That youth and observation coppied there;
> And thy Commandment all alone shall liue
> Within the Booke and Volume of my Braine. . . .
> My Tables, my Tables; meet it is I set it downe.[18]

"Hamlet's writing," Marjorie Garber notes, "is thus already a copy, a substitution, a revision."[19] But, however belated or unoriginary, Hamlet's table, his commonplace book, is nevertheless said to be *instrumental,* too: "[N]ow to my word; / It is; Adue, Adue, Remember me."[20]

Could the dreams of our copyist be of use, of instrumentality in this way — could classical remembrances be instrumental, at the level of subjectivity? Could we say that the copied commonplaces might have a use within rhetoric and oratory, and that they might simultaneously be instrumental in the production of a subjectivity quite different from the one we imagine is our own? There is no telling here, just more archiving. On three occasions in these seven pages, the archiving of classical dreams and their meanings or eventualities, is interrupted (but choosing this word already cooks the books) by another kind of list (Fig. 8.2):

To kill serpente	victory
To see sayles of shipps	euell
yt your teethe ar blooddy — —	yr owne death
yt your teethe ar drawne out	an others death
that birdes enter into an howse	losse
To weepe	ioy
To handle mony	anger
To see dead horses	good luck

. . .

To enter into waters	bad luck
That Eagles fly ouer yr head	bad fortune
That yu see yr face in ye water	longe life
To follow Bees	gayne
To bee maried	death of kindred
To worship God	gladnes
To looke in a glasse	a childe
To haue oyle powred on yu	Joye
A sheepe spetially white	very goode fortune[21]

Or — I can't resist — part of the third list:

Digginge out the eyes	death
to go slowely	a calamitous iourney
to runne	good fortune
to eate lettice	death
To eate eggs	troubled.[22]

How are these inscriptions to be read? Do they, coming as they do between and amongst the compilations of classical dreams, signify more signs drawn from antiquity, here gathered and synthesized as, literally, commonplaces?[23] Or are they an interruption in the transcription of antiquated dreams and an attempt to transcribe early modern dreams, which are, in this generalized form of the lists, either dissimilar from or continuous with the classical dreams? "[T]he technical structure of the *archiving* archive," writes Derrida, and here he is only belatedly theorizing or transcribing a commonplace that has characterized the best recent work in post–New Bibliography or the History of the Book —"also determines the structure of the *archivable* content even in its very coming into existence and in its relationship to the future." What is the relation of the technical structure — the classical dreams, the lists of "manifest dream content" and their meanings — to the archivable content?

There is, again, no guide to the interpretation of this archive, only the archiving archive. There is the mode of address of these lists, directed to a "you" that is perhaps the writer himself or his reader or circle of readers, a grammatical second person that tends to read as the present tense, circa 1610: "yt your teethe ar blooddy . . . yr owne death."

There is too, a moment where the lists slip or diverge from a translatory mode into an imperative:

to purge the feete	resoluinge of cares
To haue the~ broade	trouble.
To haue the~ cutt of	take no iourney [24]

Even before they're cut off, "the feete" are at a distance from the second person here (unlike the teeth, they are not "yours"), but they speak to the second person, they instruct him (her?) to "take no iourney." Again, though, is this an imperative archived from the classical texts, or is this the imperative of gathered early modern dreams?

There is an additional moment that may help us understand the bearing of the historical archive on the other archive that is perhaps folded into it:

Pope Leo the tenthes mother, that shee was dd [25]
deliuered in the Cathedrall Churche, of a very } his popedom.
great and gentle lyon.

The heare of yr head to bee wooll longe sicknes

Philip of Constant. that an eagle lifted } Empor after Justinia~
vpon his head ————————

To fighte wth a Thracian sworde player ——— a rich wily wife [26]

These are instances not of the breaking off of a long classical sequence with a sustained list of decodings, but an interspersing of such decoding and historical dreams. The juxtaposition of locutions is momentarily fascinating here, for what is the likelihood, on first reading, that we imagine dreams of Thracian sword players to have been commonplace in early modern England circa 1610, as commonplace as, say, the dream of a sheep specially white? [27] Is this history or is this dreamwork? Or, of course, both?

"There can be no doubt," writes Freud, "that that apparatus has only reached its present perfection after a long period of development" (*ID* 604). By *apparatus*, Freud means here "the psychical apparatus" of any given individual (*ID* 604), but I want to notice (too briefly) that this

term in Freud's context might help us to see the philology of phylogeny (as well as ontogeny)[28] in this manuscript — the way in which the apparatus for the compiler here is an accumulation in/through history, an analysis of dreams over "a long period of development," from before the common era through the early modern one.[29] This is to raise in passing the possibility of taking our term *Renaissance* more literally here, with an emphasis on the *Re-* rather than the *naissance*, in the sense that what we may be reading in this archive and its juxtapositions is the rebirth or rather the imagined redreaming of the dreams of a classical era. Is this commonplace book early modern or late classical?

I also want, however, to take Freud's comment about the long development of the psychical apparatus more literally, with regard to these pages — that is, to think more broadly about the long development of the apparatus of this *manuscript* for its copyist. For, though I have been concentrating on just a few pages of it, there are other pages, many others, and the elaborate apparatus into which these pages have been placed, or the archiving archive through which the archivable archive has been imagined and thus produced, may be of relevance here.

"Dreames," the pages I have been reading, occupy leaves 76r through 79r, which is to say that there are about 150 pages of manuscript before "Dreames," and this hand continues to write through page 87r. The hand has numbered these pages himself — and has even extended his apparatus in advance through page 109r, though he doesn't write that far, and these later pages begin to be occupied by another, or later, hand. The hand we have thus far traced — let us refer to him as "Greg Arundell,"[30] one of several signatures that appear at the end of this book, though, as we will see, the matching of hands and signatures is a complicated one — is *pre*-occupied with the numbering of pages, for he has also provided, as part of his apparatus, a topical table of contents for the first eighty-nine leaves of this book.[31] Preceding himself (preceding his and our reading), he has imagined the possibility of an archive (see Fig. 8.3):

<div align="center">

A

Artes	3
Animata	12
Arma Deorum	17
Apparell	30
Accidentes	31
Amarosa	67
Affabilety	81

</div>

Fig. 8.3 Case Ms A 15 179. Courtesy The Newberry Library, Chicago.

Each of these topics is given its own page or set of pages; if the Order of Things here seems absurd, we might nevertheless think about the long development of this apparatus, the gathering of these fragments or extracts, and the interest of Greg Arundell in a kind of order — a mania for it, we might even say, for his pages bespeak an astonishing attention to sorting. Within the topics I've mentioned are lists that seek to order, characterize, and enumerate: On the page devoted to "Verba," a list of "Tongues":

> Tongues
> Greeke Copious
> Latin exquisite
> Italian pleasant
> Spanish maiestical
> French delicate
> Dutch manly
> Hebrew significant
> English dogged[32]

Elsewhere, on the page titled "Parentes Bastards. Childre~ Marriage" (35–35v), among other lists, these: "Good fathers bad childre~," "Wome~ marryinge theyr husbandes greatest enemyes," "Spurÿ" (bastards), "Nurses" ("Paris a Beare . . . Romulus a Wolfe").

If these pages have a seeming interest in trivia ("in princes," the name of Henry is "fatal" in England; "All the popes Alexanders had Antipopes"; "Bulls cannot abide red apparell nor Elephantes white," "Female childre~ cry E. / male crye A'), the book nevertheless aspires not only to provide a kind of early modern card catalogue that will archive and (thus) organize all history and experience by topic (in this, the book follows the commonplace model of Erasmus and others), but also, I think, to provide this archive as a kind of guide that may become not just a trivial archive but also a *performative* or instrumental structure.[33] How else to read the lesson of this list, headed "women made"?:

> weme~ made
> Hercules effeminate
> Hanibal carelesse
> Anthony vnfortunate
> Tarquin miserable.[34]

The logic of pre-scription (here enacted through a misogyny that recurs throughout the book) might in other words describe the logic of the book at large, beyond this page devoted to "Feminæ." The imperative book: "Take no journey." "Remember me." "These few Precepts in thy memory / See thou Character . . ."[35]

What I also want to emphasize about this commonplace book is its almost complete investment in, inscription into, the commonplace, which I would also read here as the social or the dispersed, as opposed to or rather *oblivious of* "the personal" in the modern sense.[36] This is how I would read the page "Pantomimus," directly preceding the pages on "Dreames," in its attempt to tell its reader what to do with the head, face, hair, brows, eyes, legs, and hands, in order to convey, to allow the legibility of, certain emotional states. What are the commonplace gestures of the body? How are the body and its parts understood, and how are dreams of the body read? "That yr teethe are blooddy."

Things-in-common (the commonplace body, the commonplace dream): This is precisely the point of most interest to Greg Arundell, and the place at which Freud, interpreting dreams, throws up his hands: "I cannot disguise from myself," Freud writes (and his locution is itself interestingly individuated),

> that I am unable to produce any complex explanation of this class of *typical dreams*. My material has left me in the lurch precisely at this point. . . . If anyone feels surprised that, in spite of the frequency precisely of dreams of flying, falling, and pulling out teeth, etc., I should be complaining of lack of material on this particular topic, I must explain that I myself have not experienced any dreams of the kind since I turned my attention to the subject of dream-interpretation. (*ID* 307, emphasis added)[37]

But if, as Derrida suggests, "what is no longer archived in the same way is no longer lived in the same way,"[38] we might observe that Freud's commonplace dreams may have disappeared precisely as and because he turned his archiving attention to the subject of dream-interpretation.[39] I don't want to press this argument about Freud's text, since I think it would require one to analyze more attentively than I will here the additive structure of Freud's book, and indeed a larger archive of texts that gather and compile an archive of dreams and thoughts about the archiving of dreams, his own and others, over the course of several decades.[40]

I do, however, want to press or inscribe a related point in relation to the early modern commonplace book, to note, amongst these commonplaces, no interest in what so occupies Freud: the individuation that characterizes for him a psychic life. To attend to this, I turn to a list on leaf 31v, headed "Men could not abide":

> Men coulde not abide
> Humfrey Larder must pisse at playinge on a bagpipe.
> Sr Wilm Gorges to haue the dore fastned vpon him. . . .
> Mr Blewet, dogs to gnaw a boane.
> Tho. Gawayn biting of cloath.
> Lady Heneage smell of Roses
> Antony Mayny of kent a shouldr of mutton. . . .
> Mr Broughto~ a [brest?] of mutton. . . .
> Mis Heale see gape. gape too. . . .
> John Willms see a tap run~inge must pisse.

In the context of a book that circa 1999 seems full of irreconcilable trivia, it is instructive that these notations occur in a section of the manuscript seemingly designed to archive that which escapes the larger categorizing insistence of the book. These things are precisely *not* commonplace, and are thus to be separated out and marked as inassimilable to "the common"—in a section called "strange propertyes accidentes." The individual here—the man who pisses upon hearing the bagpipe; Mistress Heale, who will gape when gaped at—is an accident, has a strange property.

The very identity of the compiler of commonplaces here, the hand I have been referring to as connected to the name and person Greg Arundell, is bound up in these questions. For, in what we would view as a strange property or accident of this text, there is apparently no proper propriety to the manuscript. Not only does this book get used diachronically by other hands (many pages in the middle section of the book are occupied by a late seventeenth- or eighteenth-century hand, and there are, in other hands, entries dating into the first decades of the nineteenth century), but on the last page of this book (Fig. 8.4), the signature of Greg Arundell (a resident of Cornwall who received an Oxford M.A. in 1606 and lived from about 1583 until at least 1657), a signature in a hand that recalls the hand we have been reading, is by no means alone.

Fig. 8.4 Case Ms A 15 179. Courtesy The Newberry Library, Chicago.

Below this (or above it, since it is upside-down), there is the signature, or name, John Arundell, in a different ink and a larger hand (but still an italic hand that resembles the one we have called Greg), with the notation "eius Liber / Anno domi~ 1659."[41] Above this, another signature (crossed out) "Greg Arundell," in a probably later hand.[42] And turning the book again upside-down, we find that the first seventeenth-century signature we noticed—"Greg: Arundell" in the familiar hand—is supplemented (below and to the right) by "Greg: Arundell" in a different hand, a hand that seems less accomplished, as if it were practicing the signature, or the words, "Greg Arundell." To complicate the relation of signature, identity, and practice with regard to the various signings of "Greg" on this page: the Gregory Arundell who apparently began this book had a grandson named Gregory Arundell (son of his son John, who also had a son John). Are these descendants practicing signing "Greg: Arundell," or practicing being/becoming/copying "Greg: Arundell"? ("[N]ow to my word . . . Remember me"?) There are other signs, too, of practice: "the the the" written across the page in secretary hand; "and the" in secretary, with its distinctive looped *e*'s; and then a series of *e*'s written, or practiced, in the italic form (more like an ε) used by the hand in "Dreames."

How will we, then, read these marks? As signatures, the sign of propriety? Or as commonplaces, as practice? Which Greg Arundell is the signature here, and which the practice? Is the "individual" (an individual to whom I have been attributing an *interest* in the archive, a *mania* for order [Fig. 8.5]) an accident, a strange property of copying?[43]

Now, one might argue that, in connecting these material practices of writing in this particular book with a reading of early modern dreams, I am ignoring the variety of interpretive models for dreams in early modern England—models that, as Marjorie Garber has shown, appear in astonishing variety even in so restricted a cultural location as the plays of a particular playwright named Shakespeare.[44] I emphasize these details, however, because I think the modes of production (to which Garber herself is attuned in reading dreams performed in differing theatrical contexts) and the archives thus produced have much to tell us about the mode of dreaming itself. I want to notice the way in which this book and the dreams in it are generated out of a structure of *copying*, out of a practice of replication—gathering and transcribing from Plutarch, Montaigne's essays, Herodotus, and many other sources. If, as I am arguing, the transcription and interpretation of dreams here may be not simply informational but also *instrumental* (performative—a way of copying

D E R J C · Di ea re ita cenfurrunt
S Q R E Q R X J S E H L X R E
Siquid rogatus est quod rogari
non mihi sit, eius hac lege
nihil rogatus esto·

A Circle as O
Demicircle C
2 demy circles S

perpendicular single 1
side { acute angled V
duble { acute and obtuse X

Right and perpendi-
cular makinge right
angells·
 L
 T
 F
 E
 H

Lynes

Romayn
letters
ar made
either of

perpendicular and
side makinge acute
angles·
 N
 Z
 M
 K

Right and side makinge
on triangle and 2 obtuse A

Side and perpendicular
makinge on acute
angle & 2 obtuse Y

circle and Right Q

Demicircle and
perpendicular
 P
 P
 G
 B

Demicircle perpendi-
cular and side ma-
kings an acute angle R

All ar made of
of these O
 1

Christians writ frō left hande to the Right
Jews from Right to the left·
Chinois frō thē up to yᵉ bottom·
Mexicans from the Bottom to yᵉ top·

in an archive that will structure what we call "lived experience"),[45] we can notice that the structure of signing, of identifying, may itself participate in such a performative structure: Does the copyist copying the copyist Greg Arundell's signature read this book in order to emulate or copy Greg Arundell? Is the John Arundell who notes his possession of this book in a seemingly later hand ("eius Liber / Anno domi~ 1659") practicing signing and copying and gathering like his kinsman?

In asking these questions, I mean to suggest that our interpreting of dreams, circa 1610, must be read in relation to other concerns about rhetoric and philology in this period.[46] I would want to see the larger structure of copying in this manuscript (both the copying of hands and the copying of dreams translated from Rome and out of Latin) as related to questions of pedagogy and the training of (especially) boys to write and to handwrite through the emulation of classical texts and italianate (humanist) hands. To learn Latin is to translate Cicero into English and then back again (in the right hand), and to structure one's "own" rhetoric through his. As Jonathan Goldberg, upon whose book *Writing Matter* I have been relying in this discussion, remarks, translation "extends well beyond the writing exercises that filled the notebooks of grammar school children, for the proprieties that mark the hand are also behavioral paradigms for structures of decorous and refined behavior."[47] As Mary Crane has noted, instructions for keeping commonplace books sometimes specified that the book be written in the italic hand ("Roman characters"), thus linking the mode and conduct of copying with the matter copied.[48] The copying of languages and rhetorics and hands and commonplaces and maxims—thus inseparable in the pedagogy of the period, as Erasmus advises in *De Copia*—is also inseparable from the formation of the individual and "his" behaviors (even, I'd add, his dreams—whether of Thracian sword players or local, pastoral sheep).

Furthermore, if we take seriously Freud's observations on the importance of words and puns in dreams, dreams as subject to their own syntactic laws, the reliance of his own interpretations on figures of speech, linguistic resemblances among terms, and so on, it would be important to consider how a *different* linguistic field before lexical standardization, "confirmed by other philologists," might make a significant difference in the reading and writing of dreams. That is to say, if early modern English, in Juliet Fleming's words, was "ruled differently—perhaps in accordance with a rhetorical rather than grammatical, lexical, and orthographic order,"[49] or if, as Margreta de Grazia has argued, the "pun" (the conjunction or overlap of

what we now take to be discrete words in one graphic shape or sound) was not a strange property or accident in early modern English as it is for us, but rather the unstructured structure of this language, how does one read the terms of early modern dreams?[50] (To put this in the most unlearned of terms: If the Freudian slip is not the telling exception but the vernacular, the commonplace, then how and what does one read?)[51]

I mean here to point out not only the alterity of the significations assigned to dreams in the early modern period ("to eate lettice . . . death") but also to notice that the very archives in/through which these significations are stored may be at some distance from our own archives, rhetorics, ideas of the archive, and ideas of rhetoric. In a culture in which *lettuce* is spelled a dozen different ways and is remarkably close to the "different" word *lattice* (also spelled in a dozen different ways, many of which are common with *lettuce*), and in which *lettuce* has not yet moved away from its Latin root *lactus* (milk) and is often still spelled with a c *(lectuce)*, how do we read Greg Arundell's moment of lettuce intolerance?[52] Freud, also interested in vegetation, writes: "No knowledgeable person of either sex will ask for an interpretation of asparagus."[53] Perhaps — but I suddenly find myself wanting to be a person more knowledgeable about early modern dreams of lettuce, contemplating a whole new (which is to say *old*) approach to "salad days,"[54] or the report of Falstaff's dying hallucination (also the archiving of a "significant" Hebrew text): "[He] babbled of green fields."[55]

This last is of course a famous Shakespearean crux, famously emended by Theobald; the First Folio text reads, "a Table of greene fields."[56] A meal, or a book, of lettuce. "[T]o eate lettice . . . death." My tables, my tables: Meet it is I set down in *my* table-book, then, two final commonplaces; first, Freud's dream:

> I had written a monograph on a certain plant. The book lay before me and I was at the moment turning over a folded coloured plate. Bound up in each copy there was a dried specimen of the plant, as though it had been taken from a herbarium. (*ID* 202)

And, second, the dream of a patient, which Freud copies out, into his book:

> "I dreamt," she said, "of what I really did yesterday: I filled a small trunk so full of books that I had difficulty in shutting it and I dreamt just what really happened." (*ID* 221)[57]

NOTES

In writing this essay I have benefited from the discussion and suggestions of a number of expert readers in several contexts. I want to record my gratitude to Rebecca Bach, Barbara Claire Freeman, Diana Fuss, David Golumbia, Jay Grossman, William Sherman, and Lynn Wardley for generous attention to early versions of this essay; the audience at the conference "Psychoanalysis and Historicism in Early Modern Studies," in which context this essay was first imagined; Peter Stallybrass and the seminar on the History of the Book at Penn; Susan Zimmerman and the Folger Library colloquium on sexuality and subjectivity; the Renaissance Colloquium at the University of Delaware; Garrett A. Sullivan, Jr. and the English Department at Penn State University; Mark Bland, Peter Blayney, Roger Thompson, and Georgianna Ziegler for suggestions about early modern dreams and manuscripts. I am especially grateful to the Newberry Library and its staff for access to and assistance with the manuscript under discussion.

1. "A Dream Is a Wish Your Heart Makes," from *Cinderella*, animated film, Walt Disney Co., 1950.

2. Sigmund Freud, *The Interpretation of Dreams*, trans. James Strachey (New York: Avon, 1965), 353 n 3. Subsequent citations will be parenthetical and refer to this commonplace reprint of the text in the *Standard Edition*, vols. 4 and 5, hereafter cited as *ID*. Another extract: "It would scarcely repay the trouble if we were to treat the historical significance of dreams as a separate topic" (*ID* 652).

3. Jacques Derrida, *Archive Fever: A Freudian Impression*, trans. Eric Prenowitz (Chicago: University of Chicago Press, 1996), 16−17.

4. Derrida, *Archive Fever*, 9.

5. Case MS A 15 179, The Newberry Library, Chicago, hereafter cited "MS." The following evidence is relevant to a dating of the manuscript: As discussed below, the final page of the manuscript includes a signature dated 1659; on the basis of handwriting similarities, this seems to me to be the latest date attributable to the section of the manuscript with which I am concerned. According to Mark Bland, the paper in the manuscript "has a pot watermark with the initials PBO, which corresponds with Heawood 3575, dated to c. 1608" (electronic correspondence with the author); Bland also suggests that the binding of the volume seems no later than c. 1615−20. On 83r, there are two relevant entries in the manuscript, references to "George Abbott now Archb. of canterbury" and to an incident dated three years after "I proceeded Mr of Arte 1606." Abbot was Archbishop of Canterbury from April 9, 1610, through his death, August 4, 1633, although it seems likely that this reference dates to the years before his sequestration and virtual retirement, beginning in July 1627 (see *DNB* [1921], vol.

1: 5–20). Gregory Arundell (one of the signatures in the manuscript, as discussed in detail below) received an M.A. from Oxford on July 3, 1606 (*Alumni Oxoniensis*, ed. Joseph Foster [Oxford: Parker and Co., 1891], 1:33). Among other internal references that might be used to establish dates, there are references to books published in 1616 (Bland, correspondence). The evidence thus suggests not a book "composed" at a given date (it is impossible to date the manuscript on the basis of any one reference), but compiled, used, consulted, and enlarged, probably over a number of years, probably (though not certainly) beginning around 1608. The book, it should also be noted, may recopy parts of another prior or simultaneously maintained commonplace book: there is a group of pages entitled "The lesser pap [=paper] book."

6. On the ideological associations of hands and handwriting in this period, see Jonathan Goldberg's indispensable reading of early modern hands writing, *Writing Matter: From the Hands of the English Renaissance* (Stanford: Stanford University Press, 1990).

7. MS., 76–76v. In the manuscript, there is a single bracket } around the entire text of the dream represented here at left (see figures). Certain aspects of the layout of the manuscript cannot be represented easily in print; excepting these assimilations to the present context and some ellipses (which are mine), the text has not been edited.

8. MS., 76. Many of the dreams in the text are cited in other early modern contexts. This dream is mentioned in Juan Luis Vives's dream and commentary on Cicero's Dream of Scipio; see Vives, *Somnium et Vigilia in Somnium Scipionis (Commentary on the* Dream of Scipio*)*, edited with an introduction, translation, and notes by Edward V. George (Greenwood, SC: Attic Press, 1989), 29. Significantly, the context in Vives is a "debate on dreams" amongst a senate of classical figures and authorities, concerning whether dreams are in fact reliably premonitory.

9. This accords with David Halperin's discussion of classical dreams in *One Hundred Years of Homosexuality and Other Essays on Greek Love* (New York: Routledge, 1990), 37–38.

10. François Berriot makes a related point about lists of dream "keys" in printed French texts: "les clés ont une nette tendance à 'désexualiser' le corps" (24). See "Clés des songes françaises à la Renaissance," in *Le Songe à la Renaissance,* ed. Françoise Charpentier (Institut d'Études de la Renaissance et de l'Age Classique, Université de Saint-Étienne, 1987), 21–31.

11. Appendix A: "A Premonitory Dream Fulfilled," in *ID* 661–64.

12. This is perhaps the place to record as a formative influence on this essay Stephen Greenblatt's controversial article "Psychoanalysis and Renaissance Culture," in *Literary Theory/Renaissance Texts*, ed. Patricia Parker and David Quint (Baltimore: Johns Hopkins University Press, 1986), 210–24.

13. For an account of a Spanish woman dreaming premonitory dreams possibly *in order to have* an instrumental, political effect, see Richard Kagan, *Lucrecia's Dreams: Politics and Prophecy in Sixteenth-Century Spain* (Berkeley: University of California Press, 1990), in particular the conclusions of his epilogue, 159–66.

14. To think about this dream especially in the early modern context, it would be important to engage Gail Paster's work on early modern women as "leaky vessels" and her specific attention to women and urination in *The Body Embarrassed* (Ithaca: Cornell University Press, 1993), 23–63. (Or to take this even further, following Steven Mullaney's recent review of Paster's work, we might think of dreams themselves as part of a different kind of body, the permeable, "fungible" humoral body, through which fluids, humors, even dreams are constantly entering and exiting [see *Shakespeare Quarterly* 48, 2 (1997), 242–46]. In contradistinction to Freud, many early modern texts on dreaming assume that dreams come from outside the body thus construed.) On dreams and futurity, see *ID* 39n, 97, 659–60, 652.

15. Among many examples one might cite (see also references in Beal and Marotti below), I think of Houghton MS Typ 35 (Harvard University), apparently the commonplace book of "Jacques de Lyndsay," with its inscriptions in English, Latin, and French, including household remedies, recipes for making various powders, cures for fistula and ulcers, instructions for invisible ink and letters secreted in eggs, hymns, prayers, and astrological charts. I'm indebted to an unpublished essay by Aviva Briefel for bringing the full import of this astonishing manuscript to my attention.

16. Though he largely restricts "usefulness" to intellectual knowledge rather than more practical knowledges, Peter Beal calls "usefulness" "the key concept" of commonplace books; see "Notions in Garrison: The Seventeenth-Century Commonplace Book," in *New Ways of Looking at Old Texts: Papers of the Renaissance English Text Society, 1985–1991*, ed. W. Speed Hill (Binghamton, NY: Medieval and Renaissance Texts and Studies in conjunction with Renaissance English Text Society, 1993) 131–47, 134. On reading for commonplaces, see also William H. Sherman, "Reading: Modern Theory and Early Modern Practice," chapter 3 of *John Dee: The Politics of Reading and Writing in the English Renaissance* (Amherst: University of Massachusetts Press, 1995). On the compendious quality of early modern commonplace books, see Arthur F. Marotti, *Manuscript, Print, and the English Renaissance Lyric* (Ithaca: Cornell University Press, 1995), 18–22, and Sherman's introduction to and descriptions of *Renaissance Commonplace Books from the Huntington Library* (Adam Matthew Publications, 1994), 9–16. On tensions between the early modern commonplace book and modern conceptions of authorship and writing, see Max W. Thomas, "Reading and Writing the Renaissance Commonplace Book: A Question of Authorship?" in

The Construction of Authorship: Textual Appropriation in Law and Literature, eds. Martha Woodmansee and Peter Jaszi (Durham: Duke University Press, 1994), 401–15.

17. *Collected Works of Erasmus: Literary and Educational Writings 2, De Copia / De Ratione Studii,* vol. 24, ed. Craig R. Thompson (Toronto: University of Toronto Press, 1978). On the idea that early modern reading practices were "meant to serve as preparation for public performances . . . a tool, not an end" (128), see Anthony Grafton, "*Discitur ut agatur*: How Gabriel Harvey Read His Livy," in *Annotation and Its Texts,* ed. Stephen A. Barney (New York and Oxford: Oxford University Press, 1991), 108–29.

18. *The Tragedie of Hamlet, Prince of Denmarke,* in *Mr. William Shakespeares Comedies, Histories & Tragedies* (London: Isaac Iaggard and Ed. Blount, 1623), as reproduced in *The Norton Facsimile: The First Folio,* prepared by Charlton Hinman (New York: Norton, 1968), TLN 782–88.

19. Marjorie Garber, *Shakespeare's Ghost Writers: Literature as Uncanny Causality* (London: Methuen, 1987), 153. In general, my reading of *Hamlet* here is indebted to Garber's treatment of this passage, as well as to Margreta de Grazia's account of Hamlet's textual psyche in "Soliloquies and Wages in the Age of Emergent Consciousness," *Textual Practice* 9, 1 (1995), 67–92. On the relation between memory and writing materials, see, for example, *Wilson's Arte of Rhetorique 1560,* ed. G. H. Mair (Oxford: Clarendon, 1909), 214:

{
 i The places of Memorie are resembled vnto Waxe and Paper.
 ii Images are compted like vnto Letters or a Seale.
 iii The placing of these Images, is like vnto wordes written.
 iiii The vtterance and vsing of them, is like vnto reading.

20. *The Tragedie of Hamlet,* TLN 795–96.

21. MS., 76v. The suggestion, perhaps surprising to modern eyes, that marriage would be linked with death is supported by an early modern translation of Artimedorus: "TO dreame to be deade, is wedding to him which is to marry, for death and marriage represent one another. And therefore, for the sicke to dreame they are maried, or they celebrate their weddi[n]gs is a signe of death." *The Ivdgement, Or exposition of Dreames, Written by Artimodorus, an Auntient and famous Author, first in Greeke, then Translated into Latin, After into French, and now into English* (London: for William Iones, 1606), 96.

22. MS., 78v.

23. For an important discussion of the commonplace (as well as its constituent elements, *common* and *place*), see Mary Thomas Crane's *Framing Authority: Sayings, Self, and Society in Sixteenth-Century England* (Princeton: Princeton University Press, 1993), especially 3–10. Crane is interested primarily in "sayings"/senteniae largely not present in the Newberry manuscript, and her

discussion centers on the influential theory of gathering commonplaces (rather than commonplace books in manuscript); nevertheless, her study is an important context for thinking about the manuscript.

24. MS., 78v.

25. The abbreviation *dd* is used elsewhere in these pages, apparently to mean "delivered"; here, then, there's a redundancy.

26. MS., 78.

27. "Nine out of ten people in Elizabethan England were rural dwellers, and sheep outnumbered people, perhaps by as many as three to one"; Louis Adrian Montrose, "Of Gentlemen and Shepherds: The Politics of Elizabethan Pastoral Form," *ELH* 50, 3 (1983), 415–60, 421.

28. This is to say, a writing practice that structures the development of the kind/genus in/through history; and, at the same time, perhaps, the development of the person that recapitulates the development (history) of the "species." I have in mind here a process akin to Pierre Bourdieu's conception of the *habitus*, defined as "a product of history [that] produces individual and collective practices—more history—in accordance with the schemes generated by history. It ensures the active presence of past experiences." *The Logic of Practice*, trans. Richard Nice (Stanford: Stanford University Press, 1990), 54.

29. Needless to say, these are (post)modern designations of period. By appropriating the term *development*, I do not mean to imply a model of progress or teleology.

30. As described below, the name is given both as an apparent abbreviation ("Greg:" for "Gregory") and as a name ("Greg").

31. On the prevalence of this method, see Beal, "Notions in Garrison."

32. MS., 6. This list seems to derive in part from Richard Carew, "The Excellencie of the English Tongue, by R.C. of Anthony Esquire to W.C.," in William Camden, *Remaines of a Greater Worke concerning Britaine* (1614); reprinted in Richard Carew of Antony, *The Survey of Cornwall &c.*, ed. F. E. Halliday (London: Andrew Melrose, 1953), 303–8. "The Italian is pleasant . . . The French, delicate The Spanish majestical The Dutch manlike" (307). Notably, the manuscript both adheres closely to Carew (who hailed from a parish close to that of the manuscript's probable initial copyists; see note 41 below) and diverges from it remarkably in its valuation of English (dogged, or excellent?).

33. MS., 53–53v, 30, 35v.

34. MS., 7.

35. Polonius to Laertes, *The Tragedie of Hamlet*, TLN 523–24. This citation may in turn suggest the proximity of the commonplace book to the genre of fatherly advice in manuscript and print; on this, see *Hamlet*, the Arden Shakespeare, ed. Harold Jenkins (London: Methuen, 1982), "Longer Notes" (1.3.58–80), 440–42,

which cites numerous classical and sixteenth-century examples. Jenkins is at the same time eager to guard against the implication that *Hamlet* is a commonplace book and Shakespeare a copyist; though several of Polonius's precepts were "recurrent" and "proverbial," he maintains that "Shakespeare characteristically phrases them afresh" (441). On transmission between father and son, see note 41 below.

36. Beal's analysis stresses the personal aspects of commonplace books, but note how the second sentence in this passage sits only uneasily with the first: "[E]very commonplace book is a *unique* document, a *unique* witness to the tastes, values, and thinking of a *specific* person or group. Compilers of commonplace books and miscellanies could sometimes *copy* portions—even large sections— from *other* people's *compilations*" (133, emphasis added). If we were to imagine commonplace books as the precursors of modern journals (or diaries, in the American sense of that term), we would nevertheless want to notice (1) that there are significant shifts along the axes of public/private, copied/original, and "individual"/social in this transition, and (2) that this shift is not completed (if ever) until very recently. As Jay Grossman's work shows, Emerson was continuing to keep something we now call a "journal" that nevertheless looks very much like a commonplace book (and is in part written/copied into his father's material books) well into the nineteenth century ("Emerson Composing," paper delivered at the "Cultures of Writing" conference, Case Western Reserve University, February 1997). Lois Potter has persuasively suggested to me Burton's *Anatomy of Melancholy* as a text treating subjectivity that might be productively seen as intermediate between the commonplace book and the first-person analytical account. I'm grateful to graduate students in English 229x, Harvard University, spring 1997, for asking me to think about the relation of commonplace books to diaries.

37. In light of a number of entries in the manuscript, it may also be useful to put some pressure on Freud's sense that "[d]reams are completely egotistical" (*ID* 358). The idea that the dreamer's ego is always present or displaced in the dream, "concealed, by identification," would be further complicated by some analyses of subjectivity, the "individual," and identification in the early modern period; see, for example, Francis Barker, *The Tremulous Private Body: Essays on Subjection* (London: Methuen, 1984); Catherine Belsey, *The Subject of Tragedy* (London: Methuen, 1985); Greenblatt, "Psychoanalysis"; Peter Stallybrass, "Shakespeare, the Individual, and the Text," in *Cultural Studies*, ed. Lawrence Grossberg, Cary Nelson, and Paula Treichler, with Linda Baughman, and with assistance from John Macgregor Wise (New York: Routledge, 1992), 593–610.

38. Derrida, *Archive Fever*, 18.

39. As a corollary: Freud's own methods of dream interpretation may have become premonitory/performative for himself and for his patients in producing

through the discourse of analysis a structure that subsequently "comes true." I am indebted to John Parker of the University of Pennsylvania for this point.

40. I mean to gesture here, as in the opening pages of this essay, toward Freud's *The Interpretation of Dreams* as itself a kind of commonplace book. It is a cumulative text, compiled over time, incorporating footnotes and passages added later, including not only material "by" Freud (or we might say "by" his patients) but also the work of Otto Rank and Robitsek (among others; see chapter 6, esp. 408f.), and enacting an elaboration of itself from first publication through the latest revisions. See also 440n, 546n on Rank's interpolated essays. The point can also be extended with attention to translations and editions, in Freud's lifetime and beyond.

41. The reference within the manuscript to the copyist's receipt of an M.A. in 1606 is the basis of my identification of the copyist with Gregory Arundell of Cornwall, "cler. fil.", who received an Oxford M.A. on July 3, 1606 (see note 5 above). Since he is recorded as having matriculated at Exeter College on February 29, 1599–1600, at the age of sixteen (*Alumni Oxoniensis*), he was probably born in 1583–84 and was apparently living in 1657 (J. L. Vivian, ed., *The Visitations of Cornwall, Comprising The Heralds' Visitations of 1530, 1573, & 1620* [Exeter: William Pollard & Co., 1887], 13). Although the John Arundells of seventeenth-century Cornwall are legion, the most likely candidate is clearly Gregory's son John, who was living at least until 1657. William Scawen, whose name also appears on the page, matriculated at Queen's College (December 5, 1617, age sixteen), was apparently born in 1600–01, and died in 1689 (*Alumni Oxoniensis*, IV:1323; *Visitations* 422). There is some evidence of the connection of the Scawen family and this branch of the Arundells: Gregory Arundell's daughter Dorothy married Trehane Scawen (born c. 1612), who later became the guardian of Gregory's grandson (Dorothy's nephew) Francis Arundell in 1658; Trehane Scawen was William Scawen's first cousin. William Scawen also had a son named William Scawen (c. 1636–1709). See Vivian, *Visitations*, 13 and 422.

Another way to think about this book is to contemplate its locales, trajectory, or geographical circulation. Gregory's father, Walter Arundell, was rector of the parish of Sheviock, Cornwall, for forty-four years, dying in 1629 (*A Complete Parochial History of the County of Cornwall* [Truro: William Lake, London: John Camden Hotten, 1872], 4:146–49); the relevant branch of the Scawens lived in the adjoining parish of St. Germans, where William Scawen (father and son) were buried (*Visitations* 422) and which the earlier William apparently represented as MP in 1639 (*Complete Parochial History* 2:55). The fragmentary line ("by me of A [or "G A"?] of the ꝑish [=parish] of Erme of") raises the possibility that the manuscript also traveled to that parish, about 40 km to the west. (Lacking additional evidence, I would also want to leave open the question of

whether this manuscript was used serial-individually or communally, "privately" and/or familially, etc.) For a brief contemporary account of Sheviock and St. Germans parishes, see Richard Carew of Antonie, Esquire, *The Svrvey of Cornvvall* (London: by S.S. for Iohn Iaggard, 1602), 108–109v.

42. I base my sense of "later" on the fact that the *e* characters in this signature are neither secretary form nor the form used by the predominant italic hand and resemble a printed or modern cursive *e*.

43. MS., 43v. This is not to say that this "mania for order" was necessarily unusual in the period, as Erasmus's description of a method for commonplace books suggests: "[P]repare for yourself a sufficient number of headings, and arrange them as you please, subdivide them into the appropriate sections, and under each section add your commonplaces and maxims; and then whatever you come across in any author, particularly if it is rather striking, you will be able to note down immediately in the proper place, be it an anecdote or a fable or an illustrative example or a strange incident or a maxim or a witty remark or a remark notable for some other quality or a proverb or a metaphor or a simile" (638); see *Collected Works of Erasmus,* vol. 24 (cited above), esp. 635–48. The question is whether this copyist's orderings exceed what we might call the "cultural mania" around these questions of ordering and sorting, of which Erasmus's text is both an example and an instrument. On the problem of the word *individual* for speaking of persons in this period, see Stallybrass, "Shakespeare, the Individual, and the Text"; Jeffrey Masten, *Textual Intercourse: Collaboration, Authorship, and Sexualities in Renaissance Drama* (Cambridge: Cambridge University Press, 1997), 50–52.

44. Marjorie Garber, *Dream in Shakespeare: From Metaphor to Metamorphosis* (New Haven: Yale University Press, 1974). For a survey of materials on dreaming available in and influencing early modern England, see Garber's introductory chapter, as well as the larger survey in the first chapter of *ID*. There are a variety of additional early modern dream materials one might usefully place in conversation with the manuscript under examination — from the most ephemeral to the most culturally sanctioned. Some examples: Nashe's pamphlet, *Terrors of the Night*; the 1606 English translation of Artemidorus, *The Ivdgement, or exposition of Dreames, Written by Artimodorus, an Auntient and famous Author, first in Greeke, then Translated into Latin, After into French, and now into English* (London: for William Iones, 1606); "On Dreams," in *The Works of Sir Thomas Browne*, ed. Geoffrey Keynes (London: Faber and Faber, 1928) 3:230–33; Thomas Hill's *The Moste pleasuante Arte of the Interpretacion of Dreames* (London: by Thomas Marsh, 1576); the diary of Simon Forman (see esp. 3, 24, 31 in the published text), and, among others, Louis Montrose's discussion in "Shaping Fantasies: Figurations of Gender and Power in Elizabethan Culture," in

Rewriting the Renaissance: The Discourses of Sexual Difference in Early Modern Europe, eds. Margaret W. Ferguson, Maureen Quilligan, and Nancy J. Vickers (Chicago: University of Chicago Press, 1986); the papers of Archbishop Laud; the 1641 pamphlet *The Divine Dreamer*; and, in a larger European context, Vives's text cited above (apparently the text of a 1520 lecture in Louvain/Leuven and Paris), and the dreams of Lucrecia de León, as analyzed in Kagan, *Lucrecia's Dreams* (cited above).

45. I mean *performative* here in a not necessarily intentional sense; see Andrew Parker and Eve Sedgwick, Introduction, *Performativity and Performance*, Essays from the English Institute (New York: Routledge, 1995). Erasmus outlines another (and more intentional) form of instrumentality in discussing dreams as part of rhetoric: "Some people invent dreams as well, though possibly these should not be introduced except in display speeches, like Lucian's dream, or when we narrate them as genuine visions in order to encourage or deter our hearers. This is the case with Prodicus' invention about Hercules. . . . Of the same sort seems to be St Jerome's dream about being flogged for being a Ciceronian. In my young days I too toyed with something on these lines" (24:634).

46. On some larger issues of philology, the linguistic field, and orthography/skaiography toward which I gesture here, see Jeffrey Masten, "Pressing Subjects; or, The Secret Lives of Shakespeare's Compositors," in *Language Machines: Technologies of Literary and Cultural Production*, Essays from the English Institute, eds. Jeffrey Masten, Peter Stallybrass, and Nancy J. Vickers (New York: Routledge, 1997).

47. Jonathan Goldberg, *Writing Matter*, 42–43.

48. Mary Thomas Crane, *Framing Authority*, 85–86, quoting from Wolsey's instructions to a schoolmaster at Ipswich; see also 232 n37.

49. Juliet Fleming, "Dictionary English and the Female Tongue," in *Enclosure Acts: Sexuality, Property, and Culture in Early Modern England*, eds. Richard Burt and John Michael Archer (Ithaca: Cornell University Press, 1994), 301–2.

50. Margreta de Grazia, "Homonyms before and after Lexical Standardization," in *Shakespeare Jahrbuch* (1990), 143–56. It is interesting to compare in this context Foucault's evocation of aphasiacs in the opening pages of *The Order of Things*.

51. A similar problem is described, without the historical dimension I am here invoking, in Jane Gallop's "The Dream of the Dead Author," in *Reading Lacan* (Ithaca: Cornell University Press 1985): "The difference between a joke and a Freudian slip is generally understood to be whether the speaker intends the effect or not, whether the speaker has cognizance of the knowledge inscribed in his utterance. Yet the 'subversion of the subject' [in Lacan] means that we can no longer distinguish clearly between the intended joke and the unwitting slip" (176).

52. *OED*, 2nd edition on CD-ROM, entries for *lettuce* and *lattice*. As several people have reminded me, there are additional resonances here: e.g., a woman's name; the phrase "let us." Cf. this entry in Artimedorus (1606 trans.): "Lacatiue herbs are good for those which are in debte" (40). For Freud's treatment of verbal condensation and puns in *ID*, see esp. 318–39.

53. *ID* 217.

54. Cleopatra: "My Sallad dayes, / When I was greene in iudgement, cold in blood," *The Tragedie of Anthonie, and Cleopatra*, as reproduced in the Norton facsimile of the First Folio, TLN 608–9.

55. William Shakespeare, *King Henry V*, The Arden Shakespeare, ed. J. H. Waller (London: Methuen, 1954), 2.3.17.

56. *The Life of Henry the Fift*, as reproduced in the Norton facsimile of the First Folio, TLN 839. The line does not appear in the 1600 quarto's otherwise similar version of the passage. For extended commentary on this most famous of Shakespearean cruxes, see the appendix to Gary Taylor's Oxford edition of the play (New York: Oxford University Press, 1982).

57. Cf. Artemidorus (1606 trans.): "[To dream] Of bookes. Bookes are the life of him which dreams of them: to dream to eate them is good to schoole maisters & al which make profyt by books & which are studious for eloquēce[,] to others it is suddaine death" (95).

CARLA MAZZIO

THE MELANCHOLY OF PRINT

Love's Labour's Lost

I. TECHNOLOGIES OF LOVE

What cannot be declared by the melancholic is nevertheless what governs melancholic speech—an unspeakability that organizes the field of the speakable.
—*Judith Butler,* The Psychic Life of Power

True love lacketh a tongue.
—*John Lyly,* Euphues and his England *(1578)*

In the medical and poetic discourses of early modern England, loving is often a matter of having one's breath literally taken away. Physiologically, love melancholy was diagnosed in terms of a kind of romantic arrhythmia or cardiac arrest; irregular or neglected breathing producing sighs, stutters, broken speech, and silence. Lovers, writes Robert Burton in *The Anatomy of Melancholy*, not only suffer "palpitation of the heart," but "*cor proximumori* . . . their heart is at their mouth."[1] Indeed, cardiac, respiratory, and vocal motions were interdependent in a range of early texts, and broken hearts and broken speech went hand in hand. The true lover, according to Hoby's 1561 translation of Castiglione's *Il cortegiano*, has a "burninge hart . . . a colde tunge, with broken talke

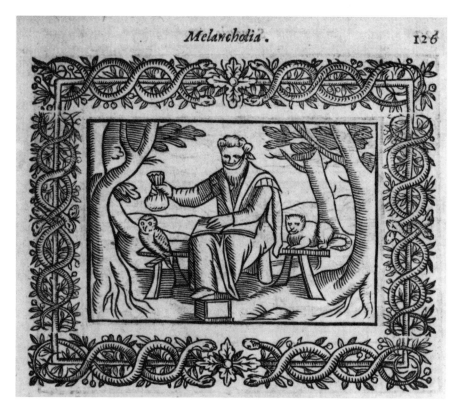

Fig. 9.1 "Melancholia," from Henry Peacham, *Minerva Britanna* (London, 1612).

and sodeine silence."[2] In love lyric of the period, hearts bleed, pens weep, and eyes speak volumes, while language seems in many ways disassociated from the human voice, somehow stuck in the throat or on the tip of the tongue. The beloved, urged to "hear with the eyes" "what silent love hath writ" (Sonnet 23), is asked again and again to animate the voice of the lover. Although many critics have found in the sixteenth-century love lyric "the deeply felt utterances of a self-expressive speaking voice," it is striking how often the ultimate sign of love was precisely the failure of voice.[3]

"True love lacketh a tongue," writes John Lyly in a sentiment that, interestingly enough, seems to have become all the more popular just as discourses of love were becoming more and more available through the medium of print. Indeed, to begin to place tropes of amorous inarticulacy

in a broader cultural context, I want to argue throughout this essay that the vocal insufficiencies of the melancholy lover in late-sixteenth-century England were in many ways conditioned by the shifting status of the voice in print.[4] In what may be the genesis of the title of Shakespeare's *Love's Labour's Lost*, for example, John Florio suggests in *First Fruits* (1578) that love need not be spoken of because it is already written and printed in excess: "We need not speak so much of loue, all books are ful of loue, with so many authours, that it were labour lost to speake of Loue."[5] The "loss" Florio imagines here is not so much the lost labor of love as the lost labor of speech in a world where passion and interiority are already located in printed books, which themselves seem almost to possess an interior, to be "full of love." The extent to which the sheer proliferation of amatory discourses in printed texts of the period could be imagined to result in a loss of voice is staged in *Love's Labour's Lost*, a play where texts themselves are "full of love" (4.2.769) and lovers full of text, and where the melancholy of love articulates a melancholy of speech in a world dominated by technologies of writing and print. That is, love melancholy, the most prominent disease in the play, is at once a dramatic realization of well-known Petrarchan conceits (where eye and text mediate or utterly replace tongue and voice) and a historically specific social ailment, articulating the oral and psychic self-estrangement of speakers living in a culture in transition to print.

In an analysis of the vocal dimensions of melancholy, Juliana Schiesari has distinguished between male melancholia, which is marked by a "topos of expressibility," and female depression, which is marked by "inarticulate babble."[6] But what is striking in a range of sixteenth- and seventeenth-century English texts is how often male melancholia articulates a cultural condition of vocal vulnerability, a marked failure of oral expression linked specifically to an overdependence on books. The prototypical melancholic in Henry Peacham's *Minerva Britanna* (Fig. 9.1), whose "mouth, in signe of silence, vp is bound," is identified by a gag over his mouth and a book in his hand. While Schiesari, revisiting Freud, reads the "excessive verbalism" of Hamlet as a quintessential sign of the male melancholic, what is often at stake for the melancholic is not so much "excessive verbalism" as what might rather be called an "excessive textualism": a dramatically alienated form of orality that tends to foreground the distinctly bookish origins and dimensions of speech.[7] Hamlet may well be a case in point. As Margreta de Grazia has recently noted, in the 1603 quarto Hamlet is said to enter "poring upon

a booke" just before launching into "To be or not to be": "Is it possi-
ble," she asks, "that Hamlet's, Shakespeare's, the culture's most cele-
brated soliloquy, is read from a book?"[8] To extend the question to
consider forms of melancholy more generally, what if melancholia is it-
self primarily a symptom of reading or, in the case of early modern
drama, of reading aloud?

In *Love's Labour's Lost*, symptoms of love melancholy — the broken-
ness of speech, the stammering of voice, the sense of breath being taken
away — are all staged as problems of reading aloud. Lovers onstage em-
body a kind of physiology of reading marked by a conspicuous domi-
nance of eye, heart, and book over tongue.[9] The heart of lovestruck
Navarre is not only "with print impressed," but "his tongue, all impa-
tient to speak and not to see, / Did stumble with haste in his eyesight to
be; / All senses to that sense did make their repair . . . / Methought all
his senses were lock'd in his eye" (2.1.238–41). Similarly, in *Much Ado
about Nothing*, Benedict imagines the power of love over Claudio as a
shift from hearing to seeing or reading words; Claudio has "turned or-
thography, his words are a very fantastical banquet. . . . May I be so
converted to see with these eyes?" (2.3.18–22).[10] The heightened visual
sensations of love are here aligned with the distinctly ocular and graphic
dimensions of speech: the lover here and elsewhere becomes shorthand
for speakers who speak as if they were reading and writing, and the dis-
tinctly bookish speech of the lover becomes a kind of mouthpiece for
broader issues of linguistic self-estrangement.[11] Indeed, it might be said
that in representations of lovesickness in sixteenth-century England,
the "melancholic ego" is itself conditioned by the "bibliographic ego" as
lovers and texts entwine in a discourse that conflates love melancholy
with the conspicuous proliferation of text in the social world.[12]

According to Freud, "If one listens patiently to a melancholic's many
and various self-accusations, one cannot in the end avoid the impression
that often the most violent of them are hardly at all applicable to the pa-
tient himself, but that with insignificant modifications they do fit some-
one else, someone whom the patient loves or should love."[13] What can
often be discerned in the early modern discourses of love melancholy is
the systematic introjection not so much of qualities of the beloved as of
qualities of textuality more generally. "Sorrow," reads George Whet-
stone's *Heptameron* (1582), is "The Great Impression."[14] And if "impres-
sion" in the post-Gutenberg era was a stamp of print as well as thought,
the melancholic, that most impressionable of types, may be seen as a

kind of walking pathology of print.[15] The melancholic, according to Andre Du Laurens's *Discourse of the Preservation of the Sight* (1599), not only "loues silence out of measure, and oftentimes cannot speak," but his emotional habits result in the production of "impressions" that are always the same: "there is difference in the maner of their impressions . . . in melancholike persons, the braine may seeme to haue gotten a habit, and therewithall the humour which is drie and earthie, hauing set his stampe in a bodie that is hard, suffereth not itselfe easily to be blotted out."[16] Similarly, as Jacques Ferrand writes in *Erotomania, A Treatise Discoursing of the Essence, Causes, Symptomes, Prognosticks, and Cure of Love or Erotique Melancholy* (1640),

> For all Passions, that are of any long continuance, doe imprint ill Habits in the Mind; which by length of time growing stronger, are very hard to be removed . . . he that hath contracted such an Amorous Disposition, is in love with every one that he sees.[17]

Interestingly, here it is the mechanical reproducibility of emotional life itself that constitutes the melancholic disposition. The "Amorous Disposition," like a printing press or a compulsive habit, reproduces versions of same regardless of the context.[18]

In *Love's Labour's Lost* melancholy emerges as a form of textual reproduction, and vocal expressions of woe are themselves "lost" precisely because they are taken directly from printed books: "How can thou part sadness and melancholy," (1.2.7−8), asks Armado, in a conversation that seems almost to emerge from the opening pages of Timothy Bright's 1586 *Treatise of Melancholie*, which focuses entirely on *"Howe diverslie the word Melancholie is taken."*[19] Indeed, throughout the play, the persistent sense that *love* has overthrown oratorical power is entwined with the fact that books have overthrown the power of the tongue as "conceit's expositor" (2.1.72): performances of speech are repeatedly imagined as forms of reading and writing, voices and passions are driven by a distinctly visual and spatial logic linked to the structure of the material book. While the "bookish" nature of the play has often been taken to be its ultimate failing, it is precisely the thematized failure of theatrical mimesis and oral performance that makes the play such a powerful commentary on the intersecting logics of love melancholy and expanding literacy. Love itself is staged as a kind of drama of public reading: the

play foregrounds not performance but performance *texts*—from sonnet to play text to schoolbook to dictionary—and most characters rely on conspicuously public texts for the articulation of self. As such, the play—always negotiating between text and staged voice—positions its own medium as an analogue to what might be seen as the increasingly scripted performances of identity, and the increasingly estranged conditions of orality, in the early age of print. By focusing in particular on the relationship between speech and the unprecedented publication of love in both poetic and educational books in sixteenth-century England, I will argue that the melancholy of love can be seen, in the play and in early modern culture, not only as a product of print, but as a nostalgia for speech. Dramas of love, in this respect, can be seen as a kind of elaborate exercise in catching one's breath at the very moment it's being taken away.

II. ROMANCE LANGUAGES

In short, love is an affliction, and by the same token it is a word or letter.
—*Julia Kristeva,* Tales of Love

Oh Amo, thou has ever too many words . . .
—*Andrea Guarna,* Bellum Grammaticale *(1511)*

"Honorificabilitudinitatibus," one of the many bookish words in *Love's Labour's Lost*, is a word that literally takes one's breath away (5.1.40). The respiratory and vocal demands of wrapping one's mouth around hard words in the play are linked again and again with the conditions of loving so much that speech becomes difficult. Indeed, lovers in the play are as much love-struck as what Montaigne would call *lettreferits* or "word-struck," the mark of pedants who speak "as though their reading has given them, so to speak, a whack with a hammer."[20] The absurdity of "loving by the book" is a recurrent trope in Shakespearean comedy, where humanist and courtly models of engagement meet, clash, and generally result in the lost labor of love. The bookish lover tends to fail as a speaker, and love melancholy articulates as much an emotional condition as a more general problem of translating books into conversations. What I want to consider are the pedagogical contexts of just this problem by exploring the use of love lyric in printed textbooks about conversation. For a range of educational manuals, newly available in the sixteenth

century, draw on the structures, vocabularies, and thematics of love, and might be seen as a powerful instance in early modern culture where love becomes a matter of learning (but not quite knowing) how to speak. *Love's Labour's Lost* actually engages with a number of these textbooks, which feature elaborate exercises drawing on the lexicon of love, the love letter, the poetic blazon, the sonnet, the ballad and the rhyme. Turning first to a series of language manuals and then to the play itself, I want to explore the fusion of love and learning, lyric and argument, heart and tongue, in and around the play.

The first words one learns in a foreign language are often words of love (*amo, amas, amat; je vous aime, je t'aime; te amo*) and in many early language textbooks, grammatical "moods" and constructs of active and passive voice were taught through a lexicon of love. John Brinsley's *Ludus Literarius: Or, The Grammar School* (1612), prescribes the following fairly typical dialogue for student and teacher:

> Q. I doe loue, or I loue?
> A. *Amo*
> Q. Grant I loue.
> A. *Vtinam amen.*
> Q. I may or can loue.
> A. *Amem.*
> Q. When I loue?
> A. *Cum amem.*[21]

Early pronunciation manuals frequently drew attention to language learning as a kind of loving: William Salesbury's 1550 guide to the pronunciation of letters opens by appealing to the "philoglottous" or "Langage Louers" and George Delamothe's *The French Alphabet* (1595) opens with an extended discussion of the "mutuall loue and agreement, betweene him that dooth teach, and him that dooth learne."[22] But in addition to prefatory commonplaces about the love of wisdom and the use of "love" as a paradigmatic verb, textual and pedagogical dimensions of love in practices of language acquisition and rhetorical facility were marked in a range of sixteenth-century textbooks. Erasmus' *De copia* (1512), for example, mobilizes the language of love to teach young students the art of writing and speech, listing "*desperdita amore* (Suetonius): madly in love," "*tui cupientissimus*: longing eagerly for you," and "*sic omnia tua exosculatur*: he so kisses all that is yours" among twenty-

three possible expressions of love, all part of an exercise designed to help students develop eloquent and varied habits of articulation.[23] Similarly, in *Bellum Grammaticale*, an academic grammar play performed for Elizabeth at Oxford in 1592, Amo, the king of verbs, presides over Grammarland along with "Poeta," the vividly melancholic king of nouns.[24] In this play, as in the hugely popular prose text upon which it was based (Andrea Guarna's *Bellum Grammaticale*, printed seventy-five times in the sixteenth century alone), the anatomy of love is an anatomy of grammar: a conflict between Amo (as verb and love) and Poeta (as noun and poet) leads to a civil war between parts of speech; towns such as "E, I, [and] O" are taken, "irregular" grammatical factions are created, and although Amo triumphs and reconciles with Poeta, the triumph of love and of "love-poetry" is essentially an intellectual one of letters and learning.[25]

The power of love as a vehicle for expanding literacy, as a basis of not so much intimate as social and even international relations, might be gleaned by considering the uses of love letters and love poetry in manuals on rhetoric, grammar, and foreign languages. At the end of Jacques Bellot's *The Englishe Scholemaister* (1580), one of the first English grammars for Frenchmen, is a fourteen-page *The Poesy or Nosegay of Loue. Conteyning the Posies of sondrye Flowers, Herbes, and Plants. That are put commonlye in Nosegays. Directed to the true Louers.* This text, with English and French in parallel columns, contains extended lists of flowers ("Bouquet d'Amours"), foods ("La Salade d'amours"), and colors ("La Devise des couleurs") of love:

Le Geneure auec	The Junyper with
ses fleurs, se	his flowers, is
prend pour, Vous	taken for, You
desrobez mon coeur.	steal away my heart . . .
La Plumersoe, ou	The Primerose,
Primerose, signifie,	signifieth,
le commence a	I beginne to
vous aimer.	loue you . . .
La Saule, se prend	The Willow tree,
pour, Espargnez moy.	is taken for, Spare me . . .
L'incarnat,	The fleshe colour,
se prend pour,	is taken for,

Desespoir, ou	Desperation, or
Torment en	Torment in
amours.	loue . . .[26]

Here the elements of love-lyric and language-lesson meet: tropes of love melancholy and isolated units of the poetic blazon are transformed into an elaborate list of adjectives, nouns, and verbs. What is striking here is the way in which the very discourse of love and poetic emblazoning is itself emblazoned (in every sense of the word *blazon*, which meant to describe, to partition or catalogue, and to publish) and aligned along the visual co-ordinates of the page.[27] Like the main text of the *Scholemaister*, which be-gins by listing letters of the alphabet and ends by listing the seasons, the *Poesy* is structured as an extended list, concluding with a ballad and a series of sonnets. While the manual mimics poetic language and courtly lyric, in many ways it radically decontextualizes the language of love, not only from interpersonal contexts and continuous narrative sequences, but from the elite contexts of traditional lyric composition. As with so many early ver-nacular language manuals, which were largely designed for use outside the classroom, poetic modes are here essentially a vehicle for public education: the poetic blazon is a pedagogical tool, and the closing sonnets exhibit first and foremost a wealth of accumulated learning.

Similar uses of love poetry, love letters, and poetic emblazoning sur-face in the language manuals of John Florio and John Eliot.[28] In these texts, Petrarchism and pedagogy converge: acts of discursive and imagis-tic partitioning so integral to amorous epideictic become part of a broader program of learning and linguistic mastery. While Nancy Vick-ers has emphasized the psychic valence of the anatomical blazon, which "almost literalizes the logic whereby the self is collected, defined, and displayed *through* the process of splitting and exhibiting the other,"[29] it might also be noted that in the most practical sense, the blazon as a mode of erotic description was compatible with the needs of foreign lan-guage manuals in print. For these manuals, which sought to teach basic nouns such as parts of the body and adjectives such as sizes, were struc-tured according to loosely organized lists of isolated particulars and were themselves "collected, defined, and displayed *through* the process of splitting and exhibiting the other."[30]

It is no coincidence in this respect that the first words the pedant Holofernes speaks in *Love's Labour's Lost* fuse the language of the trans-lation dictionary with that of the poetic blazon:

> The deer was, as you know, *sanguis*, in blood; ripe as the pome-
> water, who now hangeth like a jewel in the ear of *coelo*, the sky,
> the welkin, the heaven; and anon falleth like a crab on the face
> of *terra*, the soil, the land, the earth. (4.2.3–7)

The ultimate failure of the blazon as a method of organizing speech is here underscored by the subtle allusion to Actaeon, that prototype of amorous emblazoning who was ultimately transformed into a deer, deprived of voice, and torn to bloody bits by his own hounds. But more generally, the pedagogical uses and abuses of love poetry are foregrounded throughout this scene, as Holofernes teaches a text that is itself a "canzonet": "Let me hear a staff, a stanze, a verse" (4.2.100), he says of Berowne's love sonnet to Rosaline, transforming the very lexicon of poetic form into a word list. While this may add weight to arguments equating Holofernes with Florio, what is on display here and throughout the play, in broader terms, is the use of distinctly literary and textually based discursive forms for the practice of speech: "You find not the apostrophus, and so miss the accent: Let me supervise the canzonet," says Holofernes to Nathanial (4.2.115–16), chiding him for reading the sonnet improperly.[31]

Throughout *Love's Labour's Lost*, love becomes a pre-text in the most literal sense, serving as a vehicle for the transmission of conspicuous book learning, for the articulation of rudiments of language, letters, and knowledge. If love in the play seems comic because of its detachment from specific persons and contexts, this may be seen to reflect the many public uses and articulations of love in the period, which often seemed defamiliarized through structures of listing, repetition, and mechanical reproduction. The language of love melancholy and poetic emblazoning in the play is not only referentially remote from actual beloveds, but is also entwined with a range of distinctly bookish and public discourses of woe. At one point lovesickness is presented as a rudimentary exercise for the use of prepositions: after pointing out that Armado has forgotten his love, Moth says, "Negligent student! learn her by heart."

> *Arm.* By heart, and in heart, boy.
> *Moth.* And out of heart, master: all those three I will prove.
> *Arm.* What wilt thou proue?
> *Moth.* A man, if I live; and this, by, in, and without, upon the
> instant: by heart you love her, because your heart cannot

> come by her; in heart you love her, because your heart is in
> love with her; and out of heart you love her, being out of
> heart that you cannot enjoy her.
> *Arm.* I am all these three.
> *Moth.* And three times as much more, and yet nothing at all.
> (3.1.33–46)

The question of whether the heart is "in" love, or whether one is "out of
heart," or loving "by" heart, while epistemologically and psychosomati-
cally complex, reduces the anatomy of heartbreak to an anatomy of
grammar.[32]

The grammar of the heart, or rather, the accumulation of prepositions
and synonyms in oral expressions of love, amounts to what Erasmus
terms a kind of "battologia," a vice of using words "more suitable for
exercises than real speeches":

> I observe that some public speakers of otherwise distinguished
> reputation, especially among the Italians, actually set out to
> waste time with strings of synonyms like this, as if that were
> some splendid achievement. It is just like someone expounding
> the verse from the psalm, "Create in me a clean heart, O God"
> by saying "Create in me a clean heart, a pure heart, an unsullied
> heart, a spotless heart, a heart free from stain, a heart unstained
> by sin, a purified heart, a heart that is washed, a heart white as
> snow," and so on, right through the psalm.
> "Richness" of this sort is practically battologia.[33]

The specter of lexical accumulation (or listing in public) in *Love's
Labour's Lost* speaks less to the vice of a particular speaker than to the
expanding literacies of the period, where new dictionaries, conversa-
tion manuals, and vernacular textbooks were creating whole new possi-
bilities and problems for oral exchange.[34] Given proliferation of
translation dictionaries, making dictionaries or word lists was itself, as
Peter Levins writes *Manipulus Vocabulorum* (1550), "counted but as lost
laboure."[35] The culture of "lost laboure" in Shakespeare's play is not
simply a matter of loving or simply a matter of listing, but really a mat-
ter of loving to list.

Indeed, early vernacular textbooks were generally incremental in
structure (moving from lists of letters to lists of sentences and finally to

categorically organized clusters of poetry and dialogue) and may well be seen to have created a kind of phenomenology of the list in the increasingly literate cultures of early modern England. "By, in, and without . . . I am all three of these": the structure of the list organizes the discourse of love here and in all of Armado's speeches and letters, where synonyms, numbers, and parts of speech abound in ways that comically disrupt a continuous narrative flow. Indeed, falling in love for Armado is a kind of fall into *lists*, that structural feature of discourse that theorists of literacy such as Jack Goody have linked specifically with communities of writing and print.[36] While it may well be an overstatement to say with Goody that there is no "oral equivalent" to the list as a form of discursive organization, the distinctly visual, graphic, and spatial dimensions of lists (which are in general more amenable to eye than ear) repeatedly surface in the mouths of characters in *Love's Labour's Lost* in ways that register the influence of printed textbooks.[37] The logic of the list might well be seen as a dominant principle of the play, which begins, for example, with the reading of "Items" on a contract, and which foregrounds letters of the alphabet, parts of the body, seasons of the year, basic numbers and forms of measure, figures of speech, and words in the dictionary. Similarly, word lists in Jacques Bellot's *The Englishe Scholemaister* are categorized in terms of the numbers, the days of the week, the months of the year, the four winds, the seven planets, twelve astrological signs, and finally, the four seasons. Like Bellot's *Poesy*, which closes with a sonnet entitled "De faire tout en saison," the anonymous early French textbook *A very necessarye boke bothe in Englyshe & in Frenche* (1550) comes to a close with a rehearsal of the seasons and the "names of the yere."[38] Colors, flowers, and seasons, parts of the visible and temporal world, were as integral to discourses of love as they were to popular language textbooks, a fact that informs the melancholic dimensions of speech in *Love's Labour's Lost*.[39]

The catalogic, indexical, and visual structures of love and learning in the play may well be a send-up of Bellot in particular, whose textbooks on speech were in circulation in the final decades of the sixteenth century. His *Familiar Dialogues* (1586), another manual with French and English dialogues printed in parallel columns, features a whole series of conversations that consist entirely of lists (questions such as "What collor haue ye?" are answered with a list of colors, enhancing the reader's vocabulary and ability to converse at once).[40] Again the *Poesy or Nosegay of Love* draws together the catalogic dimensions of love and

learning by foregrounding the isolated discursive units of love such as
colors and flowers, and deploying sonnets and a ballad at the close of
the text ("Balade sur la devise des Couleurs"), about the colors of love.
The list of colors in his *Familiar Dialogues*, but most especially in his
Poesy (which reads, for example, "Le Roux, signifie, Petitesse, Humilite,
ou melencolie en Amours / The russet coulour signifieth Lowelinesse,
Humillitie, or mellancholye in Loue") resonates with the textual color-
philia of *Love's Labour's Lost*. The first scene of the play foregrounds Ar-
mado's "sable-colored melancholy," in which he emblazons his own
writing, the "snow-white pen" and "ebon-coloured ink" of his own text
(1.1.238–39).⁴¹ Even the play's closing songs about winter and spring,
which many have read as an ultimate reconciliation of art and nature,
read at first like a rudimentary list of flowers and colors of love: a vocabu-
lary list transformed into a song about the seasons: "When daises pied
and violets blue / And lady-smocks all silver-white / And cuckoo-buds
of yellow hue / Do paint the meadows with delight . . ." (5.2.886–89).⁴²

The conspicuous textuality of listing as a quality of speech is high-
lighted in the play's emphasis on love poetry as "numbers" (4.3.318),
where lyric becomes detached from the acoustics of music and ab-
stracted as a form of counting: "he came, one; saw, two; overcame,
three," reads one amorous "ballad" (4.1.80). Interestingly, Bellot's final
pronunciation guide, *The French Method* (1588), concludes with a chap-
ter on versification, in which the ballad, sonnet, envoy, and a range of
French verse forms are defined and demonstrated, and metrics are
strung out in narrative form like so many numbers on a page. What "the
French men doe call *Enuoy*," he writes, "Is made sometimes of seuen
meeters, and sometimes of fiue: Being of seuen, it is formed of three
colours, The first and second meeters being one colour, the third,
fourth, and sixt, of an other, and the fift, and seuenth of another."⁴³ This
vocabularly of the abstract poetic coordinate is taken rather literally by
the speakers of *Love's Labour's Lost*. Indeed, the much ado about "l'en-
voy" in the play (a word unique in the Shakespearean corpus, uttered a
mind-numbing sixteen times in fifty-three lines [3.1.66–119]), which is
formally defined (79–80), repeatedly demonstrated with a poem about
counting (81–95), and translated and mistranslated at length (66–119),
arguably sends up the scholastic appropriation of lyric in Bellot. But
more generally, the recurrent link between poetic forms and "numbers"
(from Holofernes' treatment of *L* as a letter and a roman numeral to the
arithmetic thematic of the "l'envoy" itself)⁴⁴ speaks to the insinuation of

formal vocabularies of versification and number into spoken verse forms. It renders comic and absurd the movement of poetry from the domain of the ear to that of the eye (and vice versa).[45]

While the play is often said to have no single source, it takes pains to dramatize the many textual sources of melancholy utterance in printed books of the period, working to foreground what might be seen as a fundamental textuality of voice. The "ballad" about King Cophetua that Armado decides, as he puts it, to "newly writ o'er" is a case in point (1.2.108), for what he creates while drawing on an "oral" tradition is ironically a text that in addition to rehearsing fundamentals of grammar, vocabulary, and composition, features Latinisms, and demonstrates an expressed contempt for the vernacular ("O base and obscure vulgar!" [4.1.69–70]). And all for a woman who is, in fact, illiterate:

> By heaven, that thou art fair, is most infallible; true, that thou
> are most beautious, truth itself, that thou art lovely. More fairer
> than fair, beautiful than beauteous, truer than truth itself, have
> commiseration on thy heroical vassal! The magnanimous and
> most illustrate king Cophetua set eye upon the pernicious and
> indubitate beggar Zenolophon, and he it was that might rightly
> say, *veni, vidi, vici;* which to annothanize in the vulgar (O base
> and obscure vulgar!) *videlicet,* he came, saw, and overcame: he
> came, one; saw, two; overcame, three. Who came? the king: why
> did he come? to see: why did he see? to overcome. To whom
> came he? to the beggar: what saw he? the beggar: who overcame
> he? the beggar. . . . Thus, expecting thy reply, I profane my lips
> on thy foot, my eyes on thy picture, and my heart on thy every
> part. (4.1.61–85)

This "ballad" is essentially a series of lists, moving from adjectives to numbers to prepositions to body parts. Emblazoning in this letter is just one of many forms of list making and is at once a symptom of reading and of love.

Armado's creation of a literate "song" for the benefit of an illiterate, combined with his contempt for illiteracy, is perhaps a perfect metaphor for the pretensions and narcissism of the lover. But it also parodies the uses of love lyric in educational practice of the period and seems to reflect the many claims made about the pedagogical value of love poems in print in the latter half of the sixteenth century. The first major printing of

vernacular love lyric in England, *Songs and Sonnets* (1557), for example, was justified by Tottel on the grounds that "learned" lyrics might "profit . . . English Eloquence" and prove beneficial even to the "rude skill of common eares."[46] The emphasis on love lyric and love letters as a kind of lingual and acoustical enhancement calls to mind John Eliot's *Ortho-Epia Gallica* (1593). The following love letter, which Eliot claims to have reproduced from an original, might be juxtaposed to Armado's ballad:

> *Mistress your beautie is so excellent, so singular, so celestiall, that I believe Nature hath bestowed it on you as a sampler to shew how much she can do when she will imploy her full power and best skill. All that is in your selfe is but honie, is but sugar, is but heavenly ambrosia. It was to you whom Paris should have judged the golden apple, not Venus, no, nor to Juno, nor to Minerua, for neuer was there so great magnificence in Juno, so great wisdome in Minerua, so great beauty in Venus, as in you. O heavens, gods and godesses, happie shall he be to whom you grant the fauour to col you, to kisse you, and to lie with you. I cannot tell whether I am predestinated by the Faries, wherefore I commend me to your good grace, kissing your white hands, humbly I take my leaue without Adieu.* (160)

What is remarkable about this amorous epistle is that it is framed as part of a lesson on speech and pronunciation: on the right-hand margin of the page (and on the left-hand margin of the facing page in French) are guides to the proper pronunciation of vowels and consonants. That is to say, this literary letter in a printed manual on vocabulary and pronunciation finds its parallel in *Love's Labour's Lost*, not only in Armado's silly ballad but in the transformation of love letters into *spoken* discourse both in the play and in the domain of public theater.[47]

If the habitual assumption of London playgoers, as Andrew Gurr has suggested, was "that poetry was words for speech rather than the page," then a play such as *Love's Labour's Lost* becomes all the more interesting because it stages as comic spectacle the composition, circulation, and reception of love poetry; that is, it stages the pathologies of poetry meant as words for the page.[48] Throughout the play, the oral performance of poetry is disrupted precisely because it is imagined to be governed by acts of seeing, and ultimately acts of reading. Just after Holofernes

chides Nathanial ("You find not the apostrophus, and so miss the accent: let me supervise the canzonet" [4.2.115−16]), he underscores the distinctly visual regime of both poetry reading and pedagogical practice by rephrasing his role as a "super-*visor*" as one who "overglance[s] the superscript" (4.2.126). The many poems within the play are not only "read aloud" but are "supervised," "overglanced," "o'er-eye[ed]" (4.3.77) and "overview[ed]" (4.3.172). In the first letter read aloud in the play, the scopophilia of the lover translates into a form of graphic narcissism: "a most preposterous event, that draweth from my snow-white pen the ebon-coloured ink, which here thou viewest, beholdest, surveyest, or seeth" (1.1.233−35). Even in the first moments of the play, love melancholy is linked to variations on the verb "to see."

The ocular thematics of the love sonnet have recently been seen to be compatible with the influence of print technologies, which, according to theorists such as Walter Ong and Marshall McLuhan, contributed to the predominantly visual orientation of Western culture.[49] As Wendy Wall writes, "In the sonnets, writers refocus this newly important visual force by rendering it frighteningly desirable and perverse."[50] But at the same time, it is precisely the visual dimensions of the love lyric that, when enacted on stage, become a vehicle for articulating the relatively *undesirable* situation of the sonneteer who is not only made into a spectacle but is quite visibly detached from his own voice. Again, Navarre, "with print impressed," becomes a kind of embodiment of sonnet tropes: speechless, shy, "all his senses . . . lock'd in his eye" (2.1.241). The figuration of the king as a kind of transparent eyeball, paired by Berowne's striking image of Longaville as a veritable ocular foundation, a street paved with eyes, emphasizes the unsettling dominance of the visual over (and under) the oral.[51]

The double sense in which love melancholy in this play is "with print impressed" is foregrounded by the representations of lovers as books, words, and margins.[52] But it is also thematized by the physical movement of love sonnets in the social world of the play, by what might be seen as the dramatic enactment of the very process of print.[53] The rhetoric and the phenomenon of inadvertent publication in early print culture, where writers claimed to be embarrassed by the unauthorized publication of their work, might well be taken to inform the many scenes of textual circulation on the Shakespearean stage, where letters and poems are stolen, decontextualized, recontextualized, and commercialized within the domain of both play and theater. As Wall describes the social

logic of the prefatory disclaimer, the "strategy of disassociating text and author created a skewed vision of printed texts; they seemed to be private words snatched away from their producers and offered for sale to the public."[54] The circulating sonnets of Beatrice and Benedict in *Much Ado about Nothing*, which are "stol'n" and made public without their consent (and which attest to their love even against their verbal protestations), seem a dramatic enactment of this very phenomenon.

Indeed, this phenomenon is perhaps nowhere more apparent than in *Love's Labour's Lost*, where the embarrassments of inadvertent publication and uncontrolled circulation in many ways constitute the plot of the play. In what has aptly become known as the "sonnet-reading scene" (4.3), individual lovers read their poems aloud in what they think is a private space, but are in fact overheard or, as Berowne tellingly puts it, their "secrets [are] heedfully o'er eye[d]" (76), first by one, then two, then three, and finally four distinct audiences. As secret spaces of composition become unmistakably public and lovers and love poems are transformed into distinctly *visual* spectacles, what is arguably dramatized is the place of the sonneteer in a world where audiences (and indeed, sonneteers) are quite literally proliferating.[55] Although, as Arthur Marotti points out, "socially prominent courtiers . . . essentially thought of poems as trifles to be transmitted in manuscript within a limited social world and not as literary monuments to be preserved in printed editions for posterity," by the century's end sonnets were, of course, being printed and circulated in unprecedented numbers.[56] This fact is reflected not only by the production of sonnets on stage in *Love's Labour's Lost*, but by the fact that within the play there is no limit to the social world in which sonnets circulate.

The sonnet-reading scene, in which lovers unknowingly "publish" their sonnets, is itself a microcosm of poetic representation in the play, where sonnets are misdirected and read by the wrong people and by the wrong social groups. Armado's sonnet for Jaquenetta is read in the company of Maria, Katherine, Rosaline, Boyet, the Princess, Costard, "lords, attendants, and a Forester" (4.1), and Berowne's sonnet for Rosaline is read in the company of Holofernes, Nathaniel, Dull, Costard, and Jaquenetta (4.2). And as if to register the relation between the composition of a single love sonnet and the "compilation" of a book of sonnets, Katherine mocks Dumain's lyric by imagistically transforming it into a book of "some thousand verses . . . / A huge translation of hypocrisy / Vilely compil'd, profound simplicity" (5.2.50−53). The translation, compilation, and

imagined proliferation of common verse here seems to align the poetic longing of a single "faithful lover" with the process of book production itself. The play stages the comedy of affected learning and rituals of courtship in an era in which, as Nashe put it, "everie grosse brainde Idiot is suffered to come into print" and in which printed texts enabled anyone who could read to access the previously private forms of textual exchange in elite literary and court circles.[57]

Shakespeare seems to be staging not simply the absurdities of excessively literate characters, as has frequently been argued, but the social drama of a rather expansive and expanding reading public. The lover, the sonneteer, and the scholar become available models of speech and performance for a range of social types, enacting — broadly speaking — a transformation of culture through the publication of poetic and scholarly texts in the vernacular. In many sixteenth-century printed texts, the term scholar itself came to include anyone who could read; not only the "learneder sort," as Edmund Coote put it in the preface to *The English Schoole-Maister, Teaching all his Scholers, of what age soever, the most easie, short, and perfect order of distinct reading, and true writing our English tongue* (1596), but foreigners and "unskilfull . . . men and women of trades (as Taylors, Weauers, Shop-keepers, Seamsters, and such other) as have undertaken the charge of teaching others" (Sig. A3).[58] Similarly, the textual culture in *Love's Labour's Lost* that emerges in act 1 as the exclusive province of the "little academe" quickly comes to include women, servants, foreigners, and even those who cannot read or write. Although Navarre opens the play by celebrating the elitism of the scholarly "academe" and the transcendence of the book (1.1.56), idealist conceptions of texts clash again and again with materialist conceptions of the physical book in the social world. Moth, himself a "page," literally follows Armado, imagining himself as a "sequel" (3.1.130). Holofernes, "man of letters," articulates standards of learning for even members of the "little academe," deeming Berowne's own sonnet to be "very unlearned" (4.2.152).

The language of textbooks that informs Holofernes's and Armado's use of love poetry is paralleled by the aristocratic tropes of conversation as instruction, and the comedy of a quintessentially *educational* poetics might well be seen to be dramatically magnified through the very concept of Navarre's "little academe." The irony of scholarship in this "little academe" is that it produces anything but the powerful orator, that humanist ideal who speaks powerfully and well, who does things with

words, and (perhaps most importantly) who speaks to others. What all of the lovers and scholars have in common in this play is a notable detachment from the audience they presume to know. Interestingly, this detachment had a corollary in Ramist rhetoric, which "virtually banished the audience by contemptuously considering them unnatural to the conditions of thought."[59] Ramus himself went to the College of Navarre, and it is at the very least suggestive, given the educational poetics at work in *Love's Labour's Lost* that Ramus believed poetry to be the ultimate pedagogical tool.[60] Indeed, Navarre's "little academe" may in many ways be read as a spoof on Ramist educational theory, which was marked by a prioritization of the written over the oral, by an "insistence that the elements of words and of all expression are not sound . . . but letters," and by a devaluation of the classical rhetorical ideal in which the orator could incite passion by understanding the passion and the very soul of his listener(s)."[61] As Walter Ong puts it in a discussion of the compatible logics of Ramism and print culture, in Ramist rhetoric "the role of voice and person-to-person relationships in communication is reduced to a new minimum":[62]

> The Ramist arts of discourse are monologue arts. . . . In rhetoric, obviously someone had to speak, but in the characteristic outlook, fostered by the Ramist rhetoric, the speaking is directed to a world where even persons respond only as objects—that is, say nothing back.[63]

This dynamic is played out in a number of ways by the members of Shakespeare's mock French academy, where sonnets are composed for people imagined not only as "objects," but also as simple reflections of the academy itself. While the women are "the books, the arts, the academes" (4.3.548), the scholars themselves, as Berowne puts it, are "authors of these women" (4.3.355). Even as Berowne tries to distance himself from the constraints of academe in this famous speech, over the course of it love seems to become more and more bookish (353–58). Interestingly, two versions of the speech itself were printed in the 1598 quarto, marking signs of revision, so that even as Berowne tries rhetorically to abandon "literal" books, the printed text calls attention to the ambiguous status of his speech *in* a printed book. It is to the dramatic implications of speech in print that I would now like to turn, considering aspects of the play and the 1598 quarto that foreground the interan-

imation of oral/aural and visual/textual technologies so marked in printed books about speech in the late sixteenth century. The typographic dimensions of the quarto highlight the relations between reading, speaking, and loving in the play and call attention to the difficulty of wrapping one's mouth around a word.

III. WORDS MADE VISIBLE

Thou consonant!
> —*Holofernes to Moth,* Love's Labour's Lost

In "Prickly Characters," a recent essay on Shakespeare and punctuation, Bruce Smith writes, "Printhouse compositors, no less than William

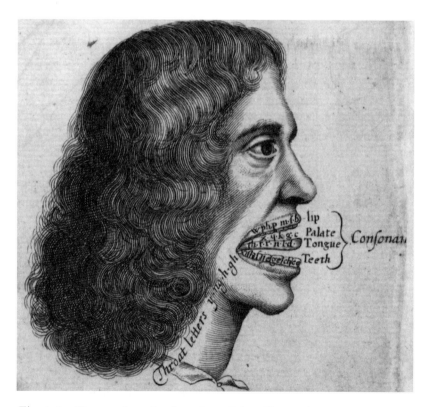

Fig. 9.2 Illustrated speaker from Owen Price, *The Vocal Organ, or A new Art of teaching the English Orthographie* (London, 1665).

Shakespeare and Richard Burbage, spoke, read, and wrote within an *episteme* that gave primacy to voice and ear, not print and eye. They understood writing to be a transcription of voice, and they marked punctuation in accord with that understanding."[64] But at the same time, with the development of print and the expansion of literacy, the marked visibility of typography, of punctuation, of alphabetic and lexical units was often seen to compete with that privileged "episteme that gave primacy to voice and ear." As the orthographer John Hart himself plainly put it in his preface to *A Methode or comfortable beginning for all unlearned whereby they may be taught to read English* (1570), educational "books (which are dumbe masters) . . . often preuail more than the liuely voyce."[65] Indeed, in the latter half of the sixteenth century, the specular dimensions of language and sound were increasingly foregrounded with the proliferation of textbooks on language and pronunciation. As the "dumb master" (the printed language textbook) became more and more dominant as a pedagogical vehicle in the sculpting of popular literacy; as books began to compete with persons as repositories of knowledge;[66] as printed texts began to "preuail more than the liuely voice" (precisely for teaching "the framing and sweete tuning of thy voyce"),[67] print and eye became increasingly central to the transmission and acquisition of knowledge about speech. On stage, the ascendancy of a predominantly visual linguistic episteme was perhaps most apparent in the tradition of academic drama, which included texts such as *Bellum Grammaticale* and *Heteroclitanomalonomia*, a grammar play written in English, featuring characters such as Parenthesis, who holds "Semicircles in [his] hand" to represent himself.[68] In a later variant of this tradition, the dramatic tension of Samuel Shaw's *Words Made Visible* (1679) hinges precisely on the marked visibility of grammatical and social positions, with characters such as "Mr. Article, the King's Attorney General" and a cast (or typecast) of those representing nouns, verbs, pronouns, participles, adverbs, conjunctions, prepositions, and interjections.[69]

Love's Labour's Lost stages the drama of articulation in a world of shifting epistemes, where "dumb masters" not only inform but consistently threaten to "prevail" over the "liuely voice."[70] Throughout the play, words are not so much spoken by as graphically relocated in the mouths of characters. Not unlike the speaker with a mouthful of consonants in Owen Price's orthographic treatise (Fig. 9.2), Holofernes's mouth seems less an instrument of speech than a repository for letters. Not only does he rehearse a "script" not meant nor suitable for social interaction

or dramatic performance: "a, e, i . . ." (5.1.52), but at one point he cre-
ates a panegyric to the letter *L*, and relates to other characters as if they
were parts of speech (calling Moth, for example, a "consonant"). Speech
itself becomes the dominant spectacle of the play, the mouth a site to be
seen. Mocking the scholars, Moth notes that "they have been at a great
feast of languages and stolen the scraps," and Costard responds, "O, they
have lived long on the alms-basket of words. I marvel thy master hath
not eaten thee for a word; for thou art not so long by the head as hon-
orificabilitudinitatibus" (5.1.35–40). This word, which would make
even Lucian proud, is perhaps the most remarkable example of textual
indigestion on the Shakespearean stage.

Even Moth, who mocks the scholars, has "fed on the dainties that are
bred in a book" (4.2.23), and his alignment with the scholars is implicit in
his very name. Although Moth has been regularly glossed as an "Eliza-
bethan and Shakespearean spelling" for *mot* or *mote*, meaning "word"
or a "tiny particle,"[71] G. Blakemore Evans, editor of the *Riverside,* re-
tains the spelling of *Moth* because of the "possibility that Shakespeare
was thinking primarily of the insect."[72] That this "page" may also be a
"moth," that insect who was imagined as a consumer and a perpetual
threat to books (Burton imagines neglected text, for example, "with
moth & bookworms bit"), is teasingly apt in a play about "bookworms"
who are said to consume texts.[73] Onomastically as well as thematically,
Moth (whose name suggests at once a word, a textual parasite, and a
"mouth" itself) thematizes the satiric relocation of a textual world to the
space of the embodied and the oral. While Rosaline longs for her power-
ful orator, at whose words "younger hearings are quite ravished, so
sweet and voluble is his discourse" (3.1.70), this seductive relation of
rhetor to body, of word to oral and aural, is contrasted with Berowne's
distance from the phonic, signaled at one point by the fact that he actu-
ally *tells* his ear to listen: "Listen, ear!" (4.3.42). Although it has been
argued that the play ultimately valorizes the "converse of breath," the
immediacy of the embodied and the oral over the distanced and the
written, the play goes far in undermining this dichotomy and instead
thematizes the nostalgic dimensions of a culture that longs for a dis-
course that breathes, whispers, seduces, and ravishes.[74] Indeed, the oft-
cited fantasy of an unmediated relation between—in Rosaline's
words—the "ear" and the "fair tongue" (3.1.70–76, reiterated again at
5.2.833–61) is called into question by the structure of repetition and de-
ferral at the close of the play. The ability of Berowne to shake the powers

of books and become sensitized to the "sickly ears" of the "speechless sick," we are told, "would take too long for a play" (5.2.870). Theater falls short as a vehicle for the cultural work to be done here, and the deferral of comic integration is linked (particularly through Navarre's consolatory speech, in which he still seems to have "all his senses . . . lock'd in his eye") with the persistent ocularity and textuality of spoken utterance.

The final song of the play, which has frequently been read as a kind of perfect conclusion (where the play "returns," as Kenneth Muir puts it, "to natural forms of speech and behavior"),[75] arguably repeats the play's central joke by registering a textbook term that was used precisely to describe the failure of conclusions: The "cockoes song" in Thomas Wilson's *The Rule of Reason* (1553) is a term for a conclusion which simply "repeated [w]hat was spoken before":

> *Repetitio princippii*, the cockoes song, that is, repetyng of that wholy in the conclusion, whiche before was only spoken in the first Proposicion: or els by things doubtful to proue thinges that are as doubtful. . . . The conclusion is not well gathered, for it should not bee vniuersall, but particular, and therefore seyng the same is repeated that was spoken before, without any good probacion: in my mind it maie be called the Cuckowes song.[76]

This particular textbook is arguably parodied in the first moments of the play as well, as Costard repeats variations of "the manner and form following":[77]

> In manner and form following, sir; all those three: I was seen with her in the manor-house, sitting with her upon the form, and taken following her into the park; which, put together, is in manner and form following. Now, sir, for the manner,— it is the manner of a man to speak to a woman; for the form,— in some form. (1.1.202−8)

If "it is the manner of a man to speak," that speech here is utterly confounded, a sign Costard may be drawing pearls of wisdom from Wilson, who uses this very language, interestingly enough, to extend his discussion of the "false conclusion(s)" of "the Cuckowes song":

The fault that is in the forme, or maner of makyng, as we call it, maie be dissolued, when we shewe that the conclusion, is not well proued by the former Proposicions, and that the argument, is either not well made, in Figure or in Mode, or in both. . . . Thus we see a false conclusion, made of two vndoubted true Proposicions . . . the faulte is in the fourme, or maner of makyng and argument. . . . Some time the fault is onely in the matier, and not in the maner of makyng and argument, whereof there are diuerse examples aboue rehearsed. Sometimes the faulte is bothe in the matier, and in the maner of makyng an argument.[78]

Although Arden editor R. W. David glosses Costard's speech as a "set expression of the time," perhaps the emphasis should be on "set," as the play's direct engagement with *The Rule of Reason* calls attention to the influence of printed books *about* speech in this period, many of which were easier to read than to be spoken aloud.

The textual history of the play in many ways foregrounds the difficulty in using the visual and largely decontextualized medium of print to *represent* an oral, theatrical, and contextually based medium, at least in the terms expected by many twentieth-century textual editors. G. R. Hibbard, for example, writes about the 1598 quarto:

Q is *unactable* for a number of reasons. First it is plagued by a superfluity and confusion of names. Of its twenty characters, only six . . . have each a single consistent speech prefix for their parts. . . . Such variations in nomenclature as these are, of course, common enough in a dramatist's early drafts, *where he is naturally more concerned with a character's relation to others on stage than with that character's often arbitrary personal name*, and they strongly suggest that Q represents the play in a pre-performance state (italics added).[79]

Hibbard here describes what he takes to be a confusing textual condition, but his words might well double as a reading of the plot of the play. Within *Love's Labour's Lost*, "unactability," or bad theater, is imagined as a condition of expanding literacy and social life, a product of emergent forms of textuality that impede what might otherwise be seen as fluid performances of selves, communities, and cultures. As for the "confusion of names," most readers of the play will attest to the difficulty of

keeping the names and identities of the characters straight, even when working with modernized editions with consistent speech prefixes. Many of the characters share such common linguistic traits stemming from linguistic habits of the sixteenth century that they are in many ways not only substitutes for each other, but substitutes for language itself. That is, the "characters' relation to others on stage," to adapt Hibbard's phrase, reflects a confusing textual condition linked to characters on the page. Within the play, it is precisely the logics of textual and representational "superfluity and confusion" that thwart the power of speech, recognition, theatricality, and coherent action. And given that *Love's Labour's Lost* is engaged with concerns about the implications of print and publication, it is only appropriate that the printed text of the play registers signs of the very "unactability" thematized by the play.[80] Indeed, R. W. David's description of the quarto, in which "[m]isprints abound, mostly 'literals'—one letter used for another," could not more perfectly describe the most basic plot element of the play: the mistaking of "one letter for another."[81] David's description of the printing of the quarto continues:

> The punctuation is chaotic: not even the most advanced theories of Elizabethan "rhetorical punctuation" can make it consistent even with itself. Most significant of all, the compositor had not learnt to "lock up" his type properly, so that when it was shaken, either in being carried to the press, on being dabbed with the inking balls, or under the stress of the actual impression, the letters tended to fall apart from each other or were jerked out altogether.[82]

The "stress of the actual impression," the lack of self-consistent punctuation, and the literal instability of the letter that led, in the printing of the quarto, to the disintegration of verbal units and coherent systems all find a conceptual counterpart in the play of letters, identities, and emotions in *Love's Labour's Lost*.

Linda McJannet has recently challenged the binarism between stage and page, emphasizing the way printed plays could "suggest aspects of an audience's aural and visual experience in the theater":[83]

> [T]he design of printed plays . . . had mimetic qualities: it preserved or extended dramatic decorum onto the page by suggesting

special vocal effects (such as reading aloud, dialects, or foreign languages), textual props (such as letters and proclamations), a cleared stage, and the movement of characters in and out of our field of vision.[84]

But at the same time, it might also be said that the more self-consciously textual (or "unactable") drama was, the more it could translate mimetically onto the printed page. What is suggestive about the first quarto of *Love's Labour's Lost* is the way in which font variations register the fundamental *writtenness* of the play. Indeed, it is the very writtenness of the play that disrupts mimesis on stage that most clearly translates, in true mimetic form, onto the printed page. The distinctly textual basis of Armado's melancholy, for example, is comically underscored by the fact that his first letter, "in ebon-coloured ink," is reproduced in the quarto in italic font:

> *Ferd. So it is besedged with sable coloured melancholie, I did commende the black opressing humour to the most holsome phisicke of thy health-geuing ayre: And as I am a Gentleman, betooke my selfe to walke: the time When? about the sixth hour, When Beastes most grase, Birds best peck, and Men sit downe to that nourishment which is called Supper: So Much for the time When. Now for the ground Which? which I meane I walkt upon, it is ycliped Thy Park. Then for the place Where? where I meane, I did incounter that obscene & most propostrous euent that draweth fro my snowhite pen the ebon coloured Incke, which here thou viewest, beholdest, suruayest, or seest.* (1.1.233–47)[85]

While italics are used in the conventional manner throughout the quarto to signify words that are not meant to be spoken, such as stage directions (*"He reads the Sonnet"*) and speech prefixes (*"Arm."*), they are also often used to signify words that are not *meant* to be spoken but are. The quarto italicizes outrageous inkhornisms (*"posterior* of the day"), foreign words (Holofernes' speeches are littered with italics), much of the pageant of the Nine Worthies (which has the effect of foregrounding the relative "unworthiness" of the actors), the communal Petrarchan love lyric from the Muscovites to the ladies (which is itself read by a *"Page"*), marks of writing (*"Item"*), and all nationalities and names. While the italicization of characters' names is a common feature of

printed plays, it nonetheless stands out in this particular text, as the typography aligns the very names of the characters within the play with other forms of distinctly written discourse. On the printed page, the speech prefix and the name exist in a typographic continuum; character meets character in a graphic enactment of the very "subject" of the play.

McJannet has further argued that the freestanding, left-hand speech prefix of Elizabethan page design visually "signals the autonomy and integrity of the character. He or she has a vocal and therefore existential independence, appearing in the dramatic text without introduction or qualification of any other discernable voice."[86] But while page design may preserve an "independence of voices and . . . theatrical presence," the integrity of voice can just as well be undermined by typographic features.[87] In addition to the typographic correlation between speech prefix and explicitly *written* elements of spoken utterance in *Love's Labour's Lost*, for example, the vocal and "existential independence" of characters can be seen to be undermined by the variation of prefixes, which alternate between individual names (Navarre, Holofernes, Jaquenetta) and social types (King, Pedant, Maid); as well as by the use of the same speech prefix for two different characters: *Boy* is a prefix used for both Moth and Boyet.[88] By and large, these and other seeming inconsistencies have been corrected in contemporary editions of the play. As such, a certain integrity of character and autonomy of voice has been edited into many modern editions by the standardization of speech prefixes and by the preference for distinctive names over character type.

If, as Smith has suggested, recent editing practices influenced by the primacy of visuality and print often downplay the sonic and embodied dimensions of early modern typography, so too do these editing practices (which standardize spelling and punctuation) often eclipse the striking textuality of many printed plays. Thematically as well as typographically, *Love's Labour's Lost* calls attention to the materiality of the text.[89] An edition of the play that retained many of the individuated letters in the quarto, rather than spelling them out, would highlight many of the play's jokes *about* letters. A line uttered shortly after Holofernes's veritable panegyric to the letter *L*, for example, which reads in the 1598 quarto as "Sir, I prayse the L. for you" becomes, in the 1623 folio, "I praise the Lord for you," a transcription that (though logical, as *L.* was a common abbreviation for *Lord*) dilutes what seems to be a fairly straightforward joke about the deification of letters and learning (partic-

ularly as Nathanial follows this praising of *L* with the line "and so may my parishioners, for their Sonnes are well tuterd by you").[90]

In this play about "characters," divinity is embodied in a capital *L*, beauty is "Faire as a text B" (5.2.42) and the very sigh of the lover is reduced to a text "so full of Oes" (45). Given the thematic emphasis on individuated letters, one can imagine a production of the play that, based on the quarto, would *not* translate single letters into words, and would, for example, highlight the graphic dimensions of the lover's vocabulary (riddled as it is with O's and I's). Particularly given the extent to which Rosaline foregrounds the silly literality of Berowne's "love letters," it is tempting to read the quarto text of Berowne's solitary lament, "O and I forsooth in loue," as if the letters themselves were the mutually enchanted subjects of the sentence (3.1.175).[91] The entrances and exits (the very first of which reads, "Enter Ferdinand K. of Nauar") might well be incorporated into dramatic performance. Such a performance would of course dramatize the editorial decisions at work for any reader or listener of the play, but it would also emphasize the thematized relation between alphabetic units and exclamations of love, and highlight the drama of a play that essentially stages itself as a book.

IV. TALKING CURES

So when love angred in thy bosome raves,
And grief with love a double flame inspires,
By silence thou mayst adde, but never lesse it:
The way is by expressing to represse it.
 —*Phineas Fletcher,* Poeticall Miscellanies *(1633)*

The Italians most part sleep away care and grief. . . . Danes, Dutchmen,
Polanders, and Bohemians drink it down; our countrymen go to plays.
 —*Robert Burton,* The Anatomy of Melancholy *(1621)*

It is no coincidence that many of Shakespeare's dramas about love and lost love double as conspicuous performances of literacy. In *Romeo and Juliet*, Capulet, with typical sensitivity, gives his illiterate servant an invitation list to read. The servant, exclaiming, "I must to the learned" (1.2.44), brings the list to Romeo, who baldly states, "I can read," and proceeds to demonstrate, reading the lengthy list aloud (1.2.57–71).[92]

The significance of this act as a performance of literacy is foregrounded by the fact that the actual content of the list is relatively insignificant in terms of the plot of the play — most of the names never surfacing again. Like Armado's Latinate letter to an illiterate wench, what is thematized here is, on the one hand, the social distinctions between literate and illiterate, and, on the other, the rapid flow of information between literate and illiterate communities through the phenomenon of reading aloud. This flow of information through oral reading is a hallmark of sixteenth-century discourses of love and the early modern theater alike.

Indeed, it might well be said that the performativity of an increasingly literate social world finds its parallel on the early modern stage. The dramatic figure of the love melancholic is a particularly charged locus of performativity where experiences of interiority are frequently counterposed with distinctly textual domains of prescribed subjectivity. In *Love's Labour's Lost,* the trauma of grief *is* the drama of literacy. Tropes of woe drawn from Petrarchan lyric double as (and are doubled by) tropes of a specific form of representational loss: a melancholy of representation where books render strange voices of passion and intimacy. This doubling is thematized even in the final act of the play as books lead — in more general terms — to thwarted communication between lover and beloved: "I understand you not, my griefs are double," says the grieving Princess after listening to Navarre's overly technical consolatory speech (5.2.744). Here bookishness has the effect of literally "doubling" grief. Not only does the lover fail as a speaker, but his failed speech leads to the production of sadness.

The position of the lover between script and speech, book and theater, is at once encapsulated and problematized in Shakespeare's Sonnet 23:

> As an unperfect actor on the stage,
> Who with his fear is put beside his part,
> Or some fierce thing replete with too much rage,
> Whose strength's abundance weakens his own heart;
> So I for fear of trust forget to say
> The perfect ceremony of love's rite,
> And in mine own love's strength seem to decay,
> O'ercharged with burthen of my own love's might.
> O let my books be then the eloquence,
> And dumb presagers of my speaking breast,
> Who pleade for love, and look for recompense,

More than that tongue that more hath more expressed.
O learn to read what silent love hath writ.
To hear with eyes belongs to love's fine wit.[93]

Like the drama of desire in the play, where "contempt will kill the speaker's heart / And quite divorce his memory from his part" (5.2.149–50), this sonnet imagines the silent and fearful lover in terms of an uncertain relation between actor and script. Like the play, "books" replace the voice of the lover and mediate the overwhelming passion of his "speaking breast." But what is represented here as a strength of love becomes a vulnerability on stage; the phenomenon of the silent and "imperfect actor," paired in the poem with a singular and unspeakable passion, translates on stage as a largely collective problem of emotional disengagement and vocal self-alienation. What is imagined in the sonnet as an erotics of synesthesia becomes on stage a comedy of disintegration, where "hearing with the eyes" what silent love hath writ foregrounds a distinctly alienated form of orality.

Love in an age of print may well have moved the rhetoric of intimacy further and further out of context, opening even wider the gap between lover and beloved already so integral to courtly love. But at the same time, for this poet-dramatist, for whom books became plays, and for whom printed cultures were transformed into communities of speech, perhaps hearing with the *ears* what silent love hath writ opened up a whole new way, in the early age of print, of both loving and learning by the book. For it is in the space of the theater, where pages come alive and characters body forth, where voices are already alienated from themselves, where books both take the breath away and give it life again, that the lost labor of love may well be found.[94]

NOTES

My warmest thanks to Marge Garber, Jeff Masten, Valerie Traub, Andrea Henderson, David Hillman, and the members of the Shakespeare Seminar at Harvard (particularly Bill Carroll and Coppélia Kahn) for commenting on an early draft of this essay.

1. Robert Burton, *The Anatomy of Melancholy*, ed. Lawrence Babb (Michigan: Michigan State University Press, 1965), 274. The link between the heart and the

tongue was commonplace in a range of medical and poetic discourses, in which, to quote John Lyly "the heart and tongue were twins at once conceived." "The heart and tongue were twins at once conceived," in *The Complete Works of John Lyly* (Oxford: Clarendon Press, 1902).

2. Baldasare Castiglione, *Il Cortegiano*, trans. Sir Thomas Hoby, *The Book of the Courtier* (London: 1561; reprint, *Tudor Translations*, no. 23), 269.

3. Mary Thomas Crane, *Framing Authority: Sayings, Self, and Society in Sixteenth-Century England* (Princeton: Princeton University Press, 1993), 136. While Crane invokes this commonplace only to go on to challenge the notion of the "self" in the lyric tradition, I want to take issue with the vocal dimensions of love in particular. Indeed, tropes of vocal impairment are particularly marked in Petrarchan discourses of sixteenth-century England, where allegories of poetic muteness converge with increasingly commonplace tropes of the lover's silent or stammering tongue. On a counterpart to the Petrarchan trope of speechlessness, the poetic appropriations of Philomela, see especially Ann Rosalind Jones, "New Songs for the Swallow: Ovid's Philomela in Tullia d'Aragona and Gaspara Stampa," in *Refiguring Woman*, ed. Marilyn Migiel and Juliana Schiesari (New York: Cornell University Press, 1991), 263–77; Jonathan Goldberg, *Voice Terminal Echo: Postmodernism and Renaissance Texts* (New York: Methuen, 1986); Patricia Klindienst Joplin, "The Voice of the Shuttle Is Ours," *Stanford Literary Review* 1 (1984), 25–53.

4. Amorous inarticulacy was of course not a new concept in this period. Indeed, the sense that one's heart belonged to another was frequently coupled with a sense that one's tongue was not one's own ("Then my tongue spoke," writes the love-struck Dante in *La vita nuova*, "almost as though moved of its own accord" [XIX]). Dante not only describes an act of poetic utterance as if words were being spoken through him, as though he has no control over his own voice or tongue, but experiences a kind of "organ failure" in the very presence of Beatrice (XIV). *La vita nuova*, trans. Barbara Reynolds (New York: Penguin, 1969). But this particular trope, the vocal-disposession of the love melancholic, becomes reanimated in the sixteenth century, as I will argue over the course of this essay, in contexts specific to the status of the voice in print.

5. John Florio, *First Fruits* (London, 1578), Sig. S3; reprints, *Florio's First Fruites*, Facsimile Reproduction, ed. Arundell del Re (1936), 165 (cited in Frances Yates, *A Study of* Love's Labour's Lost [London: Cambridge University Press, 1936], 43). My work in this essay is indebted to the early work of Frances Yates. But whereas Yates has located in the play a host of topical references to particular historical persons and court circles, arguing that the play is engaged with "anti-alien" (72) and "anti-pedagogical" (43) sentiments associated with Eliot and Florio, I want to argue that the play works in a broader

sense to stage cultural anxieties, not so much about persons as about books, about the increasingly explicit interanimation of technologies of speaking, writing, and print in a period of increased book production and public literacy. For important language debates in the play, see William C. Carroll, *The Great Feast of Language in Love's Labour's Lost* (Princeton: Princeton University Press, 1976), and for a summation of early critical perspectives on language in the play, see Louis Adrian Montrose, *"Curious-Knotted Garden": The Form, Themes, and Contexts of Shakespeare's* Love's Labour's Lost (Salzburg: University of Salzburg, 1977), 49–66.

6. Juliana Schiesari, *The Gendering of Melancholia: Feminism, Psychoanalysis, and the Symbolics of Loss in Renaissance Literature* (Ithaca: Cornell University Press, 1992). For an important psychoanalytic account of melancholia and masculinity in early modern literature, see Lynn Enterline, *The Tears of Narcissus: Melancholia and Masculinity in Early Modern Writing* (Stanford: Stanford University Press, 1995).

7. Schiesari, *The Gendering of Melancholia*, 48–49.

8. Margreta de Grazia, "Soliloquies and Wages in the Age of Emergent Consciousness," *Textual Practice* 9, 1 (1995), 67–92, 74.

9. The activity of reading was often described in physiological terms as a dominance of heart and eye over tongue. In Augustine's description of St. Ambrose reading silently, for example, "his eyes scanned the page, and his heart, explored the meaning, but his voice was silent and his tongue was still." St. Augustine, *Confessions*, trans. R. S. Pine-Coffin (Harmondsworth: Penguin Books, 1961), 114. Many symbolic accounts of the physiology of reading foreground the centrality of ocular and cardiac motion: Henry Peacham's emblem of *"Salomonis prudentia"* features an eye and heart floating over above an open book. Henry Peacham, *Minerva Britanna* (London, 1613), 40.

10. *Much Ado About Nothing*, in *The Arden Shakespeare*, ed. A. R. Humphreys (London: Routledge, 1988).

11. The sociolinguistic dimensions of love melancholy were frequently marked in send-ups of the speech pathologies of the lovesick, who were alternately mute or, to quote Nicholas Breton's 1592 *The School of Fancie*, full of "straunge languages." John Eliot's 1593 *Ortho-Epia Gallica*, a satiric manual on English and French tongues, for example, features an extended dialogue about a lovesick versifier in order to expose deficiencies of speech; while he will "neuer speake to any bodie," he is "always mumbling or recording some thing in English verse, that he hath made to his sweet-heart and minion." *Ortho-Epia Gallica: Eliots Frvits for the French: Enterlaced with a double new Inuention, which teacheth to speake truely, speedily and volubly the French-tongue* (London, 1593; photostat facsimile reproduced from the Huntington Library copy), 159.

12. On the "bibliographic ego," see Joseph Lowenstein, "The Script in the Marketplace," in *Representing the English Renaissance*, ed. Stephen Greenblatt (Berkeley: University of California Press, 1988), 265–78.

13. Sigmund Freud, "Mourning and Melancholia," in *The Standard Edition of the Complete Psychological Works*, trans. J. Strachey (London: Hogarth, 1953–74), 14:243–58, 248.

14. George Whetstone, *An Heptameron of Ciuill Discourses* (London, 1582), *A Critical Edition of George Whetstone's 1582 An Heptameron of Civill Discourses*, ed. Diana Shklanka, *The Renaissance Imagination*, vol. 35 (New York: Garland, 1987), 114.

15. Margreta de Grazia and Adrian Johns have recently explored the complex lexicon of "impression" in early modern England. See de Grazia, "Imprints: Shakespeare, Gutenburg, Descartes," *Alternative Shakespeares*, vol. 2, ed. Terence Hawkes (London: Routledge, 1996), 63–94; Johns, *The Nature of the Book: Print and Knowledge in the Making* (Chicago: University of Chicago Press, 1998), 380–443.

16. Andre Du Laurens, *Discourse of the Preservation of the Sight: of Melancholike Diseases; of Rheumes, and of Old Age* (London, 1599), 96–97.

17. Jacques Ferrand, *Erotomania, A Treatise Discoursing of the Essence, Causes, Symptomes, Prognosticks, and Cure of Love or Erotique Melancholy* (Oxford, 1640), 259–60.

18. On metaphors of print at work in Falstaff's easy loving, see Elizabeth Pittenger, "Dispatch Quickly: The Mechanical Reproduction of Pages," *Shakespeare Quarterly* 42 (Winter 1991) 4:389–408.

19. Timothy Bright, *A Treatise of Melancholie* (London, 1586), facsimile reproduction (New York: Columbia University Press, Facsimile Text Society, 1940), sig. A1.

20. Michel de Montaigne, "On Schoolmasters' Learning," in *The Complete Essays*, trans. M. A. Screech (New York: Penguin, 1991), 156.

21. John Brinsley, *Ludus Literarius: Or, The Grammar School* (London, 1612), 64.

22. William Salisbury, Letter to the Reader, *A brief and a playne introduction, teachyng how to pronounce the letters in the British tong, (now comenly called Walsh) wherby an English man shal not only w[ith] ease read the said tong rightly: but . . . attain to the true and natural pronunciation of other expediente and most excellent languages set forth by D. Salesburye* (London, 1550, reprinted Menston, UK: Scolar Press Limited, 1969). George Delamothe. Epistle to the Reader, *The French Alphabeth, Teaching in a very short time by a most easie way, to pronounce French naturally, to reade it perfectly, to write it truely, and to speake it accordingly* (London, 1595).

23. Erasmus, *De duplici copia verborum ac rerum commentarii duo* (1512), trans. Betty I. Knott, *Collected Works of Erasmus: Literary and Educational*

Writings, ed. Craig R. Thompson (Toronto: University of Toronto Press, 1978), 24:279–660, 492–93.

24. Leonard Hutten, *Bellum grammaticale sive nominum verborumque discordia civilis* (London, 1635; reprint, *Renaissance Latin Drama in England*, 12 vols. [Hildesheim: G. Olms Verlag, 1982], vol. 1). Interestingly, one of the major changes Hutton made when adapting the Italian humanist Andrea Guarna's prose text *Bellum Grammaticale* (1511) for the stage was that he made Poeta a melancholy (rather than a military) figure. For the publication history and context of *Bellum Grammaticale,* see Frederick S. Boas, *University Drama in the Tudor Age* (Oxford: Clarendon Press, 1914), esp. 256–58. Guarna's text was translated into English, French, and Italian, circulated widely in the sixteenth century, translated into English by William Hayward in 1576, and first adapted for the stage by Leonard Hutton. Hutton's play was performed for Elizabeth at Christ's Church in September 1592 but was staged earlier as well: Boas notes Sir John Harington's reference to "our Cambridge Pedantius and the Oxford Bellum Grammaticale" in 1591 (Boas, *University Drama,* 255). See Andrea Guarna, *Bellum Grammaticale: A Discourse of great War and Dissention between two worthy Princes, the* Noune *and the* Verbe, *contending for the chefe Place of Dignitie in Oration. Very pleasant and profitable,* trans. William Hayward (London, 1576; reprint, London, 1809, *A Collection of Scarce and Valuable Tracts, on the Most Interesting and Entertaining Subjects,* 13 vols., 2nd ed., Sir Walter Scott, 1:533–54).

25. I am quoting here from Hayward's 1576 translation of *Bellum Grammaticale,* 545. Also, for a variation of "Amo" as a character on stage and a principle of Latin grammar, see Samuel Shaw, *Words Made Visible: or Grammar and Rhetorick Accommodated to the Lives and Manners of Men, Represented in a Country School for the Entertainment and Edification of the Spectators* (London, 1679; reprint, *English Linguistics 1500–1800* [Menston, UK: Scolar Press, 1972]).

26. Jacques Bellot, *The Englishe Scholemaister* (London, 1580; reprint, *English Linguistics 1500–1800: A Collection of Facsimile Reprints,* ed. R. C. Alston [Menston, UK: Scolar Press, 1967]).

27. For Nancy Vickers' most recent work on the anatomical blazon, see "Members Only: Marot's Anatomical Blazons," in *The Body in Parts: Fantasies of Corporeality in Early Modern Europe*, ed. David Hillman and Carla Mazzio (New York: Routledge, 1997), 1–23. Also, on the relationship between humanist and courtly models of "gathering and framing," see Mary Thomas Crane, *Framing Authority: Sayings, Self, and Society in Sixteenth-Century England* (Princeton: Princeton University Press, 1993).

28. While John Florio suggests that it is labor lost to speak of love, he nonetheless benefits from the words of "so many authores," deploying the poetics and textual commonplaces of love as a basis of knowledge and discourse

for the purposes of translation and language learning. His English/Italian textbook *Second Fruits* (1591) devotes an entire dialogue to the pros and cons of the anatomical blazon, as well as a dialogue to the "discourse . . . of love," which consists of a seemingly endless list of proverbs and commonplaces, loosely disguised as a conversation about love. So too, Florio's *First Fruits* includes chapters on "Amarous talke"; "Discourses vpon Musicke and Loue"; "A discourse vpon Lust, and the force thereof"; "The opionion of Marcus Aurelius and Ovid, upo Loue, and what it is." Similarly, John Eliot's 1593 *Ortho-Epia Gallica* (a language and pronunciation manual with English and French on facing pages) includes a dialogue about love melancholy, reproduces a supposedly authentic love letter, and features an extended example of the anatomical blazon (see especially 155–63).

29. Vickers, "Members Only: Marot's Anatomical Blazons," 14. Also see, "Diana Described: Scattered Woman and Scattered Rhyme," *Critical Inquiry* 8 (1981), 265–80.

30. Vickers, "Members Only: Marot's Anatomical Blazons," 14.

31. On Holofernes as a send-up of Florio, see Yates, *A Study of* Love's Labour's Lost (who follows Warburton), esp. 35, 136.

32. A suggestive gloss to the spatial emphasis of being "in love" might be the Ramist treatment of "passion" in Thomas Blundeville's 1599 *The Art of Logike*, where emotion is represented diagrammatically on a single page, divided into categories, sets, and subsets in "The Table of Passion and passible qualitie" (*The Art of Logike* [London, 1599]; reprint, *English Linguistics 1500–1800* [Menston, UK: Scolar Press, 1967], 31). The influence of Ramism in English texts on rhetoric and logic in the late sixteenth century, as I will discuss shortly, may well inform this English play about a French academy where passion is, in a manner of speaking, put in its place.

33. Erasmus, *De copia*, 321.

34. In Armado's case, listing is a kind of speech exercise learned from printed books *about* speech. Although praising the good god of "extemporal" rhyme, his soliloquy about "turn[ing] sonnet" in the first act of the play reads much like the strings of commonplaces in Florio's language manuals: "Love is a familiar; Love is a devil: there is no evil angel but Love" (1.2.162–63) might be juxtaposed to a speech in Florio's *First Fruits,* which reads, "Loue is a delectable despite, and a spitefull delight. Honest loue is ordeyned of God: dishonest loue is forbydden of God. . . . Loue maketh it easie: that hardest thing that is" (71). Interestingly, this particular "dialogue" includes the lines "We neede not speak so much of loue, al books are ful of loue, with so many authours, that it were labour lost to speake of Loue" (71).

35. Peter Levins, "Preface to the Reader," *Manipulus Vocabulorum: A Dictionarie of English and Latine wordes* (London, 1550), reprint, *English Linguistics*

1500–1800 (Menston, UK: Scolar Press Limited, 1969). Importantly, Levins' text was the first dictionary published in England to be organized according to both alphabet and rhyme. Clearly designed for scholars and poets, it offers an early instance where the acoustical structure of rhyme is itself prescribed, visually organized, and made broadly available through the medium of print. It is no coincidence, in this respect, that the poem and the dictionary are never far apart in *Love's Labour's Lost*. While bad poets Armado and Holofernes are famous for speaking in "strings of synonyms," Moth goes so far as to imagine his poem or "dangerous rhyme" as a veritable definition (1.2.86–101). The textual dimensions of the rhyme, and even the translation dictionary itself, are registered by Moth's plea in creating it: "My father's wit and my mother tongue assist me!" (89).

36. On the cognitive and graphic features of the list in cultures of writing and print, see Jack Goody, "What's in a List," in *The Domestication of the Savage Mind* (Cambridge: Cambridge University Press, 1977), 74–111. "The list relies on discontinuity rather than continuity; it depends on physical placement, on location; it can be read in different directions, both sideways and downwards, up and down, as well as left and right. . . . Most importantly it encourages the ordering of the items, by number, by initial sound, by category, etc." (81).

37. On the lack of an "oral equivalent" for lists, see Goody, "What's in a List," 86–87.

38. Anon., *A very necessarye boke bothe in Englyshe & in Frenche* (1550; reprint, Menston, UK: Scolar Press, 1967).

39. For a categorical list of terms and phrases, see also Delamothe, *The French Alphabet* (1595).

40. Jacques Bellot, *Familiar Dialogues* (London, 1586; reprint, Menston, UK: Scolar Press, 1969).

41. "Green indeed," says Armado at one moment in the play, "is the colour of lovers" (1.2.81). Although this statement has frequently been read as a reference to Shakespeare's contemporary Robert Greene (see Arden, *Love's Labour's Lost*, 22 n. 81), it is also part of a conversation about the literal "colors of love" that culminates in Moth's own poem or "definition" of "white and red" (88–100).

42. William Carroll, for example, writes that "[t]he songs throughout embody the fusion of Art and Nature in a perfect whole" (220), and Thomas Greene reads the songs as "rhetorical touchstones by which to estimate the foregoing abuses of language" (*"Love's Labor's Lost:* The Grace of Society," *Shakespeare Quarterly*, 22 [1971], 315–28, 325).

43. Jacques Bellot, *The French Method* (London, 1588), Sig. Aa1.

44. The text reads: "The fox, the ape, and the humble-bee, / Were still at odds, being but three" (3.1.85–86), a play with numbers that recurs when the "three" embarrassed lovers become "four" in the sonnet-reading scene: "The

number now is even," says Dumain, to which the guilty Berowne responds, "True, true; we are four" (4.3.207–8).

45. On the movement of the lyric into print, see especially Wendy Wall, *The Imprint of Gender: Authorship and Publication in the English Renaissance* (Ithaca: Cornell University Press, 1993); Arthur Marotti, *Manuscript, Print, and the English Renaissance Lyric* (Ithaca: Cornell University Press, 1995); and Elizabeth Pomeroy, "England's Helicon: Music and Poetry in a Pastoral Anthology," *Elizabethan Miscellanies: Development and Conventions* (Berkeley: University of California Press, 1973), 93–115. The detachment of lyric from its origins in music and oral performance was in many ways marked by the proliferation of poetry on the printed page, and by the increased attention to the visual structure of poetry in the 1580s and 1590s. As Diana E. Henderson writes, "[W]ith the rise of printing and the circulation of sonnet manuscripts and miscellanies; unlike the poetry of many early Tudor courtly makers, whose lyric compositions were often recited or set to lute music . . . many Elizabethan lyrics were addressed primarily to a reading audience." *Passion Made Public: Elizabethan Lyric, Gender, and Performance* (Chicago: University of Illinois Press, 1995), 216.

46. *Tottel's Miscellany*, ed. Hyder E. Rollins, 2nd ed. (Cambridge, 1965), 2:108.

47. The clichés in Eliot's letter are themselves integrated into dialogue in the play, as Berowne says, "White-handed mistress, one sweet word with thee," to which the Princess responds, "Honey, and milk, and sugar: there is three" (5.2.230–31).

48. Andrew Gurr, *Playgoing in Shakespeare's London* (Cambridge: Cambridge University Press, 1987), 81.

49. On print and the visual orientation of Western culture, see especially Walter J. Ong, *Orality and Literacy: The Technologizing of the Word* (London: Methuen, 1982), *Rhetoric, Romance, and Technology* (Ithaca: Cornell University Press, 1971), and *Ramus, Method and the Decay of Dialogue* (Cambridge: Harvard University Press, 1958); and Marshall McLuhan, *The Gutenberg Galaxy: The Making of Typographic Man* (Toronto: University of Toronto Press, 1962).

50. Wall, *The Imprint of Gender*, 190–91, n. 40. As she writes in the same note, "If we consider this period a shift to an era in which plays are seen and reading is a private visual act, then the sonnets' preoccupation with seeing makes sense. Renaissance works generally exploit the destabilizing transition to a more sight oriented culture." Similarly, in a discussion of the visual and magical dimensions of Renaissance love sonnets, Linda Woodbridge writes in *The Scythe of Saturn: Shakespeare and Magical Thinking* (Chicago: University of Illinois Press, 1994), "Sonnet readers brought with them a vast visual semiotics of sexuality and fertility and learned to apply it to the visual and imaginative experience of reading. The very exercise must have enhanced the powers of the

eye. . . . When sonnets were printed, ancient fertility magic met modern technology, and their mutual ocularity multiplied their visual impact" (260).

51. "O, if the streets were paved with thine eyes, / Her feet were much too dainty for such tread" (4.3.274). Strikingly, Dumain responds by pointing out what an advantageous position this would be for a lover to see up his mistress's skirt as she walks "overhead" (4.3.274–76), quickly transforming a vivid antiblazon of the lover's own eyes into the lover's glimpse into "what upward lies," reasserting the power of the gaze over (even as it is tread upon by) the female body.

52.While the king's expressions are described as marginalia (his "face's own margent did quote such amazes" [2.1.245]), the scholars themselves, variously described as "book-men" (2.1.226), "book-mates" (4.1.101) and "men of note" (3.1.22), seem less an "academy" than a collection of books. Though Berowne says that bookishness is metonymic, that "learning is but an adjunct to ourself" (4.3.310), it is, in fact, synecdochal, and it is the textual parts that stand in for, and negotiate the identity of, the self. To be an academic as well as a lover in this world is literally to *embody* principles of textuality in a culture of print.

53. Shakespeare's "sonnet play," as Robert Giroux has called it, has often been read as a dramatization of tropes inherent in the Petrarchan lyric (*The Book Known as Q* [1982], 140–141, cited in *The Sonnets*, ed. G. Blakemore Evans [Cambridge: Cambridge University Press, 1997], 5 n. 3). William C. Carroll, for example, writes that "[t]he sonnet-reading scene indicates how in passages like these the linguistic dimension of the play finds an exact counterpart in the dramatic structure" (69). And more recently, David Schalkwyk and Diana Henderson have explored the social and political dynamics made explicit when sonnet turns plot; when monologue turns dialogue; when absent mistress materializes and now literally gazes at and through the poet, mocking and showing him up at every step. Schalkwyk, " 'She never told her love': Embodiment, Textuality, and Silence in Shakespeare's Sonnets and Plays," *Shakespeare Quarterly* 45 (1994), 381–407, and Henderson, *Passion Made Public*.

54. Wall, *The Imprint of Gender*, 179.

55. It is a wonderful irony in this respect that one of the first responses we have to *Love's Labour's Lost* should be written by a second-rate sonneteer and a self-professed melancholic: Robert Tofte's 1598 poem about *Love's Labour's Lost* was itself printed in his volume of love poems, *Alba: The Month's Mind of a Melancholy Lover* (London, 1598).

56. Arthur Marotti, *John Donne: Coterie Poet* (Madison: University of Wisconsin Press, 1986), 3.

57. Thomas Nashe, *Pierce Penilesse* (fol. 2, sig. B2), in *The Works of Thomas Nashe*, ed. Ronald B. McKerrow, vol. 1 (Oxford: Blackwell, 1958).

58. Edmund Coote, *The English Schoole-Maister, Teaching all his Scholers, of what age soever, the most easie, short, and perfect order of distinct reading, and true writing our English tongue* (London, 1596), reprint, *English Linguistics 1500–1800 (A Collection of Facsimile Reprints)*, ed. R. C. Alston (Menston, UK: Scolar Press, 1968). Like many other prefaces designed to appeal to a broad social spectrum, Coote invokes "scholar" to describe potential readers no less than thirteen times in the four-page preface. The book was extraordinarily popular, printed fifty-four times between 1596 and 1737.

59. Thomas O. Sloan, "The Crossing of Rhetoric and Poetry in the English Renaissance," in *The Rhetoric of Renaissance Poetry from Wyatt to Milton*, ed. Thomas O. Sloan and Raymond B. Waddington (Berkeley: University of California Press, 1974), 231.

60. As Anthony Grafton and Lisa Jardine note in *From Humanism to the Humanities* (Cambridge: Harvard University Press, 1986), Ramus looked to poetry as a way to synthesize eloquence and philosophy, so much so that, as one French contemporary put it, "He holds that philosophy is far better taught from poets than from philosophers. In this obscure conjunction of philosophy and eloquence, he teaches no Aristotle, no philosophy, but pretty much poetry alone" (167).

61. Ong, *Ramus, Method, and the Decay of Dialogue*, 308.

62. Ibid., 289.

63. Ibid., 287 (also cited in Sloan, "The Crossing of Rhetoric and Poetry in the English Renaissance," 233).

64. Bruce Smith, "Prickly Characters," in *Reading and Writing in Shakespeare*, ed. David Bergeron (Newark: University of Delaware Press, 1996), 25–44, 27. So, too, Marion Trousdale suggests that Shakespeare "reflects in his techniques as author the habits of an oral age" in which "language was speech." "Shakespeare's Oral Text," in *Renaissance Drama*, ed. Alan C. Dessen (Evanston: Northwestern University Press, 1981), 12:95–116, 105, 98. For a variation of this argument, see Trousdale's "Shakespeare's Oral Art," in *Shakespeare and the Rhetoricians* (Chapel Hill: University of North Carolina Press, 1983), 55–64.

65. *John Hart, A Methode or comfortable beginning for all unlearned whereby they may be taught to read English, in a very short time, with pleasure* (London, 1570; reprinted in *John Hart's Works on English Orthography and Pronunciation*, ed. Bror Danielsson [Stockholm: Almquist and Wiksell, 1955], 235).

66. As Lowenstein suggests in "The Script in the Marketplace," "print stimulated a competitive relation between book and person, a competition for preeminence as the locus of intellectual summation" (265).

67. Coote, *The English Schoole-Maister*, preface.

68. Anon., *Heteroclitanomalonomia*, in *The Malone Society Collections*, vol. 16 (Oxford: Oxford University Press, 1988), Fol. 121a.

69. Samuel Shaw, *Words Made Visible: or Grammar and Rhetorick Accommodated to the Lives and Manners of Men, Represented in a Country School for the Entertainment and Edification of the Spectators* (London, 1679).

70. This is not to say that the play implicitly valorizes the "converse of breath" as *contrasted* to the world of reading and books, as Malcolm Evans and Terence Hawkes have argued, but rather that it draws attention to the interanimation of speech and silent reading which is a consequence of the increasing literacy of the late sixteenth-century. See especially Malcolm Evans, "The Converse of Breath," in *Signifying Nothing: Truth's True Contents in Shakespeare's Texts* (Athens: University of Georgia Press, 1986), 39–98; "Mercury versus Apollo: A Reading of *Love's Labor's Lost,*" *Shakespeare Quarterly* 26 (1975), 113–27; and Terence Hawkes, "Shakespeare's Talking Animals," *Shakespeare Survey* 24 (1977), 47–54.

71. *A Midsummer Night's Dream*, in *The Arden Shakespeare*, ed. Harold Brooks (London: Methuen, 1979), 3.

72. *The Riverside Shakespeare*, ed. G. Blakemore Evans (New York: Houghton Mifflin, 1997), 247.

73. Burton, *Philosophaster* (1606), trans. Paul Jordon Smith (Stanford: Stanford University Press, 1931), 19.

74. See note 70, above.

75. Kenneth Muir, *Shakespeare's Comic Sequence* (New York: Barnes and Noble, 1979), 41.

76. Wilson, *The Rule of Reason*, ed. Richard S. Sprague (Northridge, CA: San Fernando Valley State College Press, 1972), 198.

77. Many critics have drawn on *The Art of Rhetorique* (1553), for example, to gloss Armado's first letter (see Carroll, *Great Feast of Language*, 48–49) but have glossed over a whole range of extraordinary passages in *The Rule of Reason* that seem to come alive over the course of *Love's Labour's Lost*.

78. Wilson, *The Rule of Reason*, 208–10.

79. *Love's Labour's Lost*, ed. G. R. Hibbard (Oxford: Clarendon Press, 1990), 57–59.

80. The centrality of the book as a structuring mechanism for the play surfaces again and again in the descriptive language of critics of the play, who often imagine it less a play than a book: Granville-Barker writes about the "pages and pages of . . . smart repartee," and Samuel Johnson writes that there is not "any play that has more evident marks of the hand of Shakespeare" (excerpted in *Shakespeare's Early Comedies*, ed. Pamela Mason [London: Macmillan Press, 1995], 194, 190). Yates imagines the play as a veritable "essay" (*A Study of Love's Labour's Lost*, 122), and Rosalie Colie refers to the play as "an anthology . . . a textbook of literary *copia* and resource" and sees each character dressed in "linguistic garb, as fully identifying as his social

role and costume" (*Shakespeare's Living Art* [Princeton: Princeton University Press, 1974], 49, 43).

81. David, xvii.

82. Ibid.

83. Linda McJannet, "Elizabethan Speech Prefixes," in *Reading and Writing in Shakespeare*, ed. David M. Bergeron (Newark: University of Delaware Press, 1996), 45–63, 59–60.

84. I thank Linda McJannet for sending me the proofs of "Mimesis in Printed Plays," an unpublished version of "Elizabethan Speech Prefixes," 69–73, 69, 73. On the expressive and largely oral dimensions of printed plays, see also Anthony Graham White, *Punctuation and its Dramatic Value in Shakespearean Drama* (Newark: University of Delaware Press, 1995).

85. *Shakspere's Loves Labors Lost: The First Quarto, 1598, A Facsimile in Photo-Lithography*, ed. William Griggs (London: W. Griggs, 1880).

86. McJannet, "Elizabethan Speech Prefixes," 53.

87. Ibid., 61.

88. The fact that the first woman Berowne converses with in the quarto is not "Ros," as most modern editions suggest, but "Kath," is also suggestive in terms of the autonomy of voice and character in the play. Although I do not agree with Capell, who argues that Berowne here does and should be speaking to "Kath," it is suggestive that what seems to be a straightforward compositorial error anticipates the ultimate confusion of lover and beloved in the masque of the Muscovites, where Berowne thinks he speaks to "Ros," but in fact speaks to someone with a very different speech prefix. This gives a whole new meaning to "wooing but the sign of she." On the logic of Capell's reading, see David, xx–xxi.

89. The idea of the material text surfaces again and again in the play to articulate a crisis of self-referential mediation, where desires articulated in and through visible texts are suspect at best. Rituals of courtship are marked by an embarrassingly graphic circulation of the love letter, which is amorous and alphabetic at once: "Ware pencils, ho! let me not die your debtor, / My red dominical, my golden letter: / O! that your face were not so full of O's," says Rosaline, in mock description that exposes the textual self-reference of the anatomical blazon (5.2.44–45).

90. *Loues Labour's lost, The First Folio of Shakespeare*, 1623, facsimile prepared and introduced by Doug Moston (New York: Applause, 1995), 131.

91. O and I, the two capital letters that most frequently stand alone in expressions of affective intensity throughout Shakespeare's plays, seem to veritably jump off the pages of the quarto and folio texts of *Love's Labour's Lost*, particularly in light of Rosaline's "literal" reading of Berowne's poem. But indi-

viduated letters that may visually enact elements of the plot are frequently modernized (*O* to *Oh*, *L*. to *Lord*) by contemporary editors, and what is often edited out is the self-referential absurdity of the lover's alphabet. Berowne's speech in the Arden begins "O! and I forsooth in love!" (3.1.168).

92. *Romeo and Juliet*, *The Riverside Shakespeare*, ed. G. Blakemore Evans (Houghton Mifflin: New York, 1997). I thank Coppélia Kahn for encouraging me to think twice about this particular list.

93. Shakespeare, Sonnet 23, *Shakespeare's Sonnets*, ed. Stephen Booth (New Haven: Yale University Press, 1977), 23.

94. As an analogue to what I am suggesting about the curative dimensions of theater, the activity of talking was often prescribed as a cure for melancholia in early medical texts. As Du Laurens writes in *Discourse of the Preservation of the Sight*, because the love melancholic "loues silence out of measure," the physician "must first of all assay to draw him with fayre words from these fond and foolish imaginations" (122). If conversation with one individual fails, then "diuers men" should be called upon to perform a communal act of name calling: "calling his mistress light, inconstant, foolish, deuoted to varietie, mocking and laughing to scorne this his greife . . ." (122–23). Though spoken words would ideally be "sufficient and able to cure this inchauntment" (123), often, confesses Du Laurens, words "can doe very little in place where melancholike conceitedness hat taken roote" (123). In *Erotomania*, Ferrand, following Burton, goes so far as to recommend "Plaies" along with other distractions such as music and feasts as a cure for the melancholic (326).

DOUGLAS TREVOR

GEORGE HERBERT AND THE SCENE OF WRITING

A Lord I had,
And have, of whom some grounds, which may improve,
I hold for two lives, and both lives in me.

—George Herbert, *"Love Unknown"*

You see that there are reasons why I advise you to read religious authors
from time to time; I mean good ones, of course.

—*Jacques Lacan,* Seminar VII

In search of a material marker to illustrate the paradoxical presence of his God as both giver and recipient of praise and devotion, George Herbert turns, in "Providence," to the pen he holds in his hand: "[S]hall I write," he asks his divine auditor, "/ And not of thee, through whom my fingers bend / To hold my quill? shall they not do thee right?" (2–4).[1] His fingers gripping the writing implement through the power of God himself, Herbert sees that his question turns back on itself: How could he not write for God, since it is through him that he writes— through him that he does "thee right"—in the first place? The second stanza of "Providence" restates and complicates the question of writing,

and with it the notion of human agency put forth in *The Temple. Sacred Poems and Private Ejaculations* (1633):

> Of all the creatures both in sea and land
> Onely to Man thou hast made known thy wayes,
> And put the penne alone into his hand,
> And made him Secretarie of thy praise. (5–8)

As "Secretarie of thy praise," Herbert writes not only for another, but about another at that other's request. The figure of the secretary calls into question how we are to understand the authorship of written texts and, with Herbert's theological concerns in mind, the exercise of human will.

In the close relationship Herbert postulates throughout *The Temple* between writing and religious devotion, the very practices intrinsic to versifying are seen as amenable to—and even exemplary of—the devout life. Again and again, Herbert seizes on the material procedures inherent in composing poetry and juxtaposes them with the practices intertwined with Christian belief, such that at times writing about and believing in God appear as mutually inclusive, cross-fertilizing endeavors.[2] In that scenes of self-analysis so often give way to moments of divine communion, Herbert's verse seems to conform most fully to expressly Protestant modes of understanding and appropriating scripture, reflecting what Elizabeth Clarke and others have termed the "Reformation emphasis on the effectiveness of the written word for salvation."[3]

Herbert's descriptions of writing demonstrate the complicated sense of agency that permeates his verse, agency that is at once acted upon and self-acting. As numerous studies have demonstrated, the Reformation theology that shaped Herbert's religious beliefs also influenced his poetic praxis.[4] And yet, as the diverse interpretations spawned by these doctrines—in both Herbert's day and our own—make clear, the verses that comprise *The Temple* resist uniform explication through the lenses provided by theological and doctrinal texts. Building on the work of scores of Herbert scholars themselves invested in exploring the intersection of historical contexts with poetic stylistics,[5] Michael Schoenfeldt has recently utilized theoretical paradigms and methodological practices associated with the new historicism in order to explore "the historically embedded language of Herbert's poetry."[6] Reacting to these literary strategies, Richard Strier points out that "[s]ince the Reformation posits the centrality of an internal, nonritual experience, it becomes a special

difficulty for New Historicism."[7] While the sociocultural orientation of the new historicism can prove invaluable — as I hope to show — in establishing the terms by which human agency was explicated by Herbert, understanding Herbert's notion of selfhood means stepping beyond, or back from, the emphasis often placed by new historicists on social exchanges and public self-fashionings.

In this essay I pursue a reading of Herbert's verse that emphasizes his attention to the material processes of writing and his rendering of the self as it is shaped and enriched through Christian belief. Through Herbert's work, I argue that early modern confessional lyricists offer a way of historicizing and explicating fundamental concepts and concerns of Lacanian psychoanalysis. I also consider the ways in which Jacques Lacan's own theorization of psychoanalysis is explicitly and implicitly indebted to Judeo-Christian motifs and significantly influenced, as Lacan himself insists, by early modern religious discourses. Questions of devotion, so integral to Herbert's project as a poet, also play a part in Lacan's self-presentation as the most truly Freudian of Sigmund Freud's followers. While mindful of the enormous differences between a Renaissance English parson and a twentieth-century French psychoanalyst, I suggest nonetheless that Herbert's laboriously and self-consciously fashioned scene of writing anticipates the scene of analysis as it is imagined by Lacan, that the latter constructs his own rhetoric of devotion keenly aware of his Renaissance precursors, and that the Jewish science of Freud's psychoanalysis is — in the hands of his foremost French disciple — rendered as peculiarly reformed through allusions and analogies that secularize religious topoi while at the same time spiritualizing psychoanalytic terminology.

Through his frequent descriptions of collaborative scenes of composition, Herbert demonstrates a distinctly Protestant understanding of human agency whereby the self is irrevocably split by sin, capable of being saved only by the grace of God. And yet to posit that the devotional subjects of Herbert's confessional lyrics yearn for salvation is not to argue that such subjects desire unified, holistic selves, or even think in such terms. In Protestant theology the movement is often simultaneously toward a self enriched by God and away from a self that is fallen. Donne, for instance, thanks his Lord in *Devotions Upon Emergent Occasions* for having "clothd me with thy selfe, by stripping me of my selfe," while, in Paul Harland's wonderful reading of *Devotion XVII*, the "island of which Donne speaks is a pun, for if no man is an I-land, a domain of

self alone, every man is potentially a Christ."[8] Such alterity is grounded, according to Protestant theologians, in scripture itself. Martin Luther, for instance, glosses Galatians 3:28 ("There is neither Jew nor Greek, there is neither bond nor free, there is neither male nor female: for ye are all one in Christ Jesus") by insisting that "in Christ, where there is no law, there is no difference of persons, there is neither Jew nor Grecian, but all are one."[9]

Luther's indifference to individual identity mirrors his insistence that it is through the grace of God alone that the human soul can be saved, a position itself developed principally through readings of the Pauline Epistles and Augustine's later works. Again according to Luther, Christ enriches the life of the believer, while to exist without Christ in oneself is to be damned, "for 'I' as a person separate from Christ belongeth to death and hell . . . Christ therefore, saith he [Paul], thus joined and united unto me and abiding in me, liveth this life in me which now I live; yea Christ himself is this life which now I live. Therefore Christ and I in this behalf are both one."[10]

Intriguingly, Lacan comes to resemble Herbert and other early modern Protestant lyricists and theologians when he emphasizes the reliance of the self on an external gaze in which — paradoxically — the language of self-scrutiny resides.[11] Reading Lacanian psychoanalysis through Protestantism — and, in this essay, Herbert in particular — reveals the debts that Lacan owes to Renaissance religious thinkers. While contemporary Lacanian theorists are for the most part hesitant to acknowledge these debts, Lacan certainly was not.[12] At one point in *Seminar VII*, for example, he insists that if you want to "understand Freud's position relative to the Father, you have to go and look up the form it is given in Luther's thought." And even more pointedly, in the same seminar, Lacan traces some of the images Freud has invested "with the quality of scientific authentication" back to Luther: "His [Luther's] choice of words is in the end far more analytic than all that modern phenomenology has been able to articulate in the relatively gentle terms of the abandonment of the mother's breast."[13] Precisely because he predates psychoanalysis, because he is ungently polemical and rebellious, and vehement in his doctrinal convictions, Luther is useful to Lacan. He articulates nothing less than "the essential turning point of a crisis from which emerged our whole modern immersion in the world."[14] He invents, in other words, the subject on which the tenets of Lacanian psychoanalysis are based.

According to Philip Rieff, psychoanalysis represents a return to early modern modes of self-introspection: "To the therapeutic of the mid-twentieth century, as to the ascetic of the Reformation movements, all destinies had become intensely personal and not at all communal. The way to this self-knowledge, which may be in itself saving, is to trace back a person's conduct from symptom to the inner conditions responsible for that symptom."[15] That these symptoms might themselves be diagnosed in vastly different ways, depending upon the historical surround of the subject, Debora Shuger has made clear.[16] More fundamentally, however, for both Herbert and Lacan, self-knowledge is in many ways an impossibility, as human agency is understood as not only fractured but *constituted* by its collaboration with another: God, in Herbert's nomenclature, the Other in Lacan's.[17] Jonathan Dollimore is right, I think, to point out that "post-structuralism rediscovered what the Renaissance already knew: identity is powerfully—one might say essentially—informed by what it is not."[18] For the poet acutely aware of the material context of his work, perhaps no person better embodies displaced identity than the secretary who writes on behalf of another.

In Jonathan Goldberg's account of early modern secretaries, the (male) writer is acknowledged as "a living pen" of his master, but also as a pen enriched rather than demeaned by its subservience to another. Reading Angel Day's *The English Secretary* (1586, 1592), Goldberg concludes that "the self that the secretary acquires is founded in an institutionalized selflessness (the privacy and privation that define the structure of the secret shared, that neither is without the other, and that the secretary must be that necessary absence in which the lord has presence)."[19] Prior to turning his back on a career at court, Herbert might well have imagined himself becoming a secretary to a prominent member of the English aristocracy; when he comes to imagine more lasting rewards, it should perhaps not surprise us that he employs a vocabulary resonating with worldly implications.[20] In any event, if not in his thoughts, such professional skills were at least in his hand; according to Amy Charles, "[t]he persistence of the secretary *e* in Herbert's handwriting supports the conclusion that secretary was the hand he learned first and turned to, probably without realizing it, under stress or in haste."[21]

Herbert's celebration of his God translates into devotional terms the secretary's dutiful obedience to his master, an obedience made material in writing. Not unlike courtiers who must place all of their faith in their

patrons if they hope to advance, Herbert's speakers occasionally comment upon their devotional obligations in terms that suggest the problems that inner autonomy can pose for both courtly and divine supplicants. As the speaker of "The Holdfast" explains,

> I threatned to observe the strict decree
> > Of my deare God with all my power & might.
> > But I was told by one, it could not be;
> Yet I might trust in God to be my light.
> Then will I trust, said I, in him alone.
> > Nay, ev'n to trust in him, was also his:
> > We must confesse that nothing is our own.
> Then I confesse that he my succour is:
> But to have nought is ours, not to confesse
> > That we have nought. (1–10)

Each expression of self-authored action here prompts qualification: The speaker can neither obey his God with "power & might" nor "trust in him," nor even confess his own nothingness. Human agency is always deferred to the same actor, Christ. In "Aaron" this transference is rendered corporeally as the speaker takes up residence in the Son of God's body, gaining a better costume in the process: "Onely another head / I have, another heart and breast, / Another musick, making live not dead, / Without whom I could have no rest: / In him I am well drest" (11–15). The suggestion that Christ's body is the holiest of residences, that in it one becomes well attired in the dress of one's master, draws on the cultural context out of which *The Temple* emerged, a context in which household service could lead to social advancement. It also echoes somewhat Luther's gloss of Galatians 2:20: "Therefore he [Paul] saith: 'Now not I, but Christ liveth in me,' Christ is my form . . . adorning and beautifying my faith, as the colour or the clear light do garnish and beautify the wall."[22]

A similar merging of selves—these more explicitly authorial—occurs in "Providence," where the speaker is not clothed by God but rather finds his verse enriched through collaboration. In "Assurance" the anguish of an independent existence in which the speaker rightly fears confrontation with "cold despairs" and "gnawing pensivenesse" is put off by the prompt intervention of his savior: "Thou didst at once thy self indite, / And hold my hand, while I did write" (16, 29–30). Just

as devotion is, in the terms of the Protestant Reformation, largely textually based and rooted in reading (especially the Bible), a common characteristic of Herbert's descriptions of religious life is their attention to writing. The two practices, reading and writing, collapse into each other in the companion poems "The Holy Scriptures" (I and II), which fetishize the Bible at its graphic level: "Oh Book! infinite sweetnesse! let my heart / Suck ev'ry letter" (I:1–2).[23] Imbibing the language of God means appropriating it as one's vocabulary for self-understanding: "[F]or in ev'ry thing / Thy words do finde me out, & parallels bring, / And in another make me understood" (II:10–12). And to the extent that such vocabulary permits replication in the poet's own writings, we should expect to find it there as well, the very letters that make up scripture reconstituting — being regurgitated as — Herbert's verse.[24]

Herbert represents his dependence on the language of God here by suggesting that it is through appropriated words that self-understanding occurs. Lacan reformulates this sentiment in a number of ways, first by insisting that analysis depends on the speech of the analysand and the presence of the analyst, which by itself creates a dialogue: "[T]here is no speech without a reply, even if it is met only with silence, provided that it has an auditor."[25] But the discourse of the Other, symbolized by the analyst's silence and the analysand's ensuing verbal free association, attests to a self-division that looms behind all utterance: The ego is never, according to Lacan, "identical with the presence that is speaking to you." Rather, there is always distance "between the subject's ego *(moi)* and the 'I' *(je)* of his discourse."[26] In "Holy Scriptures" (II), the Other is figured by "Thy words," the words of God that "finde" the speaker "out" (11). As a religious poet, one who reads the Bible and through this reading comes to write verse, Herbert often emphasizes the materiality of devotional language, which in turn materializes alterity: Scriptural verses are evoked with their "leaves" in mind (6), and the Bible is, finally, valued over the natural world: "Starres are poore books, & oftentimes do misse: / This book of starres lights to eternall blisse" (13–14).

Herbert's high regard for the writing life, the kind of existence centered around transcribing and attesting to the effects of doctrinal inspiration, is glimpsed in the first stanza of "The Windows" when he puns on the title of his book, transferring the authorship of *The Temple* to God and suggesting that it is within such a *material* realm that the poet/speaker is empowered to attest to God's glory:

Lord, how can man preach thy eternall word?
 He is a brittle crazie glasse:
Yet in thy temple thou dost him afford
 This glorious and transcendent place,
 To be a window, through thy grace. (1–5)

Such acknowledgment of God's contribution to, even ownership of, his own written praise is not far removed from "Providence" or any of the other poems in which the realm of *scripted* devotion (both scribally and performatively) witnesses the exercise of divine grace on the poet/speaker. Herbert's desire to remove his own agency from the temple he has built is a desire to authenticate his love for God by insisting that it originates with God himself. It also attests to another desire, left unspoken, to grant himself solace. In the analytic setting, a similar search for "truth," which Lacan reveals as lying "at the very heart of analytic practice" ("inscrit au coeur même de la pratique analytique"), refers to the successful identification of an unconscious tendency, which results in the analyst's experiencing tranquility ("cette paix qui s'établit à reconnaître la tendance inconsciente").[27] If the God-figure is dead for Lacan, as is maintained in *Seminar VII*, he is perhaps resurrected as the unconscious: all-knowing, all-powerful, and maddeningly elusive.[28]

In its characterization of the poet's felt experience of God's presence as unpredictable and fleeting, Herbert's "The Flower" anticipates Lacan's description of the scene of analysis, a setting in which the unconscious is always present but only sporadically accessible and often open to misinterpretation. Beginning with the arrival of a new season in the opening stanza ("How fresh, O Lord, how sweet and clean / Are thy returns!" [1–2]), the poem repeatedly emphasizes the speaker's passivity and impotence in relationship to God's omnipotence. Structurally, the poem dramatizes the speaker's inconstancy by describing first his spiritual rebirth, associated with springtime regeneration, and retrospectively in the following stanza the "shrivel'd heart" that had slipped underground in the winter, "Dead to the world" (8, 14). God's power, as seen inadequately by the speaker, evinces itself in absolutist terms ("Killing and quickning, bringing down to hell / And up to heaven in an houre" [16–17]), while ignorance marks the domain of human action: "We say amisse, / This or that is: / Thy word is all, if we could spell" (19–21). As Jeffrey Masten's study of the word *spell* has shown, from the fourteenth century into the nineteenth the word meant "to read something, to consume a supplied text —

to puzzle out a particular exemplar."[29] The localizing of human failure at the level of textual interpretation thus emphasizes at once the importance of human action (spelling) and the dependence of such action on the language of another ("Thy word").

Herbert's nuanced conceptualization of the limits and possibilities of a subject's agency might help us to understand what has often been taken as a problematic inability on the part of psychoanalysis to theorize action — problematic because the unconscious is revealed as both ungovernable and only fitfully interpretable.[30] With Herbert's often-pained devotional exercises in front of us, we are reminded of how insufficient a holistic sense of "action" would be for one who believed that self-will was undesirable, even dangerous. The kind of divided selves we encounter in the pages of Herbert and Lacan (not to mention Freud) are selves not so much constituted by agency as distinguished by its lack. In light of these similarities, it is perhaps not surprising to find in critical accounts that question the unity of the early modern "individual"— such as Peter Stallybrass's study of the word itself—an echoing of Lacan's suspicious regard for "any reference to totality in the individual, since it is the subject who introduces division into the individual, as well as into the collectivity that is his equivalent."[31]

The flashes of self-authorship that emerge in "The Flower" are contained by a dutiful acknowledgment either of God's greater mastery (his "frown" in stanza 5, the "tempests" he sends in stanza 6 [35, 42]), or of the failures of the first-person subject (for instance, his contamination by his own "sinnes" in stanza 4 [28]). Stanley Fish proposes that "The Flower" catalogues the incremental "self-diminishing action" of the speaker, but the poem's own movement seems given more to describing alternating, antithetical states of being than to charting the progress of an evaporating self.[32] Closer to my interests is the way in which the speaker himself imagines his own flowering. Intriguingly, the poem's most sustained depiction of personal regeneration occurs in stanza 6, where the writing life epitomizes the most treasured time in the speaker's tumultuous spiritual odyssey:

> And now in age I bud again,
> After so many deaths I live and write;
> I once more smell the dew and rain,
> And relish versing: O my onely light,
> It cannot be

> That I am he
> On whom thy tempests fell all night. (36 – 42)

Here organic imagery, dominant throughout the poem up to this point, gives way to scribal. The delight in writing attests to the speaker's reconnection with his spiritual self and corresponds with a renewed awareness of the natural world ("I once more smell the dew and rain"). A clear division between devout and errant selves is insisted upon by the speaker, who comes to deny his former dissatisfied incarnation ("It cannot be / That I am he") in favor of his new identity as a "relish[ing]" supplicant. When Lacan describes the episodes of resistance and transference that mark the scene of analysis he echoes confessional lyricists like Herbert, in part because the retrospective idealization of inner conflict holds the same place in the devotional practices of early modern Protestants as it does in psychoanalysis; in both cases, dramatic revelation must precede any acquisition of happiness.[33]

The degree to which Herbert sees his poetic endeavor as analogous to his religious meditation has been much debated. A poem such as "Deniall," for example, quickly proposes a direct relationship between failed prayer and poetry: "When my devotions could not pierce / Thy silent eares; / Then was my heart broken, as was my verse" (1 – 3). By so closely correlating the heart with poetry, "Deniall" invites its readers to consider the extent to which the final recuperation of rhyme — "They and my minde may chime, / And mend my ryme" (29 – 30) — might attest to a recovery of longed-for piety.[34] Strier in particular has objected to this reading, arguing that the poem's conclusion refers not to the verse itself but rather to a future state of mind: "The poet cannot, in this sense, mend his 'rhyme' himself. He cannot mend his spiritual state by mending his representation of it."[35] The speaker, however, never suggests that he alone will mend or has mended his spiritual state; the authorship is one of collaboration, the Lord's spirit first summoned by the speaker to work through his mind, and — eventually, we might assume — his hand: "O cheer and tune my heartlesse breast, / Deferre no time; / That so thy favours granting my request, / *They and my minde* may chime, / And mend my ryme" (26 – 30, italics added).

A reading of "Deniall" that posits a future state of spiritual and poetic equanimity need not choose between the two. Rather, it seems tenable in reading Herbert to see the performances of writing and prayer as often one and the same. This is not *always* the case, of course; the final

stanza of "Home," for instance, makes a tacit distinction between prayer and poetry: "My flesh and bones and joynts do pray: / And ev'n my verse, when by the ryme and reason / The word is, *Stay*, sayes ever, *Come*" (74–76). Strier contends persuasively that "Herbert never presented his utmost art as being of ultimate value," but this does not mean that he dismissed the ultimate value of writing and rewriting verse.[36] It is the performance of writing that Herbert esteems, as we saw in "The Flower," for the way in which it complements and embodies Christian faith. While the evident attention to his craft makes it clear that Herbert took his vocation as a religious poet very seriously, and while the sense throughout *The Temple* is that inferior verse done in celebration of his God would be unacceptable, it is nonetheless the act of writing that is consistently rendered as representative of religious practice.

Herbert emphasizes the similarities between the practice of prayer and the writing of poetry in "Prayer" (I), a poem that literally conflates these two realms. After considering a litany of different representations for prayer, he arrives at a final, all-encompassing abstraction: "something understood" (14). Notable here is the speaker's increased inactivity as the poem unfolds, the drift into what Helen Vendler has called "an ecstasy of passivity," and with it an increased emphasis not on speaking—as we might expect of a supplicant—but rather hearing: "A kind of tune, which all things heare and fear . . . Church-bels beyond the starres heard" (8, 13). As the poem concludes, it is not quite, as Vendler maintains, that "[f]inally the poet understands," but rather that prayer reveals itself as comprehensible (*is* understood), not only to the poet but to his God.[37] The poet is thus at once active—busy writing—and utterly passive, being written *through*. In the context of psychoanalysis we might be reminded of the analysand who speaks without thinking, or—more precisely—through whose mouth the Other comes to speak.[38] Here, as in Herbert, the speaker's agency is more operated on than self-operating.

In "The Quidditie," by contrast, it is not the poet who is acted upon so much as the poem itself, as it is subjected to a litany of negating definitions: "My God, a verse is *not* a crown, / *No* point of honour, or gay suit, / *No* hawk, or banquet, or renown, / *Nor* a good sword, *nor* yet a lute" (1–4, italics added). Verse, at the end of the poem, reveals itself as the very means by which the speaker connects with God, as "that which while I use / I am with thee," *while* here emphasizing for us that it is not the poem itself but the *process* of composition, the temporal act of writing,

that represents devotion (11–12). What we realize, when considering these poems together, is that "Prayer" (I) is a quiddity—it sets forth a series of examples that seeks to define *something*—while "The Quidditie" in fact transcribes a moment of prayer. Paradoxically, however, the very emphasis on versifying carries us away from the material text to a moment of evoked intimacy with God. This moment is caught up in, but not symbolized by, the text it both produced and was produced by; Herbert's hand, in other words, both writes the poem and in writing creates the devotional space that the poem attests to but does not replicate. Utter replication is impossible in part because a text can only anticipate and *attempt* to reach a specific audience—by claiming, for instance, that it offers "sacred poems and private ejaculations"—while prayer fosters uniquely private communion between the devotee and the divine listener. The scene of prayer, in other words, can be evoked, even analyzed, in a scripted realm, but it cannot be reenacted; and neither, in Lacan's seminar setting, can the scene of analysis.

The lacuna separating poetry from prayer can become, as in "A True Hymn," the crux on which Herbert's conflation of the writing and the religious life turns. In the poem's final stanza, a clearer qualification of the importance of verse occurs than in "The Quidditie"—a qualification appropriately enacted through a scribal metaphor:

> Whereas if th' heart be moved,
> Although the verse be somewhat scant,
> God doth supplie the want.
> As when th' heart sayes (sighing to be approved)
> *O, could I love!* and stops: God writeth, *Loved.* (16–20)

Aesthetic deficiencies, it seems, are rectifiable through divine intervention, God picking up the poet's quill and finishing the line for him. I would like to caution against this reading, however, by suggesting that Herbert is less interested in the presumed scantness of his verse than we might be. The "want" to be supplied by God in the event of moving the heart is, more than poetic improvement, spiritual redemption exercised through divine grace. Certainly God is behind the writing of the verse to the extent that he helps the poet compose the praise and hence identifies the poet as one of his elect; but such election must resist unequivocal verification through the textual traces of writing itself, since that would confer on the reader of the poem a judgment equal to that of the Creator.

Rather, what Herbert insists upon is—as Strier asserts—that devotional verse need not meet an aesthetic criterion so much as testify to the sincerity of its author's belief.[39] Writing is important principally because it attests to God's grace, not because of what is written. Lacan, of course, is similarly invested in the indirect apprehension of truth; by fixating the locus of "true" speech outside of the self, he reconjures God as a psychic phenomenon rather than an ontological one. The Other is thus, in his words, "the perfect God" ("Dieu parfait") because "whatever he might have meant, would always be the truth" ("quoi qu'il ait voulu dire, ce serait toujours la vérité").[40] It is only through this God, only by estranging the self from itself, that analysis of the unconscious can take place. According to Michel de Certeau, "Like Beckett's Godot, the Other is not only the ghost of a God removed from the history where the passage of his believers remains nonetheless engraved, but also the general structure whose theory is made possible by the erasure of religious positivity and by acceptance of its mournings."[41] The result of such a belief system, as in Herbert, is a radically dependent subject, keenly aware of the incapacity of the self not only to know itself but, more fundamentally, to constitute itself as an individuated being.

The conclusion of "A True Hymn," however, merits our attention, for here it seems we have a case not of God working through the poet, as in "Providence," so much as of God taking over the composition of the work itself. Certainly this is how Stanley Fish reads the poem, for in his account "heavenly intervention" shifts the authorship of the poem—at least rhetorically—from Herbert to God.[42] Overlooked, in this interpretation, is the simile that introduces the conceit: "As when th' heart sayes (sighing to be approved) / *O, could I love!* and stops: God writeth, *Loved*" (19–20). To insist, as does Herbert in "Providence," that his fingers bend "through" God (3), or that the parson preaches "through thy [the Lord's] grace," as we saw in "The Windows" (5), is to see human agency as fulfilled, rather than wholly supplanted, by divine omnipotence. In "A True Hymn," we might quibble with readings that remove the speaker's agency entirely by reading the final act of writing as occurring not on a page but rather on the speaker's heart, after which his hand—infused by God's power—transcribes the word into the material text.

Fish's desire to see authorship of "A True Hymn" as an either/or proposition reflects a critical reluctance or inability to recognize the complicated ways in which acts of writing (in abstract and practical terms) were carried out in Renaissance England, and the complicated

model of subjectivity proposed by Protestant thinkers. According to Luther, "Now because Christ liveth in me, therefore whatsoever of grace, righteousness, life, peace and salvation is in me, it is all his, and yet notwithstanding the same is mine also, by that inseparable union and conjunction which is through faith; by the which Christ and I are made as it were one body in spirit."[43] Likewise, by registering the frequency with which texts in this period were composed by many hands, as scholars such as Stephen Orgel and Masten have argued we should, we may more readily accept in Herbert's thematization of writing a conceptualization of the devout self as itself one of co-agency.[44] We should not be surprised, in other words, to find that the collaborative nature of textual practices might both reflect and contribute to early modern methods of psychologizing and theologizing, while these psychological and theological templates might, concomitantly, inform the compositional performances of Renaissance writers, printers, and copyists.

The blurring of self-identity brought about by the shared production of a text calls to mind Goldberg's reading of early modern writing hands, for just as the metaphor of the secretary — in a poem such as "Providence" — evokes an aristocratic realm presumably abandoned for God's altar, it also imagines a putatively hierarchical relationship between servant and master that nevertheless might be open to reconfiguration. As Angel Day points out, if the secretary "is in one degree in place of a seruant, so is he in another degree in place of a friend."[45] The secretary's dutiful execution of the tasks handed down to him by his master can bring them not only close enough to replace obligation with friendship, but also so close as to make them textually indistinguishable: the secretary forging his master's signature, even composing in his name, in effect playing his part.[46] As Richard Rambuss explains, "Secretaryship thus does not simply mean transcribing, copying down the words of the master; rather it entails becoming the simulacrum of the master himself."[47]

The duplication and conflation of agencies Goldberg and Rambuss read in the secretarial scene of writing encompass the dénouement of "Jordan" (II). The poem first relates the speaker's failed attempts at composing devotional verse, his initial desire to incorporate "quaint words, and trim invention" leading to verbal excess: "Nothing could seem too rich to clothe the sunne, / Much lesse those joyes which trample on his head" (3, 11–12). Writing here does not come easy; the speaker acknowledges frequently having to begin anew ("I often blotted what I

had begunne" [9]), and the repeated recognition of his own, inadequate possessions—"my lines . . . My thoughts . . . my brain" (1, 4, 7)—reveal the writing to be very much his own. The end of the poem, however, conditionally reimagines the writing scene, now with companionship: "But while I bustled, I might heare a friend / Whisper, *How wide is all this long pretence! / There is in love a sweetnesse readie penn'd: / Copie out onely that, and save expense*" (15–18). Directed now not to compose but to copy, the speaker will presumably uncover, in a subsequent piece of writing toward which the poem beckons, a more sincere language by which to express a self that now contains the internalized voice of another.

The whispered advice thus injects into a devotional relationship so often imagined hierarchically a note of compassionate, if not intimate, friendship between collaborating writers. We might recall Christ in the Gospel of John—"Ye are my friends, if ye do whatsoever I command you" (15:14)—for in "Jordan" (II) the writing scene and the relationship it evokes make the divine and earthly domains interpenetrate each other; the closeted scene of human writing thus overlaps with the celestial scene of divine mediation performed by the (human) son of God. The friend of "Love Unknown," more unambiguously human than the friend of either "Jordan" (II) or "The Holdfast," nonetheless also attests to Herbert's fascination with selves that contain, and are contained by, others, both human and divine.[48] In all of these poems, potentially demarcated boundaries of subjectivity disappear as the speakers reach out to think and act through others.

In light of such scribal resonances in "Jordan" (II), the attempts made by some critics to dismiss the poem's intimation of a future scene of writing seem unnecessary, even misguided, for rather than compromising devotional exercise, writing seems to emblematize it.[49] Nonetheless, as "Jordan" (II) makes clear, as well as the opening stanzas of "Affliction" (I) and "The Forerunners," not all kinds of writing in Herbert represent the right form of devotion. The problem posed by ornate writing is a serious one, and yet serious more for its reflection of lackluster devotion than for its stylistic impoverishment. The speaker in "The Forerunners," for example, strikes a note of indifference with regard to the diminution of his poetic powers, although he does so in a poem that brims with proof of its creator's skills: "Must dulnesse turn me to a clod? / Yet have they left me, *Thou art still my God*" (5–6).

The danger of ornamental verse in the context of religious writing is akin to the danger of inauthentic speech in the context of the analytic

setting: Both suggest insincerity and hence both sully a potentially transformative encounter with the Other. Herbert presents his language of devotion as the appropriated discourse of another, and often describes the scene of writing as intensely collaborative and rewarding. The scene of writing is by no means the only scene in which Herbert imagines transcendent encounters with his Lord; preaching, praying, and speaking to God without pen in hand are all experiences Herbert praises and values, but in the context of composing religious lyric, the act of writing itself assumes greater and greater importance. Equally dissected by Lacan, as we shall see, is another site where therapeutic process, self-disclosure, and—at times—revelation intersect: the scene of analysis.

With a perhaps surprising degree of frequency, Lacan incorporates the language, metaphors, and institutions of Western religion so as to force his listeners to think through religious topoi in order to arrive at psychoanalysis. According to Michel de Certeau, "Lacanian discourse . . . has its history, its narratives, and its theoretical loci: it is Christian."[50] Indeed, the rhetorical flair that so distinguishes Lacan's writings and seminars, visible in those gestures that mark his prose and speech as both playful and—at times—contentious, consistently draws on Christian and biblical motifs. Hysteria, he notes in *Seminar XI*, points to "some kind of original sin in analysis." Like Christ's apostles, early psychoanalytic practitioners are said to have carried on Freud's teachings by a comparable "virtue of a certain naivety, a certain poverty, a certain innocence." When Lacan corrects a view held by some analysts that the unconscious dictates neuroses, he insists that "Freud can quite happily, like Pontius Pilate, wash his hands" ("Freud a très volontiers le geste pilatique de se laver les mains").[51]

 While Lacan pauses occasionally in *Seminar XI* to remind his listeners that "Freud was not Christ" or that the analyst is "not God for his patient," the very dismissal of such faulty analogies introduces the (mistaken) correlation into the lectures themselves.[52] Well aware, as evidenced in particular by his paper "The Freudian Thing" (1956), of how stubbornly resistant a "circle of misunderstanding" is to analytical or critical intervention, Lacan willingly scatters such traces throughout his 1964 seminar.[53] The effect is contradictory, even paradoxical: On one level, as Bruce Fink has argued, Lacan places psychoanalysis "in the privileged position of being able to help us figure out what a science or a religion is, from outside, as it were, from some other position."[54] This position is

nevertheless rhetorically and conceptually indebted to religion, insofar as Lacan fashions psychoanalysis as a discourse that can profit by reincorporating the symbols and concepts it inherits from its Western intellectual and spiritual heritage. Thus, when Lacan notes that "the strength of the churches resides in the language that they have been able to maintain," he implies that spiritual and/or theological terminology and vocabulary are important for both religion and psychoanalysis.[55] Subjecting Christianity to psychoanalysis becomes for Lacan analogous to subjecting the analysand's repression and resistance to the procedures of analysis itself. Christianity, in other words, functions as the cultural opposite to psychoanalysis, while psychoanalysis — in the hands of Lacan — reveals itself to be not so much opposed to the Judeo-Christian tradition as nourished by it. According to Lacan, "[T]here is a paradox involved in practically excluding from the debate and from analysis things, terms, and doctrines that have been articulated in the field of faith, on the pretext that they belong to a domain that is reserved for believers."[56] Thus is narcissism, in *Seminar XI*, explained through a reference to Thomas Aquinas' *velle bonum alicui*, while St. Paul's abrogation of the Law in Romans 7 is repeatedly evoked in *Seminar VII* as a way of returning to Freud's formulation of the pleasure principle.[57] And indeed we might contrast Freud's frequent returns to Renaissance *texts* with Lacan's return to a Renaissance psyche, one that increasingly envisions itself as a self-authoring agent while at the same time subscribing to a belief system that subsumes such agency under divine operation.

With Lacan's view of the fractured self in mind, it is striking to see him seize on a term so at the heart of Herbert's poetics precisely because this term inflects his own understanding of agency: "A notion as precise and articulate as grace is irreplaceable where the psychology of the act is concerned, and we don't find anything equivalent in classic academic psychology."[58] A return to theological vocabulary here replaces a return to psychological terminology because the former is more pertinent to Lacan's interests than the latter. Psychoanalysis is thus necessarily understood at least in part through Judeo-Christian templates, for, in the words of Suzanne Kirschner, "the contours of the psychoanalytic developmental trajectory are derived less from empirical observation than from the redeployment of a preexisting cultural template to a new context, the recently delineated domain of the psychological."[59]

Lacan forces psychoanalysis into close habitation with its Judeo-Christian heritage in the hope of grounding its terms in the discourses

through which notions of identity came to be most significantly formulated in European culture. His efforts reveal the ambitious program he has in mind for psychoanalysis, which he envisions as reunderstanding and reconstituting the very vocabulary by which the subject might understand him- or herself. Lacan's turn to religion, however, also engenders other questions, ones regarding the extent to which psychoanalysis itself demands belief on the part of its practitioners, and hence the degree to which it can be regarded as a science. As John Guillory points out, "The possible indistinction between religion and science at the level of the unconscious is the achievement of psychoanalysis to have discovered, but at the (possible) cost of its own scientificity, if science itself is to fall from its heaven of reason. To put this in other thematic terms, we have a right to ask what the (master) analyst wants, science or religion."[60] In *Seminar VII* and *XI*, the mutually exclusive categories of science and religion are increasingly revealed, in the case of psychoanalysis, to be mutually informing and informed. The evidentiary value of "true speech," for example, serves a diagnostic purpose at the same time that its designation as "truthful" requires faith in an evaluative procedure that is not on the surface "scientific."

Rhetorically, however, Lacan — particularly in *Seminar XI* — uses the Church explicitly as an analogy for the institution of psychoanalysis, and this analogy is itself a symptom for Lacan's own professional desires: that psychoanalysis should work as a science while somehow occupying the cultural place of a religious institution, a (reformed) institution that he will have created. Early in the seminar Lacan proposes, while at the same time qualifying, an analogy between religious and psychoanalytic institutions: "I am not saying — though it would not be inconceivable — that the psycho-analytic community is a Church. Yet the question indubitably does arise — what is it in that community that is so reminiscent of religious practice?"[61] One answer to Lacan's question, proposed by Adam Phillips, is psychoanalysis itself. Commenting on Freud's well-known animosity toward religion, Phillips remarks that he "disparages religious belief in a way that he has taught us to interpret; so we can ask a simple question: What is the doubt he is trying to stifle by his overinsistent critique?"[62] The doubt, it seems, remains intrinsic to the very practices of analysis and interpretation Freud sanctions. Thus, as Phillips puts it, "the one thing psychoanalysis cannot cure, when it works, is belief in psychoanalysis. And that is a problem."[63]

It is perhaps with Freud in mind that Lacan comes to insist that "psycho-analysis is not a religion. It proceeds from the same status as Science *itself*." Still, there is something unpersuasive in this pronouncement, particularly in that it has already been qualified by the very un-Freudian recognition that religion "nowadays enjoys universal respect."[64] If Freud — in Phillips' words —"internalized the ancient Jewish struggle between idolatry and True Belief,"[65] Lacan at times saw in the disagreements between European psychoanalysts in the 1950s and 1960s a secular reenactment of early modern religious controversy, hence his telling reference to Erasmus in "The Agency of the Letter in the Unconscious, or Reason Since Freud" (1957).[66]

Regardless of the degree to which Lacan sees psychoanalysis as scientific, or his own work within a particular professional domain as paralleling the work of earlier, religious reformers, it is the belief in the transformative capabilities of psychoanalytic techniques on its human subjects that ultimately redeems the work of the analyst. The analytic scene, in fact, is a moment that — like its Christian analogue in scenes of sacramental practice — asks its participants to believe in transformative ceremonies without being able to prove necessarily that they have taken place:

> In every religion that deserves the name, there is in fact an essential dimension reserved for something operational, known as a sacrament.
>
> Ask the faithful, or even the priests, what differentiates confirmation from baptism — for indeed, if it is a sacrament, if it operates, it operates on something. Where it washes away sins, where it renews a certain pact — I would put a question-mark here — Is it a pact? Is it something else? What passes through this dimension? — in all answers we get, we will always find this mark, by which is invoked the beyond of religion, operational and magical. We cannot evoke this operational dimension without realizing that within religion, and for strictly defined reasons — the separation and impotence of our reason, our finitude — it is this that is marked with oblivion.
>
> It is in as much as psycho-analysis, in relation to the foundation of its status, finds itself in some way struck by a similar oblivion, that it manages to rediscover itself, marked, in ceremony, with what I will call the same empty face.[67]

It is not merely that Lacan sees psychoanalysis re-encountering a "similar oblivion" experienced in Christian ceremony, or that the limitations of human agency and reason experienced in the dialectic of the self with the Other are foreshadowed in the devotional experiences recorded by Christians such as Herbert, but that Lacanian psychoanalysis understands such an "empty face" ("face vide") by reconfiguring the vocabulary of religious faith. Through his suggestion that psychoanalysis "finds itself in some way struck by a similar oblivion" ("se trouve en quelque sorte frappée d'un oubli semblable"), Lacan cryptically transforms his description of religious practices to be in some undisclosed way analogous to psychoanalytic ones.[68]

Lacan's evocation of Judeo-Christian motifs and symbols shares with Herbert's emphasis on writing a desire to interrogate as performative what it is exactly that constitutes and represents devotion: in the case of Herbert to an inscrutable God, and in the case of Lacan to a therapeutic program grounded on a set of psychological and analytical premises. In *The Temple*, religious devotion exhibits a discursive dependence on God in order to make gestures of obedience toward him. "Assurance," for example, makes much of this dependence, as when the speaker admits, "If all the hope and comfort that I gather, / Were from my self, I had not half a word, / Not half a letter to oppose / What is objected by my foes" (21–24). The letters and words that form the verbalization of the speaker's faith depend upon divine language, such that "Thou [God] are not onely to perform thy part, / But also mine" (27–28). The psychoanalytic appeal to that formulative, linguistic power located beyond the domain of the self is well known; Lacan in fact glosses *thou* as "reserved [in English] for the call from God and the appeal to God, and which is the signifier of the Other in speech."[69] Both discourses, rooted in alterity, similarly rely upon truth claims: For Lacan, analysis "can have for its goal only the advent of a true speech" ("ne peut avoir pour but que l'avènement d'une parole vraie"), which is made possible by the Other, "the guarantor of Good Faith" ("garant de la Bonne Foi"), while for Herbert the aim of the devotional lyricist is to exhibit true faith, that which is unsullied by ornamental, or insincere, speech.[70]

According to Thomas Merrill, in Renaissance religious lyric "the sheer presence of 'God,' implicitly or explicitly felt within a linguistic context, radically changes the semantic terrain; it literally tyrannizes the structure of the discourse into which it is introduced."[71] For Lacan as well, the symbolic ordering of language enacted by the Name-of-the-

Father places the subject in a deferential, even dependent, position in regard to the Other. As François Regnault has pointed out, the way in which religion situates "the symbol at so high a level . . . leads Lacan to be truly interested in theology, much more so than Freud, and essentially in Christian theology."[72] Structuring his analytical methods around a secularized, theocentric model of language and the unconscious, Lacan mimics the Catholic practice of confession and the more specifically Protestant emphasis on unembellished, unrehearsed disclosure. Thus is speech in Lacan, according to de Certeau, "structured like that of the person praying."[73]

Perhaps nowhere more dramatically than in "The Collar" does the scene of analysis as described by Lacan resemble one of Herbert's depicted scenes of devotion. Like an analysand, the speaker resists the suffering prompted by his exposure to the Other, not only in the opening lines — "I struck the board, and cry'd, No more. / I will abroad" (1–2) — but also through the litany of questions he poses. These nine queries are all put forth in the first half of the poem, the final string preceding a tonal and perspectival shift that attests to the speaker's self-division:

> Is the yeare onely lost to me?
> Have I no bayes to crown it?
> No flowers, no garlands gay? all blasted?
> All wasted?
> Not so, my heart: but there is fruit,
> And thou hast hands. (13–18)

The reference to hands here is meant to remind the speaker of the possibility of engaging physically with the material world of satisfaction. Admonished by what has traditionally been read as the speaker's will but what Strier has persuasively described as a voice more demonically extrinsic to the speaker's, the heart is encouraged to forsake its lacerating engagements with mental occupations: "[L]eave thy cold dispute / Of what is fit, and not. Forsake thy cage, / Thy rope of sands, / Which pettie thoughts have made" (20–23).[74] Thinking too much, trying to order one's impressions and formulate arguments as to "what is fit, and not," does not present itself as a viable alternative to the speaker's ranting and raving, the emotional volatility of which is registered by the arrangement of the poem in a single stanza — which forces the reader to experience the drama without respite — as well as its erratic rhyme and meter.

What the poem comes to endorse, in opposition to unfettered self-pity, is submission and obedience to another:

> But as I rav'd and grew more fierce and wilde
> > At every word,
> Me thoughts I heard one calling, *Child!*
> > And I reply'd, *My Lord.* (33–36)

The speaker's journey through extreme emotional states ends with a grateful, nearly instantaneous response to the voice of another, one that does not pose questions as he himself did but rather establishes an unexpected identity ("*Child*") and with it certainty and peace of mind. Barbara Lewalski's reading of the poem through Romans 8:14–19 emphasizes the speaker's assurance that, in being called a child of God, he becomes an heir to his kingdom. Thus is acquiescence presented through a familial model rather than one of enforced bondage.[75] When the speaker responds to his Lord he is released, we might imagine, from the vexing relationship he has had with himself, characterized by his interior dialogue. The external voice thus initiates a turn from self-sustained introspection — introspection that was deficient, ironically, because it *was* self-sustained — toward truthful dialogue with an all-powerful voice located outside of the speaker's self.

While the child's call from God is neither feasible nor desirable in the therapeutic context of psychoanalysis, what we do encounter in "The Collar" is a speaker not only deeply fractured by his own lacerating self-regard but also engaged by the external voice of God, a voice appropriately emblematic of Lacan's Other in that it is ventriloquized by the poet himself. Indeed, attention is drawn in the poem to the voice Herbert responds to, a voice not immediately identified as God's but one that rather requires the speaker to have faith in its divine origins: "*Me thoughts* I heard *one* calling" (italics added). Again, we might recall Lacan's definition of the Other in "The Freudian Thing": "The Other is, therefore, the locus in which is constituted the I who speaks to him who hears, that which is said by the one being already the reply, the other deciding to hear it whether the one has or has not spoken."[76] If we imagine the speaker's reply to the presumed voice of the Lord as unavoidable, we recognize — in Protestant theological terms — the irresistibility of God's call, which in the context of Lacan's writing is analogous to the formulative discourse of the Other, to which one cannot but reply. The

extreme degree to which the speaker's self is destabilized in the course of "The Collar," made a victim of antagonistic interventions and soothed only by the presumed voice of another, is diminished somewhat by a reading such as Strier's, which emphasizes the "wholeness of the narrator's personality."[77] What we might stress more emphatically are the extreme hardships suffered by the speaker at his own hands before he is made aware of his proper relationship to God, and the deeply divided nature of the self that the poem presents: a self, recalling Luther's commentaries, that responds to the Lord with a voice that is not fully his own, but God's as well.

In her reading of "The Collar," Vendler stresses the "analytic phrases" of the poem's dénouement ("as I rav'd," etc.), the way in which, by the end of the poem, "analysis has removed the narration from an unmediated form to a mediated form."[78] Vendler's own awareness of the analytical nature of the poem underscores how dramatically the speaker's self-interrogation plays out, and the degree to which it prompts — on the part of its readers — a desire to make sense of the supplicant's self as it is described in the poem. Turning back to the "unmediated form" of self-probing, we see the speaker's earlier insistence on expressive latitude once again paralleling the way he lives his life and the way he writes: "My lines and life are free; free as the rode, / Loose as the winde, as large as store" (4–5). The speaker's own curtailment of his *vers libre* disquisition on suffering reveals not that "free" living or writing is an illusion for Herbert, but that they are emblematic of a kind of freedom that one should avoid.

For Lacan, of course, the search for "true" speech through free association redeems itself in the analytical scene. The speaker's inner turmoil in "The Collar" also serves a greater purpose, for it is only after he has come to judge his own discourse, only after he has "rav'd and [grown] more fierce and wilde / At every word" (33–34), that he is able to call out to his Lord as a devoted subject. The problematics of conceiving of a human agent as freely "self"-governed (or cohesively imagined as a unit of individuated being) are intriguingly probed by both Lacan and Herbert. At the same time, the *merits* of human action itself provoke widely different assessments. The opportunity for human action afforded by Lacanian psychoanalysis in the analytical setting merits greater acknowledgment than it has often received, for Lacan steadfastly insists that the analysand must work through the "problematic of desire" in order to achieve the goal of analysis, a "realization of oneself":

> There is no doubt that in the course of this process the subject
> will encounter much that is good for him, all the good he can do
> for himself, in fact, but let us not forget what we know so well
> because we say it everyday of our lives in the clearest of terms:
> he will only encounter that good if at every moment he elimi-
> nates from his wishes the false goods, if he exhausts not only
> the vanity of his demands . . . but also the vanity of his gifts.[79]

What Lacan lets go of, in a Nietzschean sense, is the harboring of delud-
ing, "false" beliefs. This release, because it is left largely untheorized,
makes psychoanalysis resistant to methodological generalization, for each
scene of analysis is shaped by both the analyst and the analysand, the lat-
ter giving away his or her illusions, the former giving only — according to
Lacan —"what he has." The radical liberalism of such a practice asks its
subject to speak freely in order to assume what Lacan calls "his [the sub-
ject's] own law."[80] In contrast, for Herbert one is free only to fall. Divine
grace alone confers election, and it is only this election that matters, not
the self-scrutiny bred by anxiety over such election. The voice that inter-
venes midway through "The Collar" suggests that the heart "be thy law"
(25), but this option is identified in the poem as a false one. Thus, if the
bout of anxiety recorded in "The Collar" gives way to a state of happi-
ness, such attainment — if only in the least important of realms, the
earthly — is also sought by the analysand as imagined by Lacan: simi-
larly sought, and similarly sanctified by belief and language systems
predicated upon externally postulated authority figures.

When Jacques Derrida turns to Freud's own scene of writing he comes
to see in the analytical techniques espoused a seemingly endless accretion
of interpretative gestures: "[T]he substitution of signifiers seems to be the
essential activity of psychoanalytic interpretation," he writes.[81] Derrida
uncovers in psychoanalytic practice, through the scribal metaphors that
litter Freud's accounts of the unconscious, the way in which written per-
formance reifies the deferral of desire. It is, according to Derrida, within
the account of writing that the unconscious is summoned as necessarily
absent by the textual trace it leaves behind as a copy. The real scene of
such transcription is never, in effect, captured; rather, "[e]verything be-
gins with reproduction. Always already."[82] Neither is the original scene
of writing one of whole or self-contained agency. Instead, the traces that
remain attest to a "two-handed machine, a multiplicity of agencies or
origins."[83]

It is toward this deferred scene of writing, a scene repeatedly pushed away by its own textual traces, that Herbert's poetry so often directs itself, in the process articulating Christian faith as one of perpetually deferred and hence inexhaustible longing. Lacan describes the practice of psychoanalysis as similarly enamored, not of God but rather of the unconscious, which is always "on another stage, in another scene . . . repeated."[84] Returning to Herbert's poetry with renewed recognition of how faith is a desire for that which is always already elsewhere reminds us that belief in any set of doctrines and praxes is never reducible to the contents of these doctrines and praxes themselves. Herbert's language of devotion characterizes itself by an acute awareness of the psychology of longing, by its recognition that the scene of writing can only insufficiently record any encounter with the divine, but that the partiality of these transcriptions itself attests to the wonder and completeness offered through communion with the Other.

NOTES

This essay benefited enormously from the feedback and suggestions offered by many scholars, especially Barbara Lewalski, Jeffrey Masten, and Helen Vendler.

1. George Herbert, *The Works of George Herbert*, ed. F. E. Hutchinson (Oxford: Clarendon Press, corrected ed. of 1945, first published in 1941). All subsequent citations of Herbert are from this edition, unless otherwise noted.

2. According to Heather Asals, "the references in *The Temple* to the poet's practice of the physical act of writing, to the *event* of his transcribing of the poem, have gone virtually unnoticed by modern criticism" (*Equivocal Predication: George Herbert's Way to God* [Toronto: University of Toronto Press, 1981], 18).

3. Elizabeth Clarke, "Silent, Performative Words: The Language of God in Valdesso and George Herbert," *Literature and Theology* 5, 4 (1991), 355–74, 355.

4. See, for example, Barbara Kiefer Lewalski, *Protestant Poetics and the Seventeenth-Century Religious Lyric* (Princeton: Princeton University Press, 1979), esp. chapter 9; Richard Strier, *Love Known: Theology and Experience in George Herbert's Poetry* (Chicago: University of Chicago Press, 1983); Joseph H. Summers, *George Herbert: His Religion and Art* (Cambridge: Harvard University Press, 1954), esp. chapter 3; and Leah Sinanoglou Marcus, "George Herbert and the Anglican Plain Style," in *"Too Rich to Clothe the Sunne": Essays on George*

Herbert, ed. Claude J. Summers and Ted-Larry Pebworth (Pittsburgh: University of Pittsburgh Press, 1980), 179–93.

5. See in particular Diana Benet, "Herbert's Experience of Politics and Patronage in 1624," *George Herbert Journal*, 10, 1–2 (1986–87), 33–45; Sidney Gottlieb, "The Social and Political Backgrounds of George Herbert's Poetry," *"The Muses Common-Weale": Poetry and Politics in the Seventeenth Century*, ed. Claude J. Summers and Ted-Larry Pebworth (Columbia: University of Missouri Press, 1988), 107–18.

6. Michael C. Schoenfeldt, *Prayer and Power: George Herbert and Renaissance Courtship* (Chicago: University of Chicago Press, 1991), 12. For Schoenfeldt's acknowledged, although qualified, indebtedness to the new historicism, see 13.

7. Strier, *Resistant Structures: Particularity, Radicalism, and Renaissance Texts* (Berkeley: University of California Press, 1995), 73.

8. John Donne, *Devotions upon Emergent Occasions*, ed. Anthony Raspa (Oxford: Oxford University Press, 1987), "Prayer II," 13; Paul W. Harland, " 'A True Transubstantiation': Donne, Self-love, and the Passion," in *John Donne's Religious Imagination: Essays in Honor of John T. Shawcross*, ed. Raymond-Jean Frontain and Frances M. Malpezzi (Conway: University of Central Arkansas Press, 1995), 162–80, 172.

9. Martin Luther, *A Commentary on St. Paul's Epistle to the Galatians*, ed. Philip S. Watson, based on the Middleton edition of the 1575 English version (London: James Clarke, 1953), 343.

10. Ibid., 168.

11. Schoenfeldt briefly remarks upon the similarities between Lacan and Herbert's renderings of the self as fundamentally, and linguistically, dislocated. See *Prayer and Power*, 53. See also Jonathan Goldberg, *Voice Terminal Echo: Postmodernism and English Renaissance Texts* (New York: Methuen, 1986), esp. 115–16.

12. For an important exception see Michael Eigen, who argues that Lacan, as well as Winnicott and Bion, "made highly sophisticated attempts to articulate the faith dimension [in psychoanalysis], a 'critical faith' which functions both as a formal condition that makes psychoanalytical experience possible and, descriptively, as a specific state of mind (i.e. the psychoanalytic attitude)" ("The Area of Faith in Winnicott, Lacan and Bion," *International Journal of Psycho-Analysis*, 62 [1981], 413–33, 431).

13. Jacques Lacan, *Seminar VII: The Ethics of Psychoanalysis, 1959–1960*, ed. Jacques-Alain Miller, trans. with notes by Dennis Porter (New York: W. W. Norton, 1992, first pub. Editions du Seuil, 1986), 97, 93. According to Michel de Certeau, *Seminar VII* represents a critical moment in Lacan's career: "The transformation consists in rethinking, in terms which are no longer those of the past, the return of religious history" (*Heterologies: Discourse on the Other*, trans. Brian Massumi [Minneapolis: University of Minnesota Press, 1986], 60).

14. Lacan, *Seminar VII*, 93.

15. Philip Rieff, *The Feeling Intellect: Selected Writings* (Chicago: University of Chicago Press, 1990), 12–13. For a sustained critique of the ways in which psychoanalysis redeploys Judeo-Christian motifs and theories of the self see Suzanne R. Kirschner, *The Religious and Romantic Origins of Psychoanalysis: Individuation and Integration in Post-Freudian Theory* (Cambridge: Cambridge University Press, 1996).

16. "The guilt, conflict, depression, violence, infantile longings, and acute self-debasement, which in Donne, Herbert, and Bunyan characterize the inner lives of the saints," she writes, "in Baudelaire, Berryman, and Plath seem rather evidence of deep psychological disturbances" (Debora Kuller Shuger, *The Renaissance Bible: Scholarship, Sacrifice, and Subjectivity* [Berkeley: University of California Press, 1994], 195).

17. De Certeau sees "a monotheistic form" in Lacan's capitalizations of key terms: "Such formulations, and a thousand others similar to them, like the analyst's apparatus, gradually bring the strange impression that the house is haunted by monotheism" (*Heterologies*, 58).

18. Jonathan Dollimore, *Radical Tragedy: Religion, Ideology, and Power in the Drama of Shakespeare and His Contemporaries* (Durham: Duke University Press, 1993, first pub. Harvester Wheatsheaf in 1984), "Introduction to the Second Edition," xi–lxviii, xxxi.

19. Goldberg, *Writing Matter: From the Hands of the English Renaissance* (Stanford: Stanford University Press, 1990), 265, 269.

20. As Schoenfeldt notes, the two University Orators who preceded Herbert at Cambridge, Sir Robert Naunton and Sir Francis Nethersole, both became secretaries of state (*Prayer and Power*, 86).

21. Amy M. Charles, *A Life of George Herbert* (Ithaca: Cornell University Press, 1977), 213.

22. Luther, *Commentary on Galatians*, 168.

23. Cf. chapter 4 of *A Priest to the Temple, or, The Country Parson, His Character, and Rule of Holy Life*: "But the chief and top of his [the parson's] knowledge consists in the book of books, the storehouse and magazene of life and comfort, the holy scriptures. There he sucks and lives" (228).

24. Herbert reifies his dependence on the very words of holy scripture for his own self-expression and self-understanding in a number of poems, among them "Discipline": "Not a word or look / I affect to own, / But by book, / And thy book alone" (9–12).

25. Jacques Lacan, "The Function and Field of Speech and Language in Psychoanalysis," in *Ecrits: A Selection*, trans. Alan Sheridan (New York: W. W. Norton, 1977), 30–113, 40. All passages in the original French are from *Ecrits I* and *II* (Paris: Editions du Seuil, 1966).

26. Ibid., 90. Likewise, the "true subject of the unconscious and the ego . . . [is] constituted in its nucleus by a series of alienating identifications" ("The Freudian Thing, or the Meaning of the Return to Freud in Psychoanalysis," 114–45, 128).

27. Ibid., 118; *Ecrits I*, 214.

28. See Lacan, *Seminar VII*, 179–82.

29. Jeffrey Masten, "Pressing Subjects; or, The Secret Lives of Shakespeare's Compositors," in *Language Machines: Technologies of Literary and Cultural Production*, ed. Masten, Peter Stallybrass, and Nancy Vickers (New York: Routledge, 1997), 75–107, 77.

30. For a reading, and defense, of agency as it is understood in psychoanalysis, see Paul Smith, *Discerning the Subject* (Minneapolis: University of Minnesota Press, 1988), 72–73.

31. See Stallybrass, "Shakespeare, the Individual, and the Text," in *Cultural Studies*, ed. Lawrence Grossberg, Cary Nelson, and Paula A. Treichler (New York: Routledge, 1992), 593–612; Lacan, "The Function and Field of Speech and Language in Psychoanalysis," 80.

32. Stanley Fish, *Self-Consuming Artifacts: The Experience of Seventeenth-Century Literature* (Berkeley: University of California Press, 1972), 157.

33. See Lacan, *Seminar XI: The Four Fundamental Concepts of Psycho-Analysis*, ed. Miller, trans. Sheridan (New York: W. W. Norton, 1981), 127–28. All passages in the original French are from *Le Séminaire XI: Les Quatre Concepts fondamentaux de la Psychanalyse* (Paris: Editions du Seuil, 1973). For "the satisfaction that marks the end of the analysis" see "Preface to the English-Language Edition," in *Seminar XI*, viii. See also "The Demand for Happiness and the Promise of Analysis," in *Seminar VII*, 291–301.

34. See Lewalski, *Protestant Poetics*, 299; and Chana Bloch, *Spelling the Word: George Herbert and the Bible* (Berkeley: University of California Press, 1985), 278.

35. Strier, *Love Known*, 191. Helen Vendler also reads the speaker's recuperation as occurring in the future, but for her the "envisaged happiness" will nonetheless demonstrate itself through versifying: Herbert "will be cheered and tuned, and can chime and rhyme" (*The Poetry of George Herbert* [Cambridge, MA: Harvard University Press, 1975], 260).

36. Strier, *Love Known*, 195.

37. Vendler, *Poetry of George Herbert*, 39.

38. See Lacan, *Seminar XI*, 131.

39. See Strier, *Love Known*, 202.

40. Lacan, *Seminar XI*, 36; *Séminaire XI*, 45.

41. De Certeau, *Heterologies*, 61. I have corrected this translation slightly.

42. See Fish, *Self-Consuming Artifacts*, 202. In *Voice Terminal Echo*, Goldberg also insists on a forfeiture of authorship on the part of Herbert, but he resists substituting a single author figure for another, arguing that "there are only other voices in Herbert's text, and that they are always explicitly represented as written" (107).

43. Luther, *Commentary on Galatians*, 169.

44. See Stephen Orgel, "What is a Text?" reprinted in *Staging the Renaissance: Reinterpretations of Elizabethan and Jacobean Drama*, ed. David Scott Kastan and Peter Stallybrass (New York: Routledge, 1991), 83–87; Jeffrey Masten, *Textual Intercourse: Collaboration, Authorship, and Sexualities in Renaissance Drama* (Cambridge: Cambridge University Press, 1997), esp. chapters 1 and 2.

45. Angel Day, *The English Secretary, Or Methode of writing of Epistles and Letters* (London, 1599; facsimile reprint, Gainesville: Scholars' Facsimiles and Reprints, 1967), 2:106.

46. See Goldberg, *Writing Matter*, chapter 5, esp. 265–69.

47. Richard Rambuss, *Spenser's Secret Career* (Cambridge: Cambridge University Press, 1993), 43. Speculating on the single secretary hand that appears to have penned the *Williams* manuscript of Herbert's verse, Amy Charles reads in the simple spellings, self-corrections, attention to spacing, and skillful accommodation of an overarching order of the poems a possible synthesis of poetic intention with scribal talent: "If Herbert was not the actual copyist," she writes, "he must have worked with him far more closely than one normally does with a copyist" (*Life of Herbert*, 80).

48. See Strier's reading of "Love Unknown," *Love Known*, esp. 161.

49. See Rosemond Tuve, *Essays by Rosemond Tuve: Spenser, Herbert, Milton*, ed. Thomas P. Roche Jr. (Princeton: Princeton University Press, 1970), 167–206, 176; Strier, *Love Known*, 197.

50. De Certeau, *Heterologies*, 59.

51. Lacan, *Seminar XI*, 12, 160, 22; *Séminaire XI*, 30. Here I have corrected the translation slightly.

52. Lacan, *Seminar XI*, 159, 230.

53. Lacan, "The Freudian Thing," *Ecrits*, 130.

54. Bruce Fink, "Science and Psychoanalysis," in *Reading Seminar XI: Lacan's Four Fundamental Concepts of Psychoanalysis*, ed. Richard Feldstein, Fink, and Maire Jaanus (Albany: State University of New York Press, 1995), 55–64, 57.

55. Lacan, "The Function and Field of Speech and Language in Psychoanalysis," 72. Regarding Lacan's comparisons of analysts to saints and the community of psychoanalysis to a church, see Philippe Sollers, "Freud's Hand," in *Literature and Psychoanalysis, The Question of Reading: Otherwise*, ed. Shoshana Felman

(Baltimore: Johns Hopkins University Press, 1982, first pub. *Yale French Studies,* 1977), 329−37.

56. Lacan, *Seminar VII,* 170.

57. See Lacan, *Seminar XI,* 191; *Seminar VII,* 95, 177. For St. Paul's relevance to psychoanalysis see Slavoj Žižek, *The Ticklish Subject: The Absent Centre of Political Ontology* (London: Verso, 1999), 145−51.

58. Lacan, *Seminar VII,* 171.

59. Kirschner, *The Religious and Romantic Origins of Psychoanalysis,* 7.

60. John Guillory, *Cultural Capital: The Problem of Literary Canon Formation* (Chicago: University of Chicago Press, 1993), 190.

61. Lacan, *Seminar XI,* 4.

62. Adam Phillips, *On Kissing, Tickling, and Being Bored: Psychoanalytic Essays on the Unexamined Life* (Cambridge: Harvard University Press, 1993), 120.

63. Ibid., 121.

64. Lacan, *Seminar XI,* 265, 264. Here I have corrected the translation slightly.

65. Phillips, *On Kissing, Tickling, and Being Bored,* 118.

66. See Lacan, "The Agency of the Letter in the Unconscious or Reason since Freud," *Ecrits,* 146−75, 174.

67. Lacan, *Seminar XI,* 265.

68. Lacan, *Séminaire XI,* 296.

69. Lacan, "On a Question Preliminary to Any Possible Treatment of Psychosis," *Ecrits,* 179−225, 215.

70. Ibid., "The Function and Field of Speech and Language in Psychoanalysis," 88, "The Agency of the Letter," 173; *Ecrits I,* 184, 285.

71. Thomas F. Merrill, "Sacred Parody and the Grammar of Devotion," *Criticism* 23, 3 (1981), 195−210, 197.

72. François Regnault, "The Name-of-the-Father," in *Reading Seminar XI,* 65−74, 68.

73. De Certeau, *Heterologies,* 59.

74. See Summers, *George Herbert,* 91−92; Strier, *Love Known,* 222−27.

75. Lewalski, *Protestant Poetics,* 295−96; see also Bloch, *Spelling the Word,* 166−67. In his reading of "The Collar," Goldberg seizes on the use of fonts: "[O]therness is rendered proprietary through italicization, which is also how the voice finally owns its response" (*Voice Terminal Echo,* 103).

76. Lacan, "The Freudian Thing," *Ecrits,* 141.

77. Strier, *Love Known,* 226.

78. See Vendler, *Poetry of George Herbert,* 132.

79. Lacan, *Seminar VII,* 300.

80. Ibid., 300.

81. Jacques Derrida, "Freud and the Scene of Writing," in *Writing and Difference*, trans. with additional notes by Alan Bass (Chicago: University of Chicago Press, 1978), 196–231, 210.

82. Derrida, "Freud and Writing," 211.

83. Ibid., 226. More recently, Derrida has returned to his reading of Freud to emphasize further the intimate relationship between the development of psychoanalytic theory and the available technologies of writing. Arguing that "the technical structure of the *archiving* archive also determines the structure of the *archivable* content even in its very coming into existence and in its relationship to the future," Derrida also draws attention to the "exceptional role . . . played at the center of the psychoanalytic archive by a handwritten correspondence" (*Archive Fever: A Freudian Impression*, trans. Eric Prenowitz [Chicago: University of Chicago Press, 1996, first pub. Editions Galilée, 1995], 17).

84. Lacan, "The Subversion of the Subject and the Dialectic of Desire in the Freudian Unconscious," *Ecrits*, 292–325, 297.

DEPTH PERCEPTIONS

JONATHAN GOLDBERG

THE ANUS IN <u>CORIOLANUS</u>

This paper was originally written for a plenary session at a meeting of the Shakespeare Association in 1994. Indeed, its delivery there was recently noted in an essay by Cynthia Marshall, who takes me to task for my mode of delivery, for some of the language used in this essay, and for my distribution on that occasion of an image that, she reports, "clearly shocked some members of the audience."[1] While I have not included the supposedly offensive image here (and Marshall might be shocked to discover that a woman drew it), the text of this essay remains close to the original version as delivered.[2] Uncensored, this paper probably cannot receive the G rating that Marshall seems to think appropriate for texts or images aimed at adults (in this, she resembles other regulators worried about the Internet and TV, and incapable of distinguishing violence from sexuality); nonetheless, it may yet register as a necessary intervention in Shakespeare studies.

In a paragraph on the names in *Coriolanus* in the section of comments following his essay "*Coriolanus*—and the Delights of Faction," Kenneth Burke notes that "though the names are taken over literally from Plutarch, it is remarkable how tonally suggestive some of them are."[3] If Volumnia's name speaks volumes, the "tonal suggestion" of the name of the hero is equally remarkable. "In the light of Freudian theories concerning the

fecal nature of invective," Burke writes, "the last two syllables of the hero's name are so 'right,' people now often seek to dodge the issue by altering the traditional pronunciation (making the *a* broad instead of long)."[4]

Burke on the whole is suspicious of psychoanalytic readings of the play, yet that is the route that seems to him to indicate the "rightness" of the anus in Coriolanus, and it is therefore of some interest that avowedly psychoanalytic readings of *Coriolanus* by Janet Adelman and her followers (among whom I would include the author of *James I and the Politics of Literature*) stay within the domains of orality in the play, richly symptomatic as they are, and on a number of registers.[5] Only Stanley Cavell, in the postscript to his essay "*Coriolanus* and Interpretations of Politics" in his volume of Shakespeare essays, *Disowning Knowledge*, picks up where Burke left off.[6] It's perhaps worth remarking that just as Burke's note on the anus occurs as part of a set of comments appended to the body of his essay, Cavell's afterthoughts come in a similarly well-positioned postscript. Pursuing a route from the oral to the anal, Cavell takes Coriolanus's "horror of putting in his mouth what (. . . in his fantasy) comes out of the mouths of others" as an indication that what is involved in Coriolanus's disgust at the "rank-scented meinie" (3.1.65, to recall one of the phrases of his delicious invective) is "imagining that in incorporating one another we are asked to incorporate one another's leavings, the results or wastes of what has already been incorporated."[7]

Cavell finds support for his analysis in the fable of the belly offered by Menenius Agrippa in the opening scene of the play as he attempts to placate the revolting plebeians, clamoring for food. This is an apt site, it seems to me, since Cavell's speculations take up precisely what Menenius's tale omits; his alimentary allegory leaves out any mention of elimination, presenting the belly as a site of distribution, as if without a remainder. Yet, the language used to describe the belly is undeniably anal: It is the "sink o' th' body" (1.1.121) according to the first citizen, a "gulf" in the accusations against the belly voiced in the allegory (1.1.97); even in Menenius's defense, the belly is left, after distributing flour to all the parts of the body, with nothing but "bran" (1.1.145), uneatable refuse. In the allegory, then, the belly assumes the position of the anus, receiving what is normally expelled; a closed economy is imagined in which waste is consumed.

Ingestion and evacuation, inside and outside, change places. That equivocation, however, shapes the delivery of the fable. It is to be noted,

for instance, that what Menenius offers his listeners is "a pretty tale" (1.1.89), and the telling of it he describes as a "venture / To stale't a little more" (1.1.90–91). The economy of speech, even, as here, in an attempt at pacification, takes the form of an offer of words as if they came from the anus, a stale tale. Indeed, Menenius interrupts his tale with a belly laugh, "a kind of smile, / Which ne'er came from the lungs, but even thus—" (1.1.106–7), a bodily gesture that may as easily be a fart as a belch. This speech, however gentle or good-humored it appears to be, is directed against the plebeians as much as are the invectives that Coriolanus hurls. To put it crudely, Coriolanus hurls shit at the plebeians because he experiences their words as shit hurled at him; Menenius's stale tale is a euphemized and seductive version of this. To Coriolanus, the strength of the plebes lies in their breath, and he imagines war as one way "to vent / Our musty superfluity" (1.1.224–25). *Vent* (or Menenius's stale venture) and *superfluity* are terms that recur in the play and seem to point to a disposable excess—to the waste products to which Cavell refers. Burke and Cavell's argument, therefore, seems apt: One site of the anal economies of the play is speech. I would add, however, as some indication of the extent of this economy, that the social processes of the play are insistently about evacuation (banishment) and entrance, often across forbidden thresholds, and suggest that the equivocations of inside and outside in Menenius's fable have their counterparts in the mirroring locations of Coriolanus. Accused of being the enemy of the people, he joins the enemy after his banishment.

These ins and outs are not all that explicitly anal, and perhaps one ought not put these matters more crudely than the play seems to. That, at any rate, is the position that Cavell takes. It follows from his desire to hold on to his thesis (indebted to Adelman) that the primary circulation in the play is oral; for him this is not only a psychological datum but the basis for political communion. "The very suggestion of the element this postscript invokes," he writes, "is apt to stifle what the body of my essay takes—correctly, I persist in thinking—as fundamental in the play, namely the circulation from mouth to mouth of language."[8] Curious figures insist upon themselves in this formulation: the worry about stifling; the question of what is fundamental in the play. The fear is that the fundament might indeed be fundamental.[9] (Cavell's language recalls the birth of Gargantua, forced to emerge from Gargamelle's ear after her vaginal canal is blocked when her fundament collapses, emitting turds that some take at first to be her baby.)[10] Cavell goes on to suggest—as

perhaps this allusion to Rabelais does too—that it is difficult to think about these matters without joking, and his tone, in considering "the element" his postscript invokes, is much like Menenius's in his civilized fable of the belly. Trying to maintain the proper tone, Cavell writes, with delicate philosophical distance, that such matters appear "in the part of the world I know, mostly in slang, or jokes, . . . and in expressions rejecting the words of others by asking what they are trying to hand you, or by naming the product as the droppings of horses or bulls."[11] It would almost seem for Cavell as if the only place that the anus exists is *in language* and that it can only be spoken through these circumlocutions, displacements perhaps akin to those in *Coriolanus*. Cavell worries the question of how to "allude to the fecal issue" (a pregnant phrase to which I will return) "in unprotected prose."[12] He worries, to put it bluntly, about covering his ass, and confesses to shame, embarrassment, and the need to find a way of preserving the decorum of civility in the play's "assessments":

> It was coming to see more unprotectedly that Shakespeare's *Coriolanus* is itself exactly in struggle with this question of explicitness and naming . . . that I was shamed into making my embarrassment (of style, say) more explicit in this note. The implication is that to avoid risking one's critical balance in traversing this play is to avoid a measure of participation in the play's assessments of the balance civilization exacts.[13]

Embarrassed assessments: Is the anus perhaps more inescapable than Cavell imagines, more than just the locus of shame and shit? Once one has granted the possibility that oral and anal exist in a substitutive relationship in the play, can one still hold on to an uncontaminated sphere of orality or attempt to write in a language that would avoid—or even void—the anus? Cavell attempts to do so as a way to secure the play as a civilized document and as a site for a liberal politics of speech. But, I would argue, this involves a misreading, not only of the body economies of the play, however fantasmatic they may be, but also of a body politic more absolutist and exclusionary than Cavell seems willing to imagine. And beyond that, it involves anal economies that go beyond the regions that Cavell would keep in place.

Recall, for instance, that Menenius, however much his first speech offers itself as tactful persuasive utterance, later in the play, in dialogue

with the tribunes, reports himself as "one that converses more with the buttock of the night than with the forehead of the morning" (2.1.50–52). This important association of nocturnal pleasure with the buttocks is immediately followed by lines in which Menenius "spend[s] his malice in [his] breath" (2.1.53) attacking the tribunes as those who have an altogether different relationship, he claims, to their posteriors: "When you are hearing a matter between party and party, if you chance to be pinched with the colic, you make faces like mummers, set up the bloody flag against all patience, and, in roaring for a chamber-pot, dismiss the controversy bleeding, the more entangled by your hearing" (2.1.72–77). While this exchange secures the association of shit and invective, it also opens around the anus the dynamics of pleasure and pain that many readers will recognize as crucial throughout the play. Further substitutions seem at hand, for instance a route from the bleeding bowels of the tribunes to the orifices of Coriolanus's body, the wounds that he is obliged to and refuses to display when he stands for the office of consul. To pursue this point would necessarily extend the standard psychoanalytic equation of words, mouths, and wounds. And, in terms of a more immediate reading of the play, it suggests that we reconsider what it means when a character who "converses with the buttock of the night" can, a bit later in the same scene (2.1.142ff.), tally up and locate every hole in Coriolanus's body, a body whose wounds, after all, Coriolanus refuses to display in public.

These speculations suggest that it is time, as Gail Kern Paster has urged, to stop protecting Shakespeare from "anal contamination," time to open the question of anal erotics.[14] Paster goes some way in this direction in the third chapter of *The Body Embarrassed*. Noting the early modern attachment to enemas and the conceptualization of sexual release as a purgation congruent with bloodletting and other procedures meant to ensure humoral balance, Paster forthrightly locates a homology between sexual pleasure and anal pleasure, in a word, the sexual pleasure of the relaxation of the sphincter as shit passes through it. Indeed, for some Renaissance authors that Paster cites, including Sir John Harington, author of the resonantly punningly titled *Metamorphosis of Ajax*, the pleasures of the privy exceed those of coitus, especially when the latter is attached to the body of a female whore: "Harington's praise of the privy suggests . . . that in metonymic exchange between whore and privy, the privy gains in innocence as well as desirability at the expense of the corrupted female body," Paster comments.[15] Further, by locating

early modern toilet training in the maternal domain, Paster points to the privileged site in which oral commands and anal performance are intimately linked, making oral/anal substitutions all the more likely, as might be assumed as part of the pedagogic relationship between Coriolanus and his mother; the spitting of blood from Hector's wound that Volumnia imagines in a substitutive relationship with the milk from Hecuba's breast (1.3.40–43), and, by analogy, her own, in this light can as easily figure in an exchange in which the refuse from the mouth takes the place of anal evacuation, where the bloody breast anticipates the ulcerated bowels of the tribunes. "The blood I drop is rather physical / Than dangerous to me" (1.5.18–19), Coriolanus claims. And we might add here that the scene at the breast also involves another substitution: the hurling mechanism of blood is both phallically and anally assaultive.

This substitution gives some reason to extend the understanding of anal eroticism that Paster offers; she sees "the privy as a displacement for the female body" (160), defecation as a substitute for vaginal intercourse. Terms such as *sink* and *gulf* easily make these connections, and my point is not to dispute the analogy but to suggest that the model of substitution and displacement deployed by Paster (on good psychoanalytic warrant) inevitably assumes a proper and singular form to sexuality and closes off other possibilities too quickly. Paster as much as admits this when she describes anal eroticism of the Elizabethan sort as a site of "greater psychic intensity than we consider normal today."[16] "Today," she comments, "we associate any sexual use of the laxative purge with the practice of anal intercourse among male homosexuals;" Elizabethan practices, she implies, were "abnormally" more widespread.[17] Yet, following Paster's reading, it would seem as if purgatives and anal intercourse were only male practices then and now, and that they constituted a form of heterosexual intercourse manqué. The very logic of displacement suggests otherwise. And although far more forthright than Cavell in her chapter called "Covering His Ass," a certain amount of modern, civilized, knowing occlusion is going on. Why not covering *her* ass?[18] Paster misses the opportunity to pursue those questions when she analyzes Titania's love for her ass.[19] Or to engage the question asked by Jeffrey Masten: "[W]hat would 'anality' mean — would it exist — as a psychoanalytic structure" in these historico-cultural contexts?[20]

Why should the pleasures of the anus be thought of only in terms of its evacuative function? Answers are not far to seek. Anal eroticism, as described by Freud, involves infantile fantasies of anal birth ("fecal

issue," to recall Cavell's nice phrase), where the delivery of the stool stands for the delivery of the baby, and where the anus would seem therefore to function in the way Paster takes it to be, as a substitute vagina.[21] In a groundbreaking study, *Homosexual Desire*, which first appeared more than twenty-five years ago, Guy Hocquenghem titled a chapter "Capitalism, the Family, and the Anus," describing the ways in which the Oedipal organization of modern society depends upon the sublimation of the anus; anal control secures the most private site of the body, the place where one learns what is one's own, what must be kept clean, what must be kept out of circulation.[22] Part of the way this is done is through the Freudian fantasmatics of the anus as substitute vagina; another way is through associating the anus entirely with its excremental functions, so that lack of control, as in violent speech, comes to be seen as an unruly insistence of that which should be kept hidden and private. The privatization and sublimation of the anus suggests to Hocquenghem why homosexuality threatens society, because whether or not homosexuals perform anal sex, homosexuality affirms the anus as a site of desire. It thereby threatens the proprieties of modern economies of all kinds—individual and social boundaries and principles of regulation. If we inflect Hocquenghem's arguments in the direction of the Elizabethan period as Paster describes it, where anality is not a delimited phenomenon, this suggests that the modern economies—psychic and capitalist—that Hocquenghem describes are not yet in place in Shakespeare's world. The anus may not need *or have* the civilized covering that Cavell assumes.

To further this point, it is apt, now, at last, to cite the lines from the play that have motivated this inquiry from the start, Aufidius welcoming Coriolanus to the enemy camp:

> . . . that I see thee here,
> Thou noble thing, more dances my rapt heart
> Than when I first my wedded mistress saw
> Bestride my threshold. . . .
> Thou hast beat me out
> Twelve several times, and I have nightly since
> Dreamt of encounters 'twixt thyself and me—
> We have been down together in my sleep,
> Unbuckling helms, fisting each other's throat—
> And wak'd half dead with nothing. (4.5.116–19, 122–27)

It is clearly no overstatement to regard these lines as sexual, or to see a relationship between the wedded mistress (whom, Aufidius assures Coriolanus, he loved—"Know thou first, / I lov'd the maid I married" [4.5.114–15]) and the nocturnal enemy now crossing the threshold like a bride, or between the fisted throat and the vagina. But, to follow the argument I have been presenting, this scene of fisting also must be read as a displacement of anal sex to the mouth.

If Aufidius's dream participates in the substitutive equation of mouth and vagina, one needs to note that the ordinary word used for the vagina in the play is *womb*—a word that also means "belly" and "bowels." When, at the end of the play, Coriolanus stages an attack on his native place—that is, the site from which he first emerged, his mother's womb (5.3.123) as much as the city of Rome—that act realizes what he says outside the gates of Antium, the enemy city: "My birthplace hate I, and my love's upon / This enemy town" (4.4.23–24). It's often been noted that Coriolanus has two names, one his family name, the other the name of the Volscian town of Corioles that he single-handedly defeats, and it is perfectly easy to read his assault on Corioles, his bloody emergence alone from its walls, as a rape and birth fantasy. But if Coriolanus has these two relations, one origin in the maternal, natal womb, and the other in the enemy's place, that fantasy of second birth involves an unnatural site of origination—the enemy's gates, which open to release him, bleeding. The play here traffics in a fantasy of origination in an alternative to the "natural" site, a fantasy of anal birth. And more than that: The site of Coriolanus's love, after all, is the enemy town—and the enemy whose threshold he crosses like a longed-for bride, or fuck buddy.

This makes further sense of the standard psychoanalytic perception that Aufidius and Volumnia are versions of each other, lovers and enemies; the erotic intensity of Coriolanus for Aufidius, the man explicitly named as the object of his "soul's hate" (1.5.10), is obviously equivalent to the fully ambivalent feelings he has toward his mother. At the end of the play, after all, she kills him as much as Aufidius does, and her final taunt that convinces him not to invade Rome—that he is a foreign "fellow" born of a Volscian (5.3.178)—has its counterpart in the maternal sadism of Aufidius calling Coriolanus "boy" (5.6.100). Adelman sees in Aufidius an alter ego, a brother, and a father figure; but, in fact, Coriolanus has plenty of substitute fathers—Menenius, who appropriates the language of paternity, and his general Cominius, under whom he serves. Both of these relations are also eroticized: Coriolanus, for instance, embraces

Cominius on the battlefield "[i]n arms as sound as when I woo'd; in heart / As merry as when our nuptial day was done, / And tapers burn'd to bedward!" (1.6.30–32), while Menenius explicitly names himself Coriolanus's "lover" (5.2.14)—a term that, however much the Arden editor, for instance, would like to translate it as "friend," will not be capable of de-eroticization once we recall Coriolanus's own description of "[f]riends . . . , / Whose double bosoms seem to wear one heart, / Whose hours, whose bed, whose meal and exercise / Are still together, who twin, as 'twere, in love / Unseparable" (4.4.12–16).[23] As for his relationship with Aufidius, however much it might be thought of as being within the family—insofar, that is, as Aufidius is the Volscian "mother" of Coriolanus, say—it is also important to recognize the intense eroticism of their relationship, which the terms *alter ego* or *brother* diffuse, but which is evident not only in the dream that Aufidius reports but also in the comments of the servants who witness their embrace: "Our general himself makes a mistress of him" (4.5.199–200), the third servingman comments in lines that are perfectly ambivalent about whether it is Coriolanus or Aufidius who is in the so-called female position, as ambivalent about position as is the case in the imagined scene of mutual fisting. In short, the parallelism between Volumnia and Aufidius, the casting of male-male relations within the terms of gender-differentiated ones (husband and wife, man and mistress) as the sites of Coriolanus's hate and love, of a simultaneous embrace and rejection, establishes these love/hates in the endlessly substitutive locus of womb/bowel.[24]

Moreover, as doubly born, Coriolanus himself is doubly gendered, as Cominius reports when he narrates the life of Coriolanus (2.2.82–122), which passes through an "Amazonian" phase (2.2.91). This further complicates the division natural/unnatural, with female and male as "mothers." One site for these meetings that complicate gender difference and the meaning of the natural is the anus, as both "natural" (i.e., a bodily site shared by men and women) and yet as "unnatural" (because it produces "nothing," to recall Aufidius's lines). This is what I think makes for the "rightness" of the anus in Coriolanus, for it suggests that the anus is the *productive* site for the character in the play and not merely to be read within the Freudian trajectories of shame and sublimation. Coriolanus's career of attempted self-authorship represents a desire to become a machine, to "live" in some realm that is not the biological. The fantasy of the play thus involves a dream of authoring and of self-authoring that transgresses even the transgressive desire that the play

suggests in its equation of womb and bowels. For in paralleling the loves of Aufidius and of Volumnia, in equating hetero and homo desire *and its betrayal*, the play looks beyond these forms of sexuality, or, perhaps, imagines an "inhuman" sexuality that would not be subject to betrayal. This is a form of reproduction glimpsed in the sonnets, in the artifices of image production. Aufidius's dream may be Shakespeare's, too.

NOTES

1. Cynthia Marshall, "Wound-man: *Coriolanus*, Gender, and the Theatrical Construction of Interiority," in *Feminist Readings of Early Modern Culture*, ed. Valerie Traub, M. Lindsay Kaplan, and Dympna Callaghan (Cambridge: Cambridge University Press, 1996), 93–118; her comments on my essay occur on 118 n. 59.

2. The image, by Phoebe Gloeckner, illustrates a work of fiction, "Snake Dance," by M. I. Blue, in *Future Sex* 5 (1993), 40–41, and shows a fist emerging from a throat against an intestinal background; the gender of the hand or of the fisted figure in the image cannot be determined. It is hardly a stretch to argue that the fisted throat in Gloeckner's image is connected viscerally to a suggestion of anal fisting; her image thus makes explicit what I argue for in the reading of *Coriolanus* that follows.

3. Kenneth Burke, *Language as Symbolic Action* (Berkeley: University of California Press, 1966), 96. Further citations are drawn from the same page of the essay.

4. It is worth remarking that preserving the Latin pronunciation could remind one that *ring* and *anus* are identical in that language—a point not lost in the final scene of *Merchant of Venice*.

5. See Janet Adelman, "'Anger's My Meat': Feeding, Dependency, and Aggression in *Coriolanus*," in *Shakespeare: Pattern of Excelling Nature*, ed. David Bevington and Jay L. Halio (Cranbury, NJ: Associated University Presses, 1978), reprinted in *Representing Shakespeare: New Psychoanalytic Essays*, ed. Murray Schwartz and Coppélia Kahn (Baltimore: Johns Hopkins University Press, 1980), and the basis for sections of chapter 6 in Adelman, *Suffocating Mothers* (New York: Routledge, 1992). Cf. Jonathan Goldberg, *James I and the Politics of Literature* (Baltimore: Johns Hopkins University Press, 1983), 186–93.

6. All citations are from Stanley Cavell, *Disowning Knowledge in Six Plays of Shakespeare* (Cambridge: Cambridge University Press, 1987); the *Coriolanus* essay first appeared without a postscript under the title "'Who Does the Wolf Love?': Reading *Coriolanus*," *Representations* 3 (1983): 1–20.

7. Ibid., 169. All citations of *Coriolanus* are from the Arden edition, ed. Philip Brockbank (London: Methuen, 1976).

8. Cavell, *Disowning Knowledge*, 170.

9. This is the relationship in the early modern period argued by Jeffrey Masten in "Is the Fundament a Grave?" in *The Body in Parts*, ed. David Hillman and Carla Mazzio (New York: Routledge, 1997), 129–45; for further thoughts about the relationship between foundational politics and modern anxieties, see Lee Edelman, "Capitol Offenses: Sodomy in the Seat of American Government," among other essays gathered in his *Homographesis* (New York: Routledge, 1994), as well as Leo Bersani, "Is the Rectum a Grave?" *October* 43 (1987): 197–222.

10. François Rabelais, *Gargantua et Pantagruel*, 1.6.

11. Cavell, *Disowning Knowledge*, 170.

12. Ibid., 175.

13. Ibid.

14. Gail Kern Paster, *The Body Embarrassed* (Ithaca: Cornell University Press, 1993), 143.

15. Ibid., 155.

16. Ibid., 114.

17. Ibid., 135.

18. For some considerations of this topic in early modern texts, see my "*Romeo and Juliet*'s Open Rs," in *Queering the Renaissance*, ed. Jonathan Goldberg (Durham, NC: Duke University Press, 1994), 218–35, and "Margaret Roper's Daughterly Devotions: Unnatural Translations," in Jonathan Goldberg, *Desiring Women Writing: English Renaissance Examples* (Stanford: Stanford University Press, 1997), 91–113. For one example of the ways in which lesbian anal desire might overlap with gay male and heterosexual desire, see the contemporary image that I discuss in the Introduction to *Reclaiming Sodom* (New York: Routledge, 1994).

19. This is also the case in Bruce Thomas Boehrer, "Bestial Buggery in *A Midsummer Night's Dream*," in *The Production of English Renaissance Culture* (Ithaca: Cornell University Press, 1994), 123–50, whose analysis of bestiality in the play never ponders the possibility that "ass" could signify anatomically, something worth considering, to follow a remark I make in *Sodometries* (Stanford: Stanford University Press, 1992), 275 n. 8, that Bottom and the Indian boy are in a substitutive relationship in the play.

20. See Masten, "Is the Fundament a Grave," in *The Body in Parts*, 145 n. 47.

21. Freud comments on the primordiality of fantasies of anal birth in his analysis of the Wolf Man's version of the primal scene as *a tergo* intercourse, a point emphasized in Lee Edelman's reading of the case in "Seeing Things," *Homographesis*, 173–91. For this reason, it is suspect simply to follow the strand in

Freud's thought that equates the anus with and considers it a substitute version of the presumptively primordial vagina, as Paster does, and as also can be seen in Avital Ronell, *"Le Sujet Suppositaire*: Freud and Rat Man," in *On Puns*, ed. Jonathan Culler (Oxford: Basil Blackwell, 1988), 115–39, or in Lucinda Dixon's analysis of representations of enema procedures in early modern Dutch painting, in *Perilous Chastity* (Ithaca: Cornell University Press, 1995), 147–53.

22. Guy Hocquenghem, *Homosexual Desire*, trans. Daniella Dangoor, preface by Jeffrey Weeks, was recently reissued with a new introduction by Michael Moon (Durham, NC: Duke University Press, 1993); the original French text dates from 1972, the English translation from 1978.

23. For a crucial statement of the eroticism of friendship, see Alan Bray, "Homosexuality and the Signs of Male Friendship in Elizabethan England," *History Workshop Journal* 29 (1990), 1–19, reprinted in a slightly revised form in *Queering the Renaissance*, 40–61.

24. These arguments are meant to counter those who see the intense male-male relations in the play as invidiously in competition with heterosexuality, that is, as the supreme instance of the supposedly typical male eroticizing of violence, inevitably at the expense of women, inevitably taking the form of male-male sexuality. See, e.g., Peter Erickson, *Patriarchal Structures in Shakespeare's Drama* (Berkeley: University of California Press, 1985), 5–6, for a male feminist statement of this position in a reading of the lines spoken by Aufidius to Coriolanus (Erickson's position conveniently exonerates straight men), or Alan Sinfield, *Faultlines* (Berkeley: University of California Press, 1992), 136, where the bond of Aufidius and Coriolanus is similarly treated as stigmatizing women as well as aimed at effeminate men; Sinfield thus implies that male homosexual relationships should be modeled on politically progressive heterosexual lines.

KATHRYN SCHWARZ

BREAKING THE MIRROR STAGE

Ladies can laugh at Ladies, Knights at Knights.

—*Spenser,* The Faerie Queene

I want to start with something familiar, and ask that it be read for the moment not as a theory, but as a story.

> The *mirror stage* is a drama whose internal thrust is precipitated from insufficiency to anticipation—and which manufactures for the subject, caught up in the lure of spatial identification, the succession of phantasies that extends from a fragmented body-image to a form of its totality that I shall call orthopaedic—and, lastly, to the assumption of the armour of an alienating identity, which will mark with its rigid structure the subject's entire mental development.[1]

As a paradigm, Lacan's description of the mirror stage is so familiar as to read like a trope, the projection backward of a myth of origin rather than a developmental narrative mimetically related to the process it de-scribes. I would like here to make it strange by making it plot. If the

mirror stage is not necessarily the biography of every child, it is precisely that of Spenser's Britomart, who falls in love with Artegall's magically generated reflection and disguises herself as a knight in order to pursue it. Like Lacan's subject, she looks in a mirror, sees a fully articulated image of agency, is caught up in a succession of fantasies — and takes on "the armour of an alienating identity" in order to become what she desires.

I offer this less as a Lacanian reading of *The Faerie Queene* than as a suggestion about early modern mirror tricks, for Britomart's transformative look in the mirror reflects a larger fascination with the relationship between identity and misrecognition.[2] In *Staging the Gaze*, Barbara Freedman writes, "Renaissance mirror games arrange for a flattering self-portrait to come into focus precisely in that moment when a distorted image could be relegated to a field of erring sight."[3] Britomart's quest takes place on that field. Through her disguise plot, *The Faerie Queene* plays out the processes of enabling misperception, with their constant if displaced reminders of the "distorted image" out of which they are produced. The mirror game that produces the Knight of Chastity stands in a supplementary relationship to allegorical and chivalric systems of identity, generating both the substantiation and the implicit threat that supplementarity implies. For Britomart, in her misunderstanding of Artegall's likeness and in her encounters with him while disguised, the play of knowledge and error, distortion and ideal, produces a specifically gendered negotiation of identity, implicating both the allegorical relationship between Chastity and Justice and the performative relationship of masculinity to men.

Like other narratives of knights and quests, *The Faerie Queene* presents chivalric encounters in which opponents, held in equation by the visible display of armor and the equally rigid apparatus of heroic codes, affirm identity through the mediating conceit of the mirror image. Because knights look and act alike, variations on victory and defeat only consolidate a constant masculine chivalric ideal. Dependent on a logic within which difference works to affirm the ultimate power of sameness, such consolidation is inevitably fragile, vulnerable to the conditions of its production. This becomes sharply visible when women play men, enacting masculinity without reference — or with disconcertingly effective reference — to the body beneath. In Britomart's quest as in other encounters between men and women who look like them, the identity constructed by apparent masculinity is at once true and false, at once illusion

and effective performance. Through such encounters, early modern texts set up terms made familiar less by heroic quests than by theories of subjectivity: anticipating the Lacanian mirror stage, chivalric narratives figure successful role-playing as a complicated compromise between identity and difference, deception and revelation, violence and desire. In heroic encounters as in the mirror stage, self-articulation occurs through the intervention of an image that both is and is not logically connected to the body to which it refers. Identity depends on confrontation, emerging from an appropriative rather than a naturalized relationship between body and act; for both chivalric and Lacanian subjects, an idealized externalized image emerges from aggressive misunderstanding, and "the armour of an alienating identity" is a prize worth fighting for.

When that armor is attached to women, the process is rather more complicated. Early modern fascination with this possibility suggests the sense in which self-construction is always in part contingent on mistake; the homosocial ideal that equates men to one another and leaves women out entirely is complicated by the tendency of women to reappear in unexpected places. Like Lacan's description of the "trotte-bébé," the "support, human or artificial" that at once enables the subject's vision of self-sufficiency and provides a material reminder of the condition of dependence, early modern narratives of encounters between men and armed women suggest a profound ambivalence toward the role women play in the formation of identity.[4] If chivalric encounters between men incorporate two bodies into the moment of mirroring, that doubleness might resolve itself into a single heroic image. But when one of the men proves not to be a man at all, the doubling of bodies exposes what Lacan terms the "fictional direction" taken by fantasies of mirroring, and the shift from identity to difference requires a transition from homosocial to heterosexual aggression. In her reading of Lacan, Jacqueline Rose writes, "The image in which we first recognise ourselves is a *misrecognition*," and for knights looking at women in armor, the misrecognition does not remain in place.[5]

Fascination with a simultaneity of female bodies and masculine acts cannot be detached from the anxiety of impersonation—of, quite literally, an effective assumption of the personal signifiers that chivalric convention predicates as innate. Martial female performances suggest not only that gender is a construct, but that its shifting terms undermine the hierarchical relationship between homosocial structures of power

and the heterosexuality through which they are reproduced. As the disguise breaks down, as the illusion of identity between men gives way to a confrontation between men and women, chivalric tropes become domestic stories, and the narcissism of homosocial violence yields to the assertions of difference implicit in heterosexual desire. In *Between Men* Eve Sedgwick explains her use of the phrase "male homosocial desire": "To draw the 'homosocial' back into the orbit of 'desire,' of the potentially erotic, then, is to hypothesize the potential unbrokenness of a continuum between homosocial and homosexual—a continuum whose visibility, for men, in our society, is radically disrupted."[6] In juxtaposing the terms "homosocial" and "heterosexual" in my analysis of chivalric encounters, I am pointing to a different and less obviously scandalous continuum, which links men's lateral interactions with one another to their hierarchical intercourse with women. But this link, like the one that Sedgwick describes, becomes transgressive in becoming visible; the transition from social to sexual, yoked to that from homo- to hetero-, imposes simultaneity and even identity on modes of connection that gendered hierarchies work to distinguish. When heroes confront Amazons, the illusion of identity between men gives way to a negotiation between men and women, revealing that homosocial and heterosexual negotiations are played out through the same bodies and in the same narrative space.

This is the disruptive potential of Britomart's quest. She is connected to Artegall mimetically through allegory and armor, and teleologically through her desire to marry him and have his child. As this doubled bond suggests, desire generates contradiction in *The Faerie Queene*, working as a repetitive pattern, allegorical and structurally homosocial, through which the poem's conflicts appear and recur, but also imposing a heterosexual and historical move forward into generation.[7] Maureen Quilligan writes, "To make a female an actor in an allegory is to complicate an already complicated set of gender distinctions in an already complicated genre of narrative."[8] In Britomart's quest, both distinct kinds of narrative and discrete categories of gender intersect: She is at once allegorically constant and sexually progressive, a deictic mediator between the iconographic and the domestic. There is a basically unlikely relationship between her maternal destiny and the martial means she uses to get there, a gap in the syllogism between looking for and looking like a man.

The eagerness with which Britomart pursues her quest has been characterized by some readers as unseemly, despite the narrator's perhaps overly emphatic assurance: "Not that she lusted after any one; /

For she was pure from blame of sinfull blot" (3.2.23.7−8).[9] Yet the fear of sexual excess is in some sense a displacement, for Britomart, confronting a mirror image of her future and her quest, might be transgressive less in desire than in recognition. Looking in the mirror, she at first sees only what is familiar: "Her selfe a while therein she vewd in vaine" (3.2.22.6). The image of Artegall follows —"A comely knight, all arm'd in complet wize"— and the relationship between these reflections is immediately complicated and doubled, for Britomart will become a knight in order to pursue one. The construction of her heroic masculinity suggests that the two moments of perception — of herself, and of "a comely knight"— are not different, that Britomart's image incorporates the alien armor that follows. Suggestively, she speculates that she has become a new Narcissus:

> I fonder, then *Cephisus* foolish child,
> Who hauing vewed in a fountaine shere
> His face, was with the loue thereof beguild;
> I fonder loue a shade, the bodie farre exild. (3.2.44.6−9)

Glauce assures her that the identity is false, that Britomart is "nought like" Narcissus, who "[w]as of himselfe the idle Paramoure; / Both loue and louer, without hope of ioy" (3.2.45.1−3). Britomart's image, Glauce insists, possesses a body other than her own, a discrete identity; Britomart "lou'st the shadow of a warlike knight; / No shadow, but a bodie hath in powre" (3.2.45.6−7). The fear of becoming both subject and object of desire is countered by this certainty that there is a body out there somewhere, if only Britomart can find it.

Despite this reasoning, the image that rhetorically intervenes between Britomart and narcissism is not Artegall but female sexual monstrosity. Glauce asks her, "What need ye be dismayd, / Or why make ye such Monster of your mind?" (3.2.40.1−2), and offers her a catalogue of what she is not, beginning with incestuous Myrrha and ending with bestial Pasiphae. But Britomart, rather than recoiling from such monstrosity, recognizes it as satiable, as an enterprise in which desire possesses sufficient agency: "For they, how euer shamefull and vnkind, / Yet did possesse their horrible intent" (3.2.43.6−7). Forbidden union, as *successful* union, has its own monstrous appeal; these women get what they want. For all its containment within the subjunctive, this is, I think, one of the most transgressive moments in the poem. Britomart's

desire produces not the deliberate masochism of Petrarchan conceits or the mistaken sterility of narcissism, but the monstrously acquisitive specter of female sexual agency. Saving Britomart from herself, various readers have argued that her desire for that which is *outside* displaces both narcissism and monstrosity, that her synthesis of masculine and feminine roles enables movement away from these debasing or self-devouring models. As Mihoko Suzuki writes, "Britomart, though androgynous, is not self-contained to the point of narcissism; unlike Virgil's Camilla, who suppressed her sexuality in order to wed herself to war, Britomart seeks Artegall to achieve that ideal union between the sexes which Spenser figures in the emblem of the Hermaphrodite."[10] The literalism of a male body, as object of the quest, intervenes in the closed system of desire to disrupt the narcissistic potential of Britomart's heroic image. Because Glauce is right, because Artegall exists, both Britomart's quest and her synthetic identity direct her desires outward.

But the models Britomart presents for understanding desire are paradigmatic. Her readings of the mirror construct an opposition between narcissism and versions of desire that are reproductive and domestic: incest and bestiality produce mothers and children, and in substituting the image of Pasiphae or of Myrrha for that of Narcissus, Britomart imagines her desire first as a pattern of homoerotic stasis and then as a story of generative domestic excess. There is a tension here between ways of gendering the agency of desire, and also between desire as triangulated homoeroticism and desire as heterosexually dyadic. Narcissus presents the static image of a man looking at a man and turning away from a woman — one way of understanding Britomart's own glance in the mirror. But her moment of transformation is also a movement through time, for Britomart is also a woman looking at and for the father of her child. These two structures characterize her quest; desire on that quest is synchronically triangulated through her apparent masculinity, but the aggressive materiality of reproduction progresses toward a reduction of triangles into pairs.

I will suggest that this collapse of mutually affirming masculinity into heterosexual domesticity is an anxiety repeatedly expressed through the amazonian stories that are told and retold in early modern exemplary texts. For these texts, as for *The Faerie Queene*, meeting the same partner in battle and in bed — never an easy transition — is a possibility that does a good deal of imaginative work. But I want to turn first to the image of the hermaphrodite that ends the original version of Book 3,

which is closely implicated in the tension between desire as structural, static, and iconographic and desire as progressively reproductive. Spenser's Hermaphrodite, formed in the union of Amoret and Scudamour, is produced by Britomart's successful performance as a knight, and she regards it with a sense of distance and of lack: "*Britomart* halfe enuying their blesse, / Was much empassiond in her gentle sprite, / And to herselfe oft wisht like happinesse" (3.12.46a.6−8). Restored to one another, Scudamour and Amoret have what Britomart does not, and her masculine chivalric performance has completed a quest and enabled a conjugal union neither of which is her own. Yet at the same time the hermaphroditic synthesis of woman and knight, of female body and masculine act, precisely mirrors the condition of Britomart herself, so that her distance from it suggests a certain fragmentation, a pulling apart of function and form. Britomart is aggressively doubled, and when the text describes her as "halfe enuying," we might logically pause to ask: Which half?

In this sense the hermaphrodite might represent not what Britomart wants but what she already is. Her quest can be seen as a series of iconographic moments in which her synthesis of qualities triumphs over more single-minded notions of that which is masculine or feminine; Lauren Silberman writes, "In fashioning a female hero, one who dons armor in pursuit of love, Spenser moralizes and transforms Ovid's paradox that the triumph of Hermaphroditus' manhood is also its loss into the paradoxical giving and withholding of the self that defines chastity in Book III."[11] There is a certain narrative danger in this idealizing impulse, as Britomart's self-sufficient doubleness might displace her quest for Artegall, not by drawing her into narcissism or monstrosity, but by making the quest irrelevant: What, unwary readers might be tempted to ask, does she need *him* for? Book 4 presents a figure who carries this logic to completion; the veiled doubled body Scudamour describes as standing guard over Amoret might be for Britomart a kind of self-fulfilling prophecy.

> [F]or, they say, she hath both kinds in one,
> Both male and female, both vnder one name:
> She syre and mother is her selfe alone,
> Begets and eke conceiues, ne needeth other none. (4.10.41.6−9)

Doubly sexed, singly named, and parthenogenetic, this figure displaces the earlier object of Britomart's gaze, for the hermaphroditic and potentially generative union of Scudamour and Amoret does not conclude the

third book of the revised *Faerie Queene*. If the initial image of the hermaphrodite is displaced by the chaste masculinity of Britomart in Books 4 and 5, that image reappears, revised, in the temple of Venus, its generative power posing an alternative conclusion to the Knight of Chastity's quest.

Yet again I want to shift, as that quest shifts, from iconography to narrative. The hermaprodic goddess of Scudamour's description, like the Roman statue to which Scudamour and Amoret are compared, is a static image of doubleness, a version of power that stands still. But the Hermaphroditus myth is a story, and in Ovid's version it is a story of transformation not irrelevant to Britomart's own. Hermaphroditus, like Narcissus, is to be found by a pool; like Narcissus too, he is not interested in girls. But the nymph Salmacis is no Echo; instead, "willde he nillde he," "wound about him like a Snake," she imposes her body on that of Hermaphroditus in an appropriatively phallic gesture of possession, and Hermaphroditus himself, who "wist not what love was," is passive, already dispossessed.[12] The result is synthesis: "They were not any lenger two: but (as it were) a toy / Of double shape. Ye could not say it was a perfect boy / Nor perfect wench: it seemed both and none of both to beene" (4.468–70). Like Britomart's mirror-vision, the spectacular desire of Salmacis—"She first the yongman did espie, / And in beholding him desirde to have his companie"—produces a doubled identity, and that doubleness is contained within a single body (4.383–84). Unlike the triangulated stillness of Narcissus, this narrative is dyadic and progressive; the story of Hermaphroditus figures a shift in which the masculine gives way to the female, an evocative model for Britomart's own quest. Like Britomart, Salmacis becomes what she wants, but the insistence of her body transforms our understanding of her object. The story of Hermaphroditus is another return to the mirror stage, in which identity with the object of desire produces a body that is irretrievably alien, detaching subjectivity and agency from any conventionally embodied understanding of difference.[13]

If these are the consequences of explicitly female sexual aggression, Glauce's reassurance might precisely oppose the generation of chivalric ideals: narcissism, rather than a cautionary tale, becomes a mechanism that preserves the conditions of exclusive masculinity into which Britomart deliberately and prosthetically enters. Narcissism's preoccupation with an image of identity, imagined not as a mistake but as a hierarchy of value, forecloses gaps between body and image, referent and display, and if Narcissus is guilty of a lack of detachment, there is strength in

that position. In his discussion of object choice, Freud insists that narcissism refers always to the future and to the past, retreating deictically from the subject's present moment: "That which he projects ahead of him as his ideal is merely his substitute for the lost narcissism of childhood — the time when he was his own ideal."[14] But in its Ovidian form the myth presents a union of subject and object characterized by an immediacy exactly as irresistible as it is mistaken. For Narcissus, frozen in contemplation of his image, the equation of identity and desire occupies an endlessly expansive *now*. His story suggests a model for social and chivalric connections: narcissism might be a template for patriarchal logic, organizing a system in which men look exclusively at and for their own images. Read as a condensation of male bonding, narcissism distinguishes homosocial from heterosexual desire, reinforcing gendered hierarchies; it makes homoeroticism less a cause of social anxiety than a system of social privilege; it identifies likeness as the best reason for desire.

This is the narcissism generated by chivalric ideals of exclusive masculinity: homoerotic, homosocial, pragmatically idealized and naturalized in the present tense. Disguised, Britomart enters into this economy, offering a mirror image to the knights she encounters that gains in value as she defeats them; for chivalric heroes, as for Lacanian subjects, the externalized vision of superior agency precipitates a statement of identity. Unexpectedly, the revelation of Britomart's female body might supplement and even catalyze this system of idealized masculine exclusivity, rather than disrupt it. In chivalric heroic encounters, men bond with men across the bodies of women. Represented through violence, this is nonetheless a system of exchange, and the narrative investment in that violence makes the primacy of interest in homosocial rather than heterosexual interactions all the more clear. Theorists ranging from Gayle Rubin to David Halperin have described the ways in which the generative materiality of women's bodies enables and perpetuates homosocial bonds; to quote Teresa de Lauretis's summary of Halperin, "[I]t is the female reproductive body that paradoxically guarantees true eros between men."[15] In this sense encounters between men and martial women are remarkably efficient, providing both the appearance of idealized masculinity and the female body that lends homoerotic violence a social fiction of cause: battles may be explained through women, but they are precipitated by envy, emulation, the seduction of the mirror.

The fantasy that drives representations of Amazon encounters promises that that mirror will at once work and break, that the martial woman

who looks like a man might play two parts in the triangle that structures chivalric heroism. The chivalric hero of the Amazon encounter, confronting a body that mirrors his own, responds with the simultaneity — and indeed causality — of identity and violence that characterizes chivalric heroic encounters in general; the appearance of an image that occupies the hero's own representational space creates the indistinguishable desires to admire it and to kill it. The representational doubleness of martial women makes this doubled desire productive, enabling them to battle knights and at the same time provide the prize, the idealized feminized body that remains when the armor comes off. Such triangulation, at once narcissistic and heterosexually acquisitive, is a fantastic ideal, a synthesis of violence and sex composed of two bodies and an act. René Girard has shown that desire works through violence and through triangles: "Nothing, perhaps, could be more banal than the role of violence in awakening desire," he argues, and adds, "Two desires converging on the same object are bound to clash. Thus, mimesis coupled with desire leads automatically to conflict."[16] Sedgwick has demonstrated that those violent rivalrous triangles are homoerotic as well; she writes of Girard's model, "[T]he bonds of 'rivalry' and 'love,' differently as they are experienced, are equally powerful and in many senses equivalent."[17] It is perhaps surprising if one of the two men between whom such a transaction occurs turns out to be an Amazon, but it is also, if somewhat oddly, convenient.

Analyzing the relationship between identification and desire in Jacobean drama, Jonathan Dollimore writes, "[T]he male is required to identify with other males but he is not allowed to desire them; indeed, *identification with* should actually preclude *desire for*. Conversely, those whom he is supposed to desire, and always in specified ways, namely women, he is discouraged from identifying with: that would equal effeminacy; so in relation to them *desire for* precludes *identification with*."[18] The conflation of identification and desire, which Dollimore describes as an effect of male sexual jealousy, is transgressive, even dangerous. But in Amazon encounters such a conflation seemingly becomes safe. Chivalric contests populate the narcissistic economy with two bodies, reinforcing the equation of identity and desire, and the revelation that one of those bodies is female gives desire an acceptable place to go. Artegall's encounter with Britomart can consummate without compromising homosocial relations; encounters between martial women and men pursue eroticism to its logical ends, but with the understanding

that it will produce, not sodomy, but heterosexual generation. The process through which eroticized contest becomes sexual conquest reinforces both homosocial and heterosexual systems of connection, reifying their mutual dependence and identifying the relationship between their conditions of eroticism as that between theory and practice. Male homosociality both veils and makes use of heterosexuality; the suffixes "social" and "sexual" are successfully distinguished, not by their force or their cause or even by the players involved, but by the different utility of their effects.

But as the process of revelation denaturalizes the referential assumptions of masculinity, the shift from homosocial to heterosexual connection gives an odd twist to the privileged relationships and identities it is invoked to support. In *The Tears of Narcissus*, Lynn Enterline writes, "[T]he entanglement of narcissism in melancholia, or of self-reflection in self-loss, disturbs the representation of a stable, or empirically knowable, sexual difference."[19] Encounters between men and masculine women, which both invoke and radically alter the narcissistic mirror, play out this failure of difference and its intimations of loss. Men who see martial women as women see themselves differently, their response imposing its own gap between body and act, for if martial female roles are transformed by the moment of exposure, so, too, are the heroically violent roles played by men. The transition from the doubling articulated through triangulation to the doubleness of conjugal pairs disrupts the symmetrical performance of masculinity on both sides; thus when Artegall strikes off Britomart's helmet with his sword, when sameness becomes difference and the martial body has a woman's face, he quite literally loses his grip.

> And as his hand he vp againe did reare,
> Thinking to worke on her his vtmost wracke,
> His powrelesse arme benumbd with secret feare
> From his reuengefull purpose shronke abacke,
> And cruell sword out of his fingers slacke
> Fell downe to ground. (4.6.21.1−6)

Artegall, described by Scudamour as "now become to liue a Ladies thrall," is less like Narcissus here than like a victim of Medusa.[20] And if Medusa, as mythology insists, is at once beautiful and deadly, Britomart echoes this doubleness, her body continuing to signify violence even as it is erotically transformed. As Artegall discovers, Britomart

is an intimidating figure to defeat or to desire; hers is a synthetically generative and martial vision of agency, suggesting not that bodies are veiled or displaced by acts but that both are insistently present, complicating the conditions of male response. The perception of doubleness extends beyond Artegall, informing other responses to Britomart as well:

> For she was full of amiable grace,
> And manly terrour mixed therewithall,
> That as the one stird vp affections bace,
> So th'other did mens rash desires apall,
> And hold them backe, that would in errour fall. (3.1.46.1−5)

As long as Britomart looks and acts like a man, her martial encounters reinforce the triangulated structures of homoerotic violence that make chivalric heroism work. Battling Scudamour over Amoret, or Artegall over False Florimell, she is dangerous only in a conventionally masculine sense. But at the moment of revelation, when it becomes clear that female sexual agency does not displace or disable masculinity but causes and constructs it, the roles change. Silberman describes the transition as a kind of chivalric Freudian slip: "The erotically charged rematch between Britomart and Artegall appears as an accidental slip from the homosocial into the heterosexual," she writes, and goes on to suggest the uneasiness generated by that "accident." "Seen in the context of the homosocial camaraderie of Artegall and Scudamore, as well as their imagined homosocial rivalry with Britomart, the fight between Britomart and Artegall appears anomalous and disruptive."[21] This moment, structured as a conflict between systems of desire, is less accidental or anomalous than it is the function of the martial woman's role in the poem. As Natalie Zemon Davis, in her consideration of female agency in its demonized and idealized forms, concludes, "The virtuous virago could be a threat to order after all."[22]

Britomart's identity as both masculine and female presents not a narrative of development or transformation but a problem of simultaneity. As the repeated image of her revealed face juxtaposed to her still-armored body suggests, she is not only both but aggressively both *at once*, making masculinity visible as a female performance. Because of this doubleness, Britomart's relationship to Artegall, first in disguise and then out of it, does not impose a distinction between the homosocial and the heterosexual; such a distinction would in a sense contain the

anxiety of doubleness by breaking the narrative in half, locating the homosocial chivalric encounter at the text's center and leaving heterosexual resolution in the conventional "happy ending" position offstage. Desire might be the cause of chivalric heroism, consummation its effect, as the narrator assures the reader at the beginning of Book 4: "[A]ll the workes of those wise sages, / And braue exploits which great Heroes wonne, / In loue were either ended or begunne" (Proem, 3.3–5). But chivalric heroism itself should occupy a space between, motivated but not interrupted by heterosexual preoccupations. Achieved, the union of Artegall and Britomart might resemble that of Scudamour and Amoret, or of Florimell and Marinell; postponed, it might echo that of Red Cross and Una. In these other cases, the relationship of sexual union to chivalric pursuit is one of reciprocal displacement, through which marriage truncates the quest or the quest defers marriage, each structure defining identity in distinct and discrete terms. Britomart's doubled identity precludes such discretion. Her performance links homosociality to heterosexuality through the continuity of eroticism, suggesting that both the systems of desire and the bodies within them may be vulnerable to mutual substitution. As John O'Connor observes of *Amadis of Gaul,* "Moreover, since Amazons in armor are indistinguishable from knights, two fighters frequently discover after many blows and perhaps a good deal of gore that they are lovers or even husband and wife."[23]

The discrete assumptions of transition, whether from homosocial to heterosexual bonds or from chivalric to domestic narrative, are obscured by an economy of distributed—and implicitly redistributable—roles. Catalyzing constant erotic response even as she is herself profoundly inconstant in her relationship to gendered convention, Britomart embodies simultaneities and connections that dislocate categories of difference, bringing wives onto the battlefield and knights into the home and, by giving these figures narrative continuity across the boundaries of coherent performative space, threatening the terms of identity on which the narrative itself rests. The relationships between women and men are not subordinated to male homosocial bonds but intervene in their constitution. Rather than being identified in terms of difference that naturalizes hierarchy—the other, the matter, the object, the abject—women figure the potential failure of difference in the workings of bodies and acts, agency and performance. To work as domestic closure, *The Faerie Queene* must identify Britomart's disguise *as* a disguise, as a fiction, asserting that to recognize a woman as a woman is to put her in her place. But that

recognition, located in the midst of an exclusively male homosocial context in which the female body being looked at continues to play a persuasively masculine part, unwrites any naturalized equation of sexual to social identity, imposing instead the need for an artificial and forceful assumption of roles.

Susanne Woods argues of Book 5, "[Spenser] subverts his own message of masculine privilege, from the sympathetic features of the Radigund portrait to the ironic use of Britomart to restore masculine rule to the Amazons."[24] Such subversion is implicit in Britomart's doubled identity from her first appropriation of armor. Mary Villeponteaux writes, "Britomart's disguise unsettles identity, presenting a challenge to the patriarchal notion that authority is something biologically masculine, invested in the male at every social level."[25] I would go farther, arguing that the performance of female masculinity suggests not only that roles can be manufactured out of contradictions, but that this malleability of the apparently innate might be a source of power; not only is gender a construct, but constructed masculinity works most effectively when its relationship to the body is one of paradox. For men, chivalric heroism sets up a referential relationship between sexual and martial agency, equating heroic victory and sexual potency, sexual failure and heroic defeat: male heroes insist on the absolute condition of possession, and become vulnerable to absolute loss. "Why is fixation on the penis (and by extension, the phallus) not called a fetish when it is attached to a man?" Marjorie Garber asks in *Vested Interests*. "The concept of 'normal' sexuality, that is to say, of heterosexuality, is founded on the naturalizing of the fetish. And this in turn is dependent upon an economics of display."[26] Swords are fetishes for heroes, providing protection not only through martial utility but through a naturalized relationship to the male body itself; that naturalization has its risks and its costs. "Hercules served Omphale, put on an apron, took a distaff and spun," Robert Burton reminds his readers; "Thraso the soldier was so submissive to Thais, that he was resolved to do whatever she enjoined. . . . And as Peter Abelard lost his testicles for his Heloise, he will I say not venture an incision, but life itself."[27] Within such relentlessly referential logic, when the hero drops his sword, the fate of Abelard cannot be far behind.

Artegall seems particularly susceptible to this threat of detachment. He is a changeling; he wears another hero's armor; he is accompanied by Talus, who attenuates Artegall's own connection to allegorical function. When Artegall borrows Braggadochio's shield, Braggadochio easily takes

credit for the victory that results: "for Sir *Artegall* / Came *Braggadochio*, and did shew his shield" (5.3.14.7−8). To paraphrase O'Connor, knights in armor are indistinguishable from knights, and Artegall regains his position only by disarming to display his wounded body. As evidence, the gesture works against itself. Heroic male identity cannot be proved by armor, which circulates through a system of exchange; but it also cannot be proved by the body, exposure of which removes the objects through which identity has been defined. If Britomart's revelation after battle asserts synthesis, the parallel moment in which Artegall reveals himself suggests fragmentation. When, two cantos later, Radigund disarms him, she only reiterates a vulnerability already implicit in his own acts:

> Then tooke the Amazon this noble knight,
> Left to her will by his owne wilfull blame,
> And caused him to be disarmed quight,
> Of all the ornaments of knightly name,
> With which whylome he gotten had great fame. (5.5.20.1−5)

Removed from his armor, Artegall is not the man he used to be. Judith Anderson writes, "[Artegall] has always a choice between being Justice, a virtue and an abstraction, and being a Knight, a virtuous man and a human being";[28] but, deprived of the equipment that identifies him as a knight, an abstraction, and a man, he has no choice at all. In a peculiarly revealing moment, he is described as "preseru'd from yron rust," as if nothing separates the man from his equipment. When that separation is forcibly imposed, *The Faerie Queene* suggests, there may be nothing left.

A very different signifying structure connects the body and acts of Britomart. Weapons for her are not fetishes or metaphors, but objects that get things done; if the sword lacks a genital referent, it is nonetheless efficiently allied to the female body that uses it. Glauce assures various knights that that body does not pose a sexual threat:

> Ne thenceforth feare the thing that hethertoo
> Hath troubled both your mindes with idle thought,
> Fearing least she your loues away should woo,
> Feared in vaine, sith meanes ye see there wants theretoo. (4.6.30.6−9)

Having constructed Britomart's masculinity, if not out of whole cloth, at least out of borrowed armor, Glauce insists that there is nothing in it.

But what is in it, of course, is Britomart, and, as her doubled identity produces effects without any naturalized relationship to cause, it puts in question not masculinity itself but its connection to men. In *Female Masculinity*, Judith Halberstam writes, "[F]emale masculinities are framed as the rejected scraps of dominant masculinity in order that male masculinity may appear to be the real thing. But what we understand as heroic masculinity has been produced by and across both male and female bodies."[29] As a self-sufficient construction, Britomart's artefactual heroism creates a fissure in *The Faerie Queene*'s referential assumptions. For Artegall, as for Hercules and Achilles, effective masculinity — the "real thing" — requires the visible causality that links body to act; feminization can never be only skin deep, for the revelation that a hero can be reconstructed undermines his essential connection to his role. But the constructed Britomart *is* the allegorical Britomart, the exposure of her body revealing not essence but contradiction and disabling not her but men. Gender becomes recognizable as a performance less because women's bodies can take the place of men's than because masculinity was never exclusively male to begin with; if the rules of the game depend on artifice, then anyone can play. And the threats posed by female masculinity to gendered hierarchies are, for early modern writers, hardly a revelation. Spenser suggests that women are displaced from conventionally masculine heroic acts not by nature, but by a kind of historiographic petulance; "record of antique times," he argues, suggests that female martiality was a commonplace, "Till enuious Men fearing their rules decay, / Gan coyne streight lawes to curb their liberty" (3.2.2.1; 5–6). Femininity, Spenser concludes, is an invention, and a fairly recent one at that.[30]

" '[S]ex' is an ideal construct which is forcibly materialized through time. It is not a simple fact or static condition of a body, but a process whereby regulatory norms materialize 'sex' and achieve this materialization through a forcible reiteration of those norms," Judith Butler writes.[31] The "regulatory norms" through which categories of sex — as reproductive sexuality and as the embodied referent of gender — are imposed in *The Faerie Queene* complicate the notion of normativity itself. As Britomart, prosaically motivated by a desire for marriage and children, pursues that desire through a series of transvestite acts, the conventions of domesticity become implicated in the shifting conditions of display. Heterosexual domestic ideals, rather than reimposing the hierarchies disrupted by Britomart's effective masculinity, are produced out

of that masculinity, and it is this understanding of the domestic — as performative, only unexpectedly normative, and forcibly imposed not on women but on men — that connects Britomart to Radigund. If, as readers have always noted, the two women look almost exactly alike, this is less because Britomart is as bad as Radigund, or almost as bad, or potentially as bad, than it is because they want the same thing.[32] Britomart, the hopeful wife, like Radigund, the jilted mistress, constructs masculine violence out of an aggressively conventionalized understanding of heterosocial relations; both the Knight of Chastity and the Amazon Queen pursue a state in which men can be men and women can cease to act like them. Their desires anticipate the concluding gesture of the pamphlet *Haec Vir*, in which the "masculine-feminine" speaker pleads, "Cast then from you our ornaments, and put on your owne armours: Be men in shape, men in shew, men in words, men in actions, men in counsell, men in example. . . . Comelinesse shall be then our study; feare our Armour, and modestie our practice."[33] But the aggressive return to a normative distribution of gender roles exposes those roles *as* distributed, passed out in a kind of heterosexual butch/femme dynamic which suggests that sexual hierarchies, like sexual differences, are only as constant as they are constantly enforced.

The convergence of Britomart and Radigund might reflect a larger concern with extremes: stories about martial women accommodate both militant chastity and sexual excess, hinting at a certain connection between them. If Britomart is like chaste Penthesilea, and Radigund is like the sexually ravenous Amazons of the new world, they are, in that contrast, somewhat like one another; both sexual excess and sexual resistance oppose the utilitarian middle ground of feminine domesticity. Yet it is the move onto that middle ground that most directly threatens Artegall. Once and nearly twice defeated by Britomart in battle, and finally unmanned by the penetration of her armor that reveals the body beneath, he postpones the heterosexual happy ending only to rediscover it as a kind of repetition compulsion. In his encounter with Radigund Artegall yields yet another battle to female masculinity, and here conventional domesticity produces its own parodic mirror image: Artegall leaves a wife behind only to be put in the place of one, dressed in women's clothing and set to spin.[34] The transition from homoerotic identity to heterosexual difference, however apparently efficient as a chivalric economy, results quite literally in Artegall's downfall: From his horse, from his allegorical role, from the naturalized assumption of masculine display.

This is the fault built into the fantasy. If martial women promise a fabulous synthesis, drawing together chivalric and domestic ideals, the simultaneous reference of those ideals to a single body exposes the tension between them. And, perhaps oddly, that tension does damage to men. Even as armed women fall victim to feminization, seduction, and other acts of violence, they produce a series of reciprocal victims who, like Artegall, choose the wrong moment to put down the sword. Desire for a martial woman, however thoroughly she is disarmed and objectified, precipitates a crisis of sexual discretion; if mirror games consolidate masculine identity through illusion, the illusion is as fragile as it is persuasive. Jane Gallop writes, "What appears to precede the mirror stage is simply a projection or a reflection. There is nothing on the other side of the mirror."[35] But the conflict between men and martial women materializes the relationship between image and object, placing two bodies uneasily in the same representational space and leaving them to fight it out. In such a narrative, what is on the other side of the mirror is not fiction, but women.

In homosocially governed triangles, the third term is an idealized woman who, whether veiled by Amazonian armor or displaced like the Echo of Narcissus, is always effectively absent, an abstraction masquerading as an object. But the third term of the Amazon encounter, as I will suggest, is a monstrous domestic product, an echo of the logical extremes through which heterosexual convention produces demonized women and broken men. For if heterosexual domesticity can be figured as a product of chivalric violence, it cannot easily be separated from the effects of that violence; convergences of martial and marital roles, contingent on the belatedness of discovery, do not displace armed conflict with marriage but suggest an equation between the two, displacing instead the moment at which domestic structures socialize desire. There is no gap between violent and erotic response, and Britomart's anticipation of a union that might be a battle—"Tell me some markes, by which he may appeare, / If chaunce I him encounter parauaunt; / For perdie one shall other slay, or daunt" (3.2.16.3–5)—participates in a narrative mode that focuses less on the salutary taming of masculine women than on the conviction that domesticity does violence to men. Marriage, rather than resolving the threat of female agency, brings it closer to home, and the relationship between battlefield and bed is one less of transition than of analogy.

As they replace triangulated homoeroticism with a direct confrontation between women and men, stories about amazonian sexuality reflect

a more general fear of heterosexual emasculation. Narratives that follow Amazons from battlefield to bedroom often expose not the desirable objectified female body but the disabled bodies of men. William Painter, in *The Palace of Pleasure*, writes of the Amazons, "If by chaunce they kept any [male children] backe, they murdred them, or else brake their armes and legs in sutch wise as they had no power to bear weapons."[36] The threat synecdochically figured in the missing Amazonian breast becomes explicit in these narratives of horrific maternal practice: fear of a devouring female body, left behind in the formation of masculine identity, reappears in the violently reproductive bodies of Amazons. The result, for men, is in effect a projection back through the mirror stage, a return to disarticulated bodies without the power to act. Montaigne, in his essay "Of Cripples," reads this process erotically: "[T]hey say in Italy as a common proverb that he does not know Venus in her perfect sweetness who has not lain with a cripple. . . . For the queen of the Amazons replied to the Scythian who was inviting her to make love: '*The lame man does it best!*' In that feminine commonwealth, to escape the domination of the males, they crippled them from childhood — arms, legs, and other parts that gave men an advantage over them — and made use of them only for the purpose for which we make use of women over here."[37] Montaigne's "over here" suggests the deictic fragility of relationships between gender and power, and Artegall in Radegone has definitely gone "over there."

Montaigne's narrative is less arcane than it is a causality written backward. As early modern texts pursue the association between female sexuality and male disintegration, they suggest that men are always potentially victims, always imaginably "over there."[38] "What greater captivity or slavery can there be (as Tully expostulates) than to be in love?" Burton writes. "'Is he a free man over whom a woman domineers, to whom she prescribes laws, commands, forbids what she will herself; that dares deny nothing she demands; she asks, he gives; she calls, he comes; she threatens, he fears; *Nequissimum hunc servum puto*, I account this man a very drudge.'"[39] Artegall's experience in Radegone plays out the anxieties attendant on the transition from triangulation to duality, from martial to domestic spheres. Analyzing the Britomart/Radigund encounter in relation to Queen Elizabeth I, Quilligan writes, "Female authority here is not funny, because it is real."[40] I would suggest that it is "real" in a broader sense, reflecting the potentially subjected position imposed on men not only by female sovereignty, but by marriage. As

they become not enemies in arms but recognizable agents of female sexual desire, martial women might simply be women, Artegall's heroic fall reduced to the quotidian condition of Burton's "drudge." Indeed, Spenser's narrator himself effects such a reduction, telling the reader who condemns Artegall, "[N]euer yet was wight so well aware, / But he at first or last was trapt in womens snare" (5.6.1.8–9). The loss of heroism, of effective masculinity, is here neither cataclysmic nor even shocking, but simply inevitable. Identified as the conclusion to Britomart's quest, Artegall risks losing his own. The resulting causality, in which heterosexual response produces the need to escape, is spelled out in the proem that anticipates the lovers' mutual discovery: "*Both Scudamour and Arthegall / Doe fight with Britomart, / He sees her face; doth fall in loue, / and soone from her depart*" (4.6).

The clichés in which heterosexual excess confers masculinity on women and femininity on men become plot, and, finding himself the protagonist of such a story, Artegall can regain his own narrative only by leaving behind women, and romance, and happy endings, entirely. Katherine Eggert suggests that Book 5's aggressive shift into historical allegory enables his escape, and writes, "[I]n the view of the male characters who are the necessary partners in this enterprise, marriage seems largely to replicate the dangers to heroism embodied in Acrasia's bower: marriage does not sharpen knightly instruments, it suspends them."[41] With Artegall's rescue and restoration, *The Faerie Queene* ends that suspension as it moves out of domestic space; the events of Book 5 that follow the conflict in Radegone have often been described as the most relentlessly historically allegorical of the poem, reasserting Artegall's claim to a space in which a man can be a knight. Yet this shift back is in itself enabled by a reassertion of homosocial triangulation that puts Artegall in the wrong kind of role: in the redemptive battle between Britomart and Radigund, the structure of two knights fighting over a lady reappears, but the "lady" is Artegall himself.

Killing Radigund, Britomart again reduces three to two, and for Artegall the only solution is to leave; deferral of his domestic role is a powerful necessity. According to Merlin, that role is not only emasculating but deadly, perpetuating a privileged homosocial space only until the fulfilment of Britomart's generative quest.

> Long time ye both in armes shall beare great sway,
> Till thy wombes burden thee from them do call,

> And his last fate him from thee take away,
> Too rathe cut off by practise criminall
> Of secret foes, that him shall make in mischiefe fall. (3.3.28.5–9)

After the birth of their child, Artegall and Britomart are different and Artegall dies. As a mystified afterthought in a prophecy that has already reached its more important conclusion, his death suggests the extent to which heroic male identity, confronted by Amazonian synthesis, falls apart. The simultaneity of female body and masculine act leaves little space for men, and if this is an economy that contains martiality and re-productivity in a single physical space, the chivalric triangle might collapse not into an anxiety-ridden dyad but into efficient singularity. As a disposable husband, Artegall suggests a starkly pragmatic definition of male utility: in the absence of parthenogenesis, heterosexuality is necessary, but it tenure is brief.[42]

I am not, of course, suggesting that Britomart kills Artegall, but rather that domestic imperatives remove him from allegorical efficacy without giving him anywhere in particular to go. This process, literalized by Radi-gund, is connected to Britomart only implicitly by prophecies and threats. Instead, our final vision of Britomart and Artegall shows us one last set of mirror games. After Artegall has been disjoined from the conditions of heroic masculinity, Britomart sustains his role. Dolon, who shelters and betrays her, knows who she is: "For sure he weend, that this his present guest / Was *Artegall*, by many tokens plaine" (5.6.34.1–2). As Artegall had been divested of his visible tokens, stripped of the armor and the accessories that made him the man he was, so Britomart again becomes the image of the object of desire, her subjectivity defined through and as an empowered illusion. Any idea of integrated male identity is here fully exposed as fantasy, for, if the body of Artegall has been displaced from masculine heroic discourse, the Knight of Justice nonetheless remains in play.

When Britomart reaches Artegall, she cannot look at him. Like Artegall earlier in the poem, she confronts an unexpected embodiment of femininity. Unlike Artegall, she averts her gaze, her response to this final break in the mirror echoing that of Perseus, who avoids the consequences of monstrous transformation by knowing when—and how—to look away.

> At last when to her owne Loue she came,
> Whom like disguize no lesse deformed had,

At sight thereof abasht with secrete shame,
She turnd her head aside, as nothing glad,
To haue beheld a spectacle so bad. (5.7.38.1−5)

For Radigund's tyranny to be redressed, Justice must literally be re-dressed, and Britomart, acting like and as Artegall, reconstructs him in her own armored image: "In which when as she him anew had clad, / She was reuiu'd, and ioyd much in his semblance glad" (5.7.41.8−9). Object and image reverse positions through the prosthetic distribution of armor, and Artegall, confronted by a rescuer who doubles as a wife, goes away again. That recession into allegorical distance restores the pattern: lives are threatened, armor is taken by violence and restored by grace, objects of desire are found and lost, and the chivalric repetition compulsion goes on.

Yet Britomart has been for Artegall a rather dangerous supplement, displacing him as an allegorical signifier and as a heroic performance in the very acts through which she restores him to himself. I have suggested that chivalric mirror games work like and indeed as theories of subjectivity: As attempts to articulate links and tensions among gender, violence, eroticism and social order, early modern representations of female masculinity anticipate our own preoccupation with signifying contradiction. In *The Faerie Queene,* as in texts of this period more generally, Amazon encounters reveal the precarious foundations on which conventions of identity rest, displaying oppositions and hierarchies in their natural, if only potential, state of collapse. Tacitly recognizing that effect, Artegall asks another amazonian victim, "[H]aplesse man, what make you here? / Or haue you lost your selfe, and your discretion?" (5.4.26.1−2). For *The Faerie Queene* discretion, as categorical difference or as the ability not to tell the wrong story, is more easily lost than found.

NOTES

1. Jacques Lacan, "The Mirror Stage," in *Écrits: A Selection,* ed. and trans. Alan Sheridan (New York: W. W. Norton & Company, 1977), 4.

2. Edmund Spenser, *The Faerie Queene* (1590, 1596), ed. Thomas P. Roche, Jr. (New York: Viking Penguin, 1978, 1987). All references are to this edition.

3. Barbara Freedman, *Staging the Gaze: Postmodernism, Psychoanalysis, and Shakespearean Comedy* (Ithaca: Cornell University Press, 1991), 7.

4. Lacan describes the infant's relationship to his support in these terms: "Unable as yet to walk, or even to stand up, and held tightly as he is by some support, human or artificial (what, in France, we call a 'trotte bébé'), he nevertheless overcomes, in a flutter of jubilant activity, the obstructions of his support and, fixing his attitude in a slightly leaning-forward position, in order to hold it in his gaze, brings back an instantaneous aspect of the image" ("The Mirror Stage," 1−2).

5. Jacqueline Rose, "Introduction II," in *Feminine Sexuality: Jacques Lacan and the école freudienne,* ed. Juliet Mitchell and Jacqueline Rose, trans. Jacqueline Rose (New York: W. W. Norton, 1982), 30. Emphasis in original.

6. Eve Kosofsky Sedgwick, *Between Men: English Literature and Male Homosocial Desire* (New York: Columbia University Press, 1985), 1−2.

7. Lauren Silberman reads this tension as a symptom of what she terms "problems of representing experience," particularly in Book 4. In her reading, the opposition of homosocial to heterosexual narrative structures critiques homosocial repetition as static and arbitrary, while offering a positive view of the "asymmetric" progress of Britomart's desire. See *Transforming Desire: Erotic Knowledge in Books III and IV of* The Faerie Queene (Berkeley: University of California Press, 1995), esp. 105−9. See also her contrast of Britomart to Marinell, 28−29. My own reading will suggest that the static, interchangeable conditions of homosocial identity create an economy that is protected and idealized, and to which heterosexual desire represents a threat.

8. Maureen Quilligan, "The Comedy of Female Authority in *The Faerie Queene,*" *English Literary Renaissance* 17 (1987), 163.

9. See, for example, Michael Leslie's claim that "Britomart is the fitting heroine for a book containing Argante, Ollyphant, and Paridell, not because she is their opposite, but because she is so like them. Comparing her with Argante is not merely facetious: both are energetically pursuing men for frankly sexual purposes" (*Spenser's 'Fierce Warres and Faithfull Loves': Martial and Chivalric Symbolism in* The Faerie Queene [Cambridge: D. S. Brewer, 1983], 83).

10. Mihoko Suzuki, *Metamorphoses of Helen: Authority, Difference, and the Epic* (Ithaca: Cornell University Press, 1989), 154. See also Silberman's discussion of the relationship between narcissism and the Hermaphrodite in "The Hermaphrodite and the Metamorphosis of Spenserian Allegory," *English Literary Renaissance* 17 (1987), esp. 217.

11. Silberman, "The Hermaphrodite," 217. Readers of *The Faerie Queene* have consistently attempted to attach a redemptive meaning to the potentially grotesque and disruptive hermaphroditic simile; see, for example, C. S. Lewis,

The Allegory of Love: A Study in Medieval Tradition (Oxford: Oxford University Press, 1936), 344; Thomas P. Roche Jr., *The Kindly Flame: A Study of the Third and Fourth Books of Spenser's* Faerie Queene (Princeton: Princeton University Press, 1964), 134–36; and Kathleen Williams, who argues, like Silberman, for a transition from the image of the actual mythological figure of the hermaphrodite to Britomart's successful synthesis of doubly gendered terms ("Venus and Diana: Some Uses of Myth in *The Faerie Queene*," in *Spenser: A Collection of Critical Essays*, ed. Harry Berger Jr. [Englewood Cliffs, NJ: Prentice-Hall, 1968], 110).

12. *Shakespeare's Ovid, Being Arthur Golding's Translation of the Metamorphoses*, ed. W. H. D. Rouse (Carbondale: Southern Illinois University Press, 1961), 4:440–52.

13. For a reading of the opposition between idealized androgyny and monstrous hermaphroditism, see Phyllis Rackin, "Androgyny, Mimesis, and the Marriage of the Boy Heroine on the English Renaissance Stage," *PMLA* 102 (1987), esp. 29. For an analysis of the figure of the hermaphrodite in *The Faerie Queene*, see Donald Cheney, "Spenser's Hermaphrodite and the 1590 *Faerie Queene*," *PMLA* 87 (1972).

14. Sigmund Freud, "On Narcissism: An Introduction" (1914), in *General Psychological Theory*, ed. Philip Rieff (New York: Collier Books, 1963), 74.

15. Teresa de Lauretis, "Sexual Indifference and Lesbian Representation," in *The Lesbian and Gay Studies Reader*, ed. Henry Abelove, Michèle Aina Barale, and David M. Halperin (New York: Routledge, 1993), 143. Halperin discusses male appropriations of the feminine and thus of reproductive sexuality: "[I]t looks as if what lies behind Plato's doctrine is a double movement whereby men project their own sexuality onto women only to reabsorb it themselves in the guise of a feminine character. This is particularly intriguing because it suggests that in order to facilitate their own appropriation of the feminine men have initially constructed femininity according to a male paradigm while creating a social and political ideal of masculinity defined by the ability to isolate what only women can actually isolate—namely, sexuality and reproduction, recreative and procreative sex" (David M. Halperin, "Why is Diotima a Woman?" in *One Hundred Years of Homosexuality and Other Essays on Greek Love* [New York: Routledge, 1990], 142–43). For de Lauretis' discussion of this structure in terms of "the heterosexual social contract by which all sexualities, all bodies, and all 'others' are bonded to an ideal/ideological hierarchy of males," see her 142–44.

16. René Girard, *Violence and the Sacred,* trans. Patrick Gregory (Baltimore: Johns Hopkins University Press, 1972, 1977), 144, 146.

17. Sedgwick, *Between Men*, 21.

18. Jonathan Dollimore, *Sexual Dissidence: Augustine to Wilde, Freud to Foucault* (Oxford: Clarendon Press, 1991), 305.

19. Lynn Enterline, *The Tears of Narcissus: Melancholia and Masculinity in Early Modern Writing* (Stanford: Stanford University Press, 1995), 8–9.

20. 4.6.28.8. Artegall's response, like the genealogy of his armor, locates him in the tradition of Achilles, whose response to the Amazon queen Penthesilea is the *locus classicus* of such heroic confusion. Having killed Penthesilea, Achilles sees her face and falls in love with her, briefly exchanging his martial identity for that of a lover; Thomas Heywood gives a highly conventional account of this moment.

> No sooner was the battaile done
>> Her golden helme laid by,
> But whom by armes she could not take,
>> She captiv'd with her eye.

(*The Exemplary Lives and Memorable Acts of Nine the Most Worthy Women of the World: Three Iewes. Three Gentiles. Three Christians. Written by the author of the History of Women* [London, 1640], 104.) Achilles' emotion, however heartfelt, confers disarming power on a corpse, and is thus firmly identified as at once brief and subjunctive; in a sense, I would suggest, Artegall's response to Britomart is complicated less by the fact that she is beautiful or armed or stubbornly violent than by the fact that she is not dead.

21. Silberman, *Transforming Desire*, 106.

22. Natalie Zemon Davis, "Women on Top," chapter 5 in *Society and Culture in Early Modern France* (Stanford: Stanford University Press, 1975), 145.

23. John J. O'Connor, Amadis de Gaule *and Its Influence on Elizabethan Literature* (New Brunswick: Rutgers University Press, 1970), 33.

24. Susanne Woods, "Amazonian Tyranny: Spenser's Radigund and Diachronic Mimesis," in *Playing with Gender: A Renaissance Pursuit*, ed. Jean R. Brink, Maryanne C. Horowitz, and Allison P. Coudert (Urbana: University of Illinois Press, 1991), 59.

25. Mary Villeponteaux, "Displacing Feminine Authority in *The Faerie Queene*," *Studies in English Literature* 35, 1 (1995), 60. Villeponteaux discusses this constructed masculinity in relation to Queen Elizabeth I, arguing that Spenser displays ambivalence in his representations of martial women.

26. Marjorie Garber, *Vested Interests: Cross-Dressing & Cultural Anxiety* (New York: HarperCollins, 1992), 119.

27. Robert Burton, *The Anatomy of Melancholy. What it is. With all the Kindes, Causes, Symptomes, Prognostickes, and seuerall cvres of it. By Democritvs Iunior* (Oxford, 1621), 3.2.3.

28. Judith H. Anderson, " 'Nor Man It Is': The Knight of Justice in Book V of Spenser's *Faerie Queene*," *PMLA* 85 (1970), 66.

29. Judith Halberstam, *Female Masculinity* (Durham and London: Duke University Press, 1998), 1–2.

30. In *Female Pre-Eminence* Agrippa anticipates Spenser, concluding his catalogue of martial female performances with a comment on the fragility of socialized essentialism: "[By] unworthy, *partial* means, they are forc'd to give place to Men, and like wretched *Captives* overcome in War, submit to their *insulting Conquerors*, not out of any natural or divine reason, or necessity, but only by the prevalency of *Custome, Education, Chance, or some tyrannical* occasion" (*Female Pre-eminence: or the Dignity and Excellency of that sex, above the Male* [1509], trans. H[enry] C[are] [London, 1670], 77). See also Sir Thomas Elyot, who writes, "As concernyng strength and valiaunt courage, whiche ye surmise to lacke in them, I could make to you no lesse replicacion, and by old stories and late experience proue, that in armes women haue ben found of no littell reputacion, but I will omit that for this time, for as muche as to the more parte of wise menne it shal not sound muche to their commendacion" (*The Defence of Good Women* [London, 1545], sig. C7v). Clearly, for Elyot, women can take, and have taken, the place of men; the question remains as to whether they should have or should.

31. Judith Butler, *Bodies that Matter: On the Discursive Limits of "Sex"* (New York: Routledge, 1993), 1–2.

32. For readings that present the opposition between Britomart and Radigund in terms of their potential as doubles, see, for example, A. C. Hamilton, *The Structure of Allegory in* The Faerie Queene (Oxford: Clarendon, 1961), 183; Suzuki, *Metamorphoses of Helen*, esp. 181–88; Woods, "Amazonian Tyranny," 55; Davis, "Women on Top," 133; John Erskine Hankins, *Source and Meaning in Spenser's Allegory: A Study of The Faerie Queene* (Oxford: Clarendon, 1971), 174; Louis Adrian Montrose, " 'Shaping Fantasies': Figurations of Gender and Power in Elizabethan Culture," in *Representing the English Renaissance*, ed. Stephen Greenblatt (Berkeley: University of California Press, 1988), 46.

33. *Haec Vir, or The Masculine-Feminine* (London, 1620), sig. C5.

34. Suzuki suggests ways in which Artegall, Radigund, and Britomart are linked by various shared character traits, and argues that these links cause structures of allegorical opposition to break down; see chapter 4 in *Metamorphoses of Helen*, esp. 181–86.

35. Jane Gallop, *Reading Lacan* (Ithaca: Cornell University Press, 1985), 80.

36. William Painter, "The First Nouell: The hardinesse and conquests of diuers stout, and aduenturous women, called Amazones," in *The Second Tome of the Palace of Pleasure, Containing Store of Goodly Histories, Tragical Matters, and Other Moral Arguments, Very requisite for Delight and Profit, Chosen and Selected out of Divers Good and Commendable Authors* (1566, 1575; London: reprinted for Robert Triphook by Harding and Wright, 1813), 3.

.•.

37. Michel de Montaigne, "Of Cripples," in *The Complete Works of Montaigne*, trans. Donald M. Frame (London: Hamish Hamilton, 1958), 791.

38. Rebecca Bushnell argues that female desire in this period is always potentially a form of tyranny: "Woman is represented as framed in nature as what the 'male' tyrant becomes: the principle of the lower and ferocious power of desire usurping the sovereignty of reason" ("Tyranny and Effeminacy in Early Modern England," in *Reconsidering the Renaissance: Papers from the Twenty-First Annual Conference*, ed. Mario A. Di Cesare [Binghamton, NY: Medieval and Renaissance Texts and Studies, 1992], 342). For an extended discussion of the anxieties displayed in the image of female dominance, see Davis, "Women on Top."

39. Burton, *The Anatomy of Melancholy*, 3.2.3. For a more optimistic account of the relationship between female and male desires, see Maureen Quilligan's analysis of Venus and Adonis in *The Faerie Queene*; Quilligan reads this relationship as "a vision of male sexuality brought safely and creatively under the control of an awesome female power," and links it to Britomart's own generative function ("The Gender of the Reader and the Problem of Sexuality [in Books 3 and 4]," in *Critical Essays on Edmund Spenser*, ed. Mihoko Suzuki [New York: G. K. Hall, 1996], 141).

40. Quilligan, "Comedy of Female Authority," 171.

41. Katherine Eggert, " 'Changing all that forme of common weale': Genre and the Repeal of Queenship in *The Faerie Queene*, Book 5," *English Literary Renaissance* 26, 2 (1996), 269. Eggert goes on to argue that the replacement of "feminine rule" by "masculine poetics" ultimately proves a fantasy (see 284–86). See also Sheila Cavanagh's discussion of the pattern of male escapes from female desires in *Wanton Eyes and Chaste Desires: Female Sexuality in* The Faerie Queene (Bloomington: Indiana University Press, 1995), 54.

42. This generative pragmatism is schematized, again allegorically, in Charles Butler's study of bees. In *The Feminine Monarchie* Butler makes it clear that husbands should know when to leave. "After wich time [of breeding], these *Amazonian* Dames, having conceived for the next yeer, begin to wax weeri of their mates, and to like their room better than their company. . . . You may soomtime see a handful or two before a Hive, wich they had killed within: but the greatest part flyeth away, and dyeth abroad" (*The Feminine Monarchie: or, The Historie of Bee's* [Oxford, 1634], 70. I have modernized *th* and *ch* contractions throughout).

DAVID HILLMAN

THE INSIDE STORY

A kind of vertigo blurs the edge between outside and inside.

—Jean Starobinski, "The Inside and the Outside"

Structures of belief and doubt are powerfully bodied forth through the spatial metaphor of the inside and the outside. The extent of one's skepticism or trustfulness depends, as I argue below, upon one's conception of the relation between inner and outer.

The division of both the self and the world into an interior and an exterior is a necessary step in the construction of a coherent sense of identity, particularly in its formative stages; and this spatially imagined self has proved to be a fruitful model in describing emergent states of subjectivity—both for historicist scholars of the early modern period and for psychoanalytic theorists. Understanding why this might be so offers the potential of illuminating a number of aspects of the early modern world, such as its remarkably widespread preoccupation with all things inward (and above all with the entrails of the human body) or its vigorous rehearsal of ideas (national, social, and medical) of incorporation and expulsion. These, I will argue, are inseparable from the rise of

skeptical forms of thought and the onset of the multiple crises of identity and faith that so deeply marked the Renaissance world.

The inward/outward binary is inseparable from the ways in which persons and societies understand themselves and their bodies. In the transitional culture of sixteenth- and seventeenth-century England, its role in the construction of an early modern subjectivity is discernible both in fields of practice and in the symbolic order of language. In a wide variety of areas—including nation building, land and property enclosure, architecture, anatomy, medicine, and religious and legal discourse—the metaphor acquired newly intense resonances during this period. At the same time (or rather, speaking historically, at a much later time), this same spatial binary figures centrally in psychoanalytic conceptions of the early stages of identity formation, where the division between self and other is thought to be marked as originally more or less synonymous with the split between interior and exterior.

In this essay I attempt to trace the uses of the spatial metaphor of inner and outer and some of the ways in which it has profound ties to questions of faith and doubt. I begin by briefly examining the role of this binary in the constitution of the subject as it is understood by psychoanalysis; I then outline, following the work of several recent scholars, some ways in which the figure can be seen to be pervasive in early modern English culture. Finally, I turn to one early modern text—*Hamlet*—that engages the question of inward and outward through its protagonist's obsessive attention to the body's innards and a concomitant attachment to an idea of the truth as something specifically and exclusively interior.

Throughout, I have tried to avoid privileging either historicist or psychoanalytic methodologies. The relation of the inside/outside metaphor to structures of belief and skepticism can, I think, be understood both in implicitly transhistorical psychoanalytic (and philosophical) terms and in culturally specific historical ones. A choice between these methodologies, which have in recent years found themselves so often at odds with each other, seems to me quite unnecessary, and indeed detrimental to a wider understanding both of the historical roots of psychoanalytic conceptions and of the psychological roots of historical processes.[1] Perhaps we could say (with deference to Starobinski) that a kind of vertigo blurs the edge between historicism and psychoanalysis.

• • •

The individual tends to place the happenings of fantasy inside and to identify them with things going on inside the body.

—*D. W. Winnicott*

I take as my point of entry Freud's comment in *The Ego and the Id* that "the ego is first and foremost a bodily ego; it is not merely a surface entity, but is itself the projection of a surface."[2] That is, the ego according to Freud is constructed around—as a projection of—the boundary between the interior and the exterior of the body: "A person's own body, and above all its surface, is a place from which both external and internal perceptions may spring."[3] Freud went on to elaborate upon this idea in the essay "Negation." Here he describes the ontogenetic origins of mental life, and postulates that all thoughts start off as corporeal impulses—more specifically, the impulse to take something into or expel something from the body:

> Expressed in the language of the oldest—the oral—instinctual impulses, the judgement is: "I should like to eat this," or "I should like to spit it out"; and, put more generally: "I should like to take this into myself and to keep that out." That is to say: "It shall be inside me" or "it shall be outside me." As I have shown elsewhere, the original pleasure-ego wants to introject into itself everything that is good and to eject from itself everything that is bad. What is bad, what is alien to the ego and what is external are, to begin with, identical.[4]

Intellectual life itself, according to Freud, is born out of the working out of the corporeal topography of interior and exterior. And this, he goes on to suggest, is true not only in relation to the primary thinking connected to the pleasure principle, but also in relation to the more developed modes of thinking (albeit now at one remove from the body):

> The other sort of decision made by the function of judgement— as to the real existence of something of which there is a presentation (reality-testing)—is a concern of the definitive reality-ego, which develops out of the initial pleasure-ego. It is now no longer a question of whether what has been perceived (a thing) shall be taken into the ego or not, but of whether something

which is in the ego as a presentation can be re-discovered in perception (reality) as well. It is, we see, once more a question of *external* and *internal*. What is unreal, merely a presentation and subjective, is only internal; what is real is also there *outside*. In this stage of development regard for the pleasure principle has been set aside.[5]

We may wish to take issue with Freud's surprising assertion that the pleasure principle can be "set aside" so easily; that more mature forms of judgment can ever rise so clearly above the earlier, pleasure-driven forms is a moot point. In any event, Freud portrays the opposition inner/outer as inherent to the working of both the reality principle and the pleasure principle, the former through the mechanism of testing inner ideas (or "presentations") against outer facts, the latter through (originally bodily) processes of what later came to be called introjection and projection. Hence it is, presumably, that the earliest formative stages of infancy are, according to Freud, the oral and the anal — based, that is, on intensely cathected apertures that mark the boundary, and simultaneously the possibility of crossing the boundary, between inside and outside; nor does mature genitality — the third stage in Freud's view of human development — escape this characterization. Hence, too, the tremendous significance of fantasized processes of introjection and projection (based, again, on fundamental bodily activities of incorporation and expulsion) in the constitution of the self. These processes lead, according to the standard psychoanalytic elucidation, to the construction of what Freud eventually came to call the "internal world," a world populated with detailed, complex fantasies of internal objects.[6] In the psychoanalytic depiction, then, the spatial schema of inside and outside becomes an important metaphor — perhaps the primary metaphor — in the subject's early narrative of existence. The growth of self-awareness, the first forms of both pleasure and reality principles, the origins of thought itself — all are, according to Freud, constructed around what Julia Kristeva has called "the ambiguous opposition I/Other, Inside/Outside — an opposition that is vigorous but pervious, violent but uncertain."[7] It is uncertain because corporeal and mental mechanisms alike reveal the vulnerability of the distinction between inner and outer; these processes — based as they are on the orificial nature of the body and on the body's or ego's ability to incorporate or expel parts of the outer world — themselves inevitably

undermine any clear distinction between the internal and the external. We have our exits and our entrances.

The world is all outside, it has no inside.
 —*Ralph Waldo Emerson*

The inside/outside binary is indeed a precarious foundation upon which to build a self, for the apparent opposition between these terms is, as Kristeva herself has shown, problematic and eminently deconstructible. For one thing, in matters of human subjectivity—to quote Jean Starobinski—"the relative position of inside and outside constantly shifts"; even more fundamentally, it is *only* "outside, through the mediation of exteriority, that the hidden part, the dissimulated identity, can become manifest."[8] Since the beginning of the last century, philosophy has increasingly come to question the distance and difference between an ostensibly transcendent "inner" meaning and mere "outer" signs—a distinction upon which Western metaphysics has relied since its inception. "What is inwardly is also found outwardly, and *vice versa*," declared Hegel, followed by Nietzsche: "[T]he 'apparent inner world' is governed by just the same forms and procedures as the 'outer' world."[9] It is, of course, Wittgenstein above all who has pointed out the misperceptions underlying the uses of the inside/outside opposition. At the center of his philosophy lies the view that "an 'inner process' stands in need of outward criteria"; or, as one commentator elaborates: "What we so misleadingly call 'the inner' *infuses* the outer. Indeed, we could not even describe the outer save in the rich terminology of the inner."[10] Nor, indeed, could we describe the internal save through the external; as Jacques Derrida has put it, alluding to metaphysical appeals to inner or intrinsic meaning, "the presumed interiority of meaning is already worked upon by its own exteriority."[11]

 More recently, theorists of the body and its acculturation have repeatedly underlined the precarious nature of the inner/outer boundary. Elizabeth Grosz speaks of the need for "a way of problematizing and rethinking the relations between the inside and the outside of the subject," describing "the torsion of the one into the other, the passage, vector, or uncontrollable drift of the inside into the outside and the outside into the inside," on the analogy of a Möbius strip. For her, the body has historically been understood as "the symptom and mode of expression and

communication of a hidden interior or depth"; what she finds in the interior, however, is no more than "the illusion or effects of" depth.[12] Again, Judith Butler notes both the importance of the binary of inside and outside to questions of identity ("[T]he spatial distinctions of inner and outer . . . facilitate and articulate a set of fantasies, feared and desired. . . . 'Inner' and 'outer' constitute a binary distinction that stabilizes and consolidates the coherent subject") *and* the fact that "for inner and outer worlds to remain utterly distinct, the entire surface of the body would have to achieve an impossible impermeability."[13] As philosophy has shown, the separation of the inside from the outside is hardly an open-and-shut case.

Faith is under the left nipple.
 —Martin Luther

It is this desire for "an impossible impermeability" that makes people cling so tenaciously, and in the face of so much uncertainty, to the idea of the separation of inner and outer. And it is the disjunctive potential of the binary — its very instability — that ties it so closely to questions of belief and doubt. Here I want to return for a moment to Freud's essay "Negation," where the formation of belief is hypothesized as having depended at the beginning of mental life upon pleasure-directed bodily activities: "protobelief" (and what we might call "protoskepticism") derives, according to Freud, from the incorporation (or expulsion) of a thought felt originally to be a corporeal thing: " 'I should like to take this into myself and to keep that out.' "[14] Holding something to be true, Freud seems to suggest, stems from the earliest form of acceptance, taking it in and holding it within one's body, just as the earliest form of rejection, the expelling of something from one's interior, is the corporeal origin of the formation of doubt; we see here, as Freud goes on to say, "the derivation of an intellectual function from the interplay of the primary impulses."[15] (Winnicott speaks of "the extremely early age at which a human being can attempt to solve the problem of suspicion by becoming suspicious of food . . . using doubt about food to hide doubt about love.")[16] Freud goes on to suggest, as we've seen, that more developed forms of belief rely equally crucially upon the inside/outside disjunction: Believing something to be true entails a matching of inner idea and outer facts. In both cases, belief (or protobelief) depends on the

sense of the bridgeability of the potential gap between inner and outer, a sense that the inside is accessible or corresponds to the outside. Belief here seems to be inseparable from an acceptance of the interpenetrability of self and world, or self and other, an acknowledgment of the outer world (or of the other) akin to its incorporation or introjection into one's own bodily interior.[17] And, conversely, skepticism derives from and relies upon an idea of the boundary between inner and outer as relatively impermeable, a refusal to acknowledge the inherence of inner in outer (and vice versa).[18] In this way, the skeptic *renders* "the inner" unknowable.[19]

These thoughts go some way toward explaining the peculiar significance that the body's "otherworld interior" (in Ted Hughes' phrase) holds in relation to ideas of belief and doubt.[20] The very interiority (or otherworldliness) of the inner positions it as the paradigmatic locus of doubt—and hence, too, of the potential for the removal of doubt. In its broad outlines, this claim seems to have something approaching transhistorical validity. In *The Body in Pain*, Elaine Scarry argues that it is the unsharability, the unrepresentability, of pain that makes it a philosophical exemplum of both skepticism and certainty; and, like pain, all inner events (whether bodily or otherwise) can be described as "at once something that cannot be denied and something that cannot be confirmed"— this can in fact be taken as a good working definition of "the inner."[21] In both Old and New Testaments, Scarry argues, "the interior of the body carries the force of confirmation"; "the fragility of the human interior and the absolute surrender of that interior does not simply accompany belief . . . [it] *is itself belief.*" "Belief in the scriptures," she adds, "is literally the act of turning one's own body inside-out."[22] To say it again: Skepticism involves a stubborn insistence on the idea of the boundedness of one's body or self, on the opacity that divides outer from inner; belief, the acceptance of the permeability of that boundary—of the representability (or this-worldliness) of the inner.[23] The willing suspension of disbelief is the disavowal of the temptation to harden one's body, or one's idea of the other's body; it entails the abjurement of the (defensive) wish or need to cordon off the interior from all that lies outside it.

The problem of certainty and doubt is intimately tied to the so-called problem of other minds, which, as I understand it, is in turn inseparable from the problem of other bodies. I am relying here upon the work of Stanley Cavell, who, following the later work of Wittgenstein, has characterized the problem as one of finding "the correct relation between

inner and outer, between the self and its society."[24] Skepticism (conceived of here as the motivated doubting of the possibility of knowledge of the other) and belief (construed as an overcoming of such doubt, and thus the acknowledgment of the other) can be understood, as I have begun to suggest, in terms of one's relation to the body's topography. For the skeptic, the potential for a gap between the private, interior self and its external expression (in words, gestures, or actions) typically takes the form of the sundering of self and other into an inside and an outside, with an ever-present potential for a breach between the two. "Alterity," writes Jean Starobinski, "is something more concrete than the antithesis between said and unsaid. It takes on spatial dimensions: what goes unsaid is actively hidden in the heart, the space of the inside—the interior of the body is that place in which the cunning man dissimulates what he doesn't say. A simple image attributing a palpable, invisible, forbidden *place* to the silent *other*."[25] The sense of the opaqueness of the other to one's self is the source of what I take to be a central drive of skepticism—the drive to access the interior of the body of the other (the anatomist, from this perspective, is the skeptic par excellence). If the interior is where the other's innermost truth is imagined to be located, the skeptic appears to be searching out this ulterior truth *within* the body, beyond the veils of its surface. And while this search may look like a desire to overcome the boundary between inner and outer, it is in fact, to use Cavell's term, a cover story, a refusal to acknowledge the inherence of the inner in the outer.[26]

Such a search is figured paradigmatically in the story of Doubting Thomas, the skeptical apostle:

> But Thomas, one of the twelve, called Didymus, was not with them when Jesus came. The other disciples therefore said unto him, We have seen the Lord. But he said unto them, Except I shall see in his hands the print of the nails, and put my finger into the print of the nails, and thrust my hand into his side, I will not believe.
>
> And after eight days again his disciples were within, and Thomas with them: then came Jesus, the doors being shut, and stood in the midst, and said, Peace be unto you. Then saith he to Thomas, Reach hither thy finger, and behold my hands; and reach hither thy hand, and thrust it into my side: and be not faithless, but believing. And Thomas answered and said unto him, My Lord and my God. Jesus saith unto

him, Thomas, because thou hast seen me, thou hast believed:
blessed are they that have not seen, and yet have believed.
(John 20:24–29)[27]

Beyond the obvious fact that the skeptic's will to confirmation here is
openly penetrative, I note the passage's stress on multiple layers of exteri-
ority and interiority. Thomas begins the narrative outside: outside the cir-
cle of apostles (the community of believers) and outside the structure (of
belief?) in which they convene, as well as resolutely outside the body of
Christ (almost as if to say, if one believes oneself to be outside, one *is*). And
if belief is a consequence of having access to the inside, Thomas is offered
interior upon (or within) interior: "And after eight days again *his disciples
were within, and Thomas with them.*" We are not told "within" what — the
interiority as such, it seems, is all we need to know; and the text goes out
of its way to mark the absolute boundary between inside and outside with
the (apparently) narratively superfluous "the doors being shut." "In the
midst" of this closed inner space stands Christ, offering the interior of his
body, ringed by these concentric structures, as proof of his divinity.

Perhaps, though, we should read the phrase about "the doors being
shut" as referring to the miraculous nature of Christ's appearance *in
spite of* the closure of the doors, to his transcendence, that is, of the en-
tire inner/outer problem.[28] For Christ's offer of his interior is an undo-
ing of the boundary between inside and outside, as his blessing of "they
that have not seen" is an overcoming of the need for proof. The will-
ingly received stigmata and wound in his side literally puncture the
boundary, the integument, separating him from the world. (Wittgen-
stein: "An enclosure with a hole in it is as good as *none*.")[29] And as if to
underline this thought, we never hear that Thomas actually touched the
wounds on Christ's hands, thrust his hand into Christ's side; Christ's
speech — the offer itself — is enough, doing away with the need for
penetrative confirmation from without.

*The body is a model which can stand for any bounded system. Its bound-
aries can represent any boundaries which are threatened or precarious.*

 —Mary Douglas

"When there is within a society a crisis of belief," argues Scarry, "that
is, when some central idea or ideology or cultural construct has ceased

to elicit a population's belief . . . the sheer material factualness of the
human body will be borrowed to lend that cultural construct the aura of
'realness' and 'certainty.' "[30] More specifically, when there is within a soci-
ety a crisis of belief, recourse tends to be made to fantasies of a clearly
defined boundary between the inside and the outside. During periods of
extreme instability in a society's (as in an individual's) self-identity, the re-
turn to the body is often simultaneously a return or regression to a defen-
sive insistence on an absolute inner/outer gap, and the insistence will be
strident in proportion to the depth of the crisis. (Indeed, such stridency is
a sure sign of a profound crisis in a belief system.) Concomitantly, periods
of such heightened anxiety tend to bring with them a preoccupation with
fantasies of and about the body's interior, as if to accentuate the idea that
this is in and *that* is out (and never the twain shall meet).

That early modern England was just such a society in crisis — torn
between violently differing religious positions, on the cusp of the tec-
tonic shifts that marked the transition to modernity in every area of
life — hardly needs restating here. The period brought with it far-reach-
ing upheavals — in social identity, in religious belief, in people's trust in
the efficacy and truthfulness of exterior signs as such; skepticism is an-
other name for these epistemological anxieties.[31] And in terms of what
Louis Montrose has called "the historical specificity of psychological
processes," the English Renaissance can be seen to be a period during
which the always-anxious relation between inside and outside was espe-
cially fraught and the recourse to the body's visceral or symbolic inte-
rior evident in many different fields of both praxis and discourse.[32]

Everywhere in the period we find, as Katharine Eisaman Maus has
shown, an urgent insistence on "the sense of discrepancy between 'in-
ward disposition' and 'outward appearance,'" a widespread "'inward-
ness *topos.*'"[33] Concomitants to this pressure can be found in several
aspects of early modern English language, culture, and society. Anne
Ferry has traced the rise of a vocabulary of "inwardness" in sixteenth-
and seventeenth-century English language, while Maus herself high-
lights the rhetoric of interiority in (especially) religious and legal dis-
courses.[34] The science of anatomy achieved an unparalleled prominence
during this period, and its texts revealed in ever greater detail and accu-
racy the shapes and textures of what one early modern anatomist called
"the internal cosmography of the human body."[35] And just as the emergent
new science turned its attention first and foremost (through dissection) to
the body's innards, religious discourse became increasingly saturated with

the rhetoric not just of interiority but very specifically of the body's contents, and especially with the wounds, blood, heart, and bowels of Christ—as if doubting Thomases everywhere suddenly needed confirmation of their belief through access to the interior of the divine body. (Perhaps, too, we could understand this engrossment with divine entrails as something in the nature of a rearguard action in the face of science's invasions and reifications of the inner layers of the human frame.)[36] At the same time, this privileging of the inner was matched by a growing separation of interior spaces from exterior ones. Social historians have described the simultaneous rise of a newly important idea of intimacy and privacy[37] and an architecture that increasingly allowed for the creation of new kinds of private space—"closets," inner "cabinets," studies, or intimate libraries—sanctuaries for the sequestration of the self; these constituted, as Alan Stewart has recently argued, "a key location for the emergence of the modern subjectivity."[38] Civilizing processes and technologies throughout the sixteenth and seventeenth centuries increasingly cordoned off the body's interior and its products, hiding away the grotesque body, with its orifices and protuberances—an "enclosure of the body" that, as Peter Stallybrass has written, "emphasized the borders of a closed individuality";[39] this emphasis on the boundary between inner and outer was, of course, especially strict in its delimitation of the thresholds of sexuality (and especially of women's sexuality).[40]

To these symbolic and concrete figurations of the rigid separation of inner from outer we could add several other early modern loci of insistence on ideas of inclusion and exclusion. The emergence of the idea of Britain as a single nation was founded upon the myth of a unified body politic enclosed on all sides by protective boundaries of water—a "fortress built by Nature for herself," as Gaunt famously put it, a "precious stone set in the silver sea, / Which serves it in the office of a wall, / Or as a moat defensive to a house" (*Richard II*, 2.1.46–48).[41] By the same token, the construction of English national identity based itself, as Richard Halpern puts it, upon "the inclusion or exclusion of various social groups from privileged participation in the . . . community and its representations."[42] One analogue to this was the rapidly growing practice of land enclosure and its accompanying discourses of debarment and expulsion.[43] Another, in a very different sphere, was the field of medical practice, which unremittingly (one might also say mercilessly) stressed processes of elimination (purging, bloodletting, etc.) and ingestion.[44] Similarly, the emphasis on possession and exorcism in the period partakes of this desire for the purification of the interior

of the body and is of course intimately tied to questions of belief and skepticism. All these are instances of a cultural fantasy of a pure, privileged interior strictly separable from external contamination. Hence we find in the period a consistent stress, in a number of different areas, on "the figure of enclosure":[45] the enclosure of the body, its sexuality and its inner workings; of the island nation, and of specific areas of its land; of property, and of private spaces within property excluded from public access; and of the self, the private individual, whose boundedness and inaccessibility were objectified in the idea of a personal interior unavailable to the outside world.[46] And, following what has been said above, we can take this multiple insistence on enclosure as a symptom of the early modern period's increasingly skeptical worldview.[47]

One could say, then, that from one perspective *the* project of early modern England was the renegotiation of inside/outside boundaries. The stridency of the rhetoric surrounding these renegotiations can in part be attributed to the fact that ideas about the separateness of the individual, the impermeability of the body, or the fixedness of the nation were as yet emergent, less well established than they may appear to many today, and hence a source of high anxiety in the period. But this stridency also bears witness to the instabilities that lie at the heart of all attempts to distinguish inner from outer. For one thing, the very act, the *process*, of distinguishing between the two undermines (as we have already seen) its own declared goal, for while processes of incorporation and expulsion may ultimately be aimed at creating a perfect, closed interior, how can the body (of the individual, of the land, or of the nation) help but be seen as endlessly permeable if it at the same time allows — *needs*, in fact — so much taking in and letting out? More crucially, there is an inescapable contradiction between the display of, and the idea of, the inside: The very avowal of a privileged interiority seems inevitably to betray itself in the act of its avowal, in its deictic referral to the inner. There is, for instance, a publicness about early modern representations of secret spaces that undoes any true idea of secrecy. As Alan Stewart puts it, "[F]ar from rendering relationships and transactions secret, the closet paradoxically draws attention to those relationships and transactions, and marks them off as socially and ethically problematic." And as Patricia Fumerton has argued, "[E]ven the most private rooms in Elizabethan houses . . . were sites where privacy could never be achieved"; "the private could be sensed only through the public."[48] Similarly, anatomy's intrusions into the deepest layers of the human body inevitably

transformed the interior of the body into external, objectivized matter: as Devon Hodges has argued, "the process of anatomy is paradoxical because it both is and isn't a way of uncovering the truth . . . by stripping away a body to reveal its contents the inside *becomes* the outside."[49] If the inner is constituted almost by definition by its unimpeachable privacy or secrecy — its inaccessibility to the world — the act of saying "*Hic est interior!*" undoes its very "innerness."

[Hamlet *is*] *a tragedy the interest of which is above all* ad et apud intra *[toward and about the inside].*

—*Samuel Taylor Coleridge*

The early modern obsession with questions of inner and outer is nowhere more evident than in Shakespeare's *Hamlet*. The play reflects endlessly on these questions — on, for example, the opposition between a soliloquized interior and an endlessly theatricalized exterior. From the opening moments of the play, with Francisco's command to a muffled figure in the night, "Stand and unfold yourself" (1.1.2), a persistent concern throughout is with what cannot be seen or known — with the "undiscover'd country" that lies beyond a threshold, an arras, or a "bourn" (3.1.79).[50] The question of what lies within — within the armor of the ghost, beneath the smiling exterior of a person, within the very bodies of the different protagonists — occupies a number of the play's characters, not least among them Hamlet himself. What is anatomically and physiologically inside people is something Hamlet harps on repeatedly.

Hamlet's first sustained speech in the play expresses a paradigmatically skeptical point of view, that of the archetypal outsider:

'Tis not alone my inky cloak, good mother,
Nor customary suits of solemn black,
Nor windy suspiration of forc'd breath,
No, nor the fruitful river in the eye,
Nor the dejected haviour of the visage,
Together with all forms, moods, shapes of grief,
That can denote me truly. These indeed seem,
For they are actions that a man might play;
But I have that within which passes show,
These but the trappings and the suits of woe. (1.2.76–86)

Hamlet's declaration is a deeply skeptical refusal to accept the inherence
of the inner—"that within"—in the outer, and the outer here extends
beyond mere clothes or even words to include all bodily signs—sighs,
tears, facial expressions. It is because breath *can* be "forc'd"—because
all external manifestations are *potentially* false—that all signs, "all
forms, moods [i.e., 'external appearance'], shapes," are dismissed as un-
able to denote truly an interior truth.[51] As Maus points out in discussing
this speech, "[I]t is hard to imagine what could possibly count as 'true
denotation' for Hamlet."[52] The exterior, simply by dint of being exte-
rior, seems to him utterly insufficient as a means for the expression of
the deepest truths. ("What is bad, what is alien to the ego and what is
external are, to begin with, identical," as Freud puts it above.) Hamlet's
angry skepticism may in part be attributable to his perception of his
uncle's consummate ability to "smile, and smile, and be a villain"
(1.5.108), but it goes much further than this, coloring (in "solemn
black") his entire worldview. His "I have that within which passes
show" figures "th' exterior [and] the inward man" (2.2.6) as separated
by an almost unbridgeable gulf; such a view denies the possibility of
ever being known by another, and simultaneously of ever truly know-
ing another, since the truth is buried deep "[i]n my heart's core, ay, in
my heart of heart" (3.2.73). For Hamlet, the problem of other minds is
inseparably a problem of other bodies; these bodies have their own
truths, and access to these truths is to a remarkable extent equated,
through much of this "incorps'd" (4.7.86) play, with access to the inte-
rior of the human body.

As if to body forth, to place concretely onstage, Hamlet's fantasy of
an absolute boundary between the inside and the outside comes his fa-
ther's narration of the manner of his death. The crisis in the play, we
learn, has been occasioned by an attack on the interior of the body of
old King Hamlet, an attack that sharply emphasizes the body's bound-
aries. The ghost's account is vivid in its details:

> Sleeping within my orchard,
> My custom always of the afternoon,
> Upon my secure hour thy uncle stole
> With juice of cursed hebenon in a vial,
> And in the porches of my ears did pour
> The leperous distilment, whose effect
> Holds such an enmity with blood of man

That swift as quicksilver it courses through
The natural gates and alleys of the body,
And with a sudden vigour it doth posset
And curd, like eager droppings into milk,
The thin and wholesome blood. So did it mine,
And a most instant tetter bark'd about,
Most lazar-like, with vile and loathsome crust
All my smooth body. (1.5.59–80)

The account strikingly depicts the effects of the poison upon the body of old King Hamlet: first an internal thickening, a posseting or curding, followed immediately by a hardening of the boundaries. The formerly markedly open corpus of the king, whose "porches" and "natural gates and alleys" have so easily received the poison, is now instantly "bark'd about," "lazar-like," "All" enclosed in a "tetter," a "vile and loathsome crust." Death by tetter is an apt image to set in motion a play so intensely engaged with skepticism, which can indeed be described as a kind of psychic death. The hardened "crust" of King Hamlet's corpse acts as a ghostly precursor or model for the several other hardened bodies in the play, above all that of Hamlet himself, whose "too too solid flesh" (1.2.129)[53] is repeatedly portrayed by him as constricted within a "mortal coil" (3.1.67).[54] Heartsick skepticism of this kind can leave one in a state of extreme corporeal and emotional solitude.

Hamlet's sense of being cut off from access to the interior leads to a preoccupation with the entrails of bodies — his own as well as others. Through much of the play, the Danish prince relentlessly, almost obsessively, fantasizes about "the inmost part" (3.4.19) of his nearest and dearest — "the pith and marrow" (1.4.22), "the guts of a beggar" (4.3.31) or of Polonius (3.4.214), "the lungs . . . liver . . . gall . . . offal" (2.2.570–76), and so on. Underlying this visceral preoccupation and his rage in expressing it is, it seems, the idea that the truth is inaccessible from without. And, more often than not, the truth is felt to be connected to an idea of internal sickness: "Something is rotten *in* the state of Denmark" (1.4.90, emphasis added). This "something" remains vague, hidden away within the body; thus Hamlet's explanation of Fortinbras' Polish expedition:

This is th' impostume [abscess] of much wealth and peace,
That inward breaks, and shows no cause without
Why the man dies. (4.4.27–28)

Like Hamlet's "that within which passes show," this too "shows no cause without." Again, Hamlet warns his mother that her avoidance of the truth

> will but skin and film the ulcerous place,
> Whiles rank corruption, mining all within,
> Infects unseen. (3.4.149–51)

Presumably the recollection of the manner of his father's death contributes to Hamlet's assumption that the source of the "corruption" must be "unseen," "inward," hidden by a skin or film. And presumably Hamlet's disgust with the "rank corruption" of the interior is connected to a sense of the danger or contamination associated with the interiors of other people's bodies.

"But to the quick o' th' ulcer" (4.7.123): We seem to have arrived again at or near the paradoxical nature of the attempt to separate the inside from the outside, for if one is going to persist in declaring the inner to be inexpressible, one cannot at the same time insistently claim to be able to discover precisely what lies within everyone else—or, indeed, even within oneself. If the interior is unutterable, why soliloquize at all? Hamlet's sense of the unbridgeability of inner and outer sits ill, too, with his penetrative impulse to open up the very bodies of the figures surrounding him—his recurrent impulse to partake of what he calls "the soul of Nero" (3.2.385).[55] "I'll observe his looks," he says of his uncle, and adds, without apparent hesitation, "I'll tent him to the quick" (2.2.592–93). If, we might ask, "that within . . . passes show," how might observing Claudius's looks provide a means of access to "the quick"?

But Hamlet's penetrative urge, along with his strident emphasis on the rupture between the inside and the outside, finally make their quietus in the graveyard scene of act 5. For what Hamlet finds among the bones and skulls in the graveyard is that there is no access to thought, emotion, or living truth through access to the inner: "nor th' exterior nor th' inward man" (2.2.6) is irrefutably able to express these. Now he finds nothing but death hidden beneath the body's (or indeed the earth's) skin. What had begun, for Hamlet, as a fantasy of the insufficiency of the external has turned by the end of the play into an understanding of the insufficiency of the internal. For what is inside is neither more nor less revealing than what lies on the surface: "Did these bones cost no more the breeding than to play at loggets with 'em? Mine ache

to think on 't" (5.2.90–91). His own corporeal interior reacts less than favorably to Yorick's skull and the other human remains: "My gorge rises at it" (5.2.181), he says; and, he finds, mortality stinks:

> *Hamlet:* Dost thou think Alexander looked o' this fashion i' th' earth?
> *Horatio:* E'en so.
> *Hamlet:* And smelt so? Pah! *[Puts down the skull]*
> *Horatio:* E'en so, my lord.
> *Hamlet:* To what base uses we may return, Horatio! Why, may not imagination trace the noble dust of Alexander till a find it stopping a bung-hole? (5.2.191–94)

Is this all there is stopping the inner from becoming the outer — a little dust, even if it is that of Alexander? A patch of clay, though it may once have been Caesar's own body?

> Imperious Caesar, dead and turn'd to clay,
> Might stop a hole to keep the wind away.
> O that that earth which kept the world in awe
> Should patch a wall t'expel the winter's flaw. (5.2.206–9)

There is here still a last-ditch attempt to hold inside and outside apart, but the wryness of Hamlet's ditty expresses how near he is to relinquishing the fantasy. Gone is the stark insistence on the clear disjunction of the two — the separation between them is, Hamlet seems to realize, a precarious patchwork, as tenuous as the gap that separates life from death.

The movement away from this clear dichotomy echoes Hamlet's gradual ripening away from the stark alternatives of "To be or not to be": by the final scene, his meditation on the fall of a sparrow and the readiness being all is summed up with the calm simplicity of "Let be" (5.2.220). The final moments of the play reveal a Hamlet who has come some distance from his earlier skeptical self. Hamlet's dying words to Horatio could hardly be further from his opening speech about "that within which passes show":

> If thou didst ever hold me in thy heart,
> Absent thee from felicity awhile,
> And in this harsh world draw thy breath in pain
> To tell my story. (5.2.351–54)

"If thou didst ever hold me in thy heart": a possibility that a man in the grip of skepticism's boundedness could not bring himself to believe; but the doubter has, with almost his dying breath, "let belief take hold of him" (1.1.27). Where earlier Hamlet had rejected as inherently untruthful all external emanations from the body's interior — all "windy suspiration of forc'd breath"— he now enjoins his friend to "draw thy breath in pain / To tell my story." His way of putting this, his slightly odd accent on the drawing of the breath before its exhalation in the telling of the story, calls attention to the corporeal process of respiration. Breathing, as D. W. Winnicott has put it, "may be associated now with intake and now with output. An important characteristic of breathing is that . . . it lays bare a continuity of inner and outer, that is to say, a failure of defenses."[56] "It is the breathing time of day with me" (5.2.171): Hamlet's implicit acceptance of the mutual interpenetration of internal and external (figured in breathing *and* in speaking truthfully) undoes his perception through most of the play that breath, in its joining of insides and outsides, can only be a kind of contagion ("[H]ell itself breathes out / Contagion to this world" [3.2.380–81]), and that speaking is almost always inevitably a degradation ("That I . . . / Must like a whore unpack my heart with words" [2.2.581]). Breathing is still imagined here as a difficult, painful act ("draw thy breath in pain"), but it is now no longer something horrifying. In act 5, wrote Walter Benjamin, Hamlet "wants to breathe in the suffocating air of fate in one deep breath."[57]

The endings of several of Shakespeare's plays turn to the idea of breath and breathing to figure a maturation toward an acceptance of one's indwelling in the world (and vice versa). Notable among these are *King Lear*, *Othello*, and *The Winter's Tale*, where the overcoming of an excessive stress on the absolute separation of the corporeal inside from the outside, self from other, is repeatedly imagined through the trope of breath.[58] Breathing, as the psychoanalyst Michael Ergen points out, represents a "basic, sustaining interpenetration [which] provides a bodily form for communion and relatedness in life. It helps support the current of hope and trust in personality"; "[I]n breathing the insides of the body are continuously fed by the outside world, a continuous interpenetration of bodily depths and open expanse."[59] If in *Hamlet* the early rejection is figured as a stubborn refusal to accept the interpenetration of inner and outer, these plays portray different versions of a similar skepticism. These involve far more than I can discuss here. In brief, we can say the following: that Lear tries to banish all unwanted inner elements —

above all his daughters—from the interior of his body, only to find that these have all along been unavoidably (or, more precisely, unvoidably) within; that Othello is infected (by Iago) with a need for, as Janet Adelman has recently put it, "the rigid demarcation and differentiation of the body's interior," the need "to keep the barrier between inner and outer perfectly intact"—only to realize that such rigidity is tantamount to death;[60] and that Leontes' outright refusal of any inhabitation of his interior—a refusal that, again, has fatal consequences for those who are closest to his heart—can only be overcome through an acknowledgment of the interinanimation (to use Donne's word) of the very bodies of self and other. In each case the skeptical position can only be undone— hesitantly, painfully—by the skeptic himself. The strident insistence on an absolute separation of inner and outer collapses in upon itself, as the external world and its inhabitants are found to be always already within, and the private, internal world is revealed to be expressible, after all, in the "forms, moods, shapes" of the body and the words that emerge from its interior.[61]

NOTES

I am grateful to Elizabeth Freund, Carla Mazzio, Ruth Nevo, Curtis Perry, Adam Phillips, Peter Platt, Alexis Susman, Doug Trevor, and Margot Waddell for their helpful and thoughtful comments on this essay.

1. On the problematic status of psychoanalysis as a methodology for interpreting early modern texts, see especially Stephen Greenblatt's influential "Psychoanalysis and Renaissance Culture," in *Literary Theory/Renaissance Texts*, ed. Patricia Parker and David Quint (Baltimore: Johns Hopkins University Press, 1986), 210–24.

2. Sigmund Freud, *The Ego and the Id* (1923), quoted from *The Standard Edition of the Complete Psychological Works of Sigmund Freud*, 19:26, trans. and ed. James Strachey (London: The Hogarth Press, 1981) (henceforth referred to as *SE*). In a footnote later (1927) added to this passage, Freud explained that "the ego is ultimately derived from bodily sensations, chiefly those springing from the surface of the body. It may thus be regarded as a mental projection of the surface of the body." On this text, see especially Elizabeth Grosz's discussion in *Volatile Bodies: Toward a Corporeal Feminism* (Bloomington: Indiana University Press, 1994), 33–39.

3. Freud, *The Ego and the Id,* 25. Recent psychoanalytic writings have at times focused upon the body's surface as a central locus for the formation of identity. See, e.g., Esther Bick, "The Experience of the Skin in Early Object-Relations," *International Journal of Psychoanalysis* 49 (1968), 484–86, and Didier Anzieu, *A Skin for Thought*, trans. Daphne Briggs (London: Karnac, 1990), esp. 61–80.

4. Freud, "Negation" (1925), *SE*, 19:237; emphasis in the original.

5. Ibid.; emphasis in the original.

6. *An Outline of Psychoanalysis* (1940), *SE*, 23:205.

7. Julia Kristeva, *Powers of Horror: An Essay on Abjection*, trans. Leon S. Roudiez (New York: Columbia University Press, 1982), 7.

8. Jean Starobinski, "The Inside and the Outside," *The Hudson Review* 28, 3 (1995), 333–51, 351, 348.

9. G. W. F. Hegel, *Encyclopedia*, trans. Gustav E. Mueller (New York, 1959), 139; Friedrich Nietzsche, *The Will to Power*, ed. Walter Kaufmann, trans. Kaufmann and R. J. Hollingdale (New York: Vintage, 1967), 264.

10. Ludwig Wittgenstein, *Philosophical Investigations*, trans. G. E. M. Anscombe (New York: Macmillan, 1953), 153e (sec. 580); P. M. S. Hacker, *Wittgenstein on Human Nature* (London: Phoenix, 1997), 43.

11. Jacques Derrida, *Positions*, trans. Alan Bass (Chicago: University of Chicago Press, 1981), 33.

12. Grosz, *Volatile Bodies*, xii, 116.

13. Judith Butler, *Gender Trouble: Feminism and the Subversion of Identity* (New York: Routledge, 1990), 134.

14. The term "proto-belief" is Richard Wollheim's, from his illuminating discussion of Freud's "Negation" in *The Mind and Its Depths* (Cambridge, MA: Harvard University Press, 1993), 69–75.

15. *SE*, 19:238. In his most famous case history, *From the History of an Infantile Neurosis (The Wolf-Man)*, Freud relates the following: "We know how important doubt is to the physician who is analysing an obsessional neurosis. It is the patient's strongest weapon, the favorite expedient of his resistance. This same doubt enabled our patient to lie entrenched behind a respectful indifference and to allow the efforts of the treatment to slip past him for years together. Nothing changed, and there was no way of convincing him. At last I recognized the importance of the intestinal trouble for my purposes; it represented the small trait of hysteria which is regularly to be found at the root of an obsessional neurosis. I promised the patient a complete recovery of his intestinal activity, and by means of this promise made his incredulity manifest. I then had the satisfaction of seeing his doubts dwindle away, as in the course of the work his bowel began, like a hysterically affected organ, to 'join in the conversation', and in a few weeks' time recovered its normal functions after their long impairment" (*SE*, 17:73).

16. D. W. Winnicott, "Appetite and Emotional Disorder" [1936], in *Collected Papers: Through Paediatrics to Psycho-Analysis* (New York: Brunner/Mazel, 1958, 1992), 40.

17. Here I am using the terms *introjection* and *incorporation* more or less interchangeably and somewhat loosely; for a "weak" view of the differences between the two, see J. Laplanche and J.-B. Pontalis, *The Language of Psychoanalysis*, trans. Donald Nicholson-Smith (New York: Norton, 1973), 229–31; for a much "stronger" view, see Nicolas Abraham and Maria Torok, "Mourning *or* Melancholia: Introjection *versus* Incorporation," in *The Shell and the Kernel*, ed. and trans. Nicholas T. Rand, 1:125–38.

18. When I speak of "skepticism," I mean both doubt regarding the existence of the outer world (external-world skepticism) and doubt about the possibility of knowing the other (which we might call internal-world skepticism). On the relation between the two forms of skepticism, see esp. Ludwig Wittgenstein's *On Certainty*, ed. G. E. M Anscombe and G. H. von Wright, trans. Denis Paul and G. E. M. Anscombe (New York: Harper Torchbooks, 1972); on one major difference between them, see Stanley Cavell, *The Claim of Reason: Wittgenstein, Skepticism, Morality, and Tragedy* (Oxford: Oxford University Press, 1979), 451–53. My understanding of these issues is indebted to Cavell's work, especially to *The Claim of Reason* and to *Disowning Knowledge in Six Plays of Shakespeare* (Cambridge: Cambridge University Press, 1987).

19. The inner *is*, of course, unknowable from a certain (skeptical) perspective — insofar, that is, as one equates knowability with epistemological certainty.

20. Ted Hughes, "The Machine," in *Birthday Letters* (London: Faber, 1998), 25.

21. Elaine Scarry, *The Body in Pain: The Making and Unmaking of the World* (New York: Oxford University Press, 1985), 13.

22. Ibid., 215, 205, 190; emphasis in the original.

23. Or, conversely, the inherence of the otherworldly or divine in this world — religion's antiskeptical position.

24. Cavell, *The Claim of Reason*, 329.

25. Starobinski, "The Inside and the Outside," 336; emphasis in the original.

26. The desire for access to the interior can hardly but be mixed with a significant degree of fear and loathing, and hence with a strong desire for opacity (coupled, perhaps, with an envy of the other's apparent opacity). Melanie Klein, in particular, has described children's fantasies about the insides of the mother's body as a potent mixture of fascination and terror.

27. Authorized King James Version. See Scarry, *The Body in Pain*, 214–15, for a reading of this passage in terms of the different forms of verification in the Old and New Testaments.

28. I thank Margot Waddell for this suggestion.

29. Ludwig Wittgenstein, *Philosophical Investigations*, 45e (sec. 99).

30. Scarry, *The Body in Pain*, 14.

31. At a fundamental level, these crises were inseparable from, as Thomas Docherty puts it, "a conflict between one mode of authority whose source is external, 'other-directed,' . . . and another mode which claims internal, self-directed authority." *On Modern Authority: The Theory and Conditioning of Writing, 1500 to the Present Day* (New York: St. Martin's Press, 1987), 49.

32. Louis Adrian Montrose, " 'Shaping Fantasies': Figurations of Gender and Power in Elizabethan Culture," in *Representing the English Renaissance*, ed. Stephen Greenblatt (Berkeley: University of California Press, 1988), 31–64, 33.

33. Katharine Eisaman Maus, *Inwardness and Theater in the English Renaissance* (Chicago: University of Chicago Press, 1995), 15, 13. The crisis occasioned by the rise of print technology and the consequent (apparent) schism between the word and the flesh out of which it originally emerged has strong affinities with the desire for access to inner spaces, especially of the human body. The less words seemed to be emerging literally and inevitably from the mouths and hence the interiors of the speakers, the greater the skepticism about the integrity of the relation between word and flesh (or, often, in the discourse of the period, "tongue" and "heart"). See Elizabeth L. Eisenstein, *The Printing Press as an Agent of Change: Communications and Cultural Transformations in Early-Modern Europe* (Cambridge: Cambridge University Press, 1979); Marshall McLuhan, *The Gutenberg Galaxy: The Making of Typographical Man* (Toronto: University of Toronto Press, 1962); and Carla Mazzio, "Sins of the Tongue," in *The Body in Parts: Fantasies of Corporeality in Early Modern Europe*, ed. David Hillman and Carla Mazzio (New York: Routledge, 1997), 53–79.

34. Anne Ferry, *The "Inward" Language: Sonnets of Wyatt, Sidney, Shakespeare, Donne* (Chicago: University of Chicago Press, 1983), 1–70.

35. Giovanni Ciampoli, "Del corpo humano. Discorso primo," in *Prose di Monsignor G.C.* (Venice, 1676), 44, cited in Piero Camporesi, *The Anatomy of the Senses: Natural Symbols in Medieval and Early Modern Italy*, trans. Allan Cameron (Cambridge: Polity Press, 1994), 96. Devon L. Hodges, *Renaissance Fictions of Anatomy* (Amherst: University of Massachusetts Press, 1985), and Jonathan Sawday, *The Body Emblazoned: Dissection and the Human Body in Renaissance Culture* (London: Routledge, 1995) both show convincingly how important the "culture of dissection" (Sawday, viii) was to the early modern world.

36. For a short survey of this religious preoccupation with the body's interior, see my "Visceral Knowledge: Shakespeare, Skepticism, and the Interior of the Early Modern Body," in *The Body in Parts*, 80–105, as well as Michael Schoenfeldt's "Fables of the Belly in Early Modern England," in the same volume (242–61). Human innards are figured in the period as the central locus of

connection with divinity; "God's immediate, superhuman knowledge of the hidden interior of persons," writes Maus, "is one of the primary qualities for which he is admired and feared by many early modern Christians" (Maus, *Inwardness and Theater*, 10). Divine entrails are equally marked as (antiskeptically) open to human access. This relates most often to Christ's interior, but also sometimes to the interior of God himself: as, for instance, the seventeenth-century theologian Thomas Goodwin put it, "the *Bowels* are of all the most *inward*, and therefore of all other speak what is most inward in God himself." (*Of the Object and Acts of Justifying Faith*, in *The Works of Thomas Goodwin* [London, 1697], 4:88).

37. See, e.g., Lawrence Stone, *The Family, Sex and Marriage in England 1500–1800* (New York: Harper Torchbooks, 1977), 169–72, 223–24, 245–46, and Orest Ranum, "The Refuges of Intimacy," in *A History of Private Life*, volume 3: *Passions of the Renaissance*, ed. Roger Chartier, trans. Arthur Goldhammer (Cambridge: Harvard University Press, 1989), 207–63.

38. Alan Stewart, *Close Readers: Humanism and Sodomy in Early Modern England* (Princeton: Princeton University Press, 1997), 161–87, 171. See also Ferry, *The "Inward" Language*, 47; Stone, *The Family, Sex and Marriage*, 169–70, 245–46; Ranum, "The Refuges of Intimacy," 217–29; and Roger Chartier, "The Practical Impact of Writing," in *A History of Private Life*, 3:111–59.

39. Peter Stallybrass, "Patriarchal Territories: The Body Enclosed," in *Rewriting the Renaissance: The Discourses of Sexual Difference in Early Modern Europe*, ed. Margaret W. Ferguson, Maureen Quilligan, and Nancy J. Vickers (Chicago: University of Chicago Press, 1986), 123–44, 125. See also Norbert Elias, *The History of Manners*, trans. Edmund Jephcott (New York: Pantheon, 1978), and Elias, *The Civilizing Process*, trans. Edmund Jephcott (New York: Pantheon, 1978); Gail Kern Paster, *The Body Embarrassed: Drama and the Disciplines of Shame in Early Modern England* (Ithaca: Cornell University Press, 1993); and Stephen Greenblatt, "Filthy Rites," *Daedalus* 3 (1981), 1–16.

40. See Stallybrass, "Patriarchal Territories," 125–33; Elias, *The History of Manners*, esp. 70–84; Paster, *The Body Embarrassed*; and Patricia Parker, "*Othello* and *Hamlet*: Dilation, Spying, and the 'Secret Place' of Woman," in *Shakespeare Reread: The Texts in New Contexts*, ed. Russ McDonald (Ithaca: Cornell University Press, 1994), 105–46. As Stallybrass shows, the intersections of class, race, and gender immensely complicated this redrawing of the boundaries between classical and grotesque bodies.

41. See, for example, Stallybrass, "Patriarchal Territories," 129–30; Linda Woodbridge, "Palisading the Elizabethan Body Politic," *Texas Studies in Literature and Language* 33 (1991), 327–54; Willy Maley, " 'This Sceptred Isle': Shakespeare and the British Problem," in *Shakespeare and National Culture*, ed. John

J. Joughin (Manchester: Manchester University Press, 1997), 83–108. Stally-brass shows how the myth of Elizabeth I's virginity—the sign of a "perfect and impermeable container"—functioned (in deeply problematic ways) "as emblem of national 'integrity' " (129–30).

42. Richard Helgerson, *Forms of Nationhood: The Elizabethan Writing of England* (Chicago: University of Chicago Press, 1992), 279; cf. Stallybrass, "Patriarchal Territories," 130: "The nation-state was formed according to new canons of incorporation and exclusion."

43. See Richard Burt and John Michael Archer, "Introduction," in *Enclosure Acts: Sexuality, Property, and Culture in Early Modern England*, ed. Burt and Archer (Ithaca: Cornell University Press, 1994). Curtis Perry has pointed out to me the oversimplification involved in this use of the term *enclosure* as simultaneously an economic and a metaphoric term in this period—the fact that the argument as stated above makes the economic issues seem somehow secondary to the culture's body image projections. His criticism is well taken.

44. See Schoenfeldt, "Fables of the Belly," 250–51: "[N]early all medical interventions in the period short of surgery are intended to expel such pernicious excess, through purgation or phlebotomy, or to correct a humoral imbalance through ingestion." See also Nancy G. Siraisi, *Medieval and Early Renaissance Medicine: An Introduction to Knowledge and Practice* (Chicago: University of Chicago Press, 1990), 78–114, and Paster, *The Body Embarrassed*, 8–13.

45. Burt and Archer, *Enclosure Acts*, 2.

46. This is one of the reasons for the obsessive anxiety about the tongue in many early modern texts. As Carla Mazzio has pointed out, the tongue is the only body part naturally capable of being either inside or outside the body, making it "particularly suitable for the articulation of collapsing distinctions" ("Sins of the Tongue," in *The Body in Parts*, 56–57).

47. On the rise of philosophical skepticism in the period as a concomitant of the early modern world's social and religious crises, see "Visceral Knowledge," 81–86.

48. Stewart, "Epistemologies," 184; Patricia Fumerton, *Cultural Aesthetics: Renaissance Literature and the Practice of Social Ornament* (Chicago: University of Chicago Press, 1991), 76–77, 109, cited in Stewart, "Epistemologies," 168. Cf. Ann Rosalind Jones and Peter Stallybrass' more general comment about the early modern period: "the supposedly 'private' sphere . . . can be imagined only through its similarities and dissimilarities to the public world" ("The Politics of *Astrophil and Stella*," *Studies in English Literature* 24 [1984], 53–68, 54).

49. Devon L. Hodges, *Renaissance Fictions of Anatomy* (Amherst: University of Massachusetts Press, 1985), 68–69; emphasis added.

50. All quotations from *Hamlet* are from *The Arden Shakespeare*, ed. Harold Jenkins (London: Routledge, 1982). For an extended discussion of *Hamlet* in relation to

these questions of skepticism and the inside/outside binary, see my "Hamlet's Entrails," in *Strands Afar Remote: Israeli Perspectives on Shakespeare*, ed. Avraham Oz (Newark and London: University of Delaware Press, 1998), 176–202; a shorter version of this essay ("Hamlet, Nietzsche, and Visceral Knowledge") was published in *The Incorporated Self: Interdisciplinary Perspectives on Embodiment*, ed. Michael O'Donovan-Anderson (Lanham, MD: Rowman and Littlefield, 1996), 93–110.

51. Arden edition, citing Alexander Schmidt's gloss, in *Shakespeare Lexicon and Quotation Dictionary*, 3rd ed. (New York: Dover Publications, 1971), 1:736.

52. Maus, *Inwardness and Theater*, 1.

53. I here adopt the Folio reading (rather than the Second Quarto's "sullied").

54. More specifically, the hardened exterior of King Hamlet's corpse can be understood as preventing its symbolic incorporation into the bodies of its survivors—a necessary step in the mourning process. On the idea of an edible paternal corpus and on this incorporative process in *Hamlet* (and in Freud's "Mourning and Melancholia"), see "Hamlet's Entrails," 180–85.

55. Nero appears throughout the Renaissance as the prototype of the cruel anatomist. Shakespeare refers to him in *King John* ("You bloody Neroes, ripping up the womb / Of your dear mother England"—5.2.152–53) in relation to (in the words of the Oxford editor of that play) "the legend that Nero committed the murder [of his mother] himself and ripped open [her] womb in order to see the place whence he came." I discuss Hamlet's "Nerosis" at greater length in "Hamlet's Entrails," 188–91. On anatomy as a particularly concrete form of skepticism, see "Visceral Knowledge," 83–85.

56. *The Family and Individual Development* (London: Tavistock, 1965), 9.

57. Walter Benjamin, *The Origin of German Tragic Drama*, trans. John Osborne (London: Verso, 1977), 137.

58. Note Lear's stress on Cordelia's breath ("Lend me a looking-glass, / If that her breath will mist or stain the stone, / Why then she lives"; "This feather stirs, she lives!" "Why should a dog, a horse, a rat, have life, / And thou no breath at all?": 5.3.262–64, 266, 307–8); Othello's on Desdemona's breath, before and after suffocating her ("O balmy breath, that dost almost persuade / Justice to break her sword!" "Whose breath, indeed, these hands have newly stopp'd": 5.2.16, 202); and Leontes' on Hermione's breath ("when your first queen's again in breath"; "[He] could put breath into his work"; "Would you not deem it breath'd?" "What fine chisel / Could ever yet cut breath?": 5.1.83, 5.2.97–98, 5.3.64, 78–79). The citations are from *The Riverside Shakespeare*, ed. G. Blakemore Evans (Boston: Houghton Mifflin, 1974).

59. Michael Eigen, *The Electrified Tightrope*, ed. Adam Phillips (Northvale, NJ: Jason Aronson, 1993), 45. Cf. Starobinski, "The Inside and the Outside," 341:

"Holding one's breath . . . represents an elementary but fundamental form of self-control exercised at that verge where a personal inside and outside take shape."

60. Janet Adelman, "Iago's Alter Ego: Race as Projection in *Othello*," *Shakespeare Quarterly* 48, 2 (1997), 125–44, 132, 133. On *Othello* as a play that is profoundly concerned with issues of skepticism and belief, see Cavell, "Othello and the Stake of the Other," in *Disowning Knowledge*, 125–42.

61. One is moving here in the direction of an intermediate area of experience that is neither internal nor external, neither subjective nor objective—a transitional or potential space of relating the two through use of fantasy. This is the creative space of trust between mother and infant, self and other, about which D. W. Winnicott has written so luminously. (See, e.g., "Transitional Objects and Transitional Phenomena," in his *Playing and Reality* [London: Tavistock, 1971]. 1–25.) It provides an alternative to the stark separation of inner and outer that lies at the root of the skeptic's refusal to take one's place in the world and to acknowledge the world's place within the self. One can perhaps view the ending of a play such as *The Winter's Tale* as reaching toward such an imagination of a space that transcends the skeptic's separations—an unfixed, paradoxical space that is neither inner nor outer but "in the between" (*The Winter's Tale*, 3.3.61).

KATHARINE EISAMAN MAUS

SORCERY AND SUBJECTIVITY IN EARLY MODERN DISCOURSES OF WITCHCRAFT

Elizabethan and Jacobean musings on the nature of human subjectivity are highly unsystematic and inexplicit. There is nothing in this period on the order of Locke's *Essay Concerning Human Understanding* or Hume's *Treatise of Human Nature*. What the historian or literary critic encounters instead is a set of truisms repeated under predictable conditions—the sermon, the consolation, the treatise on political theory, the advice to a son, the speech in Parliament or in the courtroom. Taken together, these truisms can seem contradictory in their implications, and their deployment may appear to be more a matter of decorum, of what seems appropriate to a particular situation, than a matter of what seems true to the speaker in some abstract or absolute sense. When we write upon Renaissance subjectivity we must, therefore, rely heavily upon inference, and our conclusions vary wildly depending upon which texts we privilege and how we extrapolate from them.[1] This essay shall describe a bit of the available variety, but I have no ambition to offer a "unified field theory" of the Renaissance subject, a project that indeed seems impossible.

At the same time, it is important to recognize, self-reflexively, that we moderns and postmoderns are rarely paragons of philosophical rigor ourselves. In the late twentieth century persons may be construed as (for instance) moral agents, political actors, hominids, entrepreneurs, immortal

souls, neural nets, consumers, parties to contracts, or members of social groups, as seems convenient to a particular writer or within a particular discipline. Drastically different conceptions of personhood can seem simultaneously plausible not only within the same culture, but even to the same person, provided the discursive domains in which those conceptions are activated remain distinct. To take a modern example, an advertising executive who accepts a "strong" notion of individual initiative and accountability for making her personal and political decisions, and therefore votes Republican, may nonetheless think of the consumers to whom she directs her advertisements as deeply suggestible and as possessing tastes largely determined by class, race, age, zip code, and other demographic factors. Likewise, a sixteenth-century physician may, when thinking "medically," write as if human beings are entirely material entities, but when in church have no trouble accepting the existence of an immortal, immaterial soul. Ordinarily the different implications of various "theories of the person" become conspicuous rather than merely implicit only when they are forced into collision.

Early modern writing on magic and witchcraft, I believe, represents an instance of such a collision. Different parties brought to the debate different conceptions of the nature of subjectivity, different claims about how the body and soul interact, different convictions about what was naturally and supernaturally possible. Modern commentators have underestimated the significance of these differences, however, because to us the skeptics look obviously right and the witch-hunters are hard to take seriously. Although plenty of people nowadays believe in the possibility of witchcraft, the efficacy of exorcism, and the power of magical rituals, few of them teach humanities in North American or Western European universities. We consult Evans-Pritchard, Malinowski, Notestein, Thomas, Macfarlane, Larner, Willis, Sharpe, and so on to learn why historically or geographically distant people could prosecute their neighbors for apparently impossible offenses; we learn that magical beliefs are traceable to social breakdown, religious illusion, scientific naïveté, psychological disorder, resentment of mothers, or mere human wishfulness in the face of an uncontrollable universe.[2] Unfortunately, however plausible these explanations seem, they do not reveal why magic and witchcraft should be *debatable* matters in early modern Europe. Perhaps it is easier to show why a society might uniformly succumb to witchcraft beliefs than why intelligent people should vigorously contend over them. Among the cadre of elite men who wrote about witchcraft in England or

on the Continent, it is hard to argue that particular believers — the political theorist Jean Bodin, the Puritan minister William Perkins, or the Aristotelian physician John Cotta, for instance — were more troubled or less sophisticated than skeptics such as Johann Weyer, Reginald Scot, or Edward Jorden. Certainly the age was scientifically uninformed, but that ignorance was shared by those who discounted as well as by those who subscribed to magical beliefs. Reginald Scot mistrusts stories of ghosts, witches, pacts with the devil, alchemical transformations, and miraculously efficacious amulets, but he believes that gemstones acquire special powers from the influence of the planets, that a hare's foot bone mitigates cramp, and that menstrual blood engenders serpents.[3]

Without rehabilitating the pro-witchcraft position or minimizing the savagery of witchhunting, I want to recapture some sense of the uncertainty with which intelligent Renaissance commentators can regard the issue. This recapturing will involve turning the usual question about witchcraft belief on its head; instead of asking, "What made witchcraft beliefs possible in the early modern period?" I shall ask something like, "Why could (some) early modern people *disbelieve* in witches?" In their own time the skeptics' insistence upon the impossibility or unlikelihood of witchcraft, sorcery, and demonic possession is hardly self-evident; nor could they have then seemed, as they do in retrospect, prophets of an epistemic shift. So what allowed them to hold the views they did? What rhetorical techniques did they employ to try to convince others?

The first part of this essay analyzes some of the terms of the debate about witchcraft and magic, terms that are interesting in their own right. I shall then argue, much more sketchily and speculatively, that the positions taken by these writers exemplify a larger opposition between two ways of thinking about the self, ways that correlate imperfectly but tellingly with modern perspectives. Finally I shall suggest that these partial affinities may help explain some features of the twentieth-century reception of Jonson and Shakespeare.

Witchcraft polemicists of the late fifteenth, sixteenth, and early seventeenth centuries are not neatly divided into opposing camps, but occupy myriad positions. Believers disagree about the effectiveness of witchcraft, the possibility of "white" magic, and how often supernatural events occur. Some believers emphasize the harm witches do, others the witch's impious contract with the devil. Among skeptics, Reginald Scot regards all magic and witchcraft as impossible; Johann Weyer believes in magic

and demonic possession but considers witches the victims of illusion; Edward Jorden believes merely that many supposedly magical effects are traceable to natural causes, so court proceedings against witches are unusually error-prone.[4] A moderate believer such as William Perkins — who believes in witches but strictly limits their powers — is in some points closer to a moderate skeptic such as Johann Weyer than he is to extremists such as Jakob Sprenger and Heinrich Kramer, the fanatical authors of *Malleus Maleficarum*.

Nonetheless, believers characteristically accept three distinguishable but related kinds of what I shall call "permeability." And the more zealous the witch-hunter, the more dangerously pervasive he imagines sorcery to be, the more fully these permeabilities dominate his thinking. So Sprenger and Kramer articulate them in an especially clear, uncompromising fashion (that is why I'll quote from *Malleus Maleficarum* so often). In more temperate writers such as Cotta or Perkins, they are less prominent but still decisive.

The first kind of permeability is between one individual and another. Possessions and bewitchments require the devil, sorcerer, or witch to achieve entry into an apparently separate being. Devils colonize the unfortunates whom they wish to "possess," acting and speaking from within their bodies. Witches cast beams from their evil eyes into the vulnerable interiors of their enemies, and recite charms that invade the udders of their neighbors' cattle. Some believe that demons can extract semen from unsuspecting victims and then inject it into sexual partners to whom they appear in the form of incubi. Those who believe in witches fiercely debate the means by which these entries take place: for some, the sorcerer him- or herself can invade another person's body; for others, such invasion is the prerogative of the devil, who does the sorcerer's bidding. Despite these disagreements, for believers in witchcraft the boundaries between one person and another seem thin — almost nonexistent — and easily overridden.

Christians can take such views only so far, because they must leave some latitude for the operation of free will. Even Sprenger and Kramer respect the orthodox view that reserves a bit of the human interior from the purview of anyone but God, "for the devil cannot know the inner thoughts of the heart except conjecturally from outward indications" (*MM* III.13.223).[5] Nonetheless, for believers in witches, that protected realm tends to become drastically compressed. Devils can ruin a person's possessions and reputation, disrupt his memory, plague him with delusions,

deprive him of his reason, rob him of his penis, occupy his body, transport him through the air to distant locations, kill him or his children, change him into a beast, and afflict him with leprosy, convulsions, epilepsy, or blindness. The comprehensive possibilities of molestation conceded to powerful supernatural agents by believers in witchcraft seriously compromise the basis upon which any individual might exercise his supposedly free will.

A second kind of permeability important for believers in witchcraft is the capacity of minds or spirits to influence bodies. The theory of such influence is developed with great subtlety and elaboration by sixteenth-century Neoplatonist magicians such as Giordano Bruno and John Dee, for whom reality consists of ideals apprehensible by the mind alone and not the by senses, which testify merely to a secondhand, subordinate copy-world. Less philosophically painstaking writers similarly insist upon the influence over the realms of the body by the realms of the mind. Daily experience, they claim, shows that mental attitudes affect bodily states, so that, for instance, a man who could easily balance on a narrow log several inches off the ground would fall as a result of his own terror if he were compelled to walk on the same log suspended over an abyss. Mind-body permeability permits and reinforces intersubjective permeability. Since, as we have already seen, the boundaries between one person and another are insubstantial, it is almost as easy for one person's thoughts to affect another person's body as it is for his thoughts to affect his own.

Since "the spiritual nature is superior to the bodily" (*MM* 1.4.109), it seems to follow that matter must obey the behest of devils, who are spirits themselves. Thus believers in witches tend to seem indecisive on the subject of physical metamorphosis, sometimes claiming that it involves a manipulation of material objects, sometimes insisting that such manipulation is itself illusory. Devils, they variously assert, can "occupy" real bodies, manufacture their own out of air, or merely present an apparition to eye or mind. If there were originally important scholastic distinctions here between accidents and substances, writers of witchcraft tracts tend to confuse or forget them. And this confusion is not surprising in a universe where the difference between the material and the mental worlds seems to dissolve, or rather to become of questionable consequence, even while the mental world retains a certain priority.

The third kind of permeability is between illusion and reality. If the "reality" of supernatural mischief is questionable, so is the authenticity

of its victims' experience. When, for instance, witches remove men's penises, do they actually excise the organs, or do they merely create an illusion of castration? Some writers believe that to grant the former would allow too much power to an agent of the devil, others that to grant merely the latter unduly minimizes the witch's threat. But the problem often arises not as a controversy between writers holding different positions, but as an inconsistency or oscillation among various options by the same writers. Once the world is imagined to be constituted along porous mentalist lines, then some of the ordinary criteria for distinguishing between the realm of the imaginary and the realm of the real simply evaporate.

"Imaginary" effects are no less threatening, to many witchcraft believers, than "real" or material ones. The fact that a witch cannot "really" deprive a man of his penis, but merely creates a "glamour" that makes him believe that he is so deprived, is no consolation to James I, who found himself impotent on his wedding night. That a young girl may not "actually" have become a filly, but only seemed to become a filly to herself and others, is almost a distinction without a difference in a system in which mental convictions play such a crucial role.

Skeptics, by contrast, reject of all three of the "permeabilities" accepted by believers, and extreme skeptics, such as Reginald Scot, reject them more emphatically than do their moderate colleagues. Scot insists upon obvious and durable boundaries between realms that his opponents imagine as tenuously divided or coexistent. Individuals, in his view, are self-enclosed, autonomous entities, sturdily fortified against the stratagems of others. Their minds cannot be invaded by other minds, and their bodies are stolidly insusceptible to alteration by nonmaterial means: "Neither witches, nor any other, can either by words or herbs, thrust into the mind of a sleeping man" (Scot 10.5.103). Just as Scot rejects the penetrability of individuals, he distinquishes with equal rigor between material and mental phenomena. Any contract between devil and human being is nonbinding, he argues, because of the radically different natures of the two parties. Under such circumstances, magical transformation of bodily substance seems wildly unlikely: "To bring the body of a man, without feeling, into such a thin airy nature, as that it can neither be seen nor felt . . . is very impossible" (Scot 5.4.56).

The skeptical distinction between material and mental realms serves less to deny any association between them, than to define the terms in

which that association might take place. Material circumstances can, indeed, affect mental states: Weyer explains how ointments made from opium and nightshade can seep through the skin and operate on the imagination; all skeptics argue that melancholic humors or organic dysfunctions derange the mind. But the process cannot ordinarily work the other way around.[6]

> Melancholic humor (as the best physicians affirm) is the cause of all their strange, impossible, and incredible confessions: which are so fond, that I wonder how any man can be abused thereby. Howbeit, these affections, though they appear in the mind of man, yet are they bred in the body, and proceed from this humor, which is the very dregs of blood, nourishing and feeding those places, from which proceed fears, cogitations, superstitions, fastings, labors, and such like. (Weyer 3.11.33)

While for believers in witchcraft reality permeates "downward" from the spiritual to the material world, for skeptics "a thick vapor proceeding from crudity and rawness in the stomach . . . ascend[s] up into the head [and] oppresseth the brain" (Scot 4.11.49).

Thus as it could not among the believers, for skeptics reducing mental phenomena to material ones, accounts for them become a form of explanation and contemptuous dismissal. Once the bodily is identified with the real, the claim that witchcraft is "all in the mind"—a premise with which many witchcraft believers would substantially agree—becomes tantamount to an assertion that witchcraft does not exist. Weyer claims that because a demonic pact is "confirmed by the deceptive appearance of a phantasm, or a fancy of the mind or the phantastical body of a blinding spirit . . . it is therefore of no weight" (3.3.173). Purely mental events are hardly substantial enough to take seriously; bodily operations, on the other hand, however mysterious, belong to the domain of "nature" and do not require supernatural explanations.

When the material world is given this kind of absolute priority, then the actuality of any nonbodily experience or entity seems to be in question. Scot's resolute materialism has left him open, in his day and ours, to the charge of "Saduceeism"—that is, of denying the existence of the supernatural realm—or even of covert atheism.[7] The less extreme Weyer attempts to retain a place for an autonomous spiritual realm by asserting that devils exist even though witches do not. But

the inconsistency of his position renders it highly unstable and vulnerable to attack. Witchcraft skeptics attempt to restrict what can affect the self, to find causes for even its most remarkable demeanors within the boundaries of an isolated, demystified body. This isolation has an ethical corollary: if people are sequestered from one another, each person is responsible for his or her own fate. Both Scot and Weyer argue that people who think they suffer harm from "witches" nurse an arrogant conviction of unmerited injury without considering how they might have brought their tribulations upon themselves.

> [F]ew or none can (nowadays) with patience endure the hand and correction of God. For if any adversity, grief, sickness, loss of children, corn, cattle, or liberty happen unto them; by and by they exclaim upon witches, as though they themselves were innocents, and had deserved no such punishments. (Scot 1.1.1)

Skeptics suggest that the causes of witchcraft accusations originate in the pathology of the accuser, not the accused. Moreover, granted that accused witches are indeed spiteful and melancholic, their malice remains lodged securely within themselves. Thus Weyer argues that the target of a curse need not be alarmed by it: "[W]e see clearly that [curses] have no effect upon other parties; they merely injure the soul of the person who speaks the evil" (4.18.330).

Since, however, the facts witchcraft skeptics as well as believers must confront are troubling almost by definition, the consolations of skepticism are rather limited. If each individual is isolated within his own body, then reasons for his odd behavior must be discoverable in the body's remarkable attributes. Weyer assures us that "worms of prodigious size are sometimes produced from natural causes within the bodily cavities" (4.16.325); so are peculiar stones, balls of hair, and other unlikely excrescences. Matter in general, and the human body in particular, is a doppelganger in the skeptical literature: on one hand, banal and familiar; on the other, weird and alien. The permeability of consciousness to outside influences has been not so much banished as ascribed to a different domain. For this reason, it may not be surprising that witchcraft skeptics such as Weyer and Jorden are often credited with surprisingly "modern" insights into human psychology. Their modernity consists in their attempt to explain strange, out-of-control, unwilled phenomena in

terms of the internal operations of the human subject, rather than ascribing them to some kind of invasion from the outside. But this must mean that people are not always aware of or in control of their own inner depths.

Two ways of thinking about the problem of the "alien within" correspond to what Scot calls the "two kinds of witches." The first is the "cozening witch," or trickster. If the self is enclosed within the boundaries of the body, if its truth is imagined as interior and invisible, then deceit becomes a live possibility. The notion of fraudulence, tied in as it is to personal gain at the expense of the community, becomes an important explanation for many kinds of apparently magical performances. The cozening witches "take upon them, either for glory, fame, or gain, to do any thing, which God or the devil can do" (Scot 1.3.5). Scot, Weyer, and Harsnett provide outraged accounts of magicians' tricks: the alchemist who absconds with a wealthy yeoman's fortune; the quack who deflowers a young virgin, claiming thus magically to cure her ailing father; the priest who forces a "possessed" girl to breathe in drugs that disorient her, making her seem demonic even to herself.[8]

Fraudulence reassures the skeptic, because it accords with a skeptical conception of human beings as essentially isolated from one another. The fraud consciously makes exploitive use of his own skilled body: making objects vanish by sleight of hand, twisting his limbs into apparently impossible positions to convince the gullible that he harbors demons. His ruthless entrepreneurial self-interest is untrammeled by community norms or by compassion for the people he cheats. And he knows his tricks will work because his audience, themselves limited to the deceptive evidence of their senses, cannot penetrate the workings of his hidden consciousness.

By those who believe in its efficacy, magic is imagined as a blasphemous parody of religious ritual. The skeptical denial of magic also involves parody, but since the threat is differently conceived, so is the nature of the counterfeit. The theatrical expertise of the cozening sorcerer is a parodic, "hollow" version of the skeptics' invulnerably self-sufficient subject. The fraudulent sorcerer controls the mechanisms of separation, of "boundedness," crucial to Scot's account of the operations of human subjectivity. The skeptics defend against—I am tempted to say exorcise—this treacherous hollowness by techniques of satiric exposure, of "discovery." Once fraudulence rather than supernatural malfeasance is the crime, the paranoia of the witch-hunter becomes

transformed into the paranoia of the detective, suspicious of other people's motives but assuming that a natural explanation is retrievable.

Fraudulence does not explain all cases, however. Even believers in witchcraft admit that some accusations of witchcraft are false, cases of mistakes on the part of witnesses or tricks on the part of the accused. How are skeptics to explain such mysterious phenomena as group panics? Hysterical paralysis? "Sincerely" possessed people? Those who spontaneously confess to bewitching their neighbors despite the horrible consequences to themselves?

For these cases, skeptics develop a theory of insanity which allows them to maintain, even to reinforce, the notion of "bounded" selfhood upon which their skepticism depends. Insanity, in their view, involves unshared and unshareable delusions: optical illusions, strange phobias, the idiosyncratic malfunctioning of the liver or womb. Weyer provides especially varied examples of such delusions: a man who believes himself to be an earthen vessel, another who thinks that everyone he encounters is accusing him of sodomy, a woman who complains groundlessly that her food is laced with pepper and her genitals are gangrenous (3.7.183–86). Mental illness, defined as individual eccentricity, thus becomes an ultimate form of self-enclosure.

In other words, while the fraudulent witch consciously masters and exploits the boundaries between one person and another, the "sick" witch is nightmarishly entrapped within the walls of selfhood. Thus it is not entirely surprising that the two kinds of witches are often distinguished along familiar gender lines. Cozening witches, in Scot, are generally male, "sick" witches by and large female. Scot notes that "sick" witches are typically old and deformed. But while for the believers malformation is a sign of guilt, for Scot it is a proof of innocence: "For alas! What an unapt instrument is a toothless, old, impotent, and unwieldy woman to fly in the air?" (1.6.8). The "illness" model of witchcraft saves the life of the accused, but at a cost; the witchcraft skeptic denies the suspect's moral agency, since little is imagined to inhabit "that sex which by reason of temperament is inconstant, credulous, wicked, uncontrolled in spirit, and . . . melancholic" (Weyer, 3.6.181). The ferocity of the witch-hunters' misogyny and ageism should not conceal the fact that for their skeptical opponents as well, the elderly female body is unreliable, grotesque, and out of the control of the person who inhabits it.

Scot recounts the story of Ade Davie, a woman plagued by guilt because she believed she had contracted with the devil and bewitched

her family (Scot 3.10.31–32). Her loving husband, upon hearing her confession, assured her that "none evil can happen to them that fear God," and prayed with her throughout the night when the devil was supposed to take her away. Around midnight "they heard a great rumbling below . . . which amazed them exceedingly, for they conceived that the devil was below, though he had no power to come up because of their fervent prayers." In the morning, the noise turned out to have been caused by a dog attacking a sheep carcass hung outside the house. Ade Davie was cured, "shamed of her imaginations, which she perceiveth to have grown through melancholy. God knoweth she had bewitched none, neither ensued there any hurt unto any, by her imagination, but unto herself." Ade Davie is as incompetent, though for different reasons, as the witches decried by the believers, and as needy of male regulation.

Earlier I claimed that the witchcraft debate is an instance of ideological collision. Two incompatible ideas about subjectivity — both of which are in some sense "available" to early modern Europeans — are forced by the terms of the debate into open competition. Ordinarily, "permeable" and "impermeable" models of the person seem to have attached to different structures of thinking and feeling, so their plausibility in particular situations depends heavily upon matters of context and decorum. The differences between them, in other words, are as much generic differences as anything else. In literature and in paraliterary forms such as saint's lives and travel narrative, the "permeable" subject typically inhabits the domain of romance, wonder, sexual fascination, and religious mysticism, creating those conundrums of inside and outside much loved of Elizabethan sonneteers:

> Leave lady in your glasse of christall clene,
> Your goodly selfe for evermore to vew:
> And in my selfe, my inward selfe I meane,
> Most lively lyke behold your semblant trew.
> (Edmund Spenser, *Amoretti*, 45)

Even as erotic love apparently arises from the depths of the enamored individual, those depths seem constituted by what has pierced them like an arrow, inscribed them like a pen, pressed upon them like a signet ring, or invaded them by stealth. Lover and beloved, image and truth,

"semblant" and reality interpenetrate in an imaginative union that pre-
dates and sometimes replaces a physical one.[9] Likewise, the religious be-
liever invites a divine encroachment likened by John Donne, in the *Holy
Sonnets*, to military invasion and rape; by George Herbert, in "The Altar,"
to a stonemason chiseling letters on stone; by virtually every preacher
of the period to "harrowing," the painful but salutary plowing of fur-
rows into the soil of the believer's heart. In both love and religious po-
etry the subject may be, in fact, initially "hard-hearted," difficult to
puncture.[10] His ultimate inability to resist may thus seem to testify to
the strength of the invading power as much as to the structure of his
consciousness. But this subjective toughness is a sign of sin in religious
poetry, immaturity in love poems. It must be overcome and mollified,
turned into a "good" vulnerability.

The affinities between the witch-hunter's dread and a lover's enthu-
siasm or a believer's piety may at first glance seem strange, but in fact
the former is merely a paranoid inflection of the latter. The witch-
hunter is terrified by a susceptibility that might in some circumstances
seem less threatening, even welcome or salutary. The trial scene in
Othello exemplifies the proximity. Brabantio accuses Othello of witch-
craft and Othello, with Desdemona's help, defends himself by making
Desdemona's desire for him seem the operation of ordinary *eros* rather
than of black arts: but ordinary *eros* works just the way witchcraft
would, by erasing the boundaries between persons and allowing Des-
demona to "see Othello's visage in his mind." The panic, bliss, and
yearning are all predicated upon a conviction that the boundaries be-
tween persons, and between the inside and outside of individuals, are
penetrable. This common underlying principle helps explain why
erotic experience, religious worship, and magical captivation so
routinely become metaphors for one another in Renaissance poetic
practice.

The skeptical or antimagical treatises, on the other hand, with their
resolute materialism, typically employ the reductive methods and as-
sumptions of satire: a genre that from time immemorial has operated by
uncovering a "base"—that is, bodily, this-worldly, self-interested, and
local—explanation for behaviors that pretend to be spiritual, transcen-
dent, altruistic, or universal. And like their counterparts in the romance
genres, the satirists can use the resemblances between related kinds of
pretension to segue from one kind of disparagement to another. In *Egre-
gious Impostures*, Samuel Harsnett employs a typical satiric technique

when he ridicules the possession of a young girl by what her Jesuit exorcists claimed were multitudes of demons: "[M]illions of devils, like herrings in a barrel, were packed up in Sara Williams" (51). Translating the ethereal substance of the devils into ludicrously material terms, he discredits not merely her possession but the religious claims of her Catholic exorcists. A priest places holy relics on the belly of a supposedly possessed man, but the victim confesses that he "was eased . . . by the bending of my body forward, which is cause of breaking of wind" (p. 263). The ejection of "evil spirits" is, in fact, merely a fart.

In Renaissance drama the difference between skeptic and believer is rather neatly encapsulated in the strikingly different way in which those perennially contrasted dramatists, Ben Jonson and William Shakespeare, use witchcraft and magic in their plays for the public theater. Shakespeare—whatever his now-irrecoverable attitudes toward "real-world" witchcraft and sorcery may have been—writes plays permeated by supernatural agency. Fairies, witches, ghosts, soothsayers, premonitory signs, and uncanny magical occurrences haunt his plays, from the early *Comedy of Errors* and *Henry VI* plays, through *Midsummer Night's Dream, Julius Caesar,* and *Hamlet,* to *Macbeth* and *The Tempest.*[11] *Macbeth* and *Lear* make it clear that Shakespeare read skeptical treatises by Scot and Harsnett attentively, and *Macbeth* foregrounds some of the crucial debates about the freedom of the will, optical illusion, and the extent of witches' power over the physical world, that were staples of treatises both for and against witchcraft. But whereas Shakespeare mines Scot for information, he ignores Scot's claim that witchcraft is impossible. The extent of the power of Shakespeare's witches in *Macbeth* is never entirely clear, but that they do possess power, if only the power of prophecy, is never in doubt. In *Midsummer Night's Dream,* the affinities between the Shakespearean dramatic subject and the self as conceived by witchcraft believers is even more vividly clear. Puck's exotic magical flower-juice invades the porous consciousness of its unwitting victims, producing an immediate and exorbitant effect—an effect that is, however, exactly the same as everyday sexual desire, which seems to well up spontaneously from the lovers' inner depths. The ridiculous permeability of Titania, Lysander, and Demetrius is the source of much of the play's comedy as well as the precondition for its eventually neat heterosexual coupling. Barry Weller notes that the effect is to dissolve clear boundaries between individual characters and to confuse their "reality status":

> [C]haracters which exist primarily as metaphors — the fairies, as an explanatory trope for both the disruption of nature and the irrationality of love, are the most accessible examples — may be mistaken for imitations of entities which have a visible and separate identity.[12]

In such a fluid dramatic universe, as Weller acknowledges, the difference between a "metaphor" and a "visible and separate identity" becomes entirely unclear: "Shakespeare's drama derives much of its power and continued vitality from inviting and even nourishing such misunderstanding." The "misunderstanding" here is structurally identical to the wittily deliberate confusion between original and mirror image in the Spenser sonnet quoted above, and to the less innocuous difficulty in distinguishing, in cases of suspected witchcraft, between what emanates from a victim and what ought to be ascribed to outside agency.

In contemporary critics of the play, this difficulty has, not surprisingly, produced a bifurcation. Some see the magical ministrations of Oberon as benevolently motivated and his victims as collaborating in and eventually welcoming their fates. Others see his applications of love-juice as rapes even more disturbing than the sexual violence to which Theseus alludes in the opening words of the play.[13] Actually, the "light" and "dark" readings of *Midsummer Night's Dream* have more in common than might at first be evident. They tend to make personal liberation, sexual consent, and the gratification of spontaneous desire ethically central — the first by applauding elements in the play that encourage such freedom, the second by deploring the ways in which that freedom is curtailed. But in fact, when personal boundaries and the difference between illusion and reality become as blurry as they are in *Midsummer Night's Dream*, the result is a crisis for the status of individual intention and consent, similar to the crisis of free will in *Malleus Maleficarum*. On one hand, a desire for freedom of sexual choice — a desire with which the audience is encouraged to sympathize — motivates the lovers' flight from Athens to the wood and sets the comic plot in motion. On the other hand, if doing something against one's will feels exactly the same as doing something according to one's will, then the status of "free choice" in sexual matters, and thus the difference between consensual and forced desire, eventually seems almost chimerical. Feminist critics have emphasized the way male authority figures in the play coerce the women — Hippolyta is a royal rape victim, torn by Theseus from the sisterhood of

the Amazons; Titania suffers a spousal brainwashing that forces her to break her promise to her votress. Helena laments the way "maturation" has shattered her previously tight and unproblematic bond with Hermia:

> O, is all forgot?
> All schooldays' friendship, childhood innocence?
> We, Hermia, like two artificial gods
> Have with our needles created both one flower,
> Both on one sampler, sitting on one cushion,
> Both warbling of one song, both in one key,
> As if our hands, our sides, voices, and minds
> Had been incorporate. (3.2.202−9)

Heterosexuality ruins female friendship and seems to diminish the importance of relationships among women. But Oberon's victims are not merely female (Titania) or lower-class (Bottom), but include the elite men Lysander and Demetrius. In fact, Demetrius must remain permanently "under the influence" in order for the characters to pair off neatly at the end of the play.

Love in *Midsummer Night's Dream*, for both men and women, is not a choice but a form of compulsion. Not coincidentally, the most grimly pessimistic reading of the play to date is by Laura Levine, a critic who has previously written perceptively about James I's *Daemonologie*.[14] Levine's reading shares the witch-hunter's fear of invasion without acknowledging that early modern culture gives an alternative, less paranoid account of such incursions in some other texts that lie behind *Midsummer Night's Dream*: in Petrarchan poetry, which complains bitterly about love's duress even while insisting that consummation is devoutly to be wished; in Neoplatonic treatises on the benign possibilities of musicoastrological influence; and in the literature of worship — specifically Paul's letter to the Corinthians, which Bottom bungles in his wondering attempt to describe his experience as the forced companion of Titania's bed.[15] These latter texts, too, are at times full of anxiety, but unlike the witchcraft treatises, they are full of elation as well. Happiness seems the effect not of successful self-assertion, of "getting one's way," but of submitting to forces beyond one's control. Self-loss is bliss not merely in *Midsummer Night's Dream* but in all the early modern texts that respond with excitement to the prospect of being overpowered.

Now, many feminists, myself included, regard invitations to such bliss with considerable suspicion, because for women, ideologies of self-loss have so often blinded us to our own interests. That *Midsummer Night's Dream* is a play about "equal-opportunity penetration" might not redeem its politics. Perhaps it is worth noting, however, that what's at issue here is not simply or primarily a question of female subordination, but a question about the very conditions in which both male and female subjectivity become possible.

Ben Jonson, like Shakespeare, read Scot and other witchcraft polemicists attentively. Voltore's possession, in *Volpone*, is a fake as theatrically extravagant and as venally motivated as anything in *The Discovery of Witchcraft*, complete with convulsing victim, vomited pins, and finally the spectacular eviction of an evil spirit: "See, where it flies!" cries Volpone, "In shape of a blue toad, with bat's wings!" (5.12.30–31). Subtle and Face's jargon-slinging in *The Alchemist* owes much to Scot's description of the way alchemists use incomprehensible terms of art "to astonish the simple":

> subliming, amalgaming, engluting, imbibing, incorporating, cementing, ritrination, terminations, mollifications, and indurations of bodies, matters combust and coagulate, ingots, tests, . . . waters corrosive and lincal, waters of albification, and waters rubifying . . . oils, ablutions, and metals fusible. Also their lamps, their urinals, discensories, sublimatories, alembics, viols, croslets, curcubits, stillatories, and their furnace of calcination; also their soft and subtle fires, some of wood, some of coal, composed specially of beech, etc. (14.1.204)

But unlike Shakespeare, Jonson is a legitimate heir to Scot's satiric skepticism and to the axioms that generate that skepticism. Like Scot's "witches" and their victims, Jonson's characters are isolated within the perimeters of their own defiantly material bodies; his comedy, as Gabriele Bernhard Jackson writes, is "the comedy of minds which never touch, of confinement within an insurmountable point of view."[16]

Jonson's satiric, antimagical conception of dramatic character has had consequences for the kind of things that have seemed possible to say about his plays and the characters within them. While Jonson, the author, has occasionally been subject to psychoanalytic criticism,[17] no one delves into the fictional psyche of Mosca, Truewit, Brainworm, or Bartholomew

Cokes as they do into Othello, Hamlet, Isabella, or Macbeth. Shakespeare's plays have proven a rich mine for psychoanalytic criticism ever since Freud and Ernest Jones, and many of the most trenchant insights of twentieth-century Shakespeare criticism are impossible to imagine without the stimulus of psychoanalysis. I don't think this is coincidental—*pace* Stanley Fish, I don't think that literary works merely submit to the tools of the analyst, but that they suggest likely instruments for their interpretation, if only by appealing in particularly importunate ways to roughly like-minded readers.[18] Whether or not psychoanalysis is "true," it's proven itself to be a fertile way to think about Shakespeare, and many critics in this tradition have speculated that somehow Shakespeare intuited the fundamental insights of Freudian theory: that, as James Calderwood puts it, psychoanalytic theory can enable the critic to describe "features of [his plays] that had in Shakespeare's time a local habitation but no name."[19]

Shakespeare's apparent prescience, I would argue, is due to the fact that the "magical" theory of the person overlaps in some crucial ways with Freud's. I do not, of course, wish to conflate contemporary psychoanalytic theory with beliefs in magic and witchcraft. Psychoanalysis provides a highly elaborate developmental account of the individual, whereas in the witchcraft treatises I have been discussing, the model of the human subject is not explicitly articulated. Moreover, the question of agency is settled differently by the psychoanalyst and the witch-hunter: What the psychoanalyst attributes to the unconscious mind of the suffering patient, to an "alien within," the witch-hunter blames upon the criminal activities of an outside perpetrator. To this extent, psychoanalysis aligns itself with the protopsychological strain of witchcraft skepticism rather than with witchcraft belief—indeed, Peter Swales has argued that Freud revised his original seduction theory of hysteria after reading the witchcraft skeptic Johann Weyer, an author he greatly admired.[20] This difference may also explain why psychoanalytic critics of Shakespeare typically convert his supernatural characters—the fairies in *Midsummer Night's Dream*, the ghost in *Hamlet*, the witches in *Macbeth*, Ariel in *The Tempest*—into allegories of the author's or the "real" protagonists' psychological processes.[21] What is (more or less) "outside" in the magical account is (more or less) "inside" in the psychoanalytic one, even granted that, as we have already seen, the magical model of selfhood renders these categories highly unstable.

Despite these differences, in its original Freudian form as well as in its multifarious offshoots, psychoanalytic theory has several key points of similarity with witchcraft belief. Like the witchcraft believer, the psychoanalyst is fascinated by psychosomatic illness, with ways that a primarily mental or spiritual condition finds expression through the body in symptoms variously construed as demonic possession, bewitchment, or the effects of neurosis. Like witchcraft belief, too, psychoanalysis construes the individual as an entity who is made, or who makes himself, largely by invasions or internalizations of the external world: the idealized mother, the punitive father, the good or bad breast, and so on. The psychoanalytic subject, especially in the privileged period of early childhood, is astonishingly permeable to outside influence—indeed, as Freud writes in *Civilization and Its Discontents*, the young infant "does not as yet distinguish his ego from the external world as the source of the sensations flowing in upon him . . . originally the ego includes everything, later it separates off an external world from itself." This separation process, however, is error-prone and fraught with difficulty:

> Pathology has made us acquainted with a great number of states in which the boundary lines between the ego and the external world become uncertain or in which they are actually drawn incorrectly. There are cases in which parts of a person's own body, even portions of his own mental life—his perceptions, thoughts, and feelings—, appear alien to him and as not belonging to his ego; there are other cases in which he ascribes to the external world things that clearly originate in his own ego and that ought to be acknowledged by it.[22]

As a result, Freud writes, the apparent autonomy and unity of the ego are illusory even in apparently healthy, well-adjusted individuals, a fragile boundary mechanism imposed between the external world, on one hand, and the unconscious, on the other. At the same time, research among "savages" and neurotics convinced Freud that human beings were naturally prone to a delusion he called "omnipotence of thought," the belief that "wishing makes it so," which he insists is fundamental to magical thinking. "[Man] turns his emotional cathexes into persons, he peoples the world with them and meets his internal mental processes again outside himself."[23] In other words, the individual, formed in the first place by processes of introjection, then sees the outer world in

terms of projection, as a mirror of the psyche. Although Freud focuses on phenomena alien to most readers—the customs of exotic tribes or the sufferings of the insane—his argument gets its punch from his insistence that these apparently outlandish cases provide the materials for a general theory of "normal" psychic functioning.

By contrast, Jonson's fascinating monsters of self-interest and blind inconsiderate need, as well as his less compelling virtuous characters, typically cannot be penetrated either to good effect or to bad. When they are delusional (which is often), their mistakes arise, like those of Weyer's melancholics, not from oversensitivity but from a gross lack of alertness to the external world. Jonson's staging of such impervious characters dovetails neatly with his interest in the effects of nascent urban capitalism upon individuals and social groups. For the Jonsonian dramatic character, like the Shakespearean one, has an inexact modern corollary— not the fragile, continually renegotiated subjectivity of psychoanalysis, but the person as construed by capitalist economics. The "capitalist" subject is firmly delimited, driven by self-interest and a desire for self-aggrandizement. Isolation, not an oceanic sense of union with the cosmos, is the original condition of this subject, who typically modifies that natural separateness by contract, barter, and other associations of mutual material advantage rather than by ties of emotion or tradition. Shakespeare, as many critics have noted, typically figures the transactions between theater company and audience in terms of imaginative substitution and surrogacy;[24] but Jonson figures the experiences of the public theater as an entrepreneurial drama of consumption, and casts the theatrical transaction—most overtly in the induction to *Bartholomew Fair* but also in his typically assertive prefaces—in essentially contractual terms.[25]

Early modern versions of such firmly bounded characters were almost invariably satiric, as they are in the "anti-acquisitive" Jonson.[26] But just as erotic and religious poetry gives a positive spin to the fragile self of the witchcraft treatises, so this latter form of selfhood can likewise be rendered more appealing. We see the effects of that transformed perspective in the contractualism of John Locke's *Second Treatise of Government*, in the self-reliant ingenuity of Daniel Defoe's *Robinson Crusoe*, or in Adam Smith's defense of individual self-interest in *The Wealth of Nations*. The most fertile ground for the antimagical theory of the self has been, by and large, not literature or literary criticism but, since the eighteenth century, the disciplines of economics, law, political science, and the natural sciences.

Partly because of this disciplinary division, Shakespeare has tended to seem central to the project of literary criticism while Jonson has typically seemed marginal or secondary. As Freud remarks in *Totem and Taboo*, in the modern world magical thinking has retained its power

> in only a single field . . . only in art does it still happen that a man who is consumed by desires performs something resembling the accomplishment of those desires and that what he does in play produces emotional effects—thanks to artistic illusion—just as though it were something real. People speak with justice of "the magic of art" and compare artists to magicians.[27]

It is not surprising, then, that those of us who concern ourselves with artistic phenomena should be drawn to theories that share elements of magical beliefs. Like our Renaissance predecessors, most of us are creatures of decorum, employing our varied models of subjectivity where they seem apt, without much bothering ourselves about consistency across discursive domains.

NOTES

1. I describe some of the disagreements in the introductory chapter of *Inwardness and Theater in the English Renaissance* (Chicago: University of Chicago Press, 1995). The present essay develops out of work I did in the course of writing that book. I have presented earlier versions at the Modern Language Association of America conference, the Shakespeare Association of America annual meeting, the CUNY Graduate Center, the University of Nevada at Reno, the University of Chicago, and the University of California-Berkeley. I thank the audiences at those events for their insights.

2. Witchcraft has produced a vast and fascinating scholarly literature; my list is meant to be merely representative of the many thought-provoking discussions of the topic. The full references are: Wallace Notestein, *A History of Witchcraft in England from 1558 to 1718* (Washington: American Historical Association, 1911); E. E. Evans-Pritchard, *Witchcraft, Oracles, and Magic among the Azande* (Oxford: Clarendon, 1937); Bronislaw Malinowski, *Magic, Science, and Religion and Other Essays* (Westport, CT: Greenwood Press, 1984); Alan Macfarlane, *Witchcraft in Tudor and Stuart England: A Regional and Comparative Study* (New York: Harper and Row, 1970); Keith Thomas, *Religion and the Decline of*

Magic (New York: Scribner, 1971); Christina Larner, *Witchcraft and Religion: The Politics of a Popular Belief* (Oxford: Basil Blackwell, 1984); Deborah Willis, *Malevolent Nurture: Witchhunting and Maternal Power in Early Modern England* (Ithaca: Cornell University Press, 1995); J. A. Sharpe, *Instruments of Darkness: Witchcraft in England 1550–1750* (New York: Penguin, 1996).

As for the skepticism of twentieth-century intellectuals, the exception that proves the rule is Montague Summers, the modern editor of *Malleus Maleficarum* and Reginald Scot's *Discovery of Witchcraft*. Summers believes that witches really did perform all kinds of malevolence under the devil's tutelage, that it was right to hang or burn them, and that they continue to wreak havoc in our midst today under the guise of Communism. He seems quite absurd.

3. Reginald Scot, *The Discovery of Witchcraft* (1584), ed. Montague Summers (London: John Rodker, 1930), 178, 173, 169. A list of the "believers" and "skeptics" I cite, and their availability in modern English-language editions, may be helpful. I list the date of the first publication, but readers should keep in mind that some of these treatises were very frequently reprinted: *Malleus Maleficarum,* for instance, went through thirty-four editions between 1486 and 1669. In the camp of "believers" I refer to: Heinrich Sprenger and Jakob Kramer, *Malleus Maleficarum* (orig. pub. 1486), trans. and ed. Montague Summers (New York: B. Blom, 1970); Jean Bodin, *De la demonomanie des sorciers* (orig. pub. 1580), trans. and abridged by Randy A. Scott, *On the Demon-mania of Witches* (Toronto: Centre for Reformation and Renaissance Studies, 1995); William Perkins, *A Discourse of the Damned Art of Witchcraft* (London, 1610); John Cotta, *The triall of witchcraft, shewing the true method of the discovery* (London, 1616); James VI of Scotland (later James I of England), *Daemonologie* (orig. pub. 1597; facsimile reprint, New York: Da Capo Press, 1969). In the camp of skeptics, qualified or complete, in addition to Scot (cited earlier in this note), are Johann Weyer, *De praestigiis daemonum* (1563), translated as *Witches, Devils, and Doctors in the Renaissance,* ed. George Mara et al. (Binghamton: Medieval and Renaissance Texts and Studies, 1991); Samuel Harsnett, *A discovery of the fraudulent practises of J. Darrel* (London, 1599) and *A declaration of egregious popish impostures* (London, 1603); and Edward Jorden, *A briefe discourse of a disease called the suffocation of the mother* (London, 1603).

4. In this essay I shall use the term *skeptic* to refer to those writers who express disbelief in witchcraft or magic. Their position does not necessarily correlate with other forms of skepticism (about the origins of sense impressions, about other minds, etc.).

5. I shall refer to Sprenger and Kramer's *Malleus Maleficarum,* Weyer's *De praestigiis daemonum,* and Scot's *The Discovery of Witchcraft* in the twentieth-century editions cited above, modernizing spelling myself when the editor has

not already done so. In the citations, the first two numbers refer to book and chapter numbers, the last to page number; thus someone using other editions can find the quoted passage easily.

6. The biblical story of Laban's sheep leads Scot reluctantly to admit that a mother's imagination may affect the appearance of a child within the womb. Otherwise, the process only works the other way.

7. For the charge of Saduceeism, see, for example, James I, *Daemonologie*, 2; for a modern echo, see Montague Summers' 1930 introduction to *The Discovery of Witchcraft*. Sydney Anglo argues persuasively that even though Scot denies the charge, Saducceeist conclusions seem inescapable given his premises ("Reginald Scot's *Discovery of Witchcraft*: Skepticism and Saduceeism," in *The Damned Art: Essays in the Literature of Witchcraft* (London: Routledge and Kegan Paul, 1977), 106–39.

8. Scot 15.3.206–7; Weyer, 5.15.408–9; Harsnett *passim*.

9. Hence Joan Couliano, *Eros and Magic in the Renaissance* (Chicago: University of Chicago Press, 1987), provocatively identifies the psychological processes of *eros*, as described in the Petrarchan poetic tradition, with Neoplatonic dreams of magical manipulation of other people, an identification that he traces to Giordano Bruno's *De vinculis*.

10. I owe this observation to Richard Strier.

11. The most thorough recent discussion of Shakespeare's persistent interest in sorcery, witchcraft, and the supernatural is Linda Woodbridge's *The Scythe of Saturn: Shakespeare and Magical Thinking* (Urbana: University of Illinois Press, 1994). Stephen Greenblatt likewise argues for the seriousness of Shakespeare's engagement with magical beliefs in "Shakespeare Bewitched," in *Shakespeare and Cultural Traditions,* ed. Tetsuo Kishi, Roger Pringle, and Stanley Wells, (Newark: University of Delaware Press, 1994), 17–42.

12. Barry Weller, "Identity Disfigured in *A Midsummer Night's Dream*," *Kenyon Review* 7 (1985), 66–78, 77.

13. For a classic example of the first view, see C. L. Barber, "May Games and Metamorphoses on a Midsummer Night," in *Shakespeare's Festive Comedy* (Princeton: Princeton University Press, 1959), 119–62; for an especially uncompromising, clearly argued example of the second, see Laura Levine, "Rape, Repetition, and Closure in *A Midsummer Night's Dream,*" in *Feminist Readings of Early Modern Culture: Emerging Subjects*, ed. Valerie Traub, M. Lindsay Kaplan, and Dympna Callaghan (Cambridge: Cambridge University Press, 1996), 210–28.

14. Laura Levine, *Men in Women's Clothing: Antitheatricality and Effeminization 1579–1642* (Cambridge: Cambridge University Press, 1994), 108–33.

15. For the Neoplatonic strain in *Midsummer Night's Dream* and its literary-historical background, see Richard Cody, *The Landscape of the Mind: Pastoralism*

and Platonic Theory in Tasso's Aminta and Shakespeare's Early Comedies (Oxford: Clarendon, 1969). Gary Tomlinson suggestively describes the way Ficino's music theory encourages "the spirit's and the soul's receptivity to beneficial influences from the stars" in *Music in Renaissance Magic: Toward a Historiography of Others* (Chicago: University of Chicago Press, 1993), esp. "Musical Possession and Musical Soul Loss," 145–88.

16. Gabriele Bernhard Jackson, Introduction to *Ben Jonson: Every Man in His Humour* (New Haven: Yale University Press, 1969), 21. Jonson's "skepticism," it is worth adding, is confined to his plays for the public theater. In *The Masque of Queens, Mercury Vindicated from the Alchemists at Court, Oberon,* and other court entertainments, magic rules; and the notes to *The Masque of Queens* are important for indicating Jonson's wide acquaintance with witchcraft literature. I suggest some reasons for the difference in outlook in plays and masques in "Satiric and Ideal Economies in the Jonsonian Imagination," *English Literary Renaissance* 19 (1989), 26–49, and *Ben Jonson and the Roman Frame of Mind* (Princeton: Princeton University Press, 1985), 102–10.

17. Examples of psychoanalytic accounts of Ben Jonson include Edmund Wilson, "Morose Ben Jonson," in *The Triple Thinkers* (New York: Harcourt Brace, 1938); Elihu Pearlman, "Ben Jonson: An Anatomy," *English Literary Renaissance* 9 (1979), 364–94; and David Riggs, *Ben Jonson: A Life* (Cambridge: Harvard University Press, 1989). In *Ben Jonson and the Roman Frame of Mind,* I argued that Jonson's conceptions of dramatic character and of comic form differ from many modern readers', because he inherits from Roman moral philosophy assumptions about sexual desire and social life incompatible with the assumptions of literary critics who work in the philosophical tradition of Plato, Augustine, and Freud. I still believe this general account to be true, but in this essay I am more interested in Jonson's historically immediate context than in his remoter literary ancestors.

18. Stanley Fish claims that "interpretive strategies . . . give texts their shape, making them rather than, as is usually assumed, arising from them." *Is There a Text in This Class? The Authority of Interpretive Communities* (Cambridge: Cambridge University Press, 1980), 13.

19. James Calderwood, *A Midsummer Night's Dream* (London: Harvester Wheatsheaf, 1992), 2.

20. Freud originally held that female hysterics had been sexually abused by their fathers; in a famous, controversial revision, he claimed that these paternal seductions were fantasized by the daughters and represented repressed wishes. Peter Swales' essay "Freud, Johann Weier, and the Status of Seduction: The Role of the Witch in the Conception of Fantasy" is summarized and cited in the introduction to the English translation of Weyer cited above, but the essay itself was privately printed in 1982, and I have been unable to acquire a copy.

21. For examples of this phenomenon see, for instance, Janet Adelman, *Suffocating Mothers: Fantasies of Maternal Origin in Shakespeare's Plays, Hamlet to the Tempest* (New York: Routledge, 1992); Meredith Skura, *Shakespeare the Actor and the Purpose of Playing* (Chicago: University of Chicago Press, 1993); C. L. Barber and Richard Wheeler, *The Whole Journey: Shakespeare's Power of Development* (Berkeley: University of California Press, 1986).

22. Sigmund Freud, *Civilization and Its Discontents,* trans. James Strachey (New York: W. W. Norton, 1961), 15, 13.

23. Freud, *Totem and Taboo: Some Points of Agreement between the Mental Lives of Savages and Neurotics,* trans. James Strachey (New York: W. W. Norton, 1950), 92.

24. David Marshall thus suggests that *Midsummer Night's Dream* is preoccupied with "problems of representation and figuration: not only whether the play can be staged but also what it means to present a vision or image to someone else's mind, to ask another person to see with one's eyes, to become a spectator to someone else's vision" ("Exchanging Visions: Reading *A Midsummer Night's Dream,*" *ELH* 49 [1982]: 543–75, 546–47). And Garret Stewart argues for an analogy between dream and Shakespearean drama: "[T]he surrogate or symbolic selves that people our dreams as well as the actors who board our stages undergo the very experiences from which we as spectators benefit as if such experiences were ours" ("Shakespearean Dreamplay," *English Literary Renaissance* 11 [1981], 44–69, 52).

25. For the deep significance of emergent contractual thinking on Jonson's plays, see Luke Wilson, *Agencies and Artifacts,* forthcoming.

26. The phrase is L. C. Knights' in *Drama and Society in the Age of Jonson* (London: Chatto and Windus, 1937).

27. *Totem and Taboo,* 90.

LEGACIES

MARGRETA DE GRAZIA

WEEPING FOR HECUBA

"Stand and unfold yourself," the sentinel commands the cloaked figure approaching on the bitterly cold battlements.[1] The same might have been commanded of Hamlet when he first enters at the court nuptials, inappropriately dressed in a dark cloak.[2] He, too, appears to be concealing something. But what Hamlet conceals cannot, like a hidden weapon, be brandished: "I have that within which passes show" (1.1.85). The grief he bears cannot be externalized because it is in excess of all customary "forms, moods, shapes" (1.1.82). Instead it must remain fast within: "Break, my heart, for I must hold my tongue" (1.1.159), inaccessible to the prying Gertrude and Claudius as well as to generations of querying critics. And yet there is a scene in which Hamlet does give vent to his grief, not only openly but flamboyantly. He not only speaks, he overspeaks; even the deferential Horatio bids him "be quiet" (5.1.260). He not only acts, he overacts; his mother apologizes for his intemperance, and so later will he.

The occasion for this display of grief is Ophelia's burial. After her body has been lowered into the grave and as the sexton is about to shovel earth over her, Laertes leaps into the pit, declares his wish to be buried alive with her, and calls down over them a mountain of dust higher than Olympus:

> Now pile your dust upon the quick and dead
> Till of this flat a mountain you have made

T' o'ertop old Pelion or the skyish head
Of blue Olympus. (5.1.244–47)

Challenged by Laertes' outburst, Hamlet, thought to be dead or in England, stands and unfolds himself, "This is I, / Hamlet the Dane" (5.1.250–51). Provoked by what he takes to be Laertes' attempt to "outface" him (273), he swears to do (or outdo) whatever Laertes does: "What wilt thou do for her? . . . show me what thou't do . . . I'll do't" (5.1.266–72). Laertes leaps into the grave, and Hamlet follows him: "Be buried quick with her, and so will I" (5.1.274).[3] Laertes has "prate[d] of mountains (5.1.275)," and Hamlet echoes him, invoking a still bigger mound over the grave, reaching not just to the Olympian summit but to the burning zone of the sun, a land mass so high it would outscale Laertes' mound, reducing it from a peak on the surface of the earth to a bump on the surface of the skin, from a mountain to a "wart":

> let them throw
> Millions of acres on us, till our ground,
> Singeing his pate against the burning zone,
> Make Ossa like a wart. (5.1.275–78)

The play, then, features two scenes in which Hamlet draws attention to his grief. One occurs after his father's funeral, the other at Ophelia's burial. In the one, he keeps his cloak on and conceals his grief; in the other, he flings off his cloak and declaims his grief. Although it would seem that their common emphasis on grief would draw these scenes together, there is no critical tradition for pairing them. The first scene is key to all modern readings of Hamlet's character; no analysis of Hamlet's interiority, individuality, or subjectivity can do without the "within" (1.2.85) he there withholds. The second scene, however, is largely ignored, despite the fact that it features Hamlet's one and only assertion of his royal identity: "This is I, Hamlet the Dane." This makes it all the more remarkable that when the outburst is discussed, it is only to disclaim it as a psychological aberration, much as Hamlet disclaims it, both to Horatio—"I forgot myself" (5.2.76)—and, more extravagantly, to Laertes, "Hamlet does it not, Hamlet denies it. / Who does it then? His madness" (232–33). In short, one scene has been found in character, the other out of character. Yet why have the two not been seen as complementary, one of grief held in, the other of grief let out? Why has a critical

tradition so intent on locating what is "within" Hamlet not noticed the scene in which he puts it on full display?

In this century's most influential interpretation of *Hamlet*, the nature of Hamlet's grief is not only inexpressible; it is unknowable, even to Hamlet himself. What Hamlet cannot know is that the death of his father has caused him to feel not only grief but guilt. His father's loss has stirred up in him the repressed memories of the desires Freud named after Oedipus: the parricidal and incestuous desires felt in infancy and repressed thereafter.[4] It is the guilt Hamlet feels at the inchoate memory of his own desire to kill his father that prevents him from killing the man who actually had done so. After Freud, Hamlet ceased to be the hero identified with Romantic introspection or Hegelian self-consciousness, for neither form of self-reflexivity could access the very area that explained his character. As Freud noted, by locating the cause of Hamlet's problem in the unconscious, he could explain what other interpretations could not even address: why a character of Hamlet's insight was unable to discern within himself the reason for his own delay. The answer set new limits on the reaches of consciousness: the psyche could not know its own innermost workings.[5] Hamlet needed Freud to illuminate the obscure region necessarily concealed "within," and Freud met that need: "I have here translated into consciousness what *had to remain* unconscious in the mind of the hero" (italics mine).[6]

According to Freud, Hamlet's inner workings remained concealed not only from Hamlet but from everyone who had experienced the play during the three hundred years between Shakespeare's writing and Freud's reading. Until Freud discovered the Oedipal complex, the cause of Hamlet's inhibiting guilt could not be known. How was it, then, that Shakespeare in 1600 was able to dramatize what was not known until 1900? In the letter of October 15, 1897, in which he first makes the connection between unconscious repression and Hamlet's delay, Freud himself puzzles over the anachronism, wondering if "[s]ome real event" in Shakespeare's life had not precipitated his dramatization of Hamlet's unconscious.[7] By the time the theory was published in *The Interpretation of Dreams* (1900), he had discovered what that "real event" was. In a recent book on Shakespeare, he found "that the drama was composed immediately after the death of Shakespeare's father."[8] Shakespeare "was still mourning his loss" and experiencing "a revival, as we may fairly assume, of his own childish feelings in respect of his father." As Hamlet could not have

known why he behaved as he did, so too Shakespeare could not have known why he wrote what he wrote. His unconscious troubled its way into that of his character. As Freud concludes several years later (1908), Shakespeare himself at this time had been grieving his father's death, "the most important event, the most poignant loss of a man's life."[9] What Hamlet, Shakespeare, and Freud have in common, then, is the death of fathers: "[y]our father lost a father, / That father lost, lost his" (1.2.89–90). As Claudius insists, this is the "common theme"(103), and one to which both Shakespeare and Freud gave very particular attention.

As Freud noted, he found the connection between the death of Shakespeare's father and his writing of *Hamlet* in a book on Shakespeare written by George Brandes and published in 1896.[10] In his highly acclaimed *William Shakespeare: A Critical Study*, Brandes began his discussion of *Hamlet* by stating that Shakespeare suffered a great loss in 1601. He determines this from an entry in the Stratford Parish Register of burials for 1601: "Septem. i. Mr. Johannes Shakespeare." Also relevant, he claims, was an earlier entry from 1596: "August 11, Hamnet filius William Shakespeare" (342). Brandes concludes that as a result of his father's death, compounded by the earlier death of his son, "the fundamental relation between son and father preoccupied [Shakespeare's] thought, and he fell to brooding over filial love and filial reverence. In the same year *Hamlet* began to take shape in Shakespeare's imagination."[11] By aligning these documents with the roughly contemporaneous play, Brandes infers Shakespeare's state of mind. With the same materials, Freud probes further, into the "deepest stratum of impulses" (311), and finds the Oedipal source of Shakespeare's famously faltering character.

Freud ignores, however, another bit of documentary evidence that Brandes had used to connect Shakespeare to his writing of *Hamlet*. A purchase deed records that "[i]n 1602 he buys, at Stratford, arable land of the value of no less than L320, and pays L60 for a house and a piece of ground" (155). The deed provides another point of entry for Shakespeare's personal life, through not the grieving son Hamlet but rather the anonymous "fellow" whose skull Hamlet takes up in the churchyard: "We see that he may very well have been thinking of himself when he makes Hamlet (5.1) say beside Ophelia's grave: 'This fellow might be in 's time a great buyer of land, with his statutes, his recognizances, his fines, his double vouchers, his recoveries'" (155–56). Brandes mentions other documents recording Shakespeare's purchase of

the real estate that made him "one of the largest and richest landowners in his native place." Had these deeds not surfaced, Brandes concludes, Shakespeare's preoccupation with property would have remained not only unknown, but unimaginable: "[T]hey give us [insight] into a region of Shakespeare's soul, the existence of which, in their absence, we should never have divined" (155).

While Freud builds on Brandes' application of one kind of document, he makes no mention of the other. While he sees "the deepest stratum" of Shakespeare's psychic life in the record of his father's burial, he shows no interest in what might have been "divined" from the deeds of his property transactions. Freud's disregard for the second kind of document may cast some light on the puzzle with which this essay opened: Why has the land-crazed expression of grief in the graveyard not been seen in relation to Hamlet's deeply internalized mourning at court? In what follows, I will be proposing that there is indeed a direct connection between the burial plot of the parish register and the real estate plots of the deeds of trust. Both are basic to the "common theme" of the death of fathers. Freud may have been more historical than he knew in emphasizing a theme that Romanticism largely effaced by abstracting Hamlet's consciousness from parental or generational relations. Yet Freud's reading of generational transition gives no thought to the very patronymic and patrimony that Shakespeare appears to have deliberately introduced in his rewriting of Saxo and Belleforest.[12] He cannot see, therefore, that the death of Hamlet's father is in an important respect *un*common. Commonly the death of a highborn father is attended by the passing down of property and title. But Hamlet is left with nothing but his father's proper name. His father's death is common in the sense Hamlet puts into play: "Ay, madam, it is common"; like that of a commoner without rank and property, it leaves the son empty-handed. I will be claiming that Hamlet's grief cannot be understood without a sensitivity to what he has lost. The high hysterics and histrionics over Ophelia's body and the clay pit, I will argue, provide the highly material terms of Hamlet's bereavement.

From beginning to end, what has become known as the "graveyard scene" focuses on land. The sexton's entrance with groundbreaking tools—spade and pickaxe—signals that the wood of the stage floor is to represent earth to be broken.[13] Correspondingly, the open trap in the stage floor is to stand for a hole in that ground. The digging of the sexton keeps earth in view

throughout this scene, particularly the "pit of clay" (5.1.94), which is also the subject of his song. Upon entering, every character gravitates toward the pit and all of them eventually end up clustered around it for the burial service. The sexton steps in and out of the grave in the process of making it; the corpse is lowered into it; the two young men leap in and scramble out. As space is organized around the clay pit, so too is time. The scene lasts as long as it takes to prepare a grave and inter a body, beginning with the sexton's instruction to "make her grave straight" (5.1.3) or in alignment with the church altar, continuing with Laertes' charge to "Lay her i'th'earth" (5.1.231), and ending with the King's promise, "This grave shall have a living monument" (5.1.292).[14]

That a scene in a graveyard preparing for a burial should be concerned with earth is not surprising. The Bible, last wills and testaments, and the burial service all refer to death as the body's return to the element from which it originated, what Hamlet terms the "fine revolution" (5.1.89), the final return of earth to earth, ashes to ashes, dust to dust. What is surprising, however, is that issues of entitlement should arise around this little "pit of clay." The sexton's opening question about the location of the grave — "Is she to be buried in Christian burial?" (5.1.1) — is also a question about the jurisdiction of church land. The decision to bury the body in the sanctified ground within the churchyard has been reached, it appears, only after a debate between the Crown and the Church. The Crown claimed that the body should be laid to rest in "Christian burial," within the sanctified churchyard; the Church, deeming the cause of death "doubtful" (5.1.220), insisted it be buried "out" of Christian burial, in what Q1 calls "the open fieldes."[15] The "crowner" (5.1.4) determined the case in the favor of the Crown, from whom he derived both his name and magistracy. The dispute, while settled by the inquest, raises the question of who presides over church lands. After Henry VIII's confiscation of church property, the answer was not obvious.[16] Did canon law or statute law determine who received the benefit of interment in sanctified ground? In this instance, it appears that the Church's instructions were overruled by the Crown. As the priest presiding over the burial begrudgingly concedes to Laertes, "great command o'ersways the order" (5.1.221), an opposition which appears more starkly in Q1: "And but for fauour of the king, and you, / She had been buried in the open fieldes."

The issue of entitlement comes up again, in relation to the grave plot rather than the yard entire, in Hamlet's first question to the sexton,

"Whose grave's this, sirrah?" (5.1.115−16). The sexton takes the question to be about ownership rather than interment. Since the sexton stands in the grave as he digs it out, he owns it by right of occupancy: "Mine, sir" (5.1.117). His misunderstanding of Hamlet's question is in keeping with the numerous quips and sallies by which he has asserted his dominion over the churchyard. The name by which he is addressed, "Goodman Delver" (5.1.14), designates a relation to the earth in which he takes great pride.[17] Those who work the soil — gardeners, ditchers, and grave makers — trace their lineage back to Adam, "the first that ever bore arms" (5.1.33) and therefore the most "ancient gentlemen" (5.1.29−30). The "arms" borne by the peasant are the tools with which they dig. They serve as weapons with which to fight, as they indeed did serve during the various peasant uprisings of the period. The spade or shovel also relates to symbolic coats of arms, providing the shape of the shield or escutcheon on which the armorial bearings were emblazoned.[18] The right to bear both types of arms — military and heraldic — was once limited to those holding land. After boasting of his ancient lineage, Delver certainly uses his "dirty shovel" (5.1.100) as a weapon. The stage direction in Q1 has him flinging it up out of the pit just as Hamlet approaches it ("he throwes up a shouel," H4r). As Hamlet anxiously remarks, the sexton uses it to "jowl" skulls to the ground (5.1.75) ("joles their heads against the earth," Q1), knocking them upon their "mazards" (5.1.88) and sconces (5.1.100), assaulting them to the point of liability or "action of battery" (5.1.101). That he targets the head in particular suggests that his aggression is aimed at his social superiors, as if he would give them their comeuppance, particularly the court jester, who had once put him down by pouring a flagon of Rhenish on his head.[19] As lord of the cemeterial domain, the sexton exercises his proprietary right to dispose of his land at will. He admits "tenants" (5.1.44) and makes "houses" (5.1.59) to receive the dead in "the bringing home / Of bell and burial" (5.1.226−27), what the sexton in Q1 refers to as "the long home" (H4r), the traditional phrase for the resting place of death derived from Ecclesiastes 12:5. Though he boasts that his "houses" will last till the end of time, the residency of his tenants seems quite short-term. In clearing out one grave in order to make room for the latest arrival, former residents are evicted from their acreage, more like "guests" (5.1.95) than "tenants," disinterred from their sacred plots as they would be dispossessed of their landed estate.

Hamlet, returning from his voyage at sea and still wearing his "sea-gown," ends up joining the sexton on the terra firma of the burial ground.

The graveyard setting prompts what has always been recognized as a meditation on the vanity of all earthly things. What has not been noted, however, is the extent to which Hamlet's renunciation of earthly things concentrates on earth itself. Unlike the *vanitas* paintings that feature a full array of vanities — paintings, musical instruments, coins, jewelry, goblets, books — this *contemptus mundi* is limited to the desire for dominion, what would have been symbolized by the globe or map. The worldly figures held in contempt are not only great world conquerors such as Alexander and Caesar but lesser landlords, those of "some estate" (5.1.214) now residing in the churchyard. Hamlet imagines that the exhumed skulls belonged to lords and ladies like "Lord Such-a-one" (5.1.84) and "Lady Worm" (5.1.87). He considers one well-born skull after another until he comes upon one that might have been a lawyer, possessing the arguments, instruments, and suits to defend the acquiring and holding of property. There is such a close connection between the law and the land whose tenure it was instituted to secure and protect that Hamlet's speculation slips seamlessly from the lawyer to a landlord, "a great buyer of land" (5.1.102). Most probably, the lawyer has become a landlord through his manipulation of legal mechanisms and machinations; "his statutes, his recognizances, his fines, his double vouchers, his recoveries" (5.1.102–4) work in place of lineage to make him "an inheritor" (110). In the end, all that is left of his land is the dust in his cranium, a "fine pate full of fine dirt" (5.1.105–6), and the small stretch of land covered by his shrinking body, no bigger than the box filled by the disintegrating "parchment" (5.1.112) deeds of trust that once secured his vast holdings.

Hamlet's meditation enlarges from local domain to global dominion when he considers those who obtained land not through the right of the law but through the might of conquest. Emperors who were in life as grand as the extent of their empires are in death reduced to infinitesimal particles of the continents they once owned. Alexander, whose conquests extended across three continents, amounts to no more than "noble dust" (5.1.197–98). Caesar, "that earth which kept the world in awe" (5.1.208), shrinks to a piece of loam with which to mend a wall. Whether ancient emperors or modern landlords, men enlarge themselves with land in life, only to dwindle in death to earthy bits and pieces. Tenants who once held land are now held by the land, "clawed" (Q2) or "caught" (F) in death's "clutch" (5.1.71), snatched by the grave represented onstage by the trap.

In his appearances before and after the graveyard scene, Hamlet is similarly preoccupied with examples of territorial transfer, one on the model of Caesar and Alexander, the other on that of the lawyer and landowner. As Hamlet leaves Denmark at the end of act 4 (in Q2), the Norwegian troops have landed. The army is led by the same prince who at the start of the play threatened to invade Denmark in order to recover lands lost by his father long ago. He now enters not to conquer Danish land but to cross it, having asked for permission to march peacefully through Danish "dominions" (2.2.78) and received it (4.4.1–4). His army is headed for Poland to fight not for "the main" (4.4.15) of Poland and not for its "frontier" (4.4.16), but rather for "a little patch of ground" (4.4.118) smaller than the grave plot that will be needed to contain the bodies of those who will die fighting for it. When Hamlet appears after the graveyard scene, he encounters the domestic counterpart to the imperially ambitious Fortinbras. The courtier Osric, a "Bragart Gentleman" in the stage directions of Q1 (I2r), has enlarged himself through purchase of "much land and fertile" (5.2.86); he has grown "spacious in the possession of dirt" (5.2.88–89). Indeed, his inflated rhetoric, grandiose gestures, and extensive headgear all express a desire to expand himself still further.[20] At the same time, his outlandish manner indicates how recently landed he is. He is "water-fly" (5.2.82–83), belonging by nature to the elements of water and air, not earth. Recently landed, he has not mastered the manners of those who are born to the manor and makes good sport for someone like Hamlet, who was, and someone like Horatio, who was not (he has "no revenue . . . but [his] good spirits" [3.2.58]), yet has no aspirations but to serve his lord.

As in the graveyard, Hamlet in these two encounters derides the desire for land, finding a "fantasy" in Fortinbras's imperial ambitions and "bubbles" in Osric's courtly pretensions. The *contemptus mundi* of the graveyard is thus framed by additional renunciations of dominion and domain. Men make themselves great in life through acquisitions of land by birth, law, money, and arms. But this desire for self-aggrandizement repeatedly finds its end in dust, reduced either to the small stretch of burial ground coterminous with the dead body or to the infinitesimal particles of that very element that in varying measures was once the object of desire. That man should end up earth is familiar from a biblical tradition whose first man is named "clay" (Adam for *adamah*, "soil, clay"), who is born out of the earth which after sin he must work before dying back into it. But the human/*humus* connection has particular relevance to

a system in which property and proper names are synonymous: *Denmark* names both king and kingdom, *house* names both estate and family line, *manor/manner* refers to both landed property and the defining property of its occupants, *court* to both royal residence and its attendants, and *groundling* to persons who stand on the ground (for a penny and temporarily).

Looming large over the graveyard *contemptus mundi* is the event that would require the giving up of the world itself, at least the terrestrial world. Interment was to prepare the body ultimately for the end of the world: corpses were laid to rest with their heads to the west so that they might rise at Judgment Day with "face to the east."[21] Doomsday is specifically invoked both in the sexton's boast that his graves will last until then and in the priest's judgment that Ophelia's body should have "in ground unsanctified been lodg'd / Till the last trumpet" (5.1.222–33). As the burial service promises, that final blast would signal the final transformation of corruptible flesh to incorruptible spirit and of terrestrial world to celestial kingdom. Doomsday has a more pervasive relevance, however, in this graveyard in which land and landholding figure so prominently. One of the great institutions of English history, the Domesday Book, fixed the relation between the end of the world and the lay of the land. The Domesday Book, the great survey made by William the Conqueror shortly after the Norman Conquest, determined the extent, value, ownership, and occupancy of all the land of England. It constituted a legal record that continued to be consulted in property disputes and settlements throughout the Middle Ages and the early modern period.[22] The book was named after Doomsday in order to confer the finality and irrevocability of the upcoming event upon its record of property holdings throughout the realm.[23] But, as we have seen, the graveyard scene unsettles the status quo by putting earth in motion, whether in the form of the upturned earth of the grave, the transferral of properties, or the shifting continents of empire. In this respect, it is more in keeping with the radical millenarian belief extending from the Middle Ages to well into the seventeenth century that Christ's Second Coming would establish a messianic kingdom on earth lasting a thousand years, in which all property would be held in common until the final reckoning of Judgment Day.[24]

The sexton's subversive digging and Hamlet's curious considering together emphasize the alienability of land. The one form of property thought to be "real" because immobile, and therefore the most stable

basis for both personal identity and social organization, will not stay in place. The earth of which graves, plots, estates, countries, and empires are made is in motion, more like the fluctuating sea, whose constant movement precluded its territorialization and lent itself so readily to the piratical plundering of the likes of the seafaring pirates who take Hamlet hostage. The dominant topic of the graveyard scene, what might be termed its topographical topos, is *Sic transit gloria mundi*—the transience of earthly things (what Q1 terms a "pittiful transformance," Iv) illustrated by transfers of property, translations of empire, and transformations or "fine revolutions" undergone by the dead body as it returns to dust, a process from *caro* to *vermis* to *pulvis* represented by mortuary sculpture called *transi*.[25]

In the graveyard scene, amidst so many instances of things passing, it is surprising that no mention is made of the man whose "passing through nature to eternity" (1.2.73) featured so prominently at the start of the play. At the burial place, before so many signs of the reduction of humans to *humus*, of dust to dust, one might expect some word of "the majesty of buried Denmark" (1.1.51). It is true, of course, that Hamlet's royal father was "quietly inurn'd" (1.4.49) within the church proper rather than buried in the open churchyard. All the same, Hamlet's curious consideration seems initially to be moving in his direction when the first skull he contemplates brings to mind "Cain's jawbone, that did the first murder" (5.1.76) and set the precedent for "a brother's murder" (3.3.37). So, too, he touches upon his father's world when he imagines the skulls were once those of court figures and learns that one was his father's own court jester. At the play's opening, Hamlet's mother had urged against such morbid speculation: "Do not for ever with thy vailed lids / Seek for thy noble father in the dust" (1.2.70–71). If Hamlet is doing any such seeking here, however, he has substituted the "noble dust of Alexander" (5.1.197–98) for that of his own "noble father."[26]

Although Hamlet makes no mention of his father in this scene, the sexton does, in telling Hamlet how long he has been grave maker: ever since "that day that our last King Hamlet o'ercame Fortinbras" (5.1. 139–40), "that very day that young Hamlet was born" (5.1.143). Neither those lands acquired at his birth nor the Danish realm itself has passed to him at his father's death. Only his father's name remains as Hamlet's birthright; the title and entitlement that traditionally attend the patronymic have gone elsewhere. I will be suggesting that *Hamlet* dramatizes

the difficulty of mourning a father who did not make good the promise of the patronymic. The merely nominal connection between deceased father and surviving son troubles the transition at death from one to the other. In Denmark's elective monarchy, filial succession is not automatic, as it is in an absolute monarchy, but requires parliamentary backing. Hamlet, the "sole son" (3.3.77) of the king, does not inherit his title, king, nor his estate, the kingdom. Until Claudius's ascension, the expectation appears to have been that young Hamlet would succeed old Hamlet. His birth on the day of Denmark's territorial expansion was certainly auspicious, and he seems to have been generally regarded as the next in line: "Th' expectancy and rose of the fair state" (3.1.154). Upon his father's death, however, he lacks what he does not receive until, ironically, his uncle is made king. No sooner does Claudius ascend the throne than he publicly proclaims his newly adopted son "the most immediate to our throne" (1.2.109; 3.2.332–33). By this proviso, Hamlet becomes de facto king for the brief interval between Claudius's death and his own. In that short period of about thirty lines, he manages to do what his father apparently failed to do during his thirty-year reign: give his voice for the succession, even as the lethal poison runs through his system.

A constitutional form that does not guarantee patrilineal inheritance gives an odd twist to "the common theme" of the death of fathers in England where patrilineal descent was considered to have existed since time immemorial.[27] In Hamlet's case, the father's domain does not pass to the son, nor do the other patrinomial bearers of lineage. Indeed his father takes the most significant ancestral object to the grave with him.[28] As is noted within the play repeatedly, the ghost appears in armor: armed "from head to foot" (1.2.228), "my father's spirit—in arms" (1.2.255). Theatrical ghosts, however, tended to appear in winding sheets, like the "sheeted dead" (1.1.118) that gibbered in the Roman streets.[29] In the *Spanish Tragedy*, the Ghost of Don Andrea does return in arms because he died on the battlefield and must await the proper burial ritual before passing to the underworld. Hamlet's father, however, died napping in the garden; although his soul was unprepared for God, his body was accorded a proper burial, "quietly inurn'd." Why, then, does he return brandishing the arms which should have been placed over his tomb and then passed on to the son? That the son may have had use for those arms is suggested when he returns to Danish soil without an army and unarmed—"alone," as he writes to Claudius, and "naked on your kingdom" (4.7.42), a detail Claudius incredulously repeats: "'Naked'" (4.7.50). Fortinbras, true to his name,

twice appears armed and with an army on Danish soil with the intention of recovering "by strong hand" (1.1.105) the lands and honor lost by his father.[30] Laertes, too, returns to Denmark armed and with enough armed men behind him to overcome the king's officers, overwhelm his Switzers, crash through the palace gates ("The doors are broke" [4.5.111]), and threaten insurrection ("riotous head" [4.5.101], "giant-like" rebellion [4.5.121]). Both Fortinbras and Laertes take to arms in order to recover their lost patrimony. Fortinbras wants back the lands his father lost in combat with old Hamlet. Laertes wants back his father: "Give me my father" (4.5.116), "Where is my father?" (4.5.128). It is, of course, his father's honor that he wants returned to him, the honor lost as a result of his obscure "hugger-mugger" (4.5.84) burial that took place without the "formal ostentation" (4.5.212) of the ceremony designed to secure the transmission of a nobleman's estate to his heir. The absence at his father's grave of "trophy, sword, . . . hatchment" (4.5.211), the markers of aristocratic lineage, symbolically cuts Laertes off from the family line, and he publicly pleads for official reinstatement by "some elder masters of known honour" (5.2.244).

The coat of arms that verbally and symbolically doubles with armor would have appeared on other objects besides the hatchments. The armorial design would, for example, have been engraved on the father's signet or seal. Hamlet at sea does have his "father's signet" (5.2.49), "the model of that Danish seal" (5.2.50), in his possession, and it saves his life by enabling him to substitute a forged commission for the original, "[t]he changeling never known" (5.2.53). It is during this adventure that Hamlet most resembles his father by issuing a command that looks just like one his father might have issued and that has the same sovereign effect ("Guildenstern and Rosencrantz go to 't," [5.2.56]). "Why, what a king is this!" (5.2.62) exclaims Horatio, as if he were seeing in young Hamlet the image of old Hamlet. And yet even here the process of filiation is suspect. As Hamlet allows, it is not by his father's provision that he possesses the royal signet, but by providence ("Why, even in that was heaven ordinant!" [5.2.48]), or as Horatio puts it in Q1, "by great chance" (H3v). In addition, Hamlet's use of the seal generates not legitimate issue, but a nonlineal "changeling." The imprinting or sealing metaphor functions typically to establish paternity and patrilineality, to the exclusion of the mother's genetic contribution. It represents the reproduction of the father by and in the son, as when Polonius uses it to signal the permission he gives Laertes to return to France: "[u]pon his

will I seal'd my hard consent," the father's approval coinciding with the son's desire, phrased to suggest the legal instrument of inheritance — the testamentary will — onto which the testator set his seal (1.2.60).[31] No such affiliation is implied when the metaphor is applied to old Hamlet and his son, however.[32] Hamlet's use of it to idealize his father ends up throwing into doubt his mother's chastity and his own paternity. In comparing the pictures of the two brothers, Hamlet likens his father's lineaments to a pantheistic imprint: "Where every god did seem to set his seal" (3.4.61) — Hyperion stamped his curls, Jove his brow, Mars his eye, Mercury his stance. While Hamlet intends the metaphor of multiple siring to idealize his male lineage, it utterly bestializes the female; as Shakespeare would have found Amleth saying to Geruth in Belleforest's *Histoires Tragiques*, "[I]t is the way of bitches to consort with several partners and to desire marriage and coupling with various masters."[33] The divine paternal composite appears to have left no mark on the son, however, for by Hamlet's own admission, he is no Hercules (1.2.152).

The paternal insignia may have been displayed at another site of reproduction. If the royal and noble beds in Shakespeare's England are any gauge, the "royal bed of Denmark" (1.5.82) would have had the family crest engraved in its wooden frame and embroidered into its counterpane. The head of the stately oak bed made for James at Montecute House in Somerset, for example, was carved with the royal coat of arms in imposing full relief and flanked by the escutcheons of both his son and his son-in-law.[34] By a kind of talismanic logic, the ancestral imprint presided over the site of generation, as if to reinforce the defining male stamp on the retentive female material. By due course, the next royal wedding in Elsinore should have been that of the prince and not of the queen, and the bed would have passed to Hamlet. But here, too, there is an upset. To the torment of both father and son, the best bed passes to the queen and her consort. The father imagines the once "celestial bed" (1.5.56) to be now teeming with "garbage" (1.5.57); the son envisages it as a "nasty sty" (3.4.94). Hamlet does his best to obey the ghost's injunction, "Let not the royal bed of Denmark be / A couch for luxury and damned incest" (1.5.82–83) when he bids his mother, "[G]o not to my uncle's bed" (3.4.161). Yet the play's repeated linking of the bed with the throne suggests that the obsession is not merely sexual. In his inaugural address, it is unclear whether Claudius is thanking his counselors for approving of his marriage or of his coronation. In the ghost's account as well as in both the silent and spoken version of the *Mousetrap* play,

the kingdom is obtained by both seducing the queen and seizing the crown. Her title as "imperial jointress" preserves the ambiguity by suggesting that the empire was her "jointure," the property she received at marriage and was entitled to retain after her husband's decease. If this is the case, as indeed it was in Shakespeare sources, kingship would require conjugal union with the "imperial jointress," being "conjunctive" (4.7.14) with her or of "one flesh" (4.3.55). That Claudius has succeeded in attaining this union remains a source of disgust to Hamlet up to the very end, when he makes sure the two are conjoined or united in death by drinking the "mixture rank" (3.2.251) from the same cup: "Drink off this potion. Is thy union here? Follow my mother" (5.2.331–32).[35] It is no wonder, then, that her sexual appetite is of such obsessive concern, for whom the "imperial jointress" chooses to "hang on" (1.2.143) has political consequences. Whether she links herself to an angel or "preys on garbage," whether she feeds on a "fair mountain" or battens on a "moor" (3.4.66, 67), whether she prefers old Hamlet or Claudius, Claudius or young Hamlet, is a state affair. As it turns out, the election after King Hamlet's death does follow Gertrude's desire, what her first husband terms "the will of [the] most virtuous-seeming queen" (1.5.46). In the absence of any directive from the father, it appears to be guided by the mother's will; Parliament endorses the object of her desire rather than the king's son and namesake.

The death of Hamlet's father is, by common-law standards at least, notably uncommon. The patrinomial properties that secure lineal continuity — land, title, arms, signet, royal bed — do not pass to the son. Hamlet's father appears to have died without having made provisions for either his estate or his soul; he apparently died intestate as well as "unhousel'd, disappointed, unanel'd" (1.5.77). After his death, no paternal directive secures Hamlet's inheritance. In place of such a voice or will is a posthumously given command, "Revenge his foul and most unnatural murder" (1.5.25). As if to hold on to this legacy, Hamlet inscribes it dutifully in his table-book, effacing all prior proverbial maxims in order to make room for his father's word.[36] The memory tablet, whether mental or material, is where paternal precepts are traditionally inscribed, as we have just witnessed in a previous scene, when Polonius bids Laertes, "And these few precepts in thy memory / Look thou character" (1.3.58–59). The vast storehouse Laertes has received over the years might be reduced to the one single commandment that underlies them all: "Honor thy father." That this preceptorial imprint has taken is evident when

Laertes returns in a rage from France to avenge his father's death. To do any less, he claims, would be an admission of bastardy: "That drop of blood that's calm proclaims me bastard, / Cries cuckold to my father" (4.5.117–18).

By Laertes' logic, Hamlet's "calm" in avenging his father—his "blunted purpose" (3.4.111) or his "dull revenge" (4.4.33)—reveals not weak filiation but illegitimacy. For Laertes, the father's link to the son runs through the blood; and yet, as Polonius's routine charactering on his son's memory suggests, it needs to be artificially fortified through mnemonic impressions. Hamlet's father leaves his son's memory insufficiently "impressed," having provided him with no title, armor, signet, royal bed, or will, but only with the extremest form of the patriarchal commandment "Honor thy father": "Revenge thy father." Though Hamlet inscribes the precept in his memorial tablet, his father's ghost must all the same return to remind him, "Do not forget" (3.4.110). The difficulty remembering his father without memorabilia or "remembrances" is suggested even before the ghostly visitation when he comes faintly, fleetingly, and tentatively to mind, "My father. Methinks I see my father . . . In my mind's eye" (1.2.184–85). The mental figment takes on some phenomenality when it appears on the platform as the spectral likeness of his father; by the time it reappears to only Hamlet, however, it may have faded back to its earlier imaginary status, as Gertrude assumes— "This is the very coinage of your brain" (3.4.139)— introducing the stamping metaphor at another site of vexed filiation, the son in this instance reproducing the father. Although Hamlet insists on drawing out the mourning period for his father, he experiences two odd lapses of memory, feigned or real, in reference to the time of his death. In his first soliloquy, the "two months" (1.2.138) he says have elapsed since his father's death contract to the mere "little month" (1.2.147) since his burial. He stumbles over the same fact again before the performance of *The Mousetrap*: "[M]y father died within's two hours" (3.2.125), he recalls; "Nay, 'tis twice two months" (3.2.126), Ophelia corrects him. But Hamlet gets it wrong again: "die two months ago" (3.2.128). Another bit of apparent memory loss sets in around an event so momentous in the history of Denmark that time is told from its occurrence. The sexton measures how long he has been grave maker from "that day that our last King Hamlet o'ercame Fortinbras" (5.1.139–40). "How long is that since?" asks Hamlet. "Every fool can tell that," answers the sexton, as if Hamlet were the only one in the realm who did not know. For the duration of the entire fifth act, Hamlet's father appears to have been forgotten.[37] Hamlet

had warned that if a man wishes to be remembered after death, he "must build churches then, or else shall a suffer not thinking on" (3.2.131−32). Without any material legacy from the father, the son's memory cannot be kept green.

To return to Ophelia's burial: The funeral procession cuts off Hamlet's *contemptus mundi* exercise; he has just finished reducing the global conquerors Alexander and Caesar to bits of loam and plaster when he spots the royal cortege. After having so studiously abstracted himself from contemptible earth in this scene, Hamlet at Ophelia's grave ends up engrossed in it, leaping into the grave and ranting of mountains. After downsizing empires and estates and plots, he projects a cosmic land mound, "[s]ingeing his pate against the burning zone" (5.1.277). It is as if the desire he has just renounced, the desire to make oneself great through land, has returned, like the bad dreams that he earlier admitted were keeping him from being contented within the confines of a nutshell (2.2.254−56), a parodic version of the orb or globe that symbolized royal power and dominion.

The return of the bad dreams is prompted when the corpse in the grave is imagined as a bride in a bed. Gertrude sets off the fantasy when over the grave she scatters flowers that were intended, she says, for Ophelia's and Hamlet's bridal bed:

> Sweets to the sweet. Farewell.
> I hop'd thou shouldst have been my Hamlet's wife:
> I thought thy bride-bed to have deck'd, sweet maid,
> And not have strew'd thy grave. (5.1.236−39)

The prospect of Hamlet and Ophelia in the marriage bed launches Laertes into the grave to catch the bride "once more in [his] arms."[38] This is, after all, the union Laertes has feared from the very start, when before leaving for France, he warned Ophelia not to open her "chaste treasure . . . / To [Hamlet's] unmaster'd importunity" (1.3.31−32). Now preempting Hamlet, Laertes has Ophelia to himself in a grave that is both a marriage bed and a family house, occupied by a brother and sister pretending to be lord and lady of the manor, sealed off from outsiders, with a massive estate outside the front door. It is in response to this scene that Hamlet's jealousy flares up. His words and gestures seem calculated to prove him the better man, starting with the declaration of

his peerless identity, " This is I, Hamlet the Dane." As if in competition for her hand, Hamlet offers to go to whatever extremes Laertes will go, and proposes a hysterical wooing match: "*Woo* 't weep, *woo* 't fight, *woo* 't fast, *woo* 't tear thyself, / *Woo* 't drink up eisel" (5.1.270−71, italics added). True to his word, Hamlet does just what Laertes has done, matching both his gymnastic feat and his rhetorical *tour de force*:

> Dost come here to whine,
> To outface me with leaping in her grave?
> Be buried quick with her, and so will I.
> And if thou prate of mountains, let them throw
> Millions of acres on us. (5.1.272−76)

Now two men are in the grave with Ophelia, fighting to possess the same plot and the same female. It is, of course, a triangle we have seen before, both incestuous (the woman is sister to one of her lovers) and fratricidal (the men are close enough in blood to be termed brothers (5.2.239, 249).[39] Hamlet appears to win the competition, to out-Laertes Laertes, perhaps with a lustier leap, certainly with the larger priapic mound. His "millions of acres" outsize Laertes' mountain of dust; his pile overtops Ossa, Pelion, and Olympus to brush against the sun itself. This is the stuff patrilineal dreams are made of: estate and generation endogamously enclosed. It is the paramount fantasy of exclusive domain, all the more poignant and ludicrous because both estate and bride have been lost to the patrilineal foul-up. The fantasy is performed as the line of both men is on the brink of extinction. Though their grief is expressed in terms of dust rather than tears, earth rather than water, it matches in its extremity that of Niobe (1.2.149) and Hecuba (2.2.497−514, 552−53), the two types of extreme grief mentioned in the play. It was after seeing all her children destroyed that Niobe became "all tears," even after her transformation to stone. It was after seeing her teeming progeny wiped out that Hecuba wept so profusely, as did all who subsequently recited or heard her tragedy. Both women are emblems of insuperable grief in a patrilineal system that can imagine nothing more tragic than genealogical extinction.

To return to Shakespeare: Around the time of his father's death, Shakespeare owned land and had arms and a title. He did not, however, inherit them directly from his father. His father, burdened by debts in his

later years, his land mortgaged and sold before his death, is assumed to have died intestate.[40] Though he left no material will, a spiritual will was discovered more than a century after his death, hidden high in the rafters of his house.[41] He appears, then, to have made provisions not for his survivors but for his soul, securing a dwelling for it in Christ, "to be perpetually inclosed in that eternall habitation of repose."[42] The land his son came to own, he purchased himself. The title and arms he came to bear were also, it is assumed, acquired by him.[43] Having provided himself with the inheritance he did not receive from his father, Shakespeare was then left with no male heir to receive it from him. At the time of his father's death, he had already lost his only son. That son's name was Hamnet, an alternative spelling of the name Hamlet, which as a common noun designated a division of land, like the hamlet of Old Stratford in which much of the land Shakespeare bought was located.[44] Before dying, Shakespeare went to exceptional testamentary lengths to bypass his female descendants, secure his property exclusively for his male descendants, and thereby hold together his holdings.[45] At his death, all his "lands, tenements, and heriditaments whatsoever" passed, for want of a male heir, to his daughter; at her death, however, they were to have passed to her first son "and to that son's lawful male heirs, and (in default of such issue) to the second son's lawful male heir, and so on to the second, third, fourth, fifth, sixth, and seventh sons."[46] Meanwhile the Shakespeare title would be preserved, symbolically at least, in the monument erected shortly after his death in Holy Trinity Church, with his recently acquired heraldic arms, helm, and crestlike hatchments carved in stone above his own effigy. There is some indication that Shakespeare may have been as determined to hold together his earthly remains as his estate. Engraved on the slab over his grave in the churchyard is an epitaph, sometimes attributed to him. It warns against the kind of disturbances witnessed in the graveyard scene: "Forbeare, to digg the dust encloased heare. Bleste be y man y spares theses stones, and curst be he y moves my bones." According to legend, he also left behind instructions to be buried seventeen feet underground rather than the customary six.[47]

To return to Freud: On June 23, 1882, upon just arriving in Hamburg, Freud wrote a charming letter to his fiancée, Martha Bernays, back in Vienna. It tells of his having gone to a stationer to order her "despotic stationery"; engraved with their initials "intimately entwined," it could be used only to write to him.[48] Freud describes how the stationer, "an old Jew," explained that he would have to delay the order because of his

observance of Tisha b'Av, the mourning period commemorating the destruction of the Temple of Jerusalem. Freud, less devout than the old stationer, grumbles that he had already been inconvenienced by this mourning period: "Just because Jerusalem had been destroyed I was to be prevented from speaking to my girl on the last day of my stay. *But what's Hecuba to me?*"[49] The stationer mourns the destruction of the Temple of Jerusalem as the player had mourned the fall of Troy. Freud, however, identifies with Hamlet, marveling that the mere memory of ancient ruination should continue in the present to be so affecting. But in the case of Tisha b'Av, it is not only its temporal remoteness that leaves Freud unmoved, it is the event itself. Why mourn the "collapse of that visible temple"? It was, he maintains, precisely its destruction that preserved the Jews from extinction. Once it was destroyed, "the invisible edifice of Judaism became possible." The Jews possessed no Temple in Jerusalem. Freud's father never owned a house during a time when laws restricted Jews from owning and transmitting property.[50] Fathers and forefathers were to be remembered without the mnemonics of place. Generations were bound together, still patrilineally, not through the transmission of estate but through a legacy imagined to be of comparable inalienability. The generational tie was guilt, activated at the death of the father. According to Freud, Freud experienced it while writing about Shakespeare, Shakespeare experienced it while writing *Hamlet*, and Hamlet experienced it in the play that has continued since the onset of the modern period to bear so tellingly on the ever-changing here and now.

NOTES

1. *Hamlet*, ed. Harold Jenkins (London and New York: Methuen, 1982), 1.1.2. All citations are from this edition and will henceforth appear in text.

2. Roland Mushat Frye maintains that Hamlet's "inky cloak" would have covered him "from head to toe." See *The Renaissance* Hamlet: *Issues and Responses in 1600* (Princeton: Princeton University Press, 1984), 100. To illustrate the unsuitability of Hamlet's attire during the court festivities, he superimposes a sketch of the principal mourners in the funeral procession of Elizabeth I onto a painting of Elizabeth I in festive procession (Fig. III.13), 101.

3. Because the stage direction *"Hamlet leapes in after Leartes"* appears only in Q1, some editors and directors have preferred to spare Hamlet the undignified leap into the grave (see, for example, Harley Granville-Barker, *Prefaces to*

Shakespeare [Princeton University Press: Princeton, 1946], 139, n. 19). In both Q2 and F, however, Hamlet announces the jump: "Dost come here to whine / To outface me with leaping in her grave? / Be buried quick with her, and so will I" (5.1.272–74). That Hamlet did indeed take this leap in early productions is indicated by the anonymous author of the elegy on Richard Burbage, "Oft have I seen him leap into the grave" (printed in E. K. Chambers, *The Elizabethan Stage* [Oxford, 1923], ii.309); that Nicholas Rowe introduced the stage direction "Hamlet leaps into grave" into his 1709 edition suggests that the tradition resumed after the Restoration.

4. Freud first published his reading of Hamlet in *The Interpretation of Dreams* (1900), though he had discussed it in a private letter dated October 15, 1897. For the astonishing number of times he repeated his theory in his writings up until the time of his death, see Norman N. Holland, *Psychoanalysis and Shakespeare* (New York: Octagon Books, 1979), 61. On *Hamlet* as "a half-hidden center of preoccupation throughout Freud's work," see Marjorie Garber, *Shakespeare's Ghost Writers: Literature as Uncanny Causality* (London and New York: Methuen, 1987), 159.

5. Freud's disciple Ernest Jones saw as early as in 1908 how Freud's reading of *Hamlet* and his understanding of the human psyche both undermined the supremacy of consciousness: "We are beginning to see man not as the smooth self-acting agent he pretends to be, but as he really is: a creature only dimly conscious of the various influences that mould his thought and action." See *Hamlet and Oedipus* (New York and London: W. W. Norton and Co., 1976), 52 and n. 1.

6. Sigmund Freud, *The Interpretation of Dreams*, in *The Basic Writings of Sigmund Freud*, trans. A. A. Brill (New York: Modern Library), 310.

7. Freud, *The Complete Letters of Sigmund Freud to Wilhelm Fliess, 1887–1903*, ed. and trans. Jeffrey Moussaieff Masson (Cambridge, MA: Harvard University Press, 1985), 272–73.

8. In the eighth edition of *Dreams* (1930), Freud inserted the notorious footnote, "Incidentally I have in the meantime ceased to believe that the author of Shakespeare's works was the man from Stratford." This denial, however, did not alter the importance of the father's death to the writing of the play. Though Freud's new candidate, Edward de Vere, was only twelve when his father died and his mother soon remarried, he was still feeling the loss when he came to write *Hamlet*. See Holland, *Psychoanalysis and Shakespeare*, 58, and Harry Trosman, "Freud and the Controversy over Shakespeare's Authorship," in *Freud: The Fusion of Science and Humanism*, ed. John E. Gedo and George Pollack (New York: International Universities Press, 1976), 311.

9. This quote appears in the second preface (1908) to *The Interpretation of Dreams*, as cited by Garber, *Shakespeare's Ghost Writers*, 165.

10. George Brandes, *William Shakespeare: A Critical Study* (New York: Macmillan, 1902). Page references to Brandes appear in text. For evidence of Freud's detailed use of Brandes' book, see James Strachey's translation and edition of *Civilization and Its Discontents* (New York and London: W.W. Norton and Co., 1961), 44, n.5. James Joyce also read Brandes' *Study*, and in *Ulysses* draws on the materials Freud ignored regarding Shakespeare's interest in property, though in regard to Shylock, not Hamlet. See Richard Halpern, *Shakespeare among the Moderns* (Ithaca and London: Cornell University Press, 1997), 159–68.

11. The date of a play's composition is always problematic since the quarto title pages record the date of publication. The dating of *Hamlet* has been further complicated by topical allusions within the play, external references to a play called *Hamlet* that predate the first quarto (1603), and the often conflicting evidence of the three early texts (1603, 1604/5, 1623). Recent editors tend to date the play before the documented death of Shakespeare's father in 1602, as does Jenkins who concludes after his lengthy analysis of the relevant materials that the "essential *Hamlet*" was being staged as early as the end of 1599 and certainly in the course of 1600 (13).

12. In Saxo's *Historiae Danicae* and Belleforest's *Histoires Tragiques*, Horwendil is the father and Amleth the son; in combating his Norwegian counterpart, Amleth's father stands to gain or lose ships' treasure rather than ancestral land. See Jenkins, 93.

13. The first Restoration quarto of 1676 specifies that the clowns enter "with Spades and Mattock." See Jenkins, 376.

14. R. S. Guernsey, *Ecclesiastical Law in* Hamlet (New York: Shakespeare Society of New York, 1885), 8, 14.

15. *The Tragicall Historie of Hamlet* (1603), I2v. Quotations from Q1 are from *Shakespeare's Plays in Quarto: A Facsimile Edition of Copies Primarily from the Henry E. Huntington Library*, ed. Michael Allen and Kenneth Muir (Berkeley and Los Angeles: University of California Press, 1998), and signatures are in text.

16. On the complicated question of royal jurisdiction over church lands before and after the dissolution of the monasteries, see David Loades, *Tudor Government: Structure of Authority in the Sixteenth Century* (Oxford: Blackwell, 1997), 191–200.

17. The radical sect known as the Diggers drew their name from the association of the digging of the land with the upheaval of the landed. According to Annabel Patterson, the name first appeared in the Midland Risings of 1607. See Patterson, *Shakespeare and the Popular Voice* (Cambridge: Basil Blackwell, 1989), 179 and n. 22.

18. Frye reproduces an engraving of a gentleman sexton (c.1594), with spade in hand (and pick axe and skull in background) and escutcheon directly above it. *The Renaissance* Hamlet, 226.

19. For the association of the sexton with peasant protest and egalitarianism, see Robert Weinmann, *Shakespeare and the Popular Tradition in the Theater: Studies in the Social Dimension of Dramatic Form and Function*, ed. Robert Schwartz (Baltimore and London: Johns Hopkins University Press, 1978), 239−40, and Patterson, *Shakespeare and the Popular Voice*, 93−106.

20. On the "puffed-up" or "swollen" rhetoric of the Shakespearean upstart and its relation to the inflation of titles, honors, and money, see Patricia Parker's comments on Parolles, Oswald, and Osric in *Shakespeare from the Margins: Language, Culture, Context* (Chicago and London: University of Chicago Press, 1996), esp. 213−20.

21. See Clare Gittings, *Death, Burial and the Individual in Early Modern England* (London: Croom Helm, 1984), 139.

22. The classic study on this survey is Frederic William Maitland, *Domesday Book and Beyond: Three Essays in the Early History of England* (Cambridge: Cambridge University Press, 1921). There may be particular reason for associating Domesday with a play set in twelfth-century Denmark. The book was a geld-book, registering taxable land, and originating in the Danegeld, the tribute paid to the Danes before the Conquest. Claudius pretends to send Hamlet to England to collect the Danegeld, "[f]or the demand of our neglected tribute" (Jenkins, 286 n. 172); Claudius refers again to England's "homage" to Denmark in expressing certainty that England will obey his command to execute Hamlet on arrival (4.3.61−71).

23. The title of the survey is explained in a twelfth-century reference: "This book is metaphorically called by the native English Domesday, that is the Day of Judgement. For as the sentence of that strict and terrible last account cannot be evaded by any subterfuge, so when this book is appealed to on those matters which it contains, its sentence cannot be quashed or set aside with impunity." Richard fitz Nigel, *Dialogus de Scaccario: The Course of the Exchequer,* quoted by David Bates, "Domesday Book 1086−1986," in *Domesday Essays,* ed. Christopher Holdsworth, Exeter Studies in History, no. 14 (Exeter: University of Exeter Press, 1986), 1.

24. For the belief, based on the Book of Revelation (20:4−6), that Christ's Second Coming would establish a messianic kingdom on earth, see Norman Cohn, *The Pursuit of the Millennium: Revolutionary Millenarians and Mystical Anarchists of the Middle Ages* (London: Pimlico, 1993). Of particular relevance are his discussions of the peasants' revolt (198−204) and the Anabaptist movement (252−88). On the duration of millenarian and egalitarian prospects into the period of the English Revolution, see Christopher Hill, *The World Turned Upside Down: Radical Ideas During the English Revolution* (New York: Viking Press, 1972).

25. On the late medieval *transi* figures in various states of decomposition, see Erwin Panofsky, *Tomb Scupture: Four Lectures on Its Changing Aspects from*

Ancient Egypt to Bernini (New York: Harry N. Abrams, 1992 [1924]), 64–66 and Figs. 257–266b. For *transi* tombs in England after the fifteenth century, see Frye, *The Renaissance* Hamlet, 232–36.

26. Shakespeare's audience, if not Hamlet, might well have associated the pit onstage with the spirit of Hamlet's father, as Andrew Gurr allows in "The Shakespearean Stage," in *The Norton Shakespeare,* eds. Greenblatt et al. (New York: W. W. Norton and Co., 1997), 3290.

27. For the "canons of descent" governing inheritance until well into the nineteenth century, see Paul S. Clarkson and Clyde T. Warren, *The Law of Property in Shakespeare and the Elizabethan Dramatists* (New York: Gordian Press, 1968), 207–30.

28. On the heraldic ritual of passing the coat of arms and the arms of the father to the son at the father's death to symbolize the transfer of titles and power, see Gittings, *Death, Burial, and the Individual,* 176–78.

29. Ann Rosalind Jones and Peter Stallybrass discuss "the unusual, if not unique" armored attire of King Hamlet's ghost, as well as its function as a genealogical mnemonic, in "Of Ghosts and Garments: The Materiality of Memory on the Renaissance Stage," *Renaissance Clothing and the Materials of Memory* (Cambridge: Cambridge University Press, forthcoming).

30. Pyrrhus is another son who appears armed and in arms to avenge his father's loss (2.2.446–88) by slaughtering the father of fifty sons, "old grandsire Priam," to the horror of the mother whose "o'erteemed loins" bore those sons. The Greek warrior anachronistically acquires for himself a feudal coat-of arms made up of enemy Trojan blood; he is "smear'd / With heraldry" by the blood of two generations ("blood of fathers, mothers, daughters, sons") which is then "[b]ak'd and impasted" by the fires of Troy. The destruction of the dynastic source is compared to the remorseless battering of armor, "never did the Cyclops' hammers fall / On Mars's armour" (2.2.485–86). The description is studded with heraldic terms: "sable," "gules," "trick'd," and "gore." For their significance, see Thomas Woodcock and John Martin Robinson, *The Oxford Guide to Heraldry* (New York: Oxford University Press, 1988), 197–207, 68.

31. For this customary testamentary practice and its representation in several plays, see Clarkson and Warren, *The Law of Property,* 21.

32. On the shared semantics and mechanics of generational and textual imprints, see Margreta de Grazia, "Shakespeare, Gutenberg, and Descartes," in *Alternative Shakespeares,* vol. 2, ed. Terence Hawkes (London and New York: Routledge, 1996), esp. 74–82.

33. Quoted by Jenkins, 92, from Sir Israel Gollancz, *The Sources of* Hamlet (1926).

34. See the description of the bed made for Henry VIII at Whitehall in Simon Thurley, *The Royal Palaces of Tudor England: Architecture and Court Life, 1460–1547* (New Haven: Yale University Press, 1993).

35. In both Saxo and Belleforest, Jutland passes to Amleth's father as well as to his uncle through Gerutha, daughter of Roric, king of Denmark. On "imperial jointress," see Jenkins, 179 n. 9, and the long note on 434. For the importance of language of "joinery" around questions of marriage, succession, and inheritance, see Parker, *Shakespeare from the Margins*, 112.

36. For examples of such collections of paternal precepts from classical, medieval, and Renaissance times, see Jenkins, 440–41.

37. He alludes to him only once, and then as "king" rather than "father," though the queen remains his "mother": "He that hath kill'd my king and whor'd my mother" (5.2.64). That he does not mention his father in the final act, when the ghost's "dread command" is at last fulfilled, also seems noteworthy. As the arrival of the English ambassadors reminds us (5.2.377), it is customary for the one who issues a command to give thanks at its execution.

38. The stage directions for Q2 call for "a corse" and for Q1 and F "a coffin." Frye argues that the former was "far more frequent" in the period (*The Renaissance Hamlet*, 351 n. 63).

39. In his apology to Laertes, Hamlet refers to him as "my brother" (5.2.239) and calls the duel "this brothers' wager" (5.2.249). This would make him loving brother to Ophelia as well: "Forty thousand brothers / Could not with all their quantity of love / Make up my sum" (5.1.264–66).

40. Samuel Schoenbaum itemizes John Shakespeare's debts and losses as well as his sale and mortgaging of his own lands, including property inherited by his wife, in *William Shakespeare: A Documentary Life* (Oxford: Oxford University Press, 1975), 36–37.

41. On John Shakespeare's spiritual testament, see Schoenbaum, *William Shakespeare*, 41.

42. Schoenbaum reproduces the spiritual testament as transcribed by Edmond Malone and printed in his 1790 edition of Shakespeare (*William Shakespeare*, 42). The quotation is from section 13 of the document.

43. On the father's earlier failure to obtain the grant and for evidence that it was his son who succeeded in doing so, see Schoenbaum, *William Shakespeare*, 36–37, 166–73.

44. On the interchangeability of the two names, both derived from the Norman name Hamon, see A. Rhodes, "Hamlet as Baptismal Name in 1590," *Notes and Queries*, 11th ser., IV, Nov. 4, 1911, 395.

45. Richard Wilson discusses the extraordinary measures Shakespeare took in his will to keep his estate intact in perpetuity by bequeathing it exclusively to first-born males and thereby avoiding any future division. See "A Constant Will to Publish: Shakespeare's Dead Hand," *Will Power: Essays on Shakespearean Authority* (New York: Harvester Wheatsheaf, 1993), 184–237, esp. 209–11.

46. Schoenbaum, *William Shakespeare*, 248.

47. For both the epitaph and the legend, see Schoenbaum, *William Shakespeare*, 250, 252.

48. *Letters of Sigmund Freud*, ed. Ernst L. Freud, trans. Tania Stern and James Stern (New York: Dover Publications, 1992), 17–22, 18.

49. *Letters of Sigmund Freud*, 19.

50. On the Freuds' material circumstances, see Marianne Krull, *Freud and His Father*, trans. Arnold J. Pomerans (New York: W. W. Norton, 1986), 147–51.

SECOND-BEST BED

Itm I gyve vnto my wief my second best bed wth the furniture Itm I gyve
& bequeath to my saied daughter Iudith my broad silver gilt bole All the
Rest of my goodes Chattels Leases plate Iewels & househod stuffe whatso-
ever after my dettes and Legassies paied & my funerall expences dis-
charged I gyve devise & bequeath to my Sonne in Lawe Iohn Hall gent &
my daughter Susanna his wief.

—William Shakespeare's will

If others have their will Ann hath a way.

—James Joyce, Ulysses

When Shakespeare left his "second-best bed" to his wife, Anne Hatha-
way, in his will, he left as well a seductive historical conundrum. Is the
phrase "second-best" a sign of his estrangement from the marriage, or
was the "best" bed in the house given to guests, so that the "second-
best" was the connubial couch—the one, as Shakespeare biographer
Sam Schoenbaum remarks with deadpan wit, "rich in tender matrimo-
nial associations"?[1]

Jane Cox, a specialist in old legal documents at the Public Records Office in London, recently described the second-best bed forthrightly as a "miserable souvenir." "This was no 'affectionate little bequest,'" she remarked, "neither was it usual for a seventeenth-century man, of any rank, to make no overt provision for his wife in his will. Of [a] sample of 150 wills proved in the same year . . . about one third of the testators appointed their wives as executrixes and residuary legatees. None left his wife anything as paltry as a second-best bed. Bedsteads and bedding were without doubt valuable and prized items and they were normally carefully bequeathed, best beds going to wives and eldest sons."[2]

But Shakespeareans are an ingenious lot, and much ingenuity has been expended in explaining, or explaining away, the problem of second-bestness in bed — or in beds. First there is the matter of "dower right," the provision of English common law that automatically entitled a widow to a life interest in her husband's estate. Since this was the law, and known to be the law, there was no reason for Shakespeare to make a specific bequest to his wife at all. The diary of the Reverend John Ward, vicar of Stratford-upon-Avon during the lifetime of Shakespeare's daughter Judith, poses and answers the question to his own satisfaction, at least:

> But why, it has been asked, leave the wife of his youth "his second best bed," and not his first best bed? It will not, I think, be difficult to give a most satisfactory answer to this query. Shakespeare had expressly left to his daughter, Susanna, and her husband, Dr. John Hall, "all the rest of his goods, chattels, leases, plate, and household stuffe whatsoever"; and supposing, as is most probable, Mrs. Shakespeare to have resided with them after her husband's death at New Place, she would there have the use and benefit of every article, as in her husband's lifetime. There is, I presume, a special reason why the second best bed was deemed by him so precious a bequest "to his wief"; few, if any, either in London or in the country, are themselves in the habit of sleeping on the first best bed;— this was probably by Shakespeare reserved for the use of Jonson, Southampton, the aristocratic Drayton, or for other of those distinguished persons with whom he is known to have been in habits of intimacy. The second best bed was, doubtless, the poet's ordinary place of repose,— the birthplace of his children; and on these and

many other grounds it must have been, to Mrs. Shakespeare, of more value than all the rest of his wealth.[3]

Still, some modern commentators have privately — and not so privately — mused that he might have spared her a tender word. "Most of the wills of this period are personal and affectionate," writes biographer Marchette Chute, but "Shakespeare was one member of [his acting] company whose will does not show a flicker of personal feeling."[4]

G. E. Bentley complained that the will's single and possibly slighting proviso for Anne Hathaway had "given rise to many romantic or lurid tales."[5] E. K. Chambers, the great historian of the Elizabethan stage, declared, "A good deal of sheer nonsense has been written about this." Chambers and others, taking recourse (or refuge) in historical fact, suggest that "Mrs. Shakespeare would have been entitled by common law to her dower of a life interest in one-third of any of the testator's heritable estates in which dower had not, as in the case of the Blackfriars property, been legally barred" — thus raising the inconvenient fact that the Blackfriars house *had* been left away from Shakespeare's wife, and by legal means.[6]

And there was the undeniable and unhappy fact that the bequest of the bed was not even part of the original text, but was instead interlineated, inserted (perhaps, like Hamlet, we could say "popped in") after the fact. Like the wedding itself, it was, apparently, an afterthought.

"It is observable," noted the eighteenth-century Shakespeare editor Edmond Malone in a famous commentary, "that his daughter, and not his wife, is his executor; and in his Will, he bequeaths the latter only an old piece of furniture; nor did he even think of her till the whole was finished, the clause relating to her being an interlineation. What provision was made for her by settlement, does not appear."[7]

The context of Malone's remark is a reading of Sonnet 93 and Malone's contention is that the poet is writing "from the heart" about sexual jealousy. "That our poet was jealous of the lady," rejoins George Stevens with some asperity, is "an unwarrantable conjecture. Having, in times of health and prosperity, provided for her by settlement (or knowing that her father had already done so), he bequeathed to her at his death not merely *an old piece of furniture*, but perhaps, as a mark of peculiar tenderness, "the very bed that on his bridal night / Receive'd him to the arms of Belvedira." And why did Shakespeare initially omit to leave her anything? "His momentary forgetfulness as to this matter, must be imputed to disease" (1:655).

Malone, of course, will have none of this. His riposte is meant to be withering; it is clear to him that Shakespeare felt, and exhibited, nothing but contempt.

> His wife had not wholly escaped his memory; he had forgot her — he had recollected her — but so recollected her, as more strongly to mark how little he esteemed her; he had already (as it is vulgarly expressed) cut her off, not indeed with a shilling, but with an old bed.

"However," Malone went on to remark astringently, "I acknowledge, it does not necessarily follow, that because he was inattentive to her in his Will, he was therefore jealous of her. He might not have loved her; and perhaps she might not have deserved his affection" (1:657).

Scholars and sentimentalists of the following centuries struggled to resist or overturn this uncharitable assessment. The author of *Shakespeare's True Life* (1890), once again citing dower right as the reason why the playwright made no express provision for his wife's maintenance, observes, "The bequest which he makes to her in his will, of his 'second-best bed,'— doubtless that in which as husband and wife they had slept together, the so-called 'best' being reserved for visitors — is intelligible enough, and needs none of the disquisitions of the would-be wise."[8] In *Shakespeare's Marriage* (1905) Joseph William Gray is similarly confident: "It is difficult to believe that the bequest of the 'second-best bed' was intended for a slight, as is sometimes asserted. Even if feelings of dislike had been rankling in his mind, it is questionable whether he would have adopted such a contemptible method of expressing them."[9] We could hardly call this a psychoanalytic approach to the problem, but it does struggle toward the psychological, though here, too, it uses history (or lore) to shore up its claims: "The only tradition which indicates Anne Shakespeare's opinion of or regard for her husband is that she 'greatly desired to be buried with him.'" (The "tradition" dates from Dowdall's *Traditional Anecdotes of Shakespeare, Collected in Warwickshire in the Year 1693*.)[10] The grave thus becomes the first-best bed, to which all others are second.

In 1918 Charlotte Stopes offered an argument based on sentiment and the humbleness of Anne Hathaway Shakespeare's origins, assuring her readers, "There is nothing derogatory in the legacy of the second-best bed; it was evidently her own last request. She was sure of her widow's *third*;

she was sure of her daughters' love and care, but she wanted the bed she has been accustomed to, before the grandeur at New Place came to her."[11]

The authors of *Shakespeare's Town and Times* give a halcyon picture of the final years in Stratford: "At the time of the poet's death, we may imagine his wife, then over sixty years of age, as a brisk and kindly dame, her hair shot with silver and her step less firm than when she was wooed in Shottery fields, but with eyes still bright and cheeks still ruddy."[12] And Shakespeare biographer A. L. Rowse, a hundred years later, offers an equally benevolent view: "Most of his Will is concerned with the disposition of property among his family, most of it going to his heir, his elder daughter Susanna. She and her husband, Dr. John Hall, would naturally have the best double bed, so it was characteristically considerate of Shakespeare to specify that his widow, Ann, should have the next best bed for herself."[13]

From Malone's time to our own, then, we have moved from a characteristically cruel Shakespeare motivated by sexual jealousy to a characteristically considerate one motivated by fine family feeling, both predicated on the evidence of that second-best bed.

These explanations, or excuses, or explainings away, had become so notorious by the beginning of this century that James Joyce could not resist mocking them in *Ulysses*. Stephen Daedalus and his friends are discussing Shakespeare and the neglected, patient "Mrs S." "He was a rich country gentleman, Stephen said, with a coat of arms and a landed estate at Stratford and a house in Ireland yard, a capitalist shareholder, a bill promoter, a tithefarmer. Why did he not leave her his best bed if he wished her to snore away the rest of her nights in peace?" Stephen's friend, the Englishman John Eglinton, is inclined to defend the playwright, and Joyce has him do so in Shakespearean blank verse:

>You mean the will.
>But that has been explained, I believe, by jurists.
>She was entitled to her widow's dower
>At common law. His legal knowledge was great
>Our judges tell us.

But Stephen, whose sympathies are with the wife, will have none of this. His mordant reply picks up the rhythms of Eglinton's verse and then breaks into mocking pseudo-Elizabethan song:

And therefore he left out her name
From the first draft but he did not leave out
The presents for her granddaughter, for his daughters,
For his sister, for his old cronies in Stratford
And in London. And therefore when he was urged,
As I believe, to name her
He left her his
Secondbest
Bed.
 Punkt.
Leftherhis
Secondbest
Leftherhis
Bestabed
Secabest
Leftabed.

Woa!

Eglinton has recourse to the other stock answer: beds were valuable, "pretty countryfolk had few chattels then," but again Stephen's curiosity is piqued by Anne Hathaway: "She lies laid out in stark stiffness in that secondbest bed, the mobled queen, even though you prove that a bed in those days was as rare as a motorcar is now and that its carvings were the wonder of seven parishes."[14]

There have been other skeptics, enough to generate an entire philosophy of Shakespearean furniture. Samuel Neil's 1847 guide to *The Home of Shakespeare* describes the appointments of Anne Hathaway's cottage, including "Shakespeare's courting chair," so called by Shakespeare enthusiast Samuel Ireland (the father of William Henry Ireland, shortly to become famous for his forgeries). The chair, the author admits, is not the same one that was there in the sixteenth century—the latter having been bought for a stiff price by a central European princess—but it is "a very old chair" nonetheless, and the "absence of the *genuine* chair was not long felt." "It is but fair to add, that those who are skeptical are not met by bold assertions of its genuineness, although there be no denial of its possible claim to that quality; but all credulous and believing persons are allowed the full benefit of their faith."

And there was also "an old carved bedstead, certainly as old as the Shakesperian era," which "has been handed down an heirloom with the house. . . . Whether there in Anne's time, or brought there since, it is ancient enough for her and her family to have slept in, and adds interest to the quaint bed-room in the roof."[15] Any bed that Shakespeare—or his wife, or both—might have slept in had become a vital accessory after the fact.

But it was the famous second-best bed that had the first claim on the public's—and the scholars'—attentions. The bed—that elusive and fantasmatic bed—has often seemed, in fact, something that could be fixed by history, by scouring the archives and the annals. Much energy has been expended on a search for other, similar bequests, to normalize or contextualize the apparent oddity of Shakespeare's interlineation. Thus, for example, scholars have located a number of other second-best beds in legal documents, including wills. In 1573 one William Palmer of Leamington left his wife Elizabeth his "second-best fetherbed for hir selfe furnished, And one other meaner fetherbed for her mayde . . . And that I wolde have hir to live as one that were and had bien my wife."[16] So the second-best bed could be not only an affectionate bequest but, apparently, a status symbol. Palmer's will was seen by Schoenbaum as a knife that cut both ways, since, by contrast, Shakespeare's bequest "is unaccompanied by any expression of testamentary emotion, as in the Palmer will"; Schoenbaum promptly speculates that "perhaps his lawyer did not encourage, or permit, such embellishments."[17] Like Stevens' earlier conjecture that Shakespeare was too far gone with illness to think up any pretty thoughts for the occasion, this exculpatory speculation raises as many questions as it answers.

The best bed would technically qualify as an heirloom, an article of personal property handed down with the estate. Richard Marley in 1521 left his son his "best fetherbed," and, as historian Frederick Emmison suggests, "it is the eldest son, and not the widow, who gets the best bed."[18] In a will dated December 22, 1608, Thomas Combe left all bedsteads to his wife "except the best," which was bequeathed, "with the best Bedd and best furniture thereunto belonging" (that is, the sheets, pillows, linens, and so forth) to his son.[19] John Harris, a notary residing in Lincoln, left his wife two beds: "the standing bedstead in the little chaumber, with the second-best featherbed I have, with a whole furniture therto belonging and allso a trundle-bedsted with a featherbed, and the furniture therto belonging."[20]

"A second time I kill my husband dead / When second husband kisses me in bed," intones the Player Queen in *Hamlet* (3.2.184–85), echoing the advice of Sir Walter Raleigh to his son: "[L]eave thy wife more than of necessity thou must, but only during her widowhood, for if she love again, let her not enjoy her second love in the same bed wherein she loved thee."[21] Here the problem is that of the second becoming the first: The second love threatens to render the first husband's bed retroactively (and posthumously) second-best.

Scholar Joyce Rogers concludes from her own examination of medieval and Renaissance legal documents that many items other than beds are described in wills as "best" or "second-best," and makes a persuasive argument that this practice is linked to the medieval legal traditions of heriot and mortuary: the "best" things were given to the lord as a kind of tithe; after this the "second-best," or next-best, chattel was reserved to the church as a "mortuary," or reparation for the soul. Thus the jurist Sir William Blackstone, lamenting the passing of "the old common law," saw among those rights disappearing both the dower law or dower right and the "custom of many places . . . to remember his lord and his church, by leaving them his two best chattels."[22] "After the lord's heriot or best good was taken out, the second best chattel was reserved to the church as a mortuary."[23] Here, as Rogers points out, is quite a different valuation for "second-best." Instead of connoting something like "second-rate" or "secondhand"—something, that is, near the notional bottom of the heap—it instead repositions the "second-best" close to the top: "Thus the infamous phrase, 'second-best,' so often taken as an intentionally malicious slur, may be understood in ancient context as a parting tribute of profound meaning."[24]

Does this recourse to history resolve the problem of the "second-best bed"? On one hand, we have learned that the surviving son—or, in Shakespeare's case, daughter—often got the best bed. On the other, we have seen that "second-best" (especially "with the furniture") is actually pretty good, and that its standing in law was traditional and honored. This would seem to be a "solution" of sorts to the "problem" of Shakespeare's misogyny, or jealousy, or licentiousness, or homosexuality, or—at the very least—flight from the marriage and from Stratford, of which the "second-best bed" has been such a potentially tantalizing clue. In fact, there is no problem.

Or is there? The fact is that these "facts" will not make the problem go away, because Shakespeareans, professional and amateur alike, do not

wish it to go away, however much they may protest to the contrary. We prefer the problem to any answer. The second-best bed, that perfect tester for the intersection and mutual embeddedness of historicism and psycho-analysis, is an overdetermined site for critical curiosity. The bed functions eroto-historically as the equivalent, in material culture, of the navel of the dream, locus at once of procreation, legitimate and illegitimate (born on which side of the blanket?), inheritance, and sexual fantasy, the scene of the primal scene. It is not an accident — as psychoanalytic critics like to say — that of all the elements in the Shakespeare story, and the Shake-speare will, the "second-best bed" has excited so much interest and con-troversy that will not be quieted or subdued by a simple "answer" from history. For we do not want just the history, we want the story.

One evidence for this is the frequency with which the second-best bed has figured *in* a story. A 1993 novel by Robert Nye, *Mrs. Shake-speare, The Complete Works*, discloses that the "first best bed" was in fact the playwright's bed in London, where he engaged in sexual relations with Southampton (whom we may recall the Rev. Mr. Ward to have imag-ined visiting New Place and sleeping there in the household's "first best bed") and also with his wife when she came to visit. Initiated into sodomy ("what men do") by her husband, the delighted Mrs. Shake-speare finds a newly erotic pleasure in their marriage (as indeed does Mr. Shakespeare). The bequest of the "second best bed," she understands, is not "an insult" but a tribute to the memory of "that other bed, in every sense the best one," in which she had the best sex of her life.[25] This queer narrative of female eroticism is a Shakespeare bedtime story for the 1990s. But it also — and this is perhaps more pertinent — conjures the scenario that lies behind the cultural fascination of the bequest: the spec-tacle of Shakespeare — our Shakespeare, *unser Shakespeare*—in bed.

An earlier attempt at fiction offers a wry "historicist" approach. *No Bed for Bacon*, a 1941 comic novel by Caryl Brahms and S. J. Simon, evokes an Elizabethan England in which Raleigh longs chronically for a new cloak, Shakespeare for a perfect play (*Love's Labour's Won*), and Bacon for a bed. Sixteenth-century monarchs and great landowners took their own beds with them on their progresses, and Elizabeth, according to the plot, is in the habit of presenting her favorites with "country bed-steads slept on by the Queen."[26] The comic conceit of *No Bed for Bacon* is that Bacon wants an Elizabethan trophy bed. But Bacon's longing is destined, of course, to go unsatisfied. The elusive bed is periodically glimpsed offstage; reports suggest that it has been delivered to Anne

Hathaway's cottage; Shakespeare changes the subject whenever Bacon brings it up. The second-best bed is the *objet petit a* for both Bacon and the Shakespeare scholars gently satirized in the text.

No Bed for Bacon takes a creative approach to history, beginning with a "Warning to Scholars" that "This Book is Fundamentally Unsound," and a prefatory page that cites the great American pragmatist Henry Ford: "It was Henry Ford who is said to have remarked that 'History is Bunk.' The authors of this book have in a number of works set out to prove the point." But if "History is Bunk," in the context of our inquiry we may be moved to ask whether it might also be said that "History is Bunk Beds." Indeed, a little reflection suggests that it is not only the "*bunk* bed" but the "*queen* bed," the "*king* bed," the "*California* king bed" (suitable for watching Branagh and Pacino movies), and perhaps especially, in light of Shakespeare's family, the "*twin* bed" that have some relevance for Shakespearean clinophiles.

"Shakespeare's will would not have been thought funny if his second-best bed had been a singleton," observes Reginald Reynolds in a 1952 book on the social history of the bed.[27] But what if the bed had been a twin? The decade of the fifties, the decade of *Pillow Talk*,[28] was the modern heyday of the twin bed (a cultural innovation that dates, in point of fact, to a Sheraton design in the late eighteenth century, when they were invented "to keep lovers cool during the hot summer months").[29] Here are some striking statistics: The percentage of twin beds relative to all beds purchased in the United States in the prewar period was 25 percent; by 1950, according to a number of studies, it had risen to 68 percent. And the scuttlebutt on twin beds was that — far from producing twins, as Shakespeare's bed had done (with some help from its tenants) — twin beds produced divorce. Or so said the director of the (American) Family Relations Institute in 1947: "This movement towards twin beds must stop. . . . The change from a double bed to twin beds is often the prelude to a divorce."[30]

"Twin Beds for Divorce" was the title of another article, published in the previous year. But a British judge called upon to rule in a 1950 divorce case as to whether a married couple sleeping in twin beds was sharing "the matrimonial bed" or occupying "separate sleeping accommodation" decided emphatically that the former was the case. Are twin beds one "bed" or two? Identical or fraternal? It depends upon the nature of the (legal) case. If they slept in twin beds, neither could be said, for legal purposes, to have left the other's "bed and board." "I cannot,"

declared the judge, "regard twin divan beds in a married couple's bed-room as being otherwise than the matrimonial bed."[31] "The bed," in the terms of this ruling, henceforth could mean "the beds"; when there were two in the same room, neither, presumably, was second-best. Here we may seek further corroboration from an important and neglected work on beds by the early Marx—the early *Groucho* Marx. In a 1930 volume called *Beds* (described on the back cover as "the sleeper of the year"), Groucho notes that "couples often become confused and get into the same twin bed by mistake, which explains why one bed is worn out more quickly than the other."[32]

But if in life twin beds could cause divorce, in Hollywood they were the very sign of marriage. "Twin bed marriages," writes Parker Tyler, a historian of sex in films, "actually mark a whole Hollywood epoch of bedroom customs." One of the ironclad rules was that though a man and a woman could be shown alone together in a bedroom, even in their nightclothes, "there couldn't be a double bed waiting to accommodate their conjugal embraces; rather, there had to be *twin beds*."[33]

Hollywood, the California king bed, and Groucho Marx may lead us to a consideration of a recent manifestation of the second-best bed in public culture, the recent furor about Clinton's use of the Lincoln bed-room. This hallowed White House chamber, where Lincoln never slept (but in which he was autopsied and embalmed, and where some say his spirit still walks abroad), has become the centerpiece in an American po-litical scandal ("Hark! Who lies i' th' second chamber?").

"Ready to start overnights right away," wrote Clinton in a memo to his staff. It turned out that some 938 supporters and friends had availed themselves of the opportunity to stretch out on the long and lumpy mattress of the Lincoln bed. *Newsweek*, unable to resist the obvious wit-ticism, headlined its article on the presidential bed trick "Strange Bed-fellows."[34]

Best bed? or second best? For the guests of the Clintons—like, pre-sumably, the guests of the Lincolns—the best was not good enough.

Some denizens of the Lincoln bedroom had more spectral expecta-tions. Though Lincoln never slept there, it was an office in his lifetime, and he is said to have visited, postmortem, when the fancy took him. Winston Churchill is said to have encountered the Great Emancipator's ghost, and Queen Wilhelmina of the Netherlands once saw "an ectoplasm in a stovepipe hat."[35] The most numinous encounter with Lincoln was imagined, perhaps not surprisingly, by Ronald Reagan, who confided his

excitement to a group of junior high school students: "If he is still there, I don't have any fear at all! I think it would be very wonderful to have a little meeting with him, and probably very helpful."[36] It seems that Hillary Clinton's chats with Eleanor Roosevelt may have had Republican—and presidential—precedent.

The seemingly inconsequential saga of the Lincoln bedroom, then, engages not only history but also, and even more crucially, psychoanalysis: narratives of the ghost, the revenant, the father, the family romance, the unattainable object of desire—and, perhaps even more crucially, the undecidable question of how we can tell first-best from second-best. Is the first-best bed the bed slept in by the First Family—or the bed that has come to signify (though, as we have seen, it never cradled) the most beloved president of them all?

On the key question, the question of how to distinguish the "first-best" from the "second-best" bed—and what is at stake in that distinction—we may get some assistance from Plato. Let us turn for a moment to that controversial section of the *Republic* in which he speaks of the role of the poet and artist, for the object that Socrates holds up to Glaucon as an exemplary "thing" is the *bed*. And what we discover if we do so is that there are for our consideration not two beds, but three:

> Here we find three beds; one existing in nature, which is made by God, as I think that we may say—for no one else can be the maker?
>
> No one, I think.
>
> There is another which is the work of the carpenter?
>
> Yes.
>
> And the work of the painter is a third?
>
> Yes.
>
> Beds, then, are of three kinds, and there are three artists who superintend them: God, the maker of the bed, and the painter?
>
> Yes, there are three of them.
>
> God, whether from choice or from necessity, made one bed in nature and one only; two or more such beds neither ever have been made nor ever will be made by God.
>
> Why is that?
>
> Because even if He had made but two, a third would still appear behind them of which they again both possessed the form, and that would be the real bed and not the two others.[37]

"Very true," says Glaucon obediently, and so we may perhaps say as well. The third bed, the spectral bed—the bed, we may say, of Goldilocks, the bed that is, but only in fantasy, "just right"—appears "behind."

Plato's "third" bed is the *form* of the bed—"that would be the real bed and not the two others." But the thirdness of the bed disrupts, in what is by now a familiar fashion, the unsatisfactory binary of the carpenter's bed and the painter's bed, the material object-in-history and the object-in-representation. And it is the third that, according to Plato, is the "real" one.

The carpenter is a maker and the painter an imitator. Of their two beds, which is the "second-best"? That of the artist, the "imitator of that which others make"? Or is it in fact the case that the "third bed" is—by its very nature—the "best bed," so that the artifacts of both carpenter and painter are—again, by their very nature—only "second-best"? The "real" is the one that we *cannot* see, "the essential object which isn't an object any longer, but this something faced with which all words cease and all categories fail."[38] And this, needless to say, is not Plato's "real" but Lacan's.

Furthermore, this central passage from the *Republic* that we have been considering, about the three beds, comes from Benjamin Jowett's translation of Plato. But this is not the only way to construe the passage or its key word. The Greek word here is *kline*, from *klinein*, "to slope or lean"—the word from which we get *recline, incline,* and *decline.* And in Paul Shorey's translation of Plato for the Bollingen Series, the word (or concept) is translated as not *bed* but *couch.*

The resulting rhetorical questions have a special resonance for readers today.

> What of the cabinetmaker? Were you not just now saying that he does not make the idea or form which we say is the real couch, the couch in itself, but only some particular couch?[39]

"Some particular couch": Here we arrive at the scene of psychoanalysis, ground zero for Freudians, that celebrated piece of furniture that Freud historian Peter Gay repeatedly calls "the famous couch." Freud's couch, the centerpiece of the doctor's office, the gift of a grateful patient, was draped with Persian carpets, one of which hung behind the couch like an Elizabethan arras.[40] Biographer Gay pictures the expansive

founder of psychoanalysis "look[ing] around his consulting room from his comfortable upholstered armchair behind the couch."[41] When Freud became virtually deaf in his right ear as a result of operations on his oral cavity, "the couch was moved from one wall to another so that he could listen with his left."[42] (Shakespeareans will recall that Julius Caesar had a complementary infirmity, being deaf in his left ear rather than his right.) And the couch was moved once again, near the end of Freud's life, when the family was forced to leave Vienna and to resettle in London. "The possessions he had had to ransom from the Nazis — his books, his antiquities, his famous couch — were placed in the new house at 20 Maresfield Gardens so that the two downstairs rooms resembled, as closely as possible, the original consulting room and study in Berggasse 19."[43] In a fascinating essay on the architecture and symbolism of Freud's office, Diana Fuss and Joel Sanders suggest that "the sexual overtones of the famous couch — the sofa as bed . . . discomforted Freud's critics and, if Freud himself is to be believed, no small number of his patients."[44] Once, in its earliest history, Freud's couch had been used for hypnosis, a technique he abandoned, but the couch itself remained as a relic or "remnant" of "psychoanalysis in its infancy."[45] Fuss and Sanders aptly describe the office as "the birthplace of psychoanalysis."[46]

Here we might think of that other birthplace, now held in trust for the nation: "The Holy of Holies of the Birthplace was the low, the sublime Chamber of Birth," writes Henry James.[47] "It was as empty as a shell of which the kernel had withered. . . . [I]t contained only the Fact — *the* Fact itself." *The* Fact is the fact of the unnamed Shakespeare's birth, though to give it a name is to destroy the wicked subtlety of James' parlor-trick prose. In guidebooks of the period — to which James may well have had recourse — words such as *relic* regularly appear, and even the most current twentieth-century guidebook calls the house, and the birth room, a "shrine."[48] Though the room James visited was empty and evocative, today's Shakespeare birth room, outfitted for our more literal age, contains not only a period bedstead standing in for the Fact of his conception, but also a cradle.

Freud's take on *Hamlet* (like that of his disciple, Stephen Daedalus) had placed the mother's bed squarely front and center. As Gary Taylor notes, what had been "the closet scene" now became, in Dover Wilson's *What Happens in Hamlet*, "the bedroom scene." By the 1940s the bed had become a standard prop, and in 1948 Laurence Olivier brought the Freud-Jones *Hamlet* — and the maternal bedroom — to the world screen.[49] "Let

not the royal bed of Denmark be / A couch for luxury and damned incest" (1.5.82), enjoins the ghost-king in *Hamlet* to the conflicted son. In this parental prohibition, bed and couch, those two Freudian props, again function as not-quite synonyms. But exactly whose incest is being prohibited — the uncle's or the son's?

In classic Freudian readings the eavesdropping scene in Gertrude's closet or bedroom is another thinly disguised wish appearing as a projection: Polonius ("that great baby" [2.2.382]) takes the place of the child in the primal scene, who wants to spy on his parents' lovemaking in bed — and perhaps even, in fantasy, to witness his own conception[50] — takes the place, that is, of Hamlet, or of Freud.[51] Freud had famously written to his friend Fliess that he had found "in my own case, too, [the phenomenon of] being in love with my mother and jealous of my father," and his conviction that this was "a universal event in early childhood" was tied, once again, to his reading of *Hamlet* as a confessional text. So for Freud the story of Hamlet was overtly and self-evidently the story of Shakespeare: "It can of course only be the poet's own mind which confronts us in Hamlet."[52]

By 1919, about twenty years later, Freud was referring readers, in a footnote, to Ernest Jones's fuller psychoanalytic account of Hamlet and Oedipus, where we are told in a chapter called "The Hamlet in Shakespeare" that "the poet himself . . . had been hastily married, against his will . . . — an act for which he never forgave his wife, and to which we may ascribe some part of his misogyny."[53] But by 1930, in another footnote (his favorite mode of self-interrogation), Freud quietly disavowed his entire biographical reading: "Incidentally, I have in the meantime ceased to believe that the author of Shakespeare's works was the man from Stratford."[54] "Shakespeare wrote *Hamlet* very soon after his own father's death," he had asserted in his *Autobiographical Study* (1925). But in 1935 he inserted a footnote that caused great consternation to his English translator: "This is a construction which I should like explicitly to withdraw."[55]

And here we have a good theoretical instance of what might be called the logic of the second-best bed. This disavowal of Shakespeare's authorship (about which I have commented at some length elsewhere)[56] may be usefully compared to that other famous Freudian disavowal, the disavowal of the seduction theory. In the latter Freud revised his early view that the origins of neurosis lay in "infantile sexual scenes" or "sexual intercourse in childhood." But now Freud claimed that the "seduction theory" was

not grounded in historical fact — that is, that his patient's intimations of "sexual intercourse in childhood" had not really taken place. Rather, these "seductions" were fantasies: "I was at last obliged to recognize that these scenes of seduction had never taken place, and that they were only fantasies which my patients had made up."[57] The "real" bed of incest or seduction was second-best to the fantasy — indeed, it was now only the fantasy that was "real."

With the concept of the primal scene Freud had a similar problem: Were these mental images of memories of parental coitus or fantasies, "real" or "imagined," psychoanalysis or history? The question was, he thought, undecidable in the general case. His account of the Wolf Man story emphasizes the degree to which the reality of the primal scene is only grasped by the child after the fact, by "deferred action"; on the other hand, retrospective fantasies are triggered by some real-world clues or symptoms, such as familiar noises or the sexual encounters of animals.[58]

That the primal scene itself should be poised between — or overlap — the boundaries of so-called reality and so-called fantasy is, for the terms of my argument, crucial. For what I am proposing is not just that the bequest of the second-best bed inserted belatedly into Shakespeare's will is a good example of the interpretative tensions between psychoanalysis and historicism, but rather that it embeds those tensions in a cultural icon — Will's will, "what he hath left us" — that is the primal scene of poesis, the primal scene of our literature. In other words, the second-best bed as cultural legacy is an overdetermined instance of primal rivalry between psychoanalysis and history. This is what accounts for its fascination. Psychoanalysis, as we can see from the examples of the seduction theory and the primal scene, is itself precisely about the relationship between history and psychoanalysis.

In revising his "seduction theory," Freud decides in favor of fantasy over history, and thus, as many have remarked, through this very act of disavowal creates the discipline of psychoanalysis. What I am suggesting here is that in revising his identificatory relationship with "Shakespeare," Freud performs a very similar act of disavowal, though apparently in the opposite direction (seeming, that is, to choose history over fantasy).

When he accepted the Goethe Prize from the city of Frankfurt, Freud directly addressed the rival claims of history and psychoanalysis, acknowledging both the limits of biographical knowledge and the psychoanalytic reasons that lay behind the quest for historical details. Biographers, even

the best of them, cannot explain either the artist or his work, "[a]nd yet there is no doubt that such a biography does satisfy a powerful need in us. We feel this very distinctly if the legacy of history unkindly refuses the satisfaction of this need—for example, in the case of Shakespeare." Was "the author of the Comedies, Tragedies and Sonnets" the "untutored son of the provincial citizen of Stratford" or the "nobly-born and highly cultivated" aristocrat Edward de Vere? How can we justify "a need of this kind to obtain knowledge of the circumstances of a man's life when his works have become so important to us?" Freud's answer is that we are in quest of father figures, teachers, and exemplars—and also that we need to think them finer than ourselves. Biographical research often produces unwelcome bits of information that tends toward the "degradation" of the same great man we so wish to admire.[59] "The man of Stratford," wrote Freud in a fan letter to the most vigorous proponent of the Oxford theory, "seems to have nothing at all to justify his claim, whereas Oxford has almost everything."[60] History is the fantasmatic sign of the family romance Freud elects to believe as truth.

So where we saw, a moment ago, that psychoanalysis was itself founded on the borderline between history and psychoanalysis, so we can see now that the same is the case with history. The family romance of Oxford as the better Shakespeare reverses the pattern of fantasy as the better seduction. History itself is about the relationship between history and psychoanalysis.

Neither historicism nor psychoanalysis, in short, will benefit from a Procrustean view. What becomes most evident is the difficulty of making a bed while lying in it—a task, perhaps, beyond even the talents of Procrustes.

NOTES

All citations of Shakespeare in this essay are from *The Riverside Shakespeare*, second edition, ed. G. Blakemore Evans (Boston: Houghton Mifflin, 1997).

1. S. Schoenbaum, *William Shakespeare: A Documentary Life* (New York: Oxford University Press, 1975), 247.

2. Jane Cox, cited in a 1997 book supporting the claim that the Earl of Oxford wrote Shakespeare's plays. Joseph Sobran, *Alias Shakespeare: Solving the Greatest Literary Mystery of All Time* (New York: Free Press, 1997), 27.

3. John Ward, *Diary of the Rev. John Ward*, arranged by Charles Severn (London: Colburn, 1839), 56–58.

4. Marchette Chute, *Shakespeare of London* (New York: Dutton, 1949), 320.

5. Gerald Eades Bentley, *Shakespeare: A Biographical Handbook* (New Haven: Yale University Press, 1961), 63.

6. Sir Edmund K. Chambers, *William Shakespeare: A Study of Facts and Problems* (Oxford: Clarendon Press, 1930), 2:173.

7. Edmond Malone, ed., *Supplement to the Edition of Shakespeare's Plays Published in 1778 by Samuel Johnson and George Stevens* (London, 1780), 1:653.

8. James Walter, *Shakespeare's True Life* (London: Longmans, Green, 1890), 386.

9. Joseph William Gray, *Shakespeare's Marriage: His Departure from Stratford and Other Incidents in His Life* (London: Chapman & Hall, 1905), 140–41.

10. John Dowdall, *Traditional Anecdotes of Shakespeare, Collected in Warwickshire in the Year 1693* (London: Thomas Rodd, Great Newport Street, 1838).

11. C[harlotte] C[armichael] Stopes, *Shakespeare's Environment* (London: G. Bell, 1918), 6.

12. H. Snowden Ward and Catharine Weed Ward, *Shakespeare's Town and Times* (London: Dawbarn and Ward, 1896), 137.

13. A. L. Rowse and John Hedgecoe, *Shakespeare's Land: A Journey through the Landscape of Elizabethan England* (San Francisco: Chronicle Books, 1987), 190.

14. James Joyce, *Ulysses*, ed. Hans Walter Gabler (New York: Vintage Books, 1986), 166–69.

15. Samuel Neil and F. W. Fairholt, *The Home of Shakespeare* (London: Chapman and Hall, 1847), 22–23.

16. Mark Eccles, *Shakespeare in Warwickshire* (Madison: University of Wisconsin Press, 1961), 164–65.

17. Schoenbaum, *William Shakespeare*, 247.

18 Frederick George Emmison, *Elizabethan Life: Morals and the Church Courts* (Chelmsford: Essex County Council, 1973), 31.

19. E. Vine Hall, *Testamentary Papers II: Wills from Shakespeare's Town and Time*, 2nd series (London: Mitchell Hughes and Clarke, 1933). Cited in Joyce Rogers, *The Second Best Bed: Shakespeare's Will in a New Light* (Westport, CT: Greenwood Press, 1993), 77.

20. James O. Halliwell-Phillipps, *Outlines of the Life of Shakespeare*, 10th ed. (London: Longmans, 1898), 1:259. Cited in Rogers, *The Second Best Bed*, 77.

21. Cited by Schoenbaum, 302–3, who in turn cites G. R. Potter, "Shakespeare's Will and Raleigh's Instructions to His Son," *Notes and Queries* (1930), 364. The passage, as Schoenbaum notes, appears in Raleigh's posthumous "Remains."

22. Sir William Blackstone, *Commentaries on the Laws of England: A Facsimile of the First Edition of 1765–1769,* vol. 2: *Of the Rights of Things* (1766), intro. by A. W. Brian Simpson (Chicago: University of Chicago Press, 1979), 492–93.

23. Ibid, 425.

24. Rogers, *The Second Best Bed,* xvii.

25. Robert Nye, *Mrs. Shakespeare, The Complete Works* (London: Sinclair-Stevenson, 1993), 212.

26. Caryl Brahms and S. J. Simon, *No Bed for Bacon* (New York: Thomas Y. Crowell, 1941, 1950), 24.

27. Reginald Reynolds, *Beds* (London: Andre Deutsch, 1952), 142.

28. *Pillow Talk,* 1959. A film called *Twin Beds,* a comedy about a neighbor constantly interrupting a married couple, appeared in 1942.

29. Alecia Beldegreen, *The Bed* (New York: Stewart, Tabori and Chang, 1991), 36.

30. Paul Popenoe, cited in Reynolds, *Beds,* 139.

31. Reginald Sharpe, Kansas City *Evening Standard,* December 13, 1950. Quoted in Reynolds, *Beds,* 141.

32. Groucho [Julius H.] Marx, *Beds* (Indianapolis and New York: Bobbs Merrill, 1930), 26.

33. Parker Tyler, *A Pictorial History of Sex in Films* (Secaucus, NJ: Citadel Press, 1974), 61.

34. Howard Fineman and Michael Isikoff, "Strange Bedfellows," *Newsweek,* March 10, 1997, 22–28.

35. Richard Lacayo, "Step Right Up," *Time,* March 1997, 34.

36. "Still Around: Ghosts of Lincoln and His Era," in *New York Times,* February 13, 1987, A18.

37. Plato, *Republic* X, trans. Benjamin Jowett, in David H. Richter, *The Critical Tradition: Classic Texts and Contemporary Trends* (New York: St. Martin's, 1989), 22–23.

38. Jacques Lacan, *Seminar II: The Ego in Freud's Theory and in the Technique of Pyschoanalysis, 1954–55,* trans. Sylvana Tomaselli, notes by John Forrester (New York: Norton; Cambridge: Cambridge University Press, 1988), 164.

39. *Republic,* trans. Paul Shorey, in *Plato, The Collected Dialogues,* ed. Edith Hamilton and Huntington Cairns (New York: Pantheon, 1961), 821.

40. From Marie Bonaparte's notes, cited by Gay: "Madame Freud informed me that the analytic couch (which Freud would import to London) was given to him by a grateful patient, Madame Benvenisti, around 1890." Peter Gay, *Freud: A Life for Our Time* (New York and London: Norton, 1988), 103.

41. Gay, *Freud,* 171.

42. Ibid., 427.

43. Ibid., 635.

44. Diana Fuss and Joel Sanders, "Berggasse 19: Inside Freud's Office," in *Stud*, ed. Sanders (Princeton: Princeton Architectural Press, 1996). See also Sigmund Freud, "Papers on Technique," in *The Standard Edition of the Complete Psychological Works of Sigmund Freud,* ed. James Strachey (London: Hogarth Press, 1953), 12:139.

45. Freud, "Papers on Technique," 12, 133. Fuss and Sanders, "Berggasse 19," 129.

46. Fuss and Sanders, book proposal for MIT Press, "Berggasse 19: Inside Freud's Office."

47. Henry James, "The Birthplace," *The Jolly Corner and Other Tales* (London: Penguin, 1990), 122.

48. See, for example, Samuel Neil, *The Home of Shakespeare* (Warwick: Henry T. Cooke and Son, 1888), 19. Neil quotes Douglas Jerrold, from James O. Halliwell-Phillipps, *The Life of William Shakespeare* (London: J. R. Smith, 1848), 39.

49. Gary Taylor, *Reinventing Shakespeare* (New York: Weidenfeld and Nicolson, 1989), 261–62. A 1927 Prague production had presented a "prominent bed" and Gertrude in her nightgown.

50. This view is put forward by Otto Rank, *Das Inzest-Motiv in Dichtung und Sage* (Leipzig: Franz Denticke, 1912).

51. Freud, *The Interpretation of Dreams*, in *Standard Edition*, 4:266.

52. Stephen Daedalus makes the same biographical assumptions: "Is it possible that the player Shakespeare, a ghost by absence, and in the vesture of buried Denmark, a ghost by death, speaking his own words to his own son's name (had Hamnet Shakespeare lived he would have been prince Hamlet's twin), is it possible, I want to know, or probable that he did not draw or foresee the logical conclusion of those premises: you are the dispossessed son: I am the murdered father: your mother is the guilty queen, Ann Shakespeare, born Hathaway?" Joyce, *Ulysses*, 155.

53. Ernest Jones, *Hamlet and Oedipus*, rev. ed. (New York: W. W. Norton, 1949), 121.

54. Freud, *Interpretation of Dreams*, 266 n.

55. Freud, *An Autobiographical Study* (1925), *Standard Edition*, 20: 63–64 n.

56. Marjorie Garber, *Shakespeare's Ghost Writers* (New York: Metheun, 1987).

57. Freud, *An Autobiographical Study*, 34.

58. "I was the first," Freud insists, asserting his own primacy over Adler and Jung, "to recognize both the part played by phantasies in symptom-formation and also the 'retrospective phantasying' of late impressions into childhood and their sexualization after the event." Sigmund Freud, "From the History of an Infantile Neurosis," *Standard Edition*, 17:103 n.

59. Freud, "The Goethe Prize" (1930), trans. Angela Richards, *Standard Edition*, 21:211.

60. Letter from Freud to John Looney, June 1938, in J. Thomas Looney, *"Shakespeare" Identified as Edward de Vere the 27th Earl of Oxford*, 3rd ed., ed. and augmented by Ruth Loyd Miller (Port Washington, NY: Kennikat Press, 1975), 2:273.

CONTRIBUTORS

Tom Conley is Professor of French in the Department of Romance Languages at Harvard University. He is the author of *Film Hieroglyphics: Ruptures in Classical Cinema* (1991), *The Graphic Unconscious: The Letter of Early Modern French Writing* (1992), and *Self-Made Map: Cartographic Writing in Early Modern France* (1996). He has translated Gilles Deleuze's *The Fold: Leibniz and the Baroque* (1993) and Michel de Certeau's *The Writing of History* (1988), *Culture in the Plural* (1997), and *The Capture of Speech and Other Political Writings* (1997), and is an editor of *French Culture, 1900–1975* (1995) and *Identity Papers: Contested Nationhood in Twentieth-Century France* (1996).

Margreta de Grazia, Professor of English at the University of Pennsylvania, is the author of *Shakespeare Verbatim: The Reproduction of Authenticity and the 1790 Apparatus* (1991), and editor of *Subject and Object in Renaissance Culture* (1996). She has written a number of influential articles on Shakespeare and the history of language and print and is currently at work on a book entitled *Unmodernizing the Early Modern.*

Marjorie Garber is William R. Kenan Jr. Professor of English and Director of the Center for Literary and Cultural Studies at Harvard University. She is the author of *Dream in Shakespeare: From Metaphor to Metamorphosis* (1974), *Coming of Age in Shakespeare* (1981), *Shakespeare's Ghost Writers: Literature as Uncanny Causality* (1987), *Vested Interests: Cross-Dressing and Cultural Anxiety* (1991), *Vice Versa: Bisexuality and the Eroticism of Everyday Life* (1995), *Dog Love* (1996), *Symptoms of Culture* (1998), *Sex and Real Estate* (2000), and *Academic Instincts* (2000).

Jonathan Goldberg is Sir William Osler Professor of English at Johns Hopkins University. He is the author of *Endlesse Worke: Spenser and the*

Structures of Discourse (1981), *James I and the Politics of Literature: Jonson, Donne and Their Contemporaries* (1983), *Voice Terminal Echo: Postmodernism and English Renaissance Texts* (1986), *Writing Matters: From the Hands of the English Renaissance* (1990), and *Sodometries: Renaissance Texts, Modern Sexualities* (1992). He coedited *John Milton* (1991) with Stephen Orgel, and was also the editor of *Queering the Renaissance* (1994), *Reclaiming Sodom* (1994), and *Desiring Women Writing: English Renaissance Examples* (1997).

John Guillory is Professor of English Literature at New York University. He is the author of *Poetic Authority: Spenser, Milton, and Literary History* (1983) and *Cultural Capital: The Problem of Literary Canon Formation* (1993).

David Hillman is training to become a child psychotherapist at the Tavistock Centre in London. He is the coeditor (with Carla Mazzio) of *The Body in Parts: Fantasies of Corporeality in Early Modern Europe* (1997), editor of *Authority and Representation in Early Modern England*, by Robert Weimann (1996), and coeditor (with William West) of the forthcoming *Shakespeare and the Power of Mimesis*, also by Weimann. He is currently completing a book entitled *Shakespeare's Entrails: Solitude, Skepticism, and the Interior of the Body*.

Ann Rosalind Jones is Esther Cloudman Dunn Professor of Comparative Literature at Smith College. She is the author of *The Currency of Eros: Women's Love Lyric in Europe 1540–1620* (1990) and the coauthor (with Peter Stallybrass) of the forthcoming *Renaissance Clothing and the Materials of Memory*. She also coedited a special issue of *Women's Studies* (1992) with Betty Travitsky.

Jeffrey Masten is Professor of English at Northwestern University. He is the author of *Textual Intercourse: Collaboration, Authorship, and Sexualities in Renaissance Drama* (1996). He has edited *The Old Law*, which will appear in Oxford's *Collected Works of Middleton*, and he is an editor (with Nancy Vickers and Peter Stallybrass) of *Language Machines: Technologies of Literary and Cultural Production* (1997). His current work is on the philology of sex in early modern England.

Katharine Eisaman Maus, Professor of English at the University of Virginia, was awarded the Roland Bainton Book Prize for *Inwardness*

and Theater in the English Renaissance (1995), and is the author of *Ben Jonson and the Roman Frame of Mind* (1984). She is an editor of *The Norton Shakespeare* (1997), the editor of *Four Revenge Tragedies* (1995), and a coeditor (with Elizabeth D. Harvey) of *Soliciting Interpretation: Literary Theory and Seventeenth Century English Poetry* (1990).

Carla Mazzio is Assistant Professor of English at the University of Michigan and member of the Michigan Society of Fellows. She is coeditor (with David Hillman) of *The Body in Parts: Fantasies of Corporeality in Early Modern Europe* (1997) and coeditor (with Susan R. Suleiman, Alice Jardine, and Ruth Perry) of *Social Control and the Arts: An International Perspective* (1991). She has published in *Modern Language Studies* and *Studies in English Literature*, and is currently completing a book entitled *The Inarticulate Renaissance*. She will begin teaching at the University of Chicago in 2001.

Karen Newman is Professor of English and Comparative Literature at Brown University and author of *Shakespeare's Rhetoric of Comic Character: Dramatic Convention in Classical and Renaissance Comedy* (1985), *Fashioning Femininity and English Renaissance Drama* (1991) and *Fetal Positions: Individualism, Science, Visuality* (1996). Her essay for this volume is part of a book in progress on cultural fantasy and urban space in early modern France.

Kathryn Schwarz is Assistant Professor of English at Vanderbilt University. She has published work in *Shakespeare Studies*, *Studies in English Literature*, and several anthologies, and is finishing a book entitled *Mankynde Women: Amazon Encounters in the English Renaissance*, forthcoming from Duke University Press.

James R. Siemon is Professor of English at Boston University. He is the author of *Shakespearean Iconoclasm* (1985), the editor of the New Mermaid *Jew of Malta*, and the editor of the forthcoming Arden edition of *Richard II*. His forthcoming book, *Word Against Word,* is about social distinction and dialogic relationships in early modern literature and culture.

Peter Stallybrass is Professor of English and a member of the Program in Comparative Literature and Literary Theory at the University of Pennsylvania. He is coauthor (with Allon White) of *The Politics and Poetics of*

Transgression (1986), and (with Ann Rosalind Jones) of the forthcoming *Renaissance Clothing and the Materials of Memory*, coeditor (with David Scott Kastan) of *Staging the Renaissance* (1991), coeditor (with Margreta de Grazia and Maureen Quilligan) of *Subject and Object in Renaissance Culture* (1996), and coeditor (with Jeffrey Masten and Nancy Vickers) of *Language Machines: Technologies of Literary and Cultural Production* (1997). He is presently completing a collection of essays on English Renaissance cultural politics.

Douglas Trevor is Assistant Professor of English at the University of Iowa. He has published on Montaigne, has work forthcoming on Donne, and is finishing a book entitled *The Reinvention of Sadness: Scholarly Method and Melancholy in Early Modern England*.

Eric Wilson is an Assistant Professor of English at Washington and Lee University. He has published work in *Modern Language Studies* and has just completed his dissertation on education and edification in early modern London.

INDEX